*Talmudic Stories*

# Talmudic Stories
## Narrative Art, Composition, and Culture

Jeffrey L. Rubenstein

The Johns Hopkins University Press
*Baltimore & London*

© 1999  The Johns Hopkins University Press
All rights reserved. Published 1999
Printed in the United States of America on acid-free paper
2 4 6 8 9 7 5 3 1

The Johns Hopkins University Press
2715 North Charles Street
Baltimore, Maryland 21218-4363
www.press.jhu.edu

Library of Congress Cataloging-in-Publication Data will be found
at the end of this book.
A catalog record for this book is available from the British Library.

ISBN 0-8018-6146-2

*To my father*

# Contents

*Preface* ix
*Acknowledgments* xi
*Abbreviations and Conventions* xiii
*Tractates* xv

Chapter 1
## Introduction    1

Chapter 2
## Torah, Shame, and "The Oven of Akhnai" (Bava Metsia 59a–59b)    34

Chapter 3
## Elisha ben Abuya
Torah and the Sinful Sage (Hagiga 15a–15b)    64

Chapter 4
## Torah and the Mundane Life
The Education of R. Shimon bar Yohai (Shabbat 33b–34a)    105

Chapter 5
## Rabbinic Authority and the Destruction of Jerusalem (Gittin 55b–56b)    139

Chapter 6
## Torah, Lineage, and the Academic Hierarchy (Horayot 13b–14a)    176

Chapter 7
## Torah, Gentiles, and Eschatology (Avoda Zara 2a–3b)    212

Chapter 8
## Conclusion    243

Appendix: Hebrew/Aramaic Texts    283
Notes    297
Selected Bibliography    407
General Index    417
Source Index    427

# Preface

This book is about the stories of the Babylonian Talmud: How should we understand them? Where do they come from? Why are they in the Talmud? How do they relate to talmudic law? The six central chapters offer detailed analyses of six famous talmudic stories and discuss many other stories in relation to them. The main texts include the story of the "Oven of Akhnai," where the sages reject God's intervention in the legal process; the story of Elisha b. Abuya or "Aher," the Other; the story of R. Yohanan b. Zakkai's escape from Jerusalem and encounter with the Roman general Vespasian; and the story of R. Shimon bar Yohai and his thirteen-year sojourn in the cave.

The book is intended for scholars of Talmud, rabbinic literature, and late antiquity, as well as for the general audience interested in prominent tales of the sages. I have tried to confine technical discussions to the notes and to avoid as much jargon as possible. Chapter 1, which reviews previous scholarship and discusses methodological considerations, is primarily for scholars. The wider audience may wish to skip this chapter (or to read only the first few pages, which provide an overview) and proceed immediately to the stories. The main sections of Chapters 2–7, the literary analyses of the stories, will have the most appeal for the general reader. Discussions of earlier sources and compositional techniques will be of more interest to scholars; these sections can be skimmed or skipped without loss. The latter parts of each chapter, devoted to the wider contexts of the stories, should be of interest to both audiences.

All rabbinic texts have been translated into English. I have provided Hebrew/Aramaic texts of the main stories at the end of the book for those who prefer to work with the original language. The texts follow manuscript traditions and may deviate from the versions found in standard printings of the Talmud.

# *Acknowledgments*

It is a great pleasure to acknowledge the teachers and colleagues who have contributed to my thinking and share credit for whatever is of virtue in this book. David Weiss-Halivni, Shamma Friedman, and Ofra Meir, three of the main scholars upon whose work I build, gave generously of their time and wisdom. They discussed issues with me at length, read drafts of chapters, made numerous helpful suggestions, and patiently heard me out even when my views departed from their own. I thank them for encouraging my research and guiding me in the proper direction.

My colleagues Lawrence Schiffman and Michael Satlow read an earlier draft of the manuscript. I am grateful to them for their attentive reading and extensive comments. They forced me to clarify my ideas, saved me from errors, and are responsible for numerous improvements in both organization and content. Many other scholars read individual chapters and provided insightful comments and criticisms: Aharon Amit, Michael Berger, Robert Chazan, Shaye Cohen, Hasia Diner, Ari Elon, Yaakov Elman, David Greenstein, Christine Hayes, Jay Harris, Martin Jaffee, Richard Kalmin, Jonathan Klawans, Baruch Levine, Joshua Levinson, Francis Peters, Jay Rovner, Seth Schwartz, and Elliot Wolfson. I thank them for sharing of their knowledge.

I am grateful to my colleagues in the Skirball Department of Hebrew and Judaic Studies, New York University, for their encouragement and support. I was fortunate to have had the opportunity to discuss with them many issues relating to my work. I thank Robert Chazan and Lawrence Schiffman, the former and current chairpersons of the department, for creating a fertile environment for scholarship and making available the resources at their disposal. I am also much indebted to the graduate students

of my Talmud seminars with whom I studied these texts and tested my readings.

Earlier versions of several chapters appeared in the following journals, and I thank the editors for permission to reprint and revise them here: "Elisha ben Abuya: Torah and the Sinful Sage," *Journal of Jewish Thought and Philosophy* 7 (1998), 141–222 (=Chapter 3); "Bavli Gittin 55b–56b: An Aggada and its Halakhic Context," *Hebrew Studies* 38 (1997), 21–45 (=Chapter 5); "An Eschatological Drama: Bavli Avodah Zarah 2a–3b," *Association for Jewish Studies Review* 21:1 (1996), 1–37 (=Chapter 7).

I warmly thank all of my family, relatives, and friends for their support. My mother, father, brother, and extended family have given me unceasing encouragement and love: Denise, Arthur, Errol, Evelyn, Milton, Ronald, Miriam, Shulie, Rena, Talia, Sarah, Gili, Dani, Miri, Tracey, Ivor, Maureen, and even Ezra.

My wife, Mishaela, has been a constant source of love, support, and devotion. She believed in the project even when I had my doubts. Without her I would not have so greatly enjoyed the enterprise.

Talmudic stories tell of the sages struggling to balance the demands of their vocation, the study of Torah, with their other responsibilities. My father, Dr. Arthur H. Rubenstein, always satisfied both the demands of his vocation, the practice of academic medicine, and his responsibilities to his family, friends, and community, despite some extremely trying circumstances. He is admired by colleagues, students, and patients and loved by family and friends. This book is dedicated to him.

# Abbreviations and Conventions

Full bibliographic information for the editions listed below appears in the Selected Bibliography.

References to rabbinic texts provide the page numbers of the editions used in parentheses following the citation. Thus *SifNum* §150 (196) = *Sifre* to Numbers, paragraph 150, p. 196 in Horovitz's edition.

All translations of rabbinic texts are my own unless otherwise indicated. Translations of biblical verses are from the New Jewish Publication Society translation, although I have freely modified them when needed.

Hebrew transliteration is phonetic: '=א '=ע, q=ק, kh=כ, ts=צ. The letter *t* signifies both ת and ט, *h* signifies both ה and ח, *s* signifies both ס and ש. The *dagesh* is generally not represented. When a philological point is at issue w=ו, ḥ=ח and ṣ=צ.

| | |
|---|---|
| *AJSR* | *Association for Jewish Studies Review* |
| ANRW | Aufstieg und Niedergang der Römischen Welt |
| ARN | '*Avot derabbi natan* |
| *ARNA* | '*Avot derabbi natan*, version Λ (ed. S. Schechter) |
| *ARNB* | '*Avot derabbi natan*, version B (ed. S. Schechter) |
| b | Bavli (Babylonian Talmud) |
| b. | ben, bar (=son of) |
| BT | Babylonian Talmud |
| *DQS* | *Diqduqei sofrim*, ed. Rabbinovicz. For *Seder Nashim*, ed. Avraham Liss |
| *EY* | '*Ein ya'akov* |
| GenR | Genesis Rabba (=*Midrash bereshit rabba*, eds. J. Theodor and H. Albeck) |
| *HTR* | *Harvard Theological Review* |

| | |
|---|---|
| HUCA | *Hebrew Union College Annual* |
| JBL | *Journal of Biblical Literature* |
| JJS | *Journal of Jewish Studies* |
| JQR | *Jewish Quarterly Review* |
| JPS | Jewish Publication Society |
| JSHL | *Jerusalem Studies in Hebrew Literature* |
| JSJ | *Journal for the Study of Judaism* |
| LamR | Lamentations Rabba (ed. S. Buber) |
| LevR | Leviticus Rabba (=*Midrash vayiqra rabba*, ed. Margulies) |
| m | Mishna |
| Maharsha | Commentary of Samuel Edels, printed in standard editions of the Talmud |
| *MidTan* | *Midrash tannaim* to Deuteronomy (ed. Hoffman) |
| ms, mss | manuscript, manuscripts |
| OG | '*Otsar hageonim* (ed. B. Lewin) |
| PT | Palestinian Talmud. First printing, Venice, 1523 (reprint: Leipzig, 1925). |
| PAAJR | *Proceedings of the American Academy for Jewish Research* |
| PRE | *Pirqei derabbi 'eliezer* |
| PRK | *Pesiqta derav kahana* (ed. Mandelbaum) |
| QohR | Qohelet Rabba (Vilna printing) |
| R. | Rabbi (Palestinian sages are usually designated as "Rabbi"; Babylonians as "Rav") |
| RSBG | Rabban Shimon ben Gamaliel |
| RSBY | Rabbi Shimon bar Yohai |
| RuthR | Ruth Rabba (ed. M. Lerner) |
| SongR | Song of Songs Rabba (Vilna printing) |
| *SifDeut* | *Sifre* to Deuteronomy (ed. L. Finkelstein) |
| *SifNum* | *Sifre* to Numbers (ed. H. Horovitz) |
| t | Tosefta (ed. S. Lieberman or M. Zuckermandel) |
| *Tanhuma* | *Midrash Tanhuma* (nidpas) |
| *TanhumaB* | *Midrash Tanhuma* (ed. S. Buber) |
| TK | *Tosefta Kifshuta* (Lieberman) |
| var | variant reading |
| WCJS | *World Congress of Jewish Studies* |
| y | Yerushalmi (Palestinian Talmud) |

# Tractates

References to tractates are preceded by b (=Babylonian Talmud), y (= Yerushalmi or Palestinian Talmud), t (=Tosefta), or m (=Mishna). Thus bNaz 35a refers to Babylonian Talmud, Tractate Nazir, folio 35a, and tBer 6:5 refers to Tosefta, Tractate Berakhot, chapter 6, paragraph 5.

| | | | |
|---|---|---|---|
| Ah | ʾAhilot | Makh | Makhshirin |
| Ar | ʿArakhin | Me | Meʿila |
| AZ | ʿAvoda Zara | Meg | Megilla |
| BB | Bava Batra | Men | Menahot |
| Bekh | Bekhorot | Mid | Middot |
| Ber | Berakhot | MQ | Moʿed Qatan |
| Bes | Besa | MS | Maʿaser Sheni |
| Bik | Bikkurim | Naz | Nazir |
| BM | Bava Metsia | Ned | Nedarim |
| BQ | Bava Qama | Nid | Nidda |
| De | Demai | Par | Para |
| Ed | ʿEduyot | Pe | Peʾa |
| Eruv | ʿEruvin | Pes | Pesahim |
| Git | Gittin | Qid | Qiddushin |
| Hag | Hagiga | RH | Rosh Hashana |
| Hal | Halla | Sanh | Sanhedrin |
| Hul | Hullin | Shab | Shabbat |
| Kel | Kelim | Sheq | Sheqalim |
| Ket | Ketubot | Shev | Sheviʿit |
| Kil | Kilayim | Shevu | Shevuʿot |
| Ma | Maʿaserot | Sot | Sota |
| Mak | Makkot | Suk | Sukka |

| | | | |
|---|---|---|---|
| Ta | Ta'anit | Yad | Yadayim |
| Tam | Tamid | Yev | Yevamot |
| Ter | Terumot | Yom | Yoma |
| Toh | Tohorot | Zev | Zevahim |

# Talmudic Stories

# Chapter 1

## *Introduction*

R. Abba said Shmuel said:
The House of Hillel and the House of Shammai disputed for three years. These said, "The Law (*halakha*) is according to us," and those said, "The Law is according to us." A heavenly voice went forth and said, "Both these and those are the words of the living God. But the Law follows the House of Hillel."

And since "These and those are the words of the living God," why did the House of Hillel merit that the law be established according to their [words]?

Because they were pleasant and modest, and they would teach their words and the words of the House of Shammai. Not only that, but they would mention the words of the House of Shammai before their own words. (Babylonian Talmud, Eruvin 13b)

This well-known story of a heavenly voice that resolved an intractable human conflict raises a number of questions. How does the Torah of "the living God" include two contradictory opinions, two mutually exclusive rulings? Does Shmuel mean that conflicting interpretations are equally "true"? If so, why not accept both opinions as valid practices; why decide one way or the other? An anonymous interlocutor already articulated the major puzzle: why should the law follow the House of Hillel? Yet the answer, stated by another anonymous voice, invites further probing. Why should character or disposition be related to legal primacy? Why specifically the traits of pleasantness and modesty rather than brilliance,

intuition, or patience? What motivated the Hillelites to preserve the words of Torah of the Shammaites, and why does this redound so greatly to their credit?

Turning from narrative content to composition provokes additional questions. Who are the anonymous voices responsible for the discussion of Shmuel's statement? Is this a later, secondary development? In other words, would Shmuel himself have given or approved of this solution? If not, do we have two competing visions of authority—that Shmuel attributes Hillelite supremacy to arbitrary divine fiat, whereas later anonymous sages insist on the importance of character? These considerations in turn trigger questions about the cultural matrix in which the story was produced. What institutional setting explains the emphasis on pleasantness and modesty? Does the portrait of the Hillelites preserving their opponents' opinions reflect the values and enterprises of those anonymous voices? What was the purpose of the talmudic redactors who preserved and transmitted this story? And why did they include it in this section of Tractate Eruvin?

This book attempts to answer such questions through detailed study of six of the longer stories of the Babylonian Talmud (=BT). Each chapter applies three interrelated modes of analysis. First, a literary analysis elucidates the narrative art, structure, and principal tensions of the story. Second, the story's composition and antecedent sources are assessed, together with its redactional setting within the the larger literary unit of talmudic discourse (*sugya*). Third, the story is located within the general cultural context of the talmudic redactors by coordinating the major tensions and themes with those found in other talmudic sources.

The basic argument of the book is as follows. The redactors of the BT constructed stories by reworking earlier narrative sources in the same way as they reworked earlier legal traditions to fashion talmudic *sugyot*. To understand the stories they created it is profitable to use the critical methods appropriate for both the genre of the material and the redactional process. Literary analysis, which attends to the narrative art and rhetorical tendencies of didactic stories, should be combined with source-criticism and redaction-criticism, which recognize the composite, multitiered nature of the talmudic text. Analysis of talmudic stories along these lines opens a window to the cultural world of the redactors. Their primary value was the study of Torah for its own sake, and they pursued their studies in the rabbinic academy, a highly structured scholastic institution. The stories they created express the tensions inherent in the Torah-centered worldview and the conflicts that arise between Torah study and other values. At the heart of each story is the enterprise of integrating aspects of rabbinic culture with

the dominant value of Torah as a pattern of life and a path to the holy. Like the legal discourses of the BT, the stories generally do not offer simple conclusions. They provide the sages a way to ponder the tensions inherent in their culture, not an easy means of resolving them.

This introductory chapter discusses the central issues relating to the two major trends in rabbinic scholarship upon which my work is founded. The first is the understanding of rabbinic stories as didactic tales rather than reliable historical accounts. The second is the recognition of the literary character and compositional process of the Babylonian Talmud. After summarizing these advances in critical scholarship, I will discuss my methods and goals in more detail, set forth some assumptions, and define important terms.

## The Rabbinic Story: Historical Account or Didactic Tale?

Rabbinic literature contains hundreds of stories about rabbinic sages and other historical figures who lived during the second temple and rabbinic periods. These stories appear in compilations redacted long after the events reported. The Babylonian Talmud, for example, redacted in the fifth through seventh centuries C.E., contains traditions about the Tannaim who flourished in the first two centuries C.E. This temporal distance raises questions about the reliability of the sources. Do later compilations preserve accurate records of events that occurred centuries earlier? Even if the redaction of the text was roughly contemporaneous with the event described, can we trust that the authors had accurate information? If not, what are we to make of this massive literature?

From the beginnings of the academic study of Judaism in the nineteenth century (*Wissenschaft des Judentums*) until recently, scholars considered such stories as reliable historical sources. Rabbinic stories supplied a mine of data that could be used to reconstruct the Jewish past. While scholars recognized the exaggerated, legendary, and contradictory aspects of the stories, they believed that behind the trappings lay a "historical kernel" that could be discerned through discriminating critical analysis. These assumptions produced an odd paradox: scholars read less and less of the content of stories, ignoring layers of legendary accretion corrupting the pure historical core. Yet they managed to compose complete biographies of sages and detailed reconstructions of rabbinic history by harmonizing the remains and adding a healthy dose of imagination. The results were predictably subjective: one historian's kernel was another's husk.

Jacob Neusner demonstrated the flaws of this method on a systematic,

principled basis.[1] Neusner and his students collected traditions about the sages and made two crucial observations. First, different traditions found in different rabbinic documents—sometimes in the same document—irreconcilably contradicted each other, and no methodological criteria enabled the scholar to distinguish true history from fiction. Second, later texts consistently embellished stories from earlier sources. Previous scholars tended to consider all versions as divergent, but fundamentally reliable, accounts of the same historical event. Neusner showed that the later versions were not independent historical testimonies but resulted from the nature of the transmission process. As stories were passed down from one generation to another they were changed, expanded, and combined with other traditions. This revolutionary approach called into question not only the results of previous histories of the rabbinic period but also the basic viability of the project.

Neusner combined this methodological criticism with skepticism regarding the accuracy of attributions and the traditions in general. Even the earliest versions of traditions could not be trusted because they appear in sources redacted many years after the events. Traditions found in the Mishna, edited about 200 C.E., were of questionable worth in reconstructing the lives of the Pharisees or early rabbis who lived in the first century. Only credulous historians, in Neusner's view, consider factual the traditions found in the BT, which reached completion only in the seventh century, about the sages who flourished in the third through fifth centuries. If scholars who believe that King David said and did all the things the Bible claims he said and did are considered gullible, so too scholars who believe rabbinic traditions about Hillel, Akiba, or Rabbi Zeira. Such credulity also fails to appreciate the functions of biographical traditions to model behavior, create group identity, and provide founding myths. Neusner concluded that biographical traditions were not historical testimonies but stories told by later sages for didactic and theological purposes. Rather than use stories to reconstruct the historical events and biographies described in the stories, Neusner studied the "development of tradition," the process of accretion and transformation that took place over time.

The old, historically oriented method destroyed, Neusner's strictures left open the question of how this literature should be studied. Together with his diachronic approach Neusner applied a type of structuralist literary analysis popular among the literary critics of the times. He emphasized the structure of the story as the key to its meaning, but he skimmed over details of the plot, narrative technique, use of language, and other literary considerations. His basic interests were consistently historical, and he attempted

to place his structural analyses in historical and social contexts. Essentially Neusner shifted the historical context from that of the characters within the stories to that of the storytellers who told them. Neusner was not a literary critic and perhaps should not be faulted for neglecting to appreciate the rich narrative art of rabbinic stories. Yet for all his awareness of the literary processes that governed the transformation of traditions, he made only rudimentary beginnings in describing the literary characteristics of the sources themselves. Despite Neusner's voluminous writing, the genre, narrative art, and literary traits of rabbinic stories remained to be explored.[2]

## Rabbinic Story and Biography in Late Antiquity

The rabbinic story was a product of late antique culture, so the characteristics of late antique literature, especially history and biography, are relevant to its proper understanding.[3] Yet the historians Neusner attacked rarely attempted to place the rabbinic story in a wider literary context. Influenced by the dominant methods and interests of their times, they sought history—to know "what actually happened"—and they assumed that the rabbis had a similar investment in the historical record. This nineteenth-century concept of history, however, certainly does not characterize the ancients' attitudes toward the past, nor that of most premodern cultures.[4] The distinctions between historical "truth," verisimilitude, and outright fiction were blurred in classical history-writing, for the authors were interested in teaching morals, demonstrating a thesis, or the need to supply a past where no information existed. By assuming that rabbinic stories were transmitted to report historical events as they "actually happened," these historians committed a grave anachronism.[5] But there is an even more basic issue. Before asking about the nature of ancient history-writing and how it differs from modern conceptions, one must ask whether the literary work at hand is indeed history. Classical authors themselves drew a distinction between the genres of history and biography.[6] And whatever the extent to which ancient historians strove for "truth" and historical accuracy, ancient biographers operated with different conventions and goals.

Even as Jewish historians pursued their historical reconstructions, some classicists and literary historians began to investigate the genre of the rabbinic story against its late antique background.[7] Classical literature exhibited a variety of genres and literary forms: satire, parody, fable, romance, anecdote, oration, thesis, biography. Should rabbinic stories be identified with one of these? To mistake the genre of a literary work inevitably produces misinterpretation. One who fails to recognize satire as satire

misses the point entirely, to say nothing of one who takes a fable relating the interactions of two animals as realistic description. Henry Fischel questioned whether the historians properly understood the genre of their rabbinic sources: "Before any effort is made to utilize materials of rhetorical coloration, whether Greco-Roman or Near Eastern, for historiography or biography, the question of the literary genre of the material must be clarified."[8] He pointed out that some rabbinic stories with a clever sage, dense antagonist and didactic punch resemble Roman fables. Why could later sages not have used earlier masters rather than animals as characters? If so, then a story about Hillel and Shammai is of no greater historical worth than a fable of the fox and the hare.[9]

Rabbinic stories are predominantly biographical in that they focus on the lives and deeds of sages and other important figures. Even stories that mention historical events such as the destruction of the temple concentrate less on the incident per se than on the sages who played important roles in the conflict. Hence it is well worth considering genres of biographical writing in late antiquity when assessing the nature of the rabbinic story. The main difference between late antique biographies proper (*bioi*) and rabbinic stories is that the former are typically much longer, often relating the lives of a hero from birth to death, while the latter are terse, generally reporting a single episode of the subject's life. Yet we do find shorter biographical sketches in classical literature, such as some of the *Lives of the Philosophers* of Diogenes Laertes, as well as other brief biographical forms, while rabbinic texts occasionally feature composite accounts that encompass several encounters.[10] Moreover, ancient biographers worked with anecdotal sources reporting individual events and sayings, such as the *chria* discussed below. Biographers collected these sources from anthologies and handbooks, and then wove them into longer biographical narratives.[11] These sources of classical biographers resemble rabbinic stories in many respects.

Ancient biographers did not intend to present the "true" life of their subject—the life as actually lived, the "what actually happened" of the nineteenth-century historical vision. They sought "truth" in a different sense, the eternal truths that the meaning of the life of their subject held for others. The biographers constructed their subjects such that the lives embodied the values they wished to impart to their audience. They attempted to make the famous men about whom they wrote appear great by portraying the ideal life and the exemplary character. Patricia Cox observes that late antique authors themselves did not really claim historical accuracy but that the events they recorded "could have been true" or should have been true.[12]

Biographers had various social and political purposes—moral instruction, entertainment, propaganda, social criticism, behavioral modeling—and their goals and imaginative powers determined their product. As Cox writes, "We know that biography functioned in a literary sense by mythologizing a man's life, that is, by using fiction to convey truth; and we know that as a literary form biography was suitable to the creation of caricatures, portraits so dominated by the ideals imposed by the biographer that history was distorted, if not actually lost."[13]

Henry Fischel drew attention to the similarities between many rabbinic stories and a particular genre of biographical literature, the *chria* (also known as *exemplum*): a brief anecdote relating the encounters, performances, deeds, and sayings of a wise man.[14] *Chriae* emerged primarily from schools of philosophy and rhetoric, a setting that recalls the rabbinic academy and the master-disciple relationship.[15] These brief anecdotes circulated both orally and in written collections. *Chriae* satirized or criticized sages as often as they depicted their wisdom. They contained well-known proverbs and stock motifs: the sage's beginning as ignorant or impoverished, his foreign provenance, his sudden rise to a position of leadership, and so forth. *Chriae* told of well-known sages and philosophers, but the stories were designed to teach values and social ideals, not to report actual encounters or sayings.[16] Training in rhetoric even required students to invent *chriae* by imaginatively devising narratives in which to place the sayings of wise men or elaborating upon brief outlines with fictive detail.[17] Consequently themes and subthemes were constantly reused and recombined in conjunction with standard plot patterns to create new *chriae*.[18] That these qualities characterize numerous rabbinic stories has important repercussions on how stories should be studied and what we should learn from them. Fischel accordingly suggested that the quest for the "historical Hillel" may be as much of a chimera as the quest for the "historical Socrates" and other wise men who had become the subject of *chriae*.[19] Hence it is not surprising that Fischel and other scholars called attention to stunning parallels between rabbinic and Greco-Roman stories in content and dialogue, not only in form.[20] Likewise the contradictory traditions that Neusner found so frustrating to the historical project characterize classical *chriae* as much as rabbinic sources; both result from different schools shaping material for their own needs.[21]

The rabbinic stories found in Palestinian sources took shape in this cultural milieu. While the stories analyzed here derive from the Babylonian Talmud, a product of Sasanian Persian culture, most are reworkings of ear-

lier stories found in Palestinian sources. Persian historiography and biography, in any case, were much closer to legend and myth than their Hellenistic counterparts, much farther from modern conceptions of these disciplines.[22] Indeed, the fictional nature of late antique historiography and biography characterizes most ancient cultures, not only the classical world. Rabbinic stories, therefore, should not be seen as historical testimonies but as rhetoric that serves the purposes of the storyteller(s). They relate deeds of the sages that "could have happened" and speech that "should have been spoken" according to the storyteller's sensibilities. While rabbinic stories may contain some accurate historical recollections, to retrieve them is not my interest here. My analysis of the rabbinic story, like the analysis of *chriae* and ancient biographies, concentrates on the ideas and values which the story was designed to illustrate.

## Literary Analysis of Rabbinic Stories

Literary critics were not far behind the historians and classicists in recognizing the rhetorical and fictional aspects of rabbinic stories.[23] They brought to the field not only a negative critique of previous scholarship but methods to analyze the stories and recover their meaning. For if the genre of the rabbinic story was fiction or rhetoric and not historiography, then methods to study fiction were the appropriate methods to apply. Rather than try to get behind the story to a historical reality, scholars needed ways to determine the meaning of the extant text. Some form of literary criticism, not historiography, was necessary. In principle, the same approaches that suited prose fiction or even poetry should be suited to rabbinic stories as well.

Jonah Fraenkel almost singlehandedly defined the literary approach to rabbinic stories. The fruits of his labors, analyses of hundreds of rabbinic stories, appear in numerous articles and in his magnum opus, a summa of his work over the previous two decades, *Darkhei ha'aggada vehamidrash* (The Methods of the Aggada and Midrash).[24] These articles and the chapters of this book provide close readings of stories with meticulous attention to the wording, structure, and plot. He also describes the literary devices and characteristics of rabbinic stories, such as paronomasia, irony, and the use of biblical verses.[25] Both in theory and practice, in description and example, Fraenkel laid the groundwork for all subsequent literary analysis of rabbinic stories.

Fraenkel shares Neusner's rejection of all approaches that consider rab-

binic stories as historical testimonia.[26] While Neusner attacks the historical approach on the basis of external considerations such as contradictions among multiple accounts of the same event, Fraenkel focuses on the internal characteristics of the story. To read stories as history, for Fraenkel, is a fundamental category error, a misunderstanding of their genre. The linguistic precision that marks rabbinic stories reflects a process of composition determined by literary-artistic factors, not by attempts to record historical events for posterity. Rabbinic stories present cause and effect in terms of spiritual and metaphysical forces, not the material factors such as political or economic power that underlie "historical" causality. Stories are generally limited to a single event, unaware of time and space beyond their frame. History, on the other hand, places events in a sequence with each situation related to the past and the future in substantive ways. Fraenkel does not deny that numerous historical figures, events and data figure in the stories as "core material." To see that core material as the essence, however, fails to understand the literary-artistic character of the story as shaped by the authors. Stories express the spiritual world of the storytellers, not the real world of the characters.

Fraenkel considers the genre of rabbinic stories to be dramatic rather than lyric or epic. In contrast to epic, there is minimal description of the outside world; in contrast to lyric, little attention to the emotions. As in drama, the rabbinic story emphasizes human reality with its tensions and contradictions.[27] In the rabbinic worldview, ambiguous reality gives rise to tensions and oppositions in human experience which make it difficult to perceive the truth. The hero of most stories is a sage who knows or learns of the true nature of things as opposed to their surface appearance. His (or the audience's) realization comprises the didactic or ideological point of the story. Note that this discussion of the genre of the rabbinic stories invokes not the empirical genres of classical literature but the theoretical genres of literary theory.[28]

Because rabbinic stories are "literary-artistic creations"—that is, fictions—not historical testimonies, Fraenkel insists that they be analyzed with a method appropriate to their highly literary character. To decode the story and uncover its meaning the reader must apply literary analysis. Rabbinic stories always have a well-defined structure, appearing in two parts, three parts, or a chiasm.[29] Formal criteria such as the repetition of words or phrases as well as shifts in content signal the boundaries of the parts. The parts must be understood on the basis of the whole and the whole on the basis of the parts, in what Fraenkel acknowledges is a type of

a "hermeneutic circle." Interpretation therefore requires a detailed structural analysis and careful attention to the language that comprises the building blocks of structure. The reader must also be sensitive to the nuanced use of vocabulary in the dialogue of the characters, which often includes wordplays and double meanings.

A dogmatic principle of Fraenkel's is that stories display "internal and external closure."[30] By "internal closure" Fraenkel means that stories are self-contained units, complete in and of themselves. The story supplies all the information necessary for its interpretation. The end refers back to the beginning, completing the circle and sealing the story in a world of its own.[31] Indeed, this self-contained quality is part of the literary artistry of the rabbinic story. By "external closure" Fraenkel means that each story is independent of a wider narrative framework. One cannot ask what happened before or after the events related in the story, what caused the situation, or what consequences ensued. Nor do stories relate in any way to other stories, even if they portray the same character or address a common theme. Thus stories about a given sage may contradict since each story was created for its own didactic purpose. A story exists in a secluded textual space with no allusion or reference to other texts.

Fraenkel's method, then, is essentially that of the New Criticism, the school of literary criticism that flourished in the 1940s and 1950s.[32] Opposing the positivist historical orientation of the prevailing literary criticism, the New Critics minimized the importance of authorship and historical context in order to concentrate on "the text itself." The meaning of a poem or story, they argued, inheres in the text, not in the historical background, the social setting, the personality or even the explicit purposes of the author. That meaning emerges through a close reading that identifies the structure, determines the plot, describes the characters and analyzes literary devices.[33] Similarly, Fraenkel generally confines his analysis to the contours of the story, its structure, literary devices, and internal character. The result: a New Critical reading of "the rabbinic story itself."[34]

Fraenkel must be acclaimed for the scope of his work, the depth of his analysis, and his success in defining and describing the literary characteristics of the rabbinic story. His penetrating analyses invariably leave his readers with fresh understanding and insight. While I will argue that Fraenkel's approach is not sufficient, it is certainly necessary. A close reading is indispensable to the proper interpretation of a rabbinic story. I also share Fraenkel's view of the genre of the rabbinic story as fiction, and more specifically dramatic narrative.[35] Fraenkel made the crucial paradigm shift that revolutionized the interpretation of rabbinic stories.

## The Rabbinic Story in Its Cultural and Literary Contexts

Modern literary theory emphasizes the importance of contexts—cultural, historical, social, and literary—to the interpretation of literature. Neglect of the cultural and historical context of a literary work was the major complaint against the New Criticism. Opponents charged that the failure to understand the meanings of words, values, and concepts in their historical contexts and to appreciate that these meanings changed over time rendered New Critical interpretations subjective or simply mistaken.[36] How can one understand the meaning of "honor" in a poem written by a sixteenth century British nobleman unless one knows what "honor" meant at this time to this social class, which might be very different from what "honor" involves today? Likewise, failure to understand the literary conventions of a society, even when they do not correspond precisely to a cultural reality, inevitably produces misunderstandings.

The importance of the literary context to interpretation is another hallmark of recent literary theory, and especially of semiotics. Semioticians argue that language does not have a stable or determinate meaning. Language does not correspond to an objective reality beyond itself that the reader apprehends directly. There is no absolute meaning of a word, no natural relationship between a word (the signifier) and its meaning (the signified), nor even a simple, one-to-one correspondence between the two. Words, phrases, sentences—ultimately entire texts—have meanings only within specific settings. To understand the meaning of a text always requires interpretation. A reader inevitably begins the interpretive process by drawing information from the literary context as he or she attempts to make the best sense of words within sentences, sentences within paragraphs, paragraphs in light of the proximate text, and so on for larger units. Reading (or listening), in other words, has a sequential component. How we interpret a text, or any communication, depends on the preceding material, which creates certain expectations, and on the larger frame in which we encounter it. The same words have different meanings when expressed sarcastically, ironically, untruthfully, or seriously, but to judge how best to interpret them requires an assessment of their context. To quote Stanley Fish: "Consider, as an example, the sentence 'I will go.' Depending on the context in which it is uttered, 'I will go' can be understood as a promise, a threat, a warning, a report, a prediction, or whatever, but it will always be understood as one of these, and it will never be an unsituated kernel of pure semantic value."[37] While we cannot speak of meaning in an absolute sense, we can speak of a meaning in a given context. To divorce stories

completely from their literary contexts is a problematic endeavor. There is no noncontextual space in which to analyze a story any more than there is noncontextual space to define the absolute meaning of a given word or phrase.

Similar criticism should be leveled against Fraenkel's New Critical readings of rabbinic stories. His principle of closure causes him to neglect both the literary and cultural context of rabbinic stories. Fraenkel isolates the story from its literary context, that is, from the section of text in which the story is placed, the preceding and following material. He ignores the legal discussions of the Babylonian and Palestinian Talmuds in which stories are embedded. In some cases Fraenkel even detaches one episode from its narrative context and analyzes it independently, even though it comprises part of a larger plot.[38] Fraenkel likewise does not make much of the wider cultural context, namely the values, concerns, symbols, motifs, and conventions of the culture in which the story was produced. These dimensions are partially accessible to us by examining other talmudic texts, other expressions of the same talmudic culture. When confronted by a symbol, such as a column of fire, or a motif, such as a sage forgetting his studies, Fraenkel normally does not turn to other talmudic sources to understand its significance. To be fair, Fraenkel does recognize a general context, "the spiritual world of the sages," and a *Sitz im Leben,* the rabbinic academy. But these contexts have a negligible impact on the actual analysis. The academic setting guarantees little more than that stories were intended for an intellectual elite who could understand their subtleties, not as popular tales for commoners. In the undifferentiated "world of the sages" Fraenkel does not take into account whether the story is Tannaitic or Amoraic, whether of Babylonian or Palestinian provenance, although these cultural worlds were significantly different.[39] While a literary analysis of a talmudic story is indispensable to its interpretation, that analysis should not neglect contextual factors.

The importance of the literary context to the interpretation of talmudic stories has been argued cogently by Ofra Meir, whose insightful studies over the past twenty years have had neither the influence nor acclaim they deserve.[40] Like Fraenkel, Meir considers literary analysis the proper tool to analyze the rabbinic story. Her dissertation, unfortunately still unpublished, is the most thorough study of character and modes of characterization in rabbinic literature,[41] while other studies address narrative technique, symbolism, and hermeneutics.[42] One of Meir's studies of the role of the literary context examines four occurrences of "The Story of the Hasid

and the Spirits in the Cemetery," found in four different rabbinic compilations.[43] While the textual variants among the four occurrences are minimal, the four contexts are significantly different. Meir claims, convincingly in my opinion, that the didactic impact of the story—the meaning absorbed by the audience—differs in each case.[44] The disparate contexts accentuate different aspects of the story and produce different readings.[45]

In other important articles Meir demonstrates that context may also influence the text.[46] Differences between versions of a story are not arbitrary but result from the interests and pressures of the respective contexts. For example, a story of R. Hanania b. Hakinai and his wife appears in the BT and in *Leviticus Rabba*.[47] The core plot is almost identical: Hanania leaves home and studies in the academy (*beit midrash*) for twelve or thirteen years. When he finally returns and enters his house, his wife dies of shock, but Hanania protests to God and she revives. Meir points out that the context in *Leviticus Rabba* has to do with the importance of proper order. That passage concerns the death of Aaron's sons Nadav and Avihu, who deviated from the correct ritual order, and God's instructions to Aaron of how to avoid such catastrophes (Lev 16). In this context the story provides additional proof of the danger of violating the proper order of things, as did Hanania who returned home without advance warning. The beginning of the story stresses Hanania's irregular behavior by contrasting Hanania with another sage who sent letters home and kept in contact with his family. Hanania never corresponded with his wife, and when he returns, the narrator points out the abruptness of the encounter: "He entered after her [into the house] suddenly. His wife hardly had time to see him when she died." Meir notes that the BT version omits mention of the letters home and the sudden entry. There the story appears in a series of stories about sages who leave home to study in the academy for many years. The tension between study of Torah and obligations to wife and family runs through all these stories, each of which provides a different perspective. The BT story accordingly emphasizes the wife's predicament and Hanania's appreciation of her suffering: "His wife was sitting and sifting flour; she lifted her eyes, she saw him, her heart rejoiced and her spirit departed"—a description which does not appear in *Leviticus Rabba*. Thus the BT casts no blame on the sage, as does *Leviticus Rabba* through the lack of correspondence and sudden entry. Indeed, the BT follows Hanania's protest of the injustice of her fate by mentioning that he prayed for her, suggesting that his merits—apparently those earned by the long years of study—restored her to life, and not only God's mercy.

Meir offers the guarded conclusions that "the same story may reflect different aspects of a worldview, because these are not only dependent on the interpretation but also dependent on the context," and that "the literary contexts produced in the stages of the redaction of rabbinic collections shed light on the influence of context on the story brought within its frame, and about the worldview communicated by it."[48] But I think her studies show more: not only are text, context, and interpretation interrelated, but the redactors tailored the texts of stories to suit the literary contexts in which they placed them. Redactors were as much authors or storytellers as compilers, so the interpretation of a story should not be pursued independently of the literary context they chose. My work will support Meir's conclusions by demonstrating that the BT redactors reworked stories in light of the literary contexts they selected. It is untenable to claim that the process of redaction did not affect the text of the stories to any significant degree, that rabbinic stories were originally told in another setting, perhaps orally in the rabbinic academy, and later were incorporated into talmudic passages without change. No stable meaning exists without a literary context, and in the case of the BT, the redactional process shaped the story in relation to that context.

The indispensability of the wider cultural context for interpreting rabbinic stories has been argued by Daniel Boyarin in *Carnal Israel: Reading Sex in Talmudic Culture*.[49] Boyarin considers his method an example of the "New Historicism" or "cultural poetics," as he prefers to call it. As the name implies, the New Historicists reacted against the anti-historicism of the New Critics by returning to an emphasis on the historical context of literature. For Boyarin and the New Historicists, literature is a social process akin to other social processes, such as law, politics, and economics. The social meanings constructed in literature are therefore related to meanings constructed in the other cultural spheres. New Historicists consequently have an open view of texts: all texts of a given culture will be interrelated since all result from the same social processes. This means that any text, no matter what its genre, will be informed or influenced by meanings found in other texts, known as intertexts. Boyarin accordingly studies rabbinic biographical stories in light of halakhic sources:

> [T]he method of cultural poetics recombines aggada and halakha, but in a new fashion. I assume that both the halakha and the aggada represent attempts to work out the same cultural, political, social, ideological, and religious problems. They are, therefore, connected, but not in the way that the older historicism wished to connect them. We cannot read the aggada as background for

the halakha, but if anything, the opposite: the halakha can be read as background and explanation for the way that the rabbinic biographies are constructed.[50]

So Boyarin examines aggada (including stories) together with halakha as two social processes in order to recover important cultural themes. By considering a network of legal discussions, exegetical traditions and stories — intertexts — he observes the tensions of rabbinic culture.

Boyarin's work is particularly relevant to a study focused on the BT such as this, since the BT is primarily of legal character, and is organized as a commentary to the Mishna. Stories embedded in the BT should be considered in relation to talmudic halakha in general, as well as to the particular halakhot with which they are juxtaposed — which brings us back to the immediate literary context. These considerations contest the view of talmudic stories as closed and self-contained texts. I claim in each chapter that both the halakhic context of a story and other related texts indeed contribute to our understanding.

I use the term *cultural context* rather than *historical context* because our knowledge of the historical setting of the BT is minimal. The political, economic, and social situations of the Jewish communities in Sasanian Persia throughout late antiquity are known only in their most general contours. Material cultural remains of Babylonian rabbinic Jewry are almost nonexistent. Yet we do have the massive text of the BT and the numerous sources contained therein to help us understand the terms, concepts, conventions, and codes of the culture that produced it.[51] To neglect this cultural data therefore risks subjectivity and misinterpretation. To appreciate the general significance of a story requires a sense of the dominant problems and struggles of Babylonian rabbinic culture, which again must be derived from other texts. The only way to bridge the gap between the language and culture of talmudic times and language and culture today, the only way to understand how the stories fit into talmudic culture, is to exploit the full range of talmudic data available.

## The Composition and Redaction of the Babylonian Talmud

Because the redactors contextualized the stories found in the BT and contributed to their composition, it is necessary to understand their historical and social contexts and redactional methods. David Weiss Halivni has articulated a comprehensive theory of the composition and redaction of the Babylonian Talmud.[52] His theory is anchored in the distinction between

statements attributed to the Amoraim (*meimrot*) and anonymous statements (*stammot*).⁵³ After studying hundreds of talmudic passages Halivni concluded that the anonymous material always postdates the attributed statements, that the two types of statements emerge from two chronologically discrete layers of tradition. He called the tradents of the unattributed statements "Stammaim," from the word used for an anonymous section of Talmud, *stam*. Halivni also observed that statements of the Amoraim and Stammaim are of substantially different character. Amoraic statements are terse, apodictic pronouncements, while Stammaitic expressions are lengthy and discursive. More important, the Stammaitic layers contain most of the dialectic argumentation, the give-and-take of the discussion, the legal reasoning, including explications and comments on the shorter Amoraic traditions. Halivni concluded that a substantial change in legal philosophy transpired between the Amoraic and Stammaitic periods:

> At first . . . they felt no need to preserve for posterity the derivation of laws and the reasoning through which they came to their conclusions. In their eyes the conclusion was the essence and the rest was secondary, not worthy of the same precision in transmission as was required of apodictic law . . .
>
> . . . At a certain point it became more accepted that the derivation of laws deserved to be preserved and written for posterity, that argumentation, the give-and-take (even if rhetorical) has independent value and is not secondary to the conclusion that results from it. This period had tremendous influence on the study of Talmud and profound impact for the following generations. *This period is the period of the Stammaim.*⁵⁴

So highly did the Stammaim value argumentation that they discussed not only authoritative legal opinions but also discredited positions. The Stammaim, for example, explored the reasoning of opinions attributed to the House of Shammai, although the Tannaim had long before given primacy to the House of Hillel. Lengthy Stammaitic passages produce no practical conclusion and suffice with probing, testing, and justifying the various opinions.

The two-tiered view of talmudic material and the Stammaitic interest in, and provenance of, argumentation have significant implications for the composition of the Talmud. Because argumentation had not been preserved, the Stammaim were forced to reconstruct or reinvent the reasoning of the Amoraim on the basis of the meager fragments of tradition they had inherited. The Stammaim composed *sugyot* — discursive units — by embedding Amoraic statements in logical frameworks and supplying the underly-

ing reasoning.⁵⁵ Stammaim, then, are essentially the authors (they composed the bulk of the text) and the redactors (they organized antecedent traditions and provided their present frameworks) of the Talmud. They were not mere "transmitters" of Amoraic tradition, but "their hands were everywhere in the Talmud, and everything came from them."⁵⁶

The discursive interests of the Stammaim fostered the development of a distinct literary style. Halivni describes Stammaitic argumentation as "colorful, pulsating, outreaching, often presenting an interwoven and continuous discourse with a distinct identifiable style of its own." Symmetry is one aspect of "Stammaitic style": the Stammaim sometimes present contrived or artificial arguments in order to balance the presentation of opposing positions.⁵⁷ Spurious questions and false answers appear as literary devices to emphasize sections of the dialectic.⁵⁸ So too does repetition of territory previously covered. The Stammaim, then, have a deeper interest in rhetoric and style, in modes of argumentation, than in the final decision.

Shamma Friedman independently reached conclusions similar to those of Halivni.⁵⁹ He too distinguished the attributed, Amoraic statements from anonymous material; described the different characteristics of the two layers; and dated the anonymous material to post-Amoraic times (although he does not use the term "Stammaim"). He provides fourteen "stylistic and textual considerations" for separating the Amoraic kernel from its later elaboration.⁶⁰ Friedman's second major contribution is the analysis of the literary structure of the *sugya*.⁶¹ He observes that the *sugya* often has a tripartite structure, contains a series of three objections, or brings three different types of proof. Other *sugyot* are composed of units of seven, ten, or fourteen.⁶² Many *sugyot* defer the solution to the end so as to allow other sources to be introduced and discussed. The composers were therefore motivated by rhetorical, structural, and literary concerns as much as legal interests. Like Halivni, Friedman points to cases where aspects of the argumentation are spurious, and were added for the sake of rhetoric or style.⁶³

Halivni, Friedman, and other scholars debate the dating of the redactors and the breakdown of the post-Amoraic period. Geonic sources call the sages of the sixth and seventh centuries "Saboraim" and attribute to them various types of editorial activity.⁶⁴ Did the Stammaim flourish in the fifth century and precede the Saboraim? Or should the Stammaim be identified with the Saboraim of Geonic sources or with the first few generations of Saboraim?⁶⁵ In the case of aggada, the potential distinction between Stammaim and Saboraim becomes less certain. Geonic traditions about the role of the Saboraim pertain to halakhic material—technical terminology, some forms of argumentation, and occasional legal decisions. Signposts

of their editorial activity can be detected almost exclusively in the halakhic portions of the Talmud. For my purposes here it is not necessary to resolve this issue. *I use the term* Stammaim *for all post-Amoraic sages, who composed, redacted and edited the talmudic text in the fifth through seventh centuries.* It was during this time that the Babylonian Talmud text took shape.

The theories of Halivni and Friedman impact this study in several ways. In general, they provide a theory of authorship and audience, and a historical context in which to locate talmudic stories. More specifically, the identification of distinct literary strata raises the question of how to categorize stories. The redactors ultimately transmitted all talmudic material, whether early or late; whether of Tannaitic, Amoraic, or post-Amoraic provenance; whether narrative, exegetical, or legal. On the crudest level, then, every talmudic story can be attributed to them.[66] However, the extent to which they reworked their sources—hence their direct contribution to the different literary strata—varied:[67]

> 1. Tannaitic sources, that is, *baraitot:* Comparison of *baraitot* in the BT to their parallels in the PT, the Tosefta, and other Tannaitic midrashim, shows minor development in the long process of transmission.[68] The Hebrew of BT *baraitot* differs slightly from that of the Mishna and Tosefta. Awkward and difficult expressions are occasionally simplified and the style periodically adjusted. Some technical terms have been changed to conform to standard BT terminology. Most of these changes were probably unintentional, although deliberate emendations are occasionally found. For the most part, Babylonian Amoraim and the redactors attempted to transmit the *baraitot* as accurately as possible. Thus *baraitot* can be considered of Tannaitic provenance until proven otherwise.[69]
>
> 2. Amoraic dicta, that is, *meimrot.* Comparison of Amoraic dicta with those found in the PT (and occasionally in parallel *sugyot* in the BT) shows considerably more development. Some BT dicta are identical to those found in the PT; others are equivalent in content but not form; others are profoundly different.[70] In some cases the Stammaim (and perhaps later Amoraim) found it necessary to complete the truncated Amoraic traditions they inherited by adding words or phrases, interpolating, and appending prefaces or conclusions. Although the Stammaim had great respect for the precise wording of the Amoraic traditions, they sometimes modified the formulations, substituted more common words or stylized them to conform to the BT standard.[71]

They paraphrased or abstracted from specific cases to general formulations. It seems that only in rare cases did the Stammaim fictionalize attributions and thereby create pseudepigraphic Amoraic statements.[72] Considering the years that passed from the early Amoraim of the third and fourth centuries to the redactors in the fifth through seventh centuries, the degree of drift is remarkably small. In the vast majority of cases the dictum probably preserves the teaching of the Amora if not his *ipsissima verba*. The redactors did not treat dicta as inviolable, but they were very conservative in the amount of reworking.

3. Unattributed material (*stam hatalmud*). Comparison of the unattributed strata of the *sugya*, the discursive material, with that of the PT or early rescensions within the BT shows a gap of major proportions. In almost every case the redactors have freely reworked whatever rudimentary framework or basic structure they had received, supplemented it with other sources, transferred traditions from related passages and created the rich argumentation described above. This, of course, is why Halivni and Friedman attribute the anonymous strata to post-Amoraic redactors or Stammaim. As opposed to *baraitot* and Amoraic dicta, unattributed material is almost exclusively the free composition of these redactors. Shamma Friedman assesses the differences between the strata thus: "The degree of malleability of the unattributed material (*stam hatalmud*) is infinitely greater when compared with the *meimrot*."[73] Here the redactors exercised their literary talents with little restraint.

How did the redactors treat their narrative sources? What do we find when we compare BT stories with earlier versions found in Tannaitic sources or in Palestinian documents? Did they transmit narrative sources almost exactly as they received them, like the *baraitot*, or with a minor degree of editing, like Amoraic dicta? Or did they freely revise them like the unattributed material? And if so, did they rework narrative sources with the same compositional methods as applied to legal *sugyot*? In other words, to which of the literary strata should talmudic stories, as a genre, be assigned?

Only a few studies to date have attempted to answer these questions by applying the theories of Halivni and Friedman to stories or focusing on the narrative activities of the redactors. Louis Jacobs called attention to "aggadic *sugyot*" such as the "*sugya* of suffering" found in bBer 5a–b.[74] These "aggadic *sugyot*" organize exegetical and narrative traditions on a particular topic into highly structured discussions. Yaakov Elman's article

"Righteousness as Its Own Reward: An Inquiry into the Theologies of the Stam," as the title suggests, argues that the Stammaim have defined theological ideas that can be distinguished from those of the Amoraim.[75] Most significant is an illuminating article by Shamma Friedman that compares the lengthy story of R. Eleazer b. Shimon, bBM 83b–86a, with its earlier versions found in Palestinian sources.[76] Friedman shows that the BT redactors altered narrative details, added episodes, transferred motifs from disparate talmudic passages and supplied connective phrases to smooth the transitions and clarify the turns of the plot. Yet the redactors did not change the basic order of events recounted in the Palestinian antecedents, although this produced obvious problems in the flow of the new story due to the additions.[77] Friedman's main point is that the BT version cannot be relied on for historical purposes since it is a secondary reworking of Palestinian traditions, not an independent historical witness. He insists that historians determine the "literary kernel" before rendering judgments about the historical kernel. In this respect his punctilious study comes to similar conclusions regarding the literary development of rabbinic historical testimonies as did Neusner.[78] For our purposes, Friedman's study suggests that the Stammaim reworked their narrative sources with a considerable degree of freedom.[79] This book continues these studies of the redactors' handling of earlier stories. It provides comprehensive answers to the questions raised above by demonstrating that the Stammaim indeed played a significant role in producing stories and by describing the methods with which they reworked their sources.

Halivni's account of the values of the Stammaim may also shed light on the content of the stories we will examine. The Stammaim valued argumentation itself, the give-and-take of talmudic dialectic, even when it had no impact on practical law. Torah, for the Stammaim, was an ongoing process of learning and interpretation. By meditating on the reasoning behind rejected Amoraic positions, the Stammaim took the principle of "Torah for its own sake" to new levels. Torah study had always been the central value of the sages, but the Stammaim expanded and intensified its import. For the Stammaim, Halivni writes, "theoretical learning was a main mode of worship."[80] This view constructs Torah as the supreme value, the ultimate goal and underlying principle of creation, in a manner that goes beyond earlier rabbinic views of Torah. I hope to show that the general view of Torah in the stories coheres with what we should expect of the Stammaim.

Finally, the theories of Halivni and Friedman of the literary activities of the redactors, in my view, are what justify the application of literary

analysis that attributes significance to structure, repetition, and the artful use of language in general. These are the characteristics of the conscious process of Stammaitic redaction, as we know from studying legal *sugyot*, not necessarily the inherent properties of drama, fiction, ancient biography, or whatever genre we assign to BT stories.[81] Similarly, the implied audience of the Stammaim were like-minded sages in the rabbinic academy who could be expected to be persuaded by the rhetoric, to decode the structures and literary features, and to understand the conventions and cultural tensions of the stories.[82]

## *The Social Setting of the Redactors: The Rise of the Babylonian Academy* (Beit Midrash)

The findings of Halivni and Friedman that the literary strata of the Amoraim and Stammaim are distinct, and Halivni's theory that the values of the Stammaim differed from those of the Amoraim, correlate with current theories of the rise of Babylonian rabbinic institutions of higher learning. In a comprehensive study of references to rabbinic institutions in the BT, David Goodblatt concluded that large-scale institutions of rabbinic learning did not exist in the Amoraic period.[83] Throughout Amoraic times small groups of students gathered around rabbinic masters in "disciple circles." They dispersed when their masters died, moved on and perhaps attracted disciples of their own. The institutionalized *beit midrash* and *yeshiva* (academy) with their accompanying structures — buildings, hierarchies, curricula, means of financial support — were a later development: "[T]he organization of rabbinic instruction in Sasanian Babylonia was rather different from the way it has been described in medieval and modern accounts. The large Talmudic academies (*yeshivot* or *metivata*) known from the Islamic era did not exist in Amoraic times. Instead disciple circles and apprenticeships appear to have dominated academic activity."[84]

Goodblatt essentially limited his study to the talmudic sources and did not offer firm conclusions as to when such institutions developed. Geonic sources of the eighth and ninth centuries take such institutions for granted and even retroject them to much earlier periods. This places their emergence in the fifth through seventh centuries.

Isaiah Gafni challenged Goodblatt's conclusion and argued that a few talmudic traditions reflect the existence of an academy or similar institution.[85] However, most of Gafni's sources that mention the *beit midrash* or *yeshiva* — including several narrative sources — are actually found in the

anonymous strata of the Talmud, the strata Halivni and Friedman assign to the Stammaim.[86] Unfortunately, this debate took place before the theories of Halivni and Friedman gained acceptance, so neither Goodblatt nor Gafni tried to correlate references to institutions with literary strata.[87] There is no scholarly consensus on this issue, and comprehensive study remains a desideratum. But it seems that the question could be resolved by greater sensitivity to the literary strata of the BT.[88] On the one hand, Goodblatt is probably correct in concluding that talmudic evidence does not conclusively associate the Amoraim with large-scale institutions. On the other, the passages identified by Gafni (and some passages which Goodblatt recognizes as glosses) should not be ignored or explained away, but understood as evidence of post-Amoraic institutional developments of the fifth and sixth centuries.

The question of the rise of the rabbinic academy thus intersects with the question of the literary strata within the Talmud. It is likely that the two developments are related.[89] The shift in values and styles of legal expression probably did not occur in a vacuum. The very fact that we speak of "Stammaim" or "anonymous post-Amoraic redactors," that is, that these sages stopped attaching their (or their teachers') names to traditions, points to a substantive break with the past. The transition from short, apodictic utterances of the Amoraim to the discursive, verbose, argumentative expressions of the Stammaim may reflect a larger structural change in rabbinic society such as the rise of a new type of institution. Production of a distinct literary stratum suggests a distinct social setting.

The emergence of the *beit midrash* or *yeshiva* in Stammaitic times provides an institutional context for understanding the Stammaitic values and styles Halivni describes. The interests of the Stammaim are scholastic — dialectical argumentation, artificial debates, an emphasis on legal reasoning and explanation — and point to a scholastic institution. While law courts are most interested in final decisions and rulings, law academies such as the *beit midrash* emphasize argumentation, even hypothetical argumentation on behalf of minority opinions. Within the rabbinic academy the Stammaim pursued their scholastic activities, what we might call the "pure theory" of Torah. As we shall see, the stories analyzed below place numerous scenes in the academy and portray rabbis engaging in extensive dialectical debate. The picture of rabbinic activity and institutions of learning constructed by the stories suit the Stammaitic scholastic setting.

## Goals and Methods

This book comprises detailed studies of six important stories from the Babylonian Talmud. The objective is to build on the close analysis of these texts to advance our understanding of the issues discussed above.

First, the studies contribute to our appreciation of the artistry and literary features of BT stories. How did the storytellers employ wordplay, irony, dialogue, rhetorical questions, repetition, biblical verses, and structural parallels to create meaning? In this respect the book continues the work of Jonah Fraenkel and Ofra Meir in describing the poetics of the rabbinic story, although it focuses specifically on the BT.[90]

Second, these studies help us to understand the compositional methods of the redactors. To what extent and in what ways did they adapt other sources and rework earlier versions to construct new stories?

Third, study of the relationship between stories and their literary and halakhic contexts sheds light on redactional methods. Why have the Stammaim included a given story in the *sugya*? Why has this story been juxtaposed with a certain Mishna or halakhic issue?

Finally, these studies enhance our understanding of Babylonian rabbinic culture, particular that of the Stammaim. Each story addresses fundamental issues and tensions of the rabbinic worldview. By identifying those issues and tensions and relating them to issues and tensions reflected in other BT sources, we gain insight into the cultural world of the storytellers, the Stammaim. Attention to the themes and motifs repeated in several stories also helps us to recognize the dominant concerns of their culture.

These multiple interests and the complexity of the text of the BT require that several methods be employed. From the discussion of previous scholarship presented above it should be clear that no one method adequately addresses the spectrum of issues that contribute to the fullest understanding of a story. A combination of methods is necessary to manifest the full richness of a talmudic text. The three primary methods I use are redaction-criticism, source-criticism, and literary analysis.

### Redaction-Criticism

Redaction-criticism characterizes my approach insofar as the focus is the extant form of the story. I am most interested in reading the stories as formulated by the redactors, as they now appear in the BT. While the redactors sometimes built their story out of independent sources, or added an extraneous source to a given story, it is the composite product that they

created. While the redactors reworked earlier sources, it is the reworked sources, not the original forms, that they transmitted. The focus on the redacted form of the story in general, and on the redactional layers of additions to and reworkings of earlier sources in particular, is what makes this book a contribution to the study of the BT, not a study of hypothetical early traditions or "rabbinic literature" in general.[91]

The relationship of the story to its literary and halakhic contexts is also a question for redaction-criticism. Because the BT is organized as a commentary to the Mishna, every talmudic passage is located in reference to a particular Mishna-paragraph. Whatever the original provenance of the rabbinic traditions—including stories—contained in the Talmud, the redactors located those traditions in connection with a given Mishna and transmitted them to us in that context. Thus every story has a "halakhic context" provided by the proximate Mishna. In some cases a narrower halakhic context may be provided by a legal discussion that precedes the story, or by a *baraita* cited in the course of that discussion. The immediate literary context, the talmudic passages preceding and following the story, which often drift far from the content of the framing Mishna, may provide another context. A story, for example, may occur within a series of other stories or after a lengthy collection of exegetical traditions. Redaction-criticism considers the relationships of the story to these contexts and the purposes of the redactors in these juxtapositions.

Some stories of course may have but a superficial relationship to their redactional contexts. The only connection between a story and its location may be a lexical association such as a common word or name.[92] A halakhic ruling attributed to Rava may be followed by a story attributed to Rava or a story that features Rava. In such cases redaction-criticism will contribute little to our understanding of the stories. I consider it counterintuitive, however, to think that the stories in a work as carefully edited over as long a period as the BT should not have a substantive connection to the primary interests of the redactors, namely the particular Mishna, halakhic issue or theological matter at hand.[93] And I believe that the following chapters substantiate this point. But even superficial associations between stories and their redactional contexts inform us about the methods of the redactors.

## Source–Criticism

Study of the redactional form of stories requires careful attention to the BT's sources, since the specific contribution of the redactors is identified best by distinguishing their voice from that of their sources.[94] Where

the redactors changed their sources or supplemented the story they received with another source we discern the clearest signs of their activity. Attention to the redactors' methods of reworking or supplementing sources also contributes to understanding their compositional techniques.

Attention to sources is demanded, moreover, because the redactors themselves often mark the sources they integrated into larger legal, exegetical, and narrative compositions. Signs of sources include terms such as "Our rabbis taught" that introduce Mishnahs and *baraitot,* attributions such as "R. So-and so-said . . ." that introduce Amoraic statements, terms such as "They said in the West" that precede Palestinian traditions, and explicit references to documentary formulae, court decisions, epistles, homilies, and so forth.[95] In this respect the talmudic redactors differed from the biblical redactors who integrated their sources without signaling this fact to the reader. Talmudic redactors quite candidly admit that their work is a montage of earlier discourses. Indeed, if Halivni is correct, the redactors would prefer to see themselves as recovering and completing those traditions of the past rather than creating anything anew. To ignore the sources of a talmudic story therefore discounts valuable information concerning the construction of the story, information that the redactors themselves disclose. For these reasons my studies involve a certain amount of source-criticism, namely the methods that identify and distinguish the sources used in the composition of the text. However, the purpose of source-criticism is not to study the original sources for their own sake but to understand how the storytellers used their sources to create a larger story.

The main source of BT stories are the parallel versions that appear in the Palestinian Talmud, *Genesis Rabba,* and other Amoraic midrashic collections. As with all cases of parallel sources, it cannot be proved absolutely that one borrowed from the other, for it can always be argued that the borrowing went in the opposite direction, or that both versions derive from a common source. Yet it is reasonable to proceed with the hypothesis that, while the Palestinian stories in their current forms are not themselves sources of the BT, they are substantially closer to early versions subsequently reworked in Babylonia. Shamma Friedman demonstrated this point in the article mentioned above,[96] and a growing body of individual studies by other scholars supports this conclusion.[97] So too does the chronology: the BT, redacted in the fifth through seventh centuries, considerably postdates the PT, redacted in the fourth century, as well as the major Palestinian midrashic collections such as *Genesis Rabba* and *Leviticus Rabba*. It is more likely, then, that the Palestinian versions are sources of the BT than the reverse. Both the dating of the rabbinic compilations and empirical study

suggests that the BT revised Palestinian versions, rather than the other way around. My working assumption is that at some point a version close to that currently preserved in Palestinian sources reached Babylonia. Where we find major discrepancies — the addition or omission of complete scenes, the presence of new characters, and the incorporation of exegetical traditions — we should attribute the changes to Babylonian reworking.[98] Only in Chapter 2 have I catalogued each discrepancy in detail so as to establish this point and become acquainted with the methods by which the BT redactors revised their sources. In subsequent chapters I point out the principal differences and consider their implications, but do not make an exacting inventory of each and every deviation.

Even if this assumption is rejected, the Palestinian versions nevertheless provide a crucial anchor for determining the distinctive Babylonian component. That is, Palestinian versions may serve not as sources but as comparative bases. They show us the ways not taken by the BT redactors. They embody a narrative possibility realized in a similar rabbinic culture but not realized in the BT.

Source-criticism of talmudic stories may also contribute to the literary analysis in accounting for contradictions and other inconsistencies in the plot or characters. Here it is important to learn from biblical literary critics. Although the internal evidence of sources is much weaker in the case of the Bible than the BT, biblical literary critics sometimes resolve literary difficulties and contradictions by source-critical techniques. They do so despite their emphasis on the importance of holistic readings of the received text and general disdain for the source-critical approach.[99] Similarly, inconsistencies found in talmudic stories sometimes should be attributed to the fact that the redactors employed disparate sources and failed to integrate them smoothly.[100] As noted above, the Stammaim took substantial liberties with the traditions they inherited but not the freedom to reformulate them completely. They were constrained to a certain extent by the authority of tradition.[101] Awareness of the difficulties imposed by sources does not absolve us of the obligation to make sense of the text as a literary whole. But it can help to explain why certain incongruities remain despite our best efforts at holistic reading.

## Literary Analysis

"Literary analysis" is a sadly inadequate and rather general term. Of course all Talmud study is "literary analysis" by virtue of the fact that the Talmud is a literary artifact. I use this term to indicate an interest in the

literary dimensions of the text—an interest common to the literary analysis of any other piece of literature—as opposed to narrowly historical, legal, or source-critical concerns. Because the literary study of rabbinic stories is in its infancy, the broadest mode of analysis is called for, rather than one particular school of literary criticism. I have in mind the same general approach Robert Alter describes in his work on biblical narrative:

> By literary analysis I mean the manifold varieties of minutely discriminating attention to the artful use of language, to the shifting play of ideas, conventions, tone, sound, imagery, syntax, narrative viewpoint, compositional units, and much else; the kind of disciplined attention, in other words, which through a whole spectrum of critical approaches has illuminated, for example, the poetry of Dante, the plays of Shakespeare, the novels of Tolstoy.[102]

This "artful use of language" includes techniques and literary devices deployed in order to persuade, locate within the narrative structure, provide aesthetic pleasure, and achieve other such effects on the audience. Artful language is a mode of entertainment that draws the reader (or audience) into the world of the story. At the same time, recent literary criticism stresses the importance of literary devices in apprehending meaning, since no transcendental meaning of a text exists separable from its language. They are not adornments to the real "stuff" of the story, but the signifiers that form discourse in the same way as the turns of the plot and other content. Repetition of key phrases and verbal echoes, for example, produce correspondences between parts of the story, provide a means of cohesion, and invite comparisons and contrasts.[103]

Because I am a consumer of methods of literary analysis, not a producer, I have drawn on a variety of approaches. My goals are thoroughly pragmatic—to make the best possible sense of the text—so there is no reason to privilege one particular theory. I employ both traditional literary theories that view narrative as a rhetorical form for conveying meaning to the reader, as well as structuralist and formalist approaches. Recent narratological theory, especially the work of Gérard Genette, Mieke Bal, and Shlomith Rimmon-Kenan, has provided valuable concepts and modes of analysis.[104] Further references to the relevant aspects of these works will be provided in the chapters to follow.[105]

## Motifs, Themes, Cultural Context

I have identified important motifs and themes—the fixed literary images that express specific ideas in a given body of literature. Motifs are concrete images, such as a carob tree or Moses's staff, while themes are more abstract, such as measure-for-measure punishment, the blind man who sees, or the holy stranger.[106] To recognize motifs and themes is an important interpretive step since a story exists within a specific cultural context and inevitably makes use of cultural codes and conventions. Not only does awareness of motifs and themes help avoid anachronism, but it helps locate the concerns of the story among the general concerns of the redactors.[107]

Attention to the wider cultural context complements the study of motifs and themes. This involves the attempt to correlate the primary values, tensions, and problematics of the story with the general values, tensions, and problematics of its culture. Here too the principal, if not exclusive, source of information are other BT texts, both narrative and legal (intertexts).[108] If a story advances a certain view of converts, for example, then that view should be situated in terms of the general attitude, or spectrum of attitudes, toward converts found in the BT. It may be that a story's view of converts or some other subject deviates from all other views. This too is significant, for the story should then be understood as a voice of protest, as a minority view resisting the dominant cultural ideology.

To identify motifs, themes, and the wider cultural context I have searched for pertinent material and related discussions found elsewhere in the BT—a task made considerably easier these days by the concordance and computer. The relevance of these outside passages must be defended in each case, and some fits will be better than others. Such excavative research is the only port of entry to the cultural world of the BT.

## The Stories

The six stories analyzed here deal with critical aspects of the rabbinic ethos and worldview: scriptural interpretation, sin and repentance, the mundane world, gentiles, eschatology, character virtues, and the nature of rabbinic leadership. Torah in all its complexity features in each story, and provides a common thread that links the chapters together. That a great deal of literature—traditional, theological, and scholarly—invokes or appeals to these stories attests to their significance.[109]

The first three chapters analyze stories with substantial Palestinian par-

allels, which facilitate the identification of sources and of redactional activity. These texts are excellent models for illustrating the utility of a method that combines redaction-criticism, source-criticism, and literary analysis with attention to context.

Chapter 2 treats the famous story of the "Oven of Akhnai" (bBM 59a–59b). Prior discussions of this text generally do not read the story in its entirety but evaluate only the first scene or two, and fail to pay attention to the literary context. We have then a prominent test-case to see whether a reading that takes account of these factors yields a more satisfactory interpretation. Comparing the brief and unusually close PT version allows us to study in detail the changes introduced by the BT redactors. The results illustrate the variety of compositional techniques employed by the redactors to revise their sources.

Chapter 3 analyzes the story of Elisha b. Abuya or Aher, "the Other" (bHag 15a–15b). In contrast to previous interpretations, I understand the story as addressing a basic question of rabbinic culture, whether the merit accrued from the study of Torah is inviolable or contingent. This story provides examples of two common narrative techniques — the narrative exegesis of a Toseftan passage and the use of nonnarrative comments within the discourse. The BT and PT versions diverge to a greater degree than do the versions of the previous chapter. These differences can be attributed, in large part, to the efforts of the BT redactors to integrate the story with its halakhic context.

Chapter 4 takes up the story of R. Shimon bar Yohai and the cave (bShab 33b–34a). This story grapples with the deep tension in rabbinic culture between the value of Torah as opposed to demands of mundane life and worldly occupation. The relationship of the story to its literary context — actually contexts — is more complicated than the cases discussed in the previous two chapters, and the wider cultural context also contributes to the interpretation of the story in significant ways. Here the redactors supplemented the PT story by modifying sources found elsewhere in the BT, which provides another example of their compositional technique.

Chapters 5, 6, and 7 treat stories that exemplify particular literary processes or methodological issues. Chapter 5 studies the story of Rabbi Yohanan ben Zakkai and his escape from Jerusalem (bGit 55b–56b). Analysis of this text reveals that the redactors created an extended story by combining discrete narrative sources. The contextual question is particularly interesting, for there appears, on first glance, little reason the story should appear in the fifth chapter of Tractate Gittin. The story also proves to be a type of

aggadic exegesis of a Toseftan tradition. Unlike the case of Elisha b. Abuya (Chapter 3), this Toseftan tradition is not cited explicitly. Still, it is a crucial intertext that illuminates the purpose of the BT story.

Chapter 6 discusses the story of the attempt by R. Meir and R. Natan to depose Rabban Shimon b. Gamaliel from his position as head of the academy (bHor 13b–14a). The academic setting offers a more direct representation of the tensions that pervaded the institutional life of the Stammaim. The nature of the academic conflict is so interesting as to warrant an attempt to set the story in a more concrete historical context. While my findings are perforce speculative, they may shed some light on the influence of the Exilarch on the rabbinic academies in Stammaitic times. The difficulty of reaching firm conclusions in this case illustrates the general obstacles to probing beyond the cultural context of BT stories to the historical reality behind the text.

Chapter 7 analyzes a "homiletical story," a story based on the interpretation of scripture, rather than a story about the sages (bAZ 2a–3b). The story describes the unhappy eschatological fate of the gentiles and justifies it on the grounds that they did not fulfill the Torah. The redactors gloss the story with a series of comments, a type of footnoting, that questions aspects of the story. The story and comments amount to a cultural dialogue that manifests the tensions surrounding this vision of the gentiles' fate.

The final chapter synthesizes the results of the six individual studies and provides additional support from other BT stories. Because each chapter focuses on one primary text, a summary organized by topic is necessary. I will also present a more general picture of the values and worldview of the redactors.

## Translation and Terminology

I have translated each story and labeled its units so that the reader can follow the analysis comfortably. The translations replicate literary devices and structural markers such as repetitions, balanced phrasing and verbal echoes. When it is difficult to reproduce the literary device in English, as in the case of wordplay or rhyme, the Hebrew is included in parentheses. I generally underline these markers so as to allow the reader to recognize them more easily. To some extent I have sacrificed smooth, idiomatic English in order to replicate more faithfully the literary features of the original language. In this respect my translations differ from previous translations which eliminate repetitions and paraphrase in the interests of English idiom, but thereby destroy important textual features.

The translations are based on manuscripts of the Talmud. Unfortunately, there is no critical edition of the Talmud text. Much of the lower-critical work of dividing the manuscripts into families and collating variants still remains to be done.[110] Nor is it clear that we can speak of a single or original text of the Talmud, for textual transmission occurred in a relatively fluid state as late as the Middle Ages.[111] A further complicating factor is that aggadic sections exhibit a higher degree of textual variation (and of outright corruptions) than halakhic passages because the transmitters did not consider them as authoritative.

Until these issues are resolved there is no choice but to treat each manuscript independently. I have therefore translated the manuscript that contains the cleanest version of the story. By "cleanest" I mean most free of major scribal errors, omissions or blatant corruptions. Strictly speaking the analysis holds only for that particular manuscript; variant readings of other manuscripts may produce different structural divisions or alter a literary feature.[112] In practice I have not found that variant readings substantially alter the larger picture. A minor point here and there may depend on a particular manuscript tradition, but the basic reading of the story is not affected. I have attempted assiduously to resist the temptation to harmonize manuscript readings so as to produce a literarily superior text.[113] Only in cases of obvious mistakes or omissions have I emended or supplemented based on other manuscripts. Major textual variants are collated in an appendix to each chapter, and the notes occasionally refer to different interpretations that would result from the variants. Significant textual variants, moreover, sometimes signal problems in the composition, use of sources, or editing process. But I have not produced a comprehensive critical text nor collected all the variants, since most are insignificant for my purposes. The original Aramaic/Hebrew texts of the chosen manuscript (though not the variants) can be found at the end of the book.

Let me conclude this chapter by defining some of the terms I use more precisely.

### Story, Fabula, Narrative

*Story, fabula, narrative,* and other terms are used variously among narratologists.[114] I use *story,* as I have in this introduction, as a general, nontechnical term for the texts at issue. When additional precision is required, *fabula* refers to the plot set in temporal and causal order. *Narrative* or *narrative discourse* refers to the written (or spoken) words, to the story as actually encountered by the reader/audience, that is, the way that the fabula is

communicated. The order of the narrative discourse may differ significantly from that of the fabula by filling in earlier events through flashbacks or by anticipating later events through flashforwards. Thus the fabula is roughly equal to the plot, while the narrative discourse includes the rhetoric, literary techniques, and stylistic elements. This terminology facilitates distinguishing glosses, interpolations, and some Amoraic comments, which are part of the narrative but not of the fabula.

## Narrator, Author, Storyteller, Redactor

The term *narrator* applies at the level of narration, that is, to the situation of a teller and his audience. Most talmudic stories are told by an anonymous narrator. However, in some cases a story or a portion of the story is narrated by an Amora. Behind the narrator is a real author or storyteller(s). "Author" usually refers to the producer of written literature and "storyteller" to an oral performance. Scholars generally agree that the Amoraim functioned in an oral cultural milieu. The situation of the redactors is less clear, although they probably continued to work predominantly in an oral matrix, even if they consulted written sources (see Chapter 7). I generally refer to the composers of the stories as "storytellers."

*Redactors* and *Stammaim* are interchangeable and refer both to the post-Amoraic sages who edited and redacted a given story as well as the sages responsible for the placement of the story in its literary setting. Occasionally I argue that a late gloss has been added to a story. These glosses probably were added after the stabilization of the Talmud text and should not be attributed to the redactors but to copyists and glossators.

## Interpretation and Objectivity

Finally, let me address the thorny matter of *objectivity*. A perennial question regarding any interpretation of literature — actually any work of scholarship in the humanities — is the extent to which it is "objective" and replicable or "merely" the subjective reading of the interpreter. I am not claiming that my readings are the only valid readings of these stories, nor that they uncover the absolute meaning as opposed to the misinterpretations of others. Reading is a process of filling gaps in a text, and different readers will fill gaps in different ways and choose different gaps to fill.[115] A common thread of all modern literary theory is an awareness of the role of the reader in the production of a meaning. My reading — an interpretation — is conditioned by my culture, historical context, social situation, and

other "forestructures," not the least being the canons of the university. At the same time, I do not share the extreme skepticism that all readings are equally good on the grounds that no objective standards exist.[116] As Mieke Bal has argued, empirical features of stories can be identified and analyzed, and criteria for assessing the plausibility of different readings articulated.[117] According to the criteria of academic criticism at least (which are ultimately conventional), an interpretation should be judged on how well it accounts for literary characteristics, analyzes conflicts, appreciates motifs and themes in their cultural contexts, avoids anachronism and constraining theological dogmas, and satisfies shared assumptions (such as those described above). In the end the measure of a good reading is whether it persuades the reader and advances his or her understanding of the text.[118] If subsequent readings build on my work and yield better and more persuasive readings, as I hope they will, then I will feel amply rewarded.

Chapter 2

# Torah, Shame, and "The Oven of Akhnai" (Bava Metsia 59a–59b)

In recent years the "Oven of Akhnai" has become an immensely popular talmudic story. Almost every book on rabbinic theology and midrashic interpretation includes a discussion of the tale.[1] Philosophers, psychologists, and legal theorists have explicated the story in terms of their disciplines — a rare example of a talmudic passage entering the general discourse of Western culture.[2] Already articles are written not only about the story itself but also about how scholars and commentators have treated it.[3] Most interpretations of the story, however, are confined to the first scene, the conflict between Rabbi Eliezer and Rabbi Yehoshua and the celebrated rejection of the heavenly voice — "It is not in heaven." These analyses take the scene out of its narrative context by failing to attend to the entire story. In addition, discussions of the story routinely neglect the wider literary and halakhic contexts in which it is embedded.[4] This tendency is understandable, since most scholars do not approach the story as a literary composition but rather as a source of rabbinic theology, legal philosophy, or hermeneutical theory. Yet such decontextualized readings run the risk of misinterpretation; it is no surprise that a vast spectrum of theologies and interpretive philosophies have been read out of — or into — the story.

This text is therefore a good test case to see whether an analysis that focuses on literary features and takes the context into account will produce a more grounded and satisfactory interpretation. My analysis builds on the work of the few scholars who consider the story in its entirety, including Daniel Gordis, David Hartman, David Halivni, and Ari Elon.[5] Elon's

work, in particular, which focuses on Ima Shalom's efforts to prevent R. Eliezer's prayers in the final scene, makes numerous insightful observations on the literary characteristics and meaning of the story.

A close parallel to the story—apparently an earlier version—appears in the Palestinian Talmud. This affords an opportunity to compare the two stories and determine what the BT redactors have added or altered and how the changes impact the story's meaning. Tracing the provenance of the additions will allow us to assess the compositional techniques of the redactors.

## Literary and Halakhic Context

The story appears in the section of Talmud that comments on mBM 4:10. The preceding Mishnas deal with *'ona'a*, "wronging," a prohibition mentioned in Lev 25:14, "When you sell property to your neighbor, or buy any from your neighbor, you shall not wrong (*tonu*) one another." Rabbinic tradition interprets this injunction as a prohibition against charging excessive prices (mBM 4:4–7,9). mBM 4:10 then discusses a second type of "wronging" based on Lev 25:17, "Do not wrong (*tonu*) one another, but fear your God." The Mishna interprets this commandment, which does not mention buying or selling, as a prohibition against "wronging in words":

> Just as there is wronging in business (*'ona'a bemeqah*), so there is wronging in words (*'ona'a bidevarim*). One should not say to him, "How much is this object?," when he does not plan to buy it. If he was a penitent, one should not say to him, "Remember your former deeds!" If he descended from proselytes, one should not say to him, "Remember the deeds of your forefathers," as it is written, *Do not wrong or oppress the proselyte (Exod 22:20)*.

The examples reveal that "wronging in words" or "verbal wronging" applies to speech that causes pain to other human beings. A *baraita* that begins the talmudic *sugya* offers additional examples: "If he experienced many sufferings or illnesses or buried his children, one should not speak to him as did Job's companions... If ass-drivers were requesting grain from him he should not say to them, 'Go to So-and-so who sells grain,' when he knows that the man never sold grain."

Following this *baraita* the Talmud offers a series of aggadic traditions that provides further examples of verbal wronging and emphasizes the severity of the prohibition. (The references below correspond to the partial

translation provided in Appendix 1.) Verbal wronging is more serious than monetary wronging because restoration is impossible—the injury caused by words cannot be redressed (2). God himself exacts punishment for verbal wrongs and never delegates the task to his minions (8). Because the gates of *'ona'a* are always open, God always responds to such sins (8).[6] God may lock the "gates of prayer" and "the gates of repentance," that is, he may ignore prayer and atonement, but he never overlooks verbal wrongs. In these passages "verbal wronging" appears to be a broad concept that includes all types of insults, humiliation, embarrassment, and pain caused by speech. Rav's admonition that one must be particularly careful concerning the *'ona'a* of one's wife "because her tears are frequent," that is because she is easily brought to tears, implies that any speech that upsets her to the point of crying counts as a verbal wrong (7).

Several traditions use the expression "whitening the face" (*halbanat panim*), that is, causing great embarrassment or shame, as the archetype of verbal wrong (3–6). So serious is "whitening the face" of another that it is tantamount to "shedding blood" (3) and reason to lose one's share in the world to come (4). The Talmud even advises that "it is better for a man to throw himself into a fiery furnace and let him not 'whiten the face' of his fellow in public" (6).

Our story follows this extended aggadic *sugya*. The story concludes "all the gates are locked except for the gates of wronging," a maxim that appears in the aggadic *sugya* (8). The *sugya* following the story focuses on the prohibition against verbally wronging a proselyte quoted at the end of the Mishna. These halakhic and literary contexts, especially in relation to the final line of the story, suggest that the story's meaning must be related to verbal wronging and shame.[7]

## Translation and Structure

The following translation is based on ms Munich 95.[8] The major manuscript variants are collated in Appendix 2. Repeated phrases and themes are underlined. Square brackets supply words or phrases assumed by the Hebrew/Aramaic but not explicitly represented. Parentheses provide explanations of words and phrases that appear in the Hebrew/Aramaic, mainly the identification of pronouns.

> (A1) We learned there: *If he cut it (an oven) into segments and placed sand between the segments, R. Eliezer rules that it is pure and the sages rule that it is impure. And this is the oven of 'Akhnai.* [=mKel 5:10].

(A2) What is ʿAkhnai (=snake)? Rav Yehuda said Shmuel said, "Since they surrounded him with words like this snake and ruled it impure."

(B1) It was taught: On that day R. Eliezer responded with all the responses in the world, but they did not accept them from him.

(B2) He said to them, "If the law is as I say, let the carob [tree] prove it." The carob uprooted itself from its place and went one hundred cubits—and some say four cubits. They said to him, "One does not bring proof from the carob." The carob returned to its place.

(B3) He said to them, "If the law is as I say, let the aqueduct prove it." The water turned backwards. They said to him, "One does not bring proof from water." The water returned to its place.

(B4) He said to them, "If it (the law) is as I say, let the walls of the academy prove it." The walls of the academy inclined to fall. R. Yehoshua rebuked them. He said to them, "When sages defeat each other in law, what is it for you?"

(B5) It was taught: They did not fall because of the honor of R. Yehoshua, and they did not stand because of the honor of R. Eliezer, and they are still inclining and standing.

(C1) He said to them, "If it is as I say, let it be proved from heaven." A heavenly voice went forth and said, "What is it for you with R. Eliezer, since the law is like him in every place?"

(C2) R. Yehoshua stood up on his feet and said, "*It is not in heaven* (Deut 30:12)."

(C3) What is, "It is not in heaven"?

(C4) R. Yirmiah said, "We do not listen to a heavenly voice, since you already gave it to us on Mt. Sinai and it is written there, *Incline after the majority (Exod 23:2).*"

(D) R. Natan came upon Elijah. He said to him, "What was the Holy One doing at that time?" He said to him, "He laughed and smiled and said, 'My sons have defeated me, my sons have defeated me.'"

(E) At that time they brought all the objects which R. Eliezer had ruled were pure and burned them and voted and banned him.

(F1) They said, "Who will go and inform him?" R. Akiba said to them, "I will go and inform him lest a man who is not fitting goes and informs him and destroys the whole world." What did he do? He dressed in black and covered himself with black and took off his shoes and went and sat before him at a distance of four cubits and his eyes streamed with tears.

(F2) He (R. Eliezer) said to him, "Akiba, why is this day different from other days?" He said to him, "It seems to me that your colleagues are keeping separate from you." His eyes too streamed with tears, and he took off his shoes and removed [his seat] and sat on the ground.

(G1) The world was smitten in one third of the wheat, one third of the olives, and one half of the barley.

(G2) And some say that even (*'af*) the dough in the hands of women swelled up.

(G3) It was taught: It (the destruction) was so great (*'af gadol*) on that day that every place where R. Eliezer cast his eyes immediately was burned.

(H) Also (*'af*) Rabban Gamaliel was on a ship. A wave of the sea stood to drown him. He said, "It seems to me that this is because of [R. Eliezer] the Son of Hyrcanus." He stood up on his feet and said, "Master of the universe. I acted not for my honor, nor did I act for the honor of my father's house, but I acted for your honor, in order that disagreements do not multiply in Israel." The sea immediately rested from its anger.

(I) Ima Shalom, the wife of R. Eliezer, was the sister of Rabban Gamaliel. After that event she never allowed him (Eliezer) to fall on his face. That day was the new month and a poor man came and stood at the door. While she was giving him bread she found that he (Eliezer) had fallen on his face. She said, "Stand up. You have killed my brother." Meanwhile the shofar [blast] went out from the House of Rabban Gamaliel (signaling that he had died). He said to her, "How did you know?" She said to him, "Thus I have received a tradition from my father's house: 'All the gates are locked except for the gates of [verbal] wronging.'"

The story can be divided into two halves: the first relates the controversy and banning of Eliezer (A–F), the second tells of the repercussions (G–I). Each half consists of two main scenes. The first (A–D) describes the halakhic dispute and its resolution. The second (E–F) reports the ban and Eliezer's reaction. The third scene (G–H) depicts the destructive consequences that follow, including the threat to Rabban Gamaliel's life. The final scene (I) narrates Ima Shalom's futile efforts to prevent Eliezer's prayers.

This division is determined mostly by narrative content, by the different events recounted and characters acting in each scene. Two internal triplets, the three miracles (B2–B4) and three disasters (G1–G3), support this

division of the story by creating a structural parallel between the first and third scenes.[9] Another correspondence between these scenes appears in the descriptions of the protagonists' postures: Yehoshua "stood on his feet" and argued against the heavenly voice and then Gamaliel "stood on his feet" to plead against the threatening wave. The second and fourth scenes correspond in that both focus attention on Eliezer's painful reaction, also emphasizing his posture. In the second scene he sits on the ground and weeps, while in the final scene he falls prostrate. The basic structure can be illustrated as follows:

| (1) Legal dispute | (3) |
|---|---|
| 3 miracles | 3 disasters |
| God's intervention (voice) rejected by Yehoshua's principle | God's intervention (wave) restrained by Gamaliel's principle |
| | |
| (2) Eliezer banned and informed | (4) |
| Akiba's mediation | Ima Shalom's mediation |
| Eliezer's reaction; sits, tears | Eliezer's reaction; falls, prayer Gamaliel's death |

Reading horizontally, the correspondences between scenes 1 and 3 delineate the transformation that takes place when a legal dispute degenerates into the verbal wronging of one party. Both scenes mention legal principles necessary for the system to function ("It is not in heaven," "So that disagreements not multiply in Israel"). But after the personal assault on Eliezer the innocuous miracles become supernatural disasters, God's verbal intervention becomes a dangerous storm, and God's satisfied laugh in defeat becomes the temporary restraint of Gamaliel's doom. Scenes 2 and 4 emphasize the human and emotional rather than the legal and abstract. They focus on Eliezer's expressions of pain and the inevitability of divine punishment. The structure illustrates the interrelationship between the legal process (scenes 1, 3) and harmful words (2, 4), and the gravity of the latter.

One narratological curiosity is the character shift from Yehoshua as the leading opponent of Eliezer in the first scene (B4, C2) to Gamaliel as the object of God's wrath in the second half (H, I). I will attempt first to explain this shift in terms of the representational value, although source-criticism on the basis of the PT parallel will suggest a different solution. Despite this irregularity, the four scenes have been integrated by connecting words and phrases in addition to the temporal and causal sequence.

R. Eliezer appears in each scene and serves as the pivot around which action takes place.[10] Scene 2 begins "at that time" (E), which refers back to the action of the first scene. In the third scene Gamaliel realizes that the wave is "because of what was done to [R. Eliezer] Ben Hyrcanus" (G), namely the aforementioned ban (E–F). The final scene describes the situation "after that event," again referring to the ban or possibly the wave that threatened Gamaliel.[11] I stress these connections for two reasons. First, it is important to know the boundaries of the story, especially in light of the propensity of scholars to treat the first scene as an independent story. Second, while source-criticism will suggest that some parts of the story were added later, the redactors carefully integrated those additions. The redactors did not compose by crudely combining unrelated sources but by determinedly weaving disparate material into a coherent whole.

## Literary Analysis

The story begins with mKel 5:10, a dispute between R. Eliezer and the sages concerning the purity of an oven consisting of alternating segments of clay and sand. The Palestinian textual tradition of the Mishna calls this unusual oven the "oven of Hakhinai" and the Babylonian tradition the "oven of Akhna" or "Akhnai."[12] This is a proper name: the second clause of the Mishna discusses an "oven of Ben Dinai." The story, however, explains "Akhnai" or "Akhna" as "snake." On one level the many segments of the oven recall the coiled spine of a snake, and the word for segments, *huliot*, also refers to vertebrae. Yet the story interprets the name "snake-oven" not in terms of its appearance but as an allusion to the debate concerning its status. The sages ruled the segmented oven impure by surrounding Eliezer with "words like this snake," although he had brought forth every possible response, and thus the oven became known as the snake-oven. The metaphor "surrounded him with words" and the comparison to a snake are ominous. To "surround with words" has a negative connotation, suggesting that the sages spoke with cunning and guile.[13] That they "surrounded *him*" with their words also rings of a personal assault.[14] A snake surrounds its prey, squeezing, choking, and suffocating it to death. In this way the imagery hints that Eliezer will be treated in a cruel and unkind fashion. The phrase "surrounded (with) words" also echoes the expression "wronging words" of the Mishna and the preceding *sugya*.[15]

The major themes of the ensuing scene have been amply discussed in other studies, so we can suffice with a brief summary here. Although the miracles and heavenly voice prove that Eliezer's halakhic ruling is "objec-

tively" true in that it conforms with the divine will, it is not legally valid. God entrusted the Torah to the sages to administer and interpret, and they must render decisions according to the legal process, namely the decision of the majority. The sages, paradoxically, have divine authority to ignore the divine will. Their interpretation, not the original, authorial intention, establishes meaning. Daniel Boyarin brilliantly observes that the way the story makes this point adds another layer to the paradox.[16] The prooftexts cited by Yehoshua and R. Yirmiah, "It is not in heaven" (Deut 30:12) and "Incline after the majority" (Exod 23:2), have different—and quite opposite—meanings in their original contexts.[17] They are interpreted by the sages to give themselves authority to overrule the divine will. The sages' claim to interpretive authority, then, ultimately depends on the very interpretive authority that it claims!

While these paradoxes of legal authority and interpretation are the foci of the scene, the narrator subtly introduces a personal-emotional angle. The personified description of the walls' response to Yehoshua's rebuke targets honor (*kavod*). Adumbrating the major turn in the story, this explanation of the walls' behavior focuses on the dignity of the sage rather than the legal process. Ironically, the walls—inanimate, lifeless objects—try not to hurt the feelings of either sage by advocating one position, and thereby causing the other to feel rejected or shamed. They display greater sensitivity than the sages who will soon ban Eliezer thinking nothing of his honor. Attention is drawn to this contrast by the verbal link between the walls inclining (*matin*) and R. Yirmiah's appeal to the principle "incline (*lehatot*) after the majority," from the same verbal root. In a way the walls prove more true to the verse, which only enjoins that one *incline* after the majority, not that one suppress the minority completely. Miraculously inclining at an angle, neither standing upright nor falling down, the walls also contrast with Yehoshua who "stands up on his feet" and rejects the heavenly voice. These postures anticipate subsequent acts of standing and falling, the significance of which emerges in the ensuing scenes.

The appearance of the heavenly voice and its rejection by Yehoshua shift the focus from the horizontal to the vertical, from the human to the divine plane, from an internal conflict among sages to a conflict between God and the sages. The account of God's reaction in heaven removes yet another step, as does the very indirectness of the tradition: the narrator reports what Elijah said to R. Natan.[18] The human side of the confrontation, the personal honor of a sage, temporarily recedes into the background as Yehoshua and R. Yirmiah no longer address their opponent but argue legal theory with the referee. In heaven God accepts his defeat graciously,

laughing at his sons' display of independence much as a father might laugh the first time his son defeats him in a game or sport. God apparently does not feel his honor compromised by legal defeat. After all, the very sages who "defeat" him (*nitshuni*) simultaneously interpret his law and obey its dictates. Elsewhere the BT observes: "The character of the Holy One is not like the character of humans: when a human being is defeated he becomes sad but when the Holy One is defeated he rejoices."[19] This happy resolution of the divine-human conflict proves an ironic contrast to the unfortunate outcome of the terrestrial struggle between the sages, which Yehoshua also phrased in terms of "sages defeating (*menatshim*) each other." While God laughs and smiles at his defeat, Eliezer and Akiba will soon shed tears (F1–2).

Not content to have rejected Eliezer's ruling and its divine endorsement, the sages burn all objects he had decreed pure and ban him (E).[20] What provoked them to adopt such harsh measures is not completely clear. The narrator does not inform us how Eliezer reacted to the dismissal of the heavenly voice, nor whether he openly defied the sages, nor that he continued to issue practical rulings to others, nor even that he persisted to hold his contrary opinion. The sages apparently wish to take revenge at his having defied them in the first place or attempt to teach him a lesson. In any case the punishment far outstrips the crime, a nonconformist opinion concerning an unusual type of oven.[21] That the sages' actions are unjust becomes clear from Akiba's fear that if a man "who is not fitting" informs Eliezer then the entire world will be destroyed. This shocking statement suggests that an outrage of tremendous proportions has been committed. Like the sins of the generation of the flood, the sages' offense threatens the existence of the world. Indeed, Eliezer's reaction to the ban confirms the fact that the sages have overreacted.[22] Far from rejecting the authority of the sages, he accepts their decree and assumes the proper posture. His eyes "streaming with tears" express anguish and suffering, not defiance and contempt.[23]

Akiba's strategy involves a combination of delicate speech and symbolic maneuvering. His black dress and removal of shoes are signs of mourning.[24] His tears express emotional distress both in sympathy with Eliezer and at the potential destruction that he fears will ensue.[25] Rather than initiate the conversation Akiba remains in silence until Eliezer turns to him. This silence, also signifying mourning, recalls Job's friends who weep, tear their clothes, sit on the ground and remain silent for seven days (Job 2:12–13). Akiba's silence, moreover, inverts the former action of the rabbis who "surrounded" Eliezer "with words," and thereby atones for the

verbal onslaught.²⁶ The one action inconsistent with mourning rituals is the four-cubit distance, apparently the required separation from a person under a ban, which functions as an indirect means of informing Eliezer.²⁷ Note that Akiba continues the indirectness even when Eliezer questions him. He responds equivocally ("it seems to me") and tactfully, not mentioning the ban but employing the neutral and somewhat ambiguous terminology of "separation" (*bedilin*). This verb, as far as I can tell, does not refer to the ban elsewhere, and does not necessarily have negative connotations.²⁸ Given Akiba's dress and the four-cubit distance, Eliezer cannot mistake the meaning of this phrase.

Eliezer signals his acceptance of the ban by immediately observing the halakhic prescriptions of removing his shoes and sitting on the ground — the very gestures that Akiba made as signs of mourning.²⁹ The BT in fact frequently discusses the mourner and the banned person in the same passage and relates the two cases conceptually and legally.³⁰ Akiba exploits this connection to express his empathy with and devotion to Eliezer even as he remains at the mandatory four-cubit distance. While he cannot approach or embrace Eliezer's person, he adopts and embraces Eliezer's condition. Yet Akiba not only expresses his solidarity with the banned sage, but he subtly invites Eliezer to respond to the ban by imitating his ritual actions — a relatively restrained manner. This behavioral modeling and the general sensitive manner of informing prevent a stronger reaction. The sympathetic approach averts the annihilation of the world but cannot prevent great destruction. Eliezer has been reduced to sitting on the ground, and when he falls lower at the conclusion of the story, the consequences are worse.

While the ban is the ultimate cause of the destruction, the calamities occur only after Eliezer reacts to the news. The harm does not result from the promulgation of the ban but from the pain that its communication causes to a human being. Thus the sages are guilty of verbal wronging (*'ona'a*), as explicitly stated by Ima Shalom's final pronouncement (I). For this reason — so as to minimize the damage that his speech would cause Eliezer — Akiba attempts the most indirect method of informing. Yet even his oblique statement effects the humiliation of a great sage, the loss of status, and the experience of shame. Recall the tradition from the preliminary *sugya* that "one must be particularly careful about wronging (*'ona'a*) one's wife. Because her tears are frequent, wronging her is close at hand."³¹ When the sages provoke Eliezer to tears, the consequences of this injury are likewise close at hand.

Eliezer's anguished reaction to the news immediately³² unleashes divine wrath (G–H).³³ The repetition of the particle *'af* ("also" or "so") at

the mention of each calamity conveys a sense of a measured force exacting revenge (G2, G3, H). And the earlier treatment of Eliezer corresponds to the form of the destruction. The sages reject proof based on a disruption in the natural world, the uprooting of the carob tree, and now suffer a painful disturbance in the course of nature, the ruination of crops and dough.[34] The sages burned Eliezer's purities, now the world burns from his gaze (G3). Fiery devastation streams from the eyes which the sages filled with tears. The sages rejected Eliezer's backward-flowing water. Now Gamaliel is threatened by water unnaturally rising up against him (H). God apprised the sages that the law follows Eliezer "in every place"; destruction consequently occurs "in every place" Eliezer looks (G3). In the end Gamaliel's death avenges the social death of the ban. Measure for measure, the punishments fit the wrong.

The threat against Rabban Gamaliel, as noted above, is curious in that he was not mentioned earlier in the story (H). We must assume that Rabban Gamaliel was among the rabbis who banned Eliezer, for he realizes that his actions have caused the threatening wave.[35] As Patriarch and leader, moreover, Gamaliel signifies rabbinic authority and bears primary responsibility for the ban.[36] His acknowledgement of the source of the threat ("It seems to me that this is because . . .") echoes Akiba's statement informing Eliezer ("It seems to me that your colleagues . . . ), which reinforces for the audience the cause and effect relationship. Gamaliel's strategy, like that of Yehoshua, shifts the focus away from human interactions to the divine plane and to concern for the integrity of the law. Like Yehoshua, Gamaliel "stood up on his feet" and addressed God directly, insisting that he acted "so that disagreements do not multiply in Israel," and again God accepts this defense of the legal process. Just as Yehoshua prevented the walls from falling at Eliezer's behest, so Gamaliel prevents the wave from falling on him as punishment for wronging Eliezer.

It is significant that the issue of personal honor once more appears, as it had in Yehoshua's rebuke of the walls. Here Gamaliel disavows acting out of regard for personal or familial honor in an attempt to marginalize such factors. The burning and ban have proved so detrimental to Eliezer's honor that Gamaliel dare not appeal to his own. The pointed contrast between *Rabban* Gamaliel, the Patriarch who bears a special title, and "the Son of Hyrcanus," no longer even recognized with the honorific "Rabbi," calls attention to the disparity of honor. Yet Rabban Gamaliel realizes that the honor of his title, of the Patriarchal office and of the Patriarchal dynasty mean nothing when the honor of a fellow sage has been trampled. For

this reason too, perhaps, this scene features Rabban Gamaliel rather than Yehoshua, Akiba or another sage. In any case, the impassioned disavowal of honor reveals, at a deeper level, the inescapable intertwining of interpersonal relations and legal processes.

Gamaliel's success in restraining the punishment proves precarious and temporary. As we learn from the final scene, his life depends on the vigilant efforts of Ima Shalom, who is both his sister and Eliezer's wife (H). Disclosure of the kinship ties between the protagonists makes the treatment of Eliezer seem all the more harsh.[37] Gamaliel injured his own brother-in-law so grievously and brought misery within his own family. Further allusion to kinship derives from the name Ima Shalom or "Mother Peace," which also functions as a mode of characterization: like a good mother, she strives to keep the peace between brothers (in-law). The kinship motif appears yet again in Gamaliel's invoking his "father's house" in staving off the wave, and once more in Ima Shalom's tradition from her "father's house" that explains his death. These repeated references to familial relationships bring us back to God's initial designation of the rabbis as his sons. While God tolerates—even approves—his sons defeating the "father," he will not permit his sons to wrong one another, and neither "Mother Peace" nor kinship ties prevent punishment.[38] In this respect the kinship references amount to a pertinent and important lesson: rabbis must behave like a family or suffer the consequences.

The final scene, as noted above, recapitulates and intensifies the dynamic of the second scene. The colleague trying to restrain Eliezer's reaction becomes a wife and sister; the tears expressing pain become explicit prayers and confession,[39] and the posture of sitting on the ground becomes falling on the face. The intensified reaction brings about intensified destruction: the burned crops, ruined dough, and burning fire become the death of Gamaliel. These parallels suggest that the threatening wave corresponds to the poor man at the door, hence that the poor man too results from supernatural intervention seeking to avenge Eliezer. Indeed, Elon has shown that the "poor man at the door" is a common BT theme that occurs in situations when danger threatens a character and figures in the character succumbing to or surviving the threat.[40] The daughter of Akiba, for example, is saved from death on the day predicted by astrologers because she gives bread to a poor man at the door (bShab 156b), while in another story the death of a sage soon follows the arrival of the poor man (bMQ 28a). In our story disaster threatens Gamaliel, and when the poor man distracts Ima Shalom, Eliezer falls on his face in prayer. At the same time, the door is

a concrete representation of the metaphoric "gates" to which Ima Shalom refers.[41] As she opens the door Eliezer's prayers pass through the open "gates of [verbal] wronging."

In two other respects the "poor man at the door" connects to earlier parts of the story. Although provision of bread is sometimes an element of the theme,[42] here the need for bread recalls the decimated crops and ruined dough. If the lack of crops caused this scarcity of food, then Eliezer's immediate reaction to the ban contributes to Gamaliel's death. The extended causal chain (ban ▶ Eliezer's reaction ▶ damage to crops and dough ▶ [scarcity of food][43] ▶ poor man at the door seeking food ▶ Ima Shalom leaves Eliezer ▶ prayer ▶ death) demonstrates the relentlessness of divine justice in cases of verbal wronging. Second, the description of the poor man *standing* at the door continues the motif of postures that runs throughout the story. To this point Eliezer has been associated with falling—he sits on the ground and the walls fall at his behest. Yehoshua and Gamaliel are associated with standing—both stand to address God while the walls stand (or do not fall) to respect them. Here, ironically, the poor man standing at the door enables Eliezer to fall on his face, an expression of utter degradation. Consummating the incomplete fallings of the previous scenes, the concrete representation of Eliezer's humiliation simultaneously allows him to manifest his internal anguish. Ima Shalom's subsequent words to Eliezer, "stand up," again emphasize the power of these postures. Once the perpetrator has been punished Eliezer stands upright, a sign that the insult to his honor has been avenged.

The shofar blast (*shipura*) that signals Gamaliel's death is heavily charged with symbolism, as Elon has documented.[44] It functions primarily to announce death and to honor the deceased—an ironic salute in light of Gamaliel's previous disavowals of personal honor.[45] A shofar was used to publicize the decision of a judge or rabbi, and hence represents authority.[46] Bans, in particular, were effected by blasts of the shofar, as in bQid 70a: "He [Rav Yehuda] took out his shofar and banned him."[47] The BT reports several cases of banning and accompanying shofar blasts issued against those who offended a sage.[48] In this way the signal of Gamaliel's death simultaneously points to its cause: the banning of Eliezer and offense to his honor. The measure-for-measure principle is intimated once again: the same shofar used to ban Eliezer (the audience would assume the standard ceremony took place) subsequently announces the perpetrator's death.

The denouement artfully illustrates not only the cause of Gamaliel's death but its rapidity and inexorability. The temporal adverbial clause "while she was giving . . ." (*'adeyehevat*) conveys the near simultaneity of

Ima Shalom going to the door and Eliezer's fall, and the clause "meanwhile the shofar . . ." (*'adehakhi*) expresses the near simultaneity of Ima Shalom's assertion of the death and the shofar signaling it.[49] Gamaliel's death, however, is not explicitly reported by the narrator. Ima Shalom declares it in the dialogue and the narrator subsequently confirms her assertion by recounting the shofar blast, a retrospective sign of the death. This narrative device, a paralipsis or lateral omission of information,[50] affords the audience the same perspective as Eliezer, consequently the same surprise at Ima Shalom's confident assertion and wonder at the source of her knowledge. Yet her explanation makes clear that there is nothing to be surprised about. Gamaliel's death was a mechanical reflex, a completely foreseeable outcome to anyone aware of the tradition, "All the gates are locked except for the gates of wronging." That Ima Shalom knows by ancient tradition ("from my father's house") and not by some sort of prophetic ability contrasts with the supernatural phenomena of the first scene — miracles, the heavenly voice and Elijah's eye-witness account of God's words.[51] One type of divine intervention is certain: God always hears the pain of the victim of verbal wronging and immediately responds.

As a whole, the story undoubtedly has great significance for understanding the rabbinic conception of the legal process and related ideas about divine authority and human interpretation. The statements of Yehoshua, Gamaliel and R. Yirmiah stake out important positions and constitute, on one level, what the text is about. Yet these views appear within a story that focuses less on the legal controversy than its aftermath, the interpersonal relationships, emotional harm, and verbal wrong.[52] Moreover, the entire story appears in a halakhic and literary context that emphasizes these themes. Ultimately the story focuses on the tension between these two realms, between a legal process that involves interpretation, debate, and decision, on the one hand, and human feelings, emotions, and dignity on the other. If there is nothing more rabbinic than argumentation and debate, there is nothing more human than to feel pain at rejection and disgrace. In the heat of the debate it is easy to turn *ad hominem,* to reject the person rather than the position he advocates, to become frustrated and annoyed, to slip from legal discussion to insult and offense, to treat a stubborn opponent with hostility and contempt. Almost anything can be justified in the name of the legal process. We see here the familiar tension between abstract principles and concrete, human reality. By their very nature abstractions tend to divert attention from the individual plane and to minimize the significance of particular human suffering. These dangers are particularly great when the majority — confident because of its numbers, self-righteous

because it is the majority—vents its power against an individual. The story warns that the human elements must not be overlooked. Feelings of pain and humiliation matter, and must not be ignored in the name of legal considerations. God certainly cares that his law be observed and respected, but he cares more for the feelings of the creatures to whom he gave that law. God accepts principles such as "It is not in heaven" and "Incline after the majority," yet he will not accept these principles as justification for verbal wronging and causing pain. The sages must negotiate this tension so as to preserve the integrity of the law while treating each other with respect and consideration. The story, then, is not only about the nature of the legal process but about how that process must be conducted.

## The PT Story and BT Compositional Technique

At this point we shift from synchronic analysis, from reading the story as it now stands, to diachronic analysis of sources and earlier versions. How do the sources and versions contribute to our interpretation of the story and to our understanding of the compositional methods of the storytellers?

The earliest allusion to the story appears in Tosefta Eduyot 2:1, which lists "four things R. Eliezer rules pure and the sages rule susceptible to impurity." The last of these is the oven cut into segments of mKel 5:10, mentioned in the talmudic story. The Tosefta cites the disagreement exactly as found in the Mishna and then adds, "for disagreements multiplied in Israel about it." This fragmentary datum seems to allude to a Tannaitic oral tradition that significant controversies erupted over this issue. Whether that tradition was similar to the story found in the Talmuds is unknown. Most likely, the Tannaitic tradition was lost and the talmudic story created as a loose narrative exegesis of the Tosefta, an attempt to explain how and what "disagreements multiplied" specifically over this oven. While this Toseftan phrase does not appear explicitly in the PT version, it finds a reflex in the BT in Gamaliel's petition that he acted "so that disagreements not multiply in Israel" (G).[53]

The PT contains a version of the story that has much in common with the BT, found in yMQ 3:1, 81c–d:

> (a) They wished to ban R. Eliezer. They said, "Who will go and inform him?" R. Akiba said, "I shall go and inform him." He went to him and said to him, "Master, Master, your colleagues are banning you."
>
> (b) He (Eliezer) took him and went outside and said, "O Carob,

O Carob, if the law is according to their words, uproot yourself," but it did not uproot itself. "If the law is according to my words, uproot yourself," and it uprooted itself. "If the law is according to them, return," and it did not return. "If the law is according to my words, return," and it returned.

(c) All this praise and the law is not according to R. Eliezer? R. Hanania said, "When it was given, it was given only such that *incline after the majority (Exod 23:2)*."

(d1) But did not R. Eliezer know *incline after the majority (Exod 23:2)*?

(d2) He became angry (*hiqpid*) only because they burned his purities in front of him.

(e) We learned there: *If he cut it (an oven) into segments and placed sand between the segments, R. Eliezer rules that it is pure and the sages rule that it is impure. This is the oven of Hakhinai.* [=mKel 5:10].

(f1) R. Yirmiah said, "A great burning occurred on that day. Every place that R. Eliezer cast his eye was burned.

(f2) "Not only that but even one grain of wheat, half of it [that he looked upon] was blighted and half of it [that he did not look upon] was not blighted."

(f3) And the columns of the assembly house were trembling. R. Yehoshua said to them, "If the sages are fighting, what care is it of yours?"

(g) A heavenly voice went forth and said, "The law accords with my son Eliezer." R. Yehoshua said, "*It is not in heaven (Deut 30:12)*."

(h) R. Qerispa, R. Yohanan in the name of Rabbi said, "If someone says to me, 'Thus teaches R. Eliezer,' then I teach according to his words. But the Tannaim change [the names and attribute Eliezer's opinions to others]."

(i) Once he (Eliezer) was passing through a market and he saw a woman cleaning her house, and she threw it out and it fell on his head. He said, "It seems that today my colleagues will bring me near (i.e. forgive me), as it is written, *He lifts up the needy from the refuse heap (Ps 113:7)*."

Even a cursory glance at the PT reveals stunning parallels: the same characters, the ban, the miracle with the carob, the burning of crops, the heavenly voice, the quotation of Exod 23:2 and Deut 30:12. As usual, the PT version is briefer and less developed literarily. Moreover, the plot is disjointed to such a degree that it is difficult to determine the causal and

temporal sequence.[54] Section d2 tracks back to an earlier time in order to explain Eliezer's rejection of majority rule in c. The chronological sequence is probably e-d2-f-g-a-b-i-h, with c-d1 commenting on b.[55] Note that the fabula and narrative discourse coincide more closely in the BT, that is, the BT essentially presents the events in chronological order.[56]

It is crucial to observe that the literary and halakhic contexts of the stories differ significantly. The PT story appears in the section of Talmud that comments on mMQ 3:1. This Mishna lists those permitted to shave on the intermediate days of the festival, including a person whose ban has been repealed. The Talmud deals at length with the laws of the ban and then provides several stories of individuals who were banned. Thus the PT context is the ban and the story begins on that note. No mention is made of verbal wronging. In the BT, as we have seen, the story appears in the context of verbal wronging and ends on that note.

Before comparing the two stories in detail, let me point out a few differences in the order of the fabula of the two stories.[57] First, in the PT the miraculous support for Eliezer occurs *after* he has been informed of the ban (a–b), while in the BT it precedes the ban (C). Second, in the PT the *columns* of the *assembly house* tremble in the account of the destruction (f2). The BT transforms and transfers this miracle: the walls of the academy (*beit midrash*) tilt in the account of the miraculous proofs of Eliezer's opinion (B3).[58] This shift from assembly house to academy occurs in other BT versions of PT stories.[59] Third, in the PT the appeals to "It is not in heaven" and "Incline after the majority" appear at two different points (g, c) in response to two different events (the destruction, the miracles). These are connected in the BT (C1–C3) and both follow the miracles. Moreover, in the PT Yehoshua's response, "It is not in heaven," follows the destruction and perhaps attempts to contain it (g). In the BT the heavenly voice and response (C1–C2) precede the destruction. Gamaliel's plea, rather, temporarily staves off the destruction, but cannot ultimately contain it (G–H). This different sequence of events in the BT completely changes the fundamental tension. The legal controversy, its miracles and even the rejection of the heavenly voice become the prelude to the central interest — the ban and verbal wronging of Eliezer and the disastrous consequences. The account of the controversy essentially functions as an extended exposition which motivates the subsequent events. In the PT the rejection of the heavenly voice successfully contains the destruction while the ban has no deleterious consequence.[60]

My main interest is the nature, provenance and significance of the differences between the BT and PT. First, what did the BT storytellers add

## Torah, Shame, and "The Oven of Akhnai"

to or omit from the PT story (or an earlier version similar to the extant PT)? It will be helpful to classify the BT additions in terms of embellishments, expansions, and supplements. While the distinctions between these three phenomena are hard to define precisely—all involve additions, and any embellishment can be said to have expanded the text—they are used in the following sense. An "embellishment" is when the same events are recounted with added detail or description. An "expansion" is when more events are recounted in the BT, but these correspond roughly to fabula of the PT. For example, where Eliezer solicits three supernatural proofs in the BT but only one in the PT, it is an expansion. A "supplement" is when statements or events present in the BT do not correspond to any fabula of the PT.

Second, where do the additions come from? Did the BT storytellers borrow from other sources?

Third, what is the content of the additions? What do they contribute to the literary analysis of the entire story?

| BT BM 58b–59b | PT MQ 3:1, 81c–d |
|---|---|
| (A1) *We learned there . . . this is the oven of 'Akhnai. [=mKel 5:10]* | (e) *We learned there . . . this is the oven of Hakhinai. [=mKel 5:10]* |
| (A2) What is 'Akhnai (snake)? Yehuda/Shmuel: "Since they surrounded him with words like this snake . . ." | — — |
| (B1) It was taught: On that day R. Eliezer responded with all the responses . . . | — — |
| (B2) Carob | (b) Carob |
| (B3) Aqueduct | — — |
| (B4) Walls; R. Yehoshua's rebuke | (f3) Columns; R. Yehoshua's rebuke |
| (B5) They did not fall for the honor . . . | — — |
| (C1–2) Heavenly voice: "What is it for you with R. Eliezer since the law is like him in every place"; R. Yehoshua: "Not in heaven" | (g) Heavenly voice: "The law accords with my son Eliezer"; R. Yehoshua: "Not in heaven" |

| | |
|---|---|
| (C3) What is, "It is not in heaven"? | (c) All this praise... |
| (C4) R. Yirmiah: "It was already given at Sinai; it says *incline after the majority*" | (c) R. Hanania: "When it was given... *incline after the majority*" |
| (D) R. Natan came upon Elijah: "What did the Holy One say..." | — — |
| (E) They brought objects... burned them and banned him | (a), (d1–2) They wished to ban... he became angry because they burned... |
| (F1) Who will go and inform? Akiba: "I will go..." | (a) Who will go and inform? Akiba: "I will go..." |
| (F1) Akiba: "Lest a man who is not fitting go"... He went and dressed in black... | — — |
| (F2) Eliezer: "Why is this day different..." | — — |
| (F2) Akiba: "Your colleagues are keeping separate from you" | (a) Akiba: "Your colleagues are banning you" |
| (F2) His eyes filled with tears | — — |
| (G1) one third of wheat and olive, half of barley crops | (f2) half of each grain of wheat blighted |
| (G2) dough swells up | — — |
| (G3) everywhere Eliezer cast his eyes burned | (f1) R. Yirmiah: "A great burning occurred" |
| (H) R. Gamaliel and the wave | — — |
| (I) Ima Shalom | — — |
| — — | (h) R. Qerispa: "The Tannaim change..." |
| — — | (i) Refuse falls on Eliezer |

Let us take the main additions in order.

(A2) Supplement: The BT provides a symbolic interpretation of the name ʿakhnai/snake, which replaces "Hakhinai" of the PT (perhaps a deliberate change). The interpretation simultaneously provides a description—and to some extent an evaluation—of how the sages treated Eliezer, which is not mentioned in the PT.

(B1) Expansion: The PT mentions that the "sages were fighting" (f3) and the dispute over the oven. The BT adds the hyperbolic description "all the responses in the world."

(B2–3) Expansion: The BT has an additional miracle—the aqueduct. Yet there is a slight simplification in the account of the carob miracle. In the PT the carob obeys Eliezer four times.

(B5) Embellishment: The permanently tilted walls enhance the miracle. The allusion to honor is new.

(C1–C2) The BT embellishes the heavenly voice's statement with the rebuke, "what is it for you with R. Eliezer," and with the categorical rule that the law accords with him "in every place," not just here. The BT also adds that R. Yehoshua "stood on his feet" when he spoke.

(D) Supplement: Elijah informing Natan of God's reaction is a Babylonian addition.

(F1–F2) Embellishment: The account of Akiba informing Eliezer is much more extensive in the BT. Dialogue accompanies rich descriptions of Akiba's dress and gestures and of Eliezer's reaction.

(G2) Expansion: The BT adds another disaster—the dough.

(H) and (I) are Babylonian supplements.

(h) and (i) of the PT are omitted in the BT.

The different ending (h–i versus H–I) will be discussed below. Comparing the corresponding sections reveals that the BT version is consistently expanded (B1, B3, G2) and embellished (B5, C1, F1–F2). The shared story has been supplemented by the BT at two points (A2, D). Only in the description of the carob miracle is the BT more concise (b versus B2), but this simplification is compensated by an overall expansion of that scene (B1, B3).[61] The striking similarities and the consistent pattern of additions confirm our working hypothesis that the BT story is a literary revision of the PT (or a version close to the PT).

Let us turn now to the second question, the provenance of these additions. Can we identify other sources that provided raw material?

(A2): **"surrounded him with words"**: Similar expressions appear in other BT stories. In bBM 84b R. Eleazar b. R. Shimon rebukes Rabbi

(Yehuda HaNasi): "You have surrounded us with bundles of objections that have no substance." In the story of the sages and R. Dosa b. Harkinas, bYev 16a, we read: "They began to surround him with laws (*mesavevin 'oto bahalakhot*) until they reached [the question of] the daughter's co-wife." Here too the sense is that the sages acted with cunning and guile by distracting Dosa with halakhic prattle before broaching the main issue. The PT version of the Dosa story lacks this locution (yYev 1:6, 3a–b).[62]

The attribution to Rav Yehuda and Shmuel as well as the basic form of the statement probably derive from bEruv 104b: "What is the Haqer cistern? Rav Yehuda said Shmuel said, 'A cistern about which they called forth (*hiqru*) words and permitted it.'"[63] This too is a metaphoric interpretation of a proper name (Haqer/Akhnai) in terms of the type of legal maneuver (called forth words/surrounded with words) and decision (permitted it/ruled it impure).[64]

(B3): I find no parallel source, and no other case of a miracle of this type. Of course the dialogue basically follows that of the carob miracle.

(B4): The falling walls, as noted above, derive from the shaking columns of the PT. The dialogue again follows that of the carob miracle.

(B5): The figure of tilted walls has no parallel. As far as I can tell, this is pure authorial creativity.

(C1–2): God's added rebuke **"What is it for you"** is based on Yehoshua's rebuke to the walls (B4 in the BT, f3 in the PT).[65]

(D): The locution, **"R. So-and-So came upon Elijah. He said to him, 'What was the Holy One doing,'"** also appears in bGit 6b and bHag 15b. The latter is also a BT addition to a PT story.[66] The former concerns a dispute between sages, similar to our story, and God does not settle the issue but accepts both opinions as true. In several other places we find, "R. So-and-so came upon Elijah. He said to him . . ." (bBM 114a, bSanh 98a, bMeg 15b, bYev 63a). These locutions do not occur outside of the BT.[67]

Elijah's report of God's answer, **"My sons have defeated me** (*nitshuni banai*)**,"** picks up on R. Yehoshua's rebuke to the walls, "When sages defeat each other (*menatshim*), what is it for you?" In both bGit 6b and bHag 15b God calls various rabbis "my son."[68] This supplemented scene is a clear example of the storytellers' compositional techniques. They use a common BT form and recycle words from elsewhere in the story.

(F1–F2): The BT embellishments in the description of the encounter between Akiba and Eliezer are almost all stock phrases found in other sources:

"a man (or student, judge, etc.) who is not fitting"[69]

"destroy the (whole) world"[70]

"dressed in black and covered[71] himself in black"[72]
"keeping separate from . . ."[73]
"his eyes streamed with tears"[74]
"he removed himself and sat on the ground"[75]

The expression "why is this day different from other days" has no parallels. The expression "took off his shoes and sat before him at a distance of four cubits" does not appear to be a stock phrase, but both to "take off shoes" and removal to a distance of four cubits appear in numerous sources.

(G2): The swelling dough has no parallel.

(H): The description of Rabban Gamaliel on the ship is constructed from phrases and motifs found elsewhere:

"**Once Rabban Gamaliel was going on a ship**": Several Tannaitic sources (with parallels in both the PT and BT) begin stories with the formula, "Once Rabban Gamaliel and the elders were going on a ship": mMS 5:9; mShab 16:8; tShab 13:14; tSuk 2:11 (=*Sifra, 'Emor* 16:2 [102c]). *MidTan* 172 reads: "Once Rabban Gamaliel was going on a ship." A BT *baraita* places Gamaliel and Akiba on a ship (bSuk 23a), and another BT source describes Gamaliel and Yehoshua on a ship (bHor 10a). mEruv 4:1 places Eleazar with Gamaliel on a ship. Thus Rabban Gamaliel going on a ship is a well-established rabbinic motif.[76] From a source-critical perspective, then, we can explain why Gamaliel appears in the middle of our story and why the wave threatens him rather than Yehoshua. In constructing this scene from other sources the storytellers employed the standard motif of Gamaliel on a ship. This also explains why this section appears in Hebrew whereas the following section shifts to Aramaic. The storytellers here borrow the motif from Tannaitic Hebrew sources.[77]

"**A wave of the sea stood [upon him] to drown him**" (*'amad ['alav] naḥshol shebayam letab'o*): So tYom 2:4 (=bYom 38a), tBM 7:14 (=yBM 6:4, 11a; bBQ 116b), tNid 5:17.[78] There is a close parallel in bGit 56b. When Titus returns after destroying the temple, "a wave of the sea stood upon him to drown him. He said, 'It seems to me that their God only has power over water.'" Here too Gamaliel reacts to the wave, "It seems to me that . . ."[79] Both realize that God sends the wave against them because of their actions. Note that "it seems to me" also appears in Akiba's oblique statement to Eliezer (F2).

"**He stood up on his feet and said, 'Master of the Universe: [It is revealed and known before you that]**[80] **I acted not for my honor, nor did I act for the honor of my father's house'**": This protest of Rabban Gamaliel is closely paralleled in the story of Yonatan b. Uziel, bMeg 3a.

Yonatan petitions God to stop the earthquake caused by divine displeasure at his having translated the Prophets: "Yonatan b. Uziel stood on his feet and said, 'It is revealed and known before you that I acted not for my honor nor did I act for the honor of my father's house but for your honor in order that disagreements do not multiply in Israel.'" In this case too the protest mentions the danger of disagreements and forestalls a (super)natural disaster. Another parallel occurs in bTa 20a where Naqdimon b. Gorion entreats God for rain: "He stood in prayer and said, 'Master of the universe: It is revealed and known to you that I acted not for my honor nor for the honor of my father's house but for your honor so that there will be water.'" Invoking the honor of the father or the honor of the father's house also occurs in other sources (bYom 38a = yYom 3:9, 41a; ySuk 5:4, 55c = ySanh 2:4, 20b; yKet 8:6, 32b.) In bBer 28a our own Gamaliel asks R. Yehoshua to forgive him "on account of my father's honor."

**"in order that disagreements do not multiply in Israel"**: This phrase, as we noted, ultimately derives from the Tannaitic source of the story in tEd 2:1.[81] Apart from the parallel in bMeg 3a mentioned above, this phrase occurs in *MidTan* 103; yPes 6:1, 33a; ySanh 8:6, 26b; bSot 25a; bSanh 88a–88b.

**"The sea immediately rested from its anger"**: The story about the raging wave at bYom 38a also ends with this phrase.[82]

This episode with Rabban Gamaliel is thus a remarkable montage of phrases and motifs found in the BT and in other rabbinic documents. In fact the only unique words are "this is because of [R. Eliezer] the Son of Hyrcanus," which is about the minimum needed to refer to the story at hand.

(I): **"Ima Shalom, the wife of R. Eliezer, was the sister of Rabban Gamaliel"**: The identical phrase begins a story in bShab 116a.[83]

**"a poor man came and stood at the door"**: So bShab 156b. As noted above, the theme appears in bMQ 28a, bQid 81a, bKet 67b, bTa 23b, with variant wording.

**"Thus I have received a tradition from my father's house"**: In bEruv 63a (ms M) R. Eliezer answers Ima Shalom with this phrase to explain how he knew that a certain student would die soon. The story first appears in *Sifra, Shmini* 1:32 [45b].[84] In our story Ima Shalom tells R. Eliezer how she knew that Rabban Gamaliel would die. It seems that the storytellers revamped the Tannaitic story or its BT version by reversing the dialogue. This phrase also appears in numerous other sources (with minor variants): yBer 9:2, 13d; bBer 10a–b, bShab 119b, bRH 25a, bBB 110a, bSanh 89a.[85]

"All the gates are locked except for the gates of [verbal] wronging": The same phrase appears in the preliminary *sugya* in a tradition attributed to Rav Hisda (bBM 59a). This connection, in part, creates the powerful link between the story and its context.

The other phrases of this section (I) do not have exact verbal parallels. Yet the themes of a sage falling on his face (sometimes out of embarrassment) and the poor man at the door asking for bread, and the motif of the shofar, are well attested, as noted in the analysis above. This section, then, has been constructed out of common themes and motifs with a few stock phrases, although somewhat less than F1–F2 and H. Clearly we must expect that the specific dynamics of a story sometimes require unique phrasing.

These comparisons demonstrate that a significant portion of the BT additions to the Palestinian story, especially the supplemented scenes (A2, D, H, I), are comprised of stock phrases, parallel expressions, and common motifs. Now we cannot conclude that every such case involved mechanical borrowing or transference. In cases where the expression occurs only in BT parallels, not in earlier sources, it is presumably original in one of its locations. And although motifs may be borrowed or imitated, the storytellers may have drawn on a cultural repertoire of motifs without transferring them from another fixed text. But I would not want to explain away all the parallel language in this way, especially where we find the expression documented in earlier sources. We can safely conclude that *an important compositional technique of the storytellers was to borrow material from other sources and adapt, change, or manipulate it as needed.* They creatively embellished and supplemented the stories they received by drawing a great deal from other traditions.

A second compositional technique of the storytellers was to duplicate and modify language from elsewhere in the story. The narration of the miracles of the aqueduct and the walls mimics the narration of the miracle of the carob, which first appears in the PT. God's rebuke to the sages, "What is it for you" (C1), repeats Yehoshua's rebuke of the walls (B4), which also derives from the PT (f3). Elijah's report of God's reaction, "My sons have defeated me" (D), adopts the language of Yehoshua's rebuke to the walls (B4). We noted above that the BT transformed the shaking columns into falling walls.

Most important, *these compositional processes allow us to identify the storytellers as the redactors, the Stammaim.* As we know from the studies of Halivni and Friedman, the redactors constructed legal *sugyot* through a similar process of borrowing, transferring, and adapting legal traditions from ear-

lier sources and other BT passages.[86] Amoraim do not construct traditions by combining earlier sources in the same way as these scenes were fashioned. Nor do they rework earlier sources in the same way as the PT story was reworked. The BT story must be the work of the Stammaim. Henceforth I will refer to the creators of the BT stories as redactors or Stammaim, not only as "storytellers."

It should also be noted that several of the additions reflect Babylonian culture. There are no references to the shofar as a ritual announcement of death in Palestinian sources.[87] Likewise the themes of "the poor man at the door" and of sages asking Elijah about God's actions or reactions appear only in the BT.[88] That Gamaliel and Eliezer are brothers-in-law is consistent with a tendency in the BT to present Palestinian rabbis as related, even where Palestinian sources make no such claim.[89] The metaphor of "surrounding with laws" (or words/answers) is Babylonian. The Babylonian coloring demonstrates that the story was reworked to a considerable degree in Babylonia. Again we see that the BT story is not an independent witness from early times but the result of a literary process.

The third question concerns the differences in content and how these contribute to the literary analysis. The major difference is the endings (H–I versus h–i). The PT concludes with an optimistic note that the sages will forgive Eliezer and bring him back into the fold. This ending essentially justifies the ban of Eliezer, or at least presents it from a neutral perspective: the sages banned him; they may rehabilitate him. Likewise, Eliezer's disgrace shows that he was the offending party and must pay the penalty. R. Qerispa's tradition (h), a non-narrative comment reflecting on the events from a later perspective, suggests that tension remains. Some later rabbis recognize the truth of Eliezer's rulings but the Tannaim who memorize traditions refuse to dignify Torah with his name. In the BT sections H–I express sympathy for Eliezer and punish the sages, represented by Gamaliel, for their actions. Calamity is temporarily contained (H), but cannot be prevented when Eliezer reveals his pain (I). One can think of no harsher criticism of the sages than this inexorable death.[90] And the final line of course pins the blame on verbal wronging.

The other BT additions are consistent with this major divide. Most of the additions emphasize the emotional and interpersonal dimension of the story, especially the suffering of Eliezer. In the PT there is almost no reference to the hurt feelings of Eliezer or human relations in general. First, consider the encounter between Eliezer and Akiba (F versus a). In the PT Akiba simply volunteers to go and inform Eliezer of the ban and does so

directly. In the BT embellishments of this scene Akiba worries that a "fitting person" go lest the world be destroyed and dresses in black to express his own anguish. In contrast to the stark "your colleagues are banning you" of the PT, his oblique "it seems that your colleagues are separating from you" attempts to mitigate the pain the words inevitably will cause.[91] Eliezer's weeping upon hearing of his ban and sitting on the ground again emphasize the emotional toll. Second, the BT's final scene focuses on Eliezer's emotional state through his prayer and Ima Shalom's attribution of Gamaliel's death to verbal wronging. In contrast, the only emotion associated with Eliezer in the PT is *anger* (d).[92] Third, the BT mentions the honor (*kavod*) of the respective sages in the embellishment of the miracle of the walls/columns (B4 versus f3), and Gamaliel mentions honor as well (G3). The BT focuses on how the sages damaged Eliezer's honor, which produced his emotional distress—whatever the merits of their position from a strictly legal point of view. Fourth, the BT's supplemental description of the sages "surrounding" Eliezer with laws portrays their act as aggressive and cunning (A2), again focusing on human relations. The BT even emphasizes emotions in the supplemented scene recounting God's reaction. God laughs and smiles, a sharp contrast to the tears of Akiba and Eliezer.

In the literary analysis we noted the motif of standing, sitting, and falling. Over and above the references that appear in the BT's supplemented ending (Gamaliel standing in H, Eliezer falling in I), the motif appears exclusively in the BT's additions to the paralleled portions. Thus the falling walls replace the shaking columns (B4 versus f3) and the BT embellishes the miracle by mentioning that the walls neither stood nor fell and are still "inclining and standing" (B5). Herein lies the importance of the subtle BT embellishment to Yehoshua's rejection of God's intervention (C2 versus g), that Yehoshua "stood on his feet" to speak. In the BT Eliezer sits on the ground after being informed of the ban, while in the PT he solicits miracles (F2 versus b).

The emphasis on the emotions found in the BT's additions are fully suited to the BT context—verbal wronging and shame. In the PT, as we noted, the story occurs in Tractate Mo'ed Qatan, attached to a Mishna that mentions the ban, and within the context of a series of stories of individuals who were banned. Thus the BT redactors seem to have reworked and recontextualized the story simultaneously.[93] That is, the redactors have tailored the text of the story to fit the context they chose. This again supports the identification of the storytellers as the redactors, for the redactors and not the Amoraim are responsible for the Talmudic context. In terms of

methodology, this story is a good example of how literary analysis, source-criticism, and redaction-criticism mutually reinforce one another and contribute to a comprehensive interpretation.

Even if one rejects the hypothesis that the BT redactors knew a form of the story similar to that of the PT and consciously reworked it, a crude comparison of the two stories nevertheless reveals what is unique to the BT. The story combines themes of legal dispute, miracles, and authority with those of human feelings and emotional trauma. The BT redactors were interested not only in the legal process but in the human interactions that inhere in that process. To fail to appreciate this point is to misunderstand the meaning of the BT story. Indeed, readings of the story which miss this point replicate the errors of Yehoshua and Gamaliel. Just as Yehoshua and Gamaliel ignored Eliezer's feelings out of concern for the legal process, so such readings ignore what the story teaches about Eliezer's hurt feelings in favor of what the story teaches about the legal process. We have been surrounded by so many words about the "Oven of Akhnai" that we too fail to appreciate the sufferings of Eliezer. The story offers us not only a vision of the legal process, but a vision of how that process should and should not be conducted.

## Cultural Context

A wider cultural context for the story is actually provided by the aggadic *sugya* that precedes it (see Appendix 1). There is little need for additional evidence of the importance of shame and verbal wronging in the BT. Indeed, several of the traditions found in the aggadic *sugya* derive from elsewhere in the Talmud. By transferring them to their present location and constructing the preliminary *sugya*, the redactors created a literary context that reveals the cultural context of the story. Other aspects of shame appear in several of the stories analyzed in the following chapters, and I return to the subject in the conclusion. Here I will suffice by pointing to two additional texts. The first is the tradition of the heavenly voice decreeing that the law follows the House of Hillel, cited at the beginning of Chapter 1.[94] This account, like our story, grapples with a fundamental question of law and presents a paradoxical solution: two contradictory opinions are both "the words of the living God" but only one is acceptable practice. Surprisingly, the BT justifies the primacy of the House of Hillel on the grounds that they "were pleasant and modest" and taught the traditions of the House of Shammai before their own traditions. Here too we see the

Torah, Shame, and "The Oven of Akhnai" 61

connection between the legal process and ethical behavior and the priority of ethics. The treatment of other human beings, and especially competitors or colleagues in the academy, is inseparable from legal activity.

Second, the following brief story appears in bTa 9b (ms Munich 95):

> R. Shimi bar Ashi often attended [the lectures] of Rav Papa. He (Shimi) would make many objections. He (Papa) became distressed. One day he (Shimi) came upon him (Papa) fallen on his face. He heard him say, "May the Merciful One save me from the shame of Shimi." He (Shimi) resolved to be silent and not to make objections again.

This story, too, illustrates the potential of experiencing shame in the course of academic debates. In this case the student does not intend to shame the master, nor does the shame result from the rejection of a sage's halakhic ruling, but rather from his inability to answer an objection raised against his explanation. Yet we see the same gesture of "falling on the face" and painful prayers in response to experiencing shame. The student even resolves to restrain himself despite the limitation this imposes on the learning process. Again the treatment of other human beings must be balanced against the value of acquiring Torah.

APPENDIX 1: PRELIMINARY AGGADIC *SUGYA*, BAVA METSIA 58B–59A

(1) . . . If he was a penitent, one should not say to him, "Remember your former deeds!" If he descended from proselytes, one should not say to him, "Remember the deeds of your forefathers." If he experienced many sufferings or illnesses or buried his children one should not speak to him as did Job's companions, "*Is not your piety your confidence . . . Think now what innocent man ever perished (Job 4:6–7).*" If ass-drivers were requesting grain from him he should not say to them, "Go to So-and-so who sells grain," when he knows that the man never sold grain.

(2) . . . R. Yohanan said in the name of R. Shimon b. Yohai, "Verbal wronging is a more serious [transgression] than monetary wronging, since with the former it is written, *You shall fear God (Lev 25:17)*, and with the latter (Lev 25:14) it is not written, 'You shall fear God.'"[95] R. Eleazar says, "This one affects his person, while that one affects his possessions." R. Shmuel bar Nahmani said, "For this one restoration is possible while for that one restoration is impossible."

(3) A Tanna taught before Rav Nahman bar Yizhaq, "Whoever whitens

the face (=embarrasses) of another in public, it is as if he sheds his blood." He said to him, "You have spoken well. For the red [color] leaves and white comes."

(4) Abaye said to Rav Dimi, "What are they careful about in the West (= Israel)?" He said to him, "About whitening the face, as R. Hanina said, ' . . . All who descend to Gehennom rise except for three who descend and do not rise. And these are they: He who calls his fellow by a nickname, and he who whitens the face of his fellow in public, and he who has intercourse with a married woman . . . '"

(5) Rabba bar bar Hanna said in the name of R. Yohanan, "It is better for a man to have intercourse with a married woman, but let him not whiten the face of his fellow in public."

(6) . . ."It is better for a man to throw himself into a fiery furnace, and let him not whiten the face of his fellow in public."

(7) Rav said, "A man should always be careful about wronging his wife. Because her tears are frequent, wronging her is close at hand." For R. Eleazar said, "Since the temple has been destroyed, the gates of prayer have been locked . . . Even though the gates of prayer have been locked, the gates of tears have not been locked."

(8) Rav Hisda said, "All the gates have been locked except for the gates of wronging . . . " R. Eleazar said, "[Punishment] for all [sins] is by a messenger except for wronging."

### APPENDIX 2: MANUSCRIPT VARIANTS

The translation is based on ms Munich 95 (M). Variants are from Hamburg 165 (=H); Escorial G-I-3 (=E), Florence 8 (=F), Vatican 115 (=V1), Vatican 117 (V2) and Printings (P). I have listed only the more significant variants. Shamma Friedman has shown that these manuscripts divide into two basic families, HF versus MEV1V2.[96]

(A1) "'*Akhnai*." So EV1V2P. HF read '*Akhna*.

(A2) "Surrounded him with words." M reads "surrounded him with laws (*halakhot*)," against all other manuscripts. But M also reads "with words" in the parallel at bBer 19a, so the weight of the evidence supports this reading.

(B2) EV1V2P read "one hundred cubits and some say four hundred cubits." HF read "The carob uprooted itself from its place and went four cubits and returned. They said to him . . ."

(B2) "The carob returned to its place." HFE have the carob return to its place before the sages' retort. V1 omits.

(B3) "The water returned to its place." HFE omit.

(B4) "What is it for you (*ma tivkhem*)." So EV1V2. HF read *ma lakhem*.

(B3–B4). V1 reverses the order and places the aqueduct after the walls of the academy.

(B5) "It was taught." V1EHF omit.

(C) R. Yirmiah's statement: The word "written" is illegible in M and has been supplied from other mss. HF read "It was already given to us on Mt. Sinai and it is written in it 'Incline after the majority' (Exod 23:2)." EV1 read "We do not listen to a heavenly voice, since you already wrote it for us on Mt. Sinai and said to us, 'Incline after the majority.'"

(C1) V1 adds "Eliezer, my son." See the PT version.

(D) "Laughed." M seems to read "bent down (*gahin*) and smiled," a corruption of *gahikh*, "laugh," which is the reading in F (unless what looks like a ן in M is in fact a ך). H also reads "bent," a similar corruption. EV1 omit "laughed" and simply read "He smiled and said . . ."

(E) "At that time" is omitted by HF, although H has it in G1. E reads "They said: on that day . . ." V1 reads "On that day . . ."

(F1) "Dressed." MFH read *nitkasa*; EV1 read *nit'atef*. The meaning is the same.

(F1) "His (Akiba's) eyes streamed." EFHV1 omit.

(F2) V1 puts "his eyes streamed with tears" last.

(G1) "The world was smitten." HE add "'At that moment' the world was . . ."

(G2) V2 reads "the dough . . . decayed."

(H) "Was in a ship." HF read "traveling (*mehalekh*) in a ship." E reads "going (*ba'*) in a ship."

(H) "Stood to drown him." FEH read "Stood upon him to drown him."

(H) "But I acted for your honor." So FEV1. H omits.

(I) "After that event." So EV1. HF read "All her days."

(I) "The new month . . ." All other mss have been corrupted and read: "That day was the new month. She became confused as to whether it was full or deficient. Others say a poor man came . . ." On the misunderstanding that led to this corruption see Elon, *Symbolization*, 30–34.

(I) "While she was giving." V1HF read "She brought him bread. Before she came [back], she found . . ." E reads "She brought him bread. She came. She found . . ."

(I) "Meanwhile the shofar . . ." So EV1V2. V2 and E add "that he had died." However, V1 and V2 reverse the order of sentences such that Ima Shalom says to Eliezer "Get up . . ." after the announcement goes forth. F reads "*he* heard the announcement." H reads "She heard the announcement from the House of Rabban Gamaliel. She said, 'You have killed my brother.'"

Chapter 3

## *Elisha ben Abuya*

Torah and the Sinful Sage (Hagiga 15a–15b)

The figure of Elisha ben Abuya or "Aher," the Other, has long fascinated the Jewish imagination. Elisha is variously considered an arch-heretic, atheist, gnostic, or apostate, but always a sage whose abandonment of Torah so affected his rabbinic colleagues that they could no longer bear to mention his name. This unfavorable picture of Elisha is a composite produced from interpretations of the Toseftan tradition of the "Four who entered the *pardes* (orchard)," the curious epithet "Aher," later traditions of Elisha from the two Talmuds and midrashic collections, and the tendency of the folk imagination (and scholarly imagination as well) to create stereotypical villains.[1] If the sources are considered independently, however, different views emerge. Each Talmud contains an extended story of Elisha that presents a complex picture of the sage, a picture not as unambiguously negative as the popular image. Yet few scholars to date have analyzed the talmudic stories as literary wholes, for they have focused on the cryptic Toseftan tradition as the key to understanding Elisha's sin in particular and the nature of rabbinic esoteric activity in general. Because our interest is not the historical Elisha, but the story of Elisha within its context in the Babylonian Talmud, it is necessary to begin anew and read the talmudic story on its own terms.[2] The story in fact is less about Elisha than about questions that interested the rabbis: the intrinsic merit of Torah and whether it is jeopardized by sin. As with the "Oven of Akhnai," the story of Elisha ben Abuya affords an opportunity to evaluate the richness of a method sensitive to literary and contextual matters.

This chapter begins with a translation and discussion of the structure of the BT story. The second section contains the literary analysis. Here we see an interesting process of narrative exegesis: the BT constructs part of the story through a complex interpretation of the Toseftan tradition. The third section discusses the lengthy parallel story found in the PT and considers the differences between the two versions. The last two sections attend to the literary, cultural, and halakhic contexts. Here, unlike the previous chapter, assessment of the cultural context involves recourse to several other *sugyot*. The fundamental questions of the story resurface in other locations within the BT.[3]

## Translation and Structure

The BT story is based on the account of the "Four who entered the *pardes*," tHag 2:3–4, which reads as follows:[4]

> Four entered the *pardes* (orchard). One gazed and perished, one gazed and was smitten, one gazed and cut the shoots, and one went up whole and came down whole.
>
> Ben Azzai gazed and perished. Concerning him scripture says, *The death of his faithful ones is grievous in the Lord's sight* (Ps 116:15).
>
> Ben Zoma gazed and was smitten. Concerning him scripture says, *If you find honey, eat only what you need, lest, surfeiting yourself, you throw it up* (Prov 25:16).
>
> Elisha gazed and cut the shoots. Concerning him scripture says, *Let not your mouth lead you into sin (Qoh 5:5)*.
>
> R. Akiba went up whole and came down whole. Concerning him scripture says, *Draw me up after you, let us run! [The king has brought me to his chambers]* (Song 1:4).

Scholarly literature on the nature of the *pardes* and the meaning of these verses is vast. Two interpretive trends dominate the field. The first suggests that the sages were involved in mystical praxis and the descriptions hint at the nature of their mystical experience. The second takes the tradition as a parable relating to investigation of esoteric subjects or to various aspects of Torah study.[5] There is no need to enter this intractable debate except to note that this confusion characterizes the talmudic sages as much as mod-

ern scholars. Both Talmuds struggle to understand what Elisha did and what the verse means in relation to him.

The BT story appears in Tractate Hagiga 15a–b within the talmudic discussion of mHag 2:1, which will be discussed below. The Talmud cites the Toseftan passage and comments first on the reference to Ben Zoma (14b–15a). There follows a second quotation of the reference to Elisha and then the lengthy talmudic story. The translation is based on ms London 400 (Harley 5508). Manuscript variants can be found in the Appendix.

> [I] *Aher gazed and cut the shoots. About him scripture says, "Let not your mouth lead you into sin, [and do not say before the* malakh *(angel/messenger) that it was an error, else God may be angered by your talk and destroy the work of your hands (ma'ase yadekha)] (Qoh 5:5)." (=tHag 2:3)*
>
> What did he see? He saw Metatron, to whom was given permission one hour each day to sit and write the merits of Israel. He said, "It is taught that 'On high there is no sitting and no jealousy and no rivalry and no back and no weariness.' Perhaps—heaven forbid—there are two divine powers?!" Immediately they brought out Metatron and struck him with sixty lashes of fire. He was given permission to burn the merits of Aher. A heavenly voice went out and said to him, "*Return, rebellious children (Jer 3:22)* — except Aher."
>
> [II] He said, "Since that man (= since I) has been banished from that world (= the next world), I will go and enjoy myself in this world." Aher went out to evil ways (literally, "evil growth"). He found a certain prostitute. He propositioned her. She said to him, "Are you not Elisha ben Abuya, whose name went out throughout the world?" He uprooted a radish on the Sabbath and gave it to her. She said, "He is another ('aher)."[6]
>
> [III] (A) After he went out into evil ways Aher asked R. Meir, "What is written, *The one no less than the other is God's doing (Qoh 7:14)*"? He (Meir) said, "Everything that God made, He made its counterpart. He made mountains, he made hills. He made seas, he made rivers." He (Aher) said to him, "Akiba, your master, did not say this. [Rather], He made righteous, he made wicked. He made the Garden of Eden, he made Gehenom. Each and every person has two portions, one in the Garden of Eden and one in Gehenom. The righteous man, having earned merit, takes his portion and the portion of his fellow in the Garden of Eden. The wicked man, having been found guilty, takes his portion and the portion of his fellow in Gehenom."
>
> Rav Mesharshia said, "What is the verse? *They shall have a double share in their land (Isa 61:7).* And it is written, *Shatter them with double destruction (Jer 17:18).*"
>
> (B) After he went out into evil ways Aher asked R. Meir, "What is writ-

ten, *Gold or glass cannot match its value, nor vessels of fine gold be exchanged for it (Job 28:17)*"? He (Meir) said, "This refers to matters of Torah which are difficult to acquire like vessels of gold and vessels of fine gold and easy to lose like vessels of glass." He (Aher) said to him, "By God! Are they even like clay vessels?" He (Aher) said to him, "Akiba your master, did not say thus. Rather, just as vessels of gold and vessels of glass, even if they are broken, they can be restored, so a sage, even though he sins, can be restored." He said to him, "Then you too should repent." He said to him, "No, I have already heard from behind the curtain, *Return, rebellious children (Jer 3:22)* — except Aher."

(C) Our sages taught: It once happened that Aher was riding his horse on the Sabbath going on his way and R. Meir was walking after him to learn Torah from his mouth. He said to him, "Meir, return *(hazor)* back, since I have already measured by the footsteps of my horse that the Sabbath boundary is here." He said to him, "Then you too should repent (hazor)." He said to him, "No, I have already heard from behind the curtain, *Return, rebellious children (Jer 3:22)* — except Aher."

[IV] He (Meir) took hold of him (Aher) and

(A) He brought him to the academy. He said to a child, "Tell me your study verse." He said to him, *"There is no peace — said the Lord — for the wicked (Isa 48:22)."*

(B) He brought him to another academy. He (the child) said to him, *"Though you wash with natron and use much lye, [your guilt is ingrained before me — declares the Lord God] (Jer 2:22)."*

(C) He brought him to another synagogue. He (the child) said to him, *"And you, who are doomed to ruin (Jer 4:30)."*

(D) He brought him to thirteen synagogues. They recited for him in similar ways. The child in the thirteenth said, *"And to the wicked* (ulerash'a) *God said: Who are you to recite my laws [and mouth the terms of my covenant, seeing that you spurn my discipline, and brush my words aside?] (Ps 50:16)."* That child stuttered so it sounded as if he said, "And to Elisha *(ule'elish'a)* God said . . ." Some say he (Aher) took a knife and cut him up and sent him to thirteen synagogues. And some say, he (Aher) said to him, "If I had a knife with me I would cut you up."

[V] (A) When Aher died, they (the angels?) said, "Let him not be punished[7] and let him not enter the world to come. Let him not be punished since he studied Torah regularly. Let him not enter the world to come since he sinned."

(B) R. Meir said, "When I die I shall cause smoke to rise from his grave." When R. Meir died, smoke rose up from Aher's grave.

(C) R. Yohanan said, "Is it a mighty deed to burn one's master with fire?

One was among us, and yet we cannot save him? If I were to take him by the hand, who would tear him away from me? When I die I will extinguish the smoke from his grave." When R. Yohanan died, the smoke ceased from the grave of Aher. (The eulogizer said of him [Yohanan], "Even the guard of the gate [of Gehenom] could not stand before you, our master.")

[IV'] The daughter of Aher came before Rabbi [Yehuda HaNasi]. She said to him, "My master, support me." He said to her, "My daughter, whose daughter are you?" She said to him, "The daughter of Aher." He said, "Is there still his seed in the world? *He has no offspring or descendant among his people, no survivor where he once lived (Job 18:19).*"⁸ She said to him, "My master. Remember his Torah and do not remember his deeds." Fire came down from heaven and tried to burn Rabbi. Rabbi wept and said, "If this [happens] for those who dishonor her (Torah), how much the more so for those who respect her?"

[III'] How did R. Meir learn Torah from Aher? Did not Rabbah bar bar Hanna say that R. Yohanan said, "What is the meaning of *For the lips of a priest guard knowledge, and men seek rulings from his mouth; for he is a malakh* (messenger/angel) *of the Lord of hosts (Mal 2:7)*? If the master is similar to the '*malakh* of the Lord of hosts,' then they should seek Torah from his mouth, and if not, do not seek Torah from his mouth."

(A) Resh Laqish said, "R. Meir found a verse and expounded it: *Incline your ear and listen to the words of the sages; pay attention to my wisdom (Prov 22:17).* It does not say 'to their wisdom' but 'to my wisdom.'"

(B) R. Hanina said, "From here: *Take heed, daughter, and note, incline your ear; forget your people and your father's house (Ps 45:11).*" (The verses contradict each other!⁹ There is no difficulty. One is about an adult, one a child.)

(C) When Rav Dimi came up [from Israel] he said, "They say in the West (Israel): Eat the date and throw the peel away."

[II'] Rava expounded: "What is written, *I went down to the nut grove to see the budding of the vale (Song 6:11)*? Why are words of Torah compared to a nut? To tell you that just as a nut, even though it is dirtied with mud and filth, its inside is not soiled, so too a sage, even though he sins,¹⁰ his Torah is not soiled."

[I'] Rabba bar Rav Sheila came upon Elijah. He said to him, "What is the Holy One, Blessed be he, doing?" He said to him, "He recites traditions from the mouths of all the sages, but he does not recite from the mouth of R. Meir." He said to him, "Why?" He said to him, "Because he learned traditions from the mouth of Aher." He said to him, "So what? R. Meir found a pomegranate. He ate the inside and threw away the peel." He said to him, "Now He (God) says: 'Meir, my son, says, *When a human being suffers, the Shekhina — what expression does it say? 'I am light (=pained) in my head. I am light in*

my hand.' If it says 'I am saddened' on account of the blood of the wicked who are killed, how much the more so for the blood of the righteous that is spilled?" (=mSanh 6:5).'"[11]

The story has a chiastic structure:[12]

[I]   Aher rejected by God and God's servant (Metatron)
  [II]  Sins of Aher
    [III] Meir learns Torah from Aher
    (A), (B), (C)
      [IV]  God again rejects Aher; Aher brings death to child
        [V]   Death, Punishment, and Redemption of Aher
        (A), (B), (C)
      [IV'] God accepts Torah of Aher; Aher's Torah brings life to child
    [III'] Defense of Meir learning Torah from Aher
    (A), (B), (C)
  [II'] Defense of Torah of Aher
[I']  Torah of Meir who learned Torah from Aher accepted by God and God's servant (Elijah)

In section I a sage (Elisha/Aher; I use these names interchangeably) sins (or errs). God's servant, the angel Metatron, destroys his merits and God, through the heavenly voice, rejects him. In section I' God's servant Elijah relates how a sage (Meir) has erred in matters of Torah (by learning from Aher) and so his Torah has been rejected by God (who does not cite traditions in his name). God subsequently accepts the Torah of the sage and cites a tradition in his name, the reverse of the heavenly voice. Both scenes portray the situation in the heavenly realm.

Section II relates that the sage (Aher) engaged in evil ways and recounts his sinful deeds. II' defends the Torah of the sage by arguing that sin does not corrupt it.

Section III provides three accounts of Meir learning Torah from Aher. In the first two Meir interprets a verse and then Aher informs Meir of Akiba's exegesis. The third notes that Meir followed Aher "to learn Torah from his mouth." III' asks how Meir could learn Torah from Aher and presents three defenses. The first two cite verses while the third offers a parable. Thus the chiastic parallel extends to the tripartite structure and its internal variation.

In section IV God's rejection of Aher is expressed through the "prophetic" verses cited by children. Aher kills or says that he would have killed

the child, so the sinful sage is associated with death. In IV' Rabbi Yehuda HaNasi rejects the child (daughter) of the sinful sage, but God accepts and protects her (by means of a heavenly fire) when she invokes the Torah of her father. The Torah of the sage therefore brings life to that child.

Section V, also bearing a tripartite structure, is the center of the chiasm. It recounts the death, punishment, and ultimate redemption of the sinning sage. His disciple Meir and subsequently Rabbi Yohanan struggle on his behalf and prevail.

The structure is almost perfectly symmetrical with the tripartite divisions of III, V, and III' contributing to the chiasm. I say "almost" because the quadruple repetition in II is not paralleled in II'.[13]

Chiastic structures present the second half of a story as a response to the first half. As the correspondences above illustrate, and as we will see in detail below, this structure fits the narrative dynamic well. The first half recounts the rejection of Elisha, while the second relates and defends the acceptance of Elisha and his Torah, daughter and disciple. Chiastic structures also focus attention on the center of the chiasm. The posthumous fate of Aher indeed comprises the central issue of the story, as we shall see presently.

## Literary Analysis

Sections I and II are generated through an exegesis of the references to Aher in the *pardes* account. The Tosefta provides two comments, that Aher "gazed[14] and cut the shoots" and that Qoh 5:5 applies to him.[15] The opening question, "What did he see?" understands Elisha's gaze as the cause of his downfall. The content of the vision devolves from Qoh 5:5. Elisha's mouth leads him to sin in that he stated his tradition of the situation on high and wondered whether there were two divine powers.[16] The sin arises from an error: either Elisha's tradition is erroneous or he has understood it erroneously. In any case, his possible identification of Metatron as a divinity is an error. The *malakh* of the verse is the angel Metatron.[17] He is probably named because the verse uses the definite article, *the* angel, and rabbinic midrash always identifies the anonymous figures of biblical verses referenced by the definite article.[18] God's anger at Elisha's "talk" is the punishment of Metatron.[19] The destruction of Elisha's *ma'asim*, the "work" of his hands, is the burning out of his meritorious deeds.[20] Elisha cannot "say that it was an error" because the damage has been done: Metatron has already suffered and his merits have been wiped out. As the heavenly voice says, he cannot "return," that is, admit that he was at fault.

Thus section I is purely an exegesis of the "gaze" and the verse cited by the Tosefta—and an intricate one at that.[21] Almost every motif devolves from the exegesis of the source:

| Tosefta + verse | Story |
|---|---|
| Aher | Prostitute: It is 'Aher = "another" (section II) |
| gazed | He saw Metatron |
| and cut the shoots | uprooted radish (section II) |
| "Let not your mouth lead you into sin | says "Perhaps . . . two powers" |
| "and do not say before the *malakh* | heavenly voice: do not repent Metatron |
| that it was an error | tradition of situation on high leading to identification of Metatron as God |
| else God may be angered by your talk | Metatron punished (as above: says "Perhaps . . . two powers") |
| and destroy the work of your hands" | Metatron burns out Elisha's merits |

The second scene continues the exegesis of the Tosefta in several respects. First, Elisha uprooting the radish interprets the Toseftan phrase "cut the shoots" which section I neglected.[22] Second, the sin provides an etiology of the name *'Aher* which is also mentioned in the Tosefta.[23] The prostitute remarks that Elisha is "(an)other" when she sees him violate the Sabbath.[24] Finally, we should note that the vegetable metaphor in the description of Elisha going out "to evil ways," literally "evil growth" (*tarbut ra'a*), an unusual locution, also picks up on the Toseftan phrase of cutting the shoots. Elisha replaced the shoots he cut with harmful growth.

While these scenes devolve from a narrative exegesis of the Tosefta, they simultaneously play a critical role in the story. They plausibly construct Elisha as a sinning sage, a figure in which Torah and sin coexist. The first scene does this primarily through the measure-for-measure theme which determines and justifies Elisha's fate. One could object that Elisha hardly deserves his punishment. True, he "sinned" in that he said the wrong thing. But it was an error, an inadvertent sin at worst, not a rebellion. Elisha made a mistake, a peccadillo, saying the wrong thing at the wrong place at the wrong time. Note the tentative form of his statement, "Per-

haps — heaven forbid — there are two powers?!" This is no proclamation of heresy but rather an expression of shock and amazement.[25] Moreover, Elisha's error was caused by a rabbinic tradition that he had learned from his study of Torah, a praiseworthy activity. Does he deserve rejection by God and disqualification from repentance? Nevertheless, Elisha's error caused Metatron to be punished, so Metatron punishes Elisha. Metatron was struck with fiery lashes, so he burns out Elisha's merits.[26] Metatron was "given permission" to record the merits of Israel, then he is "given permission" to burn out the merits of Elisha.[27] Elisha's fate, although on one level exceedingly harsh and perhaps even unjust, on another level is fitting according to the measure-for-measure principle. Note that only after Metatron's revenge does the heavenly voice preclude Elisha repenting. Whatever God's opinion about the severity of Elisha's sin, God must allow Metatron his measure-for-measure revenge, and so Elisha loses all merit.

The second scene depicts Elisha as a Sabbath violator and sinner.[28] It is important to note that the story portrays his motivation to sin in a benign way. Elisha sins deliberately only after his merits have been erased and repentance precluded. As he quite logically reasons, "since that man (= since I) has been banished from that world, I will go and enjoy myself in this world." Elisha has nothing to lose, no possible share in the world to come (since no merits), so why not enjoy this world? Pleasure is the goal and violating the Sabbath a means to the end, not an act of rebellion. His sin is a *result* of being excluded from repentance, not the *cause* of it. Nor is his sin an outright rebellion against God such as cursing God's name, forcing others to violate the law, or, as we will see in the PT, riding his horse on the Day of Atonement near the Holy of Holies. Elisha seeks his own pleasure, as anyone not constrained by law, whether divine or human, might do.

Thus these scenes explain why Elisha became a sinner, why he cannot repent, and why he continues to be a master of Torah. All three questions are extremely difficult: how could a great master of Torah — the superior to Meir, as we learn in III — intentionally sin? And having sinned for whatever reason, why not repent?[29] And if such a sage sinned and refused to repent, why should he retain interest in and knowledge of Torah? Answer: he became a sinner because of the Metatron affair which resulted from an unfortunate peccadillo; he cannot repent because of the heavenly voice; he retains his knowledge of Torah because his sinning ways are not motivated by rebellion against God or rejection of Torah. In this way the story negotiates a very tricky path so as to make Elisha's situation verisimilar within the rabbinic worldview.[30] On the one hand, Elisha's punishment is just —

measure-for-measure no less—and his inability to repent understandable. On the other hand, his original intention was not to sin or rebel, so it is plausible that he knows Torah and that Meir desires to learn from him. Torah and sin coexist in Elisha because he has neither rebelled against God nor rejected Torah and the commandments. The construction of this figure allows the story to ponder its central question—whether the merit of Torah can be negated.

Section III introduces Meir and reports his discussions of Torah with Aher. The openings of the first two interchanges specify that the encounters took place after the incidents related in I–II. This datum occasions surprise: why should Meir interact with a man involved in "evil ways," much less debate matters of Torah with him? The answer emerges gradually from the first two discussions, which illustrate Elisha's superior knowledge of Torah, and is explicitly stated in the third: Meir follows "to learn Torah from his mouth." Besides the illustration of Elisha's proficiency in Torah, the interchanges portray him in sympathetic fashion and reiterate that he cannot repent.

In the first interchange Meir offers a banal interpretation of Qoh 7:14. He interprets the undefined "one" and "other" in terms of complementary geographic phenomena—mountains and hills, seas and rivers. In contrast to this trivial explanation Elisha quotes Akiba's exegesis, which Meir apparently did not know. The "one" and "other" refer to opposite moral phenomena—good and evil, the Garden of Eden and Gehenom—and all derive from God. Where Meir's interpretation simply affirms that God created the entire world, as any child would know, Elisha's teaches an important theological tenet and sophisticated theodicy.[31] Meir attempts a better answer to Elisha's second question concerning Job 28:17. This time he provides an analogical interpretation of the verse that teaches an important lesson about the acquisition of Torah. Yet Elisha abruptly crushes Meir's interpretation by pointing out its flaw. If Torah can be compared to the prime characteristic of various vessels—difficult to acquire like gold and easy to lose like glass—then Torah must also be ordinary or worthless like clay vessels.[32] Elisha modifies the analogy slightly by comparing the master of Torah, not Torah itself, to vessels. A second time Elisha emerges as superior to Meir in knowledge of Torah. Earlier the prostitute's statement, "Are you not Elisha ben Abuya, whose name went out throughout the world?" alluded to Elisha's greatness. That assessment is illustrated here: Elisha provides the superior expositions and knows the traditions of Akiba that Meir forgot or failed to learn.

The third encounter clinches Elisha's stature by disclosing that Meir

followed him *in order to learn Torah*.³³ Elisha and Meir are not two disciples of Akiba of roughly equal status, but rather teacher and student. Moreover, Meir follows even as Elisha violates the Sabbath by riding his horse, an incongruous scenario according to everything we would expect from rabbinic values. As the story explicitly objects later, disciples should avoid sinners rather than attend them (III'). Meir's risky pursuit of Torah illustrates its preciousness in rabbinic culture: proximity to sin proves no deterrent when Torah is to be had. Elisha's attention to piety and observance also secure his stature as Meir's superior. Contrary to our expectations, the sinning Elisha cautions the devout Meir that they approach the Sabbath limit. Meir might have violated the Sabbath in his zeal to learn Torah were it not for Elisha's scrupulousness. And Elisha realized that they approached the Sabbath limit not by any obvious means such as a sign, but by counting the paces of his horse, an impressive feat requiring forethought, constant vigilance, and amazing concentrating considering his concurrent theological discussion. Indeed, upon witnessing Elisha's meticulous attention to the commandments, Meir broaches the critical issue: why does Elisha not repent? How can a sage, so knowledgeable, so exacting, and so sympathetic to the piety of his fellow Jews, persist in such sin?

Yet the three interchanges do much more than establish Elisha as master and Meir as student. Each dialogue simultaneously relates to the plot in a substantive way and invites sympathy for Elisha. Elisha's first interpretation is ironic and self-referential. While in section I he wondered at an apparent celestial dualism and was punished, the tradition he teaches to Meir completely rejects dualism. Elisha's antidualistic exegesis attests that his statement in section I was an unfortunate error, that he never subscribed to dualistic beliefs or heresy. It makes clear that the punishment was due to the injury he caused Metatron, not retribution for disobedience or sin. The interpretation, moreover, provides an unusual theology of rewards and punishments that explains his own fate, albeit in a profoundly, unrabbinic way. Rather than each individual being rewarded or punished on the basis of his own deeds, Elisha claims that the righteous receive merit for the good deeds of the wicked and the wicked punishment for the sins of the righteous. This helps explain why Metatron can summarily destroy Elisha's merits and why God can "banish" him "from that world": because individuals sometimes are deprived of their merits, Elisha's misfortune is not exceptional. Yet this theology is completely exceptional in rabbinic literature. The reactions of the medieval commentaries indicate its problematic character. Hai Gaon writes, "This is not the truth," and Rabenu Hananel writes, "These words are not authoritative."³⁴ Now the (somewhat)

parallel version of the exegesis of this verse found in *PRK* 28:3 (426) explains that God created righteous and wicked such that the righteous can atone for the wicked—a common rabbinic idea. Similarly, the prooftexts from Isa 61:7 and Jer 17:18 cited in the name of Rav Mesharshia—which ostensibly support the "orthodoxy" of the doctrine—are used for a different purpose in *GenR* 9:5 (71), where they fit much better. Resh Laqish derives from the same verses that the righteous receive double their deserved reward for consenting to die, while the wicked receive double their deserved punishment because they bear ultimate responsibility for the death of the righteous.[35] This brief detour to the general talmudic context and to source-critical issues is necessary because only by those means can we appreciate the uniqueness of Elisha's interpretation. It appears that the redactors have reworked sources of standard rabbinic theologies to create this exceptional doctrine and have placed it in Elisha's mouth with a powerfully ironic and self-referential effect: Elisha justifies to Meir his own unjust fate. Far from being a dualist or heretic, Elisha is hyperpious, defending the justice of God at his own expense. This device encourages sympathy for Elisha and prepares the way for his salvation. Ultimately, the contrived theodicy is as unstable as Elisha's fate—Elisha eventually collects his due merit and enters the world to come.

Meir's interpretation of Job 28:17 also seems to be self-referential. He follows Elisha, despite Elisha's sinning, because "Torah is difficult to acquire" and therefore every source must be exploited. The second half of Meir's interpretation, that Torah is "easy to lose like vessels of glass," explains why Meir has forgotten his master Akiba's interpretations. Meir himself realizes that Elisha's alternate interpretation of this verse is potentially self-referential and immediately asks why Elisha does not repent. Here Meir hears (and the audience hears again) of Elisha's wretched fate. The juxtaposition of the interpretation with the recapitulation of the heavenly voice again arouses sympathy. Despite the Torah's (in Akiba's exegesis) policy that a sage who sins has a "remedy," Elisha, tragically, has none.

The third interchange continues the sympathetic depiction of Elisha. Even as the footsteps of the horse constitute Elisha's sin, both by every pace of riding and by taking him beyond the limit, they simultaneously preserve Meir's virtue by measuring the distance. Even as Elisha transgresses he expresses concern that his disciple not sin and cautions him to return. This paradoxical behavior invites the wordplay in Meir's response that Elisha too should "return" (repent). Interpretation, plot and wordplay converge as we move from Elisha's interpretation of Job 28:17 (a sage has a remedy), to Elisha's warning to Meir (return from the boundary), to Meir's

exhortation (you too return). Note that Elisha does not say that he refuses to return/repent or does not wish to repent, but that he cannot repent. While he solicits Meir's welfare by encouraging Meir to return, his own return has been blocked. In this context the Sabbath boundary is a powerful symbol of separation. It marks the division between Sabbath observance and trespass, between the community of faith and the outside world, between master and disciple. But as Elisha again explains to Meir, the boundary—both of concrete distance and symbolic value—is not the issue. Whether he crosses the boundary or returns (and whether he violates the Sabbath by riding a horse or not), his fate has been sealed by the heavenly voice.[36]

Section IV continues to explore the two prime axes of the plot: Meir's relationship with Elisha and the preclusion of repentance. While Elisha knows that he cannot repent (since he heard the heavenly voice) and the audience knows this to be true (since the omniscient narrator relates as much in I), Meir has no such firsthand knowledge. He knows only what Elisha has told him, the curious story that his master cannot return because of a heavenly voice. Undaunted or unconvinced or hoping that Elisha was mistaken, Meir demands independent evidence. To seek an oracle through the study-verse of a child is a standard technique of talmudic stories,[37] which functions in the same manner as heavenly voices, dream-visions, and messages from Elijah. These methods provide types of divine revelation in the post-biblical world after the cessation of prophecy. So the study-verses will be for Meir what the heavenly voice was for Elisha and the audience. They indeed confirm for Meir, and re-confirm for Elisha and the audience, that God wants no part of Elisha's repentance. Meir's relentless efforts of dragging Elisha to "thirteen" synagogues simultaneously establishes the depth of his commitment to Elisha and the depth of God's rejection.[38] As a disciple who has learned Torah from Elisha, who loves and owes his master, Meir continues to hope for some sign that repentance is possible, for some chance to save his master's soul. Unfortunately, the last study-verse makes matters worse. Not only does the stuttering child mention Elisha by name, but the verse—"Who are you to recite my laws and mouth the terms of my covenant (Ps 50:16)"—signals God's offense at Elisha's "reciting" and "mouthing" Torah as well. The previous verses implied only that Elisha could not repent or was doomed to ruin, but said nothing about his Torah. This development eventually has deleterious consequences for Meir, and is addressed in the final sections of the story.

Elisha's brutal reaction to the final study-verse, modeled on Jgs 19:29–

30, is the one heinous sin attributed to him. This atrocity seems out of character, and it is strange to be presented with an alternative tradition that involves no bloodshed at all: either Elisha committed a vicious murder or he simply made an angry threat. Because the image of Elisha as killer is difficult to reconcile with the previous sections, and because the text is very uncertain here,[39] I am inclined to see the comment as a later gloss based on the PT version. As we shall see below, in the PT Elisha kills children studying Torah and appears as archenemy and traitor. A reflex of the motif seems to have entered the BT and glossed Aher's rather different encounter with children.[40] Be that as it may, in its present context the murder/potential murder warns that dire consequences result from attempts to reconcile God and Elisha. God's rejection of Elisha, at least in this world, is final.

As the central hinge of the chiasm (V), Aher's death and redemption emerge as the principal concern of the composition. Some anonymous figures—perhaps angels or the heavenly retinue—unambiguously articulate the cultural problem represented by Aher, namely the conflict that arises from the coexistence of sin and Torah. Sin must be punished but Torah must be rewarded. They reconcile the opposing pressures by proposing a standoff, that Aher neither suffer for his sins nor enjoy the reward of his Torah. Note that this view presupposes that Torah has intrinsic merit. Aher's Torah was not rendered worthless by his sin and remains a source of merit, yet his sin remains equally potent.[41] Aher's disciple Meir, however, prefers a different resolution, that the sinning sage be punished for his sins and then be rewarded for his Torah. His promise to "cause smoke to rise" from his master's grave is to bring about punishment so that the reward may follow. (Printed texts add, "R. Meir said, 'It is better that he be punished and enter the world to come,'" to clarify his motive.) While Meir succeeds in effecting the punishment—and presumably the reward will eventually follow—he also causes great pain to his master. Thus Yohanan reacts with dismay, appalled that one "among us," a master of Torah, must suffer.

Yohanan proposes a third resolution, that a sage (himself) save Aher. Exactly how he accomplishes this feat is not spelled out. The allusion to his eulogy suggests Yohanan personally escorted Aher out of Gehenom and none dared stand in his way because of his stature. In any case, Aher's Torah ultimately earns him merit and a share in the world to come.[42] That Elisha's salvation depends on Meir and Yohanan emphasizes the role of disciples and the rabbinic fellowship. Yohanan stresses that Aher "was among us," a sage and member of the rabbinic community. The merit of Torah does not save him directly, but through disciples and colleagues

struggling on his behalf. Although God rejected Elisha because of the Metatron affair, Elisha's rabbinic disciples and colleagues benefited from his Torah and remain loyal.

The three scenes can be seen as three possible perspectives on the contradictory figure of the sinful sage and the status of his Torah. The first considers him a neutral figure, his merits neutralizing his demerits into a moral stalemate. The second regards him in somewhat better light. Ultimately the merit of Torah bestows its reward, but the sins likewise require punishment. The third judges him to be fundamentally deserving of reward, if not because of his own Torah then for the merit of the Torah taught to disciples and bequeathed to colleagues. Placing the scenes in a serial relationship gives primacy to the final perspective. And this coheres with the fundamentally sympathetic picture of Aher: the sinful sage deserves compassion and loyalty rather than revulsion and contempt.[43]

The merit of Torah emerges powerfully in IV′ which shifts to Elisha's daughter and Meir's disciple, Rabbi Yehuda HaNasi.[44] Because Rabbi focuses on Elisha's deeds, he cannot believe that Elisha's progeny lives, for Job 18:19 states that wicked men leave no descendants.[45] The daughter again articulates the crux, "remember his Torah and do not remember his deeds," that is, his sins. The celestial fire that almost burns Rabbi, a warning that he better not reject the daughter's plea, creates an interesting reversal. While Elisha's merits and grave were burned as punishment, Rabbi is almost burned for not rewarding Elisha's daughter. Again the merit of Torah remains intact. Just as it saved Elisha's soul in the world to come, so it saves his daughter in this world. The power of Torah to prompt divine intervention on behalf of such a sinner moves Rabbi to tears. His exclamation could well summarize the main theme of the composition: even the Torah of a sinner retains its merit and potency.

This section corresponds on several levels to IV and God's emphatic rejection of Aher. There the children of the academy or synagogue cite verses of Torah that spurn Aher;[46] here the Patriarch, the leader of the academy, cites a verse of Torah that dismisses his daughter. The sinful sage kills (or threatens to kill) a child, but mention of the Torah of the sinful sage brings life to his child. Once the sin has been removed—in V by punishment and rabbinic intervention, in IV′ through the innocence and piety of the child—the intrinsic merit of Torah endures. Thus God, at least through the heavenly fire, signals his acceptance of Aher's daughter.

The subsequent sections continue to wrestle with the contradictory coexistence of sin and Torah by focusing on the disciple. Should a disciple learn Torah from a sinful sage or is that Torah tainted? Will the disciple

become corrupted by his interactions with a sinful master? Even if he will not be corrupted, does not the association amount to complicity in sin? While section I' explores the issue in narrative form, III' and II' address the issue with exegetical traditions and argumentation. In I' God disdains Meir's traditions because he learned them from an untrustworthy source.[47] That is, a disciple should not seek Torah from a sinning master, as Rabbah bar bar Hanna / Yohanan state in III'. Both the narrative and the non-narrative sections defend the disciple learning from the sinning sage, although both express some ambivalence.

The story of Meir's posthumous fate (I') recapitulates the movement in I–V. God's rejection of Aher continues in his rejection of the Torah of Aher's disciple Meir. In place of God rejecting the sage by precluding repentance, God repudiates the Torah of a sage by not citing traditions in his name. In place of other sages redeeming the rejected sage by some supernatural force, a sage (Rabbah bar Rav Sheila) redeems Meir's name and Torah by argumentation. For the rabbis, the citation of traditions in one's name represents a type of immortality, the attainment of life-after-death through ongoing presence in rabbinic memory.[48] By rejecting Meir's traditions God destroys his name and potentially the merit for his Torah, a fate similar to that of his master. It may be worse: Elisha becomes known as "the Other," which erases his name while simultaneously preserving his Torah (Aher said . . .). Yet God initially effaces Meir's name and Torah completely.

The tradition of Meir's that God finally quotes is chosen with care. Borrowed from mSanh 6:5, the tradition depicts God's reaction at the execution of a criminal. Although the culprit sinned grievously, although it is "the blood of the wicked," God feels pain at the death. Earlier God (through the child's study-verse) called Elisha "wicked" and countenanced his punishment, but in the end God's compassion prevails. God's tender reference to Meir as "my son" and his decision to cite the tradition in his name express God's reconciliation with the disciple. Through the content of that tradition God simultaneously signals his own sadness at the suffering of Elisha, the "wicked man," and presumably his satisfaction with Elisha's salvation. While God excluded Elisha from his sons by inviting all "rebellious children / sons" to return except for him, now God designates Elisha's disciple as his son.

Sections III' and II' shift to a level of discourse outside of the story's framework, a common feature of BT stories. These sections do not represent further developments of the plot but debate or comment upon aspects of the story. They indicate that the story's treatment of the propriety of Meir's learning, Rabbah bar Rav Sheila's explanation to Elijah that "Meir

ate the inside and threw the peel away," does not do justice to the complexity of the issue. Whether a disciple should learn Torah from a sinning sage is a problematic matter requiring analysis beyond that which can be accomplished in the confines of the story. The shift in narrative level thus illuminates the main interests of the storytellers with explicit questions and explanations as to why Meir's Torah should or should not be rejected.

III' objects to Meir learning Torah from Aher, the theme of III, by invoking a tradition that forbids learning from a master who is not a *malakh* (messenger/angel). Torah, the revelation of God, should be sought from God's agents, not his rebels and opponents. The formula "Torah from his mouth" echoes Meir following Aher "to learn Torah from his mouth" (in III) and amplifies the indictment of his act. The first response answers this objection by distinguishing God's wisdom (=Torah) from the "wisdom" of the sages (=their heresies). In other words, a disciple can distinguish the true Torah from the heterodox ideas and sinful ways of his master. The second and third responses suggest that one can learn Torah (incline your ear / eat the date) and yet shun the evil ways of the master (forget your father's house / throw the peel away). Because Torah and deeds are independent, learning Torah from a sinner need not mire the student in sin. The story perhaps offers three justifications of Meir's behavior not only to create the chiastic structure but to excuse each account of his learning from Elisha (IIIA, B, C). Note that the first explanation depends on the exegesis of a verse, the second simply quotes a verse and the third offers a parable. Whatever your preferred source of authority — exegesis, scripture, or reasoning — Meir's behavior can be defended.

Section II' states explicitly that Torah cannot be contaminated by the sin of its bearer. The phrase, "a sage, even though he sins, his Torah is not soiled," echoes Elisha's interpretation of Job 28:17 in III, "a sage, even though he sins, has a remedy." Just as Elisha seemed to be a counterexample to that interpretation, so Meir was initially a counterexample to this demonstration of the uncorruptability of Torah. Yet in the end, Elisha is saved (finds a remedy) and Meir's Torah rehabilitated (not soiled). Note that sections III', II', and I' contain vegetable metaphors (date, nut, pomegranate), which echo the figurative language applied to Elisha's sin (cut the shoots, evil growth) as well as the uprooting of the radish.[49] This contributes to the correspondence of the chiastic divisions and gives the story greater coherence.

These sections defend Meir and encourage disciples to acquire Torah wherever they can. But we should not miss the opposing point of view expressed by the initial question of III', by the gloss following III'B in-

structing that children not learn from teachers who sin, and by God's initial rejection of Meir. The Amoraic attributions suggest that learning Torah from sages of questionable character remained an ongoing source of anxiety in Babylonian talmudic culture.

<center>∾</center>

In sum, the BT story is an extended meditation on the power of Torah and its relationship to sin. Is the merit of Torah absolute or contingent on observance? Does the Torah studied in one's youth earn enduring merit or can that merit be neutralized by sins? The story considers these questions by examining the figure of the sinning sage, the master of Torah who does not observe the law.

Before the story can consider such a figure it must construct one. This is no easy task. For a figure in which Torah and sin coexist is almost self-contradictory. Surely the more Torah one knows, the greater his piety and devotion to God. And would not the merit of Torah protect a sage from error? The BT plausibly constructs this figure through the Metatron debacle, the measure-for-measure theme, and the heavenly voice. A minor indiscretion, more an error than a sin, causes injury to Metatron, and the destruction of Elisha's merits follows in turn. The heavenly voice is crucial, for the voice rules out the obvious solution to the problem: that the sage repent.[50] Because repentance is not an option, Elisha has no reason to observe the commandments, so he goes forth to sin. Thus Torah and sin stably coexist until death, when rewards and punishments materialize. Through these maneuvers the story constructs a figure that allows us to ponder the question of the intrinsic merit of Torah.

The answer to these questions emerge, in part, from the relationship of the sage to his students and colleagues. Meir seeks to learn Torah from Elisha despite his sinning ways. For good reason: Elisha knows more and informs Meir of valuable traditions. As a disciple, Meir is obligated to seek his master's best interests, both in this world and the world to come. God may sever his relationship with the sage for his own reasons, but disciples owe fidelity to their masters on account of the Torah they learned. From their point of view, Elisha's Torah retains its merit even if his deeds should be abhorred. Meir cannot reconcile Elisha to God because of the heavenly voice (although he tries to do so several times), so he must reconcile God to Elisha. Eventually he and Yohanan—a disciple of Meir's disciple, a fellow member of the rabbinic fellowship—succeed in saving Elisha. While Elisha's sins may have destroyed the immediate merit of his Torah, the

Torah he imparted to his disciple must eventually earn him merit. So too his daughter is saved by virtue of his Torah.

After reaching this elegant solution the story immediately complicates matters by problematizing the Torah of the sinning sage. Two questions are considered. First, can Torah itself be tainted by sin? If so, then the Torah taught by a sinful sage loses its status as Torah, a disciple has no reason to learn from him, and the sage in turn loses the merit otherwise manifested in his disciples. Second, even if Torah cannot be tainted, should disciples learn from the sinning sage or will they be corrupted? If so, then Meir becomes a sinner and the means of, and justification for, Elisha's salvation disappear. The story resolves these questions through both discourse attributed to Amoraim and the story of God's teaching Meir's traditions. The answers, it seems to me, essentially follow from the primary question. Because the merit of Torah is intrinsic and cannot be destroyed by sin, then its essence too is incorruptible. Therefore disciples may learn Torah from a sinning sage provided that they separate the pure Torah from the sins and blasphemies of its bearer.

These resolutions should not obscure deep ambivalence and tension. The story recognizes the danger of the sinful sage and the risks involved in learning Torah from him. In the end the story sanctions his Torah and teachings while remaining conscious of the problematic nature of the endeavor.

## The PT Story of Elisha and the Comparative Evidence

The PT story of Elisha also appears in Tractate Hagiga in the talmudic commentary to mHag 2:1 (folio 77b–c), and also follows tHag 2:3, the four who entered the *pardes*. While the redactional setting is therefore identical, the stories differ in substantial ways. (The italicized portions of section [A] are citations from the Tosefta.)

[A] *Aher gazed and cut the shoots (=tHag 2:3).*
  (1) Who is Aher? Elisha ben Abuya, who would kill the young students of Torah. They said: He would kill every student whom he saw distinguish himself in Torah.
  (2) Not only that, but he would go to the meeting-place and see children in front of their teacher, and he would say, "What are these sitting and doing here? This one's profession is a builder. That one's profession is a carpenter. This one's profession is a hunter. That one's profession is a tailor." When they heard this they would leave him and go away.

> *About him scripture says, "Let not your mouth lead you into sin, [and do not say before the messenger that it was an error, else God may be angered by your talk and destroy the work of your hands (ma'ase yadekha)] (Qoh 5:5)." (=tHag 2:3)* For he destroyed the works (*ma'asei yadav*) of that man (i.e., himself).

> (3) Also, when there was a persecution, they made them (Jews) carry burdens, but they (Jews) arranged to have two carry one burden, on account of [the rule that] two who perform one labor [on the Sabbath are not culpable]. He (Elisha) said, "Make them carry individually." They went and made them carry individually, but they arranged to set [the burdens] down in a *karmelit* in order that they not carry out from a private domain to a public domain. He said, "Make them carry flasks." They went and carried flasks (which could not be set down, for they would break).

> *R. Akiba entered in peace and went out in peace. About him scripture says, "Draw me after you." (=tHag 2:4)*

[B] R. Meir was sitting and expounding in the academy in Tiberias. His master Elisha passed by riding on a horse on the Sabbath. They came and said to R. Meir, "Behold your master is outside." He ceased his homily and went out to him.

> (1) He (Elisha) said to him, "What were you expounding today?" He said, "*The Lord blessed the latter days of Job's life more than the beginning (Job 42:12).*" He said to him, "And how did you begin it?" He said to him, "*The Lord gave Job twice what he had before (Job 42:10)* — that he doubled his money." He said, "Alas for things lost and not found. Akiba your master did not expound it like that. Rather, *The Lord blessed the latter days of Job's life more than the beginning (Job 42:12)* — on account of the *mitsvot* and good deeds that he had done from the beginning."

> (2) He (Elisha) said to him, "What else were you expounding?" He (Meir) said to him, "*The end of a thing is better than its beginning (Qoh 7:8).*" He said to him, "And how did you begin it?"

>> (a) He said to him, "[By comparing it] to a man who had children in his youth who died, and in his old age who lived. Behold, 'The end of a thing is better than its beginning.'"

>> (b) "[By comparing it] to a man who did business in his youth and lost money, and in his old age and earned. Behold, 'The end of a thing is better than its beginning.'"

>> (c) "[By comparing it] to a man who learned Torah in his youth and forgot it, and in his old age and fulfilled it. Behold, 'The end of a thing is better than its beginning.'"

He (Elisha) said, "Alas for things lost and not found. Akiba your master did not expound it like that. Rather, *The end of a thing is better than its beginning (Qoh 7:8)* — when it is good from its beginning. And this matter happened to me: Abuya my father was one of the notables of Jerusalem. On the day he was to circumcise me he invited all the notables of Jerusalem and seated them in one room. [He invited] R. Eliezer and R. Yehoshua [and seated them] in a separate room. When they were eating and drinking and singing and clapping and dancing, R. Eliezer said to R. Yehoshua, 'As long as they are busying themselves with their own [business], let us busy ourselves with ours.' They sat and busied themselves with words of Torah. From the Torah to the Prophets and from the Prophets to the Writings, and fire came down from the heavens and encircled them. Abuya said to them, 'My masters! Have you come to burn down my house upon me?' They said to him, 'God forbid. But we were sitting and turning (*hozrin*) words of Torah. From the Torah to the Prophets and from the Prophets to the Writings. And the words rejoiced as when they were given at Sinai, and fire enveloped them as the fire enveloped them at Sinai. At Sinai they were given primarily in fire, *And the mountain was ablaze with flames to the very skies (Deut 4:11)*.' Abuya my father said to them, 'My masters: If that is the power of Torah, if this son of mine prospers (*nitqayyem*), I will dedicate him to Torah.' Since his intention was not for the sake of heaven, therefore it did not prosper (*lo' nitqayyemu*) for that man (= for me)."

(3) He (Elisha) said to him, "What else were you expounding?" He said to him, "*Gold or glass cannot match its value (Job 28:17)*." He said to him, "And how did you begin it?" He said, "The words of Torah are as difficult to acquire as vessels of gold and as easy to lose as vessels of glass. But just as if vessels of gold and vessels of glass are broken one can return (*lahazor*) and make them vessels as they were, so a sage who forgets his Torah can return (*lahazor*) and learn it as at the beginning."

He said to him, "Enough, Meir, the Sabbath limit is up to this point." He said to him, "How do you know this?" He said to him, "From the steps of my horse which I have been counting. And he has walked two thousand cubits." He said to him, "You have all this wisdom yet you will not repent (*hazar*)?" He said to him, "I cannot." He said to him, "Why?" He said to him, "Once I was passing by the Holy of Holies, riding my horse on Yom Kippur that fell on a Sabbath. I heard a heavenly voice come out of the Holy of Holies and say,

'*Return, rebellious children (Jer 3:22)* — except Elisha ben Abuya, for he knew my power and rebelled against me.'"

[C] And why did all this happen to him?

(1) Once he was sitting and learning in the plain of Genesaret and he saw a man ascend to the top of a palm and take the mother bird together with her young and descend safely from there. The next day he saw a man ascend to the top of the palm and take the young after shooing away the mother. He descended from there, and a snake bit him and he died. He said, "It is written, *[Do not take the mother together with her young.] Let the mother go, and take only the young, in order that you may live well and have a long life (Deut 22:6)*. Where is the welfare of this man? Where is the long life of this man?"

He did not know that R. Yaakov had previously expounded it: "*In order that you may live well* — in the world to come that is all good. *And have a long life* — in the future that is all long."

(2) Some say [it happened to him] because he saw the tongue of R. Yehuda the Baker dripping blood in the mouth of a dog. He said, "This is Torah and this is its reward? This is the tongue that used to bring forth fitting words of Torah? This is the tongue that labored in Torah all its days? It seems that there is no giving of reward and there is no resurrection of the dead."

(3) And some say that when his mother was pregnant with him she would pass by houses of idol worship and smell that stuff. The aroma seeped into his body like the venom of a snake.

[D] (1) Years later Elisha became sick. They came and said to R. Meir, "Behold your master is sick." He went desiring to visit him and found him sick. He said to him, "Will you not repent?" He said to him, "If one repents, is it accepted?" He said, "Is it not written, *You return man to dust (dakka'), [You decreed, Return you mortals] (Ps 90:3)*? Until life is crushed (*dikhdukha*) it is accepted." At that point Elisha wept and passed away and died. R. Meir rejoiced in his heart and said, "It seems that my master died repenting."

(2) After they buried him fire came down from heaven and burned his grave. They came and said to R. Meir, "Behold, your master's grave is burning." He left desiring to visit it and found it burning. What did he do? He took his cloak and spread it upon him. He said, "*Stay the night . . . (Ruth 3:13). Stay the night (Ruth 3:13)* — in this world that is similar to night. *Then in the morning (Ruth 3:13)* — this is the world to come that is completely morning. *If he will redeem you, good (Ruth 3:13)* — this refers to the Holy One, Blessed be He, who is good, as it

says, *He is good to all, and his mercy is upon all his creatures (Ps 145:9). But if He does not want to redeem you, I will redeem you myself, as God lives! (Ruth 3:13).*" And it was extinguished.
  (3) They said to R. Meir, "If they say to you in that world, 'Whom do you desire to visit?' [will you say] your father or your master?" He said to them, "I will first approach my master and then my father." They said to him, "Will they listen to you?" He said to them, "Did we not learn, *They save the casing of the scroll with the scroll, the casing of the phylacteries with the phylacteries (=mShab 16:1)*? They save Elisha-Aher for the merit of his Torah."
[E] Years later his daughters went to ask for alms from Rabbi [Yehuda HaNasi].
  (1) Rabbi decreed and said, "*May no one show him mercy, may none pity his orphans (Ps 109:12).*" They said to Rabbi, "Do not look at his deeds. Look at his Torah."
  (2) At that point Rabbi wept and decreed that they be supported.
  (3) He said, "If this one, who labored in Torah not for the sake of heaven—see what [children] he raised, he who labored in Torah for its own sake, how much the more so!"

A comprehensive analysis of this story can be found elsewhere,[51] so I suffice with a brief summary and a few general comments before detailed comparisons of the versions. Even a cursory glance reveals that the PT is a highly developed story with a precise literary structure (the tripartite division of each section); references to biblical verses, midrashic exegeses and rabbinic sources (see B1–3,D2–3); and a complex temporal structure (see below). It seems that in this case an earlier version of the PT story reached Babylonia, probably in Amoraic times, and the story continued to be refined and elaborated in Palestine after the borrowing occurred. The Amoraic comments in the BT, to the extent that they can be trusted, suggest that some version of the story was known to them, although the final story is still the responsibility of the BT redactors.[52]

Section A comprises an independent and self-contained story. The conclusion of the *pardes* passage (=tHag 2:4), the reference to Akiba, follows A and formally separates it from B–E. Moreover, the depiction of Elisha as murderer, enemy of Torah and collaborator cannot be harmonized with the largely sympathetic depiction of Elisha as Meir's teacher in B–E. In fact the three parts of A were generated through three exegeses of the Toseftan passage. The "gaze" translates into Elisha *seeing* the young students and *seeing* the children; the "cutting the shoots" (=young plants) becomes the

killing of the young students or cutting off the children from Torah; the mouth caused him to sin by telling the children to abandon their studies and telling the collaborators how to force the Jews to sin, and so forth.[53]

The core of B–E forms the basis of the BT story,[54] as can be seen from the common elements: the heavenly voice citing Jer 3:22, the discussion of Elisha and Meir including interpretations of Job 28:17, the exclamation "Akiba, your master . . . ," the episode of the Sabbath boundary with the wordplay on "return," the burning grave and the daughter(s) petitioning Rabbi for support. The fundamental conflict of the PT story is also that of Torah and sin. The story constructs Elisha as a sinning sage and a heavenly voice denies him the possibility of repentance (B–C). His disciple Meir nevertheless continues to learn Torah from him and seeks his welfare (B3, D). While God punishes Elisha after death, as indicated by the burning grave (D2), Meir manages to save his soul (D2–3). Meir explicitly explains to his students that "they save Elisha-Aher for the merit of his Torah," and Elisha's merit subsequently saves his daughters as well (D3, E). As in the BT, the merit of Torah is inviolable.

These similarities show that the BT redactors retained substantial parts of the core story and message of their Palestinian source. The few major differences in these matters will be discussed below. In addition, we will see that even the minor changes introduced by the BT redactors, such as changing the sequence of events, have a major impact. The shared story also provides the opportunity to focus on differences in the narrative discourse. That is, we will assess the different techniques with which the narratives present a similar story. The comparisons highlight the compositional strategies of the BT redactors and the subtle ways they reshaped material.

At this point we turn to synoptic charts to facilitate detailed comparisons of the stories.

*BT Hag 15a–15b*
[I] *Aher (gazed and) cut the shoots.*
  *About him scripture says . . . (Qoh 5:5)* (see IV-D)?

*PT Hag 2:1, 77b–c*
[A] *Aher gazed and cut the shoots* (=tHag 2:3).
  (1) Kills the young students of Torah
  (2) Sends children away from Torah.
  *About him scripture says . . . (Qoh 5:5)*
  (3) Collaborates in persecution

He saw Metatron
Heavenly voice, Jer 3:22 (=B3)

[II] Prostitute

[III] After he went out to evil ways, Elisha asked Meir

(a) Qoh 7:14, "Akiba your master . . ."

(see IV'?)
(b) Job 28:17, "sages who sin can be restored"
Heavenly voice, Jer 3:22
(c) Elisha on horse, Meir follows to learn Torah (=B)
Sabbath limit and warning
"will you not repent"
heavenly voice in vision, Jer 3:22

(=bQid 39b / Hul 142a)
(=bQid 39b / Hul 142a)

[B] Elisha passes by on horse, Meir goes out to him
(1) Job 42:12, "Akiba your master . . ."

(2) Qoh 7:8, "Akiba your master . . ."
Abuya story and fire from heaven
(3) Job 28:17; "a sage who forgets his Torah can return"

Sabbath limit and warning
"you too repent"
heavenly voice from temple, Jer 3:22

[C] Why did this happen to him?
(1) Theodicy 1: long life
(2) Theodicy 2: suffering of R. Yehuda
(3) Mother and idolatry

[IV] He brought him to the academy
(a), (b), (c) Recite your study-verse
(d) Some say he cut him up, some say he
said, "If I had a knife . . ." (=A1?)

[D] Years later Elisha became sick
(1) Meir visits, "will you repent?"

[V] (a) Aher dies; "let him not be punished nor enter the world to come" (=D3?)

| | |
|---|---|
| (b) Meir dies, Aher's grave burns | (2) Aher dies, grave burning Meir, cloak; Ruth 3:13 |
| (c) Yohanan dies, fire extinguished | Fire extinguished |
| | (3) Meir will approach Elisha first; "Will they listen to you?" They will save Elisha Aher for the merit of Torah, mShab 16:1 |
| [IV'] Daughter approaches Rabbi Rabbi said, "Whose daughter are you?"; Job 18:19 Fire from heaven (=B2?) Rabbi wept Rabbi said, "If so for those who dishonor her . . ." | [E] Daughters approach Rabbi (1) Rabbi decreed no support, Ps 109:12 (2) Rabbi wept (3) Rabbi said, "If so for this one who learned not for the sake of heaven . . ." |
| [III'] How did Meir learn Torah from Aher? (1), (2), (3) | |
| [II'] Torah of sinning sage remains pure | |
| [I'] God rejects Meir's Torah; God accepts Meir's Torah; mSanh 6:5 | |

A number of points emerge from the comparisons:

1. Both A in the PT and I–II in the BT interpret tHag 2:3. In the PT this section has no substantive connection to the rest of the story (other than the name of the character), and even stands in some tension with it: the image of Elisha as consummate villain clashes with the benevolent image of Elisha in B–E. The BT integrates this section with the story in several ways. The Metatron encounter is crucial to the story for it constructs the figure of the sinning sage. The theme of the heavenly voice appears again in IIIB and IIIC. Section III repeats the mention of "evil ways" from II, and thereby establishes a verbal link between the introductory sections and the continuation. It is not clear that the BT redactors knew section A, but if so, then they had good reason to discard it in favor of I–II. In any case, the BT redactors fashioned this section with brilliant narrative craft. In

contrast to the PT redactors, they simultaneously interpret almost every datum of the Tosefta, plausibly construct a sinning sage and provide the background for the story of Elisha and Meir. In addition, as we will see below, these sections relate to the larger halakhic context of mHag 2:1, with which the PT again has no connection.

Two elements of this section reflect Babylonian coloring. First, Elisha's errant tradition seems to be modeled on a statement of Rav, bBer 17a: "In the next world there is no eating and no drinking and no procreation and no commerce and no jealousy and no envy and no rivalry, but the righteous sit . . ." Both Rav and Elisha mention "rivalry" and "jealousy." The redactors here adapt the tradition to the needs of the story by referring to angelic postures and behavior "on high," not to the righteous "in the next world." Second, as David Halperin has observed, the phrase "they struck him with sixty lashes of fire," appears in two other BT descriptions of angelic punishment, Gabriel (bYom 77a) and Elijah (bBM 85b). Outside of the BT, the phrase only occurs in late midrashim that may be dependent on the talmudic accounts.[55]

2. The secondary development represented by sections III′, II′, and I′, including the story of Elijah, God, and Meir's posthumous fate, is a BT supplement.[56] (Recall that the BT redactors also added to the PT version of the "Oven of Akhnai" a scene where a sage asks Elijah about God's actions.) Nowhere does the PT version question the propriety of Meir learning from Elisha. It does not suggest that the sinning sage would lead disciples astray or teach them corrupted Torah. The BT alone problematizes these issues. This may reflect a heightened interest in issues of discipleship and mentoring in late Amoraic or Stammaitic culture.

3. The most significant differences between the stories are the constructions of the sinning sage in general and the roles of the heavenly voices in particular. The PT constructs the sinning sage through the sins of the parents (B2, C3) and the problem of theodicy (C1–C2) — sections without BT parallels. The BT, as we noted, constructs the sinning sage through the Metatron affair (I–II) — a section almost without PT parallel. "Almost" because the heavenly voice that precludes repentance does appear in the PT (B3). However, the voice functions very differently in the two stories. In the BT the heavenly voice is a consequence of the Metatron affair. It comes at the outset of the story and explains why Elisha subsequently decided on evil ways. His sins in II (and perhaps IV) were a *response* to his inability to repent — an understandable reaction and thus a plausible construction of a sinning sage. Accordingly, the BT voice does not say, "who knew my power and rebelled against me" (B3) — since Elisha did not really rebel.

And the BT moves the voice to the *heavenly temple* which Elisha experiences in his vision.[57] In the PT a voice from the *earthly temple* rejects Elisha *after* his rebellious sins, which were motivated by those other factors (parents, theodicy). Unlike the PT, the BT need not explain why a great sage abandoned his Torah and rejected God: Elisha made a mistake and God rejected him![58] This allows the BT to dispense with B2 and C1–C3 and focus more tightly on the central question,[59] the intrinsic merit of Torah. The BT changes also promote the sympathetic portrayal of Aher.

4. The distinct roles of the heavenly voices in the two stories illustrate how slight changes yield significant differences in meaning. Another example of subtle but important reworking is the dialogue between Meir and Elisha in B1–2 and IIIA. In both versions Elisha solicits Meir's interpretation of a verse, then rejects Meir's explanation with the lament "Akiba, your master . . ." and provides a superior exegesis. However, in the PT the verses are Job 42:12 and Qoh 7:8, and the exegesis concerns one's "beginning" and whether one's origins impact one's end. This is a major interest of the PT, especially whether Elisha's beginning doomed him because of the sins of his father or mother (B2, C3). In the BT the verse is Qoh 7:14 and Elisha's exegesis rejects dualism, his apparent error in I. Thus the BT redactors tailored the discussion to fit the major change they introduced, the construction of the sinning sage through the introductory sections I–II.[60]

A second example of BT reworking is the change in the scene of Rabbi and Elisha's daughters (IV'/E). In the PT Rabbi exclaims, "If this one, who labored in Torah not for the sake of heaven, see what [children] he raised . . ." The phrase "Torah not for the sake of heaven" echoes the account of Elisha's father Abuya whose intention was "not for the sake of heaven" (B2). The BT lacks the Abuya portion and therefore omits this phrase. In the PT Rabbi changes his mind and decides to support the daughters because Elisha taught them to respect Torah ("see what [children] he raised"), which relates to the prominent theme of parents and children (B2, C1, C3, D4). Rabbi appropriately quotes a verse about the treatment of orphans—the children of the wicked man (Ps 109:12). The BT does not thematize parents and children and therefore does not attribute his change of mind to the piety of the offspring. In place of the verse regarding the treatment of children Rabbi quotes a verse about the fate of the wicked man, that he will have no descendants (Job 18:19). This focuses attention on the central issue of the story, the reward or punishment of the sinful sage himself.

The altered focus also explains the curious shift from *daughters* in the PT to one *daughter* in the BT. Why this change? First, the verse Rabbi

quotes in the PT mentions "orphans," in the plural, which fits "daughters." The verse in the BT mentions "offspring," "descendant," and "survivor," all in the singular, which fit one daughter. Second, having switched the verse from Ps 109:12 to Job 18:19 and having no use for the PT version of Rabbi's expression ("not for the sake of heaven"), the BT redactors borrowed more appropriate replacement dialogue from another source. A story in bKet 66b relates that R. Yohanan b. Zakkai was approached by a poor woman: "She said to him 'My master, support me.' He said to her, 'My *daughter*, Whose daughter are you?' She said to him, 'The daughter of Naqdimon b. Gurion.' He said to her . . . She said to him, 'My Master, remember . . .'"[61] Here is a cogent example of how the redactors consciously modified the Palestinian source because of their different interests by transferring material from other rabbinic sources.

5. An important point of comparison is the order of the two versions. The temporal structure of the PT is among the most artful and complex of all rabbinic stories. The primary narrative time of B includes flashbacks to Elisha's origins in B2 and to the heavenly voice in B3. C1 and C2 are additional flashbacks to some time between these two flashbacks, for Elisha's loss of faith preceded his rebellion. C3 shifts again to the prenatal time of B2. While D1–D2 continue the primary narrative time of B, D3 involves a type of flashforward (or *prolepsis*) by discussing Meir's posthumous policy in the world to come.[62] E then continues the narrative time of B and D but catapults us to the next generation. This temporal structure arouses the reader's curiosity in much the same manner as a mystery or detective novel, which first presents the crime and then has the sleuth, along with the reader, investigate the suspects and their situations, the network of relevant relationships and other clues in order to discover what happened and why. Similarly, the story presents the figure of the sinning sage (the master of Torah riding on the Sabbath) and gradually discloses the background that explains the anomaly: the father's intention, the voice precluding repentance, the incidents that caused his loss of faith.

The temporal structure of the BT differs considerably. First, the BT begins with the scene of the heavenly voice, so when Elisha apprises Meir of the voice in IIIB–C, the flashback returns to an event within the chronological time of the story. According to the terminology developed by Gérard Genette, this flashback in the BT is an *internal analepsis* in that it does not exceed the starting point of the story.[63] The flashback to the voice in the PT (as well as the flashback to Abuya, B2) is an *external analepsis* which narrates events that precede the beginning of the narrative time (Elisha

passing by the academy). Furthermore, the flashback in the BT is a *repeating analepsis* in that it retells events previously narrated. The analepsis in the PT is not repeating, for we have not been informed of the voice independently. The BT therefore loses the "detective novel" quality of the PT but opens an ironic gap in its place: the audience learns of the heavenly voice before and independently of Meir.

Second, in the BT the salvation of Aher commences after Meir's death and fully materializes after Yohanan's death. Yet these events are narrated within the primary narrative time, which simply leaps forward to the future: there is no prolepsis but rather a considerable ellipsis. However, in IV' the BT recounts an event in the time of Elisha's daughter and Rabbi Yehuda HaNasi, who died before Yohanan. The BT, then, is chronologically out of order.[64] In the PT Meir redeems Elisha while still alive and proleptically informs his students about what will occur when he goes to the world to come. The primary narrative time remains within the span of Meir's life, and the next scene appears in its proper temporal sequence.[65] At all events, the narrative discourse of the PT differs substantially from the fabula.[66] In the BT the narrative discourse and fabula almost coincide, the only exception being the presentation of Yohanan's death before Elisha's daughter. The BT and PT versions of the "Oven of Akhnai" are characterized by the same phenomenon: the BT version essentially follows chronological order; the PT version begins with the ban and flashes back to the initial disagreement.[67]

6. The BT contains more supernatural or mythic elements than the PT. In the PT we find: (a) the heavenly fire that surrounds the rabbis learning Torah, (b) the voice from the holy of holies, (c) the fire burning the grave, and (d) Meir's assertion of what he and "they" (the angels?) will do in the world to come. All these elements appear in the BT in some form (the fire almost burns Rabbi in the encounter with the daughter; "they" are quoted directly in V). However, the BT adds the spectacularly supernatural scene describing Metatron. It also adds the final account of Elijah reporting God's repertoire of traditions and the rehabilitation of Meir. The oracular study-verses of the children only appear in the BT. And while the PT depicts Meir extinguishing the fire while perched on the grave in this world, the BT describes Meir and Yohanan accomplishing the task after their deaths, which implies that they took action in the world to come.[68] In general, supernatural elements appear more frequently in BT than PT stories. Here the higher density may also devolve from the talmudic context, as we see below.

## Literary and Cultural Contexts

In the previous chapter the literary context, namely the Mishna and its extended *sugya* about verbal wronging and shame, provided ample access to the cultural context. In the present case the contexts intersect, but other talmudic texts should be examined as well. The immediate talmudic context, the text that follows the story of Elisha, is as follows:[69]

[A] Shmuel came upon Rav Yehuda leaning his hands and standing against the door-bolt and weeping. He said to him, "Keen scholar—why are you weeping?" He said to him, "See what is written about the sages, *Where is one who could count? Where is one who could weigh? Where is one who could count [all these] towers? (Isa 33:18)*. *Where is one who could count?*—for they would count all the letters in the Torah. *Where is one who could weigh?*—for they would weigh the light and heavy in the Torah.[70] *Where is one who could count [all these] towers?*—for they would teach three hundred laws about a tower that flies in the air. (And R. Asi said, 'Doeg and Ahitofel asked four hundred questions about a tower that flies in the air.') Yet it is taught, *Three kings and four commoners have no share in the world to come [. . . . Bilaam, Doeg, Ahitofel, and Gehazi] (mSanh 10:2)*. As for us—what will become of us?" He said to him, "Keen scholar—there was filth in their hearts."

[B] What about Aher? He said to him, "Greek song never ceased from his house."

[C] They said about Aher: When he would stand up in the academy, many books of the heretics fell from his lap.

[D] Nimos the Garadite[71] asked R. Meir, "Does all wool that descends into the vat come up?" He said to him, "All that was clean on its mother comes up."

This unit addresses the topic of sages who go astray and sin. Section A mentions Doeg and Ahitofel, biblical characters consistently portrayed by the BT as brilliant scholars who turned to evil. Rav Yehuda marvels at their vast knowledge and laments that if such outstanding sages lost their share in the world to come—if their Torah did not protect them from sin—that leaves lesser sages in dire straits. Shmuel counters that they had "filth in their hearts," apparently an inner character defect or evil intention. He explains why they sinned and why other sages presumably need not worry.

The cryptic interchange in D—if we are to explain it in context—probably offers a related answer. Sages remain pure provided they were pure *ab initio,* that is, they were God-fearing before they commenced their studies. Otherwise they may not "come up" properly, that is, they may become sinners. It is unclear if the parable attributes their flaw to their parents ("clean by its mother") or to an initial state such as "filth in the heart." If parents are intended, then the explanation recalls the PT's tactic of attributing Elisha's fall to the faults of his father or mother.

B appears to be a later gloss by a glossator who realized that the explanation of the sin of Doeg and Ahitofel conflicts with the story's explanation of Elisha's sin.[72] (However, it could be the continuation of the exchange between Shmuel and Rav Yehuda.) The main story did not suggest that Elisha had "filth in his heart." Why then did he sin? The answer that Elisha was corrupted by "Greek song" attributes his downfall to Hellenistic influence.[73] C provides yet another explanation—that Elisha studied heretical books. These sections, whether authentically Amoraic or later glosses, draw on different Elisha traditions. Nothing in the story implies that Hellenism or heretical texts corrupted Elisha.[74] These comments too grapple with the question of how a master of Torah could descend into a life of sin.[75]

As a whole, the combination of the story with the following *sugya* provides a broader, more protean discussion of the problem of a sage who turns to evil. The story focuses on the ultimate fate of the sage and the *sugya* on the original cause of the sin, which the story finessed through the Metatron incident. In order to gain a deeper understanding of this issue, we should turn to the primary talmudic *sugya* concerning Doeg and Ahitofel, found at bSanh 106b. That *sugya* comments on mSanh 10:2, which states that Doeg and Ahitofel have no share in the world to come. The following is an excerpted version of the *sugya*.[76]

> (1) It is written *Do'eg* (דואג; 1 Sam 21:8) and it is written *Doyeg* (דויג; 1 Sam 22:18). R. Yohanan said, "At first the Holy One sat worrying (*do'eg*) lest this one would go out [=sin]. After he went out He said, 'Alas (וי) that this one went out [=sinned].'"[77]

> (2) And R. Yohanan said, "What is written, *And to the wicked God said: Who are you to recite my laws? (Ps 50:16).* The Holy One said to Doeg, 'Who are you to recite my laws? When you arrive at the section on murderers and slanderers, how do you interpret them?'"

(3) *And mouth the words of my covenant? (Ps 50:16)*. Rabbi [Yehuda HaNasi] said, "The Torah of Doeg was only from the lips outward."

(4) And R. Yizhaq said, "What is the meaning of the verse, *The riches he swallows he vomits; God empties it out of his stomach (Job 20:15)*?

"David said to the Holy One, 'Master of the universe, let Doeg die.' He (God) said to him, 'He swallowed riches (=Torah) and he must vomit it (=forget it).' He (David) said to him, 'Let God empty it out of his stomach [immediately].'

"He (God) said to him, 'Let us bring Doeg to the world to come.' He (David) said to him, '*God will tear you down for good (Ps 52:7)*.' He (God) said to him, 'Let traditions be recited in the academy in his name.' (David said to him), '*And break you and pluck you out of your tent (Ps 52:7)*.' He (God) said to him, 'Let his descendants be sages.' (David said to him), '*And root you out from the land of the living (Ps 52:7)*.'"

(5) And Rabbi [Yehuda HaNasi] said, "*Where is one who could count?* . . . . Three hundred problems . . . (as A above)." Rava said, "Is it such a great thing to propound problems? . . . But the Holy One requires the heart, as it says, *God sees into the heart (1 Sam 16:7)*."

(6) Rav Mesharshia said, "Doeg and Ahitofel did not understand traditions."[78] Mar Zutra objected, "Those about whom it is written *Where is one who could count?* . . . (as A above) — and yet you say that they did not understand traditions? Rather, their traditions were not in accord with the law."

(7) R. Ami said, "Doeg did not die until he had forgotten his learning."

(8) R. Yohanan said, "Three destroying angels came upon Doeg. One caused him to forget his learning . . . "

These traditions grapple with the figure of the sinning sage and the question of the coexistence of sin and Torah: how does this situation result? What is the ultimate fate of such a sage and why is that just? Several shared linguistic phrases complement the general thematic connection to the story and its following *sugya:* Doeg and Ahitofel are portrayed as great sages who "went out," that is, sinned, just as Elisha "went out to evil ways" (1). (The first printed edition actually reads "went out to evil ways" here too.) The verse quoted by Yohanan, Ps 50:16, is the very verse quoted by the final child to Elisha (2,3). Doeg and Ahitofel are depicted as great schol-

ars of Torah, as in the *sugya* following the story (4, 5, 6; note that 5, 6 quotes the same traditions as section A). Rabbi Yehuda HaNasi attempts to explain why Doeg's Torah did not prevent him from sinning (3), as did Shmuel with his proposal of "filth in the heart."

This passage, however, moves in the opposite direction as the story. For the fate of Doeg and Ahitofel is given by mSanh 10:2 — they lost their share in the world to come. The talmudic commentary to mSanh 10:2 must therefore justify this fate in view of the reward that they should have received for the merit of their Torah. While Elisha eventually entered the next world despite his sin and because of his Torah, Doeg and Ahitofel lost the next world despite their Torah and because of their sins.

Particularly interesting in relation to the story is the dialogue between David and God over the fate of Doeg (4). David demands that Doeg die as punishment for his sins, but God points out that he learned Torah (= swallowed riches), which earned him merit. Continuing the gastric imagery, God exhorts David to wait until Doeg regurgitates what he has internalized, that he forget or lose his traditions, while David insists that God make him forget immediately. This maneuver allows for Doeg's premature death, certainly a severe punishment, but does not address the question of his posthumous fate. Now God proposes three alternative mechanisms for reward, that Doeg enter the next world, that his Torah be studied in enduring rabbinic memory, or that his descendants become sages. These proposals involve forms of immortality or ways of transcending death, the fitting reward for dedication to the source of eternal life. Similarly, the story addresses the questions of Aher's entry to the world to come and whether he has descendants (the incident with his daughter and Rabbi), and includes the issue of transmitting traditions by name in connection with Meir (section I').[79] God's three suggestions for Doeg and the corresponding aspects of the story demonstrate the profound unease within rabbinic culture at the prospect that a sage, however evil, should not be rewarded. The tensions manifest here are the same as those of the story: what happens when Torah and sin coexist? Must Torah be rewarded or can it be negated by sin?

Traditions 5, 6, 7, and 8 continue the efforts of 4 to explain why Doeg's Torah failed to procure a reward. Rava devalues or revalues Torah by emphasizing inner piety over knowledge of tradition (5). This provides a neat solution to the problem of Doeg's fate but stands at odds with the importance of Torah throughout the BT. Rav Mesharshia's strategy impugns Doeg's and Ahitofel's knowledge of Torah, which clearly obviates the entire problem (6). He sidesteps rather than confronts the tension by claiming that Doeg never learned Torah worthy of merit. Mar Zutra dismisses

this easy way out, although his solution is little better. He shifts the source of merit from knowledge of Torah per se to knowledge of one aspect of Torah, authoritative practical law. The answers of Ami and Yohanan (7, 8) come back to David's demand that God cause Doeg to forget his Torah (4). Their strategy resolves the conflict by removing the source of merit, either through natural or supernatural means.

The tradition of an angel destroying Doeg's Torah (8) recalls Metatron erasing Elisha's merits, but proves more deadly. Elisha retains his Torah whereas Doeg and Ahitofel lose their merit too, and consequently any possibility of reward in the world to come. This difference is important in light of the story's maneuvering to save Elisha. Part of the strategy for justifying and effecting Elisha's salvation involved the master-disciple relationship. Elisha's Torah continued to earn him indirect merit through its embodiment in Meir, and then Meir and other disciples eventually redeemed Elisha. Because Doeg forgets his Torah he cannot teach disciples and achieve vicarious merit or posthumous salvation through their efforts. Disciples, in fact, are not mentioned in this passage or elsewhere in connection with Doeg and Ahitofel. The point is not to harmonize these *sugyot* but to emphasize the different strategies that the Amoraim and redactors employ in considering the problem of Torah and sin.

With the possible exception of Rava (5), the solutions demonstrate the difficulty within Babylonian rabbinic culture to think that study of Torah not earn reward. They reflect the axiom behind the story of Elisha: that the merit of Torah is inviolable. Punishment of a sage makes cultural sense only if he loses his Torah or does not possess true Torah. Even this solution did not satisfy all: a few folios earlier the Talmud contains an opinion that Doeg will receive a share in the world to come (contra the Mishna!).[80] The cultural logic could not be more clear: if Doeg's Torah is neither discredited nor lost, he must enjoy its merit in the world to come.

Let me briefly discuss one final *sugya* that illuminates the cultural context. A *sugya* at bSot 21a also grapples with the relationship of Torah and sin. This question arises regarding the proviso of mSot 3:4 that "merit" may suspend the effects of the "waters of bitterness" upon a suspected adulteress (*sotah*) who was in fact guilty and should have died from the ordeal. The *sugya* explains this undefined "merit" either as merit for performing commandments or for the study of Torah. There follows an extended discussion of the extent to which these two types of merit "protect" from punishment and "save" from the inclination to sin. One opinion claims that merit for a commandment protects temporarily while merit for Torah protects forever, in both this world and the world to come. Rav Yosef as-

serts that Torah study both protects from punishment and saves from sin whether one is actively engaged in it or not. Rava then objects, "Did not Doeg and Ahitofel engage in Torah? Why did it not protect them?" Rava proposes rather that Torah "protects" at all times but "saves" only when one is actively engaged in its study. We also find the opinion that, "Sin can erase [the merit of] a commandment but cannot erase [the merit] of Torah."[81]

The Amoraim quoted in this *sugya* struggle to explain how one who studied Torah could ever sin. The traditions share an unshakable belief in the power of Torah and a resistance to associate Torah with sin and punishment. I argued that this difficulty explains the story's painstaking attempt plausibly to construct Elisha as a sinning sage and also prompts Rav Yehuda's lament about Doeg and Ahitofel in the subsequent *sugya*. Here Rava articulates the problem explicitly: why did Torah not protect Doeg and Ahitofel from sin? While Rava's revision of Rav Yosef's principle solves this problem, it fails to explain why Doeg and Ahitofel lost their share in the world to come, for their former Torah study should have protected them from punishment.[82] In any case, the opinion that sin cannot erase the merit of Torah expresses the moral of the story succinctly. Indeed, the image of "erasing" the merit of Torah recalls Metatron "burning out" the merits of Elisha. Again we understand why Elisha eventually entered the world to come, Metatron and the heavenly voice notwithstanding: Torah and its merits are fundamentally inviolable.

The literary and cultural contexts thus contribute substantively to the analysis of the story. The complex relationships between sin, Torah, merit, and reward occasioned problems and tensions in the worldview of the BT. We can easily postulate empirical or psychological stimuli. Perhaps the redactors (and earlier sages) knew or knew of scholars who turned to sin and abandoned the rabbinic fold.[83] They would inevitably wonder why this happened and what fate awaited the offenders. Perhaps the redactors, for all their knowledge of Torah, felt the inexorable human inclination to sin. They would no doubt wonder why the Torah did not protect them from the "evil inclination" and what would happen if they succumbed. But postulating such causes is not really necessary. While the sages did not author systematic theology, they generated a vast body of unsystematic theology on a wide array of topics. No value was more important than Torah, and no danger more noxious than sin. To work out how and why the two could coexist were essential cultural concerns. The story and the related *sugyot* are ways of thinking about these important topics, exploring the options, and—with due caution—modeling an optimistic outcome: if Elisha ultimately enjoyed the merit of his Torah, most sages should expect the same.

## The Halakhic Context

It remains for us to consider the halakhic context. In both Talmuds the story of Elisha appears in the commentary to mHag 2:1:

[A] One does not interpret the [Pentateuchal laws of] incest before three persons, the Story of Creation before two, nor the Chariot before one, unless he is a sage who understands on his own knowledge.

[B] Whoever contemplates (*mistakel*) four matters, it would have been fitting had he not come into the world: what is on high and what is below, what is before and what is after.

[C] And whoever does not take care towards the honor of his maker, it would have been fitting had he not come into the world.

This Mishna warns against the study of esoteric subjects. It limits the venue in which sages study the creation account and Ezekiel's vision of the chariot (Ezek 1–3), scriptures associated with mystical and esoteric thought, and prohibits outright inquiry into the "four matters," apparently sensitive theological issues such as the nature of the heavenly realms. In both Talmuds the discussions preceding the story address these and other esoteric subjects with numerous traditions about the creation of the world, the structure of the cosmos, sages who expounded the "works of the chariot," and the meaning of suggestive biblical verses. The tradition of the *pardes* from tHag 2:3, which probably relates to esoteric activity of some sort, is naturally cited in the course of these discussions in both Talmuds.

The BT story, especially the vivid description of Metatron inscribing merits and receiving lashes, fits with the context of esotericism. While the BT does not explore the exact nature of Elisha's praxis or experience, the vivid description of the heavenly realm is clearly esoteric. Besides the generally esoteric tone, there is a direct connection between Elisha's mistaken tradition ("On high there is no sitting") and mHag 2:1. His tradition concerns what is "on high," and the Mishna forbids contemplating what is "on high." The verb "contemplate" or, more literally, "look into" (*mistakel*), applies directly to Elisha's activity. He both "contemplated" what was "on high," by possessing a tradition, and actually looked at the situation "on high": he saw Metatron. Elisha's initial fate in the subsequent story, that he is neither punished nor enters the world to come but just dies, corresponds to the Mishna's assessment of the offender. It "would

have been fitting" for Elisha not to have "come into the world" for his death (at first) is a simple cessation of life with no posthumous existence. Thus the first scene of the story comprises not only an interpretation of the Toseftan data but a partial exemplification of the Mishna.[84] In other words, the storytellers created a narrative exegesis of tHag 2:3 in light of mHag 2:1.

Yet Elisha's ultimate fate, to receive his share in the world to come, opposes the Mishna's condemnation of such inquiry. We should therefore understand the story as an expression of protest against or ambivalence toward the Mishna's rulings. The Mishna's restriction on interpretation and prohibition of certain areas of inquiry limit the study of Torah. This policy conflicts with the general rabbinic drive to acquire as much Torah as possible. How can a sage not study aspects of Torah when the core rabbinic value mandates that he do everything in his power to learn? Despite the dangers, is not the potential acquisition of Torah worth the risk? If the BT states elsewhere that Torah endures only for one who "kills himself over it," should not a sage risk the theological perils of esoteric study?[85] Even if he succumbs to the dangers, should not his noble motives and Torah be rewarded? Elisha embodies these tensions, for his tradition about the situation "on high" leads to his downfall, but that knowledge of tradition is Torah and should bring him merit. Meir too takes a risk to learn Torah: he learns from a dangerous source, rather than learning dangerous subjects.

It is perhaps significant that the talmudic commentary to the Mishna that precedes the story contains numerous exegetical traditions about the structure of the various heavens, which seem to describe what is "on high" (bHag 12b–13a). Ironically, the prohibition of the Mishna neither impeded the Amoraim from formulating and transmitting traditions to their disciples nor the redactors from composing them into a *sugya*. In this respect the story contests the Mishna's restriction of the study of aspects of Torah and perhaps comprises an apologia for such study among later sages or the redactors themselves. Although Aher and Meir are portrayed with some ambivalence, their ultimate rehabilitation expresses the redactors' sympathy for sages who delve into esoteric study. In the final reckoning they are sages seeking Torah, the noblest of pursuits.

This profound relationship between the story and framing Mishna does not obtain in the PT. These connections all devolve from the Metatron incident which only appears in the BT version of the story. Recall that the PT constructs the sinning sage through the sins of the parents or the problem of theodicy, not through a problematic tradition and esoteric vision. The main PT story, as far as I can see, has no other connection to

mHag 2:1. The story occurs in this section of Talmud because of superficial association: the first story (section A) interprets tHag 2:3— albeit in a way that has nothing to do with esoteric activity—and the subsequent story (B–E) follows by association: it is also about Elisha / Aher.[86]

Concern for the talmudic and literary contexts helps explain why the BT redactors interpreted tHag 2:3 in terms of the Metatron vision and eschewed the explication of the PT (section A), assuming they knew it. Sensitivity to context also explains the increased amount of supernatural elements in the BT version noted above. We have further evidence that the BT redactors worked hard to contextualize the stories. In the "Oven of Akhnai" the redactors moved the PT story from one tractate to another while reworking it to suit the new context. Here the redactors chose to retain the same talmudic context as the PT story but reworked the story to create a substantive relationship to that context.

### APPENDIX: MANUSCRIPT VARIANTS

The translation above follows ms London 400 (Harley 5508), represented below by L. The following sigla are used for other manuscripts: G = Göttingen 3; M1 = Munich 95; M2 = Munich 6; V1 = Vatican 134; V2 = Vatican 171; P = first complete printing, Venice, 1520. This is not a comprehensive critical edition, and I have cited only the major variants.

(I) "Gazed and." See n. 14.

(I) "One hour each day." M1 omits.

(I) "On high there is . . ." M1M2G add "no standing." LVP omit because the story assumes that angels stand (cf. Rashi ad loc.). This list varies slightly in the mss.

(I) "Lashes of fire." V2P add "They said to him, 'When you saw him, why did you not stand up in front of him?'" All other mss lack this question. The line seems to be a gloss.

(I) "Burn." M1V1 read "uproot." P reads "erase."

(I) "Voice went out." M1V1 add "from behind the curtain." See IIIA–B and the PT story, section B3.

(II) "On the Sabbath." M1 omits "on the Sabbath." See *DQS* ad loc. In M2 this section occurs before V.

(IIIB) "Are they even like clay vessels?" M1V1V2 add "that have no value" (or "have no substance"; *'ein bahem mammash*).

(IIIC) "Going on his way." So L. All other mss omit.

(IIIC) "To learn Torah from his mouth." M1V2 read "and learning Torah from him."

(IIIC) "He said to him, 'Meir, return back.'" M1V1V2 add "When they reached the Sabbath boundary, he said to him . . ."

(IVA, B) "Brought him to the academy." G reads "synagogue" in both. M2 reads "academy" in IVA and "synagogue" in IVB. See the following notes.

(IVA) "He said to a child." M1V2 read, "He heard a certain child reading"

(IVC) "Synagogue." So M2. M1V2G read "academy."

(IVD) "Brought him to thirteen synagogues . . . sent him to thirteen synagogues." GM2 read "synagogues . . . academies." M1V2 read "academies . . . academies."

(IVD) "Stuttered." So M1M2GV2. L reads *melaglem*, perhaps a corruption of *melagleg*, stammer. V1 reads *lig*.

(IVD) "Some say he took . . . and some say . . ." V2 is similar. M1 reads "He cut him up and sent him to thirteen academies." GM2V1 read "He took a knife and cut him up [V1 adds 'into thirteen pieces'] and sent him to thirteen academies. And some say he said to him, 'If I had a knife in my hand I would cut him up.'"

(VA) LG repeat section II before VA almost verbatim, and M2 has section II only here. This appears to be an error.

(VB) "When I die . . . ." So other mss. L adds "It is possible that he be punished. When I die . . ." P adds "R. Meir said, 'It is better that he be punished and enter the world to come. When I die . . .'"

(IV') L opens with "Our sages taught: It once happened that the daughter . . . ," a parallel opening to 3C, which also comes from the PT. But all other mss lack this opening.

(IV') "Tried to burn Rabbi." M2 reads "surrounded Rabbi's bench." V1 reads "singed Rabbi's bench." V2 reads "At that point Rabbi saw a column of fire." P reads "scorched Rabbi's bench." On fire burning a sage's bench as a divine warning see bSanh 104b.

(III'B) "R. Hanina." G reads "R. Hanania." V2 reads "R. Eleazar."

(III'C) "Eat the date and throw the peel away." M2 reads "Rav Dimi said, 'That is what people say, when you find an early (=unripe) date, eat the inside and throw the peel away.' Another version: When Rav Dimi came, he said 'They say in the West: Eat the early date and throw.'" V2 is similar. G reads "He ate the date and threw the peel away." P reads "R. Meir ate the date and threw the peel away."

(I') "Rabba bar Rav Sheila." V1 reads "Rabba bar Rav Hanan." M1 reads "Rabba bar Rav."

(I') "Recites traditions . . . does not recite." M1V2 read "teaches . . . does not teach (*garis*)." G reads "learn."

(I') "Pomegranate." V2 reads "nut."

(I') "Shekhina." M2 reads "verse." V2 omits.

## MANUSCRIPT VARIANTS TO THE FOLLOWING *SUGYA*.

(A) "See what is written." GM1V1 read "Is it a small thing that is written."

(A) "R. Asi." M1 reads "R. Abbahu." V2 reads "Abaye." GM2V1 read "R. Ami."

(B) "He said to him, 'Greek song . . .?'" So LM1. But M2V1V2GP omit "He said to him."

(D) "Nimos." V1 reads "Avinomos."

(D) "Mother comes up." M1V1 add "All that was not clean on its mother does not come up."

Chapter 4

## Torah and the Mundane Life

The Education of R. Shimon bar Yohai (Shabbat 33b–34a)

The previous two chapters explored the substantive relationships between talmudic stories and their literary contexts. The story of Rabbi Shimon bar Yohai (henceforth, RSBY) presents a more complicated case, for several points of contact link the story to the preceding talmudic discussions. While the multiple connections leave no doubt that the redactors made conscious efforts to integrate the two, they also make it difficult to distinguish the primary from the secondary—an embarrassment of contextual riches. The wider cultural context yields additional resources, for strong intertextual signals evoke other traditions that struggle with similar tensions. As in the previous chapters, comparison with the PT version sheds light on the specific interests of the BT redactors. The cumulative evidence from these considerations helps both to appreciate the fundamental message of the story and to understand why the redactors placed the story in its present context.

The story is found in bShab 33b–34a, and earlier versions appear in the PT and in several midrashic compilations. Lee Levine's important article, "R. Simeon b. Yohai and the Purification of Tiberias: History and Tradition," first delineated the story's literary features and broached source-critical issues.[1] Levine's main interests, however, were historical questions regarding the purification of the city of Tiberias and the settlement of the Galilee. To determine the "historical kernel" behind the traditions, Levine compared the versions in great detail and identified literary motifs. Thus Levine recognized the fictional dimension of the story, although his goal

was to discard the legendary embellishments so as to lay bare the historical core. Ofra Meir responded to Levine's study in a provocatively entitled article, "The Story of R. Shimon bar Yohai and his Son in the Cave—History or Literature?"[2] As the title suggests, Meir takes issue with Levine's attempt to derive history from accounts composed for literary goals. She analyzes both the PT and BT versions of the story as literary wholes and considers some of the contextual questions that I take up here. Scholarship on this story illustrates the shift described in Chapter 1 from understanding rabbinic stories as history to searching for the historical kernel to literary analysis.[3] My reading builds on the valuable work of both Levine and Meir.

## Translation and Structure

This translation is based on ms Munich 95. Textual variants and notes can be found in the Appendix.

[A] R. Yehuda and R. Yose and R. Shimon [bar Yohai] were sitting, and Yehuda b. Gerim was sitting beside them. R. Yehuda opened and said, "How pleasant are the acts of this nation. They established (*tiqnu*) markets. They established bathhouses. They established bridges." R. Yose was silent. R. Shimon [bar Yohai] answered and said, "Everything they established, they established only for their own needs: They established markets—to place prostitutes there; bathhouses—to pamper themselves; bridges—to take tolls." Yehuda b. Gerim went and retold their words, and it became known to the government. They said: "Yehuda who extolled—let him be extolled. Yose who was silent—let him be exiled to Sepphoris. Shimon who disparaged—let him be killed."

(B1) He (RSBY) went with his son and hid in the academy. Each day his wife brought him bread and a jug of water and they ate. When the decree became more severe he said to his son, "Women are simple-minded. They may abuse (*metsa'ari*) her and she will reveal [us]."

(B2) He went and they hid in a cave. A miracle happened for them and a carob tree and a spring were created for them. They sat up to their necks in sand. By day they sat and studied, and they took off their clothes. When the time came to pray they went out and dressed and covered and went out and prayed and again took off their clothes, in order that they not wear out. They dwelled in a cave for thirteen years. Elijah came to the opening of the cave. He said, "Who will inform Bar Yohai that the emperor died and the decree is annulled?" They went out and they saw men plowing and sowing. They said,

"They forsake eternal life and busy themselves with temporal life?!" Everywhere they turned their eyes was immediately burned. A heavenly voice went out and said to them, "Did you go out to destroy my world? Return to your cave!"

(B3) They dwelled for twelve months. They said, "The sentence of the wicked in Hell is twelve months." A heavenly voice went out [and said], "Go out from your cave." They went out. Wherever R. Eleazar smote R. Shimon healed. He said, "My son, you and I are sufficient for the world." They saw a certain old man who was holding two bunches of myrtle running at twilight. They said to him, "Why do you need these?" He said to them, "To honor the Sabbath." [They said] "Would not one suffice for you?" He said, "One for *Remember [the Sabbath] (Exod 20:8)* and one for *Observe [the Sabbath] (Deut 5:12)*."[4] He said to him (his son), "See how dear is a commandment (*mitsva*) to Israel." [Their minds were set at ease.]

(B4) R. Pinhas b. Yair, his son-in-law, heard and went out to greet him. He took him to the bathhouse. He was massaging his flesh. He saw that there were clefts in his flesh. He was weeping and the tears were falling from his eyes and hurting (*metsa'ari*) him (RSBY). He said to him, "Alas that I see you so." He (RSBY) said to him, "Happy that you see me so. For if you did not see me so, you would not find me so [learned]." For originally when R. Shimon bar Yohai raised an objection R. Pinhas b. Yair solved it with twelve solutions. Subsequently when R. Pinhas b. Yair objected, R. Shimon bar Yohai solved it with twenty-four solutions.

[C1] He said, "Since a miracle occurred I will go and fix (*atqin*) something, since it says, *And Jacob came whole (shalem) (Gen 33:18)*,"

— and Rav said, "Whole in his body, whole in his money, whole in his Torah." *And he was gracious to the city (Gen 33:18)*.[5] Rav said, "He established (*tiqqen*) coinage for them." And Shmuel said, "He established markets for them." And R. Yohanan said, "He established bathhouses for them." —

He (RSBY) said, "Is there something to fix (*letaqonei*)?"

[C2] They said to him, "There is a place of doubtful impurity and it causes trouble (*tsa'ara*) for priests to go around it." He said, "Does anyone know if there was a presumption of purity here?" A certain old man said, "Here and there Ben Azai cut down lupines[6] of *teruma*." He did the same. Wherever it (the ground) was hard he ruled pure. Wherever was loose he marked.

[C3] A certain old man said, "The son of Yohai made a cemetery pure." He (RSBY) said, "If you had not been with us, or even if you had been with us but had not voted with us, you would have spoken well. But now that you were with us and voted among us, should they say, '[Even] prostitutes paint each other. How much the more so [should] scholars!'" He cast his eyes at

him and his soul departed. He went out to the market. He saw Yehuda b. Gerim. [He said,] "Is this one still in the world?" He set his eyes upon him and made him a heap of bones.

The BT story has three main sections. Section A, the exposition, provides the background that led RSBY to flee. B narrates his retreat to the cave, sojourn there, and return to the outside world. C tells of the purification of some land and the opposition encountered. Formal and linguistic features support this division based on content. The first section, except for the opening line, appears entirely in Hebrew, while the rest of the story appears in the standard mixture of Hebrew and Aramaic. A loose chiastic structure unifies the second section. Both the withdrawal from and return to the world involve an intermediate stage: the sojourn in the academy (B1) and the visit to the baths (B4).[7] These episodes bracket the two periods in the cave (B2, B3). The section is also unified by the repetition of the words "go" (*'azal*) and "go out" (*nafaq / yatsa*). RSBY and his son "went to the academy" and then to the cave (B1, B2), and then "went out" twice from the cave (B2, B3). The heavenly voice and Pinhas b. Yair are also described as going out (B3, B4). The third section returns to themes of the first section, the *tiqqun* (fixing) and the encounter with Yehuda b. Gerim. The basic structure may be diagrammed as follows:

    A. RSBY's attitude to Rome and worldly institutions
        B1. Retreat from the world to the academy
            B2. Isolation from the world in the cave (1)
            B3. Isolation from the world in the cave (2)
        B4. Return to the world through baths
    C. RSBY institutes a *tiqqun*

Both sections A and C contain tripartite chiastic structures.[8] Section A features three sages sitting together, three cultural achievements celebrated by Yehuda, three dismissals of the achievements by RSBY, and three decrees by the authorities. Two corresponding independent sentences tell of Yehuda b. Gerim and function to separate him from the other three sages. The syntax "R. Yehuda opened and said (*patah ve'amar*)" is balanced by "RSBY answered and said."[9]

    [A1]  R. Yehuda and
    [A2]  R. Yose and
    [A3]  R. Shimon were sitting,

*Torah and the Mundane Life* 109

[B] And Yehuda b. Gerim was sitting beside them
  [C1] R. Yehuda <u>opened and said</u>, "How pleasant are the acts of this nation.
    (a) They established markets.
    (b) They established bathhouses.
    (c) They established bridges."
  [C2] R. Yose was silent.
  [C3/C1'] RSBY <u>answered and said</u>, "Everything they established, they established only for their own needs.
    (a') They established markets — to place prostitutes there.
    (b1') bathhouses — to pamper themselves.
    (c1') bridges — to take tolls."
  [B1'] Yehuda b Gerim went and retold their words, and it became known to the government.
[A1'] They said: "Yehuda who extolled — let him be extolled.
[A2'] Yose who was silent — let him be exiled to Sepphoris.
[A3'] Shimon who disparaged — let him be be killed.

Section C contains three interpretations of each half of the verse. The first set repeats that Jacob was "whole in" something; the second that he established something: Both the opening and closing statements of RSBY mention "fixing."

(A) He [RSBY] said, "Since a miracle occurred I will go and <u>fix something,</u> since it says,
  (B) *And Jacob came whole (Gen 33:18)."* And Rav said,
    (1) "Whole in his body,
    (2) whole in his money,
    (3) whole in his Torah."
  (B') *And he was gracious to the city (Gen 33:18).*
    (1) Rav said, "He established coinage for them."
    (2) And Shmuel said, "He established markets for them."
    (3) And R. Yohanan said, "He established bathhouses for them."
(A') He said, "Is there <u>something</u> to <u>fix?</u>"

The corresponding patterns invite us to contrast section C with A and suggest that the shift in RSBY's perspective results from the events of B. While the structure is not as tight as the extended chiasm of the previous

chapter, the basic tripartite structure is typical of rabbinic stories.[10] In the reading below we will return to the significance of the structural divisions.

## Literary Analysis

The story opens with three well-known sages sitting in discussion and a lesser known figure sitting nearby. This depiction employs a standard talmudic form in which the sage "sitting with them" subsequently asks a question or objects to the statement of his colleagues.[11] The audience therefore anticipates that Yehuda b. Gerim will act, but that he contributes nothing to the rabbinic discussion and rather publicizes their words occasions surprise. R. Yehuda's declaration also produces a sense of surprise at unrealized expectations. In the BT the term "this nation" is ambiguous and refers either to Rome or Israel.[12] When R. Yehuda declares, "How *pleasant* are the acts of this nation," the audience probably decodes "this nation" as Israel and "the acts" as study of Torah and mitzvot. The mention of markets, bathhouses, and bridges then forces the audience to revise its understanding and ponder why the acts of the Romans are so pleasant. The ambiguity and need for re-interpretation creates an engaging opening that directs the audience to contemplate the different sides of this issue.

R. Yehuda does not explain what is "pleasant" about these public facilities. Presumably he thinks of their socioeconomic functions, as does R. Shimon, but focuses on their utility, on their uses rather than abuses. Markets enhance economic efficiency, reduce prices, provide a forum for buyers and sellers to do business, constitute a place where goods are always available, and free families from the need to produce their own food, clothes, raw materials, and so forth. Bathhouses allow for proper hygiene and care of the body, and perhaps create a place for healthy social intercourse.[13] Bridges facilitate travel and transportation, enabling people to visit friends and relatives, to move larger quantities of goods, and to journey to distant places. All these concerns admittedly address the concrete needs of day-to-day life, the material and social dimensions of human existence.[14] Yet if not spiritual and sublime, these affairs are, at least for most people, very necessary.

RSBY expresses an opinion diametrically opposed to R. Yehuda, that Roman public facilities serve decadent and self-gratifying purposes. For RSBY the physical structure cannot be viewed in isolation from the cultural activities that typically take place therein, and too often those functions are depraved. This vehement denigration of Roman institutions characterizes RSBY as a rabid anti-Roman, especially when compared with the praise advanced by his colleague. R. Yose's silence suggests the intermediate posi-

tion, that public structures are neutral, worthy of neither praise nor condemnation.[15] The two extreme opinions, on the one hand, and R. Yose's silence, on the other, raise a question central to the story: what is the proper attitude toward public structures and the purposes they serve? The spectrum of views invites thought on the merits of the disparate opinions and foreshadows RSBY's change in perspective.

Present at this debate is the enigmatic character Yehuda b. Gerim. He sits with the sages and presumably studies Torah with them. However, the lack of the title "rabbi" alerts the audience at the outset that something is aberrant about him, a judgment subsequently confirmed by his indiscretion.[16] Although he does not inform on the sages directly, he recklessly repeats their words in the presence of others such that the Roman authorities learn of the discussion. So Yehuda b. Gerim bears ultimate—though not direct—responsibility for the ensuing decree. If not an outright villain, he at least displays a lack of insight and poor judgment.[17]

The improbable name "ben Gerim" meaning "son of Proselytes" contributes to his complex image. Names in many BT stories often serve as means of characterization or function as symbols of larger issues.[18] Now the BT both praises and rues conversion, asserting that "God dispersed Israel among the nations solely in order that proselytes join them" (bPes 87b), while at the same time lamenting that "proselytes are as difficult to Israel as a scab" (bYev 47b). "Yehuda the son of Proselytes" is simultaneously Jew (*yehudi*) and gentile, student of Torah and alien, so his name evokes this ambivalence and alludes to the problematic issue of gentile culture and Judaism. Is the ambient culture praiseworthy, as R. Yehuda believes, or depraved, as RSBY insists? A rabbinic disciple descended from proselytes suggests the former, but one who carelessly repeats sensitive statements exemplifies the latter. Where Yehuda the son of Proselytes (or at least his father) is a (former) gentile who appreciates the value of Judaism, Rabbi Yehuda the son of Ilai is a Jew who appreciates the value of gentile cultural achievements.

Section B commences the main plot—RSBY's retreat from the world, existence in the cave and reemergence to society. RSBY and his son withdraw from society in two steps, first to the academy and then to the cave. The verbal repetition "went . . . and hid" (B1, B2) presents the two retreats as complementary. In the academy RSBY withdraws from profane, gentile culture to holy, rabbinic society, but he remains connected to the outside world through the visits of his wife, who brings him basic necessities, bread and a jug of water. Baked bread and the vessel containing water, things cooked and crafted by humans, constitute the primitive culture that

fulfills simple human needs, in contrast to the "high culture" of markets and bathhouses. Similarly, the union of husband and wife is the most elementary human relationship. The first stage of their withdrawal consists of separation to the society of Torah within the academy while maintaining the minimal external cultural and social connections necessary for survival.

This limited withdrawal is untenable because the authorities may penetrate the sages' conduit to the outside. Note that RSBY attributes the danger to his wife's susceptibility to abuse compounded by her innate simple-mindedness, an evaluation of women borrowed from elsewhere in the BT.[19] Abuse or pain (*tsa'ar*) is associated with rape and sexual assault.[20] The sage's fear of this prospect again expresses his perspective on Rome: the authorities exploit bonds between husband and wife for evil purposes, just as their public works serve base desires. Legitimate intercourse with the wife produces Eleazar, a son devoted to Torah, but "this nation" abuses sexual relationships such that a woman "reveal" her husband and Torah be destroyed. The semiwithdrawal to the academy is jeopardized by a woman who cannot share in the world of Torah. She contrasts with his son in this respect, who studies Torah and participates in his father's world.[21] We might diagram the oppositions as follow:

| R. Shimon bar Yohai | wife | Romans |
|---|---|---|
| Torah | low culture (bread, jug) | high culture (markets, etc.) |
| Torah-society | elementary society (marriage) | complex society |
| Torah-knowledge | simple-minded | secular knowledge (technology) |

The wife mediates between RSBY's world of Torah and the outside world of Roman culture. Her mediation both facilitates RSBY's study of Torah and simultaneously constitutes a source of danger. While the affinity of husband and wife is the most primitive human relationship, it nonetheless forms the nucleus of the family, the building block of complex society. The production of food and vessels likewise involves an intricate network of cultural transactions such as the purchase of grain or clay, presumably in a market, and use of a mill or kiln. Because she shares in both worlds, her mediation is inherently precarious and the partial withdrawal unstable. The only solution is complete withdrawal from the world—which allows the story to play out the opposition in the most extreme terms. RSBY withdraws from the academy—a building after all, a sophisticated cultural

achievement—and from all contact with the outside.²² Even his spouse no longer knows his whereabouts.

The retreat to the cave achieves a complete separation from the outside world. The natural shelter of the cave replaces shelter in the academy. Food comes from completely natural sources, a carob tree and spring, in place of baked bread and the jug of water. In rabbinic sources carobs are standard animal fodder, eaten by humans only in times of famine or extreme poverty.²³ The carob tree provides the rabbis with meager and rudimentary nourishment, as befits those who withdraw from the world and almost from bodily existence.²⁴ The sages even shed their clothes and spend most of their time naked, donning garments only when they pray.²⁵ The rapid series of verbs, "they went out and dressed and covered and went out and prayed and again took off their clothes," conveys the speed at which they perform their obligation and return to the state of nature. Indeed, the image of neck-deep burial in sand portrays them as an integral part of the natural terrain, similar to carrots or tubers with the vegetable body comfortably hidden below.²⁶ Submersion in the sand of the cave contrasts with their subsequent immersion in the waters of the bathhouse, and the resulting damage to the sages' bodies is the opposite of the pampering which RSBY associated with Roman baths.

The scene portrays an existence wholly devoted to Torah. Perforce it is very close to nature; with all time and effort invested in study, there is no way to produce food, build shelter or weave clothes. RSBY's rejection of cultural institutions—markets, bathhouses, and bridges—has been pushed to its logical extreme: separation from all human culture. The oppositions can be mapped as follows.

| | | |
|---|---|---|
| cave | academy | roman structures |
| carob | bread | markets |
| spring | jug of water | markets |
| naked | clothes | clothes |
| son | wife | prostitute |
| Torah in isolation | Torah fellowship | worldly pursuits |
| nature | low culture | high culture |
| sand (pain) | | bathhouse (pampering) |
| miracles | | labor, agriculture |

After "thirteen" years—a standard BT number²⁷—Elijah, the peripatetic intermediary between the heavenly and earthly realms, initiates the sages' first move to return to society. His mediating role corresponds to

that of the wife but works in the opposite direction. As in the stories analyzed in the previous chapters, Elijah functions to reveal important information, especially God's reactions or declarations.[28] Elijah's order suggests not only that it is safe to emerge, but that God wants them to leave, a point subsequently made explicit by the heavenly voice. At the same time, that Elijah rather than an ordinary human informs the sages of the emperor's death emphasizes the degree of their isolation. They are detached from humanity and society such that only supernatural figures can reach them. Yet even Elijah refrains from approaching the sages and stops at the entrance, the liminal space between the supernatural cave and the mundane world. Nor does he address them directly but rhetorically asks who will inform the sages of the emperor's death. The reluctance to enter their cave and to converse with them creates an additional sense of distance. The sages have cut themselves off from both men and angelic beings such that Elijah himself resists entering their domain.

Immediately upon leaving the cave the sages see men plowing and sowing seed, that is, engaging in the production of food. The agricultural activity marks their return to society and everyday existence, as does a wordplay on *karvi* (plow) echoing *krakhi,* the eating of the bread brought by the wife.[29] Lacking the miraculous carob tree of the supernatural cave, ordinary people must devote themselves to basic needs, as RSBY and his son themselves required in the academy. Yet the sages fail to recognize this truth. The exclamation "They forsake eternal life and busy themselves with temporal life?" expresses their drastic perspective on such activity. This dictum explicitly articulates the opposition between Torah (=eternal life) and all outside pursuits toward which the story has been moving. At the outset RSBY condemns sophisticated commercial markets because they serve decadent purposes, while here he rejects basic subsistence agriculture and its proper purpose, the production of food. Because all everyday pursuits—not only prostitutes, tolls, and bathing—detract time from Torah he considers them illicit involvement in "temporal life." At first RSBY verbally disparages public works; here he destroys the cultural activity he witnesses. Initially he directs his animosity at Rome; here he kills Jewish peasants. In this way the story presents the fundamental opposition between devotion to Torah and worldly activity in the most extreme way.

The source of the sages' supernatural destructive power is not explained, but it apparently derives from their great knowledge of Torah. Just as their wholehearted pursuit of Torah merited the miraculous carob tree and spring, so it bestows on them miraculous powers. However, the heavenly voice, which like Elijah reveals the divine view, makes it abundantly

clear that they misuse their abilities. If public structures can be misused, so too can the powers of Torah. The voice's charge that RSBY "destroys the world ('*olam*)" plays on RSBY's focus on *hayyei 'olam* (eternal life) and problematizes, if not reverses, his values. The world is jeopardized by the holy sages who embody eternal life / world (*hayyei 'olam*), not by those who neglect Torah. With a rhetorical question ("Did you go out to destroy my world?") that echoes RSBY's rhetorical question ("They forsake eternal life . . . ?"), the voice orders the sages back into the cave. This time the decree of heaven, not the decree of Roman authorities, separates them from the world.

That the sages have sinned emerges from their self-identification with "the wicked in Hell."[30] They now seem to realize that they failed to learn the appropriate lesson during their first stint in the cave. The purpose of that sojourn was not only to preserve their lives and to study Torah, but to moderate their extreme views. The second stint then serves not only to expiate their sin and preserve the lives of others, but to teach them that complete disengagement from the world is not optimal or even desired by God, despite the possibility of incessant Torah study.[31] Total disengagement, which depends on miraculous provision of food and water, is unrealistic as most people must work to produce the basic necessities of life. Having endured the punishment and (hopefully) realized their mistake, the sages are ready to return to the society they had reviled. As opposed to Elijah's indirect communication that the emperor's decree was annulled, the second voice unambiguously informs them that God annulled his decree and that they must return to the world.

Their second exit is no longer lethal if not entirely benign. R. Eleazar still looks on the world with the radical standards of the cave and destroys, but RSBY seems to have learned the lesson, and his supernatural powers now become a force for healing. The wordplay *mahei* (smote) / *masei* (heal) emphasizes the balance of their acts, the standoff between destruction and healing, between death and life. The tension between wholesale dedication to Torah and worldly activity, then, has not been resolved completely. This tension is also manifest in the ambiguous remark, "You and I are sufficient for the world." At first glance RSBY seems to be encouraging toleration and mollifying his son: 'Because our dedication to Torah earns sufficient merit for the world, we need not demand the same of others, and we should let them be.' Yet there rings an ominous echo in the intertextual resonances of his words. The locution, as many commentators have noted, alludes to the striking traditions associated with RSBY in bSuk 45b and parallels:[32]

[A] Hizqiah said R. Yirmiah said in the name of R. Shimon bar Yohai, "I could exempt the whole world from punishment from the day I was born until now. And if Eleazar my son were with me, [we could exempt it] from the time when the world was created until now . . ."

[B] And Hizqiah said R. Yirmiah said in the name of R. Shimon bar Yohai, "I have seen those destined to ascend (*bnei ʿaliya*) and they are few. If there are one thousand, I and my son are among them. If one hundred, I and my son are among them. If two, I and my son are them."

In [A] R. Shimon recognizes his power to atone vicariously for the shortcomings of others, which supports a sympathetic interpretation of his statement in our story. But [B] expresses the same contempt for others as the charge of neglecting "eternal life" and the destructive gaze. In light of this tradition, RSBY may mean that most of humanity will perish; only he and his son who completely dedicate themselves to Torah will be saved.[33] The ambiguity is compounded by the presence of the term "life / world" (*ʿolam*), which appears here for the third time, and should be considered a keyword of the story.[34] Does "sufficient for the world" refer to the "eternal world" of Torah as in RSBY's former exclamation or to the world that the heavenly voice reprimands them for destroying?

The sages internalize the lesson and change their outlook only when they encounter a man running with myrtles on the Sabbath eve, apparently to provide a pleasant aroma in the home and to enhance Sabbath delight. The man's energy (running) and love of the commandments—that he seeks to honor the Sabbath with two myrtles—demonstrate that Jews are not concerned exclusively with "temporal life." The supererogatory second myrtle impresses the rabbis, for it shows that the man acts out of deep religious devotion and profound esteem for the Torah. A product of the same agricultural labors condemned at the first exit, the myrtles are used to observe the commandments of the Torah. Disengagement from the world in order to study Torah is not the only path to God.[35] The sages now understand that worldly occupation has value, at least when used for religious purposes. RSBY's approbation of this type of piety, "How dear is a commandment to Israel (*kama mitsva haviva*)," echoes R. Yehuda's opening praise, "How pleasant are the acts of this nation (*kama naʾe maʿaseihem*)," which RSBY had so vehemently rejected. This new slogan stakes out a middle ground and moderates his position on abandoning "eternal life." Twice the rabbis sat (=*yateiv*) in the cave holding the world in contempt, now their minds are set at ease (*yateiv daʿataihu*).[36]

Reintegration to the world commences when the sages encounter a fellow sage, R. Pinhas b. Yair. That he immediately takes them to a bathhouse for rehabilitation is an ironic contrast to RSBY's condemnation of bathhouses at the outset. Leaving the supernatural cave for the real world, no longer submerged in the sand, the sages' bodies require the therapeutic waters of the bathhouse. The sages now experience that which they began to appreciate in the previous scene—that this-worldly institutions and activities may be used for good. A second thematic connection, the description of R. Pinhas's tears causing pain (*metsa'ari*) to R. Shimon's body, echoes RSBY's worry that the Romans abuse (*metsa'ari*) his wife, which forced him to retreat from the world. The pain, like the bathhouse, marks the return to the real world of flesh and blood, of bodies that feel and suffer, as opposed to the almost disembodied, ethereal existence in the cave. Similarly, the seemingly superfluous datum that Pinhas is RSBY's son-in-law emphasizes that the sage rejoins the family he had abandoned earlier.[37]

Yet RSBY's return to the world, society, and the bathhouse does not resolve the tension between Torah and worldly activity in a facile way. Celebration of his prodigious knowledge of Torah and the reference to his dialectical skill alert us to the advantages of existence in the cave. In the BT dialectical ability, the capacity to propound objections and offer solutions, represents ultimate proficiency in Torah.[38] Although Pinhas b. Yair laments the physical toll the years in the cave have exacted on his father-in-law's body, RSBY himself recognizes the benefits. To master the Torah requires a certain degree of withdrawal from the world, and seclusion in the isolated cave surpasses the semi-isolation of the academy where Pinhas presumably has been studying.[39] The chiastic structure of the story described above emphasizes this point: the withdrawal to the cave is preceded by a stint in the academy and complete involvement in its Torah (they never leave the building!), while the emergence from the cave is followed by acknowledgement of dialectical excellence. RSBY has made quantum progress such that he now has twenty-four solutions for each objection of Pinhas, who formerly had twelve solutions for each of his—a 288-fold improvement! On the one hand, to abandon "temporal life" yields great benefits in one's knowledge of Torah. On the other hand, rejection of the world takes a physical toll on the body and requires supernatural assistance. The balanced phrasing, "Alas that I see you so" / "Happy that you see me so," like the balanced phrasing noted above ("wherever R. Eleazar smote / R. Shimon healed"), communicates the unresolved tension.[40] Eleazar destroys the outside world for lack of devotion to Torah, but RSBY heals it; Pinhas laments the cost of the years of devotion to Torah, but RSBY celebrates it. Both sides are true.

The final stage of RSBY's reintegration is his decision to "fix" something. Upon seeing the myrtles he realizes the value of "temporal life"; he subsequently experiences it himself in the baths and now he acts to improve the world for others. RSBY's plan is expressed through an interior monologue, the standard device for communicating the thoughts of a character. Robert Alter has noted that the phrasing of thought in articulated words confers a precision of language and distinct stylization.[41] Here the articulation of the verb *'atqin* ("fix") and the reference to a miracle connects to earlier parts of the story. The "fixing" of course recalls the opening debate over the Romans "establishing" (*tiqnu*) public structures (both verbs derive from the same verbal root). Mention of the miracle as the grounds for his action is more complicated. The verbal link "since a miracle happened" (*'itrehish nisa*) / "a miracle happened for them" (*'itrehish lehu nisa*) clearly points to the miracle in the cave (B2). Thus RSBY considers amelioration of the conditions of others to be the proper response to the miraculous sustenance provided by God. But why?[42] Apparently RSBY wishes to satisfy the basic needs of others just as his needs were miraculously satisfied in the cave—an application of the "measure-for-measure" principle. Because he cannot miraculously create carob trees and springs, he attempts to contribute in some other way to the betterment of the material lives of people. This interpretation also emerges from the scriptural precedent that RSBY finds for his program in Jacob's arrival at Shekhem (Gen 33:18). Jacob experienced miracles in surviving his encounter with Esau before arriving safely in Shekhem and responded by benefacting the city to which he came.[43] Likewise RSBY survived the Roman (=Esau) persecution, experienced miraculous protection and emerged "whole in body" and "whole in Torah,"[44] so he too responds by repaying others in kind.

To clarify RSBY's new outlook the redactors splice into his monologue exegeses attributed to later Amoraim that describe Jacob's contribution to the city (this phenomenon is discussed below). The resulting chiastic and triadic patterns, as we noted in the discussion of structure, resemble the form of the opening scene. Other connections to the opening include the repetition of the verb "established" (*tiqqen*), the markets, and the money and coinage, which recall the tolls derived from bridges.[45] However, the content is a profoundly ironic reversal of RSBY's previous attitude, as he now advocates the very policy he had condemned, and the supporting exegeses mention the institutions he had considered so pernicious. Moreover, the exegetical play on "he settled" (*vayihan*) as "he graced" (*vayahon*) evokes R. Yehuda's initial opinion that these institutions are "pleasant." RSBY's valuation now coheres with the opinion he formerly rejected! In

this way the later exegetical traditions highlight the sage's complete attitudinal change.

Mention of the "city" is also significant, for the city was the locus of markets, bathhouses, and the high culture that Rome represents. Now the figure of Jacob symbolizes Israel in contrast to Esau who represents Rome. Juxtaposed with the reference to Rome in the first scene, Jacob as the "establisher" of institutions symbolizes Israel appropriating Roman culture. Just as Yehuda b. Gerim signifies the confusion of Jew and gentile, or the transformation of gentile into Jew, so Jacob building markets and bathhouses represents the acceptance or absorption of gentile culture. In a similar vein, Rav's exegesis that Jacob arrived whole in body, money, and Torah suggests that all three are important and interdependent. Torah cannot be separated from attention to the body and the money needed for basic necessities, as it was in the cave.

The problem that RSBY sets about fixing—a place of doubtful impurity forces priests to make an inconvenient detour to "go around" the area—illustrates his newfound appreciation of basic human needs. While this hindrance is hardly of earth-shattering importance, it nevertheless causes the priests "pain" (*tsa'ara*), a word that connects back to both RSBY's withdrawal from the world (concern for his wife's pain) and return (the pain in the baths). RSBY realizes the value not only of major public structures such as markets and bathhouses but also of minor improvements that ameliorate the quality of life. Bridges are constructed so that people need not "go around" impassable areas such as streams or ravines. In this way the story again concretizes RSBY's change in perspective by having him provide benefit similar to one of the cultural achievements he disparaged.[46]

Exactly how RSBY purifies the area and the significance of the lupines, the hard and soft ground, and the precedent of Ben Azai are unclear.[47] Rashi reads in the miracle recounted in the PT that dead bodies rose to the surface (see the translation of the PT below).[48] While the PT version may have become garbled in the transmission process, no bodies rise in the BT.[49] Indeed, whatever we make of this method of purification, the significant point is that, unlike the Palestinian versions, the account does *not* involve miracles.[50] RSBY has returned to the everyday world from the miraculous cave and accordingly employs "natural" rather than supernatural means. He applies his knowledge of agricultural and purity law to test and determine the land's legal status.[51] While earlier he contended that Torah and "temporal life" were incompatible, he now uses Torah to make an improvement (*tiqqun*). By utilizing Torah, by applying the means to "eternal

life" to a matter of "temporal life," the story suggests that the two are not the irreconcilable opposites RSBY once had believed.

The accusation of the "old man" that RSBY purified a graveyard—a halakhic impossibility—portrays his action as controversial and bold, and thereby emphasizes the depth of his commitment to civic benefit.[52] So dedicated is RSBY to the amelioration of temporal life that he makes such a permissive ruling as to anger the more conservative sages. The mention of prostitutes in his response also points to his change in perspective. In the opening discussion he vilified the Romans for placing prostitutes in markets, while here he shows an almost grudging respect for the prostitutes' mutual support, which perhaps recognizes the positive aspects of baleful social phenomena.[53] The strange comparison with sages, moreover, implies that the world of Torah and the decadent culture RSBY initially rejected have more in common than we might think.

RSBY's charge, "If you had not been with us, or even if you had been with us but had not voted with us, you would have spoken well," is obscure. His point seems to be that in such circumstances there would be no semblance of backstabbing, as others would realize that the old man had no part in the decision. Yet mention of a vote is problematic, since the story tells of no such event and presents the *tiqqun* as the idea and accomplishment of RSBY alone. As we shall see below, the PT mentions a vote and opposition to the RSBY's purification, so this episode may be a vestige here.

The story concludes with RSBY committing two murders. The death of the accuser is the second time RSBY kills with a gaze. Continuing the reversal of his previous attitude, he now kills someone who objects to his amelioration of temporal life, as opposed to someone engaging in temporal life. The murder of Yehuda b. Gerim provides closure to the story by returning to the figure who precipitated RSBY's odyssey.[54] Ironically RSBY encounters him after going out to the marketplace. Considering RSBY's previous attitude toward markets, Yehuda b. Gerim probably least expected to encounter the sage there! The punishment seems harsh, since Yehuda was guilty of indiscretion, not malice. We have here vivid evidence that RSBY's supernatural powers are intact and still liable to explode. The rekindled, possibly unjustified destruction perhaps signals that tension between the value of Torah and outside culture remains.[55] These powers, the result of RSBY's proficiency in Torah and long years of dedication in the cave, endure, as does something of his hostility. The story fails to fully integrate the oppositions, and leaves us with a sense that the cultural tensions cannot be resolved completely.

The basic messages of this rich story—that RSBY learned a lesson and changed his extreme view, that temporal life and worldly pursuits are not worthless, that however important the "eternal life" of Torah it is untenable to expect all Jews exclusively to devote themselves to its study—are reasonably well-defined. In order to support and refine the interpretation, however, it is necessary to examine the Palestinian version and the contexts of the story.

## The PT Story, Other Sources, and Compositional Techniques

The PT version of the story appears in yShev 9:1, 38d and other versions appear in several Palestinian works: *GenR* 79:6 (941–45); *PRK* §11 (191–94); *QohR* 10:8 (26b). I will confine the comparative study to differences between the BT and PT: the other Palestinian versions differ in a few respects from the PT but are not substantially closer to the BT.[56] Levine offers detailed comparisons of the Palestinian versions and both he and Meir discuss the PT story and its context.[57] The following translation is Levine's:

> RSBY hid in a cave for thirteen years, in a cave of Terumah carobs, until his body became covered with sores.
>
> At the end of thirteen years, he said: "Perhaps I shall go out and see what is happening in the world." He went out and sat at the mouth of the cave (and) saw a hunter tracking birds (and) spreading his net. He (RSBY) heard a heavenly voice saying: "You are dismissed" and it (the bird) escaped. He said: "Without (the decree of) heaven (even) a bird does not perish, so much more a man."
>
> When he saw that things had quieted down, he said: "Let us go down and bathe (lit. become warm) at these baths of Tiberias." He said: "We ought to do something (*taqqana*) as our fathers of old have done. *And (Jacob) favored (lit. encamped before) the city (Gen 33:18)* — they established duty-free markets and sold (goods) on the market." He said: "Let us purify Tiberias." And he took lupines, sliced and scattered (them), and wherever there was a corpse, it would float and rise up to the surface.
>
> A Samaritan seeing him said: "Let me go and ridicule this Jewish elder." He took a corpse, went and buried it in a place that he (R. Simeon) had purified. He then came to RSBY and said to him: "Have you not purified that place? Nonetheless I can produce (a corpse) for you from there." RSBY, perceiving through the holy spirit that he had placed one there, said: "I decree that those above shall descend (i.e. the Samaritan should die) and that those below (the corpse) shall arise." And thus it happened.

When he passed by Migdal, he heard the voice of the scribe saying: "Here is bar-Yohai, who purified Tiberias!" He (RSBY) said to him: "I swear that I have heard (a tradition) that Tiberias would one day be purified. Even (if that were not) so, did you not vote (with those who declared Tiberias clean)?" He immediately became a heap of bones.

| PT Shevi'it 9:1, 38d | BT Shab 33b–34a |
|---|---|
| | (A) Debate of sages; markets, bathhouses, bridges; Yehuda b. Gerim |
| | (B1) academy; wife brings food and water; decree becomes severe; women are light-headed |
| RSBY hides in cave for 13 years | (B2) RSBY and son hide in cave for 13 years |
| carob tree | carob tree, spring |
| body covered with sores | remove clothes, buried in sand |
| RSBY decides to leave | |
| hunter | |
| heavenly voice about the fate of birds | |
| RSBY saw things had quieted down, leaves cave | (B2) Elijah says decree annulled; RSBY and son leave men plowing; "forsake eternal life . . ."; destruction; heavenly voice and return to cave |
| | (B3) RSBY and son in cave 12 months sentence of wicked 12 months; heavenly voice to leave cave |
| | (B3) Eleazar burns, RSBY heals; "You and I are sufficient . . ." |
| | (B3) old man running with myrtles |

| | |
|---|---|
| RSBY goes to baths of Tiberias (see above: body covered with sores) | (B4) Pinhas b. Yair takes him to baths weeps at clefts in body; "Alas that I see you . . ." RSBY's proficiency in Torah; 24 solutions |
| RSBY decides to make a *taqqana* for the city Gen 33:18; Jacob established markets | (C1) RSBY decides to make a *tiqqun* Gen 33:18 (*Jacob came whole*); exegesis of Rav: whole in body, money, Torah Gen 33:18 (*Gracious to the city*); exegesis of Rav, Shmuel, Yohanan: coinage, markets, bathhouses |
| RSBY decides to purify Tiberias | (C2) RSBY told of doubtful impurity; old man says Ben Azai had cut lupines |
| throws lupines bodies rise up | throws lupines marks off soft ground |
| Samaritan buries corpse RSBY makes corpse rise by holy spirit, kills Samaritan | |
| scribe says RSBY purified Tiberias | (C3) old man says RSBY purified graveyard |
| RSBY says scribe was at vote RSBY turns scribe into heap of bones | RSBY says old man was at vote RSBY looks at him and he dies |
| (see above: RSBY kills Samaritan) | (C3) RSBY goes to market RSBY turns Yehuda b. Gerim into heap of bones |

Because both Levine and Meir have devoted some attention to the differences between the two versions, I will focus on the main points of interest and not attempt a comprehensive comparison.[58] I begin with observations on compositional technique and then turn to the content.

1. The BT version again is longer and more developed. In Chapter 2 I categorized BT additions in terms of supplements, expansions, and embellishments.[59] Without going through a line by line analysis this time, one can easily discern all three types. A and B1 are supplemented scenes (see below). C1 and C2 are expansions. B2–B3, the sojourn in the cave, is heavily expanded and embellished. Similarly B4, the visit to the baths, is both expanded (the illustration of RSBY's dialectical abilities) and embellished (the presence of Pinhas b. Yair, the description of the body and the pain, the dialogue). The PT's scene with the hunter has been omitted, since the power of providence is not the point of the BT. The PT's encounter with the Samaritan is likewise omitted, or rather condensed considerably and transformed into the destruction of Yehuda b. Gerim at the end.

2. Several elements of the PT have been duplicated in the BT: there are two periods in the cave, two appearances of the heavenly voice, two exegeses of Gen 33:18; two murders by lethal vision following the purification.[60] The duplications provide further documentation of the findings of Chapter 2 that the compositional methods of the redactors involved imitating and adapting material from the story they received.

The BT also contains internal doublets (and triplets): two appearances of Yehuda b. Gerim (A1, C3), two destructions of people upon exiting the cave (B2, B3), two persecutions by the authorities (A, B1), and three mentions of an old man (B3, C2, C3, as opposed to a Samaritan and scribe in the PT).

3. Many of the elements present in the BT but absent in the PT are those with parallels elsewhere in the BT, especially stock phrases and common motifs, as documented in the endnotes. These include:

    a. "women are light-headed" (B1);

    b. "they forsake eternal life and busy themselves with temporal life" (B2);

    c. "the sentence of the wicked in Hell is twelve months" (B3);

    d. the allusion to another tradition attributed to RSBY, "You and I are sufficient for the world" (B3);

    e. the phrase based on another story, "Alas that I see you so . . ." (B4);

    f. the theme of difficulties, objections and twenty-four solutions (B4);

    g. the "certain old man" (C2, C3).

Moreover, most of these phrases appear exclusively or almost exclusively in the BT: (a), (b), (d), (e), (f), and (g).[61] This illustrates again that *the Babylonian redactors supplemented and reworked their sources by drawing on Babylonian motifs and traditions.* The only prominent motifs that appear in the PT are the number thirteen (of years in the cave), the heavenly voice, and the lethal gaze of a sage.[62]

4. Sections A and B1 have no parallel in the PT, which begins with the abrupt exposition, "RSBY hid in a cave for thirteen years." We are not told why he was there, and only later can we infer from the datum "things had quieted down" that there had been a persecution. What this persecution was or why it began we have no idea.[63] The BT storytellers provide background to explain why the Romans wanted to kill RSBY and why he sought refuge in a cave. This provides another example of the phenomenon noted in the last chapter, that the BT supplies a more developed exposition to the PT story.

At this point I turn to observations on the differences in content.

5. The elements that make up the fundamental tension in the BT are almost completely absent from the PT, namely Torah and *tiqqun / taqqana* ("improvement").

(a) In the BT RSBY and his son first retreat to the academy and then study Torah while in the cave. *The PT lacks the academy scene and does not mention that RSBY studied in the cave.* In the BT, RSBY and his son destroy the peasants because they "forsake eternal life," that is, do not study Torah. The PT lacks this episode. The PT briefly informs us that RSBY went to the baths at Tiberias, presumably to heal his body. The BT recasts the scene with the baths in order to emphasize RSBY's proficiency in Torah. In the PT RSBY purifies Tiberias by performing a miracle. In the BT he seems to apply his knowledge of Torah to a "place of doubtful impurity" and performs no miracle. Thus the BT presents RSBY as a master of Torah. The PT presents him as a holy man or miracle worker.[64]

The description of RSBY's new abilities in the scene at the baths, in particular, seems to reflect the Stammaitic setting. The story emphasizes dialectical skill, the ability of each sage to devise multiple responses to an objection. We are not told that after emerging from the cave RSBY knew more traditions or practical law but that he could proliferate arguments. This is consistent with Halivni's description of the Stammaitic preference for the give-and-take of academic debate.[65] Now the theme of twenty-four responses appears in another lengthy BT story. In bBM 84a R. Yohanan laments that Resh Laqish used to "object against me with twenty-four

objections and I would solve [them] for him with twenty-four solutions." This passage too is a BT addition to the PT story. Moreover, the combination of the terms "objection" (*qushia*) and "solution" (*peiroqa*) (or the related verbal forms) only appears in the BT, and almost exclusively appears in stories about the academy.[66] Thus the general description and vocabulary suggest that portions of the BT story are of Stammaitic provenance. We might say that the BT has not only "rabbinized" but "Stammaized" the character of RSBY found in the PT.

(b) The PT uses the term *taqqana* but once (RSBY's resolution to "make a *taqqana* for the city"), and the exegesis of Gen 33:18 mentions only that Jacob built markets.[67] By contrast the opening debate of the BT uses the verb *tiqqen* six times, and mentions markets, bathhouses, and bridges. Later RSBY twice states that he desires to "fix" (*taqqen*) something. This word is repeated in the exegesis of Gen 33:18, which mentions markets, coins, and bathhouses. In the PT RSBY purifies the city to repay a kindness to the Tiberians for providing the baths. The BT connects his action to the miracle in the cave. It is a product of the lesson he has learned and his change of attitude.

6. The accounts of the emergence from the cave present significant differences. In the PT RSBY hears the voice announcing the fate of hunted birds and concludes that heaven providently controls human destinies. The BT replaces this scene with the initial condemnation of the world for preoccupation with "temporal life" followed by a different lesson: that Israel is devoted to the commandments even while occupied with worldly matters. In the PT RSBY himself resolves to sit at the mouth of the cave and to depart. In the BT he is invited out by Elijah, then sent back in, and finally ordered out by the heavenly voice. This makes clear that God wants no part of his initial attitude. The messages and concerns of the two stories are therefore substantially different.

7. As noted in the literary analysis, the PT account of the purification involves miracles. Corpses rise to the surface and RSBY detects the Samaritan's attempted subversion by means of the "the holy spirit." The only supernatural element that remains in the BT acccount is the lethal vision, a product of RSBY's mastery of Torah. On the other hand, the PT account of the stay in the cave contains only one supernatural element — the heavenly voice. The BT account by contrast includes many: the carob tree and spring, Elijah, two heavenly voices, and RSBY's healing vision. Note that in the PT RSBY eats carobs that grew naturally, while in the BT "a miracle occurred" and a carob was created specially for him. Thus the shift within the BT from the miraculous life of the cave to the natural process of the

"improvement" is supported by the comparative evidence of the purification accounts.

Comparison with the PT account of the purification, moreover, helps to explain the difficulties encountered in the literary analysis. The role of the lupines in the process, the reference to a vote, and the criticism of RSBY are obscure in the BT. These incongruities are holdovers or vestiges from the PT that the BT redactors failed to integrate completely. The redactors were not completely free — or did not allow themselves complete freedom — to rework their sources. This example again illustrates the need for combining literary analysis with source-criticism. Whatever sense could be made of these problematic scenes by New Critical methods, the resulting interpretations would be speculative and incomplete in light of the source-critical evidence. We simply do not have a process of free composition where literary-artistic considerations determine every detail.

8. At this point we turn to a few further questions of the sources of the BT scenes not found in the PT. We noted above that the opening two sections of the BT (A, B1) supplement the PT account. What are the sources of this material and how was it composed?

Section A provides clear examples of compositional methods that expose the hands of the Stammaim (as opposed to Amoraim). The content was borrowed from the first part of the homiletical story found at bAZ 2b–3a, which we analyze in Chapter 7 (see p. 216 for translation). There the Romans claim that they built markets and bathhouses "so that Israel could busy themselves with Torah," while the Persians adduce bridges and cities for the same reason. God rejects the arguments on the grounds that markets are for prostitution, bridges for tolls, bathhouses for pampering, and cities for forced labor. The storytellers of the RSBY saga thus excerpted and combined words of both nations and placed them in the mouth of R. Yehuda, and put God's response in the mouth of RSBY. They selected marketplaces, bathhouses, and bridges rather than cities, war, and money, which are also mentioned in bAZ 2b, because they were concerned with institutions and culture rather than conquests.

Our storytellers borrowed from bAZ 2b rather than the reverse, as both Israel Ben-Shalom and Ofra Meir have noted.[68] First, this scene appears in Hebrew (after the introductory line) while the subsequent story is Aramaic (as is the PT version).[69] The homiletical story is entirely in Hebrew. Our storytellers added the Hebrew source to their Aramaic narrative tradition about RSBY.[70] Second, as noted, the Palestinian parallels lack this scene. While it is theoretically possible that the BT storytellers invented it de novo, the absence of a Palestinian parallel and the presence of an almost

verbatim BT parallel suggest that the storytellers drew on the ready-made source. Third, the merits or sins of Rome and Persia are a main concern in bAZ 2b. In the story of RSBY they are a prelude to the main action.

The structure of section A also derives from other BT sources. First, the opening Aramaic line adopts a common BT formula: "Rabbi *x* and Rabbi *y* and Rabbi *z* were sitting and Rabbi *w* was sitting beside them." This formula routinely functions as a prologue to the designated rabbi asking a question of the other rabbis, or objecting to what they have done, or making some pointed remark.[71] There are no other examples of this formula in a sustained story, nor of the designated rabbi doing anything but directly addressing those beside whom he sits, whereas here Yehuda b. Gerim goes and repeats their words to others.[72] It seems that the storytellers adapted a standard formula, which typically introduces a dialectical exchange, for their narrative purposes. That this formula does not appear in the PT provides additional evidence of BT coloring.[73]

Second, the overall form of the debate is modeled on a *baraita* that appears in the *sugya* just before the story (bShab 33b):

> Come and hear: When the sages entered into the vineyard at Yavneh, R. Yehuda and R. Eleazar b. R. Yose and R. Shimon were there. This question was asked before them: Why does this plague (*'askara* = croup) begin in the bowels and end with one's mouth?
>
> [1] R. Yehuda b. Ilai, the first speaker in all matters, answered and said, "Even though the kidneys advise and the heart understands and the tongue moves— the mouth completes (the slander, for which the punishment is croup)."
>
> [2] R. Eleazar b. R. Yose answered and said, "Because they eat unclean things . . ."
>
> [3] R. Shimon answered and said, "Because of the sin of neglect of Torah . . ."

Here too the *baraita* describes a discussion of three sages, including R. Yehuda and R. Shimon, and presents the opinions in the same order. The middle position shifts from R. Eleazar b. R. Yose to R. Yose, from son to father. The introductory term "answered and said" (*na'ana ve'amar*), which introduces all three opinions here, introduces R. Shimon's statement in the story.

This leaves the Roman decrees regarding the three sages. The form again seems to be patterned on another source. In bSanh 106a = bSota 11a

we find: "R. Hiyya bar Abba said R. Simai said . . . Bilaam who counseled—let him be killed. Job who was silent—let him be punished with sufferings. Yitro who fled—let his descendants merit to sit in the Hewn Chamber." Even the unimportant datum specifying that R. Yose should be exiled to Sepphoris is instructive. Why Sepphoris? Just a few pages after the story appears the phrase: "When R. Yose went to Sepphoris he found . . ." (bShab 38a). That the redactors frequently draw on "local" traditions when composing both halakhic and aggadic *sugyot* has been noted by scholars.[74] In addition, many rabbinic sources, primarily those of the BT, locate R. Yose in Sepphoris or have him report precedents that happened there.[75] For example, the BT places the court of R. Yose in Sepphoris (bSanh 32b) and notes that when R. Yose died "the roof-gutters of Sepphoris ran with blood" (bMQ 25b = bSanh 109a).[76]

Thus the storytellers composed a detailed exposition for the story of RSBY by adapting the form and content of several BT sources. They borrowed the tripartite structure and introductory terminology ("answered and said") from the preceding *baraita* and based the location of R. Yose's exile on another nearby source. The content and even wording they adapted from a homiletical story found elsewhere in the BT and introduced it with a common BT formula. We see BT coloring in the opening form, the use of "this nation" to refer to Rome,[77] and the association of R. Yose with Sepphoris. Just about the only datum of this section not taken from elsewhere is the action of Yehuda b. Gerim. That, of course, explains why RSBY hid and comprises the motivation for the entire scene.

That these "storytellers" were the redactors, the Stammaim, should be clear. These techniques—to borrow and transfer other BT sources, then to modify, transform, and adapt them to another context—characterize the activity of the redactors. Only the redactors are in a position to imitate the structure of a source that appears earlier in the *sugya,* or to draw on a local tradition, since these maneuvers presuppose a redacted text. The story has an Amoraic provenance, but it has been recast by the redactors.

Section B1, on the other hand, as far as I can tell, was not composed on the basis of other sources (except for the maxim "women are simple-minded"). This is a case of authorial creativity.

Finally, let us turn to the exegesis of Gen 33:18 (C1). Apart from the differences noted above (5.a), a significant distinction is that the BT blends in the exegeses of the Amoraim Rav, Shmuel, and R. Yohanan, who lived about a century after RSBY. From a source-critical perspective, it is clear that a later source has been incorporated into the story.[78] Yet the source has been integrated so smoothly that to determine where RSBY's words

end and the later gloss begins is no easy matter.[79] Moreover, the exegesis turns on the connection between RSBY's desire to "fix (*atqin*) something" and the interpretations of what Jacob "established" (*tiqqen*). These verbs link back to the use of this keyword at the outset and suggest that the redactors changed the language of the supplemented source to fit the story. That is, they employed the term *tiqqen* in the exegetical traditions because that word appeared earlier in the story. At the same time, the fact that the redactors preserved the attributions is significant. In contrast to the exposition, which provides no explicit markers of borrowing, here the names of the Amoraim signal the presence of another source. Once again the redactors acted with freedom (to add a later source to the story they received; to blend the source with the words of the character; to modify the language) and constraint (they preserved attributions).

## Cultural Context

The fundamental change in the story is that of RSBY's perspective, specifically toward his fellow Jews who work the land rather than study Torah, more generally toward the necessities of temporal life. This question of the importance of worldly activity is the subject of a striking debate found in bBer 35b, also featuring RSBY, which several scholars have cited in relation to our story:[80]

> Our sages taught:
> [A] "*You shall gather in your new grain (Deut 11:14)*. What does this teach? Because it says, *Let not this Torah cease from your lips [but recite it day and night] (Jos 1:8)*. Should this be taken literally? It teaches, *You shall gather in your new grain*. Perform worldly occupations (*derekh 'erets*) together with them (=Torah)." These are the words of R. Ishmael.
>
> [B] RSBY says, "Is it possible that a man plow in plowing season, sow in sowing season, harvest in harvest season, thresh in threshing season, winnow when the wind blows — then what will become of Torah? But when Israel fulfills the will of God their work is done by others, as it says, *Strangers shall stand and pasture your flocks; [aliens shall be your plowmen and vine-trimmers] (Isa 61:5)*. When they do not fulfill the will of God, their work is done by themselves, as it says *You shall gather in your new grain*."
>
> [C] Abaye said, "Many acted in accordance with R. Ishmael and prospered; in accordance with RSBY and did not prosper."

[D] Rava said to the sages, "I ask you not to appear before me in the month of Nisan and in the month of Tishrei, in order that you not be distracted by concern for your sustenance during the rest of the year."

RSBY's opinion here parallels his attitude in the first half of our story. Where R. Ishmael advocates combining Torah and work, RSBY insists that all time be devoted to Torah.[81] Abaye's sober comment moves from theological-exegetical debate to practical experience: RSBY's program often failed to yield the expected benefits (his Isaian prooftext, after all, depicts messianic times!). Rava accordingly instructs his students to prioritize agricultural labor in the appropriate seasons and to defer their studies. While he intends to facilitate study throughout the rest of the year, Rava realizes that material needs must be satisfied first. By appending these Amoraic comments to the Tannaitic dispute, the redactors of this passage reveal their bias and instruct the audience on the importance of worldly occupation.[82]

Related considerations appear in a dispute over the proper education for sons cited in bQid 82a:

[A] R. Meir says: Let one always teach his son a pure and simple profession.

[B] R. Nehorai says: I would forsake all professions in the world and exclusively teach my son Torah, for one enjoys its fruits in this world, and the principal endures for him in the world to come. This is not the case with all other professions. For when one becomes sick or old or suffers and cannot work at his profession, he starves to death. Not so the Torah, which protects one from all harm in one's youth, and gives future and hope in old age.[83]

R. Nehorai's assertion of the ultimate failure of professional occupations to sustain life is a preemptive assault directed against the obvious objection to his position—that one who devotes himself exclusively to the study of Torah will lack a livelihood.[84] Not only does Torah confer reward in the world to come, but R. Nehorai confidently expects it to provide the support necessary in this world. Aware of the problem of earning a living, he nevertheless believes that the source of "eternal life" will suffice for "temporal life" as well. Not so R. Meir, who advises that one teach children a means to sustain themselves.[85]

The dictum, "They forsake eternal life and busy themselves with temporal life?" (B2), which expresses RSBY's extreme view, also recognizes the tension between the two worlds. To further appreciate the cultural dynam-

ics of the tension it would behoove us to examine the three other citations of this dictum in the BT. Interestingly, all three appear in narrative contexts. bTa 21a recounts that two sages, Ilfa and R. Yohanan, decide to quit their studies because they suffer "extreme need." After the sages set out Yohanan hears an angel propose that he kill the sages because "they forsake eternal life and busy themselves with temporal life," but his fellow angel objects. Upon hearing the angelic conversation, Yohanan resolves to return to his studies, ruefully observing that he will exemplify the verse, "The poor shall never cease out of the land" (Deut 15:11). He attains a position of leadership, while the angels inform Ilfa that had he remained and studied, he would have achieved even higher honor. Now this story focuses on the sages themselves, rather than common Jews or gentiles, so we might expect higher pressure to dedicate oneself to "eternal life." That those who "forsake eternal life" risk death comes as no surprise. Yet here too the story recognizes the need to earn a living and the tension between full-time study and practical considerations. Rather than condemn Ilfa or kill him as the first angel suggests, the conclusion of the story presents him in somewhat tragic light.

The two other stories raise the stakes considerably. In a brief report found in bShab 10a, Rava reacts to his colleague Rav Hamnuna's lengthy prayers, "he forsakes eternal life and busies himself with temporal life!" This reaction surprises in that prayer is not only a spiritual activity but fulfills a commandment as well. Yet prayer — at least lengthy, voluntary prayer — petitions God for worldly needs. Even this limited concern for "temporal life" offends Rava because it detracts precious time from the study of Torah. A similar standard appears in the final instantiation of the dictum, a story of R. Eliezer and his students at bBes 15b. On an unspecified festival Eliezer sits and studies with his disciples. As time passes groups of students depart to enjoy their festival meals, and as each group withdraws Eliezer makes a derogatory remark about their character. Eventually he reassures the remaining students that he was not speaking of them, but about the others "who forsake eternal life and busy themselves with temporal life." Here again the text does not pit study of Torah against earning a living but against celebrating a festival, an important religious value — even an obligation, as the BT itself objects. The extreme perspective of both stories resembles that of RSBY before his education in the cave. These stories also fail to resolve the issue: the different perspectives of R. Eliezer and his students and of Rava and Rav Hamnuna express the tension but offer no clear conclusion as to proper behavior.

This cultural context gives us a broader frame in which to understand the story. However, before rendering definitive judgments concerning its redactional setting and function, it is necessary to examine the literary and halakhic contexts.

## Literary and Halakhic Contexts

The story appears within the second chapter of Tractate Shabbat in the section of Talmud that comments on mShab 2:6. This chapter treats actions performed on the Sabbath eve, especially the lighting of the Sabbath lamps. The first five Mishnas deal with the laws of the wicks, oils, and so forth. mShab 2:6 then states, "For three sins women die during childbirth: Because they are not careful about [the laws of] menstruation, the dough offering, and lighting the [Sabbath] lamps." mShab 2:7, which immediately follows the story, opens: "A man must say three things in his household on the eve of Sabbath as it gets dark: Have you tithed? Have you made an *'eiruv*? Light the Sabbath lamps!" Thus the proximate Mishnas stress proper preparation for the Sabbath and its importance: women die for careless lighting of the lamps.

The talmudic commentary to mShab 2:6 begins by engaging the Mishna directly, explaining why these sins should be punished by death and why the woman's death should occur during childbirth. After a few minor digressions, there appears a lengthy *sugya* listing numerous sins and their punishments or repercussions: one's wife dies for not fulfilling vows; children die because men neglect the *mezuza*, the study of Torah, or the fringes; rain ceases to fall because tithes are not given; robbery leads to famine, and so forth. This *sugya* of sins and punishments proceeds from and expands the talmudic discussion of the three sins and punishments specified in the Mishna. The protracted *sugya* eventually discusses what sins cause *'askara* (croup) and suggests that either the neglect of tithes or slander is responsible. In this context the Talmud quotes the *baraita* reporting the discussion of R. Yehuda, R. Eleazar b. R. Yose, and R. Shimon (bar Yohai) in Yavneh, quoted above in the discussion of sources. The *sugya* discusses RSBY's opinion at the end of the *baraita* that the neglect of Torah produces croup as follows:

> [D1] They said to him (RSBY), "Women disprove [your opinion]." (They get *'askara* but are exempt from studying Torah.)
> — They cause their husbands to neglect Torah.

[D2] Gentiles disprove [your opinion].
—They cause Israel to neglect Torah.

[D3] Children disprove [your opinion].
—They cause their fathers to neglect Torah.

[D4] Children of the schoolhouse disprove [your opinion]. (They cause no neglect of Torah, yet they get *'askara*.)
—This we explain like R. Guryon. For R. Guryon, and some say R. Yosef b. R. Shemayah, said, "If there are righteous in the generation, the righteous are taken for the sins of the generation. If there are no righteous in the generation, then the children of the schoolhouse are taken for the sins of the generation." (This is why they get *'askara*.)

The Talmud then brings a prooftext for R. Guryon's claim. There follows an unattributed question, "Why was he called 'the first speaker in all matters'"? referring to the title given to R. Yehuda in the *baraita*, and then our story.

Thus the story is formally connected to the preceding *sugya* by the introductory reference to R. Yehuda's title and ostensibly serves as its etiology. However, the title never appears in the story itself; we are to understand that when the Romans decreed, "Yehuda who extolled—let him be extolled," they granted him this honor. This reward, moreover, is a minor sidepoint that hardly figures in the plot. Still other evidence indicates that his praise for the Romans is not the original, certainly not the only, explanation of the title.[86] More importantly, the source-critical considerations presented above suggest that the redactors added the first section of the story and modeled it on the *baraita*. The first section, *including the purported etiology of the title*, is itself a result of the redactional process of integrating the story into this section of Talmd, not the reason the redactors decided to place the story here.[87] Accordingly, the introductory question should be seen as an artificial device that links the story to the literary context. It serves a mnemonic purpose in facilitating the memorization of the *sugya* through repetition and its dialogical form ("Why was he called . . . ?") thereby fashioning a smoother literary flow. Such artificial connective devices often appear in the Stammaitic strata of halakhic *sugyot*: the redactors improved the links between elements of Amoraic *sugyot* that had been juxtaposed on loose associative grounds.[88] The location of the story must be explained otherwise.

This title aside, the story intersects with the content of the *baraita* and

its brief talmudic commentary at several points. First, Yehuda b. Gerim commits a type of "slander" (*leshon har'a*) or at least "evil speech," as the Hebrew term literally translates.[89] Second, the impact of women, children, and gentiles vis-à-vis study of Torah in the analysis of RSBY's opinion contrasts with episodes of the story. RSBY's wife actually facilitates his study by bringing him food in the academy, and his son Eleazar becomes his study-partner for many years. Gentile authorities ironically are responsible for the uninterrupted period of study by forcing him to hide in the cave. Third and most significant, the issue of "neglect of Torah" coheres with the fundamental tension of the story (expressed in terms of "they forsake eternal life"). RSBY's statement in the *baraita* presents "neglecting Torah" as a serious sin, as the cause of *'askara* and its nefarious consequences. The story then offers a more complex, and ultimately tolerant, view of "neglecting Torah."[90]

The strong connections to the immediate literary context should not obscure the relationship of the story to the halakhic context provided by mShab 2:6. The episode of the old man running with myrtles on the eve of the Sabbath is a clear thematic link to the framing Mishna, which mentions the lighting of lamps on the eve of the Sabbath, and to the entire chapter of Mishna as well. (Some commentaries even connect the two myrtles to the two customary Sabbath lamps, although the Mishna does not mention two lamps—this was a later ritual development.)[91] As noted above, the myrtle episode is crucial to the plot since this encounter bears primary responsibility for the sages' change in perspective. In this halakhic context, the story's central message has to do with performing rituals and honoring the commandments as legitimate, even critical, expressions of religious piety. Jews who cannot devote themselves to the study of Torah nevertheless may be engaged in religious praxis of ultimate worth. Neglect of rituals and commandments brings death (so the Mishna); proper or supererogatory dedication to rituals and commandments saves the world (so the story).

The flip side of the contextual question is the impact of the story on the interpretation of mShab 2:6. As the previous paragraph suggests, the story focuses attention on the importance of preparations for the Sabbath and hence illuminates the Mishna's warning that women die for careless preparation of the Sabbath lamps. Indeed, this Mishnaic statement is theologically problematic, not so much because it seems cruel—that is a modern sensibility—but because lighting Sabbath lamps technically is not a commandment. The other two items mentioned in the Mishna, the laws of menstrual impurity and the dough offering, are commandments explicitly

stated in the Pentateuch that carry severe punishments in rabbinic legal theory.[92] In these cases the Mishna restates the dictates of the Pentateuch and adds only that the death will take place during childbirth. But lighting Sabbath lamps is not a commandment specified in the Torah, nor elsewhere in the Mishna for that matter.[93] Why should carelessness or neglect of this ritual invite death?[94] Now the myrtles in the story, like the lamps in the Mishna, are not positive commandments but enhance the delight of the Sabbath by providing a pleasant aroma. That they effect such a change in the sages' perspective and possibly save the old man from Eleazar's murderous gaze demonstrate that Sabbath preparations are no trivial matter. We understand why the Mishna designates death as punishment. The story helps to address the legal anomaly and functions as a narrative justification for the Mishna.[95]

The manifold connections between the story and its literary and Mishnaic contexts reveal a conscious and meticulous redactional process. It must be emphasized that not one of these connections—slander, neglect of Torah, the myrtles, R. Yehuda's title—occurs in the PT or in the other Palestinian versions. In fact the PT story occurs in Tractate Shevi'it, not in Tractate Shabbat, juxtaposed with a Mishna that deals with agricultural law. These changes strongly suggest that the BT redactors tailored the story to its context. The composition of the story—the way the narrative source was changed, supplemented and expanded—went hand in hand with the process of redacting the story in its BT context.

At this point we may turn back to the general talmudic context and both broaden and nuance our conclusions.

The story reflects a basic tension in rabbinic culture. That tension is not only Torah study as opposed to worldly occupation, but devotion to Torah as opposed to everything else, including domestic, socioeconomic, and communal life, and, as the stories of Rava and R. Eliezer suggest, sometimes even other aspects of religious life. Ideally the Torah was to be studied incessantly: "Let not this Torah cease from your lips but recite it day and night," states Jos 1:8. Yet the practical necessity of earning a livelihood and supporting a family remained. How was a Babylonian rabbi to reconcile the religious imperative (and private passion) for Torah study with his mundane needs?

Besides the personal tension experienced by each sage, this worldview occasions a theoretical tension regarding society. If the ideal is pushed to

its logical conclusion—that every Jewish male constantly study Torah—the community would collapse. Society obviously needs some to produce food and clothing, to master the art of building, to be professional artisans, to oversee communal organizations, and so forth.[96] Full-time scholars of Torah, many sages depended on these activities. How could they deny the legitimacy of such occupations? Yet how could they conceive of such mundane activities as even remotely significant compared to Torah?

The exalted view of Torah in the BT prevented other occupations and worldly endeavors from garnering much respect. At the same time, the practical needs of both individual sages and the larger society could not be ignored. The story both expresses the tension and attempts to resolve or ameliorate it. The story cautions against pressing the ideal of incessant study too far. It rejects the extreme view that Torah study is the only legitimate occupation, that this world and its activities are worthless. Yet it simultaneously celebrates RSBY's knowledge of Torah and the ideal he represents. Assessed within the halakhic context of the framing Mishna, the myrtles exemplify one approach to the dilemma. Mundane activities have the most worth when they serve to glorify or perform the commandments. If every Jew cannot study Torah, at least his involvement in the "temporal world" ultimately should further the goals of religious life. While this strategy does not solve the problem completely, it provides a possible line of thought for coping with the conflict.

### APPENDIX: MANUSCRIPT VARIANTS

Besides the Munich Manuscript (=M) the only extant manuscript of this section of Tractate Shabbat is Oxford 366 (=O). P refers to the first complete printing, Venice, 1520.

(B1) "Jug of water." O omits. In M these words appear in the margin.

(B2) "Hid in a cave." *DQS* reads "cave of Moses and Elijah." I cannot make out these words on the facsimile of ms M, although something is written there. Ms O and P have only "cave."

(B2) "They took off their clothes." O omits. Because the phrase is out of order in M, *DQS* considers it a gloss. That they had taken off their clothes is clear from the subsequent description of them putting on clothes to pray.

(B2) "They went out and dressed and covered themselves and went out." O reads "they went and dressed and covered themselves."

(B2) "Thirteen years." O reads "twelve years."

(B3) "Bunches" (*medanei*) is the reading of O; Jastrow, *Dictionary*, 734, and Jacob Levy, *Wörterbuch*, 3:31 explain it as a variant of *madanei* and ulti-

mately *maʿadanei*. See also Alexander Kohut, ed., *Sefer ʿarukh hashalem* (Vienna, 1878–92), 5:89, who reads *madanei* and Krauss, *Tosafot*, 248. M reads *mani*, "portions."

(B3) "Running at twilight." O omits. See *DQS* ad loc.

(B3) "Their minds were set at ease." Both O and M omit. It appears in P and in other text witnesses (see *DQS* ad loc.). I include the phrase because I think it is required to understand the subsequent events.

(B4) "Massaging" (*'arikh*). See J. N. Epstein, "Notes on Post-Talmudic-Aramaic Lexicography, *JQR* 12 (1921–22), 356–57, who derives it from *r-k-k*, to soften. Contrast *ʿArukh*, 1:284, s.v. *'arikh*. O reads *hakhikh*, "to rub." The basic meaning is clear from the context.

(B4) O reads, "He took him into the bathhouse and healed him. He softened his flesh."

(B4) O reads, "His tears were falling and paining (*metsavhan*) him because they burned in the clefts."

(C2) O reads, "wherever it was loose he marked out, for he took a . . . [vacat of about fourteen letters . . . ] post and stuck [it in the ground]. And wherever it was hard he ruled pure." See *DQS* ad. loc., n. ז. This addition looks like a gloss.

Chapter 5

# Rabbinic Authority and the Destruction of Jerusalem (Gittin 55b–56b)

The story of the siege of Jerusalem and the encounter between R. Yohanan b. Zakkai and Vespasian provides an opportunity to continue our study of two important issues: the compositional techniques of the redactors and the relationship of the story to its literary context. The previous chapters argued that the BT redactors supplemented Palestinian stories by adapting material from other sources, primarily passages found elsewhere in the BT. In this case the redactors have composed a sustained story by combining several independent narrative sources. They not only reworked, embellished and supplemented a single story, but integrated it with other stories so as to create a lengthy composition with a message that transcends the sum of the parts. The question of literary context is particularly interesting, for at first glance there appears no substantive connection between the story and the Mishna with which it is juxtaposed. Deeper probing, however, reveals that the story answers important questions raised by both the framing Mishna and the proximate laws of the chapter.

Numerous studies attempting to reconstruct the cause and course of the Jewish revolt against the Romans in 66–70 C.E. have treated this story from a variety of historical perspectives.[1] The impressive parallels to Josephus's account point to a substantial core of historical material.[2] However, as in other such cases, the rabbinic storytellers have subordinated history to their didactic interests. In his early researches Jacob Neusner adduced this story as a parade example of the impossibility of historical reconstruc-

tions and called attention to its literary qualities.³ A few recent studies have noted the literary characteristics and messages of the narrative building blocks of the story but have not assessed the BT version of the story in its entirety.⁴

The story actually begins a lengthy collection of narrative traditions concerning destructions, military defeats, and persecutions that extends from bGit 55b to bGit 58a. Avraham Weiss called this block the "aggadot of destruction" and considered it a self-contained source inserted into the BT with but minor editing.⁵ Eli Yassif subsequently counted twenty-five "stories of destruction" in what he termed a "story cycle."⁶ A gloss at the beginning of our story explicitly connects it to the stories of the destruction of Tur Malka and Bethar (see the translation below), which suggests that these three stories were regarded as a literary unit. Yet several other stories interpose between these three stories, and still other stories follow the third. A comprehensive literary analysis of both the three referenced stories and the entire complex is a desideratum, since these frames contribute to the initial story's context.⁷ As a first step I concentrate on the opening story, which is itself a composite of several sources.

## Translation, Sources, and Structure

The translation is based on ms Arras 969. Major variants are listed in the Appendix. The portions placed in angular brackets are glosses.⁸

[A1] R. Yohanan said, "What [is meant] by the scripture, *Happy is the man who is cautious always, but he who hardens his heart falls into misfortune (Prov 28:14)*?"

<Jerusalem was destroyed because of Qamza and Bar Qamza. Tur Malka was destroyed because of a cock and a hen. Bethar was destroyed because of the shaft of a litter.>

[A] Jerusalem was destroyed because of Qamza and Bar Qamza. A certain man whose friend was named Qamza and whose enemy was named Bar Qamza held a banquet. He said to his servant, "Go and bring me Qamza." He went and brought Bar Qamza. He (the host) came and found him sitting [at the banquet]. He said, "Since that one (you) are the enemy of that man (me), what are you doing here? Get up and leave."

He said to him, "Since I am here, let me be, and I will pay for what I eat and drink." He said to him, "No."

[He said,] "I will pay for half the banquet." He said to him, "No."

[He said,] "I will pay for the whole banquet." He said to him, "No." He grabbed him, forced him up and threw him out.

[B] He (Bar Qamza) said, "Since the rabbis were sitting and did not intervene, I will go and inform against them at the King's palace."

He said to the Emperor, "The Jews are rebelling against you."

He said, "Who says?"

He said to him, "Send them a sacrifice and see if they offer it."

He (the Emperor) sent a fine calf with him (Bar Qamza). While he was traveling he made a blemish in it, in the upper lip, and some say in the withered spots of its eye, a place which we (Jews) consider a blemish, but they (Romans) do not consider a blemish. The rabbis considered offering it for the sake of maintaining peace with the [ruling] kingdom. R. Zecharia b. Avqulos said to them, "Should they say that blemished animals may be offered on the altar?" The rabbis considered killing him (Bar Qamza) in case he should go and tell him (the Emperor). R. Zecharia b. Avqulos said to them, "Should they say that one who causes a blemish [to sacrifices] is killed?"

[B1] R. Yohanan said, "The meekness of Zecharia b. Avqulos destroyed our temple and burned our sanctuary and exiled us from our land."

[C] He (the Emperor) went and sent Nero the Emperor against them. When he arrived, he shot an arrow to the East. It went and fell in Jerusalem. To the West. It went and fell in Jerusalem. To all four directions. It went and fell towards Jerusalem. He said to a child, "Recite your study-verse to me." He said to him, "*I will wreak my vengeance on Edom through My people Israel [and they shall take action against Edom in accordance with My blazing anger; and they shall know My vengeance—declares the Lord God] (Ezek 25:14).*" He said, "The Holy One, Blessed be He, wants to destroy his house and He wants to wipe clean his hands with that man (=me)!" He fled and converted, and R. Meir descended from him.

[D] He (the Emperor) sent Vespasian the Emperor against them. He came and besieged it for three years. There were three rich men there—Naqdimon b. Gurion, Ben Kalba Savua and Ben Tsitsit Hakeset.

Naqdimon b. Gurion [was so called] because the sun cut through [the clouds] for him. Ben Kalba Savua [was so called] because whoever entered his house hungry as a dog (*kalba*) departed full (*sava*). Ben Tsitsit Hakeset [was so called] because his fringes (*tsitsit*) dragged on pillows (*kesatot*). And some say because his seat was among the Roman nobles.

One said to them, "I will supply you with wheat and barley." One said to them, "I [will supply you] with wine and oil." And one said to them, "I will supply you with wood." {The rabbis praised the wood since Rav Hisda gave

all his keys to his servant except for the key to the woodbin. For Rav Hisda said, "[To bake] one load of bread requires sixty loads of wood."}

They had [enough] to sustain [them] for twenty-one years.

There were these thugs among them. The rabbis said to them, "Let's go out and make peace with them (the Romans)." They (the thugs) would not let them. They said, "Let's go out and make war against them." The rabbis said to them, "It won't help." They rose up and burned the stores of wheat and barley, and there was famine.

[E] Marta the daughter of Baitos was the richest woman in Jerusalem.

She sent her servant and said, "Go and bring me [bread of] fine flour from the market." While he was going, it sold out. He came and said to her, "There is no [bread of] fine flour. There is good bread."

[She said to him,] "Go and bring it to me." While he was going, it sold out. He came and said to her, "There is no good bread. There is coarse bread."

[She said to him,] "Go and bring it to me." While he was going, it sold out. He returned and said to her, "There is no coarse bread. There is [bread of] barley flour."

[She said to him,] "Go and bring it to me." While he was going, the barley sold out.

[Although] she had taken off her shoes, she said, "I will go out and see whether I can find anything to eat." A piece of dung stuck to her foot and she died. R. Yohanan b. Zakkai applied to her the verse, *"And she who is most tender and dainty among you, [that she would never venture to set a foot on the ground, shall begrudge the husband of her bosom, and her son and daughter, the afterbirth that issues from between her legs and the babies she bears] (Deut 28:56)."*

Some say she ate a fig of R. Zadoq and became ill [and died]. For R. Zadoq fasted for forty years so that Jerusalem would not be destroyed. When he ate anything it could be seen from outside (because he was so thin). And when he recovered (from his fasts), they would bring him dried figs. He would suck out the juice and throw them away.

While she was dying she threw all her gold and silver into the market. She said, "What do I need this for?" Thus it is written, *They shall throw their silver into the streets, and their gold shall be treated as something unclean. [Their silver and gold shall not avail to save them in the day of the Lord's wrath—to satisfy their hunger or to fill their stomachs] (Ezek 7:19).*

[F] Abba Siqra, the leader of the thugs in Jerusalem, was the son of R. Yohanan b. Zakkai's sister. He (R. Yohanan) sent to him, "Come secretly to me." [He came.] He said, "How long will you act this way and kill everyone with starvation?" He said to him, "What can I do? If I say anything to them (the thugs), they will kill me." He said to him, "Figure out a remedy (*taq-*

## Rabbinic Authority and the Destruction of Jerusalem 143

qanta) for me so that I can get out. Perhaps it will save a little." He said to him, "Pretend you are sick, and let everyone come to visit you. Bring something rotten and place it with you and they will say that you died. Let [only] your students attend to you, for they (the thugs) know that a living person is lighter [than a corpse]." He did this. R. Eliezer went on one side and R. Yehoshua on the other side. When they reached the gate they (the thugs) wanted to stab him. He (Abba Siqra) said to them, "Should they say that they stabbed their master?" They wanted to push him. He said to them, "Should they say that they pushed their master?" They opened the gate for them.

[G] When he reached him (Vespasian), he said to him, "Peace to you, O King. Peace to you, O King." He said to him, "You deserve death on two [counts]. First, I am not a king. Second, If I am a king, why did you not come to me?" He said to him, "As for what you said, 'I am not a king,' in truth you are a king. For if you were not a king, Jerusalem would not be delivered into your hands, for it says, *Lebanon shall fall to the mighty one (Isa 10:34)* and 'mighty one' refers to a king, as it says, *His mighty one shall come from his midst (Jer 30:21)*,[9] and 'Lebanon' refers to the temple, as it says, *That good hill country and the Lebanon (Deut 3:25)*. And as for what you said, 'If I am a king, why did you not come to me?'—the thugs among us would not let me." He said to him, "If there is a jar of honey and a snake wound around it, would they not break the jar on account of the snake?" He was silent.

[G1] Rav Yosef [and some say R. Akiba] applied to him the verse, "*[God] turns sages back and makes nonsense of their knowledge (Isa 44:25)*. He should have answered him, 'We take tongs and take away the snake and kill it. And we leave the jar.'"

[H] Just then a messenger came from Rome. He said to them, "Rise, for the Emperor has died and the nobles of Rome voted to make you the leader." He (Vespasian) had put on one shoe. He tried to put on the other but it would not go on. He tried to take off the first, but it would not come off. He said, "What is this?" He (R. Yohanan b. Zakkai) said to him, "Do not worry. You received good news, [as it says], *Good news puts fat on bones (Prov 15:30)*." He said to him, "What is the remedy?" "Bring someone who annoys you and have him pass before you, as it says, *Despondency dries up the bones (Prov 17:22)*." He did this. It (the shoe) went on. He said to him, "Since you are so wise, why did you not come to me before now?" He said to him, "Have I not told you?" He said, "I also told you."

He (Vespasian) said to him, "I am going and I will send someone else. Ask something of me and I will give it you." He said, "Give me Yavneh and its sages and the line of Rabban Gamaliel and doctors to heal Rabbi Zadoq."

[H1] Rav Yosef, and some say R. Akiba, applied to him the verse, "*[God]*

*turns sages back [and makes nonsense of their knowledge] (Isa 44:25)*. He should have said, 'Let them off this time.'"

[H2] But he thought that perhaps he (Vespasian) would not do so much, and he would not save a little.

Both literary considerations and source-criticism indicate that several sources have been combined. The change in characters is the strongest literary evidence of a composite text. Bar Qamza and R. Zecharia b. Avqulos are the protagonists in A–B and promptly disappear; Nero appears only in C and Marta only in E; R. Yohanan b. Zakkai finally surfaces in E and plays the leading role in F–H. Moreover, the comments of R. Yohanan bracket sections A–B, while the pronouncements of R. Akiba / Rav Yosef have been appended to G and H. We would expect more consistency from a unified story. For example, the storyteller could have had R. Yohanan b. Zakkai consider sacrificing the animal in A or oppose the thugs in D, and thus introduce him in the initial stages of the plot.

Source-criticism confirms this analysis. A version of sections A–B appears in *Lamentations Rabba* 4:2 (= *LamR*).[10] Versions of D with F–H appear in *'Avot D'Rabbi Natan* and *LamR* 1:5.[11] A different version of D appears elsewhere in *'Avot D'Rabbi Natan* and in *Qohelet Rabba* 7:11.[12] E (the Marta tradition) appears in *LamR* 1:16 in substantially different form.[13] There is no independent parallel to C (the Nero tradition). While this episode may have originated as an autonomous source, it is possible that the redactors composed it specifically for this story.[14] The parallel versions of at least three parts of the story, namely A–B, D+F–H, and E — conforming almost exactly to the expectations of literary considerations — suggest that the redactors combined preexistent sources. Differences between versions will be assessed in greater detail below.

If the story has been amalgamated from disparate sources, then the question becomes: why consider the BT composition as a single extended story rather than three or four independent stories? From a redactional-critical perspective, the story must be considered a unity because the redactors did not simply juxtapose a series of narrative sources but wove them together with purpose. The main evidence for this claim is the reading below, which argues that each part contributes to the whole such that a well-constructed plot unfolds and consistent lessons emerge. Further evidence of integration includes: (1) connecting phrases and references, (2) the causal and temporal sequence of events, and (3) the repetition of motifs and themes.

1. *Connecting phrases and references.* C connects to B with the opening phrase, "He sent Nero the Emperor against them." The indefinite "He" refers back to the emperor mentioned in B who had "sent a fine calf" with Bar Qamza. Similarly, the opening phrase of D, "He sent Vespasian the Emperor against him," refers again to the emperor in B and echoes the sending of Nero in C. The "rabbis" blamed by Bar Qamza in B oppose the thugs in D. That conflict continues in F, where R. Yohanan b. Zakkai alludes to the famine mentioned at the end of D ("How long will you act this way and kill everyone with starvation?"). R. Yohanan b. Zakkai laments Marta's death at the end of E and then approaches Abba Siqra in F. G–H again refer to Vespasian with indefinite pronouns; we know his identity only because he besieged Jerusalem in D. Moreover, Vespasian charges that R. Yohanan b. Zakkai should have approached him earlier, which alludes to the three years of siege mentioned in D. Likewise R. Yohanan b. Zakkai's explanation, "the thugs among us would not let me" (*la shavqin*), recapitulates the narrator's words in D, "they would not let them" (*la shvaqinhu*) make peace. Admittedly, it is no major intervention to use a personal pronoun ("He sent Nero") rather than a title ("The Emperor sent Nero"). Nonetheless, such references reveal that the redactors integrated the sources so as to fashion a single story.

2. *Temporal and causal sequence.* A sustained voice narrates one scene after the next in chronological order.[15] The emperor sends first Nero and then Vespasian, then the thugs burn the stores of food, then a famine results, then Marta dies, then R. Yohanan b. Zakkai approaches Abba Siqra, and so forth. More importantly, the story presents each scene as the immediate cause of the next. Bar Qamza slanders the rabbis to the emperor because of his treatment at the banquet (A). The emperor therefore sends the sacrifice as a test (B). Because the rabbis do not offer the sacrifice, the emperor sends Nero (C) and Vespasian (D). The burning of the food causes the famine (D) that destroys Marta (E). After R. Yohanan b. Zakkai sees Marta die he realizes that the situation is desperate, accuses Abba Siqra of destroying the people and resolves to escape (F). In the parallel version in *LamR* 1:16 a different sage sees Marta's death and applies the biblical verse to her. This suggests that the redactors substituted R. Yohanan b. Zakkai in order to create a causal relationship, that is, *because* R. Yohanan b. Zakkai saw her starve he takes action.[16] Some narratologists consider causal relationships between events as the indispensable requirement

of a story, so the causal relationships among the sections argue for narrative unity.[17]

3. *Motifs, themes, and repeated words.* The motif of food and famine runs through the story. The opening scenes take place at a banquet (A), the rich men offer to supply food but the thugs burn their stores (D), Marta seeks food to no avail (E), and R. Yohanan b. Zakkai blames the thugs for starving the people (F). In addition, the idiom used for Bar Qamza "informing against" the sages involves the word for eating (B),[18] and the emperor sends a "fine calf" as a sacrifice. A second motif is shoes and feet. Marta dies because she went outside after she had taken off her shoes, and R. Yohanan b. Zakkai cites a verse that mentions feet (F). Vespasian cannot put on or take off his shoe, and R. Yohanan b. Zakkai again cites verses to help him do so (H). The servant who fails at his task is an important theme: the host's servant invited the wrong man to the banquet (A), while Marta's servant fails to find her food (E).[19] References to sending servants or commissioning tasks (*shadar/shalah*) in fact appear throughout the story: the emperor sends a sacrifice with Bar Qamza (B), then sends Nero and Vespasian (C, D); Marta sends her servant to the market (E); R. Yohanan b. Zakkai sends for Abba Siqra (F); and Vespasian informs R. Yohanan b. Zakkai that he will send someone else. Finally, the verb *sh-b-q*, "to let be, to leave alone" is a keyword. Bar Qamza asks the host "let me be" (*shvaqi*) to no avail. The thugs "would not let" (*la shvaqinhu*) the rabbis make peace (D). R. Yohanan b. Zakkai explains to Vespasian that "the thugs would not let me" (*la shvaqi*) approach (G). Rav Yosef / R. Akiba lament that R. Yohanan b. Zakkai should have answered Vespasian's parable "we leave (*shvaqinan*) the jar" and then should have asked him to "let them off this time" (*shvaqinhu*) (G1, H1). Thus the sages pay the price for watching while the host did not leave Bar Qamza be: the thugs do not let them make peace or salute Vespasian, and ultimately Vespasian does not leave Jerusalem and its inhabitants alone. The analysis below discusses the function of these motifs and themes in greater detail.

These connections suggest that, on the one hand, the story is a loosely edited composition with clear evidence of antecedent sources. Yet, on the other, the redactors have taken steps to integrate the parts and to construct a unified story. I belabor this point for two reasons. First, it helps us appreciate again the compositional techniques of the redactors. They manipulated their sources to a certain extent but did not revise them with com-

plete freedom. Second, some scholars consider this passage a collection of independent stories and treat the constituent parts rather than the whole.[20] I believe that their interpretations miss the mark because they fail to appreciate the narrative unity and therefore analyze an incomplete text. The manifold connections demonstrate that the episodes are interdependent and that they should not be read outside of the present framework. If we are to understand what the story meant to the BT storytellers (and presumably to their audience), we must analyze it in its entirety.

Finally, a word on structure. Unlike the stories analyzed in the other chapters, I discern no tight structure here. At best the story can be divided into two halves, A–E and F–H. The first half recounts the reasons for the siege and destruction, the second shifts to R. Yohanan b. Zakkai and his effort to "save a little." Yet even this division is somewhat forced, for the first half is more complex and requires the subdivisions (i.e., A, B, C, etc.) The story is actually structured by the temporal and causal sequence described above: one event causes the next from beginning to end in a linear progression. The lack of a developed structure clearly results from the composition of the story through the assembly of discrete sources. At the same time, this lack of structure other than the linear progression coheres with one message of the story: that in the absence of decisive action events tend to snowball until calamity results.

## Literary Analysis

The opening remark attributed to R. Yohanan presents the story to follow as an exemplification of Prov 28:14 (A1). Rhetorically, this opening engages the audience by inviting it to ponder how the verse applies to the unfolding story. The terse pronouncement that follows, "Jerusalem was destroyed because of Qamza and Bar Qamza," contributes to this effect. On the one hand, it begins to resolve the puzzle by decoding the "misfortune" mentioned in the verse as the destruction of Jerusalem. On the other, it deepens the riddle by the magnitude of the event: how a tragedy of such proportions resulted from "hardening the heart" and exactly what Qamza and Bar Qamza did are yet unknown.

Mention of the destruction of Jerusalem is a flashforward (prolepsis) to the end of the story that begins in the next sentence with the Qamza and Bar Qamza incident. As Rimmon-Kenan has observed, this type of narrative order—a short summary-statement of the culmination provided at the outset—has a particular effect: it shifts the narrative tension from *what* will happen (since this is known) to *how* and *why* it happened.[21] This

shift perfectly suits the didactic purposes of the story. Crucial is the lesson that the story teaches — how and why the destruction came about, hence how to avoid such tragedies in the future.

The action commences with an account of personal conflict precipitated by an innocent mistake: an inept servant confuses the master's instructions and invites his enemy, Bar Qamza, instead of his friend, Qamza. Despite the hatred and violence it is difficult to see how a private feud could culminate in the destruction of Jerusalem. Moreover, a touch of humor perhaps attends the names Qamza and Bar Qamza, reminiscent of Tweedledum and Tweedledee. Unattested as a name elsewhere in rabbinic literature, the designation "Qamza" may relate to the didactic purposes of the storyteller.[22] That *qamtsa* means "locust" in Aramaic, rendering the two characters Locust and Son of Locust, or Mr. Locust and Locust Junior, shades the playful tone with an intimation of looming troubles.[23] Locusts possess destructive potential, invading suddenly, swarming through fields, leaving desolation for miles. Starvation and death, motifs that emerge later in the story, typically follow the arrival of locusts. And when two locusts surface, more are sure to follow. Now the guests enjoy the food, drink, and gaiety of the banquet, but their state of plenty has been jeopardized by the advent of locusts.

Expelled from the banquet and publicly shamed, Bar Qamza directs his resentment not at his host but at the rabbis (B). From our study of the "Oven of Akhnai" (Chapter 2) we know well the gravity of shame in the culture of the BT.[24] The sudden reference to the rabbis, however, comes out of left field; in the exposition the narrator gave no hint that the banquet included a rabbinic presence. We would have expected this information to have been provided at the start: "A certain man whose friend was named Qamza and whose enemy was named Bar Qamza held a banquet *which the rabbis attended*." But the absence of the italicized words or some such reference — in narratological terminology, a paralipsis,[25] — is precisely the point. The sages might as well not have been present, since they took no action.[26] For both the audience and for Bar Qamza the rabbis were nonexistent. Spiritual and moral leaders of the community, the sages should not have countenanced such behavior. Because they witnessed his public humiliation and did nothing, Bar Qamza mistakenly concludes that they approved and seeks revenge.[27]

Bar Qamza's slander to the emperor tests the rabbis by putting them in a position similar to that of the banquet. There the rabbis had two options: either to intervene and prevent the expulsion of Bar Qamza or to express their outrage at such behavior by departing along with him. They

did neither. Presented with the blemished sacrifice, the rabbis again have two options: they can either offer the sacrifice, thereby appeasing the Romans and demonstrating their loyalty, or kill Bar Qamza, thereby eliminating the source of the problem. Again they do neither. The sages first fail in their role as social and moral exemplars, looking on as the host rejects Bar Qamza's offering. Then they fail in their role as community leaders, rejecting the emperor's offering as Bar Qamza looks on. This time, true, the choice is more difficult. At the banquet the choice involved the stress of confronting the host or the inconvenience of leaving without eating their fill — both unpleasant, to be sure, but not matters of life and death or sacrilege. Subsequently the rabbis must choose between committing murder and violating sacrificial law. This progression suggests that when they fail to take the necessary action a second time, then the next decision will be even more painful.

Yet it is not really the drastic nature of the action that prevents the rabbis from acting, but their fear that others might arrive at mistaken conclusions. R. Zecharia b. Avqulos[28] does not question whether murder is justified in this case, nor whether violation of the sacrificial law by offering a blemished animal may provoke divine wrath. The importance of maintaining peace with the ruling kingdom (*shelom malkhut*) justifies these measures. Rather, he fears that others might not be aware of the reason they sacrifice this particular blemished animal or murder this particular person and thereby arrive at errant halakhic inferences. Surely this is a backward sort of thinking.[29] The Torah in any case explicitly prohibits the sacrifice of a blemished animal, so there is no possibility of error.[30] In addition, a blemish in the upper lip or eye is a borderline case about which rabbinic opinions are not uncontested.[31] Now concerns that people may reach errant halakhic conclusions factor in many BT legal discussions and can influence the formulation of law. Yet here the storyteller seems to parody such legitimate concerns by taking them to an absurd extreme: despite the looming Roman threat the rabbis worry lest people somehow make an impossible halakhic inference based on a marginal case.[32] While the rabbis realize what must be done and even appreciate the reasons for taking emergency measures, this excessive caution inhibits them from acting.

At this point a comment of R. Yohanan interrupts the story and declares that the *'anvetanut*, the "meekness," of R. Zecharia b. Avqulos ultimately caused the destruction of the temple and the accompanying disasters (B1).[33] It has been noted that this comment does not do justice to the story, since it is oblivious of the complexity of events to follow and ignores the role of R. Yohanan b. Zakkai.[34] The course of events, though foreboding,

would seem to admit several possible outcomes. Why should the sages not be able to persuade the Romans of their loyalty by other means? From a source-critical perspective, it is clear that the comment originally related only to the Qamza and Bar Qamza sections (A–B), as we find in *LamR* 4:2.[35] From a literary perspective, the comment serves an important function in its present context. The pronouncement—part lament, part condemnation—signals that the crisis, the point of no return, has now passed. And it identifies the ultimate cause—meekness. As the story continues the audience focuses on this trait as an interpretive key to the moral of the story.

The negative valorization placed on *ʿanvetanut* is striking when considered within the wider cultural context. In both the BT and other rabbinic compilations *ʿanvetanut* means humility, modesty, patience, or gentleness, and is positively valorized. The translation here as "meekness" attempts to capture something of the negative valence.[36] Perhaps "wimpiness" would be more accurate, if the colloquialism can be tolerated. Whatever translation we adopt, the unexpected use of the term is significant. The introduction to the famous series of stories comparing the reactions of Hillel and Shammai to prospective proselytes enjoins, "One should always be a gentle person (*ʿanvetan*) like Hillel and not an impatient person (*qapdan*) like Shammai."[37] Elsewhere the same R. Yohanan characterizes God as an *ʿanvetan,* prays that God's attribute of *ʿanvetanut* be manifest and extols R. Hanina for being an *ʿanvetan*.[38] God, Moses, various biblical heroes, and numerous sages are regularly praised for their *ʿanvetanut*.[39] The *ʿanvetan* is promised a great reward: "Who is destined for the next world? A meek person (*ʿanvetan*), who walks humbly, stoops when entering and leaving, and constantly studies Torah without considering himself meritorious."[40] I know of no other example of *ʿanvetan* used in a negative sense in all of classical rabbinic literature.[41]

In the context of the story R. Yohanan indicts R. Zecharia's meekness, his diffidence and cowardice when faced with a situation that called for action. In the context of rabbinic values, R. Yohanan registers a protest against excessive *ʿanvetanut*. The plethora of sources advocating *ʿanvetanut* probably represent the ideal character traits of the rabbinic academy. Debate, argument, and theoretical discussion are well served by humility and respect for the opposing side and frustrated by arrogance and impatience. For sages to display overweening pride in their knowledge or to act haughtily toward those less proficient both hinders the process of learning and entails a risk. Can any sage be absolutely certain that he has fully understood the law and mastered its complexities? Recall that the tradition cited at the beginning of Chapter 1 explained that the law followed the Hillelites

because they were "pleasant and modest" and mentioned their opponents' opinions before their own.[42] In the academy there is little need for hasty decisions based on the dogmatic self-confidence that one knows the truth. But in the story the sages do not debate a theoretical point of law or Torah "for its own sake" but an urgent matter that requires immediate response. The world of realpolitik calls for decisive action. Humility and meekness will not work when choices must be made.[43]

The application of the verse R. Yohanan cites at the outset can now be appreciated: "Happy is the man who is cautious (*mefahed*) always, but he who hardens his heart falls into misfortune" (Prov 28:14). The first half of the verse celebrates the cautious and God-fearing man. The second half, however, conditions the promise of happiness with a significant reservation. Misfortune results when one "hardens his heart" and refuses to act.[44] R. Zecharia and his colleagues were extremely cautious lest their actions be misconstrued and the law misunderstood. But they "hardened their hearts" by failing to take the necessary steps to save the community from its plight, perhaps naively trusting that God would deliver them.[45] The same fear of God that instills a sense of meekness, taken too far and applied in the wrong setting, results in paralysis and misfortune, in the destruction of Jerusalem. The continuation of the story details precisely how the tragedy plays itself out.

When the sages fail to sacrifice the offering, the emperor, like Bar Qamza, arrives at a mistaken conclusion. Where Bar Qamza mistakenly interpreted rabbinic inaction as a sign of approval of the host's behavior, the emperor now interprets the nonsacrifice as a sign of revolt and sends Nero to punish the rebels (C). Ironically, the rabbis fail to act because they fear that the community will misinterpret their conduct and misconstrue the law. The Romans then misinterpret their nonaction and mistake their attitude toward Roman rule. Hoping to avoid a minor halakhic misunderstanding, the rabbis cause a major sociopolitical rift.

The brief account of Nero's predicament and solution presents a stark contrast to the rabbis. Nero displays caution by soliciting an oracle that his imperial commission to attack Jerusalem meets divine approval. He displays extreme caution by not trusting the unambiguous sign that God wants him to take the city, the supernatural force that drives all the arrows toward Jerusalem,[46] and by seeking additional confirmation. The second oracle ascertained through the study-verse of a child is ominous.[47] Ezekiel prophesies that since Edom (= Rome) acted brutally toward Israel (Ezek 25:12), God will turn his blazing anger against Edom, and then Israel will "wreak vengeance" upon their former oppressors (Ezek 25:14). The mean-

ing could hardly be more obvious: Rome will pay for devastating Israel, and presumably the Roman general will bear the brunt of the retribution. Nero, to put it bluntly, realizes that he is being used. Doubly used, in fact, by both the emperor and God. But what can he do? To abandon the campaign invites an immediate death sentence from the emperor, while to continue means momentary victory followed by inexorable vengeance by God and Israel. Nero, like the rabbis, faces a difficult decision. Indeed, he is caught in far more dire straits, for both options spell doom. Amazingly, Nero, unlike the rabbis, finds a way out. He flees and converts to Judaism, thereby avoiding the clutches of the emperor, demonstrating his faith in the God of Israel and siding with the ultimate victors.[48] The postscript noting that R. Meir descended from him makes it clear that the general's action received divine approval. Like Ruth, from whom King David descended, Nero became the father of an illustrious family in Israel.[49]

This strange and blatantly nonhistorical account functions as an ironic foil with which to compare the behavior of the sages.[50] When pressed to act by the emperor, they do not seek omens, or inquire of children, or turn to the text themselves. Nero—the Roman, the pagan, the *goy*—does. The rabbis choose to do nothing, since the two options they consider are imperfect. Nero, in a far grimmer situation, pursues a radical course of action. He displays the proper type of caution, the caution celebrated by Prov 28:14, without the hard-hearted refusal to take the appropriate measures. His caution apprises him of the gravity of the situation and the urgency to act. The rabbis' caution, by contrast, paralyzes them with the fear of the consequences of their actions and prevents them from acting. Nero's courage produces a rabbinic authority and the proliferation of Torah; rabbinic cowardice leads to the destruction of Jerusalem.

Nor do the sages seem to have changed their policy during the three years that Vespasian besieges Jerusalem (D). The narrator reports that three rich citizens supply the residents with basic necessities but tells us nothing about the sages. In the first scene they eat the food of the banquet, standing on the sidelines and oblivious to the conflict taking place. Here too they consume the food proffered by the rich and bide their time, ignoring the surrounding strife. When the rabbis finally decide that something should be done and suggest that the Jews sue for peace, the situation has become more complicated. Years of inaction produced a leadership vacuum and a new group, the thugs (*baryonei*) consolidated power. The rabbis again take no decisive action, neither attempting to eliminate the thugs nor finding a way to make peace. Whether these were feasible options but the rabbis too "meek" to act, or whether the thugs had so much control that nothing

could be done, is unclear. That the thugs apparently cannot force the community to fight the Romans suggests that the rabbis still had some clout. In any case, the rabbinic response is too little too late. Again inaction produces a difficult situation where the rabbis' options are decidedly unpleasant and severely limited. Note that here the names of the aristocrats are explicitly symbolic, which warrants a similar understanding for the other names of the story.[51]

Stalemate may suit the rabbis, but not so the thugs. They take action, burning the stores of food in order to compel the people to fight. Like Nero, they take a daring and risky course. The resulting hunger may weaken the people and they may lose the war, but the thugs have the self-confidence to pursue the policy they believe best. Again we witness the opposite of *'anvetanut*. While the rabbis believe such actions are responsible for the destruction of the city, the storyteller blames the rabbis and their diffidence. Perhaps there is an ironic twist in the resemblance of the terms *rabbanan*, rabbis, and *baryonei*, thugs, a rare word in rabbinic literature.[52] Rearranging the letters of *rabbanan* almost yields *baryonei*, thus producing a type of wordplay.[53] The *rabbanan* and the *baryonei* are related symbolically. When the rabbis fail to act as rabbis, as leaders, the antirabbis take over. They pursue a course opposite to that of the rabbis and eventually destroy the city. But at a deeper level we know that the *rabbanan* and their choices, not the *baryonei*, are to blame.

The account of Marta (Martha), like that of Nero, functions as an interlude between major turns in the plot (E).[54] In the context of the larger story it portrays the severity of the famine and the urgency of the situation confronting R. Yohanan b. Zakkai. Yet the episode simultaneously rehearses the themes of the story and provides a second illustration of its moral. As in the first scene, a notable sends a servant to carry out a simple task. In fact Marta's command, "Go and bring me (fine flour, etc.) (*zil 'aiti li*)," repeats the very words spoken by the host to his servant: "Go and bring me (Qamza)." The matter again concerns food, although in this case the servant seeks food for his master, not a guest to eat his master's food, and the account of starvation and abject death contrasts sharply with the feasting at the banquet. Unable to comply exactly with Marta's wishes because the precise item she requested is unavailable, the servant repeatedly returns for further instructions, and meantime the food runs out. The servant's failure, like that of the rabbis, is the inability to act. Although he sees different kinds of bread disappearing, he fails to purchase what remains, presumably because he fears deviating from his orders. He lacks the self-confidence to recognize the exigencies of the situation and the necessity to

make a decision. Just as the sages refuse to deviate from the commands of their master (God) and do that which was necessary, so the servant refuses to deviate from the precise orders of his master (Marta) and buy that which he could. R. Yohanan's initial proverb might equally well apply to him. "Cautious always" of not fulfilling his commission precisely, he "hardens his heart" towards Marta's suffering, does nothing, and so she "falls into misfortune." This servant displays a type of *'anvetanut*—the meekness preventing him from taking initiative. If in the first scene the servant confuses his instructions and invites the wrong person, leading to an unpleasant situation, in this case the servant does nothing, leading to death. Nonaction can be worse than wrong action—the moral of the story presented in microcosm.

These common themes—masters, servants, and food/starvation—give the story coherence and create the reversal that underscores the moral. Bar Qamza ultimately offers to pay for the entire banquet if he can stay and eat, but the master of the house refuses. Now the mistress offers all her wealth for any morsel of food, but finds none. If Bar Qamza was involuntarily thrown out of a place of bounty, now Marta voluntarily leaves a place of scarcity, her comfortable home, where she formerly entertained at similar banquets. The locust has lived up to his name, leaving no food in his path.

The alternative explanation of Marta's demise brings in its wake an independent story about Rabbi Zadoq.[55] Such "embedded narratives" always raise the issue of their relationship to the primary story.[56] Here the story of Zadoq provides a contrast to the other rabbis in the story, both the rabbis responsible for the predicament and R. Yohanan b. Zakkai. While the rabbis ate at the banquet, Zadoq fasted. Their lack of action as Bar Qamza was shamed precipitated the crisis, while Zadoq fasted to prevent the tragic outcome. Zadoq voluntarily starves himself with fasts for religious reasons; Marta and others involuntarily starve because of the rabbis' failures to control the situation. This contrast is highlighted by the perverse reversal in the life- and death-bringing figs: while Zadoq sucked the juice of figs to recover from his starvation diet, Marta becomes sick after eating from those figs in a desperate effort to stop from starving. Where Zadoq threw away the figs, Marta died from the figs and threw away her treasures. In another pointed contrast to his rabbinic colleagues, Zadoq apparently knew for forty years that Jerusalem would be destroyed.[57] R. Zecharia b. Avqulos and his associates, however, were blind to the precarious situation confronting them and to the much more imminent destruction. Yet, in the end, Zadoq's fasting accomplished nothing—for we know from the first line of the story that Jerusalem was destroyed.

A political or diplomatic response to the Roman menace was required, not religious devotion or supererogatory piety. In this respect the story of Zadoq contrasts unfavorably with the political action of R. Yohanan b. Zakkai. Rather than fast or pray, Yohanan b. Zakkai approached the Roman general to negotiate. While Zadoq's fasts could not save the city, R. Yohanan b. Zakkai's daring action not only attained Yavneh, but also the doctors to heal R. Zadoq himself (H).

The introduction of R. Yohanan b. Zakkai at this point is significant. Within the Marta episode he plays the minor role of interpreting her tragic downfall as fulfillment of Deut 28:56. However, the narrator could have done this just as easily; he, not R. Yohanan b. Zakkai, applies Ezek 7:19 to her. In other words, R. Yohanan b. Zakkai's application of Deut 28:56 is an event of the fabula while the narrator's application of Ezek 7:19 is a nonnarrative comment. As noted above, the version in *LamR* has R. Eleazar b. Zadoq apply that verse to Marta. These considerations suggest that R. Yohanan b. Zakkai's appearance here is not accidental and that his encounter with Marta should be connected with the following events. Seeing Marta in this scene and understanding the meaning of her condition motivates him to act in the next. R. Yohanan b. Zakkai, like Nero (!), turns to scripture to understand the present. He sees the Deuteronomic prophecy materializing and knows that starvation and degradation will be accompanied by defeat and exile (Deut 28:36–37, 43–48). While it seems that the prophecy can no longer be averted, R. Yohanan b. Zakkai realizes that something must be done and therefore sends for the leader of the thugs.[58] In contrast to "the rabbis" of B and D, R. Yohanan b. Zakkai recognizes the urgency of the situation and acts.

Bar Qamza's revenge is complete when R. Yohanan b. Zakkai cannot leave the city because the thugs have placed guards at the gates in order to prevent the people from deserting their cause. While Bar Qamza pleaded to stay in a place of plenty, but was forced to leave, the rabbis desire to leave a place of starvation, but are forced to stay. Because the rabbis refused to abandon the banquet along with Bar Qamza, they are now compelled to remain among thugs and starvation. Bar Qamza pleaded with his host to "let me be" (*shvaqi*), now the thugs do "not let them (rabbis) (*la' shvaqinhu*)" make peace with the Romans (D).

In contrast to the rabbis who passively watched as the host humiliated Bar Qamza, Rabbi Yohanan b. Zakkai sends for the son of his sister,[59] Abba Siqra, and charges him with destroying the people. The name Abba Siqra, "Father Murderer" or "Chief Assassin" like "Qamza" and "Bar Qamza," again relates to the didactic aspects of the story.[60] Ironically, despite the

implications of his name, Abba Siqra is no chief, for he has lost control of his own followers. Like R. Zecharia b. Avqulos and the rabbis, he faces a disastrous situation—siege and starvation—but fails to take the necessary action. R. Yohanan b. Zakkai, however, encourages Abba Siqra to find some way to enable the rabbi to escape and thereby "save a little," and together they pull off the plan.[61] For the first time, a rabbi is proactive and realistic. Of course the plan is extremely flawed. It gives up on the city, the temple, and most of the community, delivering only R. Yohanan b. Zakkai and a few disciples. Precisely this type of imperfect solution R. Zecharia b. Avqulos and the rabbis rejected. We hear him objecting, "Should they say that a sage abandoned his people?" "Should they say that a sage collaborated with the chief thug?" But the choices have progressively narrowed, leaving fewer options and more difficult decisions. For all its flaws, their attempt at least breaks the cycle of inaction and *'anvetanut*.

We should note that R. Yohanan b. Zakkai still remains somewhat passive. Abba Siqra takes the initiative, both devising the plan and deceiving the sentries at the gates.[62] But R. Yohanan b. Zakkai provided the initial impetus, summoning Abba Siqra and prodding him to act, so both deserve credit. That a rabbi and a *baryon* work together supports the suggestion that the *rabbanan* and *baryonei* are not completely distinct. Just as Nero took the initiative and abandoned his campaign, so Abba Siqra deserts his thug followers, and so too R. Yohanan b. Zakkai deserts the indistinct mass of "the rabbis," leaving the majority within the doomed city. These men eventually display the qualities celebrated by the story—the confidence to decide what must be done and the courage to take the necessary risks.[63]

Abba Siqra's responses to the sentries recall R. Zecharia's objections. Twice R. Zecharia protests to the rabbis, "Should they say . . ." (B) and twice Abba Siqra protests to the sentries, "Should they say . . ."[64] The parallel form invites the audience to compare the episodes. Once again excessive anxiety about what others will say or think is self-destructive. Because of these concerns the sentries fail at their task and permit the very sort of subterfuge that they endeavor to prevent. Inaction, again, produces failure. Reading back, we should assess R. Zecharia and his colleagues in this light. Because they worried about what others would say and think, they failed at their charge—to be community leaders and protectors.

R. Yohanan b. Zakkai leaves the city, and—no *'anvetan* he—proceeds directly to the Roman general and salutes him as king (H). Recognizing now Vespasian's authority, R. Yohanan b. Zakkai attempts to atone for the previous rabbinic neglect of the Roman sacrifices. Thus his greeting "Peace to you, O King" (*shelam 'alekha malka*) recalls the rabbis' initial inclination

to accept the sacrifice for the sake of "peace with the kingdom" (*shelom malkhut*). In two other ways he exemplifies the opposite of R. Zecharia b. Avqulos and "the rabbis." First, R. Yohanan b. Zakkai does not worry about what the current emperor, Vespasian, the Romans, or anyone else might say about his declaration, although he surely knew that he risked death. Second, R. Yohanan b. Zakkai understands the situation through his ability to interpret scripture. As he explains to Vespasian, the prophecies tell that the temple will fall to a "mighty one," and "mighty one" means a king. And he already knows from the prophecy fulfilled by Marta's downfall that the temple is about to be destroyed and the people exiled.[65] Hence Vespasian, the destroyer, must be a king. Unlike Zecharia and his colleagues who never turned to scripture, never appreciated the situation, and did nothing, R. Yohanan b. Zakkai interprets scripture to determine the historical moment.[66]

Despite this favorable contrast vis-à-vis "the rabbis," R. Yohanan b. Zakkai is portrayed with great ambivalence. He has no answer to Vespasian's parable to the effect that he should have taken action earlier.[67] Vespasian speaks the truth: R. Yohanan b. Zakkai is guilty of doing nothing for three years. R. Yohanan b. Zakkai is the story's hero, but he is a flawed hero, and the storyteller makes this point by leaving him dumb. The same judgment emerges from Rav Yosef's or R. Akiba's remark (G1), one of the nonnarrative comments which interrupt the story. The application of the biblical verse to R. Yohanan b. Zakkai judges him a fool (Isa 44:25). He should have devised a clever reply immediately, as did Abba Siqra when challenged by the sentries. This nonnarrative comment, moreover, reinforces R. Yohanan b. Zakkai's guilt. The shift from "they" in Vespasian's parable to "we" in the hypothetical answer—"we take tongs and remove the snake and kill it"—suggests that R. Yohanan b. Zakkai and the rabbis should have removed the thugs, just as they should have removed Bar Qamza when he brought the sacrifice. *We*, we sages, must get our hands dirty when the circumstances demand action. Not only did R. Yohanan b. Zakkai make no reply (since he was guilty), but had he responded, he would have betrayed his (and his colleagues') former failures.[68]

The ambivalence toward R. Yohanan b. Zakkai continues in his second interchange with Vespasian. This interchange—partially a repetition of their first conversation—occurs after R. Yohanan b. Zakkai cites scriptures which both explain the difficulties the newly-appointed emperor experiences in putting on his shoe and also provide the solution. Vespasian's questions are even better now, for if R. Yohanan b. Zakkai understands the puzzling expansion of the body, he should certainly appreciate the gravity

of the political situation. If the scriptures can be related to the swellings of flesh and bone, they should pertain to enemies, sieges, suppressing the thugs, and the survival of the city. Thus the subtle addition to Vespasian's question, *"since you are so wise,* why did you not come to me before now?"[69] You can interpret scripture to understand every situation, even my shoe problems, and yet you did nothing? Again R. Yohanan b. Zakkai has no good answer and remains silent in the face of Vespasian's criticism. This silence is all the more significant because it comes at a time when Vespasian is most vulnerable. This depiction pokes fun at Vespasian, the powerful emperor who cannot even dress himself without help, and brings him to the verge of humiliation. Yet Vespasian turns the tables and humiliates R. Yohanan b. Zakkai with the reprise of his criticism.

This encounter also contains several motifs that appear in earlier scenes. The messenger with his critical announcement recalls the messengers/servants of the host at the banquet and of Marta.[70] As noted above, Vespasian putting on his shoes recalls Marta removing her shoes before leaving her home and meeting her death. That event R. Yohanan b. Zakkai interpreted as the fulfillment of the Deuteronomic curse. Now he applies scriptures to another matter of feet and thereby convinces Vespasian of his stature. He was persuaded of the necessity to "save a little" by understanding the implications of Marta's barefoot death, and accomplished it by applying other scriptures to Vespasian's difficulty with his feet. There is also a subtle reversal of the opening scene: Bar Qamza, through no fault of his own, came uninvited to the domain of his enemy and was humiliated. Here R. Yohanan b. Zakkai, because of his and his colleagues' faults, comes uninvited to the domain of his enemy and is humbled. The sages did nothing when Bar Qamza was humiliated, and now R. Yohanan b. Zakkai receives similar treatment. These connections rehearse the didactic points of the story: failure to act causes hardships, while interpreting scripture and acting yield benefit.

The final comment of Rav Yosef / R. Akiba brings the ambivalence towards R. Yohanan b. Zakkai to a climax.[71] R. Yohanan b. Zakkai asked for the wrong thing! Here too the name "Yosef," meaning "he will add" or even "let him increase," perhaps relates to the content: Rabbi "Let Him Increase" charges that R. Yohanan b. Zakkai should have asked for more.[72] Another voice concludes with an apology: R. Yohanan b. Zakkai thought that had he asked for Jerusalem, he would have received nothing, and would not even "save a little" (H2). Yet this conclusion leaves us wondering. R. Yohanan b. Zakkai *thought* as much — but was he right?[73] Was this yet a manifestation of *'anvetanut,* a lack of confidence that led him seriously

to underestimate Vespasian's newly-found respect for rabbinic wisdom? Did he fret too much, like R. Zecharia b. Avqulos, about what others might think—that Vespasian might find the request too cocky—and so compromise what he knew to be the right thing to say? Or was R. Yohanan b. Zakkai correct in this thought process? He understood from Marta's downfall that the city was doomed and that he could only save a little. Moreover, Vespasian had become king, as the scriptures informed him, and the same scriptures predicted that the king would destroy the temple. He risked his life to escape from the city, to confront Vespasian, and now achieved the best result under the circumstances. Or, yet again, just as Nero had found a way out, perhaps R. Yohanan b. Zakkai's courage and skill now opened new possibilities and Jerusalem could be saved. Nero refused to capitulate to an oracle from the scriptures; maybe the fate of Jerusalem was not yet sealed.

This unresolved ambiguity, explicitly articulated by the conflicting judgments of the nonnarrative comments (H1–H2), expresses the fundamental tensions of the story. On the one hand, rabbis must act. They are community leaders involved in both the moral and social (e.g., the banquet scene) as well as political (e.g., the Romans) spheres of life. They alone are experts in reading and interpreting scripture, which exposes the hand of God, the real historical moment. To shirk that responsibility, as they twice did with Bar Qamza and subsequently during the siege, invites disaster. On the other hand, action involves risk. The ability to interpret scripture does not provide unambiguous insight as to what should be done. To recognize the divine hand at work is not the same as to know exactly how to act. Nero learned from scripture that he was being used, but he received no oracle on how to circumvent his predicament. If the sages are readers and interpreters of scripture, they are not prophets with a direct divine pipeline.[74] Moreover, even prophecies can be averted by repentance and meritorious action. While R. Yohanan b. Zakkai learned that Jerusalem would be destroyed, who is to say that there remained no way out? He judged that the best he could achieve was to "save a little," but his judgment remains open to question. R. Yohanan b. Zakkai did his best, but not the best. These are the sad, perhaps tragic, facts of the human (and rabbinic) condition. But they are the facts, and to fail to realize them—to be an ʿanvetan, to fear excessively and harden the heart, not to act—leads to disaster.

Ultimately the story reflects on the problems of rabbinic leadership. Rabbis, as interpreters of scripture, are the most qualified to make important decisions. Rabbis, as human beings, sometimes make mistakes in

applying their judgments to the enormous complexity of the real world. The best solution may involve compromising the ideal law of the Torah or accepting a measure of injustice. Rabbinic decisions, then, are often flawed. To opt out of positions of leadership, not to act, invites disaster. Functioning as leaders involves difficult decisions, risks errors in judgment, and often requires compromise. Such are the inevitable tensions of rabbinic activity in the real world, and if they cannot be resolved, at least they must be recognized.

## Literary and Halakhic Context

The story appears in the talmudic commentary to Mishna Gittin 5:6. This Mishna appears in a section of the tractate which strays from the main subject, the laws of divorce, and lists a variety of rabbinic amendments (*taqqanot*) promulgated "for the sake of good order" and "in the interests of peace" (mGit 4:2–5:9).[75] For example, mGit 5:3 rules that one who returns a lost object need not take an oath, "for the sake of the good order of the world" (*tiqqun 'olam*), more literally, "amending the world." Technically the finder should take an oath that he has neither withheld part of the find nor damaged it in any way. But if such an oath were required, people would be loath to return lost objects, since most people are reluctant to take oaths. Rabbinic law therefore exempts them from oaths so as to preserve "the good order of the world" and to encourage finders to return lost objects. Following the provisions "for the sake of good order of the world," mGit 5:5 lists laws directed toward the "good of penitents" and "the good order of the altar."[76]

These rabbinic amendments modify existing laws because in particular circumstances the laws produce unjust or undesirable results.[77] Rabbinic legislation of this type involves adjustment and change, typically granting exemptions from general statutes or adding conditions that limit their scope. The complexity of reality requires that laws be amended, even if strict justice is compromised.[78]

The final two Mishnas of the chapter, mGit 5:8–9, collect laws enacted "in the interests of peace." Some of these provisions also modify laws because of problems that result from specific circumstances, while others create new ordinances to obviate conflict.[79] The purpose of these enactments, like that of laws "for good order" is to prevent grave social problems.

Mishna 5:6, which precedes the story, appears directly between these sections of Mishna:

### Rabbinic Authority and the Destruction of Jerusalem    161

[A] The [law of] *siqariqon* was not applied in Judaea to those slain in the war. After those slain in the war, [the law of] *siqariqon* applied.

[B] How so? If one first bought [land] from the *siqariqon* and then bought it from the owner, the sale is void.

[C] [If one first bought it] from the owner and then bought it from the *siqariqon*, the sale is valid.[80]

[D] That was the earlier Mishna (or "teaching"). A later court said: If one [first] bought from the *siqariqon* he gives one-fourth [of its value] to the owners.

[E] When does this apply? If the owners are not able to buy it themselves. But if they can afford it, they take precedence over others.

[F] Rabbi [Yehuda HaNasi] set up a court and they voted that, if the land had been in the possession of the *siqariqon* for twelve months, whoever first buys it acquires title, but he gives the owner one-fourth.

Commentators debate the exact meaning of *siqariqon* or "the law of *siqariqon*."[81] In this context *siqariqon* refers either to Romans who "own" land in Judaea, having received it from the Roman government after the revolt, or to Jewish collaborators who illegally wrested land away from others.[82] From the standpoint of Jewish law the *siqariqon* is a thief and his claim worthless. The true owner possessed the land prior to the Roman advent. Suppose the *siqariqon* now puts the land up for sale and a Jew wishes to buy it. While the buyer must pay the *siqariqon,* he does not gain legal title by Jewish law until he compensates the original owner (who presumably cannot afford the land, or hopes to recover it without paying). The Mishna rules that if the buyer first pays the *siqariqon* and subsequently pays the true owner, the sale is not valid [B]. The concern is that the owner does not truly wish to sell the land, or sell at that price, and only acquiesces because he fears that otherwise he will receive nothing at all. If, on the other hand, the buyer first compensates the true owner and subsequently pays off the *siqariqon,* then the owner sells without duress [C].[83]

The sages subsequently changed this law [D-E]. They ruled that the original owners have the first option to buy their land back. If they cannot, another Jew may buy the land directly from the *siqariqon* and pay them

one-fourth of its value. Jewish law thereafter recognizes him as rightful possessor. Later Rabbi Yehuda HaNasi and his court limited the original owners' right to buy back their land to one year [F].

Why these changes? Apparently the initial ruling made it too expensive and cumbersome for Jews to buy land. Moreover, the owners could refuse to sell, hoping eventually to regain their ancestral fields when they had more money or through legal channels. As a result, few sales took place and the land remained in Roman hands.[84] Romans who had received land as gifts or spoils did not cultivate it, so few crops were raised and the food supply of the nation was reduced. The new law facilitated acquisition of land by no longer requiring the purchaser to pay full price to the original owners.[85] The court convened by Rabbi Yehuda HaNasi added a further incentive. The new provision assured that the original owners would not suddenly come up with their funds and exercise their option. In this way the land more speedily returned to Jewish ownership and to cultivation.

But was the new law just? It compels the original owners to sell against their wills and only grants them one-fourth of the value! Jewish law essentially recognizes Roman appropriation of the land and "collaborates" in the injustice by legitimating the sale. And Rabbi Yehuda HaNasi, leader and Patriarch of the Jews, further slighted the rights of the true owners. How could the sages countenance — even encourage — such a perversion of justice? By what authority did R. Yehuda HaNasi and his court enact such a law?

Although the term "the good order of the world" does not appear in this Mishna, the concept provides the justification for the new law and explains why it appears in this chapter and tractate.[86] Strict application of property law created an untenable situation due to the unique state of affairs following the war. The standard laws of ownership had to be adjusted due to the particular circumstances of the times and a degree of injustice tolerated in order for the world to remain in "good order." While the Mishna employs the terms "they said" and "they voted" rather than "they amended" (*hitqinu*), it describes a judicial amendment. Twice the sages amended the law so as to preserve "the good order of the world" despite the compromise entailed.

Let us now consider the placement of the story in the section of Talmud connected to this Mishna and the effect of this juxtaposition. Several points of contact link the story to mGit 5:6 and the proximate Mishnas. First, the name of the chief thug, Abba Siqra, echoes the term *siqariqon*. Second, the rabbis consider offering the blemished animal "for the sake of maintaining peace with the ruling authority (B)." This idea resembles the

principles that appear in this section of the tractate, especially "for the sake of the ways of peace." The provision "for the good of the altar," mentioned in mGit 5:5, is an example of adjusting sacrificial law.[87] Third, the Mishna deals with the repercussions of Roman confiscation of land following the war, and the story recounts the reasons for the war.

Yet the relationship between the Mishna and the story is deeper and more complex. The larger section of Mishna contains numerous examples of the sages adjusting and amending the law to further the good of society. By introducing these amendments the sages assert authority and exert power. They display the self-confidence to modify the law, to recognize that certain situations demand legal intervention and remedy. The Mishna testifies to rabbinic initiative, confidence and action—qualities diametrically opposed to those which the story blames for the disaster. Whereas the Mishna documents that the sages introduced provisions "for the sake of peace," the story laments the rabbinic reluctance to bend the law "for the sake of peace with the ruling authorities." The story is the Mishna's mirror-image. It depicts the state of the world without this sort of rabbinic activity. And it is not a happy picture.

The mirror-imaging emerges most clearly by comparing the story with mGit 5:6. The Roman confiscation of the land places the sages in a difficult situation. Strict application of Jewish property law results in disaster—the land remains in Roman hands and uncultivated. Adjusting the law violates individual property rights and recognizes the Roman land theft. Faced with this choice, the sages in the Mishna amend the law—not once, but twice. Likewise, the story portrays the sages in a predicament. There they do not adjust the law (although they think about it). The policy in the Mishna, the product of rabbinic leadership, (hopefully) results in Jews repurchasing and resettling the land. The policy in the story (or lack thereof) results in the destruction of the city and exile from the land.

The second half of the story, however, contains parallels to mGit 5:6. R. Yohanan b. Zakkai recognizes the sovereignty of the Roman emperor, just as the rabbinic court in the Mishna recognizes Roman title to the land. R. Yohanan b. Zakkai charges Abba Siqra that his followers kill the people with starvation, while the sages in the Mishna confront the devastation of the entire land due to the *siqariqon*. R. Yohanan b. Zakkai manages to "save a little," to preserve Yavneh and its institutions. Undoubtedly the sages in the Mishna believed that they were "saving a little," reclaiming whatever land they could.[88]

A halakhic tradition found in Tosefta Shabbat 16:7 provides additional support for this reading. While this tradition is not found in the immediate

literary context, it was known to the BT redactors and hence comprises part of the cultural context.[89] This passage is the only other source in rabbinic literature that mentions R. Zecharia b. Avqulos (aside from the other versions of the story).

> [A] The House of Hillel rules that they lift up bones and shells from the table, and the House of Shammai rules that they pick up the whole table and shake it off.
>
> [B] R. Zecharia b. Avqulos would not act in accordance with the House of Hillel nor in accordance with the House of Shammai, but would take [them] and throw [them] under the couch.
>
> [C] R. Yose said, "The meekness of R. Zecharia b. Avqulos burned down the sanctuary."

Bones and shells are considered *muqtsa*, items that may not be carried on the Sabbath. The House of Hillel nevertheless rules that they may be moved from the table after one has finished eating. The House of Shammai rules that they may not be touched, so one must lift the table and shake them off.[90] R. Zecharia b. Avqulos could not decide which opinion was correct, so he threw the shells and bones under the couch before he finished eating. He refused to take a stand on the disputed law and circumvented the issue by never setting down bones and shells on the table.

The BT story explains R. Yose's vehement denunciation of R. Zecharia's halakhic approach. His hostility is difficult to understand. How could a seemingly innocuous practice of throwing shells and bones under the couch lead to the destruction of the sanctuary? The story fills the interpretive gap and illustrates how the attitude underlying such behavior leads to disaster.[91] R. Zecharia's meekness and refusal to render a halakhic decision in the Tosefta parallel his meekness and refusal to act in the BT. There we learn in great detail how this attitude produces catastrophe. The two sources therefore stand in a powerfully intertextual relationship. Indeed, the story should be seen as a narrative exegesis of the Tosefta.[92]

The halakhic meekness of R. Zecharia in the Tosefta simultaneously contrasts with the halakhic boldness of his successors, the sages who made the various "amendments" in mGit 4:3–5:9 and of the court of R. Yehuda HaNasi in mGit 5:6.[93] Both the BT story and the Mishnaic rulings address the same fundamental problem. Action is as risky and problematic in everyday ritual matters as in the larger sociopolitical arena, both of which are

the responsibility of the sages. In both realms the sages interpret scripture to the best of their ability to understand the will of God. In both the sages may well make the wrong decision. Yet in both inaction is no answer. We can therefore understand why the redactors did not juxtapose the story with, say, mTa 4:6, which mentions the destruction of the temple and other disasters that occurred on the ninth of Av. The story is less about the destruction than about rabbinic responsibility and legislative initiative.

In context the story is an apologetic for specific types of rabbinic action, namely instituting amendments (*taqqanot*). The apologetic is necessary because such provisions may compromise the rights of others or countenance injustice. Moreover, the very act of "amending" exposes the imperfection or at least insufficiency of the divine law.[94] How can the sages arrogate the power to amend Torah law? As opposed to a legal or exegetical justification, the BT offers a story, illustrating the problems that result from rabbinic inaction.[95]

Yet the story provides but a partial apologetic. The necessity to compromise the law results from the rabbinic failure to act as moral and spiritual leaders at the initial banquet. R. Yohanan b. Zakkai is criticized for his inability to answer Vespasian and failure to save Jerusalem. The story expresses ambivalence toward the activity it seeks to justify, not a celebration of it. The tension of the perfect divine law and the necessity of rabbinic amendment remains unresolved. If the sages recognize that the failure to act as leaders and to make provisions results in disaster, they also know that their amendments may not turn out the way they expect. R. Zecharia worried that the people would misunderstand rabbinic action and misconstrue the law; the same danger obtains with any rabbinic innovation. Deep down lurks the question: why must we engage in this risky, uncertain activity? Is there a better way out which we—like R. Yohanan b. Zakkai—do not see? And there is no answer. By raising these issues, the story encourages meditation and thought, and portrays to the sages the tensions inherent in their office.

## Cultural Context

The need for an apology for rabbinic amendments such as that provided by our story can be understood in light of a tension regarding legislative activity occasioned by later Amoraic legal theory. Rabbinic amendments not only modify and adjust, but sometimes even abrogate, laws of the Torah.[96] This apparent overstepping of authority raises troubling questions: whence do the sages derive such power? Are there any limits? By

obeying the rabbinic amendment does one violate Torah law? Does the need for rabbinic amendment indicate that Torah law is insufficient or imperfect? The BT discusses this issue with several fixed locutions, especially, "May the court legislate to abrogate a law of the Torah?," that is, do the sages have the power to enact amendments that supersede Torah law?[97] Yizhaq Gilat has written the fundamental article on this topic, and the following discussion is indebted to his work.[98]

The most extensive talmudic discussion of rabbinic amendments is a lengthy *sugya* in bYev 89a–90b.[99] The core of the *sugya* reports an interchange between Rav Hisda and Rabba, third generation Babylonian Amoraim, although their discussion has been abundantly supplemented and expanded by the redactors. Rava asks Rav Hisda, "Is it possible that the court legislate to abrogate a law of the Torah?" and Rav Hisda responds, "Do you not think so? Did we not learn. . . . ?" The *sugya* adduces fourteen precedents to support Rav Hisda, but Rava or the Stammaim parry them all. One of these precedents derives from mGit 4:2, the first Mishna of the unit listing amendments for the sake of "good order." As a whole, the *sugya* expresses deep tensions over the question and fails to arrive at a definitive conclusion.

A case discussed in bGit 80a helps to illustrate the tensions and bears particular relevance to our topic. The issue concerns the law prescribed in mGit 8:5 that divorce documents include the name of the secular kingdom (in the date), that is, that they specify the year of the reign of the current king. The *sugya* reads:

[A] Ulla said, "Why did they amend [the law such that one must write] the kingdom in divorce [documents]? For the sake of maintaining peace with the [ruling] kingdom (*shelom hamalkhut*)."

[B] And for the sake of "maintaining peace with the [ruling] kingdom" she must be divorced and her child be a *mamzer* (if she remarried after being divorced with a document that lacked reference to the kingdom)?

[C] Yes. [The Mishna follows] R. Meir who is consistent with his principle. For R. Himnuna said in the name of Ulla, "R. Meir used to say, 'Whoever deviates from the form which the sages formulated for divorces — the woman must be divorced and the child is a *mamzer*.'"

The redactors object at B that the rabbinic amendment has frightful consequences. A woman whose divorce document neglects to mention the

ruling kingdom—a valid divorce according to the Torah but invalid now because of the rabbinic provision—and subsequently remarries is an adulteress. Jewish law will compel her to leave her new husband and will consider the child of that union to be a *mamzer*, a Jew of tainted descent. Thus an offspring of impeccable pedigree according to Torah law becomes a *mamzer* on account of the rabbinic amendment. Not only is this outcome extremely harsh, but it could be seen to cause inevitable violations of Torah law: this *mamzer* (according to rabbinic law) will marry another *mamzer*, but a Jew of pure pedigree (which the offspring is according to Torah law) may not marry a *mamzer*. At C the redactors acknowledge that these repercussions follow from the law and explain them by quoting another statement of Ulla from a different context.[100] They attribute the rabbinic amendment to Meir who, according to Ulla, disqualifies all divorce documents that deviate from standard rabbinic formulae. Like Rav Hisda, Ulla accepts that rabbinic amendments may abrogate the law of the Torah, at least according to Meir.

The objection at B expresses discomfort with the consequences of the rabbinic amendment. Note that the response succeeds in marginalizing the ruling by passing it off as the particular opinion of Meir. The *sugya* subsequently states outright that "the sages" disagreed and ruled a divorce valid even if the document only mentioned a local official. In this way the *sugya* overturns what seems to be an uncontested Mishnaic law. Of course I have quoted this example on account of the principle "for the sake of maintaining peace with the [ruling] kingdom," the same rationale invoked by the rabbis of the story as grounds to sacrifice the emperor's blemished animal before R. Zecharia b. Avqulos dissuaded them. Here the BT explicitly debates whether "maintaining peace with the [ruling] kingdom" provides sufficient reason to abrogate the law of the Torah.

Gilat shows that in many BT *sugyot* the later authorities are troubled by rabbinic amendments that abrogate Torah law and attempt to limit the phenomenon: "In early times the sages did not hold back from instituting enactments and making amendments when they saw a need, even if in doing so they sometimes abrogated a law of the Torah . . . An approach that explicitly objected to abrogating a law of the Torah appears for the first time in the name of Rabbah (bYev 89b) . . . This approach led the sages to explain Mishnas and earlier laws that seem to abrogate laws of the Torah in such a way as to limit their application to specific circumstances and to restrict their scope and significance."[101]

Gilat attributes the origins of the new approach to the development of the conceptual distinction between laws having the authority of Torah

(*de'oraita*) and laws having rabbinic authority (*derabbanan*). In Tannaitic times this distinction was not fully worked out; the sages tended to view their legislative activity as an extension of the Torah. As Amoraic legal theory became more sophisticated the sages categorized and classified laws, defined general principles, and formulated underlying concepts. Under the influence of the new categories, some Amoraim were distressed to find that certain amendments of their predecessors abrogated laws of the Torah, and they attempted to eliminate or limit the conflict.[102] Thus in the extensive *sugya* mentioned above (bYev 89a), Rava claims that rabbinic amendments can only absolve one from actively carrying out a commandment of the Torah but cannot overturn the law completely.[103] Gilat observes that the PT exhibits less ambivalence to rabbinic amendments. In one case where the BT questions the rabbinic amendment the PT simply comments: "R. Shimon b. Gamaliel spoke well for their (the sages') words abrogate the laws of the Torah."[104] Christine Hayes recently reached similar conclusions, that while "the Bavli adopts various strategies in order to redescribe all of the *taqqanot* that it identifies as ostensibly contradicting Torah law, as not in fact contradicting Torah law," the PT "is quite prepared to admit that at least some *taqqanot* are added innovations that contradict provisions of biblical law."[105]

The redactors, like the later Amoraim, inherited a legacy of Tannaitic amendments, such as those in mGit 4:2–5:9, and an advanced legal science according to which many amendments exceeded their theoretical authority. They also inherited opposing Amoraic views on the nature and extent of such amendments and various mechanisms to minimize their scope. The extended *sugya* of bYev 89a, by presenting the conflicting opinions without completely resolving the issue, expresses this enduring tension of Stammaitic times.

The story with its ambivalence and criticism of the sages should be understood against this background. On the one hand, it offers a powerful justification for rabbinic amendments: without such activity calamity results. To amend the law of the Torah is an act of courage and self-confidence, the opposite of meekness and "hardening the heart." On the other hand, the story recognizes the dangers inherent in abrogating the divine law. Rabbinic amendments result from flawed social and historical circumstances, situations for which the sages, as leaders and moral exemplars, ultimately bear responsibility. Had God not subjugated the Jews to foreign nations because of their sins, for example, there would be no need to make amendments "for the sake of maintaining peace with the kingdom," no need to compromise property law in order to redeem the land

from the *siqariqon*. In later rabbinic legal theory as in the story, rabbinic amendments are a problematic enterprise, a necessary but troubling legacy from the past.

## Comparative Evidence: The Version of 'Avot d'Rabbi Natan

In my reading the BT story expresses ambivalence towards R. Yohanan b. Zakkai and criticism of "the rabbis" as a whole. This interpretation can be strengthened by comparing the version of the story found in *'Avot d'Rabbi Natan,* version A, §4 (11b–12b), a Palestinian compilation of the fifth or sixth century C.E (=*ARNA*).[106] It is not clear that the BT redactors reworked this version of the Palestinian story. *ARNA* may have revised the BT story, or, more likely, both may derive from a common source. Nevertheless, *ARNA* embodies a way not taken by the BT redactors, a narrative possibility expressing the ideas and values of a different rabbinic community. Comparing points of difference highlights the specific interests and biases of the respective storytellers:[107]

> Now, when Vespasian came to destroy Jerusalem he said to them: "Idiots! Why do you want to destroy this city and [why do] you want to burn the temple? What do I want of you except that you send me one bow or one arrow and I will go from you? They said to him, "Just as we went forth against your two predecessors and killed them, so we will go forth against you and kill you."
> 
> When R. Yohanan b. Zakkai heard this he sent for the men of Jerusalem and said to them, "My sons. Why are you destroying this city and [why] do you want to burn the temple? What does he ask of you except one bow or one arrow and he will go from you?" They said to him, "Just as we went forth against his two predecessors and killed them, so we will go forth against him and kill him."
> 
> Vespasian had men positioned within the walls of Jerusalem. They wrote down every single word they heard on arrows and shot them beyond the walls, saying that R. Yohanan b. Zakkai was among the friends of the Emperor.
> 
> When R. Yohanan b. Zakkai had spoken to them one day, then a second and a third, but they did not accept [his words], he sent for his students, for R. Eliezer and R. Yehoshua. He said to them, "My sons. Arise and take me out of here. Make a coffin for me and I will lie down in it." R. Eliezer grasped its front and R. Yehoshua grasped its back. At twilight they carried him until they reached the gates of Jerusalem. The gatekeepers said to him, "What is this?" They said to them, "It is a corpse. Do you not know that one does not

leave a corpse overnight in Jerusalem?" They said to him, "If it is a corpse, take it out."

They took him out and carried him until they reached Vespasian. They opened the coffin and he stood before him. He (Vespasian) said to him, "Are you Yohanan b. Zakkai? Ask, what shall I give you?" He said to him, "I ask nothing of you except that I may go to Yavneh and study with my disciples, and institute prayer there, and perform all the commandments." He said to him, "Go and do everything that you wish." He (R. Yohanan b. Zakkai) said to him, "Would you like me to tell you something?" He said to him, "Speak." He said to him, "Behold, you are about to become Emperor." He said to him, "How do you know?" He said to him, "It is our tradition that the temple will not be delivered to the hand of a commoner but to the hand of a king, as it says, *The thickets of the forest shall be hacked away with iron, and Lebanon shall fall to the mighty one (Isa 10:34)*."

It was said: No more than one, two, or three days passed before there came to him a messenger from his city that the Emperor died and they voted him to be Emperor.

They brought him a catapult and drew it up against the wall of Jerusalem.[108] They brought him boards of cedar and he placed them in the catapult and he struck against the wall until he broke through. They brought him the head of a pig and he put it in the catapult and he shot it toward the entrails that were on the altar. At that time Jerusalem was captured.

R. Yohanan b. Zakkai was sitting and looking and shaking just as Eli sat and looked, as it says, *He found Eli sitting on a seat, waiting beside the road—his heart trembling for the Ark of God (1 Sam 4:13)*. When R. Yohanan b. Zakkai heard that Jerusalem was destroyed and the temple burned he tore his clothes, and his students tore their clothes, and they were sitting and crying and mourning.

This account corresponds to the second half of the BT story, sections F–H and a few aspects of D. Common elements include: Vespasian's siege of Jerusalem, R. Yohanan b. Zakkai's rebuke of his opponents, the escape in a coffin, an encounter with gatekeepers, the meeting with Vespasian, the prophecy based on Isa 10:34, the arrival of the messenger, and the request for Yavneh. Yet there are significant differences in the general content, the details of the plot, and the character of R. Yohanan b. Zakkai.

*ARNA* begins with Vespasian's attack without any explanation of how it came about or why he attacked in the first place. It lacks sections A–C of the BT story which provides this background. On the other hand, it contains descriptions of R. Yohanan b. Zakkai sitting in horror as the destruc-

tion takes place and of his subsequent reaction, which the BT lacks. The focus is R. Yohanan b. Zakkai: his pacifist policies, his awareness of the desperate situation, his plan to escape, his encounter with Vespasian, his reaction to the destruction. While the BT shows significant interest in the causes of catastrophe, *ARNA* emphasizes the figure of the sage and his policies, actions, and reaction to the destruction.

Besides these overall disparities the stories differ in many details. First, in *ARNA*, R. Yohanan b. Zakkai seeks to make peace as soon as Vespasian arrives, and the general knows of his loyalty from the spies. In the BT Vespasian besieges the city for three years and the situation becomes desperate before R. Yohanan b. Zakkai acts. Vespasian therefore questions his loyalty and rebukes him for not approaching earlier. Second, in *ARNA* R. Yohanan b. Zakkai does not consult with the head of the warmongers, who are called "the men of Jerusalem" rather than "thugs." He devises the plan on his own. Nor do the gatekeepers threaten to stab the coffin.[109] Third, *ARNA* lacks the scene with Vespasian's shoes in which R. Yohanan b. Zakkai proves his wisdom. Fourth, the order of important events differs. In *ARNA* Vespasian grants R. Yohanan b. Zakkai a request when he first meets him in return for his loyalty. After the request—perhaps as a type of quid pro quo—R. Yohanan b. Zakkai informs Vespasian that he will be king. In the BT R. Yohanan b. Zakkai's prophecy precedes Vespasian's offer and is probably its cause. Many more such discrepancies could be noted.[110]

These discrepancies contribute to the fundamental difference between the stories: the portrayal of R. Yohanan b. Zakkai. *ARNA* portrays R. Yohanan b. Zakkai as a hero. It expresses absolutely no criticism or ambivalence toward him.[111] *ARNA* lacks the two scenes in which R. Yohanan b. Zakkai fails to respond to Vespasian's questions. It lacks the explicit criticism articulated by Rabbi Akiba / Rav Yosef, the application of the derogatory verse, and the charge that he asked for the wrong thing. The change in order noted above has precisely this force. *ARNA* has Vespasian honor R. Yohanan b. Zakkai from the start and immediately grant him a request, which presents the sage as a great man whom even Vespasian respected. The BT has Vespasian humble R. Yohanan at the start and grant his request only after R. Yohanan makes up for his previous negligence and demonstrates his supernatural powers by predicting the future. In the BT Abba Siqra devises the plan, deceives the guards, and therefore deserves some credit for the escape. In *ARNA* R. Yohanan designs the plan and deserves all of the credit.[112]

The differences between the versions and the relationship of the BT

story to its context again point to the substantive contribution of the BT redactors. To support this point let me note a few differences between the BT story and other versions of its sources.

1. In *LamR* 1:5 (ed. Buber 34a–b) R. Yohanan b. Zakkai, after escaping from the besieged city, first asks Vespasian to leave Jerusalem in peace and to depart. When the general refuses R. Yohanan b. Zakkai requests that Vespasian leave open a gate and spare the fugitives. These requests obviate the criticism of R. Akiba / Rav Yosef that R. Yohanan b. Zakkai should have said, "Let them off this time" (H1). When Vespasian presents R. Yohanan b. Zakkai with a version of the snake parable in *LamR*, the sage is not silent, as in the BT, but answers that "one brings a sword and kills the snake and saves the jar."[113] The clever response again preempts application of the derogatory verse implying that he lost his wits and should have given precisely this answer (G1). The BT criticizes the sage whereas the Palestinian stories in *LamR* and *ARNA* do not.

2. *LamR* 1:16 contains two tragic stories about the downfall of aristocratic women, the first about Marta the daughter of Baitos, the second about Miriam the daughter of Naqdimon.[114] The BT account of Marta appears to conflate these two sources, for the first mentions that Marta never went out barefoot, while the second describes Miriam collecting barley from beneath the hooves of horses (because she was starving).[115] In any case, neither story in *LamR* 1:16 mentions the servant and his repeated failure to bring food. The servant's meekness and lack of initiative, which lead to disaster, recapitulate the moral of the BT, and are most appropriate there. In *LamR* 1:16 the stories illustrate the verse, "For these things do I weep, my eyes flow with tears" (Lam 1:16), by depicting the horrible fate that reduced aristocratic woman to death and starvation. The narrative differences again cohere with their respective contexts.

3. The Qamza and Bar Qamza story of *LamR* 4:2 does not begin with Prov 28:14. This verse helps explain how the BT redactors understood Zecharia b. Avqulos's failing and hence clarifies the didactic point. In addition, *LamR* 4:2 states explicitly that after the sages did not sacrifice the animal, "Immediately he [the emperor] came and destroyed the temple." The concluding comment, "The meekness of Zecharia b. Avqulos destroyed our temple," then makes perfect sense. The BT lacks this line ("immediately he came and destroyed the temple") and instead provides the lengthy account of events that led up to the destruction (C–H). But this deletion renders the lament that Zecharia destroyed the temple out of place in the BT, since it proleptically refers to the final outcome before the story narrates those events. It seems that the BT redactors excised the sentence

narrating that the emperor "immediately" destroyed the temple because they wished to add the subsequent story. The omission produces a slight difficulty in understanding the lament concerning Zecharia's meekness but allows the redactors to construct the extended course of events.[116] Most important, *LamR* does not mention that the rabbis initially were inclined to sacrifice the emperor's offering but were dissuaded by Zecharia b. Avqulos for fear of mistaken halakhic conclusions. Rather, a priest (in place of sages) refuses to perform the sacrifice because of the blemish. The problems of rabbinic amendment are not at issue in *LamR*.

These differences again indicate that the BT redactors consciously reworked their sources and fashioned them to fit the new context. Yet we also see that the redactors stopped short of revising their sources completely, and consequently interpretive seams and difficulties remain.

### APPENDIX: MANUSCRIPT VARIANTS:

The base text of the translation is ms Arras 969. The following sigla are used: Ar = Arras 969. M = Munich 95. V1 = Vatican 130. V2= Vatican 140. L = Leningrad-Firkovich I 187. P= first complete printing, Venice, 1520. Only the major variants are cited. Most variants are collated in Meyer Feldblum, *Diqduqei sofrim: masekhet gittin* (New York: Horev, 1966). See pp. 9–12 for a description of ms Arras 969 and the other manuscripts.[117]

(A) "Servant." Illegible in Ar. So other mss.

(A) "Get up and leave." MV2 omit. V1 omits "and leave."

(A) "Forced him up." MV1V2 omit.

(B) A few of the words are illegible in Ar and have been supplied from other mss.

(B) "Did not protest." P adds "this implies that they approved."

(B) "He said to the Emperor." Literally, "the Caesar" (*qeisar*). MV1V2 read "He went and he said."

(B) "Avqulos." V2L read "Avtulos." V1 marginal gloss reads "Avqalos."

(B) "In case he should go" (*dilma*). MV1V2 read "so that he not go" (*delo'*).

(B) "To sacrifices." So MV1V2 (*baqodashim*). Ar omits.

(C) "To the West. It went and fell in Jerusalem." MV2L omit.

(C) "To all four directions. It went and fell towards Jerusalem." V1 omits. MV2 read "went and fell in Jerusalem."

(C) "Vengeance on Edom through My people Israel." M adds: "That child stuttered between 'Edom' and '*adam*' (man)." See Rashi ad loc. and the similar

motif in the story of Elisha b. Abuya, Chap. 3. For another example of a stuttering child, see the version of bMeg 16a found in *Haggadot hatalmud,* cited in Segal, *The Babylonian Esther Midrash,* 3:64.

(C) On the expression "wipe clean his hands," see Rashi's commentary to Gen 32:21 and bBM 24a (ms M).

(C) "Fled and converted." Literally, "He sought, fled, and converted." M omits "sought." MV1V2 read "fled and went and converted."

(D) "Vespasian the Emperor." M omits "Emperor."

(D) "The sun cut through." Ar reads *nitqadra*. MV1 read *naqda* ("break through"). V2 reads *niqra* ("perforate"). L reads *naqdema* ("preceded"). The story of Naqdimon and the sun appears in bTa 19b–20a.

(D) "Roman nobles." M reads "nobles of the authorities."

(D) "Wine and oil." So too V2P. MV1 read "Oil and salt."

(D) "Stores of wheat and barley." M omits "of wheat and barley." V1V2 read "loads."

(E) "From the market." MV1V2P omit.

(E) "Bring me." MV1 omit "me" in several of the exchanges.

(E) "[Although] she had taken off her shoes." I have supplied "Although" to make better sense of the text. The literal reading is "She was taking off her shoes." V2 reads "one shoe."

(E) "To her foot." V2 omits.

(E) "And became ill [and died]." Ar omits "and died," which I have supplied from MV1V2P. V2 omits "became ill." The translation "became ill" for *'itnisa* follows Jastrow, *Dictionary,* 917–18, who derives it from the root *n-s-s*. This seems to be the contextual sense although this etymology is suspect. The word could be derived from *'-n-s* meaning "to meet with an accident." Levy, *Worterbuch,* 1:135 derives it from *'istenis* (delicate, weak): "she was repulsed" or "she was sickened." *Haggadot hatalmud* indeed reads *'isteniset* and explains "she was repulsed" (*nim'asa*).

(E) "So that Jerusalem would not be destroyed." MV1 omit. A superlinear gloss in V1 adds "because of the destruction."

(F) "He came." ArV1 omit. Supplied from MV2P.

(F) "Let everyone come to visit you . . . lighter [than a corpse]." The order of the clauses varies in the mss, but the content is the same. Ar omits "than a corpse," which appears in MV1V2P. L adds "rub saffron on your face." V1P add "Do not let anyone else attend to you so that they sense that you are light."

(F) "For they know (*qashvei*) that a living person is lighter." This reading is found in Kohut, *'Arukh,* 7:223, and explained as *hiqshiv*, i.e., "hear" in the sense of "know." Cf. Jastrow, *Dictionary,* 1429, who explains "they are watchful (distrustful)." MV1V2P read *yad'ei*, "know."

(G) "Peace to you O King." Not repeated in V2.
(G) "First, I am not a king." MV2P add "yet you called me king."
(G) "Why did you not come to me?" MV1P add "until now."
(G) "And 'Lebanon' refers to the temple" (Deut 3:25). MV1V2 omit. On the tradition of "Lebanon" referring to the temple, see Targum Onqelos to Deut 3:25 and Geza Vermes, "Lebanon: The Historical Development of an Exegetical Tradition," *Scripture and Tradition in Judaism* (Leiden: Brill, 1961), 26–39.
(G) "He was silent." M omits.
(G1) "And some say R. Akiba." Ar omits this here, but has it in H1.
(H) "He said, 'What is this?'" MV1V2 omit.
(H) "You received good news." MV1V2 omit.
(H) "I also told you." V1 omits.
(H1) "Would not." MV1P read "would not even."

Chapter 6

## Torah, Lineage, and the Academic Hierarchy (Horayot 13b–14a)

The story of the attempt by R. Meir and R. Natan to depose the Patriarch, Rabban Shimon b. Gamaliel, takes us into the heart of the rabbinic academy. While I argue that many BT stories were substantially revised in the Stammaitic academy and shed light on its culture, the stories set in the academy represent academic values and tensions more directly. As with other such accounts, the Stammaim projected the story upon the Palestinian Tannaitic academy and used Tannaitic sages as characters. Yet behind this veneer we discern some of the basic conflicts that characterized the later Babylonian academies. The issue is so important as to warrant more detailed consideration of the historical context than essayed in the previous chapters.

Scholarship on this story, like that on the story of R. Shimon b. Yohai (Chapter 4), illustrates the methodological shift in the study of the rabbinic story described in Chapter 1. Already in 1977 Louis Jacobs rejected the historians' use of the story to reconstruct the history of the Tannaitic period.[1] Jacobs pointed out that the story contains late Babylonian motifs: it is "a Babylonian *tale* about events said to have taken place perhaps centuries before the time when the tale was told."[2] A few years later Shaye Cohen observed that the BT often provides "fictional or embellished accounts of the internal affairs of the Palestinian patriarchate" and therefore rejected the historicity of the story. He suggested that the BT story was an aggadic expansion of a brief report found in yBik 3:3, 65c.[3] Cohen correctly appreciated that BT stories are products of literary processes and narrative re-

working. In 1984 David Goodblatt provided comprehensive evidence for these claims by demonstrating that a number of motifs and expressions are uniquely Babylonian.[4] Goodblatt concluded that the BT editors revised and augmented an earlier source for their own purposes. However, neither Goodblatt nor his predecessors analyzed the BT version on its own terms, attempted to understand its meaning, or assessed its literary and talmudic contexts.[5]

This chapter begins with the translation and literary analysis of the story and continues with a discussion of its structure. The next section briefly considers sources and compositional methods. In this case the BT redactors expanded and supplemented the PT story to such a degree as to render detailed comparisons beside the point. I concentrate instead on the provenance of several important components of the BT story in order to contribute further to our understanding of compositional techniques. Discussions of the halakhic and cultural contexts follow. The final section makes some tentative suggestions about a more specific historical context.

## Translation

The opening of the story refers to a *baraita* from tSanh 7:8 that appears in the preceding talmudic *sugya*.[6] The *baraita* describes the protocol of the rabbinic court as follows:

> [A] When the Patriarch enters all people stand and they may not sit until he says to them "sit".
> [B] When the Head of the Court enters, they make a row for him on one side (by standing up), and a row for him on the other side, until he sits in his place.
> [C] When a sage enters one stands and one sits until he sits in his place.[7]

The story interprets the *baraita* as a description of the rabbinic academy, not the court, and the offices as academic ranks, not judicial positions. The translation of the story is based on ms Paris 1337. Variants can be found in the Appendix.

> [1] R. Yohanan said, "This teaching [=tSanh 7:8] was taught in the days of Rabban Shimon b. Gamaliel."
> [2] Rabban Shimon b. Gamaliel—Patriarch. R. Meir—Sage. R. Natan—Head of the Court. When Rabban Shimon b. Gamaliel would enter, everyone would rise before him. When R. Meir and R. Natan would enter, everyone

would rise before them. Rabban Shimon b. Gamaliel said, "Should there not be a distinction between me and them?" He enacted (*taqqen*) this teaching.

[3] On that day, R. Meir and R. Natan were not there. On the morrow, when they came, they saw that they did not rise before them as usual. They said, "What is this?" They said to them, "Thus Rabban Shimon b. Gamaliel enacted (*taqqen*)."

[4] R. Meir said to R. Natan, "I am Sage and you are Head of the Court. Let us fix (*netaqqen*) something for ourselves." R. Natan said to him, "What shall we do?" [Meir said,] "We will say to him, 'Teach us [Tractate] Uqsin' which he does not know. And because he has not learned [it], we will say to him, '*Who can tell the mighty acts of God, make all his praise heard? (Ps 106:2). For whom* is it pleasing to *tell the mighty acts of God*? For him who is able to *make all his praise heard*.'"

[5] "We will depose him and then you will be Patriarch and I will be Head of the Court."

[6] R. Yaakov b. Qudshai heard them. He said, "Perhaps, God forbid, it will result in shame?" He went and sat behind the upper-story of Rabban Shimon b. Gamaliel. He repeated and taught, repeated and taught.

[7] He (Rabban Shimon b. Gamaliel) said, "What is before me? Perhaps, God forbid, there was some matter in the academy?!"

[8] He paid attention, looked into it, and repeated it.

[7'] The next day they (R. Meir and R. Natan) said to him, "Let the master teach us from [Tractate] Uqsin." He opened and taught.

[6'] After he stymied [them], he said to them, "Had I not learned it, you would have shamed me."

[5'] He ordered and they removed them from the academy.

[4'] They would write objections on slips of paper and throw [them in]. That which he (Rabban Shimon b. Gamaliel) solved, he solved. That which was not solved, they wrote the solutions and threw them [in]. R. Yose said to them, "Torah is outside and we are inside?"

[3'] Rabban Shimon b. Gamaliel said to them, "We will bring them in. However, we will penalize them such that we do not say traditions in their names." They designated [literally: raised] R. Meir "Others" and R. Natan "Some say."

[2a'] They showed them in their dreams, "Go and appease Rabban Shimon b. Gamaliel." R. Natan went. R. Meir did not go. He said, "Dreams neither help nor hinder."[8] When R. Natan went he (Rabban Shimon b. Gamaliel) said to him, "Perhaps the belt of your father benefited you in making you the Head of the Court. Shall it benefit you to make you Patriarch?"

[2b′] Rabbi [Yehuda HaNasi] taught his son R. Shimon, "Others say, 'If it had been an exchanged beast, it would not have been offered.'" He said to him, "Who are those [others] whose waters we drink and whose names we do not mention?" He said to him, "They are men who tried to uproot your honor and the honor of your father's house." He said to him, *"Their loves, their hates, their jealousies have long since perished (Qoh 9:6)."* He said to him, *"The enemy is no more; the ruins last forever (Ps 9:7)."* He said to him, "This applies only when their actions benefited [them]. As for these, their actions did not benefit [them]." He then taught, *"They said in the name of R. Meir, 'If it had been an exchanged beast, it would not have been offered' [=mBekh 9:8]."*

[1′] Rava said, "Even Rabbi [Yehuda HaNasi], who was extremely humble, said, 'They said in the name of R. Meir.' He did not say, 'R. Meir said.'"

## Literary Analysis

The first section of the story recounts a transition from equal to unequal academic honors and the resulting conflict. A statement attributed to R. Yohanan introduces and contextualizes the story (1).[9] It refers back to the *baraita* analyzed in the preceding talmudic *sugya* and presents the ruling as an innovation introduced in the days of Rabban Shimon b. Gamaliel (henceforth: RSBG). The narrator then provides background information, including the names of the characters, their respective ranks, and the prevailing situation, with noun-clauses and iterative verbs before shifting to the active voice to describe RSBG's enactment (2).[10] This shift in style matches the content, the transition from parity of honors to distinction.

| | | |
|---|---|---|
| RSBG — Patriarch | When RSBG would enter ... | RSBG said, "Should there not be a distinction between me and them?" He enacted this teaching. |
| R. Meir — Sage | When R. Meir and R. Natan would enter ... | |
| R. Natan — Head of the Court | | |

Three symmetrical statements illustrate the regnant state of equality. There follow two nearly parallel sentences — only the singular versus plural forms violating the symmetry — that separate the Patriarch from the rabbis. The incongruity that troubles RSBG, articulated through an interior monologue, already confronts the eye and ear. These two groupings receive equal honors but hold distinct ranks. For this reason the narrator neither uses a single sentence ("whenever each one would enter the people would rise before him") nor repeats the three sentences ("when RSBG would enter . . . , when Meir would enter . . . , when Natan would enter . . .") although both alternatives convey the same information.

With great subtlety the narrator hints that RSBG's motives for establishing unequal honors are less than noble. The active description "he *enacted* this teaching" contrasts with the passive voice of its referent, the opening statement "this teaching was taught." The audience may have had various expectations about the subject of the passive construction, mentally supplying "by sages," "by scholars," or "by the court."[11] Certainly the audience did not expect that the Patriarch formulated it himself and masterminded such a self-interested policy. Equally surprising is the shift in verbs from "was taught (*nishneit*)" to "he enacted (*taqqen*)." The term *taqqen* calls to mind "amendments" (*taqqanot*) — rabbinic legislation intended to ameliorate social and moral problems, as we have seen in Chapter 5. But the problem here disturbs RSBG alone, and it is not social or moral but personal and political. The subsequent explanation of anonymous students to Meir and Natan that RSBG "enacted" the change again ascribes the measure directly to the Patriarch and repeats the key verb *taqqen* (3). No communal decision of the academy, this edict resulted from Patriarchal fiat. Ironically, rather than ameliorate a problematic situation, RSBG's "*taqqana*" causes one, as we soon learn.

That RSBG imposes his will so easily intensifies the wonder already kindled by his unabashedly self-serving motives. Why did Meir and Natan not protest when he "enacted" this tradition? Only upon proceeding to the next scene do we understand how RSBG could act without their opposition — because "on that day" the two sages were not present (3). The narrator displaces this datum from its proper temporal order; we would expect, "Meir and Natan were not there, and RSBG enacted this teaching." This narrative technique, a paralipsis (a lateral omission of information), should be familiar from previous chapters.[12] Here it imparts to the audience a sense of astonishment akin to that which Meir and Natan experience when deprived of their accustomed honor. Their exclamation at the sudden change in protocol ("What is this?") balances RSBG's reaction to the initial

policy ("Should there not be a distinction . . . ?") with the perception of the offended parties.

Meir and Natan respond in kind by resolving to "fix (*netaqqen*) something for ourselves," the third appearance of the verb (4–5). The play on the two senses of *taqqen* (enact/fix) draws a parallel between the two actions. Where RSBG promulgates a new teaching, the two rabbis turn to the established corpus of tradition. In their view, one who "has not learned" the entire accepted body of tradition should not promulgate new teachings for his own honor. They aim to demote a sage who enacted a teaching by inviting him to teach: measure for measure, the reaction befits the act. Yet Meir and Natan's motives are no purer than those of the RSBG. The wordplay also suggests that the same goals motivate both sides, that the rabbis' response too is no disinterested attempt to teach the Patriarch a lesson, no public service for the common rabbinic good. Just as RSBG acted to promote his honor, Meir and Natan act in their own interests ("for ourselves"). Meir opens by mentioning rank ("I am Sage and you are Head of the Court") and concludes with brazen hopes for higher ranks.[13] Beyond this symmetry the chiastic structure articulating their scheme casts unflattering light on their purpose:

a. I am Sage and
b.   you are Head of the Court . . .
c.     . . . What shall we do? (*na'aveid*)
d.       We will say to him, Teach us [Tractate] Uqsin
e.         which he does not know
e'.         And because he has not learned [it],
d'.       We will say to him, *Who can tell the mighty acts* . . .
c'.     We will depose him (*na'avrei*) and
b'.   you will be Patriarch and
a'. I will be Head of the Court.

The first two and last two lines emphasize the goal, the promotion in rank that Meir and Natan covet. Lines c and c' contain a wordplay (*na'aveid/ na'avrei*). What they really intend to "do" (*na'aveid*) is not beckon RSBG to teach, recounted in the proximate lines d–e, but to depose the Patriarch (*na'avrei*), recounted in the corresponding line c'. Likewise lines d and d' link the two planned speeches and divulge that they are one: the first paves the way for the second. The center of the chiasm presents RSBG's lack of Torah, the source of the problem (e, e').

As opposed to this lengthy, plotting statement, Meir and Natan carry

out their scheme with the terse, three-word statement, *nitnei mar beʿuqtsin* ("Let the master teach from [Tractate] Uqsin," 7'). While brevity typifies the dialogue in most BT stories, in this case the conciseness contrasts with the verbosity of the plot. The gap between the two quotations again highlights the gap between their speech and their intention. They do not wish to learn about Uqsin but hope *not* to learn, and instead to humiliate RSBG. The slightly honorific *mar* ("master" or "sir") is equally duplicitous. This careful formulation of dialogue casts some doubt on the propriety of their designs.

The choice of test-material also betrays Meir and Natan's self-serving motivation. Uqsin, the last tractate of Mishna, represents in the BT the most challenging and complex subjects.[14] The sages do not test RSBG on the standard curriculum or even difficult matters—these he apparently knows. No ignoramus the Patriarch, though he may not have mastered the most recondite of tractates. So the storyteller(s) and audience, like the anonymous sages of the academy who accept the new teaching, may not judge RSBG enacting traditions or seeking honor to be as outrageous as Meir and Natan believe. Their justification—perhaps rationalization—for action, the exegesis about knowing "*all* His praise," that is, the whole Torah, is extreme. Who knows the entire Torah? Indeed, the simple meaning of the verse, which the audience inevitably senses while decoding the exegesis, makes precisely this point: no one can exhaust praise of God, or, translated into terms of Torah, no human being has exhaustive knowledge of tradition. Meir and Natan's *derasha* is as self-serving as RSBG's *taqqana*! If RSBG used his power as Patriarch to enact a Tannaitic teaching for his benefit, Meir and Natan mobilize their proficiency in Torah to devise a midrashic teaching for theirs.[15]

The fundamental conflict thus centers on who should receive honor in the academy and on what grounds. The tactics of both parties accordingly involve the opposite of honor—to shame the opponents. As is well known, honor and shame are critically important, interrelated concepts in many cultures, and especially in the Mediterranean world.[16] While these terms do not appear explicitly in this opening section, subsequent references indicate that issues of honor and shame create the narrative dynamic. R. Yaakov b. Qudshai's horrified reaction upon hearing of the plot mentions the potential for *shame* (6). Upon surviving the challenge the Patriarch himself emphasizes that he would have been *shamed* (6'). Later in the story R. Yehuda HaNasi refuses to forgive the conspirators because they "tried to uproot your *honor* and the *honor* of your father's house" (2b'). Reading

back, we should realize that RSBG's new policy inevitably caused Meir and Natan to experience shame when the disciples did not rise before them as in the past. Their effort to shame RSBG, then, is not merely retaliation but "measure for measure" justice (*mida keneged mida*), both the fitting response to their own shaming and the antithesis of the public honor RSBG seeks. To shame someone else ranks among the most serious sins in the view of the BT, as documented in Chapter 2.

The basis for RSBG's claim to honor is not immediately apparent. Certainly he holds the position of Patriarch, the highest academic rank. But this begs the question: on what grounds does he hold the highest rank in the academic hierarchy? His rank obviously does not derive primarily from his mastery of Torah — that is Meir's and Natan's province. Rather, RSBG's rank derives from his family lineage, from heredity. This is the force of the explanation of his son R. Yehuda HaNasi to R. Shimon: "men who tried to uproot your honor and the honor of your father's house" (2a').[17] In subsequent generations RSBG's son remembers the threat to his "father's house" and points out to his son that "your honor" too was jeopardized. At stake was not only the position of RSBG but that of his family line, by virtue of which he occupies his rank. For this reason the story pursues the course of events among Patriarchal descendants. Meir and Natan threaten not RSBG the individual, but the very basis of his position.

RSBG's admonishment of Natan accordingly emphasizes lineage. The Patriarch attributes Natan's rank to the belt (*qamera*) of Natan's *father*, that is, to his family (2a').[18] This pedigree, he concedes, provides sufficient grounds for Natan to be "Head of the Court." But Natan's admittedly exalted lineage cannot make him Patriarch, which flows through different bloodlines. Moreover, the focus on the *qamera*, a decorative belt or sash typically bestowed by the Persian emperor as a mark of prestige, is precisely the type of external sign of honor, like standing when one enters, that RSBG values. A status symbol of the ambient culture, the belt does not necessarily indicate academic ability or virtuous character.

Meir and Natan's claim to honor, by contrast, rests primarily on their knowledge of Torah. Meir apparently holds the rank of Sage solely on account of his Torah, while Natan holds the rank of Head of the Court mainly for this reason. They justify their aspirations to higher ranks on the basis of their proficiency in the entire Torah including Tractate Uqsin. They subsequently demonstrate this proficiency after being removed from the academy such that R. Yose identifies them with Torah itself: "Torah is outside and we are inside?" (4'). Yet in Natan's case lineage also contributes

to his status. Not only does his lineage impress RSBG, but even Meir respects it: he plans that Natan will become Patriarch and contents himself with the secondary position of Head of the Court.

These competing claims correspond to the two types of honor described by Julian Pitt-Rivers in his essay, "Honour and Social Status," published in John G. Peristiany's classic volume, *Honour and Shame: The Values of Mediterranean Society*.[19] Pitt-Rivers distinguishes between "honour=excellence" and "honour=precedence," between that "honour which derives from personal conduct and that honour which situates an individual socially and determines his right to precedence."[20] The former stems from character, achievement, and individual reputation, the latter from birth or antecedence. RSBG exemplifies honor=precedence and occupies the highest rank on that basis, while Meir and Natan exemplify honor=excellence (or honor=virtue) on account of their mastery of Torah.

Conflicts often arise in a given culture because individuals compete for the same public honor on the basis of different underlying rationales. In Pitt-Rivers's formulation, "no man of honour ever admits that his honour=precedence is not synonymous with his honour=virtue. To do so would be to admit himself dishonoured."[21] As head of the academy RSBG must avoid being perceived as deficient in Torah, despite the fact that his honor (=precedence) really derives from lineage. That would "admit himself dishonoured," or, in the idiom of the story, "result in shame." In other words, Meir and Natan can shame RSBG by exposing his lack of Torah because his honor is contingent on knowledge (=excellence, virtue), although not earned on that basis. Similarly, RSBG can only avoid being shamed by learning Uqsin and demonstrating his proficiency in Torah, synonymous with excellence in rabbinic culture.

What makes the tension between the types of honor particularly acute is that the Patriarchs promote their honor by manipulating traditions. They "enact" self-serving rulings to exalt themselves and to reduce the honor of their opponents. RSBG promotes his honor with the new teaching at the outset, then institutes anonymous sobriquets for the names of Meir and Natan (3'), while R. Yehuda HaNasi formulates an anomalous quotation formula for Meir (1'). Patriarchal honor does not derive from displays of public pomp or social pressure ensuring that everyone make the appropriate gestures, but from legislating such displays into Torah such that all pious sages have no choice but to comply. In other words, a gap separates the source of Patriarchal honor (lineage) from the way that honor is imposed (Torah). To add insult to injury, those preeminent in Torah not only

receive less honor but have their rightful honor reduced through Torah itself. To what extent, the story asks, should those not preeminent in Torah enjoy honors imposed by Torah and manifest in the academy?

The public challenge to RSBG renders the threat to his honor so hazardous. It is one thing if all know, privately, the true state of affairs, quite another to have it manifested in public. As Pitt-Rivers notes: "Public opinion forms therefore a tribunal before which the claims to honour are brought, 'the court of reputation' as it has been called, and against its judgements there is no redress. For this reason it is said that public ridicule kills."[22] No character doubts Meir and Natan's superiority in Torah; even the Patriarchs recognize their talents. The danger is that their superiority be publicly displayed such that all witness RSBG's lack of ability, proof that his honor=precedence is not synonymous with honor=excellence. R. Yaakov expresses horror precisely at the public showdown: "Perhaps, God forbid, *it*"—that RSBG may fail to perform before the entire academy—"will result in shame." Honor always has this competitive aspect: "The victor in any competition of honour finds his reputation enhanced by the humiliation of the vanquished."[23]

Internal feelings of shame and self-worth of course complement the public aspect of honor and shame as social forces. The story emphasizes that emotional dimension through a series of interior monologues. RSBG's initial reaction to the equality of honor, "Should there not be a distinction between me and them?" represents his thought as speech and thereby reveals his immediate perceptions. Similarly, both R. Yaakov b. Qudshai's anxious response, "Perhaps, God forbid, it will result in shame?" and RSBG's realization, "Perhaps, God forbid, there was some matter in the academy?" express thoughts. As we have observed previously, the phrasing of thought in articulated words bestows a superior sharpness and precision to indirect discourse.[24] By vividly depicting the sense of insult at the lack of honor and the horror ("God forbid") at the prospect of shame, the style of interior monologue contributes to the narrative content.

Surviving the public challenge requires that RSBG demonstrate his proficiency in Torah, which will demand assiduous study, relentless preparation, and something of a character change. For it appears that RSBG has kept his distance from the academy and its discussions of Torah. Yaakov does not approach RSBG to inform him of the plot but sits behind RSBG's upper-story at some remove from the Patriarchal domain (6). The description draws attention to the distance between the Patriarch and the sages, the very distinction upon which RSBG insisted at the outset. The Patriarch

sits in his elevated realm, alone, detached from both the study of Torah and the goings-on of the academy, while the rabbi remains down below, distant, communicating indirectly.

To fully understand the nuances of this setting it is necessary to appreciate the symbolism of the upper-story. Rabbinic sources associate the upper-story either with Patriarchal power and privilege, especially that of Rabban Gamaliel, or with significant rabbinic gatherings, typically involving votes, edicts, and divine pronouncements. In bSanh 10b–11a, for example, Gamaliel summons seven elders to his upper-story to intercalate the calender and takes offense when an uninvited eighth appears.[25] Votes on the principle of martyrdom (bSanh 74a), the famous "eighteen decrees" of the House of Shammai (bShab 12a), and the primacy of Torah or deeds (bQid 40b) take place in upper-stories.[26] In our story too the upper-story serves as the Patriarchal domain, the place inhabited by RSBG when absent from the academy. His upper-story, however, is not a place of Torah, at least not until the crisis. It is apparently because the Patriarch has spent more time in his upper-story than in the academy that his knowledge lags behind that of other sages. RSBG's upper-story, then, connotes Patriarchal authority and rank, not rabbinic gatherings to study Torah. To preserve his Patriarchal privilege RSBG must transform his upper-story from the first type to the second. When he acts like a sage and diligently studies Torah there, his position atop the academic hierarchy endures.

To avoid being shamed RSBG must bridge the gap in Torah and values between himself and the other rabbis. The story illustrates his progress by shifting the spatial description of Yaakov *behind* the upper-story to RSBG's sudden cognizance of "what is *before* (= in front of) me?" (7). Attention to Torah study becomes an immediate priority rather than a secondary, background concern. Mention of the circumstances "before" RSBG simultaneously recalls the opening description of students standing "before" the Patriarch and his desire for such honorific displays. By concentrating on the Torah-study before him, not the standing or sitting, he will be able to maintain his position. Another allusion to the opening scene appears when RSBG "stymies" his opponents, literally "stands [them] up" (*'oqim*),[27] which echoes the rabbis rising (*qamu, qaimi*) when RSBG enters. But this time it is the proper type of "standing up," a metaphoric "standing them up" without a response to his Torah, not standing up the sages to shower him with honor.

RSBG's new awareness of the importance of Torah also emerges from comparisons of his statements with that of Yaakov:

Yaakov (6):   Perhaps, God forbid, it will result in shame?!
RSBG (7):    Perhaps, God forbid, *there was some matter in the academy*?!
RSBG (6'):   *Had I not learned it*, you would have shamed me.

Each half of Yaakov's statement appears in a statement of RSBG, but to each has been added a reference to study or the academy. In the second statement RSBG explicitly acknowledges that study prevented the shaming. For this reason the narrator does not have Yaakov inform RSBG directly, for example, "You, Sir, should study Uqsin so that you not be shamed tomorrow."[28] That would be too easy. RSBG must develop an awareness of the studies and conversations of the sages if he wishes to occupy the Patriarchal office. The depiction of Yaakov studying and then RSBG imitating him and studying the same material illustrates how the Patriarch makes a rabbi his model, as does the plethora of verbs relating to study. RSBG "paid attention, looked into it and learned (*garas*, 8)"; then he "opened (*patah*) and taught (*tani*)"; and states that had he not "studied (*gemir*)," he would have been shamed (6').

Because of this new awareness and industry, RSBG triumphs in the scholastic showdown. Not only does he teach Uqsin and thwart the plot, but he turns the tables on his challengers and shames them. He "stymies" Meir and Natan, apparently by posing questions about the abstruse tractate which they cannot answer, thereby demonstrating his superiority in Torah.[29] RSBG then has both the power (as Patriarch) and reason (as master of Torah, which renders others dispensable) to exile Meir and Natan from the academy (5'). Hoping to move one notch up the academic hierarchy, the rabbis lose everything. Seeking higher academic honor, the rabbis now receive no honor at all.

This major reversal initiates the crucial narrative turn. The action in the final section (5'–1') moves in a direction opposite to that of the first section (1–5). Where the first section recounts Meir and Natan's attempt to shame the Patriarch, the final section describes their displacement from the academy and struggle to reclaim their former honor. The depiction of the sages and their Torah outside of the academy while the Patriarch leads the study session inside reverses the earlier situation when the leading rabbis celebrated their superiority in Torah within the academy while the Patriarch was absent. R. Yaakov b. Qudshai intervened on RSBG's behalf to prevent the shaming; subsequently R. Yose intervenes on Meir and Natan's behalf to restore their positions (4'). The narrative turn fittingly commences with the brief declarative sentence, "He ordered and they were

removed from the academy." A sharp contrast to the lengthy and unsuccessful plot of Meir and Natan, the terse command underscores the disparity of power. The Patriarch orders and his will is done. The rabbis plot, wait—and fail. The rest of the story describes their efforts to recover their stations.

RSBG retaliates to the assault on his honor in kind, by attempting to destroy Meir and Natan's honor. While public shame is the opposite of the public honor that RSBG deems most important, separation from the academy threatens the rabbis' prestige.[30] RSBG cannot cause them to forget their Torah, but he can prevent recognition of their knowledge by removing them from the academy.[31] Not only will no colleague ceremoniously rise when they enter, but no disciples will witness their dialectical abilities, access their knowledge of tradition, or debate their rulings.[32] The revised punishment, admitting them to the academy but rendering their traditions anonymous, impugns their honor in a different way (3').[33] Suppressing their names denies them recognition among the sages of posterity rather than honor among students of the contemporary academy. While the Patriarch's descendants will inherit his position and the family name will retain its prestige, the names and memories of these sages will be forgotten. The ingenious strategy preserves their much needed Torah while depriving them of enduring honor on that account.[34]

The general course of events suggests that the sympathies of the storytellers reside with the Patriarch. He avoids the shaming, pulls off the reversal, humiliates his opponents and reduces their honors. That Meir and Natan are instructed in their dreams to appease the Patriarch confirms this bias (2a').[35] Prominent motifs in BT stories, dream-messages, like the study-verses of children and heavenly voices, usually communicate something of the divine will.[36] The pro-Patriarchal *Tendenz* of the divine omen establishes that Meir and Natan acted improperly. One cannot claim that the story acknowledges RSBG's insidious power but considers him a tyrannical villain or judges that the rabbis' noble fight was tragically frustrated. Natan obediently goes to RSBG and appeases him, presumably apologizing for the scheme. A type of self-humiliation and submission, an apology generally satisfies affronts to honor.[37] Natan must also endure the Patriarch's rebuke ("Perhaps the belt of your father . . . "), and then presumably is forgiven and returned to his former position.[38]

Despite the Patriarchal bias, the story offers neither unconditional praise of the Patriarch nor a celebration of his policies. Above we observed the implied criticism of his motives. More importantly, while RSBG avenges the attempted shaming, his retaliatory measures, although initially

successful, are subsequently attenuated. The banishment of Meir and Natan quickly proves untenable because the sages of the academy require their knowledge of Torah and dialectical abilities. The description of their activity in terms of writing "objections" and "solutions" suggests the dialectical give-and-take of the Stammaitic academy and indicates proficiency in Torah.[39] Recall that after years of study in the cave R. Shimon bar Yohai solved every objection of R. Pinhas b. Yair with twenty-four solutions.[40] Here too the depiction of Meir and Natan proffering "objections" and "solutions" beyond the grasp of the Patriarch marks their preeminence. RSBG's modified punishment, to efface the names of Meir and Natan from rabbinic tradition, also is mitigated. The strategy succeeds at first, as RSBG's grandson R. Shimon knows nothing of Meir, but eventually R. Yehuda HaNasi restores Meir's name for posterity. Even the dream message supporting the Patriarch harbors a trace of ambiguity, for Meir's dismissal of dreams as meaningless finds precedent in several BT passages.[41] While dreams bearing specific instructions usually communicate reliable messages, there is just enough ambivalence in the BT toward dreams to leave the audience wondering whether Meir's skepticism is warranted, hence whether the Patriarch really enjoys divine endorsement.

To conclude Meir's story the narrator takes us to the next generation, to RSBG's son R. Yehuda HaNasi and grandson R. Shimon.[42] The trajectory of Meir's rehabilitation parallels aspects of his relegation at the outset. Where Meir and Natan justified deposing RSBG with scriptural warrant, now R. Shimon invokes scriptural authority to restore Meir's name.[43] RSBG's objection to the lack of distinctions and of adequate recognition of his rank galvanized him to formulate the initial "teaching." R. Shimon's objection has similar force and effect. He protests that the absence of the tradent's name prevents later sages from recognizing and honoring earlier masters, and this objection leads the Patriarch to reformulate the quotation formula.[44] The parallel movement governing Meir's relegation (insufficient honor for the Patriarch) and rehabilitation (insufficient honor for a sage) connects the two sources of honor—lineage and Torah: both must be recognized.[45]

Meir's posthumous rehabilitation cannot include the self-humbling inherent in a direct apology, but it bears a sign attesting his loss on the battlefield of honor. The unusual quotation formula imposed by R. Yehuda HaNasi seems to carry a type of stigma; apparently the indirectness ("They said in the name of R. Meir") as opposed to direct attribution ("R. Meir said") gives Meir less honor, or compels him to share the attribution with other sages who transmit his traditions. The formula "in the *name* of R.

Meir" emphasizes the restoration of his name, the loss of which troubled R. Shimon. Indeed, the words "their name (*zikhram*) is forgotten" precede R. Shimon's prooftext, while "you have destroyed their name" (*sheman mahita*) precede his father's rejoinder.[46] In the end Meir's name, hence honor, reclaims its rightful place. If Meir and Natan failed to unseat RSBG, so too the Patriarch could not completely destroy Meir's name.

The conclusion of the story, Rava's characterization of R. Yehuda HaNasi as an "extremely humble person," an *'anvetan*, serves three purposes. Structurally, it parallels R. Yohanan's opening comment, an attributed Amoraic statement, and thus provides closure to the composition. Second, it raises the stakes. Even an *'anvetan* Patriarch takes harsh steps when threatened. If the humble R. Yehuda HaNasi still felt umbrage at the old controversy, then Meir and Natan must have committed a serious offense. Woe to any rabbi who mutinies against a Patriarch of less exemplary character. Third, it informs the audience that the Patriarchs were justified in their retributive measures, that R. Yehuda HaNasi (and presumably RSBG) was not motivated exclusively by status-seeking conceit. *'Anvetanut,* as we saw in the previous chapter, ranks among the most valued qualities in the BT.[47] Explicit characterization of this sort by the narrator (or an Amora quoted by the narrator), an extreme rarity in rabbinic stories, creates a deep impression.[48] The only outside judgment passed on the characters, this editorial intrusion (albeit couched in the mouth of Rava)[49] provides another important clue to the storytellers' sympathies.

Before rendering a general assessment of the story, it will be helpful to consider the narrative structure.

## Structure

In the course of the preceding analysis we called attention to many structural devices, including verbal links, stylized repetition, and thematic parallels. The analysis suggests the following structure.

[1] Amoraic introductory statement: teaching dated to Patriarchate
  [2] Patriarch reduces Meir and Natan's honor with a teaching
    [3] Meir and Natan absent; then discover their reduced honor
      [4] The plot: Meir and Natan stress their superiority in Torah
        [5] True purpose of the plot: depose the Patriarch and claim higher ranks
          [6] Yaakov worries about shame and studies
            [7] Patriarch concerns himself with the academy

Torah, Lineage, and the Academic Hierarchy 191

[8] Patriarch studies Torah
[7'] Patriarch challenged to teach in the academy
[6'] Patriarch acknowledges that without study he would have been shamed
[5'] Meir and Natan removed from the academy and lose rank
[4'] Meir and Natan display superiority in Torah
[3'] Meir and Natan brought back into academy, but reduced in honor
[2a'-b'] Patriarch raises honor of Natan and Meir to preplot level by reformulating teachings. (Natan appeases the Patriarch; Meir is rehabilitated.)
[1'] Amoraic concluding judgment: humble Patriarch formulates teachings

The chiasm is somewhat flawed, since I have divided 2' into 2a' and 2b'. A glance at the full translation above shows that this section is considerably longer than the corresponding part (2), which violates the symmetry that chiastic structures should display.[50] Nonetheless, because I am not making claims about the "deep structure" of narrative but analyzing structure as one strategy to appreciate the dynamics of the story, this imperfection need not be fatal.[51] The heuristic value inheres in the correspondences, contrasts, and relationships between sections of the story, and these are highlighted by the chiasm, but not absolutely dependent on it.[52]

Chiastic structures generally present the second half of a story as a contrast to the first half and invite the audience to connect the corresponding sections.[53] Sections 1 and 1', the two attributed Amoraic statements, mention the Patriarch and the formulation of teachings. In both cases the formulation pertains to honor and demonstrates his ability to manipulate tradition to this end. In 2 the three figures start out equal until RSBG reduces Meir's and Natan's honor relative to his. In 2a'-2b' Natan and Meir regain something of their former honor by no longer having their names effaced from their traditions. In 2 RSBG objects that no distinction signals his higher rank, which justifies (in his opinion) reducing his colleagues' honor. In 2b' Shimon objects that masters of Torah are not known or honored, which justifies the restoration of some honor. Both the reduction and restitution are accomplished by (re)formulating traditions. In fact the asymmetry noted above, that 2a'-2b' is far longer and more complicated than 2, perhaps illustrates that to reclaim honor from Patriarchs proves considerably more difficult than to lose it.[54] In 3 Meir and Natan are absent from the academy and then discover their reduced honor. In 3'

they return to the academy but have their honor diminished by anonymization. Sections 4 and 4′ depict Meir and Natan's superiority in Torah. In 4 proficiency in Torah supplies their justification for the plot, in 4′ the reason they must be returned to the academy. These two brackets (3+3′, 4+4′) emphasize the disparity between the rabbis' plans and consequences. Instead of their Torah bestowing upon them the highest ranks, it serves only to restore them to the academy. Likewise 5 and 5′ present the ironic reversal that transpires. Meir and Natan plan to remove RSBG, but they are banished from the academy.[55]

Sections 6 and 6′ call attention to shame in the academy and how to avoid it: through study. Sections 7 and 7′ recount first the Patriarch's awareness of an incident in the academy that demands his concern ("some matter in the academy"), a possible challenge to his authority, and then the incident itself, the challenge to his knowledge. The center of the chiasm at 8 provides a picture of the Patriarch studying Torah. A crucial message of the story is that the Patriarch must study.

The contrasts between parts 1–5 and 5′–1′ emphasize the utter failure and counterproductive outcome of the scheme due to the power of the Patriarch. The plans of Meir and Natan boomerang and turn out much worse for them in the end. In the first part they aspire to move one notch up the academic hierarchy. In the final part they struggle even to be readmitted to the academy and to preserve their names. The Patriarch(s), on the other hand, retain(s) the office and power to formulate traditions as in the beginning.

The central part of the chiasm, 6–6′, is somewhat independent of the preceding and following flanks. The storytellers could have sufficed with one simple linking sentence such as "RSBG found out about the plot" or "R. Yaakov told RSBG what they said" and continued immediately with 5′, "He ordered and they removed them from the academy." Including this central unit reveals a second concern: the Patriarch, the academy, and the study of Torah. And by placing the central unit between the two halves of the chiasm, the scheme and its consequences, the storytellers mean us to connect the two. The Patriarch can prevail against such plots only by studying Torah.[56]

We mentioned in passing the repeated words that provide additional structure. Sections 1, 2, 6, 6′, 2′ use the term *teach* (*teni*), and synonyms appear in 3, 4, and 8. Five sections mention the Patriarch formulating or enacting a teaching: 2–3 (the initial tradition), 4′ (the anonymous designations) and 2′-1′ (the revised quotation formula). The motifs of rising, raising, or standing appear in 2 and 3 (rabbis rising to show honor), 6 (the

upper-story), 6' (RSBG "stands up" or stymies the rabbis; *'oqim*), 3' (they designated/raised Meir and Natan; *'asiqu*) and 2' (dreams do not "raise"; *ma'alin*). Study of Torah, the Patriarch formulating tradition, and public honor (manifested in rising) are three important concerns of the story.

As a whole, the story embodies a tension between lineage and Torah as the source of academic honor. In Pitt-Rivers's terms, there exists a tension between honor=precedence (lineage) and honor=excellence (Torah). Conflict arises because these grounds for honor are not necessarily correlated. Perhaps in the ideal world the Patriarch would be most proficient in Torah. In the world imagined in the story, probably a better reflection of reality, this happy coincidence does not occur. The story addresses the questions that result from the disjunction. Must the Patriarch be preeminent in Torah? If not, can he remain Patriarch? Should he still receive the highest academic honors? Or, from the opposite perspective: do those who are greater in Torah have a right to the highest ranks and honors in the academy?

Neither the Patriarchs nor the rabbis completely vanquish the other side, and the motives of both parties are cast in somewhat negative light. Yet the Patriarchs clearly have the upper hand and enjoy the sympathies of the storytellers. This bias is surprising. We expect a different story, or at least different sympathies, from the BT storytellers (the redactors), who valued Torah above all else: that those preeminent in Torah would receive the highest academic honors, that the status-mongering Patriarch with insufficient command of Torah would be deposed. But this is not the story they tell.

The answer to the question is therefore that the Patriarch need not be preeminent in Torah, that those sages most proficient in Torah will not necessarily occupy leading positions or receive highest honors in the academy. Torah knowledge apparently is not the exclusive basis for academic rank. Indeed, the story hints that proficiency in Torah may not be a sufficient criterion for the leading academic positions. The story serves as a warning to rabbis who, like Meir, are dissatisfied at the Patriarch (or leader of the academy) receiving the highest honor although inferior in Torah, or like Natan, who both know more Torah and have high lineage.

At the same time the story issues a warning to the "Patriarch" or some such leader of the academy. He who occupies the highest rank but lacks proficiency in Torah lives in constant danger of being shamed by others. No matter how distinguished his lineage, the academy is fundamentally a place of Torah, so he had better study as much as possible and constantly pay attention to the discussions. Perhaps he should be wary of insisting on

public displays of honor, especially when his mastery of tradition lags behind others. Certainly he should restrain himself from manipulating traditions for self-serving ends lest he provoke the wrath of other sages. RSBG staved off public humiliation only by the fortunate intervention of R. Yaakov; nothing assures that the next Patriarch will be so lucky. The section on "Cultural Context" below explores the background to these messages.

## Sources and Compositional Art

The BT story is based on a brief account found in yBik 3:3, 65c, which also relates to tSanh 7:8. We have seen in previous chapters that, while the BT supplements and embellishes Palestinian stories, it often leaves portions of the source more or less intact. In this case, however, the BT reworking is considerably more elaborate.

> When R. Meir would go up and study in the house of assembly (*bet va'ada*), all the people would see him and rise before him. When they heard this *tanna* recite [this tradition, tSanh 7:8] they wished to treat him (Meir) accordingly. He became angry and left. He said to them, "I have heard that one increases [the level] of holiness but does not decrease."[57]

In both the BT and PT Meir becomes angry when the students show him less honor. In both he winds up outside of the academy (BT) / assembly house (PT).[58] Yet the differences are striking. The PT assumes tSanh 7:8 always had been the law, but the students in the assembly house did not know it. In the BT the Patriarch institutes tSanh 7:8 as a new law. In the PT the rabbis show Meir reduced honor when they hear the law for the first time. In the BT the *purpose* of the law is to reduce Meir's (and Natan's) honor. In the PT Meir leaves the academy on his own accord; in the BT the Patriarch forces him out. The PT tells of Meir's reaction; the BT of conflict between Meir (and Natan) and the Patriarch (and his progeny). The PT has no Patriarch(s), no Natan, no attempted deposition, no punishment or rehabilitation.[59] Most importantly, it lacks the conflict between lineage and Torah as the foundation for academic honor. These changes go far beyond the reworkings of the previous chapters to the point where the stories share little substance in common. In principle, then, the redactors could take extensive liberties with their narrative sources.[60] Their narrative art involved some free and creative composition besides the usual supplementing and embellishing of previous sources.

The BT redactors reworked this PT story by drawing on Babylonian

motifs and adapting other BT passages, as Goodblatt and Jacobs demonstrated.⁶¹ Yet the main source of the BT revision remains to be identified. It appears that the redactors based at least part of their story on an interpretation of the proximate material in Tosefta Sanhedrin Chapter 7, the source of the *baraita* (tSanh 7:8). Provisions of both tSanh 7:7 and 7:10 intersect with the story. tSanh 7:7 rules that "One only asks about the current topic" and then explains: "If one asks about an unrelated topic he must say, 'I have asked about an unrelated topic.' These are the words of R. Meir. But the sages say, 'He need not [say this],' for the whole Torah is interrelated." The concern is that digressive, unrelated questions may distract attention from the judicial business at hand. tSanh 7:10 mandates:

> When a sage enters one may not ask him immediately, but [waits] until he has collected his thoughts. Similarly, when a scholar enters, one may not ask until he has collected his thoughts. If one enters and finds them discussing a law, he may not jump into their discussion until he sits and determines what topic they discuss.

Disciples should not ask their masters miscellaneous questions unrelated to topics under discussion. The source does not explicitly say why not, but the initial reference to "collecting thoughts" implies that a random question may discombobulate the sage's mind as he frantically attempts to focus on the new subject.⁶² The themes of an unrelated topic, the immediate questioning of a sage upon his entrance, and uncollected thoughts recall Meir and Natan intentionally asking RSBG about an obscure tractate in order to shame him.⁶³ We have noted in previous chapters that the redactors draw on material from the proximate BT passages found in the new context (that is, the context into which the redactors place the source) when reworking a Palestinian story.⁶⁴ Here they drew on proximate Toseftan material when they reworked a story based on a Toseftan source (tSanh 7:8). That is, they brought to bear on the story the proximate source material rather than proximate talmudic material.⁶⁵ Again we see that talmudic narrative has a strong exegetical dimension.

The final source-critical issue I will address is the opening attribution to R. Yohanan, a second generation Palestinian Amora, which raises the perennial question of the reliability of Amoraic attributions. Where this statement ends (or even purportedly ends) is not clear; the quotation theoretically could be extended until the closing statement attributed to Rava (1'). However, the shift from Hebrew to Aramaic with the line "When Rabban Shimon b. Gamaliel would enter" betrays the hand of the redac-

tors (3).⁶⁶ The PT does not attribute the story or any pertinent statement to R. Yohanan. These considerations and the numerous Babylonian motifs cast doubt on the authenticity of the attribution. We noted above the structural function: by attributing the opening line to R. Yohanan and the concluding line to Rava the storytellers mark the boundaries of the story and bracket the anonymous narration of the middle sections. Moreover, the declaration that a teaching was promulgated in a specific time functions as an effective narrative device, which creates expectations that a story explaining the circumstances will follow, much like the formula "Once upon a time." But are structure and narrative efficacy sufficient explanation for a pseudepigraphic attribution? And why R. Yohanan?

Goodblatt observed that in four other BT passages an Amora employs the phrase, "This teaching was taught in the days of R. So-and-so," and continues with an account of the circumstances that motivated the promulgation of the teaching.⁶⁷ He observed that the phrase never appears in the PT, and concluded that it is a fixed literary form reflecting the Babylonian provenance of the story. Significantly, three of these four cases are attributed to R. Yohanan.⁶⁸ Moreover, the story uses this "literary form" in an anomalous manner. In the other four cases the historicizing of the tradition and accompanying explanation resolve contradictory sources by explaining why change was necessary.⁶⁹ Our story, by contrast, does not resolve a contradiction within or between sources. It asserts that there had been an original practice (that the Patriarch, Head of the Court, and Sage received equal honor) and then accounts for the shift to the protocol legislated by the Tosefta. That is, in the other four cases two contradictory traditions appear outside of the horizons of the account, and the historical settings and stories present them as an "original" and a "reformulated" tradition. Without the talmudic accounts we would still have to explain the contradictions. Only in our case does the story invent an "original" practice and then explain why the purported change occurred.⁷⁰ It appears, therefore, that the BT redactors borrowed the literary form from the other passages and carried over the standard attribution to R. Yohanan as well. This process accounts for the attribution and the abnormal usage. The redactors adapted a fixed literary form for the purposes of their story despite the slight irregularity.

The assumptions behind the redactors' adaptation of this literary form are significant in their own right. They portray the Patriarch singlehandedly formulating a tradition de novo in response to a perceived lack of honor. As noted above, traditions are reformulated twice more in the story.

The redactors also invent a fictitious version of mBekh 9:8 ("*Others say, 'If it had been an exchanged beast, it would not have been offered'*"). A remarkable parallel emerges between the methods with which the BT redactors reworked their narrative sources and the ways the Patriarchs and their associates reformulate traditions in the story. We have seen that the redactors adapted, supplemented, modified, and embellished their narrative sources to compose a new account. Similarly, the story depicts the Patriarchs freely creating, modifying, and revising their legal sources. Both processes should recall Halivni's account of the literary activity of the Stammaim as they composed the talmudic *sugya*. Indeed, the Stammaim sometimes present both an initial and corrected version of a source, experiment with alternative formulations of traditions or entire *sugyot*, and revise their sources for legal or literary reasons.[71]

The storytellers thus portray the characters and their activities in their own image: as Stammaim who mold their sources with considerable license. The highly developed academy represented in the story, as discussed in Chapter 1, likewise reflects the institutionalized academy of post-Amoraic times, not the small-scale disciple circle of the Amoraic period. It is a building where sages are thrown out and brought in, an establishment that continues in subsequent generations, an organization with ranks, honors, and numerous students. The story offers a vivid picture of the Stammaitic academy and its activities.

## *Literary and Halakhic Context*

The story appears in the section of Talmud that comments on mHor 3:8:

[A] A priest precedes (*qodem*) a Levite, a Levite [precedes] an Israelite, an Israelite a *mamzer*, a *mamzer* a *natin*, a *natin* a convert, a convert a freed slave.

[B] When [is this the case]? When they are all equal. But if the *mamzer* is a sage and the high priest an ignoramus, then the *mamzer*-sage precedes the high priest–ignoramus.

The Mishna begins by establishing a hierarchy based on lineage. Priests, the most distinguished descent group, precede Levites and so on down the line until the emancipated slave, the lowest lineage.[72] To what "precedes" refers is not stated explicitly. The previous paragraphs discuss when males precede females and females males, and refer to provision of sustenance

and clothing, return of lost objects, redemption from captivity, and prevention of degradation. Presumably mHor 3:8 refers to these imperatives at least, and apparently to all similar needs. This is a paradigmatic statement of honor=precedence as the dominant conception.

The second part of the Mishna abruptly introduces a different criterion — proficiency in Torah — and asserts that it supersedes lineage. This provision almost eliminates lineage, which now operates only in the rare case when two individuals possess identical command of Torah. Mention of a *high* priest, the acme of priestly lineage, relegated below the learned *mamzer*, who cannot marry a woman of Israelite descent, let alone an ordinary priest, offers a striking example of the Mishna's principle. Proficiency in Torah, not lineage, determines the hierarchy.[73] This is a paradigmatic statement of honor=excellence as the dominant conception.

A related hierarchical principle operates in tHor 2:8–10, with which the talmudic *sugya* begins its commentary to the Mishna.[74] The Tosefta rules that a sage precedes the king, the king precedes the high priest, the high priest the prophet, and so on for various offices in the temple administration down to the ordinary priest. This hierarchy relates to positions in the politico-religious institutions, and the sage again occupies the head position: his honor comes before that of both kings and high priests.

The story describes a violation of the hierarchical principle established in these legal sources. RSBG possesses superior lineage, for the Patriarchal family claimed Davidic descent (see below).[75] Yet his (and his descendants') proficiency in Torah is inferior to that of Meir and Natan. That he should claim honor above that of Meir and Natan contradicts the thrust of the Mishna and Tosefta.[76]

The attempt of Meir and Natan to claim the highest honor—to "take precedence" over RSBG—fails miserably. Although they ostensibly act in line with the rulings of the Mishna and Tosefta, they lose their positions and almost have their memories effaced. The story should therefore be understood as a warning, perhaps even a voice of protest, against the view of the Mishna-Tosefta. Where the Mishna baldly asserts that the learned *mamzer* precedes the ignorant high priest, the story illustrates how this view does not always work in practice. The objective, legal prescription may create enormous problems in the actual political realm. To act in accord with the ideal of these Tannaitic sources involves great risks and may well end in disaster.[77]

The talmudic *sugya* that follows the story[78] also provides some insight into its purpose.[79]

[A] R. Yohanan said, "RSBG and the sages disagree: 'Sinai' and an 'Uprooter of Mountains'—which is superior (*'adif*)? One maintains that 'Sinai' is superior and the other maintains that an 'Uprooter of Mountains' is superior."[80]

[B] Rav Yosef was "Sinai." Rabba was an "Uprooter of Mountains." They sent there (Palestine), "Which of them is superior?" They sent [back], "Sinai is superior," as a master has said, "All need the owner of wheat."[81] Nevertheless, he [Rav Yosef] did not accept [the position of leadership]. Rabba ruled (*malakh*) twenty-two years, and then Rav Yosef ruled. All the years that Rabba ruled, Rav Yosef did not call a bleeder to his house.[82]

[C] Abaye and Rava and R. Zeira and Rabba bar Rav Matneh were sitting and needed a head (*rosh*).[83] They said, "Whoever says a thing that is not refuted will be the head." They were all refuted. Abaye was not refuted. Rabba saw that Abaye was lifting his head. He said, "Nahmani! Open [your discourse] and speak."[84]

[D] It was asked: Of R. Zeira and Rabba bar Matneh, which one is superior? R. Zeira is sharp and raises difficulties (*harif umaqshe*). Rabba bar Matneh is balanced and decisive (*matun umasiq*). Which one? [The question] stands (*teiqu*).

The section intersects with both the story and the Mishna-Tosefta on several levels.[85] The central questions are who should "rule" (*malakh*), that is, lead the sages, and on what basis, as in the story. Several text witnesses formulate this question as who "takes precedence" (*qodem*), the same language as in the Mishna.[86] One opinion is attributed to RSBG, the protagonist of the story.[87] The reference to "refuting" (*mifrakh*) in C recalls Meir and Natan raising difficulties and solving them. And Rabba calls on Abaye to "open" his discourse, just as RSBG "opened" and taught.[88]

On two points, however, the passage contrasts sharply with the story. First, the characteristics proposed for leadership all pertain to excellence in study: mastery of tradition and analytical brilliance in A and B; irrefutability of one's teaching in C; sharpness of questions or balanced decisions in D. Which of these should take precedence is unclear, but one must excel in some aspect of Torah.[89] Second, in B Rav Yosef amicably cedes the position of leadership and honor, despite the clear indication that he should rule. He even takes pains to act in an extremely humble way, avoiding the slightest show of honor.[90] Similarly, Abaye, Rava, and R. Zeira decide who will

be "head" in a peaceful manner. The characters in these accounts are all sages, not Patriarchs, and no genealogical claim competes with Torah as the grounds for leadership and the associated honors. The setting in each case is Amoraic Babylonia, not Palestine.

This concluding section portrays a world other than the story, a world without a hierarchy of lineage, where rank depends exclusively on proficiency in Torah, where honor=excellence reigns supreme. This section thus coheres with mHor 3:8 by making Torah the criterion for primacy, in this case primacy of leadership, "precedence," and the highest honors. The juxtaposition of the story with these accounts, like the juxtaposition with the Mishna, reinforces the implicit warning. To apply the criteria of the Babylonian Amoraim, to select a rabbinic leader based on knowledge of Torah, does not always work in practice—evidently in the practice of post-Amoraic times. At a more general level, the placement of the story between mHor 3:8 and these accounts focuses attention on questions of Torah, rank, and honor. The extended *sugya* comprises a meditation on the criteria for and nature of rabbinic leadership.

To appreciate the tension between the BT story and the proximate Mishna it will be helpful to consider the story which the PT redactors juxtapose with mHor 3:8. In place of the story about honors in the academy (or assembly house) the following story appears (yHor 3:8, 48c):

> Two families in Sepphoris, the Bulvati (councillors) and the Pagani (villagers),[91] would greet the Patriarch every day, and the Bulvati would enter first and leave first. The Pagani went and earned merit in Torah (that is, studied Torah). They came and asked to enter first. The question was asked of R. Shimon b. Laqish. R. Shimon b. Laqish asked R. Yohanan. R. Yohanan went and taught in the academy of R. Benaiah, "*If the mamzer is a sage and the high priest an ignoramus, even a mamzer-sage precedes the high priest–ignoramus* (= mHor 3:8)."

The elites, the councillors, took precedence over the rural commoners until the latter learned Torah. The PT follows the story by asserting that the principle was also applied in the "session" (*yeshiva*), referring either to the court or to the rabbinic academy. The tractate concludes with an exegetical tradition: "*She (wisdom = Torah) is more precious than jewels (Prov 3:15)* — even more than the one who enters into the Holy of Holies," that is, the high priest.[92] In other words, the Torah (even of the *mamzer*) is more precious to God than the high priest who enters the holiest temple precincts. This PT story quotes the conclusion of mHor 3:8, and the following passage

explicitly applies it to rabbinic institutions and supplies an exegetical justification. Thus the PT *illustrates* the principle of the Mishna. The BT story, in contrast, implicitly warns against applying the Mishna's principle to the rabbinic academy.

Contrast with the PT also suggests that the BT redactors modified their narrative sources in light of the literary contexts they selected. The PT version of the story about academic honors appears in the third chapter of Tractate Bikkurim, not in connection with mHor 3:8. mBik 3:3 reports that when pilgrims brought firstfruits to Jerusalem various temple officials went out and greeted them "according to their honor": the greater the status of the pilgrim, the more important the official who welcomed him. The PT *sugya* proceeds to discuss other types of honorific behavior, such as rising in honor of the elderly, the high priest, and the sages, and then relates its version of the story (yBik 3:3, 65c). The story presents a situation analogous to mBik 3:3 in which sages replace pilgrims as the recipients of honor, and entrance to the assembly house replaces entry to Jerusalem: the higher the academic rank, the greater the show of honor upon entry. As we noted, the story involves no tension between Torah and lineage as the basis for honor, as found in mHor 3:8 and the BT version. Evidently the BT redactors transferred the story to its new context in Tractate Horayot and reworked it simultaneously.

## Cultural Context

The tension between lineage (*yihus*) and wisdom has deep roots in biblical civilization and ancient Judaism. Priests competed with prophets or sages schooled in the wisdom tradition of the Ancient Near East for recognition as judges, interpreters, and leaders. In the second temple period the priestly theocracy and priestly-oriented parties such as the Sadducees and the Qumran sect faced similar challenges from scribes and then Pharisees, who based their claims on knowledge rather than pedigree. Even after the loss of their power base with the destruction of the temple, priests struggled with the ascending rabbinic movement to be religious leaders.[93] These competing groups contended not only for power but for status and honor as well.[94] Nor was priestly lineage the only distinguished line of descent. Davidic genealogy garnered tremendous respect from all elements of Jewish society. Both the Patriarchate in Palestine and the Exilarchate in Babylonia quickly became hereditary offices and both families traced their lineage to King David. Thus sages, wise men, and rabbis whose status devolved exclusively from knowledge faced challenges from a variety of dy-

nastic and genealogical claims. At the same time, these two bases for status and power were not always in opposition. Ezekiel and Jeremiah were priests as well as prophets; Ezra was priest and scribe; and many Pharisees and sages were priests. Rabbinic traditions remember Simon the Just as the ideal priest and sage. The Mishna and other rabbinic works are heavily invested in the temple cult and priesthood even as they glorify knowledge of Torah as the ultimate value.[95]

Understood against this background, the story grapples with the enduring tensions in Jewish society between lineage and knowledge. What still requires explanation, however, is the surprising recognition *by the Babylonian Talmud* of lineage as a basis for honor that seems to supersede knowledge of Torah. How are we to explain the high status accorded to lineage in a BT story?

Now it is well known that the Babylonians prided themselves on the purity of their pedigree.[96] bQid 69b asserts that "Ezra did not go up from Babylonia [to Palestine] before he rendered it like fine sifted flour." That is, Ezra removed all Jews of tainted descent from Babylonia when he returned to Palestine. Consequently, "all countries are as dough (impure lineage) in comparison to the Land of Israel, and the Land of Israel is as dough in comparison to Babylonia" (ibid).[97] Numerous Babylonian traditions describe sages worrying about the lineage of their prospective wives or daughters-in-law and offer various suggestions on how to determine their genealogical purity with certainty (bQid 71a–b). R. Zeira, a prominent Babylonian Amora who moved to Palestine, reportedly refused to marry the daughter of the eminent Palestinian R. Yohanan who sardonically commented, "Our teaching is fit but our daughters are not fit?"[98] The BT even claims, "When God causes his presence to rest over Israel, it only rests over its families of pure lineage."[99] To a certain extent, then, the story's emphasis on lineage coheres with general Babylonian rabbinic values. Yet the story concerns the rabbinic academy and academic rank in particular, not general social status. To what degree did lineage confer status among Babylonian rabbis and comprise a basis for academic rank?

Geoffrey Herman has argued recently that Babylonian sages valued priestly lineage much more highly than heretofore has been recognized, and that priestly lineage seems to have improved the chances for leadership.[100] Herman studied the lineage of sages reported by later traditions to have been heads of the academies.[101] Of the seven heads of the Sura academy whose lineage is known, one was a priest and two married daughters of priests.[102] Of the nine heads of the Pumbedita academy whose lineage is known, five were priests and two married daughters of priests.[103] The

precise percentage of priests among Babylonian Jewry is not known, but no evidence indicates that it was disproportionately high. Yet of sixteen (purported) heads of the academy whose lineage is known, 63 percent were related to the priesthood by blood or marriage. Herman also points out that many of the Babylonian rabbis who moved to Palestine and became heads of the Palestinian academy were priests. R. Hanina bar Hama, who led the Sepphoris academy, and Rabbis Eleazar b. Pedat, Ami, Asi, and Hiyya bar Hama, who led the Tiberian academy, were all Babylonian priests. These outstanding Babylonian Amoraim came predominantly from priestly families.[104] Many families of Babylonian Geonim, Herman notes, claimed priestly descent and cherished their ancestry. He argues that this tendency need not be seen as a later Geonic innovation but as continuous with earlier values. Babylonian sages of the talmudic period also esteemed priestly descent and apparently considered it an advantage for being appointed to positions of leadership.

Besides honoring priestly lineage, both Palestinian and Babylonian sages seem to have placed increasing value on rabbinic lineage and even developed dynastic tendencies. Gedaliah Alon called attention to rabbinic traditions concerning "the sons of sages."[105] This title apparently refers to sons of rabbis who occupied a defined position within the rabbinic hierarchy due to their parentage. Based on these and other sources, Alon concluded that in the third and fourth centuries C.E. some rabbis considered "Torah learning and status, as well as the privileges these conferred, hereditary among the families of the sages."[106] Moshe Beer argued the same point based on tendencies in rabbinic exegesis.[107]

Several BT traditions illustrate the varying perspectives on the importance of lineage vis-à-vis Torah.[108] Consider the following brief interchange:

> The rabbis said to R. Preda, "The grandson of R. Avtulos, who is tenth [generation in descent] from R. Eleazar b. Azariah, who is tenth [generation in descent] from Ezra, stands at the door."
>
> He said to them, "What is all this? If he is a scholar—that is well. If he is the offspring of nobility (*bar 'avahan*) and a scholar (*bar 'orayan*)—that is even better. If he is the offspring of nobility but not a scholar—may fire consume him."
>
> They said to him, "He is a scholar." He said to them, "Let him enter."[109]

The rabbis evidently believed that R. Preda would receive any man of such impressive lineage. R. Preda's response, "What is this?" probably means,

"What is all this lineage? Why tell me about his ancestry?" Nonetheless, he too concedes that "it is even better" if the visitor is not only a scholar but a scholar of distinguished pedigree.[110] Moreover, the response, "If he is the offspring of nobility but not a scholar—may fire consume him," shows that Rav Preda thought it inappropriate that a man of high lineage should not be a scholar. The varying assessments expressed in this dialogue almost map directly onto the three protagonists of the story: Rabban Shimon b. Gamaliel (lineage); Natan (lineage and Torah); Meir (Torah). This account also grapples with the relative importance of Torah and lineage but places greater weight on Torah than the story. It is not accidental that illustrious lineage is traced specifically to Ezra. As both priest and scribe of Babylonian provenance, Ezra presumably represented for Babylonian rabbis the ideal combination of Torah and lineage.[111]

Tensions between lineage and knowledge implicit in this talmudic passage find explicit expression in Geonic sources, which also relate directly to the basis for academic rank. Rabbi Nathan the Babylonian, a traveler who visited the Geonic academies in the tenth century, observed that lineage, not knowledge, essentially determined a sage's place. He describes the structure of the Geonic academy as follows:

> And the seven are called heads of rows. And it sometimes happens that others are greater than they in wisdom but are not appointed over them as heads of rows—not because of their intellect, but because they have inherited their father's rank. For if one of the heads of rows has died and left a son capable of filling his place, he is appointed to his father's place and occupies it. And if one of the fellows is slightly greater in wisdom than the child, he is neither promoted (over him) nor placed below his child (automatically), and it is the prerogative of the head of the academy to appoint as a head of the row whom he pleases. . . .
>
> And the father's place goes to the son unless he is seriously lacking in knowledge, in which case he is displaced; yet if there is something in him and he is worthy of sitting in one of the seven rows, he is placed there. And if he is not worthy of one of the rows, he is placed with the other members of the academy, the students. . . . And if one of the members of the seven rows is greater than another in wisdom, he is not seated in his place because he did not inherit it from his father, but he is given an increased allocation on account of his wisdom.[112]

The primary determinant of hierarchy, be it for the head of the main seven rows, within the seven rows or among the general students, is one's father's

place (echoes of "the belt" of Natan's father making him the Head of the Court in the story). Nevertheless, the tensions between lineage and "wisdom," that is, knowledge of Torah, are almost palpable. Lineage does not help those who are "seriously lacking in wisdom" or "unworthy," and the head of the academy has a certain amount of discretion to weigh the factors and assess the candidates. One wonders whether the monetary incentive pacified resentment at sitting behind an inferior, or whether challenges such as that of the story periodically erupted.

Why should Babylonian sages have valued lineage and considered it relevant to becoming head of the academy? Herman suggests that the glorification of priestly lineage devolves not only from traditional historical and theological conceptions, but may have emerged as a rival claim to the Exilarch, whose legitimacy was based on the claim to Davidic descent.[113] The sages and the Exilarchate competed throughout the Amoraic, post-Amoraic and Geonic periods for the allegiance of Babylonian Jewry and the leadership of Jewish society. A rabbinic leader boasting priestly lineage challenged the Exilarch on his own terms. Moreover, rabbinic culture gradually may have internalized the value of lineage, because of both its prominent place in Jewish history and its place in (nonrabbinic) Babylonian Jewish culture.

A second possibility is that the values of the ambient Sasanian-Persian culture influenced the Babylonian sages. A rigid and hierarchical class division, almost to the point of castes, characterized the Sasanian social structure.[114] Because Sasanian law forbade marriage between classes, commoners had little opportunity to move into the privileged classes. Ehsan Yarshater describes Sasanian ideals thus:

> [A] strict observance of distinction between the social classes . . . was considered a necessary condition for a stable and orderly society, since nothing could undermine the social order more than class confusion and elimination of class differentiation. . . . The theory was that men of low birth, even if they acquired the necessary skills, were not fit to handle the responsibilities of men of noble birth, and so it was incumbent upon kings to preserve the purity of the higher classes. Thus, it was invariably understood that the people must be kept to their own stations and might not aspire to cross the lines of social class.[115]

The upper classes zealously guarded their lineage and placed great value on noble descent. Such values were considered the defining characteristic of the dynasty: "[T]he Founder of the Sasanian dynasty is quoted as having proclaimed that 'nothing needs such guarding as degree among men,' and

is said to have established a 'visible and general distinction between men of noble birth and common people with regard to horses and clothes, houses and gardens, women and servants ... so no commoner may share the sources of enjoyment of life with the nobles, and alliance and marriage between the two groups is forbidden.'[116] That Babylonian rabbis valued high "degree among men" parallels this cultural vision. The Sasanians naturally considered noble descent a prerequisite for leadership positions. In accounts of the struggles of legendary warriors and kings, the contenders ridicule the low birth and pedigree of their rivals: "Although the importance of personal accomplishment (*hunar*) is often emphasized in the course of heroic conceits, it is evident that Iranian society placed great value upon family and descent (*gōhar*)."[117] These twin sources of prestige recall those of the story: knowledge of Torah (personal accomplishment) and lineage (family and descent).

The importance of lineage in the story, then, need not be considered anomalous within Babylonian rabbinic culture. While proficiency in Torah was the dominant value, it was not the exclusive basis for status. The story and the proximate *sugya* in bHor 13b–14a can be understood as expressions of the different valuations of lineage and Torah as criteria for academic honor and leadership.[118]

## The Historical Context

I remain somewhat dissatisfied with the preceding analysis because it does not do sufficient justice to the role of the Patriarch and the importance of Patriarchal lineage. I have interpreted the figure of the Patriarch to represent the current head of the academy and the references to lineage to represent claims to that rank based on lineage. The problem of the cultural divide—that we do not know exactly what the Patriarch represented to the BT redactors—cannot always be bridged. However, it strikes me as significant that in several places the BT employs the term "Patriarch" (*nasi*) to refer to the Exilarch (*reish galuta*).[119] If that is the case here, then the story requires a different interpretation.[120]

The Babylonian Exilarch was a hereditary office that, like the Palestinian Patriarch, claimed Davidic ancestry and took great pride in this lineage.[121] Like the Patriarch, the Exilarch received authority from the state to administer the internal affairs of the Jewish community. And like the Patriarch, the Exilarch's relationship with the sages ranged from outright hostility and competition to friendship and cooperation.[122] Some Exilarchs had close relatives who were sages; others may have spent time studying

## Torah, Lineage, and the Academic Hierarchy 207

with leading sages or sent their children to be educated among rabbinic disciples. Certain Exilarchs may have funded the academies and provided financial support for sages. While the sages benefited from the Exilarch and his authority, they also came into conflict with the Exilarchate over various issues, such as judicial decisions, synagogue practice and the loyalty of the general Jewish community. All this is difficult to determine precisely since we depend on sundry traditions interspersed throughout the BT, many of them with polemical edge or legendary coloring. At all events, the numerous stories of conflicts and struggles between sages and Exilarchs make it clear that competition between the institutions was an ongoing problem of rabbinic culture.[123]

The crucial question, for our purposes, is the extent of the Exilarch's involvement in rabbinic academies. Did the Exilarch control—or try to control—the academies? Did he have great influence on academic policy by virtue of his financial and political power? Did he appoint the head of the academy directly? Talmudic sources on this topic, unfortunately, are elliptical and vague, and do not tell us as much as we would like to know. Both Moshe Beer and (the early) Jacob Neusner assume that the Exilarchs sought to dominate the academies, appoint the leaders, and determine institutional policy.[124] Beer points to the following story from bGit 7a:

> Mar Uqba (the Exilarch) sent to R. Eleazar (head of the Palestinian academy in Tiberias): "Certain men are opposing me, and I have the power to hand them over to the government [to be put to death]. What [should I do?]" He made lines [on the page] and wrote to him: "*I resolved I would watch my step lest I offend by my speech; I would keep my mouth muzzled while the wicked man was in my presence (Ps 39:2). Even though a wicked man is in my presence, [still] I would keep my mouth muzzled.*" He (Mar Uqba) wrote to him: "They are causing me great distress, and I am not able to stand it." He (R. Eliezer) sent to him: "*Be patient (hitholel) and wait for the Lord. [Do not be vexed by the prospering man who carries out his schemes] (Ps 37:7).* Be patient for the Lord and he will make them fall dead (*halalim halalim*). [Rather,] rise early and stay later than them in the academy, and they will be finished in and of themselves." Just as R. Eleazar said this they put Geniva in chains [for execution].

Beer notes that elsewhere Geniva refers to sages as "kings," indicating that he believed that sages, not Exilarchs, should be the authorities.[125] Beer also observes that at this time Rav Huna was appointed head of the academy (according to Geonic sources), and Sherira Gaon notes that Huna was related to the Exilarch. According to Beer, Mar Uqba appointed his relative

Huna head of the academy. Geniva opposed him on the grounds that the leading sages, not Exilarchs or their appointees, should be leaders [= kings]. Then Mar Uqba murdered Geniva to assert his control and quell any unrest. Neusner accepts Beer's interpretation and goes further, postulating that the Exilarch dominated rabbinic schools for much of Amoraic times and routinely appointed leaders: "It is reasonable to assume that Geniva and with him other sages opposed the involvement of the Exilarch in the appointment of the head of the academy."[126] For Neusner it is inconceivable that the leaders of the autonomous Jewish community, who enjoyed the backing of the Persian government, did not control rabbinic academies or general rabbinic affairs. While Beer sees Geniva reacting to a novel initiative of the Exilarch to assert control, Neusner sees Mar Uqba responding to a new initiative of the sages to resist Exilarchate domination.[127] Elsewhere we hear that servants of the Exilarch murdered R. Zevid and tried to kill Rav Sheshet.[128]

The connection between our story and this analysis of the Geniva affair is straightforward. Like Geniva, Meir and Natan resist the authority of the "Patriarch" who heads the academy, that is, the Exilarch or an Exilarchate appointee. The story warns against such opposition lest rabbis meet the same fate as Geniva. Particularly interesting is R. Eleazar's advice that if Mar Uqba spends more time in the academy then his problems will disappear. If Mar Uqba (or his agents) were more proficient in Torah, and if his control of the academy were predicated on Torah, no rabbi would dispute his authority.[129] The same could be said for Rabban Shimon b. Gamaliel in the story.

Joel Florsheim and Isaiah Gafni have rejected the Beer-Neusner hypothesis, questioning both the interpretation of the Geniva affair and the general reconstruction of the Exilarchate meddling in the academies.[130] They point out that not one source in the entire Talmud explicitly mentions that Exilarchs appointed the heads of the academy, that they controlled the academies in any way, or that the sages objected to such policies. Neusner, however, claims that acknowledgement of the Exilarch's role "would quickly have been suppressed by a rabbinical redactor or tradent."[131] The possibility of suppression has an impressive parallel in our story, for RSBG at first suppresses the Torah of Meir and Natan by exiling them from the academy and then suppresses mention of Meir's name. If members of the Exilarch's family were appointed heads of the academy, they would have tried to suppress traditions of opposition to their appointment. For this reason the story may portray Tannaim in the Palestinian academy, namely, to avoid suppression by Babylonian Exilarch appointees.

Because the term "Patriarch" sometimes refers to Exilarchs, the sages would understand the true subject of the story.

This debate seems to have reached an impasse, and I am not sure how to settle the question. The criticisms of Florsheim and Gafni probably should not be dismissed easily. Scholarship has moved away from facile, large-scale reconstructions of this sort, and Neusner has repudiated his own historical account as methodologically flawed.[132] These limitations are precisely why many scholars eschew attempts to reconstruct the historical context and suffice with literary and cultural analyses of the story.

Later sources, however, offer more certain evidence concerning conflicts between Exilarchs and academy heads.[133] The *Epistle of Sherira Gaon* (late tenth century) mentions deep tensions.

> . . . the Exilarchs exercised severe authority and extensive power in the days of the Persians and in the days of the Ishmaelites. They used to buy the Exilarchate for great amounts of money, and some of them troubled the sages a great deal and oppressed them.
>
> Our ancestors were from the house of the Exilarch (*deve nesi'a* = Patriarch!). However, they abandoned all these evil practices of the Exilarchate (*nesi'ut*), and joined the sages in the academy, and sought humility and meekness and self-effacement. . . . Since the Exilarchate (*nesi'a*) ruled in this way, the heads [of the academies] were not able to avoid going before them on their festival.[134]

Sherira discusses the situation in the time of Rav Ashi, the early fifth century, although he digresses here to more general remarks. Exactly how the Exilarchs—whom he repeatedly calls "Patriarchs"—oppressed the sages is not clear. Part of the "distress" apparently resulted from having to appear before Exilarchs on their special festival and show them public honor. How painful even the memory of his predecessors having no choice but to honor the Exilarch! Sherira's emphasis that his ancestors, the pious Exilarchs, behaved with "humility" and "meekness" when they entered the academy implies that such qualities were generally lacking in Exilarchs (and probably comprises a polemic against the Exilarchs of his day). Here is a beautiful expression of how a leading sage thinks an Exilarch should behave, especially within the walls of the academy. His sentiments should bring to mind those of Meir and Natan at the outset of our story. And the issue of a "Patriarch" seeking honor should recall other themes.

While this passage of Sherira's epistle purports to describe the fifth

century, it probably retrojects the conditions of later times. Geonic and medieval sources tell of conflicts between the Geonim and Exilarchs in the eighth century, and of famous struggles, such as that of Saadia and David b. Zakkai, in the ninth and tenth centuries, when Exilarchs appointed and deposed Geonim and Geonim appointed and deposed Exilarchs.[135] Even during times of cooperation conflicts between these offices inevitably surfaced.

Robert Brody has shown that in the later Geonic period the Exilarch maintained his own academy, a type of junior partner to the Suran academy.[136] He sometimes appointed a prominent sage with the title "Head of the Court" to lead the academy in his stead and played no substantive role in its routine functioning. In such a situation one can imagine students of the academy or the "Head of the Court" himself protesting that the titular head of their academy, the Exilarch, knew little Torah. One wonders whether the Exilarch insisted on formal recognition as the leader of the academy and whether all sages relished showering a relatively ignorant figurehead with academic honor.

The period of the talmudic redactors, the fifth through seventh centuries, is one of the darkest periods in Jewish history. Did such conflicts between sages and Exilarchs begin in the eighth through tenth centuries or are they typical of the situations of the preceding centuries as well, not known to us because of the dearth of sources? If Sherira can be trusted, or if the struggles that characterized the eighth and ninth centuries also characterized the fifth through seventh, then perhaps our story reflects the meddling of the Exilarch in rabbinic academies in Saboraic times. It is even possible that the story took shape in the early Geonic period when these conflicts came to the fore.[137]

We should also note that in the ninth century and thereafter the Gaonate itself became oligarchic and dynastic. The office of Gaon — the head of the academy — typically passed to another member of his family at death, or a new Gaon was selected from a few families of distinguished lineage.[138] Intense jockeying for position among the highest rankings of the hierarchy took place. If this situation began in Saboraic times, then the story may be responding to increasing dynastic forces in Jewish society along several axes.

Because of the lack of outside sources and our limited knowledge of the history of the Saboraic and Geonic eras, these attempts to set the story in its historical context remain speculative. What we can observe, albeit in general terms, is the tension between lineage and Torah in Babylonian Jewish culture. The supreme value placed on Torah, for many sages, rendered

other claims to authority difficult to accept. However, as we have seen in other chapters, the ideal did not always translate into reality. The sages had to compromise and accommodate other values within their Torah-centered worldview.

### APPENDIX: MANUSCRIPT VARIANTS

The translation is based on MS Paris 1337 (=P). Variants are from ms Munich 95 (=M) and the Venice 1520 printing (V). I have only noted the significant variants.

(1) "R. Yohanan." M omits "Yohanan."

(2) "Rabban Shimon b. Gamaliel would enter." V reads "Rabban Shimon b. Gamaliel was there."

(3) "They saw." M omits.

(3) "What is this?" M reads "What is different today?"

(3–4) "They said to them . . . What shall we do?" M omits.

(4) "For ourselves." So V. P reads כלדלין, which should be read as כלדילן or כי לדידן.

(4) "What shall we do?" V adds "to him."

(4) "For 'whom' is it pleasing . . . he who is able to make." M omits.

(5) "You will be Patriarch and I will be Head of the Court." V reads "I will be Head of the Court and you will be Patriarch."

(6) "He repeated and taught, repeated and taught." M reads "He explained (*pashat*), repeated, and taught." V reads "He explained, repeated, and taught, repeated and taught."

(7) "Looked into it." MV omit.

(7') "Let the master teach us." MV read "Let the master come and teach us."

(6') "Opened and taught." MV read "Opened and spoke."

(4') "Throw [them]." M reads "Throw [them] outside."

(4') "That which was not solved, they wrote the solution and threw them [in]." So MV. The line is illegible in P.

(2a') "They showed them." M omits.

(2b') "Rabbi [Yehuda HaNasi]." M omits.

[2b'] "We do not mention (*mazkirin*)?" M reads "we do not recognize (*mekirin*)."

(2b') "He said to him, *Their loves, their hates, their jealousies*." M omits "He said to him, *Their loves*" and "*their jealousies*."

(2b') "As for these." MV read "As for the sages."

(1') "Rava." M omits.

Chapter 7

# Torah, Gentiles, and Eschatology (Avoda Zara 2a–3b)

The story at the beginning of tractate Avoda Zara, folios 2a–3b, must be numbered among the most fascinating rabbinic compositions. The subject is the inauguration of the "world to come." An eschatological drama unfolds as God places a Torah scroll in his lap and summons "those who busied themselves with Torah" to collect their reward. The BT redactors have annotated the story with numerous nonnarrative comments that add explanations, pose questions, offer solutions, and juxtapose related traditions—the typical features of talmudic discourse. Form combines with content to provide an impressive statement of the Torah-centered worldview of the sages and a fitting conclusion to our study of BT stories.

In contrast to the stories examined in previous chapters, this composition is a "homiletical story," marked by the introductory phrase, "R. Hanina bar Papa, and some say R. Simlai, expounded (*darash*)." Ofra Meir defines the "homiletical story" (*sipur darshani*) as "two-dimensional—both a homily and a story. As a homily, its point of departure is the biblical text—the word, utterance, verse or verses—from which new meaning is extracted. As a story, it is a verbal expression containing characters, plot and meaning."[1] The literary analysis employed in previous chapters applies to the narrative dimension of the homiletical story. To this we must add an analysis of its exegetical dimension, the interpretation of the scriptural verses that serve as pivots for the events and dialogue of the fabula.

The series of comments raises interesting redactional issues which both simplify and complicate matters. The comments are Aramaic, while the story is entirely Hebrew, so the two can be separated easily on purely formal criteria, as many scholars have noted.[2] At first sight, then, we can distinguish clearly the "original" Palestinian homiletical story—R. Hanina b. Papa and R. Simlai are third-century Palestinian sages—from the contribution of the talmudic redactors.[3] In this case the redactors seem to have left their source intact and not reworked it for their own purposes. They chose to express themselves without violating the integrity of the story through external comments rather than internal revisions. On deeper reflection, however, this scenario is uncertain. The "original" (Amoraic) story may have been reworked to the same extent as the other stories we have studied and a series of comments added as well, or subsequently added by even later redactors.[4] The problem is that we lack a parallel version of the homiletical story preserved in Palestinian texts until the post-talmudic period, so there is no independent basis for comparison.[5] While the story contains no motif, linguistic usage or vocabulary unknown to Palestinian sources, no sure signs of Babylonian influence, later Babylonian reworking cannot be ruled out.

In this case, then, we study the narrative art of the BT in a slightly different sense, namely the narrative art of the BT in its extant form, not necessarily the art of redactional composition. Yet important redaction-critical questions remain. First, the redactional setting of the story near the beginning of Tractate Avoda Zara must be considered. Second, the comments provide direct access to the ideas, values, and reactions of the redactors.[6] In previous chapters we painstakingly compared the BT and PT versions and assessed the compositional process in order to isolate the redactional contribution. Here the comments reveal the hand of the redactors and thus simplify the analysis of the cultural context.

## Translation, Structure, Orality

Joseph Heinemann noted that the tendency to comment upon aggadic and narrative sources with the give-and-take characteristic of legal *sugyot* is found predominantly in the BT.[7] We have encountered a few examples of such nonnarrative comments in previous chapters, including the objections to Meir learning Torah from Aher (Chapter 3) and the criticism of R. Yohanan b. Zakkai (Chapter 5).[8] In those cases, however, the comments were relatively brief and, at least with the objections to Meir, integrated into the

structure of the story. The present text is unusual in the frequency and length of the comments and in their deleterious effect on following the plot and structure of the homiletical story. Digressive comments constantly interrupt the flow of events and then leave off as abruptly as they begin. The student of Talmud is hard-pressed not to lose track of the action while shifting mental gears to consider the cogency of an objection. Yet we must consider whether this distracting experience results primarily from the current method of transmitting and encountering the talmudic text through reading words printed consecutively on a page. The comments would hardly interfere if they were printed in the margins (like Rashi's commentary today), or within parentheses, or as footnotes at the bottom of the page. And that is essentially what they are: a series of talmudic footnotes separated from the main text not by placement near the bottom margin but by translation into a different language.[9]

To contemplate written formats, however, is anachronistic: I use them for purposes of illustration. Talmud was oral literature that flourished in a predominantly oral cultural matrix.[10] While the sages were highly literate, they carefully distinguished the "Written Torah" (the Bible) from "Oral Torah" (rabbinic literature). All sages memorized traditions and a class of professional "memorizers" (also called *tannaim*) functioned as official repositories of oral texts. Talmudic discourse exhibits the standard features of oral literature—brevity, repetition, mnemonic devices, and formulaic patterns. Indeed, the stories presented in this book manifest these and other characteristics of orality, including wordplay, threefold repetitions, direct addresses to the audience and copious dialogue.[11] Individual sages may have jotted down notes for personal use or to facilitate memorization, but such private texts had no official status.[12] Never do the sages establish the correct version of a rabbinic source by appealing to written exemplars.

Recently Martin Jaffee has refined this view by distinguishing composition from performance.[13] He argues that the Mishna and other rabbinic works contain evidence of written sources and literary forms that suggest a process of written composition. The author-redactors drew on both oral traditions and written documents and composed texts with the aid of the technology of writing. Those texts were then memorized and "performed" in oral settings of teaching and academic debate. "Oral Torah" accordingly refers to the life-situation in which Torah flourished and the modes of teaching, transmission, and discussion if not composition.

The key question is the effect of digressive comments in an oral matrix. My sense is that they would not obtrude as much since the shifts from

Hebrew to Aramaic and from one level of discourse to another are immediately perceptible. The audience probably processed the Aramaic comment like any parenthetic comment in ordinary conversation. Shifting levels of discourse and digressions in fact characterize the entire BT. Teachers probably taught even the most elementary students in this way, reciting a text while interspersing their explanations, and students managed to differentiate the two strata.[14] Lengthy *baraitot* quoted in the BT are interrupted with comments and brief discussions and then resumed in medias res. Legal *sugyot* typically exhibit digressions in which later layers of argumentation deform highly structured internal units.[15] We should assume that the structures continued to serve mnemonic and heuristic functions despite the addition of later literary strata, for otherwise they would not have endured. Similarly, the flow and structure of our Hebrew homiletical story presumably served these functions despite the plethora of Aramaic comments. Jaffee's analysis of the interpenetration of oral and written literary processes provides a model of how the redactors formulated such a complex weaving of text and comments that simultaneously obscures and preserves the features of orality.[16]

To reproduce the two-tiered text in a written form that attempts to replicate the oral effect, I will present the Aramaic comments as footnotes in the translation. This will facilitate following the homiletical story and its structure while simultaneously retaining the presence of the comments. The translation is based on ms Paris 1337; manuscript variants can be found in the Appendix:

> R. Hanina bar Papa, and some say R. Simlai, expounded (*darash*):
> (I) In the world to come, the Holy One, blessed be He, will bring a Torah scroll and set it in his lap, and say: "Let everyone who busied himself with this come and take his reward." Straightaway the nations of the world assemble and come in confusion, as it says, *All the nations assemble as one, the peoples gather (Isa 43:9)*. God says to them: "Do not enter before me in confusion. Rather each nation should enter with its scribes," as it says, *The peoples gather (Isa 43:9)*, and "people" means a kingdom, as it says, *One people shall be mightier than the other (Gen 25:23)*.[a]

---

a. And we translate (in the Aramaic Targum), "One kingdom will be mightier than another." — But is there confusion before the Holy One? Rather (they should regroup) so that they will not be confused among each other and will understand what He says to them.

(A) Straightaway the Kingdom of Rome enters first.[b] The Holy One, blessed be He, says to them: "With what have you busied yourselves?" They say to him: "Master of the universe. We established many marketplaces. We built many bathhouses. We accumulated much gold and silver. And we only did all this so that Israel could busy themselves with Torah." The Holy One, blessed be He, says to them: "Everything you made was done exclusively for yourselves. You made marketplaces so that you could place prostitutes there, bathhouses to make yourselves beautiful. Gold and silver are my [responsibility], as it says, *Silver is mine and Gold is mine (Hag 2:8)*. Are there none among you who speak *this*?" as it says, *Who among you declared 'this'? (Isa 43:9)*, and *'this'* refers to Torah, as it says, *This is the Torah which Moses brought (Deut 4:44)*. Straightaway they depart from Him dejectedly.

(B) The Kingdom of Persia enters after it.[c] The Holy One, blessed be He, says to them: "With what have you busied yourselves?" They say to him: "We constructed many bridges. We conquered many cities. We fought many wars. And we only did all this so that Israel could busy themselves with Torah." The Holy One, blessed be He, says to them: "Everything you made was to satisfy your own needs. You made bridges so that you could collect tolls, cities so that you could impose forced labor. I am responsible for war, as it says, *The Lord is a man of war (Exod 15:3)*. Are there none among you who speak *this*?" as it says, *Who among you declared 'this'? (Isa 43:9)*, and *'this'* refers to Torah, as it says, *This is the Torah which Moses brought (Deut 4:44)*. Straightaway they depart from Him dejectedly.[d]

---

b. (i) For what reason? Because they are most important. (ii) And how do we know that they are the most important? It is written, *It will devour the whole earth, tread it down, and crush it (Dan 7:23)*. And R. Yohanan said, "This is evil Rome, whose stamp has gone forth throughout the world." (iii) And how do we know that he who is most important enters first? This follows Rav Hisda, for Rav Hisda said, "Of a king and the public, the king enters judgment first, as it says, *That he may judge his servant (=King Solomon; 1 Kgs 8:59)* first, and then it says *and his people Israel (1 Kgs 8:59)*. (iv) And what is the reason for this? If you prefer, I could say that it is not fitting to keep the king sitting outside. And if you prefer, I could say [the king should be judged] before [God's] anger is roused.

c. For what reason? Because the Kingdom of Persia is next in importance after it. How do we know it is next in importance after it? Since it is written, *I saw a second different beast, like a bear (Dan 7:5)*, and Rav Yosef taught, "These are the Persians who eat and drink like a bear, and are fleshy like a bear, and grow their hair like a bear, and like a bear they never rest."

d. And after the Kingdom of Rome entered and gained nothing, why did it (Persia) approach? It reasons: "They (Rome) destroyed the Temple whereas we built it."

(C) The same thing [occurs] with each and every nation.ᵉ

(II) (A) They say to him: "Master of the Universe. Did we ever accept it (the Torah) and then not fulfill it?"ᶠ He says to them, *"Let us hear of the things that have happened (Isa 43:9).* Those seven commandments that you did accept—when did you fulfill them?"ᵍ

(B) They say to him, "Master of the Universe. Israel, who accepted it (the Torah)—when did they fulfill it?" He says to them, "I testify for Israel that they fulfilled the entire Torah." They say to him, "Master of the Universe. Can a father testify for his son, as it says, *Israel is my first-born son (Exod 4:22).*" He

---

e. (i) What is the difference between those (Rome and Persia) which are important and those (the other nations) which are not important? Their reign will endure until the Messiah. (ii) And after they see that the first ones gained nothing, why do they enter? They reason: "These (Rome and Persia) enslaved Israel but we never enslaved Israel."

f. (i) But He would refute this [by saying], "Why did you not accept it?" Rather, they say to him, "Did you ever give it to us and we not fulfill it?"—But did he not give it to them? Is it not written, *The Lord came from Sinai; He shone upon them from Seir; He appeared from Mount Paran (Deut 33:2)* and *God is coming from Teman, The Holy One from Mount Paran (Hab 3:3).* What was He doing in Seir? What was He doing in Paran? R. Yohanan said, "This teaches that God turned to each and every nation and people [to offer them the Torah] and none accepted it, until he came to Israel and they accepted it." (ii) Rather, they say to him, "Did you ever suspend a mountain over us like a vault as you did to Israel and we did not accept it?" For it is written, *They took their places at the base of the Mountain (Exod 19:17),* and Rav Avdimi bar Hama from Haifa said, "This teaches that God suspended a mountain like a vault over Israel and said, 'If you receive the Torah—fine. If not, your graves will be right here.'"

g. How do we know that they never fulfilled them? (i) For Rav Yosef taught, *"He stands and makes the earth shake, he sees and makes the nations tremble* (vayater) *(Hab 3:6).* What did he see? He saw that the Sons of Noah did not fulfill the seven commandments which they had accepted upon themselves. Because they did not fulfill them, he released them (*hitiran*)."—Then they profit?! (Since God absolved them from doing the commandments.) If so, then we find that a sinner benefits [from his sin]?! (ii) Mar b. Ravina said, "[Rather,] it means that even though they fulfill them, they receive no reward for it."—Is this so? Have we not learned, "R. Meir used to say, 'From where do we know that even a gentile who busies himself with Torah is equal to the high priest? It teaches, *[You shall keep my laws and rules] by the pursuit of which man shall live (Lev 18:5).* It does not say "Priests, Levites and Israelites" but rather "man." This teaches that even a gentile who busies himself with Torah is like a high priest.'" (iii) Rather, they do not receive a reward equal to one who is commanded and fulfills, but equal to one who is not commanded and fulfills. For R. Hanina said, "Greater is one who is commanded and fulfills than one who is not commanded and fulfills."

says to them, "Let Heaven and Earth come and testify for Israel that they fulfilled the entire Torah." They say to him, "Heaven and Earth are not impartial witnesses, as it says, *If I had not established my eternal covenant, I would not have fashioned heaven and earth (Jer 33:25).*"h He says to them, "Let those among you come forth and testify for Israel that they fulfilled the Torah. Let Nimrod come and testify for Abraham that he was never suspected of idolatry. Let Laban the Aramean come and testify for Jacob that he was never suspected of stealing. Let the wife of Potiphar come and testify for Joseph that he was never suspected of sin. Let Darius come and testify for Daniel that he never neglected prayer. Let Nevuchadnezzar come and testify for Hananiah, Mishael, and Azariah that they never bowed to the idol. Let Eliphaz the Temanite, Bildad the Shuhite, Zophar the Naamathite, and Elihu ben Barachel the Buzite testify for Israel that they fulfilled the entire Torah," as it says, *Let them give their testimony and be vindicated (Isa 43:9).*

(C) They say to him, "Give it to us anew, and we will do it." He says to them, "Complete idiots! He who prepared on the eve of the Sabbath will eat on the Sabbath. But he who did not prepare on the eve of the Sabbath—how will he eat on the Sabbath?

(III) (A) "Nevertheless, I have a simple precept, which is called 'sukka.' Go and do it."i Straightaway each and every one makes a sukka on his roof.

(B) The Holy One, blessed be He, makes the sun blaze upon them as in the summer season. Straightaway each and every one kicks his sukka and departs, as it says, *Let us break the cords of their yokes (Ps 2:3).*j

---

h. And R. Shimon b. Laqish said, "What is the meaning of *And there was evening and there was morning the sixth day (Gen 1:31).* It teaches that God stipulated with creation and said to it, 'If Israel accepts the Torah, well and good. If not, I will return you to chaos and nothingness.'" And Hizqiah said, "What is written, *In heaven you pronounced sentence; the earth was still with fright (Ps 76:9).* If it was frightened, why was it still, and if it was still, why was it frightened? But at first it was frightened (lest Israel not accept the Torah) and subsequently it was still (after Israel accepted it)."

i. (i) How can they say this? Did not R. Yehoshua b. Levi say, "What is the meaning of *The laws and the rules which I charge you this day (Deut 7:11).* To do them *this day*, and not to do them another day. *This day* to do them, but not *this day* to receive reward [for them].—Because the Holy One does not deal despotically with his creatures. (ii) And why is it called a "simple precept"? Because it is inexpensive (Cf. mHul 12:5).

j. Blaze?! You said that God does not deal despotically with his creatures (in the previous comment)! Because for Israel too, sometimes the cycle of Tammuz (= the summer season) extends until the sixteenth [of Tishrei] and they suffer [from the heat].—But did not Rava say, "One who experiences discomfort is exempt from [dwelling in] the sukka"? Granted he is exempt from the sukka, but does he kick it?

(C) The Holy One, blessed be He, sits and laughs, as it says, *He who sits in heaven laughs (Ps 2:4)*.

The story is structured along two axes corresponding to its twofold identity as both homily and narrative. The homiletic axis revolves around the exposition of biblical verses; the narrative axis depends on the content and language. While the homilist brings numerous verses into play, his primary text is Isa 43:9, the first verse he cites, and to which he returns no fewer than five times. He links various stages of the drama to clauses of the verse, thereby creating a framework for the action and simultaneously allowing for the development of an imaginative saga, quite free from the scriptural base. After exhausting the clauses of Isa 43:9 he shifts to Ps 2:3–4 as the text for the final stages of the action (section III). The other quoted verses serve primarily as prooftexts for arguments made by characters within the fabula, not as bases for stages of the story itself.[17] Thus miscellaneous verses comprise the dialogue between the parties while Isa 43:9 and Ps 2:3–4 govern the course of the action. In this way the clauses of the expounded texts provide the principal elements of structure.

The homiletical axis, however, provides but part of the structure, for several stages of the drama lack connection to clauses of the expounded texts. Additional structure is created by a number of narrative techniques. Chief among these is the repetition of units of three.[18] There are three major scenes: the initial trial of the nations, their objections to God's justice, and their failure to observe the commandment of sukka. Both Rome and Persia cite three of their accomplishments: marketplaces, bathhouses, and money for the Romans; bridges, cities, and war for the Persians. In his rejection of their claims, God repeats this threefold litany. Three national gatherings approach God: the Romans, the Persians, and then the rest of the nations, although only the encounters of the Romans and Persians are fleshed out.

Units of three recur in the second section, the extended dialogue between the nations and God. The nations put forward three arguments: (1) We were never offered the Torah; (2) Israel never fulfilled it; (3) Give us the Torah now so we can fulfill it. The second argument itself includes three stages. First God prepares to testify for Israel, then Heaven and Earth, and finally the nations themselves. Six times — twice three — God commands representatives of various biblical nations to appear and testify concerning Israelite heroes or the entire people. The final section also includes a triplet: God enjoins the nations to build sukkot, causes the sun to blaze upon them, and laughs at their folly.

A second component of the narrative structure devolves from the use of verbs as keywords. The roots "come" (*b-w-'*) and "enter" (*k-n-s*), and their counterparts, "go" (*h-l-k*) and "depart" (*y-ts-'*) occur regularly, and signal a shift from one stage of the drama to the next. At the outset God invites the nations to *come* and receive their reward.[19] They *come* in confusion, whereupon God commands that they *enter* in an orderly manner. The Romans *enter* first. They *depart* dejectedly and the Persians *enter*. They too *depart*. In the next section God invites Heaven and Earth to *come* and testify, and then commands the nations to *come* themselves. Six times the representatives of the nations should *come* and testify. Toward the end, God tells the nations to build a sukka, and orders that they *go* and do so. Whereas at the beginning of the drama God summoned the nations to come before him, he now dismisses them from his presence. Unable to stand the heat, the nations kick their sukkot and *depart,* the familiar verb calling to mind their earlier departure in dejection. The coming, going, entering, and departing move the story along, sensitizing the audience that one scene ends and the next begins. Recall that the entire drama takes place in the world *to come,* and the focus on who enters and who leaves is quite to the point. Here structure and content intersect; the markers of stages in the drama converge with the themes the homilist seeks to emphasize.

A second set of recurring verbs includes "give" (*n-t-n*), "receive" (*q-b-l*), "fulfill" (*q-y-m*) and "make, do" (*'-s-h*). God rebukes the Romans and Persians that what they *made* only served their own interests. The nations object that they never *received* the Torah and did not *fulfill* it, then that Israel who did *receive* the Torah never *fulfilled* it. Various parties are called to testify that Israel did *fulfill* the Torah. The Isaian prooftext for the testimony reads that they "*give* witnesses." At this point the nations beseech God to *give* them the Torah now so that they may *do* it. God then orders them to *make* a sukka, and each *makes* one on the top of his roof. The making of the sukka recalls God's accusation that they "made" the bridges and markets for their own needs. It creates a parallel between the two events, and invites the audience to compare and contrast them. Below we consider the implications in greater detail.

Finally the repetition of adverbs and interrogative particles lends the composition greater coherence. Several scenes are introduced with the adverb "straightaway" (*miyyad*), which conveys a sense of urgency and almost frantic action. At the outset, "straightaway" the nations enter to collect their reward; at the conclusion, "straightaway" they kick their sukkot and leave. This macro *inclusio* both contrasts the beginning scene with the de-

nouement and unifies the composition. The interrogative particle "*kelum*," which does not translate, introduces most of the questions. God rhetorically asks the Romans and Persians, "Are there none (*kelum yesh*) among you who speak 'this?'" Later they innocently ask God, "Did we ever (*kelum qibbalnuha*) accept [the Torah]," and then rhetorically question God's proposed witnesses, "Can a (*kelum yesh*) father testify . . . ?" As we shall see, this parallel interrogative form coheres nicely with the course of the drama.

This analysis of the literary devices and structural techniques suggests the following structure:

I. God Judges the Nations

> In the world to **come,** God says: Let everyone who busied himself with this **come** and take his reward.
> **Straightaway,** the nations **come** in confusion,
> *All the nations assemble as one, the peoples gather; Isa 43:9a–b*
> God: **Enter** not in confusion,
> *The peoples gather; Isa 43:9b*
>
> A) **Straightaway,** Rome **enters**
>     A2) God: With what have you busied yourselves?
>         A3) Rome answers:
>             1. marketplaces
>             2. bathhouses
>             3. silver and gold
>         A3′) God's rejection:
>             1. marketplaces for prostitutes
>             2. bathhouses for self-beautification
>             3. gold and silver are mine; Hag 2:8
>     A2′) God: (**kelum**) Are there none who speak this?
>         *Who among you declared this? Isa 43:9c*
> A′) Romans **depart** dejectedly
>
> B) Persia **enters.**
>     B2) God: With what have you busied yourselves?
>         B3) Persia answers:
>             1. bridges
>             2. cities conquered
>             3. war

B3′) God's rejection:
   1. bridges for tolls
   2. cities for forced labor
   3. war is mine; Exod 15:3
   B2′) God: (**kelum**) Are there none who speak this?
       *Who among you declared this? Isa 43:9c*
  B′) Persians **depart** dejectedly

  C) The same thing [occurs] with each and every nation

II. The Nations Dispute God's Justness

  A)  Nations: (**kelum**) Did we **receive** Torah and not **fulfill** it?
  A′) God: When did you **fulfill** the commandments you **received**?
      *Let us hear of the things that have happened; Isa 43:9d*

  B1)  Nations: Did Israel, who **received** the Torah, **fulfill** it?
  B1′) God: I will testify Israel **fulfilled** the Torah

  B2)  Nations: (**kelum**) Can a father give evidence in favor of his son?
       Exod 4:22
  B2′) God: Let Heaven and earth testify Israel **fulfilled** the Torah

  B3)  Nations: Heaven and Earth are involved; Jer 33:25
  B3′) God: You **come** and testify
      1) Let Nimrod **come** and testify for Abraham
      2) Let Laban **come** and testify for Jacob
      3) Let Potiphar's wife **come** and testify for Joseph
      4) Let Nevuchadnezzar **come** and testify for Hananiah, Mishael, and Azariah
      5) Let Darius **come** and testify for Daniel
      6) Let Eliphaz, Bildad, Zophar, and Elihu **come** and testify for all Israel that they **fulfilled** the entire Torah,
          *Let them give their testimony and be vindicated; Isa 43:9e*

  C)  Nations: **Give** us Torah now and we will **do** it.
  C′) God: Complete idiots! He who prepares on the eve of the Sabbath . . .

III. The Nations Reject Torah

  A)  God: Nevertheless, I have an easy commandment called sukka; **go** and **do** it
  A')  **Straightaway** the nations **go** and **make** sukkot on their roofs

  B)  God causes the sun to blaze upon them
  B')  **Straightaway** they kick their sukkot and **depart,**
      *Let us break the cords of their yokes; Ps 2:3*

  C)  God laughs,
      *He who sits in heaven laughs; Ps 2:4*

## The Exegetical Dimension

Before turning to the drama itself we must examine the biblical verses that comprise its framework. Isaiah 43:9, the primary text of the homily, initiates a prophetic discourse known as a "trial speech."[20] The nations and their gods confront Israel and her God in a type of hypothetical trial. Each side brings arguments that it worships the true god. Inevitably the prophet proves Israel's case with irrefutable arguments, demonstrating the falsehood of the opposing claim:

> (43:9) All the nations assemble as one, the peoples gather
> Who among them declared this, foretold to us the things that have happened?
> Let them give their testimony and be vindicated
> That they may say, "It is true."
> (10) My witnesses are you — declares the Lord,
> My servant whom I have chosen.
> To the end that you may take thought and believe in Me,
> And understand that I am He:
> Before Me no god was formed, and after Me no one shall exist —
> (11) None but Me, the Lord.
> Beside Me, none can grant triumph.
> (12) I alone foretold the deliverance and I brought it to pass;
> I announced it, and no strange god was among you.
> So you are my witnesses — declares the Lord — and I am God.

As the nations gather together for the trial, they are challenged to provide evidence that their gods accurately foretold "this," presumably the imminent redemption of Israel or other "things that have happened" in the past. The prophet invites them to bring witnesses attesting to the divinity of their gods and to the ability of their priests to foretell the future. The implication, of course, is that they cannot. While the nations have no witnesses, God designates Israel as his. Israel knew of the "deliverance," the redemption from Egypt, which had been foretold by God and subsequently occurred. By Israel's testimony the prophet establishes the power and supremacy of his God.

The reading "they" at the end of verse 9 is problematic, for it seems that the nations must prove to themselves. Westermann therefore substitutes "we" for "they": the nations must bring us (= Israel) proof that their gods are real.[21] On the other hand, in the following verse the reading "you" ("to the end that *you* may take thought") is difficult, and most scholars emend "they (= the nations)."[22] For if Israel supply the witnesses they cannot be the audience as well. As we shall see, the homilist plays upon this confusion of who testifies for whom, upon the different ways of interpreting the scene.

This passage shares standard features with other "trial speeches" in which the nations assemble for the trial and are invited to state their case.[23] But not once does the Bible make known their claims. In the prophetic view, of course, they have nothing to say, since their gods do not exist. Some trial scenes are followed directly by a series of rhetorical questions inquiring what the pagan gods ever foretold or did; the absence of a response proves the falsity of their beliefs. The scenes always proceed directly to prove Israel's case by detailing the events that God foretold and the miraculous events wrought by God. Our text is particularly dramatic in that Israel herself takes center stage as a witness to report God's miracles. The biblical neglect of the arguments of the nations is the point of departure of the homilist. He fills in the gaps in the text, imagining how a full transcript of the trial would read.

The verses from Ps 2:3–4 derive from a related biblical scene. The setting is not a trial scene but a battle.[24] Nations assemble not to debate with Israel but to destroy her:

> (1) Why do nations assemble, and peoples plot vain things,
> (2) Kings of the earth take their stand,
> and regents intrigue together against the Lord and against his anointed?
> (3) "Let us break the cords of their yokes, shake off their ropes from us!"

(4) He who sits enthroned in heaven laughs; the Lord mocks at them.
(5) Then He speaks to them in anger, terrifying them in His rage.
"But I have installed my king on Zion, My holy mountain!"
(6) Let me tell of the decree; the Lord said to me,
"You are My son, I have fathered you this day."

Most scholars suggest that the Psalm originally served as a liturgy at the inauguration ceremony of the Israelite king or at its annual reenactment.[25] In the cyclical, mythic view of time, the nations periodically revolt against God and his elected monarch. To "break the cords" and "shake off ropes" express the motif of rebellion by a subject against his lord. God reacts first by mocking their futile efforts and then with rebuke and frightful anger. He proclaims that he has selected the Israelite king, while the king happily announces that God has called him "son." The rest of the Psalm warns the nations of the consequences of rebellion and of the awesome power of God. For the biblical authors the trial and rebellion scenes demonstrate the incontrovertible reality, power, and sovereignty of God, and the grounds for confidence in their leader.

With his midrashic, intertextual approach to the Bible the homilist links Ps 2 and Isa 43:9–15, reading the two texts as depicting the same eschatological scene. Both Ps 2:1–2 and Isa 43:9 use the terms "nations" (*le'umim*) and "peoples" (*goyim*) and both depict a gathering, so the intertextual signals are strong. The homilist expounds Isa 43:9 for the action of the trial and Ps 2:3–4 for the nations' rejection of the sukka and God's mocking laugh. Yet the courtroom setting and debate draws as much inspiration from Ps 2:1–2 as from the Isaian trial scene. In the prophetic discourse the nations do not act or argue. The homilist takes from Psalms the notion that the nations articulate their claims and take action. The prophetic challenge to "declare this" is taken up in Ps 2:1 where the nations "plot" (*yehgu*) — literally "speak" — vain things. And the word for "assemble" (*ragshu*) has the sense of gathering with schemes and plots, as in the Aramaic cognate in Dan 6:7 and 6:16.[26] The homilist fills in the missing trial speeches of Isa 43 by drawing on the aggressive conduct described in the Psalm. In other words, for the homilist Ps 2:1–2 depicts the same eschatological trial as Isa 43:9, and both inspire his exegesis. Ps 2:3–4 therefore relates to the scene following the trial.

While the drama of the homiletical story bears some affinities to the confrontation scenes of the Bible, the transformation of certain elements underscores the distance between biblical and rabbinic concerns. The issue at the Isaian trial is the true Lord, whether the God of Israel or the gods

of the nations, and the proof seems to be illustrated both for Israel and the nations. For the rabbinic homilist this is no longer the issue. When God ushers in the world to come his reality cannot be doubted. The nations do not come to demonstrate the power of their gods, but to present their merits before the God of Israel. Moreover, the homilist considers it inconceivable that the nations even contemplate a rebellion. They acknowledge God's sovereignty and at best hope to convince him that they deserve a reward. Their proclamation to "break the cords" no longer expresses a revolt against God, but rather the inability to observe the precept they tried to fulfill.

The crucial turn is the shift in who serves as witness for whom. In the Bible God appoints Israel as witnesses that he is the true God. They bring testimony that God is trustworthy and faithful, that he foretold that which subsequently happened. In the story God serves as a witness for Israel that they were a faithful people, that they fulfilled what they accepted upon themselves. Ironically Israel, far short of serving as the star witness, plays no active role in the story. While in the Bible the nations are called to bring testimony of the power of their gods, but cannot, in the story the nations are forced to testify that Israel fulfilled the Torah, and do so.

## Literary Analysis

The opening two words of the terse exposition (*la'atid lavo* = In-the-future to-come) locate the story in the eschaton. Surprisingly, the mood is not that of terror and awe, as one might expect on Judgment Day, but of serenity and calm. There are no preparatory eschatological events, no apocalyptic signs, no battles of world powers, no miraculous reconfigurations of the earth. God placing the Torah scroll in his lap or "bosom," as *heiq* literally translates, evokes an almost feminine sense of mother with child, of equanimity and intimacy.[27] He issues the summons to "whoever busied himself with Torah" with almost academic dispassion. Such a placid description conflicts with the urgency of the event—those who fail are denied an eternal reward, and perhaps should expect divine punishment—to create an ironic undertone.

As the nations eagerly push forth to collect the reward the mood shifts from the serenity of the divine proclamation to hurried action and confusion. The nations respond immediately: "straightaway" they desist from their this-worldly enterprises and enter the divine arena. Here the homilist begins to link his description to the text (Isa 43:9). He expounds the phrase "the nations assemble *as one*" to mean that they all mix together in one

indiscriminate mass. The second clause of the verse, "the peoples gather," provides a nice example of biblical poetic parallelism but a glaring redundancy for rabbinic hermeneutics. The homilist therefore takes the clause to describe a reorganization of the initial assembly, this time with each nation grouped independently and not "as one." Between the two stages the homilist supplies a divine rebuke at the disorder and command for each nation to bring forth its scribes. The initial confusion in the ranks of the nations hints that they are ill-prepared for what is to follow and that the reorganization will prove ephemeral. That God orders each to bring its "scribes" contains a similar hint. Essential to the proper functioning of the court, scribes record the proceedings and ensure that no evidence is neglected. The scribes of each nation presumably bring the record of their meritorious deeds. Yet the term *sofrim*, scribes, also refers to the precursors of the sages, "the early scholars who were called *sofrim* because they counted the letters of the Torah,"[28] and in a wider sense to all sages. They are the true class who "busied themselves with Torah," and it is self-evident that the nations have no such scribes to bring them merit.

The prooftext from Gen 25:23 that the term "people" in Isa 43:9 refers to a "kingdom" contains another adumbration of what follows. Since Gen 25:23 uses the same term *le'om* as Isa 43:9, it is not clear at first what the prooftext accomplishes. By rabbinic conventions, however, the "two peoples" in God's prophecy to Rebecca refer to the descendants of Jacob and Esau, to Israel and Edom, identified with Rome. The term *le'om* thus triggers the association of Israel and Rome, of two national entities, and indicates that the nations divide into sovereign groups. But the resonances of the prooftext are much deeper. The prophecy relates to the struggle between Jacob and Esau, between Israel and Rome, and promises that one side "would be mightier than the other." The second half of the verse continues that "the older shall serve the younger." So Rome would serve Israel—but when? For centuries Israel had served their Roman masters and nothing indicated that the situation was likely to change any time soon. The homilist foresees the fulfillment of the prophecy in eschatological times, in the very drama he narrates. At that time the Romans will claim they did everything in this world so that Israel could busy themselves with Torah—they pretend to have served Israel. The real struggle occurs, then, not as a military confrontation between kingdoms, but a courtroom action in which the Romans and other nations indict Israel. And then the prophecy will be fulfilled as Israel triumphs over the nations. At this point, however, the audience does not yet know how the story will end. The allusion to the unfulfilled prophecy creates tension and expectations. As the drama

unfolds, the tension is progressively resolved and the audience reassured that God's prophecy would come true.

The stage set, the preliminaries concluded, the court in session, Rome enters first (section IA). Rulers of a massive empire and the mightiest nation on earth, they might well expect commensurate status in the world to come. God now asks them directly with what they have "busied themselves." Yet the Romans know that God has established the Torah as the sole criterion for reward, and it is Israel, not Rome, who has fulfilled the Torah. They can neither dispute the divinely ordained measure nor claim to have occupied themselves with Torah, so they fall back on a convoluted argument. Proudly they list their accomplishments—marketplaces, bathhouses, and silver and gold—and suggest that they engaged in these enterprises in order that Israel could busy herself with Torah. They claim to have provided the institutional framework necessary for society to function and the material support required for study. As a result of Rome's achievements Israel purchased her food, clothing, and other material goods in the markets, and did not have to spend time and energy to procure them. Rome also built the bathhouses that civilized people require. In essence they argue for vicarious merit, and so lose the case from the outset. God dispenses the argument with summary judgment. The true motives of Rome emerge: this-worldly pleasures—sexual gratification, pampering the body, and money to provide for such delights. God rejects the achievements of gold and silver, declaring that he ultimately controls prosperity, so the Roman fortunes confer no merit. Note that the depiction of God has already turned to that of an imposing judge. God first invited the nations, then mildly rebuked them, and now summarily rejects their arguments.[29]

After rejecting the Roman roundabout claim, God focuses on their lack of Torah. With a rhetorical question God half inquires and half decrees that none of the Romans "speak this," which picks up on the next clause of Isa 43:9.[30] Isaiah challenged the nations to prove that their gods had foretold "this," presumably referring to the miracle he anticipates, the return from exile. But the referent for the word "this" does not appear in the verse and is not clearly spelled out in the proximate biblical passages. The homilist therefore identifies this undefined "this" with the "this" of Deut 4:44 that refers to Torah: can the Romans appeal to observance of "this" Torah as the basis for their reward? Besides creating the intertextual connection to the Deuteronomic prooftext, the demonstrative pronoun "this" echoes both God's initial invitation to those who have occupied themselves "with this" to collect their reward, and the direct question to the Romans about their activities in "this" world. "This"—Torah—should have been

fulfilled in "this" world. "Straightaway" they entered, and "straightaway" the Romans leave dejectedly.

As the Romans leave "the Persians" enter, equally eager to collect their reward. The reference is to the Sasanians, whose empire spread over the other half of the civilized world.[31] While the Jews of Palestine lived in Roman territory, the Babylonian Jewish communities lived under Sasanian hegemony, and for centuries the two empires struggled for supremacy. Masters of a vast empire, the Persians also anticipate commensurate station in the world to come. They cannot claim any more than the Romans to have fulfilled the Torah, so they too argue for vicarious reward on the basis of the bridges they built, the cities conquered, and the wars fought. God dismisses their claims with disdain, emphasizing again that their pursuits were self-serving. The success in battle merits no reward, for God determines the outcome of war. Again the homilist emphasizes that superficial signs of divine favor, silver, gold, and military triumphs, prove nothing of the true merit of their proponents. Neither the Roman pursuit of pleasure nor the Persian obsession with power deserves reward. The Persians, too, do not speak "this," and "straightaway" depart empty-handed. The same outcome, the story assures us, awaits the other nations.

Section II reveals a shift in tactics. The nations no longer claim to have fulfilled the Torah in the past but question the fairness of the standard. True, they never observed the Torah, but they never accepted it either, so the criterion for reward is unfair. God rejects this approach by charging that the nations received the seven Noahide commandments and failed to fulfill them. Here the homilist ingeniously returns to the next clause of Isa 43:9 as prooftext. "Let us hear of the things that have happened," the prophetic challenge to the nations to announce previous events foretold by their gods, becomes an indictment of their behavior. Note that the homiletical story marks the new scene and shift of tactics with a reversal of roles. The nations now make the accusations and ask the questions while God, who had just appeared as indomitable judge, responds. An echo of God's question to the nations, with the interrogative particle *kelum*, surfaces in the nations' probing of God and its parallel form. The best defense is a good offense. The nations somehow become the judge of the fairness of God's standards, and God — at least temporarily — allows himself to be relegated to defendant. For a moment the story permits the illusion that the nations stand on a par with God and may question him as equals. This reversal and the cross-examination of God contribute to the rapid movement of the homiletical story and add to the atmosphere of a trial.[32]

The shift in tactics and role reversal come to the fore with the next

question and response. No longer defending themselves, the nations question whether Israel ever fulfilled the Torah. This charge seems totally out of place, for the issue is whether the nations deserve a reward or not. From a strictly juridical point of view, that question is completely irrelevant. Moreover, in the first scene the nations claimed that their building enterprises allowed Israel to fulfill the Torah, and they deserved vicarious merit on that account. Suddenly to claim Israel never observed the Torah subverts their initial argument. What vicarious merit can they now claim? The self-contradiction exposes once again the futility of their charges. It signals that the attempt at role reversal, at posing as judge of God's justice, is another aspect of their confusion described at the initial gathering. At the same time it points to the real interest of the story. The trial is as much of the merit of Israel — of the life of Torah — as of the shortcomings of the nations. And the vindication of Israel takes place in a most ironic fashion. Without assembling in the multitude, gathering as a nation, or recounting their accomplishments, without even appearing "in person," Israel receives resounding testimony of their merits.

Tension builds up to the climactic defense of Israel through attempted testimonies and disqualifications. God initially answers the nations by testifying that Israel observed the "entire Torah," which contrasts with the inability of the nations to fulfill even the seven Noahide commandments. Another tactic has been counterproductive and only dug a deeper hole. Yet the nations temporarily escape by playing up their newly-found role as judge and disqualifying God's testimony. Relegated from his role as judge, God even loses credibility as a witness.[33] When God summons Heaven and Earth to testify for Israel, the nations again disqualify the witnesses, ruling that they are "interested parties" who owe their existence to Israel maintaining her covenant with God by fulfilling the Torah.[34] Again the nations do a disservice to their case, for they admit that Israel has a special relationship with God and that the world only exists for the sake of the Torah. The more they argue their own case, the more they emphasize the world-sustaining powers of Torah and the supremacy of Israel. The legal technicalities function as devices which enable the story to adduce additional evidence for Israel without concluding the trial. Yet legal testimony remains to be found; the suspense is not what the outcome will be, but how it will be demonstrated.

The disqualification of witnesses ironically proves their ultimate undoing, for God then has no recourse but to summon the nations themselves as witnesses. The reversal takes a full turn with the nations, who had usurped the position of judge, now forced to testify against themselves.

With six hortatory sentences God invokes representatives of biblical peoples to witness that Israel fulfilled the Torah. Originally the nations "came" forward to collect reward; now they are summoned to "come" and justify Israel's claim to reward. The formulaic pattern—let *x* come and testify about *y* that he did not do *z*—without interruption or objection, by far the longest speech, relentlessly hammers home the vindication of Israel. And the culmination, which then deviates from the formula to the general admission that all Israel "fulfilled the entire Torah," echoes God's attempted initial testimony. The homilist arrives at the final clause of his verse: "Let them give their testimony and be vindicated, that they may say, 'It is true.'" Where Isaiah summoned the nations to bring witnesses on their own behalf and vindicate their gods, the homiletical story interprets the ambiguous pronouns such that the nations produce witnesses on behalf of God and vindicate Israel; they confess that what God asserted—that Israel fulfilled the Torah—is true. This turn completes the dramatic inversion of the biblical paradigm in which Israel serve as witnesses for God. In the rabbinic version of the trial first God, then the nations, witness that Israel fulfilled the Torah.

The characters summoned to testify are chosen primarily for their multinational profiles: Chaldean (Nimrod), Aramean (Laban), Egyptian (Potiphar's wife), Babylonian (Nevuchadnezzar), Mede (Darius), and a somewhat obscure quartet, clearly brought in for additional cosmopolitan flavor—Temanite, Shuhite, Naamathite and Buzite.[35] A true gathering of nations. Yet the figures were carefully selected. These villains endeavored to prevent biblical heroes from observing the Torah or falsely accused them of sin. Nimrod, according to legend, cast Abraham into a furnace and persecuted him in other ways in order to compel him to worship foreign gods.[36] Laban repeatedly changed Jacob's wages and then accused him of stealing the household gods (Gen 31:7, 30). Potiphar's wife attempted to seduce Joseph, then falsely accused him of trying to rape her (Gen 39:14–18). Nevuchadnezzar, outraged that Hananiah, Mishael, and Azariah refused to worship the golden idol, threw them into a blazing furnace (Dan 3:13–23). After Darius commanded that all prayers be directed to him, he forced Daniel into the lion's den for praying three times each day to God (Dan 6:8–24). Eliphaz, Bildad, Zophar, and Elihu, Job's four "comforters," charged that his suffering must have been caused by sin, and incessantly harangued him to confess his misdeeds. They too falsely accused a biblical hero of transgressing God's law, and it is fitting they testify that all Israel observed the entire Torah. Laban, Potiphar's wife, and Job's companions are transformed from prosecutors to witnesses for the defense. Obviously

the impact of these specific characters is much greater than had Jethro the Midianite or King Hiram of Syria, staunch allies of Israel, testified on their behalf.[37] The subpoenaed group not only confirms Israel's fidelity but betrays the falseness of their own case. Far from having helped Israel to fulfill the Torah, as they initially claim, the nations repeatedly strove to prevent Israel from observing the commandments. Far from Israel not having fulfilled the Torah, as the nations subsequently argue, Israel did so under the most trying circumstances, even risking their lives in this world. And just as these villains falsely accused Jacob, Joseph, and Job of crimes, so the nations' arguments are exposed as baseless. The satirical element of the first scene, the confused appearance and "dejected" departure of the nations, deepens with the self-incriminating testimony.[38] The nations are not only liars and scoundrels, but buffoons.

The testimony, moreover, reveals that the nations never fulfilled the Noahide commandments, the second potential basis for reward. While testifying that Israel refused to sin, it emerges that Nimrod, Nevuchadnezzar, and Darius worshipped idols or false gods, and that Potiphar's wife tried to commit adultery. Both idolatry and sexual immorality violate the Noahide prohibitions.[39] Once again, the nations drive a stake through their own collective heart. They confirm God's pronouncement that they never observed even the minimal commandments demanded of them. This testimony essentially serves as a national *Tsidduq hadin*, the "justification of the divine decree," traditionally recited at the burial. "We know, God, that your judgment is righteous; You are justified when you speak, and pure when you judge, and it is not for us to question your decrees of judgment," runs the standard formula. Since the nations do question God's justice and protest the divine verdict, God has them justify their own fate. In this world the nations violated the commandments, in the next they rebel against the divine verdict. But in the end they will justify the justness of God. As Isaiah prophesied, they will say, "It is true." God is the true judge, the *dayyan 'emet*.[40]

Having failed to demonstrate either their worthiness or Israel's unworthiness the nations are reduced to entreat for one more chance. At this point the roles again reverse and return to those of the opening scene. The nations appear as wayward children, pathetic, humiliated, while God returns to the role of the powerful judge. His patience tried long enough, God again insults the "complete idiots" before him and rejects their miserable plea. Only those who observed the Torah in this world, who prepared "on the eve of the Sabbath," enjoy a reward in the world to come. The analogy draws upon the familiar trope of the Sabbath as a "hint of the

world to come."[41] At the same time, it emphasizes the correspondence between observance of the commandments and entry into the next world. Preparing for the Sabbath, not the construction of markets and bridges, was the appropriate provision.

Section III completes the role reversal. Again God initiates the action (A, B, C) and the nations respond (A', B'), as they did at the outset. First the nations came and recounted what they had done, to no avail; now they go and try to do what they neglected—but of course their efforts prove futile. In his infinite mercy, God proposes a "simple" precept to the nations, the commandment of the sukka, ordering them "to go and do it." Clearly the sukka stands for the entire Torah by synechdoche. By observing this one "simple" commandment the nations can prove their merit and claim a share of the eschatological reward. Of all the commandments that the homilist could have selected as the test for the nations, the choice of the sukka hardly can be serendipitous. Indeed, the sukka represents the complete opposite of the accomplishments of which the nations boasted. Bridges, marketplaces, bathhouses, and cities were the glory of antiquity. Marketplaces with columned promenades and paved streets; bridges that ingenious Roman engineers extended to dazzling spans; bathhouses with marble pools and mosaics, adorned with beautiful statues; cities with amphitheaters, fora and porticoes—these magnificent structures separated the splendor of Roman civilization from the barbarian world.[42] The sukka, on the other hand, is a simple hut, stark, fragile, and commonplace. Isaiah compares the downtrodden state of Israel to the abandoned "sukka in a vineyard," and Amos the breached Davidic kingdom to "a fallen sukka."[43] Unlike a bridge, bathhouse, or marketplace, a sukka can be easily erected and quickly destroyed. It has no aesthetic value.

The sukka is not only the structural opposite of the nations' building enterprises, but the functional opposite as well. A sukka does not provide a forum for commercial interactions, like a market, or facilitate transportation, like a bridge, or provide facilities for ablutions, like a bathhouse. Nor does a sukka allow its builders to harbor prostitutes, collect tolls, levy forced labor, or pamper themselves with hot and cold baths, steam rooms, and saunas. A sukka simply provides a little shelter from the sun or rain. And the festival sukka does not even do that. For during the festival, when one is commanded to dwell in the sukka, he is not out in the fields with no alternative cover, but within a step of his house, a far more insulated shelter from heat and rain.

This incongruity between the majestic structures of the nations and the flimsy sukka creates the irony that lies at the heart of the homiletical

story.[44] Those who build such edifices certainly should be expected to follow God's instruction without difficulty. To observe the commandment of dwelling in a sukka is easy. Nothing more is required than to sit in it and be. Hence the homilist dubs the sukka a "simple precept." It demands no travel, no labor, no effort; one need not do anything. Compared with the effort required to build bridges, conquer cities, wage war, or administrate marketplaces, simply to sit in the sukka is effortless. While the nations "straightaway" are able to construct a sukka, they prove unable to dwell there. Faced with minor discomfort the nations not only exit abruptly, but also kick their sukkot in disgust. For the festival sukka is completely otherworldly, functioning only as a means to fulfill the commandment of God. It conveys no self-aggrandizement, no this-worldly pleasure, no tangible benefit. Ironically those who construct the much more impressive markets and bridges cannot observe the simple precept of the sukka. The contrast between the sukka and the other edifices is the difference between otherworldly dedication and this-worldly success, between worship of God and self-satisfaction, between vanity and Torah, between Israel and the nations.

At this point the homilist moves from the Isaian verse to Ps 2:3–4. The nations have lost the trial — they have spoken plenty of the "vain things" to which Ps 2:1 refers — and now rebel against the commandment proposed by God. Of course the homilist has shifted far from the biblical view, which envisions an actual revolt against the Lord and his anointed, to a childish smack at the sukka God instructed them to build. When the nations "break the cords of their yokes" (Ps 2:3), they break free from the yoke of the kingdom of Heaven, not from subjugation to the Israelite king. In both cases the harmless revolt only induces God to laugh at the futile struggle. Again the irony is beautifully conveyed. While God testifies that Israel observed the entire Torah, the nations did not observe the seven they were commanded in this world, nor even the single "simple" precept in the eschaton. Yet they would demand a reward! God has good reason to laugh at their folly.

Besides the shift in base text from Isaiah to Psalms, the linguistic parallels and structure swiftly press the homily to its conclusion. The two "straightaway's" that introduce the nations' last acts of "going" to build the sukka and then "departing" (IIIA', B') echo the two "straightaway's" that introduced their confused "coming" and reorganized "entrance" (IA', B). The approach and departure are expressed with perfect symmetry. Yet within the third section the tripartite structure of God acting and the nations responding abruptly breaks off with God's final laugh (C), which

receives no answer. This structural anomaly coheres with the point of the homily. When all is said and done, the nations cannot respond. There remains for them neither objection, dispute, plea, argument, nor question of God's judgment. The drama is over.

## Literary and Halakhic Context

The homiletical story appears near the beginning of the talmudic commentary to the first Mishna of Tractate Avoda Zara, which forbids engaging in business with gentiles for three days before their religious festivals.[45] The common themes of gentiles and the religious differences between Jews and gentiles provide at least a superficial connection between the Mishna and the story. In addition, the talmudic *sugya* mentions two variant spellings of the Mishnaic term "their festivals," either 'eideihem (literally, "disasters") or ʿeideihem (literally, "testimony"); the latter is the same word that appears in Isa 43:9, the base text for the homiletical story ("let them give their testimony"). Yet the redactors have done much more than juxtapose a story because of a loose associative connection. Both internal considerations and comparison with the parallel *sugya* in the PT strongly suggest that the redactors intentionally—and somewhat artificially—inserted the story into this *sugya*, as has been observed by David Rosenthal.[46] An outline of the *sugya* in both Talmuds is as follows.

| PT AZ 2:1, 39a | BT AZ 2a |
|---|---|
| [a] Rav said ʿeideihem (testimony) and Shmuel said 'eideihem (disaster) | [A] Rav and Shmuel: One taught ʿeideihem (testimony) and one taught 'eideihem (disaster). |
| | [A1] He who taught 'eideihem is not wrong, and he who taught ʿeideihem is not wrong. |
| [b] He who said ʿeideihem [is based on] *And they themselves testify* (Isa 44:9). | [B] He who taught ʿeideihem is not wrong, as it is written, *Let them give their testimony* (ʿeideihem) *and be vindicated* (Isa 43:9) |
| [c] He who said 'eideihem [is based on] *The day of their disaster* ('eidam) *is near* (Deut 32:35). | [C] and he who taught 'eideihem is not wrong, as it is written, *The day of their disaster* ('eidam) *is near* (Deut 32:35). |

[D] He who taught *'eideihem*, why did he not teach *'eideihem* . . . ? And he who taught *'eideihem*, why did he not teach *'eideihem* . . . ?

[E] But does this [verse], *Let them give their testimony* ('eideihem) *and be vindicated (Isa 43:9)*, refer to the idolaters? [No!] It refers to Israel, for R. Yehoshua b. Levi taught, "All the commandments which Israel perform in this world come and testify for them in the world to come, as it says, *Let them give their testimony.*"

[F] Rather Rav Huna b. Rav Yehoshua said, "He who said *'eideihem* [learns] from here: *And they themselves testify (Isa 44:9)*."

[G] R. Hanina bar Papa and some say R. Simlai expounded . . . (the homiletical story)

Let us first focus on the BT *sugya* alone. It begins by introducing the two variants noted above. The *sugya* asserts that both readings are valid and provides etymological grounding by adducing two biblical verses, Deut 32:35 and Isa 43:9 (A1, B).[47] While Deut 32:35 is accepted without further discussion, the BT quickly objects to the proof based on Isa 43:9 (E) and rejects it in favor of Isa 44:9 (F). The redactors clearly knew the "correct" answer beforehand; they first propose Isa 43:9 as a spurious solution to create the rhetoric of give-and-take. To delay the correct answer until the end of the *sugya* after proposing and rejecting bogus suggestions is characteristic of BT legal *sugyot*.[48] Why offer here a spurious prooftext based on Isa 43:9? Because that verse is the homiletical story's base-text, and by bringing it into discussion, the redactors create a neat segue to the story. Moreover, the objection at E anticipates the story's content by

mentioning the eschaton, the commandments and judicial testimony. In this way the redactors construct a suitable context for both the exegetical dimension (Isa 43:9) and the narrative dimension (the eschaton, the importance of Torah) of the homiletical story they wish to introduce.

The brief parallel *sugya* in the PT confirms this analysis. The same two Babylonian Amoraim dispute [a=A], and the *sugya* grounds their two variants directly on Deut 32:35 and Isa 44:9, the same final answers as in the BT. (Note that b in the PT corresponds with F in the BT.) Here we have a picture of the pre-Stammaitic state of the *sugya*. The Stammaim simply inserted the spurious answer based on Isa 43:9 at B, added the objection at E and deferred the original answer (b in the PT) to F.[49] Thus the BT redactors carefully and thoughtfully incorporated the homiletical story into this *sugya*. They did not mechanically juxtapose stories based on loose associative connections.

Why did the Stammaim place the story at the beginning of Tractate Avoda Zara? First, the story provides a type of introduction to the tractate.[50] The need to separate from gentiles and to avoid any association with idolatry, the tractate's main topics, raise significant theological questions: Are the gentiles responsible for their religious blindness? After all, they were not given the Torah and were not part of the covenantal community. What commandments must a gentile observe? Will the gentiles ever realize the futility of their beliefs and renounce the festivals mentioned in the Mishna? Will they ever acknowledge the truth of Torah and God? What is their ultimate fate? Is that fate just? Conversely, what is the reward for accepting God and Torah and for rejecting idolatry? To observe Torah for centuries while remaining subject to the sinning gentiles must have produced periods of intense theological angst. Indeed, the BT elsewhere reports that when certain Tannaim experienced the power of Rome they broke into tears because "those gentiles who bow down to idols and offer incense to statues reside in security and peace while our temple, the footstool of our God, has been burned with fire" (bMak 24b). When would the Jews gain the upper hand over the gentiles and the reward promised for observing Torah materialize? These are important, troubling questions, for which the Mishna, primarily a book of law, offers little response. The redactors address them with the story's depiction of the eschatological trial and the supplementary Aramaic comments.[51]

Second, the negative view of gentiles reflected in the tractate's laws finds narrative expression in the story. According to the Mishna, Jews may not leave their cattle with gentiles (for fear of bestiality), nor may a Jewish woman be alone with gentiles (for fear of rape), nor should a man be alone

(for fear of murder; mAZ 2:1). Jews are limited in what they may buy from and sell to gentiles so as not to confer benefit or benefit from anything tainted by idolatry (mAZ 1:1–2:7). Idols and objects with idolatrous images are completely proscribed for Israelite use and should be destroyed (mAZ 3:1–4:6). Gentiles thus comprise a constant source of danger because of their immoral and idolatrous practices. Similarly, the story presents gentiles as deceivers, liars, and fools. Various gentiles tried to murder (Nimrod, Nevuchadnezzar, Darius), seduce (Potiphar's wife), and cheat (Laban) Jewish heroes. As the Aramaic comments point out, gentile nations destroyed the temple and enslaved the Jews (notes *d* and *e*). All law ultimately depends on a narrative superstructure that grounds its content and in which its provisions make sense.[52] The story at the outset of the tractate explains and justifies not only the Mishna's views of gentiles and idolatry, but also the fundamental rabbinic value—the Torah. For it is Torah that separates gentile from Jew in both this world (the Mishna) and in the world to come (the story).

## Cultural Context

The homiletical story offers one theological perspective on the intersection of three fundamental components of the rabbinic worldview—eschatology, gentiles, and Torah: in brief, the gentiles receive no share in the world to come because they never fulfilled the Torah. This view, in one form or another, finds expression in numerous BT sources. For example, an exegetical tradition at bMeg 15b maintains that God himself will be a crown for the righteous in the world to come. A brief story follows in which the Attribute of Justice asks God, "What is the difference between those (who receive the crown) and those (who do not)?" God replies, "Israel busied themselves with Torah (and therefore receive the reward), the nations of the world did not busy themselves with Torah." Clear, simple, and to the point. But as is well known, rabbinic theology was neither systematic nor monolithic. The BT provides diverse perspectives on the interrelationship of these components, which have been collected in various works on rabbinic theology. Christian scholarship on rabbinic Judaism, for obvious reasons, has been especially interested in exploring the attitude toward gentiles, the question of their salvation and rabbinic eschatology.[53] These multifarious and unsystematic traditions, taken together, make up the cultural context for the homiletical story.

Yet part of this wider cultural context is close at hand, provided by several of the Aramaic comments and the parallel talmudic passages from

which they were transferred. The comments in notes *f* and *g*, in particular, juxtapose opposing perspectives to challenge or nuance aspects of the homiletical story. While the comments ultimately support the assumptions of the story, they simultaneously mobilize dissenting voices from within the tradition and demonstrate that the issues are more complex than they appear. Consider note *g*. In attempting to support the story's claim that the gentiles failed to observe the seven Noahide commandments, the comment concedes not only that some gentiles do fulfill those commandments (so R. Meir, section ii), but also that they do receive a reward, only that the reward is inferior to the reward of those commanded (so R. Hanina, section iii). Against the story, then, some gentiles observe the commandments and enjoy at least some reward on that basis. While the comment does not quantify the difference in reward, there is no reason to think their loss substantial.[54] R. Meir's dictum, moreover, entertains the possibility that an idolater can "busy himself with Torah," which stands in tension with the story's repeated charge that no gentiles speak "this." Were that not enough, R. Meir grants such a Torah-observing idolater the status of the Jewish high priest, the acme of the spiritual hierarchy! Even if R. Meir deals in theory rather than empirical reality, this rhetoric of a gentile equated with the high priest presents a stark contrast to the negative images of gentiles expressed in the story. The many voices in the comment provide ample testimony of the deep tensions in the view of gentiles within the culture of the BT.

The BT also quotes R. Hanina's comment regarding levels of reward in bQid 31a. In the discussion of the commandment to honor one's parents, the BT relates that Dama b. Netina, "a certain idolater from Ashkelon," showed tremendous respect to his father and consequently God granted him a tremendous reward. A hortatory conclusion appended to the story invokes R. Hanina to demonstrate that, if those who are not commanded but nevertheless observe (e.g., Dama the gentile) receive such reward, then those who are commanded and observe (Jews), can expect even more. Here is "empirical" proof, contra the homiletical story, that at least some gentiles observed commandments, receive reward, and impressed the sages on account of their piety.

If we pursue the logic of R. Meir's exegesis it follows that gentiles have a share in Torah and presumably in the world to come. Not surprisingly, the BT contains traditions to that effect, such as bSanh 105a:

> R. Eliezer says: *Let the wicked be in Sheol, all the nations who forget God (Ps 9:18).* "Let the wicked be in Sheol" — These are the sinners among Israel. "All the nations who forget God" — These are the nations of the world.

R. Yehoshua said to him: Does it say "And all the nations"? Does it not say "All the nations *who forget God*"? Rather [this is the meaning]: "Let the wicked be in Sheol," and who are they, "All the nations who forget God."[55]

R. Eliezer claims that all gentile nations will go to Sheol (Hell) because they forget God, that is, worship idols. This position basically coheres with that of the homiletical story wherein the gentiles receive no portion in the world to come. R. Yehoshua interprets the verse narrowly: only the gentiles who forget God are identified with the wicked in Sheol. Righteous gentiles have a share in the world to come. (This is stated explicitly in the original source of this tradition, tSanh 13:2.) The BT even identifies R. Yehoshua's position with the view of mSanh 10:2, probably the majority rabbinic opinion, which singles out the few wicked gentiles who have no share in the next world.

Other BT traditions exhibit similar tensions but side with the story's negative view of gentiles. A tradition in bBB 10b offers a series of interpretations of Prov 14:34, "Righteousness exalts a nation, but the *hesed* of the peoples is sin."[56] In the Bible *hesed* typically means "kindness" or "love," but occasionally means "reproach," which is the meaning in this verse. The talmudic interpretations, however, take *hesed* in its usual sense: "R. Yehoshua said, 'Righteousness exalts a nation' — this refers to Israel . . . 'but the kindness (*hesed*) of peoples is sin': all the righteousness and kindness that the nations do counts as sin, since they only do it in order that their kingdom endure." Good deeds, in other words, confer no merit to the gentiles. Several other sages offer variations on this theme. The only favorable interpretation is attributed to R. Yohanan b. Zakkai, "Just as the sin-offering atones for Israel, so righteousness atones for the gentiles." However, he concedes that his own interpretation is inferior to those of his colleagues. Thus the *sugya* mentions a relatively favorable view of gentiles but quickly marginalizes it. Even R. Yehoshua, who reportedly claimed that gentiles have a share in the world to come in bSanh 105a, here sides with the disparaging opinions. The fundamental constraint on the favorable view of gentiles was their lack of Torah. General "righteousness" would only get you so far in the view of the BT. As another talmudic tradition asserts: "For this reason their (the nations') sentence to the Pit of Destruction was sealed — that they should have studied [Torah] but did not study."[57]

When it comes to Torah the Aramaic comments and the culture they represent reinforce, rather than problematize, the story's conception. The story attributes to the gentiles a rabbinic tradition that creation depends

on the existence of Torah. To this bold statement of the status of Torah the comment in note *h* provides two supporting traditions. God stipulated with the world on the sixth day—the day of creation of human beings who would study and observe the commandments—that its existence was contingent on Israel accepting the Torah (so Resh Laqish). Hizqiah's tradition shifts the focus to the anxiety of the personified cosmos during the revelation on Mt. Sinai lest Israel decline the Torah and it immediately dissolve into nothingness.[58] Juxtaposing the three traditions presents an impressive and sustained vision that constructs Torah in mythic terms as a "universe maintaining activity."[59] BT culture exhibits tensions concerning the image, virtue, and salvation of gentiles, but on Torah the culture speaks with one voice. As a whole, the homiletical story at the beginning of Avoda Zara offers one of the strongest presentations of the mythic view of Torah in the entire Babylonian Talmud.

### APPENDIX: MANUSCRIPT VARIANTS

The translation is based on ms Paris 1337 (=P). Variants are from ms Munich 95 (=M), JTS 44830 (=J), and the Venice 1520 printing (=V). A facsimile edition of ms JTS was published by Shraga Abramson (New York: Jewish Theological Seminary, 1957). I have not included manuscript variants of the Aramaic comments. The text of the comments is more fluid, as is typical of the Aramaic portions of the Talmud (the Stammaitic stratum).

(I) "R. Simlai." J reads "R. Sheila."

(I) "All the nations assemble as one, the peoples gather." MV omit "The peoples gather."

(I) "Each nation with its scribes." J reads "Each nation with its sages, each nation with its scribes."

(I) "Busied yourselves?" J adds "in this world." M adds it in the margin.

(IA) "Straightaway." J omits.

(IA) "Everything you made." JMV add "Complete idiots! Everything . . ." (cf. IIC).

(IA) Isa 43:9. In Isaiah, "Who amongst *them* can speak this?"

(IA) "As it says, *Who among you speaks this?*" MV omit.

(IA) "Dejectedly." M omits.

(IB) "The Kingdom of Persia enters." JV read "After the Kingdom of Rome leaves, the Kingdom of Persia enters."

(IB) "Everything you made." M adds "Complete idiots!" in the margin.

(IB) "As it says, *Who among you speaks this?*" M omits.

(IIB) "I testify for Israel that they fulfilled the entire Torah." JV omit "entire."

(IIB) "Let earth and sky come . . . the entire Torah." J omits "entire."

(IIB) "Let those among you come." M reads "Let the nations of the world come forth and . . . "

(IIB) "that they fulfilled the Torah." M omits.

(IIB) "Suspected of sin (*'aveira*)." M reads *'erva*—sexual immorality.

(IIB) Isa 43:9. So JM. P adds "This refers to Israel." This appears to be a late gloss. It could also be considered an additional talmudic comment.

(IIIC): "Sits and laughs." JM read "laughs at them."

Chapter 8

# Conclusion

Each of the previous chapters treated disparate narrative and redactional issues on a limited basis, primarily insofar as they related to the interpretation of the main story under discussion. To synthesize these findings it is necessary to consider each issue in detail and to broaden the focus so as to include relevant material found in other BT stories. It may be helpful, however, to first provide a brief overview surveying the main conclusions.

### Narrative Art

A sophisticated narrative art characterizes BT stories. Leading narrative techniques include wordplay, symbolic names of characters, irony, reversals, the use of keywords, and other modes of repetition. The stories exhibit a preference for interior monologue and dialogue to narration. They generally recount events in chronological order and make scant use of flashbacks and flashforwards. Many of these characteristics typify oral literature and result in part from the predominantly oral culture of the redactors. Their particular functions and connections to talmudic discourse are discussed in detail below.

Jonah Fraenkel's claims regarding the "closed" nature of rabbinic stories and the limited structural possibilities must be revised. Some BT stories allude to other stories, and occasionally a story refers directly to another source. These intertextual links are further evidence that stories passed through a process of reformulation by BT redactors.

## Compositional Methods and Techniques

The primary contribution of this book is the evidence that the Stammaim, the talmudic redactors, played a substantial role in constructing the lengthy, highly developed stories of the BT. They composed these stories by extensively reworking earlier narrative sources, mainly Palestinian traditions that now appear in the PT in versions similar to those transmitted to Babylonia. The Stammaim revised these sources through processes of embellishment, expansion, and supplementation. They transferred material from other BT passages, adapted it to their needs, and added stock phrases and common motifs. They often drew on proximate talmudic traditions for supplementary material. By repeating and varying elements of their sources they produced doublets: one character, event, or element in the PT becomes two in the BT. However, the redactors apparently were unable or unwilling to revise their sources totally, and consequently some interpretive difficulties remain.

This process of composition resembles the redactors' methods of composing legal *sugyot* as described by Halivni and Friedman. The Stammaim transferred legal material from one context to another; adapted legal interchanges or entire *sugyot;* employed stock legal phrases; and expanded brief Amoraic proto-*sugyot* with questions, objections, and solutions. Talmudic stories should be seen as a parallel area of redactional creativity achieved through a similar compositional process. The redactors' contribution to the final text of the Talmud lies both in the composition of narrative and legal *sugyot*. This point, in turn, argues strongly for understanding the content of BT stories as expressions of the culture of Stammaitic times.

The transferring and adapting of sources sometimes led to the production of artificial *baraitot* and Amoraic dicta. Tannaitic and Amoraic attributions contained in stories must be scrutinized carefully before they can be considered authentic.

BT stories have been integrated carefully into their redactional contexts. The redactors changed the original formulations in order to forge links to proximate material: they skillfully tailored the text to fit the new contexts in which they placed the stories. Many stories display a deep connection to the nearby Mishna or a related halakhic topic.

## Stammaitic Culture

BT stories shed light on the values of the Stammaim and the culture of the Babylonian rabbinic academy. Many lengthy stories grapple with

the tensions between the dominant value of Torah and other important concerns. The rabbinic academy is depicted as a highly developed scholastic institution with a defined hierarchy and hundreds of students. Dialectical argumentation is prominently thematized as the highest form of Torah and the leading source of academic status. Because of the intensity of argumentation, the academy appears as a hostile environment. In contrast to PT stories, images of academic "warfare" abound. The theme of shaming another sage by raising objections which he cannot solve and exposing his lack of knowledge appears frequently. These images of the academy correspond to the situation of the post-Amoraic era and share much in common with the culture and institutional developments of Geonic times. BT stories thus open a window to the world of the Stammaitic academy.

Before turning to specific issues a brief caveat is in order. Conclusions based on the detailed study of six stories, a small sample of the extensive BT repertoire, are perforce tentative. A thorough study of each topic discussed below is a desideratum. All of the observations should be modified by "it seems" or "it is likely" even when not stated explicitly so as not to weary the reader. I also ask the reader's indulgence for summarizing and referring back to earlier discussions. A degree of repetition must be tolerated in any attempt to reach general conclusions on the basis of individual studies. Yet there is a great deal more than recapitulation in the following pages, for I bring examples from numerous other stories. The primary stories are referenced by their chapter number in boldface: [2] = "The Oven of Akhnai"; [3] = "Elisha ben Abuya"; [4] = "Torah and the Mundane Life: The Education of R. Shimon b. Yohai"; [5] = "Rabbinic Authority and the Destruction of Jerusalem"; [6] = "Torah, Lineage, and the Academic Hierarchy"; [7] = "Torah, Gentiles, and Eschatology."

## The Narrative Art of the Babylonian Talmud

An understanding of the narrative art of the BT is important for several reasons. First, content is inextricably bound up with—even contingent upon—the literary analysis of narrative discourse. No adequate interpretation of a BT story, or any literary work for that matter, can ignore literary features and structure any more than the content, plot, or characters. Second, a comprehensive grasp of BT narrative art allows us to distinguish typical from anomalous features, the routine from the significant. This base of knowledge becomes relevant not only to the interpretation of other BT stories, but to comparing BT stories with those in other rabbinic documents. I have tried to discern common tendencies, features, and character-

istics, though not inviolable laws, that can be applied with profit to the analysis of other stories. Third, literary features are relevant to identifying the genre of stories and the social setting of the storytellers. Nor should we discount the inherent aesthetic interest in the workings of talmudic narrative.

Jonah Fraenkel and Ofra Meir have elucidated aspects of the narrative art of the rabbinic story.[1] However, neither has essayed a study specific to the BT: Meir focuses on the stories of *Genesis Rabba* while Fraenkel makes no distinctions among rabbinic documents.[2] I deal briefly with those aspects covered by Meir and Fraenkel and devote greater attention to topics neglected by these scholars, to specific characteristics of the BT, and to several of Fraenkel's claims which require reevaluation, although I make no claims to completeness. Let me emphasize at the outset that all comparisons between the BT and PT (or Palestinian sources in general) are of degree, not kind. Rarely, if ever, are literary devices found in the BT completely unattested in the PT.

## Wordplay

Almost every story includes wordplay or paronomasia. Thus "return (*hazor*) back . . . then you too return/repent (*hazor*)" [3]; "Wherever R. Eleazar smote (*mahi*), R. Shimon healed (*masi*)" [4]; "the rabbis (*rabanan*) oppose the thugs (*baryonei*)" [5]; "What shall we do? (*na'aveid*) . . . We will depose him (*na'avrei*)" [6]; "He ordained (*taqqen*) this teaching. . . . Let us fix (*netaqqen*) something for ourselves" [6]. Only the first of these wordplays appears in the Palestinian version, which may suggest that the phenomenon is more common in the BT.[3]

## Symbolic Names of Characters

Names of characters regularly feature in a type of wordplay such that the symbolic meaning of the name substantively relates to the narrative content. The meaning may be explicitly interpreted by the story: "Since they surrounded him with [words] like this snake (*'akhna*)" [2]. Similarly, the names of the three rich men who supply the city with food, Naqdimon b. Gurion, Ben Kalba Savua and Ben Zizit Hakeset, are explained in terms of their deeds or practices [5]. Often the symbolism is not spelled out, such as Yehuda b. Gerim (son of proselytes [4]) and Qamza / Bar Qamza (locust [5]). Names also function as a means of characterization, as in the thug leader Abba Siqra ("Chief Assassin" or "Father Murderer" [5]) and

Ima Shalom ("Mother Peace" [2]). Examples can be multiplied from other BT stories.[4]

Interestingly, several stories efface the names of sages: Elisha b. Abuya becomes Aher, "the Other" [3], while Meir's name is temporarily replaced by "Others" and Natan's name by "Some say" [5]. Thus the stories themselves thematize the importance of names and the lack thereof.

The symbolic use of names results in part from the extreme brevity of BT stories, hence the need to invest as much meaning as possible in every word. Wellek and Warren point out that naming is "the simplest form of characterization," since a carefully chosen name requires little additional description.[5] Symbolic names simultaneously signal the fictional nature of BT stories. As Michael Rifattere has argued, "Emblematic names, that is to say, patronymics with a meaning related to the part played by their bearers in a story, are especially blatant indices of fictionality."[6] The tendency toward symbolic names is less pronounced in the PT.[7]

Wordplay, symbolism, and characterization related to names have deep roots in the Bible (Moses, Abraham, Isaac, Israel, Gershom, the sons of Jacob, Naval, numerous toponyms, etc.).[8] Moshe Garsiel observes that many biblical names "contain a potential for connotative derivations which are pertinent to the plot," and argues that such punning is "a significant literary device to enrich and intensify the plot through a correspondence between names and themes."[9] The same phenomenon is widespread in classical literature and folktales.[10] In this respect talmudic stories continue in biblical and ancient models.

## Irony

Numerous examples of dramatic or situational irony appear in this selection of stories.[11] R. Pinhas b. Yair ironically heals R. Shimon b. Yohai in the bathhouse he had condemned as a decadent facility for self-indulgent pampering [4]. The sages refuse to offer the blemished sacrifice because they worry lest others misconstrue the law. The Romans then misconstrue the sages' failure to sacrifice and worse problems ensue [5]. Abba Siqra, "Father Murderer" or "Chief Assassin," has no authority over his henchmen—an ironically symbolic name [5].[12] There is irony that Elisha b. Abuya's exegesis rejects dualism in light of his punishment for wondering if there were two powers in heaven [3]. Although the gentiles boast of building magnificent structures they cannot occupy the lowly sukka [7]. Examples of verbal irony include the statement of Meir and Natan to R. Shimon b. Gamaliel, "Let the master teach us [from Tractate] Uqsin," as they

mean to embarrass him, not to receive instruction [6]. God calls the sukka a "simple precept," yet it is anything but simple for the gentiles [7].

## Reversals

Reversals, which are related to situational irony, also feature prominently in BT stories.[13] Meir and Natan plan to depose R. Shimon b. Gamaliel and move up the hierarchy, but they are banished from the academy and lose their positions [6]. R. Shimon bar Yohai resolves to "fix" (*tiqqen*) something, whereas earlier he condemned the institutions established (*tiqqnu*) by the Romans [4]. The sages who eat at the banquet during Bar Qamza's humiliation rather than leave in protest subsequently are prevented from leaving when famine strikes Jerusalem [5]. The nations initially claim that they created institutions "so that Israel could busy themselves with Torah." Ultimately, God summons their representatives to testify that they attempted to compel various biblical figures to violate the law [7].[14]

Irony and reversals contribute above all to the dramatic quality of BT stories. They have a didactic function too in effectively communicating lessons to the audience. That R. Shimon bar Yohai's initial perspective on worldly institutions is extreme becomes abundantly clear when he subsequently ameliorates a minor social inconvenience. To recognize irony and reversals, moreover, requires close attention and an awareness of different possible meanings. In this way the complexity of the BT's narrative art parallels the complexity of its legal *sugyot*.

## Interior Monologue

BT stories reveal a marked preference for representing thought as speech and representing consciousness through interior monologue rather than third-person narration. Typical is "So-and-So said (to himself) . . . ," not "So-and-so thought/felt that. . . ." The locution, "Rabbi Yaakov b. Qudshai heard them. He said, 'Perhaps, God forbid, it will result in shame?'" [6], expresses the sage's thoughts, not his speech to another character. Similarly: "He (Aher) said, 'Since that man has been banished from that world I will go and enjoy myself in this world'" [3]; "He (R. Shimon b. Yohai) said, 'Since a miracle occurred I will go and fix something'" [4]; "He said, 'Since the rabbis were sitting and did not intervene, I will go and inform against them at the King's palace'" [5]; "He said, 'The Holy One, Blessed be He, wants to destroy his house and He wants to wipe clean his

hands with that man (=me)!'" [5]; "Rabban Shimon b. Gamaliel said, 'Should there not be a distinction between me and them?'" [6]. Interior monologue is equally characteristic of PT stories.

Scholes and Kellogg claim that the ancients did not clearly distinguish thought from speech: "This concept of thought as a sort of interior dialogue, taking the same linguistic form as oral speech, remained the prevailing assumption about the nature of thought until a few centuries ago."[15] If so, then the prevalence of interior monologue in talmudic stories is standard premodern technique. Indeed, the term *'amar*, "he said," can also mean "he thought" in both biblical and rabbinic Hebrew.[16] Robert Alter has observed a similar penchant for interior monologue in biblical narrative.[17]

The prevalence of interior monologues contributes to the dramatic quality of BT stories.[18] Drama, as a genre, is constituted exclusively by dialogue and (exterior) monologue or soliloquy. While some dramas lack excitement, the direct interchanges between characters and unmediated access to thoughts and feelings through soliloquy foster drama's "dramatic" quality, that is, intense, moving, involving conflict or contrast. The predilection for dialogue and interior monologue renders a story "dramatic" in this sense. Thus Alter observes that the articulation of thought as speech allows for precise stylization and "dramatic vividness."[19] When Rabban Shimon b. Gamaliel expresses his horror that he might be shamed—"What is before me? Perhaps, God forbid, there was some matter in the academy?" [6]—the series of panicked phrases vividly communicates his fear and urgency. The interior monologue focuses the situation directly through his eyes. That many BT stories should be classified as "dramatic narratives" is due in part to the propensity for interior monologue.

## Dialogue

BT stories likewise display a penchant for dialogue. The homiletical story consists almost exclusively of dialogue [7]. Apart from the introductory narration to set the scene and the conclusion describing the nations' futility, narration appears only in the few lines stating that various nations enter or depart, that is, the briefest of stage directions. The "Oven of Akhnai" also consists primarily of dialogue, first between Eliezer and the sages, then between Akiba and Eliezer and finally between Eliezer and his wife.[20] Even the narration includes dialogical formulations: "What is *'akhnai?* . . . What is 'It is not in heaven'? . . . What did he [Akiba] do?" God's reactions too are not reported by the narrator but disclosed through dialogue between R. Natan and Elijah.

The dialogical character of BT stories derives both from the considerations discussed above in relation to interior monologue and from the dialogical nature of rabbinic activity in general. "Oral Torah," as the name implies, flourished in an oral cultural milieu. Debate, argumentation, and give-and-take are quintessential dialogical forms. According to Halivni, the Stammaim placed the highest value on dialogical give-and-take and composed legal *sugyot* in a discursive, dialogically-oriented style. The dominance of dialogue thus provides another similarity between the legal and narrative portions of the BT.

## Order

In narratological theory order pertains to the arrangement of the events in the narrative discourse as opposed to the rearranged succession of events in the fabula.[21] Stories often present events through flashbacks (retroversions, analepses) only after later developments have been narrated, or through flashforwards (anticipation, prolepses) before earlier events have been mentioned. BT stories make limited use of these devices, known as "anachronies," and tend to narrate events in their proper temporal order. The major exception we encountered was the story of the siege of Jerusalem, which begins with the conclusion, "Jerusalem was destroyed because of Qamza and Bar Qamza" [6]. Technically this line constitutes a flashforward which shifts the narrative tension from what will happen to how it happened. Yet this type of anachrony, a summary statement of the denouement at the outset, is itself a convention, and consequently less indicative of a propensity toward temporal disordering.[22] Several other BT stories have a similar temporal structure.[23]

Most flashforwards in BT stories are but brief informational points that serve to influence the audience's evaluation. The terse datum that R. Meir descended from Nero, a flashforward to a point decades after the destruction of the temple, casts Nero's action in very favorable light [5]. The conversation between R. Natan and Elijah about God's reaction to "It is not in heaven" appears near the beginning of the narrative, although their interchange must be the last event of the fabula, since Natan lived several generations after Eliezer and Gamaliel [2].[24] This description of the divine reaction informs the audience that far from taking offense at such rabbinic hutzpah, God approves, which encourages a similar response. R. Yohanan's redemption of Aher from Gehenom precedes Aher's daughter asking alms of Rabbi Yehuda HaNasi in the narrative discourse but not in the fabula, since R. Yohanan postdates Rabbi Yehuda HaNasi, who appears

in the next scene [3]. Apprising the audience of Aher's salvation secures his sympathetic and favorable image. It is significant that these latter two examples are BT supplements without counterpart in the PT versions. They result from the reworking of the PT source, namely the interpolation of an additional scene featuring a new character. Anachronies, then, should alert us to possible source-critical issues.[25]

BT flashbacks too tend to be brief detours from the chronological order rather than major disorderings of the events, and often complement what Genette calls a "paralipsis," a lateral omission of information. In such cases "the narrative does not skip over a moment of time, as in an ellipsis, but it *sidesteps* a given element."[26] A paralipsis will often be followed by a flashback to fill in the narrative gap. Thus the narrator omits mentioning that the sages attended the banquet and then incorporates a brief backward glance in Bar Qamza's remark, "Since the rabbis were sitting and did not intervene, I will go and inform against them" [5]. Similarly, the narrator does not mention that Meir and Natan were absent from the academy when Rabban Shimon b. Gamaliel instituted the change in protocol. He then resorts to a flashback, "On that day, R. Meir and R. Natan were not there," before continuing, "On the morrow, when they came . . ." [6].[27] Note that these flashbacks refer to recent events narrated in the preceding scene, not to events of the distant past that occurred prior to the beginning of narrative time. Similarly, the flashback of Elisha informing Meir of the heavenly voice refers back to the opening scene [3]. In Genette's terminology, these are "internal analepses," as opposed to an "external analepsis" that backtracks to the time preceding the beginning of the story. None of these flashbacks comprise a self-contained story of any length. The effect of temporal distortion on the audience is relatively muted.

The BT, then, seems to show a preference for straight sequential ordering with but minor temporal detours. This type of order is characteristic of folklore, fairy tales, ballads, and the like.[28] These shorter forms of narrative typically originate as oral tales, which might explain the BT's preference for sequential order as well. A comprehensive study of narrative order in BT stories is needed.[29]

## Keywords and Repetition

Martin Buber observed that the Bible repeats words and verbal roots to connect and unify parts of its stories. He called these keywords "*leitwörter*," "leading words." Robert Alter described this phenomenon in rich detail in his work on biblical narrative.[30] BT stories too make significant

use of this device. For example, the story of R. Shimon bar Yohai features the keywords "pain" (*tsaʿar*), "establish/fix" (*tiqqen*), and "world/life" (*ʿolam*). R. Shimon must hide because the Romans may "pain" his wife, and he experiences "pain" from the baths upon his return. His removal of the impurity that caused priests "pain" to circumvent reveals his newfound sensitivity to the needs and travails of everyday life. The keyword world/life (*ʿolam*), in particular, focuses the critical tension of the story. The sages burn the peasants for not dedicating themselves to "eternal life" (*hayyei ʿolam*), but God charges them with destroying the world (*ʿolam*), the real, everyday world. After their subsequent exit, R. Shimon tell his son, "You and I are sufficient for the world." It is unclear if he means the "eternal world/life" (it is enough that we study Torah; leave the others in peace) or the real world (our merit is sufficient to warrant the world's existence), or both. When he reactivates his destructive gaze and kills Yehuda b. Gerim, observing, "Is this one still in the *world*?" we wonder whether the tensions between the two worlds can be fully resolved after all. Keywords thus function as a unifying device that concentrates attention on significant issues.

"Teach/study" and the pair "stand, rise" (root = *q-w-m*) and "ascend, raise" (root = *s-l-q*) are keywords in [6].[31] "Stand, stood" is a keyword in [2] (the walls, the wave, Yehoshua, Gamaliel, and finally Ima Shalom tell Eliezer to stand up). Other keywords include "let be / leave alone" (*shavaq*) in [5], and "enter," "depart," "receive," and "fulfill" in [7].

A keyword is one type of verbal repetition. Another common type of verbal repetition is the threefold repetition of a phrase or sequence of phrases.[32] This phenomenon is well known from folklore, the Bible and literature throughout the world. Thus the narration of R. Eliezer's efforts to prove his ruling through the miracles of the carob tree, aqueduct, and walls repeats most of the description and dialogue [2]. Bar Qamza offers to pay for what he eats and drinks, then for half the banquet, then for the whole banquet, but is rebuffed each time [5]. Threefold repetitions frame the praising and condemning of Roman (and Persian) achievements in both [4] and [7]. Halakhic *sugyot* frequently include tripartite structures and repeated interrogative patterns in the argumentation.[33] In fact, some threefold repetitions of objections and responses are redundant, and were probably included in order to complete the triplet.[34] This predilection for three in both legal and narrative portions derives partially from the oral setting. Not only do repetitions of similar phrases serve a mnemonic function, but they help the audience to follow the discourse more easily.

Sometimes we find repetitions other than three. Four times the story-

teller repeats the description of Meir taking Elisha to solicit study-verses [3]. Four times Marta sends her servant to the market to purchase food [5]. Twice Aher quizzes Meir about the meaning of a verse and responds "Akiba your master...," and twice Meir implores Aher to repent [3]. Six times God commands the nations, "Let *x* come and testify about *y* that he did not do *z*" [7].

## Structure

Jonah Fraenkel argues that rabbinic stories have three structural possibilities, two parts, three parts, or a chiasm, and he documents this claim with numerous and impressive examples.[35] Of the stories analyzed here, [2] has two main parts, [3] is chiastic, [4] and [7] have three parts, [6] is a flawed chiasm, and [5] has no simple structure. On the one hand, to find these structures in such lengthy and complex stories provides additional support for Fraenkel's thesis. On the other hand, the latter two cases call Fraenkel's theory into question. Moreover, many of these divisions are based on the content or a general sense of the movement of the story, not on formal markers or repeated phrases. There is nothing wrong, in principle, with divisions based on content—my structural analyses emphasize content—except that they can become rather subjective. To engage in some self-criticism: the "Oven of Akhnai" could be divided into four parts, not two [2]; the story of R. Shimon bar Yohai could be subdivided further [4]. With enough ingenuity, just about any story can be divided into two or three parts, and perhaps even a chiasm.[36]

We should not conclude, then, that the structures of all BT stories are limited to Fraenkel's three patterns. BT stories do not display the "deep structure" of structuralist theory. Structure should be considered a strategy, both by storytellers and interpreters, to create meaning through the correspondences, changes, and symmetries of parts of a story. Tripartite and chiastic structures are not inherent properties of the BT narrative, not the sum total of structural forms, but possible organizational tools. Attention to structure frees the audience from the typical serial and linear mode of processing a story and enhances awareness of relationships between parts. Structures probably had mnemonic utility as well, always an important factor in the oral milieu. This would explain the numerous examples of highly structured units *within* the story, such as the three miracles supporting Eliezer [2], the three conversations between Meir and Aher [3], and the chiastic forms of the debate over Roman institutions [4] and of the con-

versation between Meir and Natan [6]. These internal units do not always contribute to the overall structure, and presumably serve a different function.[37]

In this respect too BT stories resemble legal *sugyot*. Many legal *sugyot* are characterized by tight three-part or seven-part structures, or display highly structured internal units, often a series of objections and responses.[38] Yet many complex legal *sugyot* evince no clear structure, or have their structure distorted by the additions of later hands.[39] So too BT stories: the redactional process is responsible, in part, both for the structuring of the material and for imperfections in the structures.

## Openness and Closure

Fraenkel argues that rabbinic stories are "closed" in two senses. First, internal closure: the story supplies all the information necessary to its interpretation and the end refers back or connects to the beginning. Second, external closure: the story has no relation to other stories but exists in a secluded textual space of its own.[40] Both of these claims are exaggerated. Internal closure in the sense of the end referring back to the beginning characterizes only two of the stories in our sample. R. Shimon b. Yohai finally encounters (and kills) Yehuda b. Gerim who transmitted his words to the authorities at the outset [4]. The eschatological drama concludes with God laughing as the gentile nations dejectedly exit, which parallels their arrival before God to collect reward at the beginning [3].[41] The notion that a story supplies all the information necessary for its interpretation is false, since there is no way to understand many terms, concepts, and motifs except by recourse to other talmudic passages. To understand why Meir and Natan plan to shame Rabban Shimon b. Gamaliel and why R. Yaakov is horrified at that thought requires an appreciation of the severity of shame in the BT as a whole. Even Fraenkel cannot avoid turning to other stories in his practice, as opposed to his theory.[42]

Fraenkel's notion of "external closure," in a certain sense, clashes with contemporary theories of intertextuality that view all texts as inevitably related to other texts and to past discourses. Theoretical considerations aside, his notion is misguided since it fails to take into account the role of the redactors. Because BT stories were filtered through the hands of the redactors and reworked in order to relate to contemporary concerns, they will be interdependent to a considerable extent. We have seen allusions to other stories that contribute substantively, perhaps indispensably, to the interpretation. R. Shimon b. Yohai's words to his son, "You and I are sufficient for

the world," allude to his statement in bSuk 45b [**4**].⁴³ Failure to recognize this allusion misses the ambiguity and impoverishes the interpretation. This case is unlike the opening of that story, which recycles language from another story [**7**] to create the dialogue, but reworks it to the point where the original context does not contribute to the interpretation.⁴⁴ Yet even these cases of recycled or adapted language argue for a more open understanding of stories. Given their synoptic, comprehensive view of tradition, the redactors probably were conscious of the intertextual resonances of parallel phrases in both creating and interpreting stories.

Some BT stories, moreover, not only allude to but presuppose other stories. The comment, "Naqdimon b. Gurion [was so called] because the sun cut through [the clouds] for him," points to a story found at bTa 19b [**5**]. In the story of R. Eliezer's death, bSanh 68a, the sages who visit him on his deathbed keep four cubits distant, and at his death R. Yehoshua exclaims, "the vow is annulled." The story never explains these elements, which refer to the ban (=the vow) in the "Oven of Akhnai" [**2**]. One cannot maintain that the story supplies all the information necessary for its interpretation as Fraenkel would have it. In the story of the deposition of Rabban Gamaliel, bBer 27b, the sages complain about Gamaliel's highhandedness, "On Rosh HaShana last year he distressed him (R. Yehoshua); in the episode with R. Zadoq concerning the firstling, he distressed him; now he distresses him again!"⁴⁵ Mention of "last year on Rosh HaShana" refers to the story found in mRH 2:8–9 and bRH 25a–b, while the "episode with R. Zadoq," a controversy about the laws of the firstling, appears in bBekh 36a.⁴⁶ These references result from the redactional process; the PT parallel to the story of Rabban Gamaliel's deposition lacks the references (yBer 4:1, 7c–d). But the redactional process is precisely that which has created BT stories. The stories are not isolated units of oral tradition culled from numerous sources of diverse provenance and preserved in their pristine states, but the product of the redactors of a single compilation. Such allusions and cross-references are extremely common in legal *sugyot*, and also result from redactional activity.⁴⁷ These considerations argue against a view of BT stories as closed, hermetically sealed texts on empirical, not only theoretical, grounds.⁴⁸

## Compositional Methods and Techniques

The BT redactors supplement, expand, and embellish their narrative sources to create extensive stories.⁴⁹ This process of composition involves techniques similar to those which the redactors employ to compose legal

*sugyot*. Their main technique is to transfer material from another source and to adapt it to the story, just as they transfer material from one *sugya* and adapt it to the needs of another *sugya*. Sometimes they adapt or repeat the language from the received source to create additional dialogue or a second event. Transferring from external sources generally produces supplements; adapting the internal language of the source generally produces expansions and embellishments. Let us examine a few examples of each type.

## Supplements

The rabbinic debate over Roman cultural institutions in [4] was transferred and adapted from the dialogue between the nations and God in [7]. This scene does not appear in the Palestinian versions. It provides the background to the story and explains why R. Shimon b. Yohai hid in the cave, a question unanswered in those earlier versions. Meir's dismissal of the dream message derives from a brief story from bGit 52a [5].

| | |
|---|---|
| They showed him (Meir) in his dream, "I destroy and you build?" | They showed them in their dreams, "Go and appease Rabban Shimon ben Gamaliel." |
| Nevertheless, he paid no attention. | Rabbi Natan went. Rabbi Meir did not go. |
| He said, "Dreams neither help nor hinder." (bGit 52a) | He said, "Dreams neither help nor hinder." (bHor 13b) |

The brief PT version lacks this scene. Whereas the borrowed rabbinic debate about Roman institutions provides an introduction to the PT story, this supplement supplies part of the aftermath. Thus BT supplements function, at least in part, to answer questions that arise in the course of reflection on a given story: What happened first? (Why was R. Shimon b. Yohai hiding in the cave?) What happened next? (What happened after Meir learned that his honor had been reduced?) These questions would arise naturally as sages studied stories in the rabbinic academy.

In some cases the redactors create the supplement by transferring and combining disparate sources. This process governs the episode of Rabban Gamaliel threatened by a wave, which does not appear in the PT version [2]:

| Sources | "Oven of Akhnai"; bBM 59b |
|---|---|
| Once Rabban Gamaliel and the elders were going on a ship (mMS 5:9, mShab 16:8, etc.) | Also, Rabban Gamaliel was on a ship |
| A wave of the sea stood against him to drown him (bYom 38a, bGit 56b, etc.) | A wave of the sea stood upon him to drown him |
| He (Titus) said, "It seems to me that their God only has power over water" (bGit 56b)[50] | He said, "It seems to me that this is because of [R. Eliezer] the Son of Hyrcanus" |
| Yonatan b. Uziel stood on his feet and said, | He stood up on his feet and said, |
| "It is revealed and known before you that I acted not for my honor nor did I act for the honor of my father's house but for your honor in order that disagreements do not multiply in Israel" (bMeg 3a; cf. bTa 20a) | "Master of the universe. I acted not for my honor, nor did I act for the honor of my father's house, but I acted for your honor, in order that disagreements do not multiply in Israel" |
| The sea rested from its anger (bYom 38a) | The sea immediately rested from its anger |

The composition of supplements provides compelling evidence that the redactors bear responsibility for BT stories. Borrowing, transferring, and adapting sources from one place to another typically occur in the redactional process, and are well-documented techniques of the Stammaim. Amoraim do not formulate their (or their teachers') dicta by transferring and combining language from other sources in this way.[51]

Some supplements lack parallels among extant sources, which suggests that they are the free composition of the storyteller(s). It is difficult to determine whether such supplements are Amoraic or Stammaitic in provenance. We should expect, after all, that Palestinian stories were reworked in Babylonia during the Amoraic period to a certain extent. Yet in some cases a persuasive case can be made that the supplement derives from the Stammaim. Consider the scene describing Meir and Natan writing objections and solutions on paper and throwing them to the students of the academy, for which there are no close parallels [6]. The combination of "objection" and "solution" in the BT occurs almost exclusively in Stammaitic strata and in stories about the academy.[52] It appears, for example, in the scene at the bathhouses, where the narrator explains that R. Shimon b. Yohai could

propound twenty-four solutions for each objection [4]. This scene too is a BT supplement to the Palestinian source which borrows dialogue from elsewhere in the BT, hence a redactional composition.[53] Taken together, these considerations point to a Stammaitic provenance.

## Expansions and Doublets

BT stories expand their sources by repeating and varying the events and dialogue, or by adding similar elements.[54] In the PT Eliezer tries to prove his case by calling upon the carob tree to uproot itself [2]. In the BT he calls first on the carob, which uproots itself and moves, then on the aqueduct, which flows backwards, and then on the walls of the academy, which start to fall.[55] In the PT Meir attempts to bring Elisha into the world to come [3]. In the BT both Meir and R. Yohanan make attempts. In the PT R. Shimon b. Yohai announces that he will "fix something" based on an exegesis of Gen 33:18 in which Jacob established markets [4]. In the BT the sage's announcement is based on exegesis mentioning markets, coinage, and bathhouses. In the first two examples the similarity between the two or three events in the BT together with the repetition of dialogue suggest that the BT storytellers varied the single event of their source, as still reflected in the PT version.[56] This process again indicates that those storytellers are the redactors, for we see a similar phenomenon in the composition of legal *sugyot* (see below). In the third example the redactors probably constructed the expansion by transferring an external source related to this element of the earlier version of the story.

The process of expansion, at a more general level, produces "doublets": one character, event, or element in the PT becomes two in the BT.[57] In addition to the examples above, in the BT R. Shimon b. Yohai spends two periods in the cave [4]. Two "emperors" approach Jerusalem (Nero and Vespasian) while Palestinian sources mention Vespasian alone [5]. Two sages, Meir and Natan, take offense when Rabban Shimon b. Gamaliel reduces their honors; only Meir appears in the PT [6]. The BT reports three types of destruction caused by the injury to Eliezer (decimated crops, swelling dough, burning); the PT mentions but two (crops, burning) [2].

Some doublets in the BT, however, cannot be traced to earlier Palestinian versions. These probably should be considered redactional expansions of an earlier Babylonian version, although the lack of external sources makes it impossible to reach firm conclusions. For example, Vespasian's question as to why R. Yohanan b. Zakkai did not submit earlier and the ensuing dialogue are repeated after the sage solves the general's shoe prob-

lems [5]. The storyteller does not even bother to spell out the dialogue but has each character recall his own words to the other: "Have I not told you? ... I also told you." However, the storyteller does repeat the ensuing nonnarrative comment and vary the ending: "Rav Yosef, and some say R. Akiba, applied to him the verse, *[God] turns sages back . . . (Isa 44:25)*. He should have said, (a) 'We take tongs and take away the snake and kill it' / (b) 'Let them off this time.'" These sections of the story are not paralleled in the Palestinian version in *ARNA*. The recapitulation of the dialogue and the comment of Rav Yosef / Akiba are probably due to an expansion of the Amoraic Babylonian source. It is highly unlikely that Rav Yosef / Akiba made two almost identical statements quoting the same verse each time.

Expansions of these various types are found in many legal *sugyot*.[58] The redactors sometimes offer two or three solutions or explanations where the PT (or the Amoraic stratum) offers a single possibility. They tend to construct dialectical argumentation for the second and third solution identical to that of the first, generating the interchanges by adapting the original solution through a similar process of expansion.[59]

### Embellishments

The BT regularly embellishes its sources by adding description and detail. R. Shimon b. Yohai, in the PT, announces that he will visit the baths in Tiberias [4]. The BT describes R. Pinhas b. Yair escorting R. Shimon b. Yohai to the bathhouse and massaging his body, the clefts in his flesh, and the tears falling into the clefts causing him pain. The PT simply reports that Akiba "went to him (Eliezer) and said to him, 'Master, Master, your colleagues are banning you'" [2]. Direct and to the point. The BT adds numerous details: Akiba dressed in black, took off his shoes, sat on the ground, and so on. The story of the attempted deposition of Rabban Shimon b. Gamaliel is heavily expanded and embellished from start to finish [6]. One exception is the story of Elisha b. Abuya in the PT, which is every bit as detailed as the BT version [3]. Further study is required to determine whether there are many other such cases.[60] Embellishments derive both from other sources within the BT and from free composition.

### Thematic Changes

In some cases the BT storytellers have not supplemented or embellished as much as freely changed or replaced elements of their sources. Often these changes substantively relate to the overall thematic reworking of

the Palestinian source. The exegetical debates between Meir and Elisha b. Abuya offer a stunning example of this phenomenon [3]. In the PT the first two debates invoke biblical verses that end with the phrase "than the beginning," Job 42:12 and Qoh 7:8, and Elisha's interpretations pertain to the question of good and bad origins. This issue connects to the important narrative thread that attributes Elisha's downfall to the sins of his parents. In the BT the sages debate the exegesis of Qoh 7:14 and Elisha's interpretation preempts dualistic theodicies. Dualistic ruminations precipitated the loss of merit and launched Elisha on his odyssey. A second example: Palestinian tradition attributes the demise of Marta (or Miriam) to her indulgent lifestyle.[61] The BT blames Marta's downfall on her servant's failure to bring food for fear of deviating from her orders [5]. Nonaction, excessive caution, and the inept servant are thematized prominently in the BT story.[62]

## Constraints

While the redactors freely modified their narrative sources, they simultaneously acted with certain constraints.[63] They either could not or did not allow themselves the license to revise their sources completely. For this reason we find incongruities and difficulties in the stories. R. Shimon b. Yohai cutting lupines to purify the land makes little sense as it stands [4]. In the PT, however, the sage performs a miracle by cutting and scattering the lupines on the earth, which causes corpses to rise to the surface. The BT redactors preserved the cutting of the lupines despite transforming the miraculous purification into a natural process. Why they preserved the episode is unclear; perhaps a legend of R. Shimon b. Yohai purifying with lupines was too well known to jettison completely. Another example: the redactors deleted the datum "immediately he (the emperor) came and destroyed the temple" from the Qamza and Bar Qamza story in order to play out the course of events in more detail through the complex story that follows [5].[64] This omission renders R. Yohanan's observation, "The meekness of Zecharia b. Avqulos destroyed our temple," difficult to understand, since no temple has been mentioned, much less destroyed. Here the redactors probably attempted to do as little violence as possible to their source while achieving their narrative aims. They excised one line but balked at revising or shifting R. Yohanan's comment to later in the story. In addition, they may have hesitated to take complete liberties with an Amoraic dictum attributed to R. Yohanan, as opposed to an anonymous story; in legal materials too the redactors freely revise the unattributed give-and-take but act

much more conservatively toward Amoraic dicta. However, there seems to be no general explanation why the redactors introduced profound changes in some cases but refrained in others.[65]

Abrupt shifts from one character to another evidence the lack of complete homogenization of sources. In the "Oven of Akhnai," Yehoshua opposes Eliezer at the outset (as he does in the PT) but subsequently is replaced by Rabban Gamaliel as the chief adversary [2].[66] The change takes place because the sources employed to create the third scene place Gamaliel on a ship, and the redactors refrained from substituting Yehoshua. Similarly, R. Yohanan b. Zakkai suddenly emerges as the protagonist of the second part of the story of the siege of Jerusalem, which derives from a distinct source [5]. The source of the first part mentions only "the rabbis," and the redactors evidently chose not to splice in R. Yohanan b. Zakkai's name. Bar Qamza, the protagonist of the first and second scenes, meanwhile drops from sight completely.[67] These phenomena illustrate the advantages of a combination of literary analysis and source-criticism, of synchronic and diachronic methods, for understanding BT stories.

## Pseudo-Baraitot

These methods of redactional compositions sometimes produce pseudo-*baraitot*, that is, later traditions that resemble Tannaitic sources. The rabbinic debate over Roman institutions [4] and the wave threatening Rabban Gamaliel on the ship [2] appear in Tannaitic Hebrew and purport to represent the words of Tannaim. Although both appear to be *baraitot*, both are redactional constructions fashioned from earlier Hebrew sources. Other pseudo-*baraitot* were generated by converting portions of Aramaic Palestinian stories into Hebrew. For example, the third dialogue between Meir and Elisha appears in the Hebrew typical of *baraitot* and is introduced by the term "Our rabbis taught." Yet in the PT this scene appears in the same Aramaic as the rest of the story. Similarly, bBB 133b-134a contains a Hebrew story of the early Tannaim Shammai and Yonatan b. Uziel, introduced by the term "Our rabbis taught." This story, however, devolves from yNed 5:7, 39b, an Aramaic, hence Amoraic, source.[68] Hanokh Albeck collected numerous examples of this phenomenon.[69] That the typical terms for *baraitot* such as "Our rabbis taught" or "It was taught" introduce some of these formulations is especially misleading. Were it not that the provenance of this technical terminology is unclear—the terms may be the work of memorizers or scribes in Geonic and medieval times—we could accuse the redactors of false advertising. As it is, the terminology may have been

added erroneously by transmitters who mistook a later narrative passage for a genuine *baraita*. At all events, the creation of fictional Tannaitic statements produces pseudo-Tannaitic material, whether or not preceded by technical terminology. Modern scholars, misled by the fluid Tannaitic Hebrew, often based historical conclusions on these sources, introductory terminology or no.[70]

A different class of pseudo-*baraitot* (and Mishnas) comprise those taught by the characters within the stories. For example, the redactors invent a hypothetical version of mBekh 9:8 that omits Meir's name ("Other say, 'If it had been an exchanged beast, it would not be offered'") for their narrative purposes [6]. The claim that R. Shimon b. Gamaliel replaced every attribution to Meir and Natan with "Others say" and "Some say" imagines an entire class of pseudo-Tannaitic sources. The story at bBM 84a describes R. Yohanan and Resh Laqish debating a tradition that runs: "The sword and the knife and the dagger and the saw and the spear—when are they subject to impurity? When their manufacture is completed." This imitation is based on mKel 14:5: "The sword—when is it subject to impurity? When it is polished. And the knife? When it is whetted."[71] There emerges a fascinating parallel between such pseudoteachings, which appear within the fabula, and the previous types of pseudo-*baraitot*, which comprise the narrative discourse. In other words, the story both may be a pseudo-*baraita* (e.g. Rabban Gamaliel on the ship) and may report a pseudo-*baraita* or Mishna (e.g. pseudo-mBekh 9:8).

## Amoraic Dicta (meimrot)

Many BT stories include Amoraic (and occasionally Tannaitic) dicta that belong to the narrative discourse rather than the fabula. These dicta, known as "nonnarrative comments" in narratological theory, remark upon, question, or object to events within the fabula; they are *not* the statements of Amoraic characters functioning as dramatis personae.[72] The judgment attributed to Rav Yosef / R. Akiba that R. Yohanan b. Zakkai made a poor request of Vespasian impacts not the course of events but our evaluation [5]. Likewise, R. Yirmiah's explanation of "It is not in heaven" merely clarifies the meaning of this statement [2]. It does not describe further actions of the characters. Several nonnarrative comments explain the propriety of Meir's learning Torah from a sinning master [4].

Some Amoraic comments, however, contribute to the fabula, at least in part. The comment of Rav Yehuda in the name of Shmuel that explains 'Akhna ("Since they surrounded him with words like this snake and ruled

## Conclusion 263

it impure") both interprets the name and describes how the sages treated Eliezer [2]. Rava's concluding comment ("Even Rabbi [Yehuda HaNasi], who was extremely humble, said . . .") reiterates the narrator's report (that Rabbi taught Meir's traditions with a distinct quotation formula) and adds the characterization of the Patriarch as humble [6]. The entirety of the homiletical story is attributed to Amoraim [7]. To some extent, then, Amoraim function as secondary narrators.[73]

What is the provenance and function of these Amoraic dicta? This phenomenon requires further study, and the following are preliminary observations. From a diachronic perspective, many of the Amoraic comments belong to the preredactional history of the story—the process of creation, transmission, reworking, and study in Amoraic times. The same problems concerning the reliability of the attribution and the drift from the original wording obtain as with all dicta. Indeed, in some cases, the dicta seem to result from compositional methods of borrowing and adaptation. The comment of Rav Yehuda in the name of Shmuel mentioned above appears to be modeled on another tradition ascribed to these masters.[74] The opening dictum of R. Yohanan, "This teaching was taught in the days of Rabban Shimon ben Gamaliel," mimics the form of other such traditions attributed to R. Yohanan [6]. Thus the same compositional process that produced pseudo-*baraitot* produced pseudo-*meimrot* as well. While I see no reason to treat the attributions with complete skepticism, the lesser authority of the aggada and these compositional processes mandate that nonnarrative Amoraic dicta be scrutinized carefully.

From a synchronic perspective, Amoraic dicta have a variety of functions. Some explain difficult aspects of the story, such as R. Yirmiah's explanation of "It is not in heaven" [2]. Other Amoraic dicta explore problematic issues or answer unresolved questions. The series of attributed comments toward the end of the story of Aher justify a sage learning Torah from a sinner [3]. This issue figures briefly in the fabula when Elijah reports that God first spurned, then taught, Meir's traditions. The nonnarrative comments provide a more protean and detailed examination of the question. Still other Amoraic comments influence the audience's evaluation of the story. R. Akiba / Rav Yosef's criticism that R. Yohanan b. Zakkai should have asked Vespasian to spare Jerusalem casts the rabbi in a negative light [5]. Without the comments the audience might have more sympathy or consider him a hero who ensured the survival of the sages.[75] We should note again the similarity of these nonnarrative comments to the variety of notes, comments, glosses, and shifts in the level of discourse that characterize legal *sugyot*.

## Local Traditions

The redactors draw on local traditions, that is, traditions appearing in proximate talmudic passages, for raw material to use in the reworking process. For example, the Romans punish R. Yose with exile to Sepphoris [4]. A few folios later appears the tradition, "When R. Yose went to Sepphoris he found . . ." (bShab 38a). The form of the pseudo-*baraita* which reports Yose's opinion, moreover, is modeled on the form of a *baraita* that immediately precedes the story.[76] The account of Nero's conversion seems to draw on a similar story of Nevuzaradan found in the same complex of stories [5].[77] The plan suddenly to ask Rabban Shimon b. Gamaliel to explain an unexpected topic probably draws on the same chapter of Tosefta as the *baraita* quoted at the beginning of the story [6].

The redactors often employ local traditions in constructing legal *sugyot*. Jay Rovner attributes this tendency to the oral matrix of talmudic culture.[78] Human memory tends to access data recently encountered. When studying an oral "text" the preceding and following texts readily spring to mind and provide convenient source-material. (The same is true when reviewing text from a scroll, which, unlike a codex or book, cannot be accessed easily by flipping pages.) The use of proximate sources is again evidence of redactional activity. For to use proximate sources presupposes that talmudic passages already have set places and an established order, which points to an early stage of redaction.[79]

## Narrative Exegesis

Many talmudic stories derive from exegeses of earlier talmudic sources, especially the Tosefta. The encounter between Elisha b. Abuya and Metatron offers a striking example of this phenomenon [3]. The phrases of the source-text, Tosefta Hagiga 2:3 and the verse it quotes, are interpreted as referents of the events of a story. In contrast to most "homiletical stories,"[80] which incorporate or at least quote the biblical verses upon which they are based, the narrative exegesis of tHag 2:3 almost stands by itself.[81]

In other cases the talmudic story bears a much looser relationship to its source. Tosefta Eduyot 2:1, for example, mentions the dispute over the "Oven of Akhnai" and adds, "for disagreements multiplied in Israel about it." The Talmuds build this brief fragment into highly developed stories, and the BT even integrates the comment into Rabban Gamaliel's petition [2].[82] The story of Qamza and Bar Qamza elucidates the puzzling condem-

nation of Zecharia b. Avqulos's halakhic praxis in Tosefta Shabbat 16:7 [5]. The story based on Tosefta Sanhedrin 7:8 supplies an etiological explanation for the different honors prescribed for different academic ranks [6]. This story also draws on the proximate Toseftan prescriptions for institutional protocol that forbid disciples to ask questions unrelated to the topic at hand.[83] The frequent use of the Tosefta highlights again the role of interpretation (in the broadest sense) and intertexts in the construction of BT stories.

These types of interpretation of Tannaitic sources resemble rabbinic exegesis of narrative biblical traditions. The sages filled gaps in elliptical biblical lives; embellished the concise style with rich detail; and created accounts of births, childhoods, marriages, and deaths where these were lacking. BT stories likewise fill gaps in the Tannaitic record of the lives of the early masters through various exegetical processes. The redactors treated the Tannaim similarly to biblical characters: as heroes from the distant past whose deeds could be fleshed out and recreated in order to inspire contemporary generations. This semimidrashic approach to Tannaitic narrative sources also parallels aspects of the late Amoraic exegesis of Mishna. Albeck observed that the Amoraim began to expound the Mishnaic text in the same way as the Tannaim interpreted scripture by finding significance in extra words, repetitions, and linguistic peculiarities.[84] The Stammaim continued the trend: they read both the Mishna and earlier biographical traditions midrashically.

In the introductory chapter I raised the question of the similarity of talmudic biographical stories to classical biographies and *chriae*, short anecdotes recounting the lives and sayings of wise men. For all that the genres have in common, these intertextual and exegetical dimensions distinguish talmudic stories from their classical counterparts. Substantial portions of many talmudic stories were generated through exegesis and gap-filling of earlier rabbinic sources. The process of composition through transferring and adapting other passages is almost unknown in the classical world.[85] In addition, BT biographical stories primarily serve the interests of the talmudic *sugya*, that is, they depend on the redactional context, to which we now turn.

## The Redactional Context

Ofra Meir argues that the rabbinic story cannot be understood apart from its redactional context. Her articles consistently demonstrate not only that the story substantively relates to its context, but that the context may

influence the text of the story.[86] These studies provide impressive support for Meir's thesis and reveal a particularly close relationship between BT stories and the halakhic contexts provided by the proximate Mishna.[87]

• The BT redactors transformed the PT story of the "Oven of Akhnai" into a story about shame and verbal wronging [2]. They redacted it in connection with mBM 4:10, the legal injunction against verbal wronging, and after numerous aggadic traditions concerning the severity of shame, embarrassment, and harmful speech.

• mHag 2:1 prohibits or limits study of certain sections of Torah and tHag 2:3 reports the experience of four Tannaim who engaged in esoteric Torah study or mystical praxis. Elisha b. Abuya's odyssey begins when his esoteric tradition about the situation "on high" coupled with his mysterious vision of Metatron prompts an erroneous comment [3]. The contradictory figure of the sinning sage approximates the Mishna's contradictory notion that Torah study can be sinful. The story's sympathetic view of Elisha, as indicated by his ultimate redemption, partially contests the Mishna's proscription of such study.

• The redactors carefully integrated the story of R. Shimon b. Yohai into its redactional context at bShab 33b, the talmudic commentary to mShab 2:6 [4]. The previous discussion introduced a tradition of R. Yehuda with the honorific title "the first speaker in all matters." The redactors formulated an Aramaic question, "Why was he called the first speaker in all matters?" as a bridge to the story, which begins with R. Yehuda's praise of the Romans. Moreover, the story is set in motion by the "evil speech" (*leshon har'a*) of Yehuda b. Gerim, which picks up on the subject of that previous discussion. More important, the peasant procuring myrtles at twilight to prepare for the Sabbath connects to the Sabbath lamps and other preparations mentioned in mShab 2:6 and 2:7. The significance of the peasant's act in the story illustrates the importance of the preparations listed in the Mishna and helps explain the belief that women die in childbirth for carelessness regarding kindling the lamps. The PT version of the story contains none of these elements and appears in a different tractate.

• The story of Bar Qamza, R. Zecharia b. Avqulos, and the siege of Jerusalem illustrates the importance of rabbinic action and the need to compromise the law in certain situations [5]. Mishna Gittin Chapters 4–5 list rabbinic enactments and legislative initiatives designed to further social and political goods. mGit 5:6, with which the story is justified, mentions rabbinic measures promulgated to encourage Jews to repurchase land from the Romans, but which deprive the original owners of certain rights. The

story functions as an extended apologia for proactive rabbinic legislation in general, for rabbinic authority to "amend" the laws of the Torah, and especially for measures that impose on individual rights for the sake of the general good.

- mHor 3:8 presents two hierarchical principles, one based on lineage, the other based on knowledge of Torah, and gives precedence to the latter. The story juxtaposed with the Mishna embodies a controversy over the primacy of lineage or Torah for precedence within the rabbinic academy [6]. While the story affirms both values, it favors lineage over proficiency in Torah. The story thus sounds a warning or protest against the Mishna and cautions sages from attempting to apply the Mishna's hierarchical principle in the contemporary academy. A much abbreviated version of the story appears elsewhere in the PT.

- The homiletical story depicting the fate of gentile nations in the eschaton appears at the beginning of Tractate Avoda Zarah, which deals with laws of idolatry and of interaction with idolaters [7]. The story functions as an introduction to the tractate by broaching fundamental questions: What is the ultimate fate of the idolatrous nations? Is that fate just? Why do they worship false gods rather than obey the Torah? And, by implication, what reward will the Jewish people receive for observing the Torah?

That the BT versions of these stories generally diverge from the PT in the parts that relate directly to their BT contexts suggests that the stories were revised and recontextualized simultaneously. This consistent finding supports the claim that the changes should be attributed to the redactors, since the textual location of a story obviously results from the redactional process. Undoubtedly, Babylonian Amoraim transmitted and transformed Palestinian stories. Yet the final form of the story—the extant, redacted story—reveals the hands of redactors who integrated it with a specific talmudic context. The strong relationship between the story and the proximate Mishna also coheres with the dominant organizational principle of the Talmud, namely that *talmud* functions as Mishna-commentary. The redactors juxtapose legal *sugyot* with the Mishna cited by, interpreted in, or generally relevant to the talmudic discussion. They not only juxtapose stories with the relevant Mishna, but use the stories to illustrate, question, explain, or protest Mishnaic rulings.[88]

## On Stammaitic Culture

### Torah

Study of Torah was the highest value in the rabbinic worldview. By Amoraic times, if not earlier, the sages conceived of Torah in mythic terms as a universe-maintaining activity:[89] "R. Eleazar said, 'Were it not for the Torah, heaven and earth would not exist, as it says, *If I had not established my eternal covenant, I would not have fashioned heaven and earth*'" (Jer 33:25) (bPes 68b). This widespread tradition, which appears several times in the BT, is placed in the mouths of the nations at the eschaton [7].[90] Were it not for the "eternal covenant," the Torah, God would "not have fashioned heaven and earth," would not have created the world. Other mythic traditions present the Torah as the blueprint of creation or the instrument with which God constructed the universe.[91] For the sages, the cosmos exists because of, by means of, and for the sake of the Torah. The BT teems with expressions of the importance of Torah that go beyond the general praise found in other rabbinic compilations, and which should not be understood as hyperbolically as might appear:

> R. Alexandri said, "Whoever busies himself with Torah for its own sake creates peace in the celestial family and in the earthly family . . ."
> Rav said, "It as if he built the heavenly and earthly temples . . ."
> Resh Laqish said, "He even protects the entire world [from punishment for sin] . . ."
> And Levi said, "He even hastens the redemption . . ." (bSanh 99b)
>
> The Holy One said . . . "Better to me is one day that you engage in Torah before me than one thousand sacrifices . . ." (bMak 10a)
>
> "Torah study is superior to the saving of life . . ."
> "Torah study is superior to building the temple . . ."
> "Torah study is superior to the honor of father and mother . . ." (bMeg 16b)[92]

BT stories express the tensions produced by a culture dedicated to Torah study above all else. The story of R. Shimon b. Yohai struggles with the value of "temporary life," of this-worldly needs and activities, including agricultural production, economic infrastructures, and cultural institutions [4]. What is the place of these values in the rabbinic worldview? How should the sages judge those who dedicate themselves to these pursuits

rather than to Torah? The story of Elisha b. Abuya also grapples with fundamental questions and apparent contradictions generated by this exalted vision of Torah [3]. If Torah study maintains the cosmos, should it not protect a sage from sin and guarantee him life in the next world? How then could a sage turn from the way of truth and become a sinner? Does sin neutralize the merit accrued from prior Torah study and nullify his share in the next world? How should disciples and other sages relate to the sinning sage, a source of both coveted Torah and dangerous behavior? The homiletical story of the eschatological fate of the nations questions the place and role of gentiles [7]. Because gentiles do not study Torah they have little worth in the Torah-centered worldview and cannot expect eschatological reward. But as they were neither given the Torah nor commanded to study, this fate seems unfair. Or were they in fact offered the Torah or another divine code? Do their this-worldly contributions facilitate the study of Torah and earn indirect merit? Despite these tensions, the story's refrain articulates the bottom line: "Who among you declared 'this'? (Isa 43:9)," this Torah. Torah is about the main measure of all things rabbinic.

Many BT stories address issues pertaining to the study and praxis of Torah in the rabbinic academy. The "Oven of Akhnai" reveals a remarkable self-consciousness about the potential disparity between rabbinic halakha and divine intent, between the Torah produced by the sages and the Torah given by God [2]. Yet the story wrestles less with this theoretical matter than the practical questions of dissent and minority opinion. Sages who gladly would have sacrificed their lives for Torah naturally defended their opinions and interpretations with unbridled passion. The disastrous conclusion of this story warns against verbally wronging an opponent, against placing the integrity of the law above human dignity. The story of the attempted deposition of Rabban Gamaliel focuses on another academic problem, the question of leadership [6]. One current of rabbinic thought believed that the sage most proficient in Torah should lead the academy and receive the highest honors. Torah, however, was not the only value of rabbinic culture, and other sages evidently considered lineage a necessary, if not sufficient, criterion. How should a conflict of honor=precedence and honor=virtue=knowledge be resolved? The story of Bar Qamza, R. Zechariah b. Avqulos and R. Yohanan b. Zakkai considers the responsibility of the sages to act as community leaders, including the difficult task of applying the dictates of the Torah to the complicated social and political realms [5]. Where the "Oven of Akhnai" grapples with the tension between rabbinic and divine interpretation, this story addresses the tension between the ideal, theoretical Torah of the academy and the practical Torah

of society. The need to adjust and compromise the laws of the Torah places the sages in a risky and unsettling position. Is the Torah not divine, perfect, flawless, and absolute? What then justifies these rabbinic interventions?

## The Academy

The classic description of the Babylonian academy of Geonic times appears in the epistle of R. Nathan the Babylonian, a traveler who visited the academies in the mid-tenth century.[93] In the following passage he describes the structure of the academy during the *kallah*, the two months during which disciples journeyed to Baghdad from their places of residence for intensive study:

> And this is the order in which they sit. The *rosh yeshivah* stands [var.: sits] at the head, and before him are ten men [comprising] what is called the "first row" (*dara qamma*), all facing the *rosh yeshivah*. Of the ten who sit before him, seven of them are *rashē kallot* and three are *ḥaverim*. They are called *rashē kallot* because each of them is in charge of ten members of the *sanhedrin*, and they are the ones called '*allufim*.
>
> ... And the seventy [comprising] the *sanhedrin* are the seven rows. The first row sits as we mentioned. In back of them are [another] ten [and so on] until [there are] seven rows, all of them facing the *rosh yeshivah*. All the disciples sit behind them without any fixed place. But in the seven rows each one has a fixed place, and no one sits in the place of his colleague .....[94]
>
> When the *rosh yeshivah* wants to test them in their studies, they all meet with him during the four Sabbaths of Adar. He sits and the first row recite before him while the remaining rows listen in silence. When they reach a section requiring comment, they discuss it among themselves while the *rosh yeshivah* listens and considers their words. Then he reads and they are silent, for they know that he has already discerned the matter of their disagreement. When he finishes reading, he expounds the tractate which they studied during the winter, each one at home, and in the process he explains what the disciples had disagreed over. Sometimes he asks them the interpretation of laws. They defer to one another and then to the *rosh yeshivah*, asking him the answer. And no one can speak to him until he gives permission. And [then] each one of them speaks according to his wisdom. And he expatiates on the interpretation of each law until everything is clear to them. When everything is fully clarified, one of them stands only to clarify the *baraita* which supports the tradition. Then the rest of the disciples closely examine it and carefully explain it. Thus they did all month long.[95]

The representation of rabbinic institutions in the longer BT stories corresponds better to this depiction of the highly structured Geonic academy than to smaller disciple-circles that Goodblatt argues characterized the Amoraic period.[96] That R. Shimon b. Yohai and his son hide in the academy points to a building, possibly a permanent institution (the PT parallel lacks this scene) [4]. Recall that the "trembling columns" of the *assembly house* (*beit hava'ad*) in the PT become "falling walls" of the *academy* (*bei midrasha*) in the BT [2].[97] Meir and Natan are both removed from and readmitted to the academy, and while outside they write questions and "throw" (=send) them inside [6]. The description of disciples rising as the leaders enter assumes a developed hierarchy with numerous participants. The academy depicted in bBer 27b-28a has a guard to keep out the unworthy,[98] and at least 400 (some say 700) benches of students within.[99]

The story of Rav Kahana depicts an academy of seven rows of students with the leader seated upon seven cushions while teaching the session (bBQ 117a). Although the story tells of the third-century Palestinian academy, several considerations suggest that the description reflects later Babylonian developments. Sperber points out that sitting upon six or seven cushions was the custom of aristocratic Persians, that the story contains Persian literary motifs and words, and that the content suggests a post-Amoraic dating.[100] Now Gafni and Schremer have shown that several of these descriptions including the rows of students are omitted in one textual tradition or appear as marginal glosses.[101] Thus the manuscripts partially preserve an earlier version of the story before its complete reworking.[102] The description of the flourishing academy packed with rows of students in a hierarchical arrangement is a late—probably very late—addition reflecting the late Saboraic or Geonic situation.[103]

Similar descriptions in other BT passages probably should be understood in this light. The story of Avdan (see below) portrays an academy with so many students sitting before the master that latecomers have difficulty reaching their places (bYev 105b). According to bKet 106a, "When the rabbis would depart from the *metivta* (academy) of Rav Huna and shake out their clothes, the dust would rise and cover the sun."[104] The long story at bBM 84b, which Friedman has shown to be of late Babylonian provenance, also depicts a hierarchical arrangement with some Tannaim seated on benches, others on the floor, and numerous sages present at the debates.[105] References to rows of students appear in several other BT sources. The account of Moses traveling through time to R. Akiba's academy reports that he sat in the eighteenth row, apparently with the most inferior students (bMen 29b). A tradition in bHul 137b ascribed to R. Yo-

hanan mentions seventeen rows of students and describes sparks flying from the mouths of the leading sages. bMeg 28b contains a brief eulogy ascribed to Resh Laqish for a student who recited traditions before twenty-four rows in the academy. Five of these six traditions purport to portray Tannaitic academies (Avdan, Akiba, bBM 84b) or are attributed to Palestinian Amoraim (R. Yohanan, Resh Laqish). Yet not one of these traditions has a parallel in the PT. In fact, only one tradition in the PT alludes to rows of students in the academy, and that tradition is suspect.[106]

The BT thus offers numerous descriptions of the rabbinic academy as a building with a hierarchical organization and rows of students. Most of these descriptions ostensibly represent Palestinian academies of the Tannaitic and Amoraic periods. Goodblatt accepted these sources as descriptions of the Palestinian reality (despite the fact that we know preciously little about the nature of the Palestinian academies).[107] From the paucity of such descriptions associated with Amoraic Babylonia he concluded that Babylonian Amoraim operated in small disciple-circles and that the Babylonian academies developed in later times. As I mentioned in Chapter 1, more research on this issue is needed in light of critical theories of the redaction of the Talmud. However, both the stories studied in this book and the evidence presented above demonstrate that the purported Palestinian provenance of these traditions cannot be accepted.[108]

I suggest that while Goodblatt correctly concluded that Babylonian academies only developed in post-Amoraic times, he misinterpreted BT depictions of Palestinian institutions. *BT traditions describing rabbinic academies reflect post-Amoraic Babylonia, not Tannaitic or Amoraic Palestine.*[109] The passages adduced by Gafni to question Goodblatt's conclusions should not be explained away (so Goodblatt), nor understood as evidence of Amoraic Babylonian academies (so Gafni), but attributed to the post-Amoraic literary stratum.[110] The redactors substantially revised earlier sources, added references to the academy, and depicted it in light of their experience. Because it is unlikely that these passages were added in Geonic times, the rise of Babylonian rabbinic academies should be assigned to the Saboraic period.

## Dialectics

Halivni argues that the Stammaim valued dialectical argumentation as the highest form of Torah and the ultimate measure of academic proficiency. Many BT stories indeed thematize "objections and solutions," the give-and-take of dialectical debate. As we have observed, this theme ap-

pears exclusively in the BT and almost always in stories about the academy. Thus the mark of R. Shimon b. Yohai's progress after his years studying Torah in the cave obtains in his ability to solve every objection with twenty-four solutions [4]. When Rabban Shimon b. Gamaliel cannot solve the objections sent to the academy by Meir and Natan, Yose observes, "Torah is outside and we are inside?" [6]. The story identifies objections and solutions with Torah itself, hence the Patriarch must readmit the sages to the academy. Similarly, the students of the academy relegate Rav Kahana from the first to the seventh row when he fails to object to R. Yohanan's teaching, and then move him forward when he repeatedly objects.[111] In the story found at bBM 84b, the sages promote R. Eleazar b. R. Shimon and Rabbi Yehuda HaNasi from seats on the floor to benches because they "object and solve." The status that accompanies dialectical ability here receives concrete representation in academic positions. The continuation of the story illustrates R. Eleazar's superiority to Rabbi Yehuda HaNasi on the basis of dialectical ability: "Whenever Rabbi [Yehuda HaNasi] said, 'I have an objection,' R. Eleazar said to him, 'Such-and-such is your objection. This will be your response. You have surrounded us with bundles of objections that have no substance.'" In this way R. Eleazar demonstrates that his colleague's objections are easily anticipated and facile.[112] Excellence in Torah requires objections and solutions of high quality.[113]

Dialectical engagement is so central to rabbinic life that the absence of a study-partner capable of objecting can be fatal. After the death of R. Shimon b. Laqish, the sages try to find R. Yohanan another companion in R. Eleazar b. Pedat "whose traditions are ready" (bBM 84a). Nevertheless, R. Yohanan laments: "Are you (R. Eleazar) like the Son of Laqish? When I made a statement, the Son of Laqish would object with twenty-four objections and I would solve them with twenty-four solutions, and thus our traditions expanded. But you say, 'There is a teaching that supports you.' Do I not know that my statements are accurate? He tore his clothes and went crying and saying, 'Where are you Son of Laqish? Where are you Son of Laqish?' He could not be consoled (or: he went out of his mind). The sages prayed for mercy for him and he died." R. Eleazar b. Pedat's vast knowledge and immediate recall has little value next to R. Shimon b. Laqish's dialectical skills. In this passage the give-and-take of argumentation signals not only proficiency but embodies the very substance of Stammaitic rabbinic life: give me dialectical argumentation or give me death![114] None of these references to dialectics appear in the PT versions, where parallel traditions exist.

Even in their life-after-death the sages anticipated academic give-and-

take. An exegetical tradition concerning the banning of Judah (son of Jacob), his posthumous punishment and the ban's annulment reports:

> (1) They did not let him (Judah) enter the heavenly academy [because of the ban]. [Moses said,] *"[Hear, O Lord the voice of Judah] and restore him to his people" (Deut 33:7).*
>
> (2) [Yet] he did not know how to engage in the give-and-take of debate with the sages. [Moses said], *"Let his hands strive for him"* (ibid.) [i.e., give him the strength to "fight" in academic debate].
>
> (3) [Yet] He did not know how to solve an objection (*lifroqei qushia*). [Moses said,] *"Help him against his foes"* (ibid.).[115]

The tradition imagines that Judah was barred from the heavenly academy[116] on account of the earthly ban until Moses petitioned that it be lifted. Yet Judah required additional intervention before he could engage in dialectical debate and "solve an objection." For the Stammaim, to be in the academy had little worth without the essence of academic life—give-and-take, questions, objections, and responses. Judah's return to the rabbinic community therefore was incomplete until he regained the ability to participate in dialectics. This depiction of the heavenly academy is both a projection of the Stammaitic academy and an expression of their hopes for otherworldly bliss—an eternity of dialectical debate. Another BT tradition of the "heavenly academy" likewise portrays a thriving scholastic institution. In bBM 86a, God disputes with "the whole heavenly academy" over a detail of purity law, and they summon Rabbah b. Nahmani to heaven to settle the issue. Such depictions of God debating within and with the heavenly academy, or with the gentiles in the eschaton [7], or with other sages over the purity of the "oven of Akhnai" [2], and even losing the arguments, construct God in the image of a sage, and a Stammaitic sage at that. God is neither absolute monarch nor indomitable judge nor exclusively a figure of authority: he is a sage who participates in academic debate.

Why did the Stammaim value dialectic as the highest form of Torah? While we can only speculate, the answer probably relates to their historical self-conception.[117] They lived in a postclassical age after the Amoraic period. The era of formal "instruction" (*hora'a*) had come to an end, as the BT itself states: "Rav Ashi and Ravina are the end of instruction."[118] These leading fifth-century sages, metonymically representing their contemporaries, were the last to have the status of Amoraim and the authority to formulate *meimrot*, apodictic rulings, and statements.[119] The Stammaim treated the legacy of the Amoraim as a more-or-less closed corpus of authoritative

traditions and did not allow themselves to "instruct" in the same manner. They dedicated themselves to interpretation of early sources, to discursive explanations of Amoraic rulings, and to relentless scrutiny of unresolved disagreements. In the newly formed scholastic academies, numerous sages gathered to argue, debate, compare, and expound the various traditions they had received from their masters. They supplied the give-and-take to the apodictic Amoraic statements and wove the two strands into the complex *sugyot* that characterize the Talmud. Training for such an enterprise involved theoretical exercises, such as articulating hypothetical questions, constructing artificial arguments, explicating minority and discredited opinions, and justifying or rejecting both sides of a disagreement. Dialectical give-and-take was the dominant method, the primary task, and the leading mode of expression of the Stammaim, and therefore became the highest value of their culture.

## Shame

Shame (*kisufa, busha*) and embarrassment (*halbanat panim, halish da'atei*)[120] feature prominently in BT stories.[121] The Roman attack on Jerusalem results from the public shaming of Bar Qamza [5]. R. Eliezer's distressed reactions express his shame at the verbal wronging and the ensuing disasters indicate the severity of the offense [2]. Meir and Natan attempt to depose Rabban Shimon b. Gamaliel by shaming him in public, for which they receive severe punishment [6].

Numerous legal, exegetical, and narrative traditions about the significance of shame appear in various contexts throughout the BT.[122] While similar sources appear in Palestinian compilations,[123] traditions associating shame specifically with the academy are almost unique to the BT. The potential shaming of Rabban Shimon b. Gamaliel takes place in the academy, and the verbal wronging and shaming of Eliezer also reflects the academic setting [4,2]. In another story Avdan shames a colleague in the academy and in turn is shamed by R. Yehuda HaNasi (bYev 105b). Upon being shamed, "Avdan became leprous, his sons drowned, and his daughters-in-law annulled [their levirate marriages]."[124] After sleeping for seventy years Honi the Circle-Drawer returns to the academy but "they did not give him the honor he deserved" (bTa 23a). He therefore prayed for mercy and died. The lack of appropriate honor made Honi feel so ashamed that he longed for death.[125]

Several stories link shame specifically to the inability to answer a question. Meir and Natan plot to shame Rabban Shimon b. Gamaliel by pub-

licly manifesting his inability to expound a particular tractate [6]. To be shamed, in other words, is to be seen lacking knowledge of Torah. In the aforementioned story of Rav Kahana, Resh Laqish warns R. Yohanan that "a lion has come up from Babylonia. Let the master carefully examine tomorrow's lesson," lest he be shamed (bBQ 117a–b). Despite the preparation, Kahana poses numerous difficulties which R. Yohanan cannot answer. R. Yohanan then mistakenly believes that Kahana laughed at him, becomes "embarrassed" (*halish da'atei*),[126] and Kahana immediately dies. Elsewhere Rav Shimi bar Ashi, who regularly raised objections during Rav Papa's lectures, hears his master praying, "May the Merciful One save me from the shame (*kisufa*) of Shimi."[127] For this reason a colleague rebuked Rav for asking an unexpected question of Rabbi Yehuda HaNasi: "Did I not say to you that when Rabbi [Yehuda HaNasi] is occupied with one tractate you should not ask him about another tractate. Perhaps he will not be acquainted with it. Were Rabbi [Yehuda HaNasi] not a great man, you would have shamed him, for he would have taught an incorrect teaching. In this case, however, he taught you correctly" (bShab 3a–b). Rabbi Yehuda HaNasi, a great scholar, happened to know the answer to Rav's question. But had he not known, or had he answered incorrectly, he would have been shamed.[128] When a colleague asked R. Eleazar a difficult question he replied, "Do you ask me in the academy about a matter which former scholars did not explain in order to shame me?"[129] Rava once attempted "to distress" R. Avia by asking him a complicated question, but R. Avia managed to answer him. Thereupon Rav Nahman b. Yizhaq observed, "Blessed be the Merciful One that Rava did not shame Rav Avia" (bShab 46a–b). The consequences for both parties would have been dire.

The importance of shame in Mediterranean society, in the Ancient Near East, and in the Bible is amply documented.[130] Certainly the importance of shame in the BT and in other rabbinic compilations derives in part from the general cultural background. However, the hyperbolic illustrations (to cause death!) and the strong association with the academy appear almost exclusively in the BT. These specific associations with shame probably relate to the nature of discourse in the Stammaitic academy and the emphasis on dialectical argumentation. Proficiency in Torah, the main source of honor, was demonstrated in academic debate. To propound cogent objections and solve difficulties, that is, to ask questions and to answer another sage's questions, displayed knowledge of Torah and earned honor. To fail to answer questions displayed a lack of knowledge in public, caused the loss of face, and produced feelings of shame. Moreover, dialectical exchanges that direct oral questions and objections at a sage are inevitably *ad*

*hominem*. The directness produces a feeling of personal assault (see below), and in the case of failure to respond, public humiliation. While dialectic and debate played a role in Palestinian rabbinic culture, these activities did not hold pride of place as the ultimate measure of Torah or rabbinic worth. A sage who did not excel in "give-and-take" but had mastered a vast amount of tradition and knew it accurately could achieve high status. The ability to propound hypothetical objections and solutions would not necessarily bring prestige, nor would the inability to answer a question impugn his position or result in shame to the same degree.

## Academic Warfare

The BT often describes the academy and academic debate with military imagery and metaphors of war.[131] Objections and solutions of dialectical encounters were analogized to the thrust and parry of a duel, to the attacks and defenses of battle. The omnipresent specter of shame or "whitening the face," which the BT explicitly compares to the shedding of blood, meant that any sage who ventured into debate risked symbolic death.[132] Our sample of stories lacks the strongest expressions of this concept, but there are intimations in R. Yirmiah's rebuke of the walls, "When sages defeat (*menatshim*) each other in law, what is it for you?" and in God's reaction, "My sons have defeated (*nitshuni*) me" [2].[133] The term "defeat" generally pertains to victory in battle, and is applied in a metaphoric sense to victory in argumentation. Likewise the conflict involving Meir and Natan against Rabban Shimon b. Gamaliel portrays the academy as a hostile and combative environment.

Traditions within the BT contrast the belligerent Babylonian sages with the peaceful interactions of their (perhaps idealized) Palestinian colleagues:

> R. Oshayya said: What is [the meaning] of the verse, *I got two staffs, one of which I named* No'am *(Grace) and the other I named* Hovlim *(Damages) (Zech 11:7)*?
> "Grace" — these are the scholars in the Land of Israel who are gracious *(man'imin)* to each other in legal [debate].
> "Damages" — these are the scholars in Babylonia who damage *(mehablin)* each other in legal [debate].[134]

The BT thus represents Babylonians as bitter rivals who viciously injure one another with contentious objections in the course of debate. In another passage R. Yose orders, "Do not let the students of R. Meir enter

here because they are disputatious; they do not come to learn Torah but to overwhelm me (*leqapheini;* literally, "strike me") with laws."[135] Such attacks require methods of defense: the story of the deposition of Rabban Gamaliel accordingly refers to the students of the academy as "shield-bearers" (*ba'alei trisim;* the PT version lacks the description).[136] The provision that "One may not enter the academy with weapons" makes good sense in this context (bSanh 82a; also lacking in the PT). A metaphoric shield protects against metaphoric academic warfare, and one generally recovers from the metaphoric bleeding that produces the ashamed "whitened face." Real weapons in such a hostile climate are too great a danger to contemplate.[137]

Reflexes of the contentious environment appear in occasional comments retrojected to the Tannaim. In bHag 3b R. Eliezer commands R. Yose, "Extend your hand and take out your eye," because R. Yose failed to honor him appropriately (and R. Yose complied!).[138] In the original Palestinian source of the story, tYad 2:16, R. Yose makes the expected gesture and receives no rebuke, much less an order of self-mutilation. When R. Akiba rejects R. Eliezer's logic in bPes 69a, R. Eliezer ominously responds, "You answered me with [the law of] slaughtering, and so you will be slaughtered to death."[139]

Another instructive Babylonian tradition—without parallel in Palestinian sources—expresses slightly more optimism: "*[Happy is the man who fills his quiver with them; they shall not be put to shame] When they contend with the enemy in the gate (Ps 127:5).* R. Hiyya bar Abba said: 'What is *the enemy in the gate?* Even a father and son or a teacher and disciple who busy themselves with Torah in one gate become enemies toward each other, but they do not move from there until they become friends toward each other'" (bQid 30b). Rashi explains that they become enemies "because they object against each other and neither accepts the other's opinion."[140] Academic debate transforms the love between fathers and sons or teachers and disciples into hostility, although friendly relations eventually prevail. Such happy outcomes apparently did not always result when unrelated or rival scholars engaged in debate. A list of "those that hate each other" at bPes 113b lists dogs, fowl, Persian priests, prostitutes—and "scholars in Babylonia"!

BT interpretations of biblical passages routinely interpret military images as metaphors for the "war of Torah." The aforecited tradition of Judah's entry into the heavenly academy interprets the phrases of Deut 33:7, "his hands strive" and "against his foes," in terms of skill in debate. To Prov 24:6, "For by stratagems (*tahbulot*) you wage war," bSanh 42a comments,

"In whom do you find the war of Torah? In one who possesses bundles (*havilot*) of Mishna." bMeg 15b interprets Isa 28:6, "Those who repel attacks at the gate" as "those who give-and-take in the war of Torah."[141]

The emphasis on argumentation, as noted above, helps explain these images of academic activity. A related factor is the oral matrix of talmudic culture. Disputes in written form—even the most vicious polemics—are mediated by texts. Oral settings lack such mediation and focus arguments directly at the opposing side in an *ad hominem* (literally!) way. Walter Ong accordingly describes oral cultures as "agonistic":

> Many, if not all, oral or residually oral cultures strike literates as extraordinarily agonistic in their verbal performance and indeed in their lifestyle. Writing fosters abstractions that disengage knowledge from the arena where human beings struggle with one another. It separates the knower from the known. By keeping knowledge embedded in the human life world, orality situates knowledge within a context of struggle.
>
> ... [V]iolence in oral art forms is also connected with the structure of orality itself. When all verbal communication must be by direct word of mouth, involved in the give-and-take dynamics of sound, interpersonal relations are kept high—both attractions and, even more, antagonisms.[142]

Orality, of course, also governed the Palestinian rabbinic schools, and we find some images of the "wars of Torah" in Palestinian sources. But the heightened value placed on argumentation in Babylonia combined with the oral matrix produced a much more intense "agonistic" ethos.[143]

## Self-Criticism

BT stories criticize rabbis and candidly illustrate their faults to a greater extent than the Palestinian versions.[144] For all their miracle-working capabilities, the sages of the BT display a thoroughly human capacity to err:

- The BT portrays R. Yohanan b. Zakkai with great ambivalence, attributing the clever escape plan to Abba Siqra and leaving the sage dumbfounded when Vespasian criticizes his delinquency [5]. Two nonnarrative comments of Rav Yosef / R. Akiba essentially call the sage a fool. The Palestinian versions, by contrast, eliminate these negative aspects and depict R. Yohanan as the consummate hero. In the BT R. Zecharia b. Avqulos and "the rabbis" refuse to offer the Roman sacrifice because of an absurd fear

of mistaken halakhic consequences. In the text of *Lamentations Rabba* from the Cairo Geniza a *priest* refuses to accept the sacrifice because of the blemish.[145]

• A heavenly voice rebukes R. Shimon b. Yohai and his son for killing their fellow Jews (!) and dispatches them back to the cave, prompting the sages to compare themselves to the wicked in Hell [3]. R. Shimon eventually reverses his condemnation of "temporal life" by instituting a *tiqqun*, thereby conceding the deficiencies of his former opinion. The Palestinian versions lack these elements; R. Shimon (and his son) are pious fugitives from persecution who miraculously purify the city of Tiberias.

• The BT depicts sages as guilty of verbally wronging R. Eliezer, which causes agricultural catastrophes and ultimately the death of Rabban Gamaliel [2]. The PT has no qualms with the ban (not verbal wronging) of R. Eliezer, whose guilt is confirmed by a humiliating incident.

• R. Eleazar b. R. Shimon in bBM 84a–b invites sufferings upon himself partially to seek assurance that he acted correctly in turning over a Jewish criminal to the Romans and partially to expiate the sin of collaboration, as observed by Shamma Friedman.[146] In the Palestinian version R. Eleazar undertakes the sufferings purely as an act of piety. There is no hint of wrongdoing, and the sage's only worry is that he once failed to punish a sinner.

• The BT contains several stories of sages propositioning women or prostitutes. bQid 39b–40a includes a cycle of three stories of well-known sages (R. Hanina b. Papi, R. Zadoq and Rav Kahana) propositioning an important woman (*matronita*), although each ultimately avoids the sin. In bQid 81b R. Hiyya bar Ashi propositions a woman he believes to be a prostitute, but who turns out to be his wife in disguise. Thrice the BT quotes a tradition of R. Elai the Elder advising that "if one sees his inclination overcoming him, let him go to a place where no one knows him, dress in black, cover himself in black, and do what his soul desires, but let him not profane the name of heaven in public."[147] In bSuk 52a Abaye notes that the [evil] inclination "works its greatest" (Joel 2:20) against the sages. The following story relates that Abaye followed an unmarried man and woman journeying together in order to prevent them from sinning. When the travelers parted ways after innocently thanking each other for pleasant company, Abaye became distressed and remarked that he could not have refrained from acting. An old man consoles him with the explanation that "the greater the man, the greater the evil inclination." Thus a leading Babylonian sage implies that he—and perhaps other sages too, especially the greatest ones—are so afflicted by their inclinations that they would engage

in forbidden sex given the opportunity. There are no parallels to these traditions in the PT or contemporary Palestinian midrashim.[148]

- Several BT stories relate that sages murdered or caused the death of other sages. In bBQ 117b R. Yohanan mistakenly thought that Rav Kahana laughed at his inability to answer talmudic queries, became embarrassed, and then Kahana dies. (Fortunately R. Yohanan succeeds in resurrecting him.) In bBM 84a R. Yohanan and Resh Laqish have a falling out, R. Yohanan feels insulted (*halish da'atei*) and Resh Laqish becomes ill. R. Yohanan cruelly ignores the pleas and weeping of Resh Laqish's wife (who happens to be R. Yohanan's sister—another kinship relationship) for her son and widowhood, and so Resh Laqish dies. (His death subsequently makes R. Yohanan despondent, as noted above.) Rav Adda b. Adda dies after mistreating Rav Dimi, and no fewer than four Babylonian sages claim credit for causing his death (bBB 22a; a helpful redactional comment informs us which of the four has the best claim!). According to bMeg 7b, Rabbah became drunk on Purim and slaughtered R. Zeira, although he managed to resurrect the corpse on the morrow. However strong the "literary" or "didactic" as opposed to "realistic" dimension of these passages, and whether we understand that the deaths were justified (hence criticism of the culprit/victim) or unjustified (criticism of the sages responsible), these traditions present unflattering portrayals of sages. Again, these sources have no parallels in Palestinian sources.

Fraenkel explains the tendency of rabbinic stories to criticize sages in terms of the didactic function. Later sages taught moral and theological lessons by highlighting the failings of even the greatest rabbinic heroes. This insight is certainly correct, but requires refinement; because Fraenkel treats rabbinic stories en masse, he did not observe the greater propensity of the BT to such negative portrayals.[149] The heightened criticism of sages in BT stories should be attributed in part to their provenance in the later Babylonian academy and their place in Stammaitic culture. Stories were reworked by the Stammaim to teach the values of their elite, scholastic culture to other sages. The "implied audience" generally was not the average nonrabbinic or peripherally-rabbinic Babylonian Jew, and the purpose was not to propagandize about the virtues of rabbinic leadership and way of life.[150] The focus, in other words, was internal, not external, and the redactors could afford to project failings and weaknesses upon earlier sages.[151] Because stories provided them a way of working through important cultural issues, they portrayed rabbinic characters with realistic limitations and faults. Criticism of sages in the PT is less acute because Palestin-

ian rabbinic institutions were less insular and the reworking of the stories was less thorough; many PT stories still bear the characteristics of the synagogual or popular setting. They were not thoroughly reworked in the Palestinian rabbinic academy.[152]

※

At the beginning of the book I noted the intriguing tradition of the intractable debates of the Houses of Hillel and Shammai and the fixing of the law according to the Hillelites. This tradition should be understood in light of aspects of Stammaitic culture. The Houses debated for three years without reaching a decision, promulgating arguments, multiplying objections and responses, engaging in the give-and-take of talmudic debate. For every argument of the Hillelites, the Shammaites mustered twenty-four counterarguments; for every objection of the Shammaites, the Hillelites devised bundles of responses. The law could only be fixed by divine fiat. However, the sages were not interested in God's legal opinions, for they had already established that "it is not in heaven." The heavenly voice ruled for the Hillelites not because God agreed with their logic, nor because of their legal or intellectual superiority, but "because they were pleasant and modest and they would teach their words and the words of the House of Shammai." Given the belligerence that characterized the academy, the heavenly voice wished to promote geniality and to encourage the sages to take seriously the opinions of their opponents. To prevail in debate—to have the law follow one's opinions—should entail these qualities rather than vicious verbal attacks, gibes, barbs, ridicule, tongue-lashing, or other rhetorical techniques typical of oral discourse. The ideal sage must incorporate the rulings he rejects into his teaching rather than suppress them and quash their proponents. In this way the Torah of the living God could expand to its infinite limits and the universe would continue to endure.

Rabbinic practice, for the Stammaim, required a combination of legal acumen and virtuous character. The ideal sage contended in the give-and-take of the academy, solved every objection with numerous solutions, propounded questions and responses at will, but never shamed his challengers or sought showy displays of honor. The legal *sugyot* of the Babylonian Talmud teach how to think like a sage. The narrative *sugyot*, the complex stories, teach how to be one. Legal *sugyot* teach how to master and produce Torah; narrative *sugyot* how to embody it.

Appendix

# Hebrew/Aramaic Texts

נוסח הסיפורים

[ ] — בגליון או בין השיטין
( ) — תיקון על פי כתב-יד אחר. עיין בנספחים בסוף הפרקים
[..] — סימן לדיאלוג. עיין בנספחים בסוף הפרקים

פרק ב: סיפור תנור של עכנאי. בבא מציעא נח,ב-נט,ב. כתב-יד מנכן 95.

[א1] תנן הת' חיתכ' חליו' ונתן חול בין חולי' לחולי' ר' אליע' מטהר וחכמ' מטמ' וזהו תנורו של עכנאי.
[א2] מאי עכנאי. א' רב יהוד' א' שמואל שהקיפוהו (דברים) כעכנ' זו וטמאו'.

[ב1] תנא אותו היום הושי' ר' אליעז' כל תשובו' שבעול' ולא קבלו ממנו.
[ב2] א' לה' אם הלכ' כמותי חרוב זה יוכיח. נעקר חרוב ממקומ' והלך מא' אמ' וא' לה ארב' אמו'. א' לו אין מביאי' ראי' מן החרו'. וחזר החרו' למקומו.
[ב3] א' לה' אם הלכ' כמותי אמ' המי' יוכיחו וחזרו המים לאחוריה'. אמ' לו אין מביאי' ראי' מן המים. וחזרו המי' למקומן.
[ב4] א' להן אם כמותי כותלי בי' המדר' יוכיחו. היטו כותלי בי' המדר' ליפול. גער בהם ר' יהושע. א' להן אם תלמי' חכמי' מנצחי' זה את זה בהלכ' אתם מה טיבכם.
[ב5] תנא לא נפלו מפני כבו' של ר' יהוש' לא זקפו מפני כבודו של רבי אליעז' ועדיין מוטין ועומדין.

[ג1] א' להם אם כמותי הו' מן השמי' יוכיחו. יצת' בת קול ואמר' לה' מה לכם אצל ר' אליעז' שהלכ' כמותו בכל מקום.
[ג2] ועמד ר' יהוש' על רגליו וא' לא בשמי' הי'.
[ג3] מאי לא בשמי' הי'.
[ג4] א"ר ירמי' אין משגיחי' בבת קול שכבר נתת לנו על הר סיני (וכתבת) אחרי רבי' להטות.

[ד] אשכחי' ר' נתן לאליהו א"ל מאי קעבי' קוד' הו' בההי' שעת'. א"ל גחי(ך) וחייך וא' נצחוני בני נצחו' בני.

[ה] באות' שע' הביאו כל סהרו' שטיהר ר' אליע' ושרפום באש ונמגו וברכוהו.

[ו] אמרו מי ילך ויודיעו. א' להן ר' עקיב' אני אלך ואודיעו שמ' ילך אד' שאינו הגון ויודיעו ויחריב את העול'. מה עש'. לבש שחורין ונתכס' שחורין וחלץ מנעלי' והלך וישב לו ברחו' ארב' אמו' וזלגו עיניו דמעו'.

[ז] א"ל עקיב' מה היום מיו'. א"ל כמדומ' לי שחבירי' בדילין ממך. אף הוא זלגו עיני' דמעו' וחלץ מנעליו ונשמט ויש' לו על גבי קרקע.

[יז] לקה העול' שליש בחיטי' ושלי' בזתי' ומחצה בשעורין.
[יט] וי"א אף בצק שביד האש' טפח.
[ז] תנא אף גדו' היה באותו היום שבכל מקו' שנתן בו ר' אליע' עיניו מיד נשרף.

[ח] אף ר"ג היה בספינה. עמ' נחשול שבים לטבעו. אמ' כמדומ' אני שאין זה אל' בשבי' בן הורקנו'. עמ' על רגליו וא' רבונו של עול' גלוי וידו' לפניך שלא לכבודי עשיתי ולא לכבו' בי' אב' עשי' אל' לכבודך עשי' שלא ירבו מחלוק' בישר'. מיד נח ימ' מזעפיה.

[ט] אימ' שלום דביתהו דר' אליעז' אחתי' דר"ג הו'. מההו' מעש' ואילך לא שבקתי' למיפל על אפי'. ההו' יומ' ריש ירח' הוה את' עני' וקאי אבבא. אדיהב' לי' ריפת' משכח דנפל על אפי'. אמר' ליה קום קטלתי' לאח. אדהכי נפק שיפור' מבי ר"ג. א' לה מנ' ידעת. אמר' לי' כך מקובל' מבי' אב' כל השערי' ננעלין חוץ משערי אונאה.

פרק ג: סיפור אלישע בן אבויה. חגיגה יד,ב–טו,ב. כתב-יד לונדון 5508

[א] אחר קיצץ בנטיעות עליו הכת' א' אל תתן את פיך לחטיא את בשרך וג'. מאי חזא. חזא למיטטרון דאתיהיביא ליה רשות חדא שעתא ביומא למיתב למיכתב זכוותא דישר'. אמ' גמירי [דאין] למעלה לא ישיבה ולא קנאה ולא תחרות ולא עורף [ולא עיפוי] שמא חס ושלום שתי רשויות הן. מיד אפקוה למיטטרון ומחיוה שיתין פולסי דנורא. איתיהיבא ליה רשותא למיקלנהי לזכוותא דאחר. יצתה בת קול ואמרה לו שובו בנים שובבים חוץ מאחר.

[ב] אמ' הואיל ואיטריד ההוא גברא מההוא עלמא ליזיל וליתהני מהאי עלמא. נפק אחר לתרבות רעה. אשכח לההיא [זונה]. תבעה. אמ' ליה לאו אלישע בן אבויה את ששמך יצא בכל העול'. עקר פוגלא ממשרא [בשבתא] והב לה. אמרה אחר הוא.

[ג] (1) שאל אחר את ר' מאיר לאחר שיצא לתרבות רעה. אמ' ליה מאי דכת' גם את זה לעומ' זה עשה האלהים. אמ' [לו] כל שברא הקדוש ברוך הוא ברא כנגדו. ברא הרים ברא גבעות ברא ימים ברא נהרות. אמ' לו עקי' רבך לא כך אמר. ברא צדיקים ברא רשעים ברא גן עדן ברא גיהנם. כל אחד ואחד יש לו שני חלקים אחד בגן עדן ואחד בגיהנם. זכה צדיק נטל חלקו וחלק חבירו בגן עדן. נתחייב רשע נטל חלקו וחלק חבירו בגיה'. אמר רב משרשיא מאי קראה. גבי צדיק' דכת' לכן בארצם משנה יירשו ושמחת העולם וג'. גבי רשעים דכת' ומשנה שברון שברם.

(2) שאל אחר את ר' מאיר לאחר שיצא לתרבות רעה. אמ' לו מאי דכת' לא יערכנה זהב וזכוכ' ותמורתה כלי פז. אמ' לו אילו דברי תורה שקשים לקנותן ככלי זהב וכלי פז ונוחין לאבדן ככלי זכוכית. אמ' לו האלוהים אפי' ככלי חרס. אמ' לו עקי' רבך לא כך אמ' אלא מה כלי זהב וכלי זכוכית אע"פ שנשברו יש להם תקנה אף תלמ' חכמ' שסרחו יש להם תקנה. אמ' לו אף אתה חזור בך. אמר לו לאו. כבר שמעתי מאחורי הפרגוד שובו בנים שוב' חוץ מאחר.

(3) תנו רבנן מעשה באחר שהיה רוכב על סוס בשבת ומהלך בדרך והיה ר' מאיר מהלך אחריו ללמוד תורה מפיו. אמ' לו מאיר חזור לאחריך שכבר שיערתי בעיקבי סוסי דעד כאן תחום השבת. אמ' לו ואף אתה חזור בך. א' לו לאו כבר שמעתי מאחורי הפרגוד שובו בנים שוב' חוץ מאחר.

[ד] (1) תקפיה עייליה לבי מדרשא. אמ' ליה לינוקא פסוק לי פסוקיך. אמ' ליה אין שלום אמר ה' לרשעים.

(2) עייליה לבי מדרשא אחריתי. א' כי אם תכבסי בנתר ותרבי לך בורית.

(3) עייליה לבי כנישתא אחריתי. א' ליה ואת שדוד מה תעשי.

(4) עייליה לתליסרי בי כנישתא. פסקי ליה כי האי גוונא. ינוקא דסוף תליסרי אמ' ליה ולרשע אמר אלהים מה לך לספר חקי. ההוא ינוקא הוה (מגמגם) בלישניה ואישתמע כמאן דאמ' ולאלישע אמר אלהים. איכא דאמ' שקל סכיניה וקרעיה ושדריה לתליסר בי כנישתא. ואי' דא' אמ' ליה אי הואי סכינא בהדאי קרעתיך [...]

[ה'] (1) [...] כי נח נפשיה דאחר אמרי לא לידון לידיניה ולא לעלמא דאתי ליתייה. לא מידן לידייניה משום דגמר באורייתא תדירא ולא לעלמ' דאתי ליתייה משום דחטא.

(2) אמ' ר' מאיר [...] מתי אמות ואעלה עשן מקברו. כי נח נפשיה דר' מאיר סליק קוטרא מקיבריה דאחר.

(3) אמ' ר' יוחנן גבורתא למיקלי רביה בנורא. חד הוה גבן ולא מצינן לאצוליה. אי נקטיה ביד מאן מרמי ליה מן ידי. מתי אמות ואכבה עשן מקברו. כי נח נפשיה דר' יוח' פסק קיטרא מקיבריה דאחר. פתח עליה ההוא ספדנא אפי' שומר הפתח לא עמד לפניך רבינו.

[ד'] [...] בתו של אחר אתיא לקמיה דר'. אמ' לו ר' פרנסני. א' לה בתי בת מי את. אמרה לו בתו של אחר. א' עדיין יש מזרעו בעול'. לא נין לו ולא נכד בעמו. אמרה לו זכור תורתו ואל תזכור את מעשיו. ירדה אש מן השמים וביקשה לשרוף את ר'. בכה ר' ואמ'. ומה למתגנין בה כך למשתבחין בה על אחת כמה וכמה.

[ג'] ור' מאיר היכי גמר תורה מאחר. והאמ' רבה בר בר חנה אמר ר' יוח'. מאי דכת' כי שפתי כהן ישמרו דעת. אם דומה הרב למלאך ה' צבא' יבקשו תורה מפיו ואם לאו אל יבקשו תורה מפיו.

(1) אמר ריש לקיש ר' מאיר קרא אשכח ודרש הט אזנך ושמע דברי חכמ' ולבך תשית לדעתי. לדעתם לא נאמר אלא לדעתי.

(2) ר' חנינא אמ' מהכא שמעי בת וראי והטי אזנך ושכחי עמך ובית אביך. קשו קראי אהדדי לא קשיא הא בגדול והא בקטן.

(3) כי אתא רב דימי אמ' אמרי במערבא אכול תמרי ושדי קשייתא לבר.

[ב'] דרש רבא מאי דכת' אל גנת אגוז ירדתי. למה נמשלו דברי תורה כאגוז. לומר לך מה אגוז זה אע"פ שמלוכלך בטיט ובצואה אין תוכו נמאס. כך תלמ' חכ' אע"פ שסרח אין תורתו נמאסת.

[א'] אשכחיה רבה בר רב שילא לאליהו. א' ליה מאי קא עביד קב"ה. אמ' ליה קאמ' שמעתא מפומיהו דכולהו רבנן ומפומיה דר' מאיר לא קא'. אמ' ליה אמאי. א' ליה משום דגמר שמעתא מפומיה דאחר. אמ' ליה מה בכך. ר' מאיר רימון מצא תוכו אכל וקליפתו זרק. אמ' ליה השתא קאמ' מאיר בני אומ' בזמן שאדם מצטער שכינה מה לשון אומרת. קלני מראשי קלני מזרועי אם כך אמ' מצטער אני על דמן של רשעים שנהרג קל וחומ' על דמן של צדיק' שנשפך.

פרק ד: סיפור ר' שמעון בר יוחאי. שבת לג,ב–לד,א. כתב-יד מנכן 95.

[א] הוה יתיב ר' יהודה ור' יוסי ור' שמעון. הוה יתיב יהודה בן גרים גבייהו. פתח ר' יהודה ואמר כמה נאים מעשיהם של אומה זו תקנו שווקים תקנו מרחצאות תקנו גשרים. ר' יוסי שתק. נענה ר' שמעון ואמ' כל מה שתקנו לצרכם תקנו. תקנו שווקים להושיב בהן זונות מרחצאות לעדן בהם גשרים ליטול מהם מכס. הלך יהודה בן גרים וסיפר דבריהם ונשמעו למלכות. אמרו יהודה יעלה יוסי ששתק יגלה לצפרי שמעון שגינה יהרג.

[ב1] אזל איהו ובריה טשו בי מדרשא. כל יומא הוה מייתי להו דביתייהו ריפתא [וכוזא דמיא] וכרכי. כי תקיף גזירתא א"ל [לבריה] נשים דעתן קלות קמצערי לה ומגליא.

[ב2] אזל טשו במערתא [...] אתרחיש להו ניסא ואיברו להו חרובא ועינא דמיא הוו יתבי עד צוורא בחליא. ביומא יתבי וגרסי והוו משלחין מנייהו. לעידן צלויי נפקי ולבשי ומכסי ונפקי ומצלו והדר שלוחי מנייהו כי היכי דלא ליבלו. אותיבי במערתא תליסר שני אתא אליהו אפיתחא דמערתא אמ' מאן מודעיה לבר יוחי דמית קיסר ובטל גזירתא. נפקו חזו אינשי דקא כרבי זרעי. אמרין מניחין חיי עולם ועוסקין בחיי שעה. כל מקום שנתנו עיניהם מיד נשרף. יצתה בת קול ואמרה להחריב עולמי יצאתם. חזרו למערתכם.

[ב2] אותיביה תריסר ירחי שתא. אמרו משפט רשעים בגהינם שנים עשר חדש. יצתה בת קול אמ' צאו ממערתכם. נפקו. כל היכא דהוה מחי ר' אלעזר הוה מסי ר' שמעון. אמ' לו די לעולם אני ואתה. חזו ההוא סבא דהוה נקיט תרי מדני דאס' וקרהיט ואזיל לבין השמשות אמרו ליה הני למה [לך]. אמ' ליה. לכבוד שבת. א"ל ותיסגי ליה בחד. [א"ל חד כנגד זכור וחד כנגד שמור.] א"ל [חזי] כמה מצוה חביבה עליהם דישראל. {יתיב דעתייהו}

[ב4] שמע ר' פנחס בן יאיר חתני'. נפיק לאפיה. עיילי לבי בני. הוו קא אריך ליה דבשריה. חזיא דהוה ליה פילי בבישריה והוה קא בכי וקא נתרו דמעיה ומצערו ליה. א"ל אוי לי שראיתיך בכך. אמ' לו אשריך שראיתני בכך שאלמלא לא ראיתני בכך לא מצאתי בי כך. דמעיקרא כי הוה מקשי רבי שמעון בן יוחי חד קושיא הוה מפרק ליה ר' פנחס בן יאיר תריסר פירוקי ולבסוף כי הוה מקשי ר' פנחס קושיא הוה מפרק ליה ר' שמעון בן יוחי עשרים וארבעה פירוקי.

[ג1] אמ' הואיל ואיתרחיש ניסא אתקין מילתא דכתי' ויבא יעקב שלם עיר שכם. ואמ' רב שלם בגופו שלם בממונו שלם בתורתו. ויחן את פני העיר. ואמ' רב מטבע תקן להם ושמואל אמ' שווקים תקן להם. ר' יוחנן אמר מרחצאות תקן להם. אמ' איכא מילתא דלתקוני.

[ג2] אמרו ליה איכא דוכתא דאית ביה ספק טומאה ואיכא לכהני צערא לאקופי. אמ' איכ' דידע דאיתחזיק טהרה הכא. א"ל ההוא סבא כאן וכאן קצץ בן עזאי תרמוסי תרומה. עבד איהו נמי. כל היכא דהוה קשי טהריה. כל היכא דהוה רפי ציינה.

[ג3] אמ' ההוא סבא טהר בן יוחי בית הקברות. א"ל אלמלא לא הייתה עמנו ואי נמי הייתה עמנו ולא נמנית עמנו יפה אתה או' עכשיו שהייתה עמנו יאמרו מפרכסת זו את זו תלמידי חכמים לא כל שכן. יהב ביה עינא. נח נפשיה. נפק לשוקא חזייה ליהודה בן גרים. עדיין ישנו לזה בעולם. נתן עיניו בו ועשאו גל של עצמות.

פרק ה: סיפור קמצא ובר קמצא. גיטין נה,ב-נו,ב.   כתב-יד אראס 969

[א1] א"ר יוחנן מאי דכתיב אשרי אדם מפחד תמיד ומקשה [לבו] יפול ברעה. אקמצא ובר קמצא חרוב ירושלם אתרנגולא ותרנגולא חריב טור מלכא אשקא דריספק חרוב ביתר.

[א] אקמצא ובר קמצא חרוב ירושל'. דההוא גברא דרחמוה קמצא ובעל דבביה בר קמצא עבד סעודתא. אמ' ליה (לשמעיה) זיל אייתי לי קמצא. אזל ואייתי ליה בר קמצא. אזל אשכחיה דיתיב אמ' מכדי ההוא בעל דבביה דההוא גברא הוא מאי בעית הכא קום פוק. א"ל הואיל ואתאי שבקי ויהיבנא לך דמי מה דאכילנ' ושתינא. א' ליה לא. אמ' ליה יהיבנא לך דמי פלגא דסעודתך. אמ' ליה לא. אמר ליה יהיבנא לך דמי דכוליה סעודתך. אמ' ליה לא. נקטיה בידיה ואוקמיה ואפקיה.

[ב] אמ' הואיל ואיתיבי רבנן ולא מיחו ביה איזיל ואיכול להו קורצא בי מלאכא. א"ל לקיסר מרדו בך יהודאי. אמ' ליה מי אמר. אמ' ליה [שדר] להו קרבנא וחזי אי (מקרבין) ליה. שדר בידיה עגלא תלתא. בהדי דקא אתי שדא ביה מומא בניב שפתים ואמרי לה בדוקין שבעין דוכתא דלדידן מומא ולדידהו לאו מומא. סבור רבנן לאקרוביה משום שלום מלכות. אמ' להו ר' זכריה בן אבקולס יאמרו בעלי מומין קריבין לגבי מזבח. סבור למיקטליה דילמא ליזיל ולימא ליה. אמ' להו ר' זכריה בן אבקולס יאמרו מטיל מום (בקדשים) יהרג.

[ב1] א"ר יוחנן ענוותנותו של ר' זכריה בן אבקולס החריבה את ביתנו ושרף את היכלנו והגליתנו מארצנו.

[ג] אזל שדריה עילוויהו נירון קיסר. כי קא אתי שדא גירא למזרח. אתא נפל בירושלים. למערב. אתא נפל בירושלים. לארבע רוחות העולם. אתא נפל לירושלים. אמ' ליה לינוקא פסוק לי פסוקיך. אמ' ליה ונתתי נקמתי באדום ביד עמי ישראל. אמ' הקב"ה קא ניחא ליה לאחרובי ביתיה ולכפורי ידיה בההוא גברא. קא בעי ערק ואיגייר ונפק מיניה ר' מאיר.

[ד] שדריה עילוויהו אספסיינוס קיסר. אתא צר עלה תלת שני. הוו בה הנהו תלתא עתירי נקדימון בן גוריון ובן כלבא שבוע ובן ציצת הכסת. נקדימון בן גוריון שנתקדרה לו חמה בעבורו. בן כלבא שבוע שכל הנכנס לביתו כשהוא רעב ככלב יוצא כשהוא שבע. בן ציצת הכסת שהייתה ציציתו נגררת על גבי כסתות ואיכא דאמ' שהייתה כסתתו מוטלת בין גדולי רומי. חד אמ' להו אנא זיינא לכו בחיטי ושערי וחד אמ' להו ואנא בחמרא ומשחא וחד אמ' להו בדציבי ושבחו רבנן לדציבי. דרב חסדא כל אקלידיה הוה מסר לשמעיה בר מדציבי דאמ' רב חסדא אכלבא דחיטי בעיא שיתין אכלבי דציבי. הוה בהו למיזן עשרים וחד שתא. הוה בהו הני בריוני. אמרו להו רבנן ניפוק וניעביד שלמא בהדייהו. לא שבקינהו. אמרו להו אינהו ניפוק ניעביד קרבא בהדייהו. אמרו להו רבנן לא מסתייעא מילתא. קמו קלנהו להנהו אמברי דחטי ושערי והוה כפנא.

[ה] מרתא בת בייתוס עתירתא דירושלים הויא. שדרתיה לשלוחה ואמ' ליה זיל אייתי לי סמידא משוקא. אדאזל אזדבן. אתא ואמ' לה סמידא ליכא חיורתא איכא. זיל אייתי לי. אדאזיל אזדבן. אתא ואמ' לה חיורתא ליכא גושקרא איכא. זיל אייתי לי. אדאזיל אזדבן. אתא ואמ' לה גושקרא ליכא קמחא דשערי איכא. זיל אייתי לי. אדאזל אזדבן שערי. שליפא מסאנא אמר' איפוק ואחזי דילמ' משכחנא מידי למיכל אותביה פרתא בכרעא ומתה. קרא עלה ר' יוחנן בן זכאי הרכה בך והענוגה וגומ'. ואיכא דאמ' גרוגרות אכלה מדר' צדוק ואתניסא. דר' צדוק אותיב ארבעי' שנין בתעניתא כי היכי דלא ליחרוב ירושלים. כי הוה אכיל מידי הוה מתחזי מאבראי וכי הוה ברי מייתי ליה גרוגרת ומייץ מימייהו ושדי להו. כי הוה ניחא נפשה אפיקתא לכל דהבא וכספא דהויא לה ושדתא בשוקא. אמרה האי למאי מבעי לי. היינו דכתיב כספם בחוצות ישליכו וזהבם לנידה יהיה.

[ו] אבא סיקרא ריש בריוני ירושלים בר אחתיה דר' יוחנן בן זכאי הוה. הוה שלח ליה אתא בצנעא לגבי. א"ל עד אימת עבדיתון הכי וקטליתון לעלמ' בכפנא. א"ל ומאי אעביד דאי אמינא להו מידי

קטלון לי. א״ל חזי תקנתא לדידי ואיפוק איפשר דהוה הצלה פורתא. א״ל נקוט נפשך בקצירי וליתן כולי עלמ׳ לשאול בך ואייתי מידי סריא ואגני גבר ולימרון נח נפשיה ולעיילון בך תלמידך דאינהי קשבי דחייא קליל. עביד הכי. נכנס ר׳ אליעזר מצד אחד ור׳ יהושע מצד אחד. כי מטא לפתחא בעו למידקריה. אמ׳ להו יאמרו רבן דקרו. בעו למידחפיה. אמ׳ להו יאמרו רבן דחפו. פתחו ליה בבא.

[ז] כי מטא לגביה א״ל שלם עלך מלכא שלם עלך מלכא. אמ׳ ליה מחייבת תרתי קטלי חדא דלאו מלכא אנא וקרית לי מלכא אנא אמאי לא אתית לגבאי. אמ׳ ליה דקאמרת לאו מלכא אנא איברא מלכא את דאי לאו מלכא את לא הוה מימסרא ירושלם בידך דכתיב והלבנון באדיר יפול ואין אדיר אלא מלך שנ׳ והיה אדירו ממנו ומשלו מקרבך יצא ואין לבנון אלא בית המקדש דכתיב ההר הטוב הזה והלבנון. ודקאמרת אי מלכא אנא אמאי לא אתית לגבאי בריוני דאית בן לא שבקין. אמ׳ ליה אילו חבית של דבש ודרקון כרוך עליה לא היו שוברין את החבית בשביל דרקון. אשתיק.

[ז1] קרי עליה רב יוסף (ואיתימא רבי עקיבא) משיב חכמ(ים) אחור ודעתם יסכל. איבעי ליה למימר שקלינן צבתא ושקלינן ליה לדרקון וקטלינן ליה וחביתא שבקינן לה.

[ח] אדהכי אתא פריסתקא עליה מרומי. א״ל קום דמית ליה קיסר ואימנו חשיבי דרומאי עלך לאותובך ברישא. והוה סיים חד מסאניה. בעי למיסיימיה לאחרינא. לא עייל. בעי למישלפיה לאידך. לא נפק. א״ל מאי האי. א״ל לא תצטער שמועה טובה אתייא לך ושמועה טובה תדשן עצם. א״ל ואלא מאי תקנתיה. אמ׳ ליה ליתי איניש דלא מייתבא דעתך מיניה וליחלוף קמך דכתיב ורוח נכאה תייבש גרם. עבד הכי עייל. אמ׳ ליה מאחר דחכמיתו כוליה האי עד האידנא אמאי לא אתית לגבי. אמ׳ ליה הא אמרי לך. אמ׳ ליה אנא נמי אמרי לך. אמ׳ ליה מיזל קא אזילנא ואיניש אחרינא משדרנא אלא בעי מינאי מילתא ואתן לך. א״ל תן לי יבנה וחכמיה ושושילתא דבי רבן גמליאל ואסותא דמסיין ליה לר׳ צדוק.

[ח1] קרי עליה רב יוסף ואיתימא ר׳ עקיבא. משיב חכמ(ים) אחור. איבעי ליה למימר שבקינהו הדא זימנא.

[ח2] והוא סבר דילמ׳ כולי האי לא עביד והצלה פורתא נמי לא הוי.

פרק ו: סיפור תורה, ייחוס ובית המדרש. הוריות יג,ב-יד,א. כתב יד פריז 1337.

[א] אמ' ר' יוחנן בימי רשב"ג נשנית משנה זו.

[ב] רשב"ג נשיא ר' מאיר חכם רבי נתן אב בית דין. כי הוה עייל רשב"ג הוו קימי כולי עלמא מקמי'. כי הוו עיילי ר' מאיר ור' נתן הוו קימי כולי עלמא מקמיהו. אמ' רבן שמעון בן גמליאל לא בעי למהוי הכירא בין דילי לדיליהו. תקין הא מתניתא.

[ג] ההוא יומא לא הוו ר' מאיר ור' נתן התם. למחר כי אתו חזו דלא קמו מקמיהו כדרגילי. אמרי מאי האי. אמרי להו הכי תקין רשב"ג.

[ד] אמ' ליה ר' מאיר לר' נתן אנא חכם ואת אב ב"ד נתקין מילתא כל דלין. אמ' ליה ר' נתן מה נעביד. נימא ליה תני לן עוקצין דלית ליה וכיון דלא גמיר נימא ליה מי ימלל גבורות ה' ישמיע כל תהלתו למי נאה למלל גבורות ה' למי שיכול להשמיע כל תהלותו.

[ה] ונעבריה ותהוי את נשיא ואנא אב ב"ד.

[ו] שמעינהו ר' יעקב בן קודשאי. אמ' דלמא חס ושלום אתי לידי כיסופא. אזל ויתיב אחורי עיליתיה דרשב"ג. גרס ותנא גרס ותנא.

[ז] אמ' מאי דקמא דלמא חס ושלום איכא מידי בי מדרשא.

[ח] יהב דעתיה עיין בה וגרסה.

[ט] למחר אמרי ליה ניתני מר בעוקצין.

[י] פתח ותני. בתר דאוקים אמ' להו אי לאו גמירנא כסיפתון.

[י'] פקיד ואפקינהו מבי מדרשא.

[ד'] הוו כתבי קשייתא בפתקא ושדו התם (דהוה מיפריק מיפריק דלא הוה מיפריק כתבי פירוקי ושדו.) אמ' להו ר' יוסי תורה מבחוץ ואנו מבפנים.

[ג'] אמ' להו רשב"ג מעיילינהו מיהו ליקנסינהו דלא לימרו שמעתא משמי' אסיקו ליה לר' מאיר אחרים ולר' נתן יש אומ'.

[ב1'] אחזי להו בחלמיהו זילו פייסו לרשב"ג. ר' נתן אזל ר' מאיר לא אזל. אמ' דברי חלומות לא מעלין ולא מורידין. כי אזל ר' נתן אמ' ליה נהי דאהני לך קומר' דאבוך למהוי אב ב"ד נשיא מי אהני.
[ב2'] מתני ליה ר' לר' שמעון בר' אחרים אומ' אלו היתה תמורה לא היתה קרבה. אמ' לי' מי הן הללו שמימיהן אנו שותין ושמותן אין אנו מזכירין. אמ' ליה בני אדם שבקשו לעקור כבודך וכבוד בית אביך. אמ' ליה גם אהבתם גם שנאתם גם קנאתם כבר אבדה. אמ' ליה האויב תמו חרבות לנצח. אמ' ליה הני מילי היכא דאהני מעשיו הני לא אהני מעשהו. הדר אתנייה אמרו משום ר' מאיר אלו היתה תמורה לא היה קרבה.

[א'] אמ' רבא אפלו ר' דענותנא הוא אמרו משום ר' מאיר אמ'. ר' מאיר או' לא אמ'.

פרק ז: סיפור הגויים ועולם הבא. עבודה זרה ב,א-ג,ב. כתב-יד פריז 1337.

[א] דרש ר' חנינא בר פפא ואיתימא ר' שמלאי. לעתיד לבוא מביא הקב"ה ספר תורה ומניחו בחיקו ואומ' כל מי שעס' בזה יבוא ויטול שכרו. מיד מתקבצין ובאין אומות העולם בערבוביא שנ' כל הגוים נקבצו יחדו ויאספו לאומים. אומ' להן הקב"ה אל תכנסו לפני בערבוביא אלא תכנס אומה אומה וסופריה שנ' ויאספו לאומים ואין לאום אלא מלכות שנאמר ולאום מלאום יאמץ

(1) מיד נכנסת מלכות רומי תחלה. אומ' להם הקב"ה במה עסקתם. אומ' לפניו רבונו של עולם הרבה שווקים תקננו הרבה מרחצאות עשינו הרבה כסף וזהב הרבינו וכולן לא עשינו אלא בשביל ישראל שיעסקו בתורה. אומ' להם כל מה שעשיתם בשביל עצמכם עשיתם שווקים להושיב בהם זונות מרחצאות לעדן עצמכם כסף וזהב שלי הוא שנ' לי הכסף ולי הזהב. כלום יש בכם מגיד זאת שנ' מי בכם יגי' זאת ואין זאת אלא תורה שנ' וזאת התורה אשר שם משה. מיד יוצאין מלפניו בפחי נפש.

(2) נכנסת מלכות פרס אחריה. אומ' להם הקדוש ברוך הוא במה עסקתם. אומ' לפניו הרבה גשרי' גשרנו הרבה כרכים כבשנו הרבה מלחמות עשינו וכולן לא עשינו אלא בשביל ישראל כדי שיעסקו

בתורה. אומ' להם הקב"ה כל מה שעשיתם לצורך עצמכם עשיתם. גשרים ליטול בהן מכס כרכים לעשות בהן אנגריא. מלחמו' אני עשיתי שנ' ה' איש מלחמה. כלום יש בכם מגיד זאת שנ' מי בכם יגי' זאת ואין זאת אלא תורה שנ' וזאת התורה אשר שם משה וגו'. מיד יוצאין מלפניו בפחי נפש.

(3) וכן כל אומה ואומה.

[ב] (1) אומ' לפניו רבונו של עולם כלום קבלנוה ולא קיימנוה. אומ' להם ראשונות ישמיעונו. אלו שבע מצות שקיבלתם היכן קייםתם.

(2) אומ' לפניו רבונו של עולם. ישראל שקיבלוה היכן קיימוה. אומ' להן אני מעיד בישראל שקיימו את התורה כולה. אומ' לפניו רבונו של עולם כלום יש אב שמעיד על בנו דכת' בני בכורי ישראל. אומ' להן יבואו שמים וארץ ויעידו בהן בישראל שקיימו את התורה כולה. אומ' לפני' רבו' של עולם שמים וארץ נוגעין בעדותן הן שנ' אם לא בריתי יומם ולילה חקו' שמי' וארץ לא שמתי. אומ' להם יבואו מכם ובכם ויעידו בישראל שקיימו את התורה. יבוא נמרוד ויעיד על אברהם שלא נחשד על ע"ז. יבא לבן הארמי ויעיד ביעקב שלא נחשד על הגזל. תבא אשת פוטיפר ותעיד ביוסף שלא נחשד על עבירה. יבא דריוש ויעיד על דניאל שלא ביטל את התפלה יבוא נבוכדנצר ויעיד בחנניה מישאל ועזריה שלא השתחוו לצלם. יבוא אליפז התימני ובלדד השוחי וצופר הנעמתי ואליהוא בן ברכאל הבוזי ויעידו בישראל שקיימו את כל התורה כולה שנ' יתנו עידיהם ויצדקו. [...]

(3) אומ' לפניו רבונו של עולם תנה לנו מראש ונעשנה. אומ' להם שוטים שבעולם מי שטרח בערב שבת יאכל בשבת ומי שלא טרח בערב שבת מהיכן הוא אוכל

[ג] (1) אלא אע"פ כן מצוה קלה יש לי וסוכה שמה לכו ועשו אותה. מיד כל אחד ואחד עושה לו סוכה בראש גגו.

(2) והקב"ה מקדיר עליהם חמה כתקו' תמוז. מיד כל אחד ואחד מבעט בסוכתו ויוצא שנ' ננתקה את מוסרותימו וגו'.

(3) הקב"ה יושב ומשחק עלי' שנ' יושב בשמים ישחק.

# Notes

Chapter 1   Introduction

1. Jacob Neusner, *Development of a Legend: Studies on the Traditions Concerning Yoḥanan ben Zakkai* (Leiden: Brill, 1970); idem, *The Rabbinic Traditions about the Pharisees before 70,* 3 vols (Leiden: Brill, 1971); idem, *Eliezer ben Hyrcanus: The Tradition and the Man* (Leiden: Brill, 1973). William Scott Green's "What's in a Name? — The Problematic of Rabbinic 'Biography,'" *Approaches to Ancient Judaism: Theory and Practice,* ed. William Scott Green (Missoula, Mont.: Scholars Press, 1978), 77–96, clearly articulates the methodological issues. Many scholars prior to Neusner rejected the historical accuracy of a given story and recognized fictional aspects of stories in general. However, Neusner was the first to reject the entire method. For summary and criticism of previous historians, see Neusner, "The Rabbinic Traditions about the Pharisees before 70 in Modern Historiography," in *Method and Meaning in Ancient Judaism, Third Series* (Chico, Calif.: Scholars Press, 1981), 185–213.

2. For illustration of Neusner's literary theory and method see "Story and Tradition in Judaism," in *Judaism: The Evidence of the Mishna* (Chicago: University of Chicago Press, 1981), 307–28. For later writings see *Judaism and Story: The Evidence of the Fathers according to Rabbi Nathan* (Chicago: University of Chicago Press, 1992). Neusner's inattention to detail calls into question his analysis since there is no guarantee that his structural judgments are persuasive. His tendency to summarize and abstract the message of the story became more pronounced in his later work which focused on the overall traits of rabbinic documents while insisting that sources be analyzed in light of documentary characteristics.

3. I refer primarily to the longer, more developed anecdotes and stories. Extremely brief one-line or two-line stories, mainly reporting legal precedents,

are common. These should be considered a separate genre and may be more reliable historically.

4. See Charles W. Fornara, *The Nature of History in Ancient Greece and Rome* (Berkeley: University of California Press, 1983), 91–141. T. P. Wiseman, *Clio's Cosmetics* (London: Leicester University Press, 1979), 23, observes, "The idea of creating history out of next to nothing was well known to the Greeks . . . and some of their techniques were borrowed by Roman historians." Concerning the Roman historian Antias, Wiseman notes, "When he wanted documentary evidence, he invented it" (ibid.). In "Lying Historians: Seven Types of Mendacity," *Lies and Fictions in the Ancient World*, ed. C. Gill and T. P. Wiseman (Exeter: University of Exeter Press, 1993), 122–46, Wiseman explores various types of lies, falsification, and fabrications that characterize ancient historiography. This characterization applies even to Thucydides. See J. L. Moles, "Truth and Untruth in Herodotus and Thucydides," in Gill and Wiseman, ibid., 88–121.

5. The Jewish historians of the nineteenth and early twentieth centuries were no more anachronistic than their colleagues. They simply applied the dominant modes and assumptions of Western historiography to Jewish sources.

6. Thus the oft-quoted statement of Plutarch (*Alexander* 1.2): "We are not writing history but lives." See Arnoldo Momigliano, *The Development of Greek Biography* (Cambridge: Harvard University Press, 1971), 1–7; Patricia Cox, *Biography in Late Antiquity* (Berkeley: University of California Press, 1983), 12–16; *Latin Biography*, ed. T. A. Dorey (London: Routledge & Kegan Paul, 1967), 5–6, 53–54. Roman imperial historians tended to include a great deal of biography in their histories, which only made their writings more fictional. See Fornara, *The Nature of History in Ancient Greece and Rome*, 180–93, who calls this process a "degeneration of history" and "intellectual debasement" (189).

7. See the articles collected in Henry Fischel, ed., *Essays in Greco-Roman and Related Talmudic Literature* (New York: Ktav, 1977), and especially the prolegomenon and the "Selected Annotated Bibliography: Monographs, Articles, and Chapters on Greco-Roman Philosophical and Rhetorical Literature and Talmudic-Midrashic Writings, 1850–1975," xiii–lxxii.

8. Henry Fischel, "Story and History: Observations on Greco-Roman Rhetoric and Pharisaism," in *Essays in Greco-Roman and Related Talmudic Literature* (New York: Ktav, 1977), 449.

9. Ibid., 449–51.

10. See the story of Elisha b. Abuya analyzed in Chap. 3, and the story of R. Eleazar b. R. Shimon, bBM 83b–85a. While neither of these resembles a classical *bios*, they do resemble some of the shorter lives of Diogenes Laertes.

See Fischel, "Story and History," 445–46; Moses Hadas, "Rabbinic Parallels to *Scriptores Historiae Augustae*," *Classical Philology* 24 (1929), 258–62.

11. Fischel, "Story and History," 451 and n. 42; idem, *Rabbinic Literature and Greco-Roman Philosophy* (Leiden: Brill, 1973), 12 and n. 101; Cox, *Biography in Late Antiquity*, 58–65; Elizabeth Haight, *The Roman Use of Anecdotes in Cicero, Livy and the Satirists* (New York: Longmans, Green, 1940), 33–78. A second important difference is that ancient biographies are the product of one author, while rabbinic stories, like the documents in which they are found, are the product of a group. However, biographers relentlessly copied, excerpted, and anthologized earlier works, and drew on anthologies and handbooks of unknown provenance. Thus ancient biographies, in many respects, are also communal efforts.

12. Cox, *Biography in Late Antiquity*, xi–xvi, 45–65. Sometimes the standards were less rigorous. See Wiseman, "Lying Historians," 137: "Cicero's Atticus used a similar phrase—'it's your choice' (*tuo arbitratu*). 'Write what you want,' said the City Prefect to the imperial biographer; 'you can safely say whatever you like'" (from Cicero, *Brutus*, 42).

13. Wiseman, "Lying Historians," 145. So Momigliano, *Development of Greek Biography*, 102: "Even historians like Xenophon with a philosophic education forgot about truth when they came to write encomia and idealized biographies." See also Wiseman, *Clio's Cosmetics*, 38: "In pursuit of the same educative ideal as Cicero, Livy and Tacitus, Valerius produced a collection of schematic caricatures in which historical accuracy is entirely subordinated to rhetorical 'point.'" On legendary elements in biographies of philosophers see Anton Priessnig, "Die literarische Form der spätantiken Philosophenromane," *Byzantinische Zeitschrift* 30 (1929), 23–30.

14. Fischel, "Story and History," 450–56; idem, *Rabbinic Literature and Greco-Roman Philosophy;* Dan Ben-Amos, "Narrative Forms in the Haggada: Structural Analysis" (Ph.D. diss., Indiana University, 1967), 160–79; Catherine Hezser, "Die Verwendung der hellenistischen Gattung Chrie im frühen Christentum und Judentum," *JSJ* 27 (1996), 371–439, with copious references. For rabbinic use of other Greco-Roman genres see A. Marmorstein, "The Background of the Haggadah," *HUCA* 6 (1929), 183–204 (on diatribe); E. Bi(c)kerman, "La Chaîne de la tradition pharisienne," *Revue Biblique* 59 (1952), 44–54; David Daube, "Alexandrian Methods of Interpretation and the Rabbis," in *Festschrift Hans Lewald* (Basel: Helbing & Lichtenhahn, 1953), 27–44; S. Stein, "The Influence of Symposia Literature on the Literary Form of the Pesaḥ Haggadah," *JJS* 8 (1957), 13–44; Shaye Cohen, "Patriarchs and Scholarchs," *PAAJR* 48 (1981), 57–86; and see Fischel's bibliography, above, n. 7.

15. See Momigliano, *Development of Greek Biography*, 71–73. On the use of

*chriae* (and other anthologies) in classical education, see John Barns, "A New Gnomologium: With Some Remarks on Gnomic Anthologies (I)–(II)," *Classical Quarterly* 44–45 (1950–51), 136–37, 11–19.

16. Fischel, "Story and History," 460–63. However, in *Rabbinic Literature*, 85, Fischel notes that "the use of a particularly literary form, even a sterotype [*sic*] such as a Sage anecdote, does not yet by itself indicate fiction. A true event can be described by means of a literary convention. On the other hand, it can be argued that no author would wish to invite disbelief in a true story by writing it in a literary genre that serves to transmit didactic-legendary material and is known as such." Fischel wavers on this point in his various writings.

17. Stanley F. Bonner, *Education in Ancient Rome* (Berkeley: University of California Press, 1977), 256–59. Similarly, students were called upon to invent stories, fables, speeches, and other rhetorical forms.

18. Fischel, "Studies in Cynicism and the Ancient Near East: The Transformation of a *Chria*," in *Religions in Antiquity, Essays in Memory of Erwin Ramsdell Goodenough*, ed. Jacob Neusner (Leiden: Brill, 1968), 374.

19. Fischel, "Story and History," 461–62, and "Studies in Cynicism and the Ancient Near East," 371–76. Classicists heatedly debated—and continued to debate—the historical worth of much of ancient biography and historiography despite the growing awareness of literary conventions. See Wiseman, *Clio's Cosmetics*, 52–53, on continuing mistakes and gullibility among classical historians. Neusner's criticism of earlier rabbinic historians as credulous and primitive is therefore exaggerated. They were not far behind classical scholars in coming to terms with the problems of historical reconstructions. See n. 5.

20. See the aforementioned studies of Fischel and the articles he collected in *Essays in Greco-Roman and Related Talmudic Literature*, and see the numerous works of A. A. Halevi, including *'Olama shel ha'aggada* (Tel Aviv: Devir, 1972) and *Ha'aggada hahistorit-biografit* (Tel Aviv: Niv, 1975).

21. See Fischel, *Rabbinic Literature*, 114; idem, "Story and History," 461; Hezser, "Die Verwendung der hellenistischen Gattung Chrie," 436–39.

22. See Ehsan Yarshater, "Iranian National History," *The Cambridge History of Iran*, vol. 3, *The Seleucid, Parthian, and Sasanian Periods*, ed. Ehsan Yarshater (Cambridge: Cambridge University Press, 1983), 366–69. "[N]o distinction was made between the factual, the legendary, and the mythical. All three are blended in a unified whole, presented as a continuous narrative of events. . . . Applying the principles of Western historical criticism, which are the product of a different environment and different intellectual concerns, will be little help in achieving an appreciation of the true purport of Iranian historiography. . . . History was not conceived as a 'discipline' to satisfy a thirst for fact, nor were its methods attuned to such a purpose. History had primarily

an edifying aim; in the hierarchical, conventional and conservative world of the Sasanian establishment, the purpose of history was to maintain and promote the national and moral ideals of the state ... Thus the historiographer, far from being an impartial investigator of facts, was an upholder and promoter of the social, political and moral values cherished by the Sasanian elite." Moreover, much of Persia was influenced by Roman-Hellenistic culture. See ibid., 12–17, 821–34, 866–74, 1029–54.

23. I am trying to avoid crude distinctions such as "historiography" as opposed to "literature." All historiography is obviously not only literature but narrative, and it need not be devoid of literary features. Fiction generally displays a greater concentration of these techniques, and poetry still greater. I am using these categories in an imprecise manner to illustrate general differences. See Linda Orr, "The Revenge of Literature: A History of History," *New Literary History* 18 (1986), 1–22.

24. Jonah Fraenkel, *Darkhei ha'aggada vehamidrash* (Masada: Yad Letalmud, 1991). See the following note and the bibliography for references to his articles.

25. Jonah Fraenkel, "Paronomasia in Aggadic Narratives," *Scripta Hierosolymitana* 27 (1978) 27–51; "Bible Verses Quoted in Tales of the Sages," *Scripta Hierosolymitana* 22 (1971), 80–99; "The Structure of Talmudic Legends," *Folklore Research Center Studies* 7 (1983), 45–97 (Hebrew); *Darkhei ha'aggada vehamidrash*, 260–73.

26. His programmatic article, "Hermeneutic Problems in the Study of the Aggadic Narrative," *Tarbiz* 47 (1978), 139–72 (Hebrew), comprises a powerful assault on the historical analyses of rabbinic stories and a prolegomenon for his subsequent studies.

27. *Darkhei ha'aggada vehamidrash*, 240–43.

28. The classification of genres in terms of drama, lyric and epic derives from Aristotle. But Fraenkel uses the genres as theoretical constructs, not as types of ancient literature. On the misinterpretation of Aristotle's classification, see Gérard Genette, *The Architext*, trans. Jane E. Lewin (Berkeley: University of California Press, 1993).

29. Fraenkel, "The Structure of Talmudic Legends," 45–97; *Darkhei ha'aggada vehamidrash*, 261–68.

30. "Hermeneutic Problems," 157–63; *Darkhei ha'aggada vehamidrash*, 237, 260–63.

31. "Internal closure is a distinct literary-artistic phenomenon. Its meaning is that every detail of the story is connected to the next [detail], every part is planned in light of the entire story, the beginning reflects the end and the end is understood from the beginning" ("Hermeneutic Problems," 159).

32. Fraenkel identifies himself with the "hermeneutic approaches" to liter-

ary criticism that descended from phenomenology; in the notes to the introduction of "Hermeneutic Problems" (above, n. 26) he refers to the work of Wilhelm Dilthey, Emilio Betti, and E. D. Hirsch. While his assumptions perhaps derive from phenomenology or hermeneutics, his practice is essentially that of the New Criticism. Fraenkel takes from hermeneutic criticism the principle that the text is a stable artifact, that the interpreter, with appropriate caution, can avoid anachronism, weed out his biases, and arrive at an "objective" understanding. He then deploys techniques of the New Criticism to analyze the meaning of the story. Unlike some practitioners of hermeneutic criticism, Fraenkel does not discuss "prejudice" (in the Gadamerian sense), "forestructures," "horizon of expectations," "hermeneutics of suspicion," and other problematic aspects of the method. One could say that Fraenkel invokes one trend among hermeneutical methods to provide a type of philosophical underpinning for New Critical readings. On the similarity between phenomenology and New Criticism see Terry Eagleton, *Literary Theory: An Introduction*, 2d ed. (Minneapolis: University of Minnesota Press, 1996), 49–50.

33. It is interesting to note that both Fraenkel and the New Critics were reacting to historicizing heresies, albeit of different types. The New Critics reacted to the prior overemphasis among literary critics of the historical background as sufficient explanation of a literary artifact. Fraenkel's insistence on the "closure" of rabbinic stories was a reaction to the method of recovering history by reconciling and harmonizing contradictory sources. While the New Critics treated the historical background as basically irrelevant, Fraenkel found that it is nonexistent. But this aspect of closure should be applied to the historical period of the characters of the stories, not the historical context of the storytellers. The events referred to in stories may be fictions, but the historical context of the storytellers may be important for interpretation. Fraenkel, it seems to me, allowed his reaction against the former to spill over into his approach to the latter.

34. However, even Fraenkel, in one of his studies, argues that three stories about R. Yehoshua ben Levi must be understood in light of each other; see "The Image of Rabbi Joshua ben Levi in the Stories of the Babylonian Talmud," *Proceedings of the Sixth World Congress of Jewish Studies–1973* (Jerusalem, 1977), 3:403–17. So in rare cases, at least, there are strong intertextual markers. In "Outer Forms and Inner Values," in *Michtam Le-David: Rabbi David Ochs Memorial Volume*, ed. Y. Gilat and E. Stern (Ramat-Gan: Bar-Ilan University Press, 1978), 120–36 (Hebrew), Fraenkel recognizes the existence and importance of literary *topoi* and explores several in brilliant fashion.

35. Fraenkel's categorization of stories as "dramatic" is confusing, since drama, at least according to Aristotle (whom Fraenkel invokes), consists exclu-

sively of dialogue, whereas stories typically involve a narrator. Thus I prefer the term "dramatic narrative." It should also be noted that Fraenkel's distinction between "history"—a better term would be "historiography"—and "literature" or "literary creation" is overstated. See n. 23. And see Wiseman, *Clio's Cosmetics*, on the blurring of history, rhetoric, and poetry in practice, even if the genres were theoretically distinct.

36. See, e.g., Robert Hodge, *Literature as Discourse: Textual Strategies in English and History* (Baltimore: Johns Hopkins University Press, 1990), 23–37; Meir Sternberg, *The Poetics of Biblical Narrative* (Bloomington: Indiana University Press), 7–22.

37. See Stanley Fish, *Is There a Text in This Class? The Authority of Interpretive Communities* (Cambridge: Harvard University Press, 1980), 284.

38. In these cases Fraenkel considers the episode an independent source which later compilers used for their own purposes. However, in *Darkhei ha'aggada vehamidrash*, 455–56, Fraenkel does observe that the BT editors occasionally incorporated aggadic sources into a larger framework. In particular, they constructed introductions and conclusions to units of aggadic material. So while Fraenkel is not oblivious to the redactional process, his analysis generally removes the story from its framework. Fraenkel is also quick to treat part of a story as a later accretion or corruption, a result of the editing process, and not as a part of the "original" story. But these purported later accretions are sometimes problematic only in that they violate what Fraenkel has identified as the ideal structure of the story. See his "Remarkable Phenomena in the Text-History of the Aggadic Stories," *Proceedings of the Seventh World Congress of Jewish Studies–1977* (Jerusalem, 1981), 3:45–69 (Hebrew). For further discussion of Fraenkel's method see the reviews of Menahem Hirshman, "On Midrash as an Art Form: Its Creators and Its Forms," *Madʿei hayahadut* 32 (1992), 83–91 (Hebrew), and Richard Kalmin, "The Modern Study of Ancient Rabbinic Literature: Yonah Fraenkel's *Darkhei ha'aggada vehamidrash*," *Prooftexts* 14:2 (1994), 189–204.

39. In cases where Fraenkel has no choice but to draw on outside sources he proceeds with great hesitation or buries the cross-references in his notes. Rarely does he take a broader view of how a story may relate to a general cultural tension. But unlike the isolation of the story from its literary context, Fraenkel's restricted attention to the wider cultural context is not a methodological principle but a tendency. In his popular book, *'Iyyunim be'olamo haruhani shel sipur ha'aggada* (Tel Aviv: Hakibbutz Hameuhad, 1981), Fraenkel does his best work in describing the broader cultural tensions that frame the story.

40. See the studies listed in the following notes and in the bibliography. Unfortunately, Meir's writings to date have not made a significant impact on

the field of talmudic-midrashic studies. This neglect may be due to the unfortunate reluctance of many rabbinists to cross disciplinary boundaries. Meir came to rabbinics somewhat from the outside, training in the disciplines of folklore and Hebrew literature and publishing primarily in journals devoted to those fields. On the importance of the redactional context see too Jacob Neusner, *Judaism: The Classical Statement. The Evidence of the Bavli* (Chicago: University of Chicago Press, 1986), 124–29.

41. "The Acting Characters in the Stories of the Talmud and the Midrash" (Ph.D. diss., Hebrew University, 1977) (Hebrew). See also her "The 'Changing Character' and the 'Character Disclosed' in Rabbinic Stories," *JSHL* 6 (1984), 61–77 (Hebrew).

42. Ofra Meir, "The Narrator in the Stories of the Talmud and the Midrash," *Fabula* 22 (1981), 79–83; "Hasipur 'al nahshon — diuqan vesemel basipur hadarshani," *Sinai* 99 (1986), 22–37; "The Story as a Hermeneutic Device," *AJSR* 7–8 (1982–83), 231–62.

43. Ofra Meir, "The Literary Context of the Sages' Aggadic Stories as Analogous to Changing Storytelling Situations — The Story of the Hasid and the Spirits in the Cemetery," *Jerusalem Studies in Hebrew Folklore* 13–14 (1992), 81–98 (Hebrew).

44. Ibid., 90, 92. She also suggests that the text of the story in the Talmud may not be the "original" formulation, although she concedes that there is no way to reconstruct that original version (90).

45. In this study and the studies cited below, Meir also offers an analysis of the story as an "isolated text." This aspect of her method resembles Fraenkel's decontextualized readings.

46. Ofra Meir, "Hashpa'at ma'ase ha'arikha 'al hashqafat ha'olam shel sipurei ha'aggada," *Tura* 3 (1994), 67–84; "The Story of Hezekiah's Ailment in the Legends of Hebrew Homiletical Literature," *Hasifrut* 30 (1981), 109–30 (Hebrew); "The Story of Rabbi's Death: A Study of Modes of Traditions' Redaction," *JSHL* 12 (1990), 147–77 (Hebrew).

47. Meir, "Hashpa'at ma'ase ha'arikha"; bKet 62b; *LevR* 21:8 (484–86). A third version of the story appears in *GenR* 95 (1232).

48. Meir, "Hashpa'at ma'ase ha'arikha," 81.

49. Berkeley: University of California Press, 1993.

50. Boyarin, *Carnal Israel,* 15–16; see his analysis of the story found in bBM 83b–85a. See also Eliezer Diamond, "Wrestling the Angel of Death," *JSJ* 26 (1995), 76–92.

51. See Christine Hayes, *Between the Babylonian and Palestinian Talmuds* (New York: Oxford University Press, 1997), 23–24, for a similar approach. Meir Sternberg, *Poetics of Biblical Narrative,* 16, makes a related observation of the

Bible: "When all is said and done, the independent knowledge we possess of the 'real world' behind the Bible remains absurdly meager, almost non-existent when compared with the plenty available to, say, Joyceans or even Shakespearians. For better or for worse, most of our information is culled from the Bible itself."

52. See the introductions to *Meqorot umesorot* (Tel Aviv: Devir and Jerusalem: Jewish Theological Seminary, 1968–94), vol. 3 (*Shabbat*) and vol. 5 (*Bava Qama*), and his English book, *Midrash, Mishnah, and Gemara: The Jewish Predilection for Justified Law* (Cambridge: Harvard University Press, 1986), 76–104. Halivni first articulated his theory in the second volume of *Meqorot umesorot* (on tractates Yoma-Hagiga), published in 1975 (1–12). He added refinements and details in the introduction to vol. 3, published in 1982. This is not meant to be a comprehensive history of scholarship on the composition and redaction of the BT or of the precursors of Halivni and Friedman. For a detailed treatment see David Goodblatt, "The Babylonian Talmud," in *The Study of Ancient Judaism*, ed. Jacob Neusner (New York: Ktav, 1981), 144–81.

53. While several scholars realized the distinct character of these strata, no one proposed a history of the talmudic text on that basis. See Goodblatt, "Babylonian Talmud," 177–81.

54. *Meqorot*, 3:9–10 (emphasis in the original). See too *Meqorot*, 5:1–21. In a survey of the entire Talmud, David Kraemer found "only thirty-three cases of explicit argumentation from the first four Amoraic generations"; "The Beginning of the Preservation of Argumentation in Amoraic Babylonia," in *New Perspectives on Ancient Judaism*, vol. 4, ed. Alan J. Avery-Peck (Lanham, Md.: University Press of America, 1989), 37–46.

55. Halivni claims that in some cases the Stammaim inherited proto-*sugyot* from the Amoraic period. Even in these cases the Stammaim had to reconstruct, complete, and integrate the material, and so must be considered the creators of the *sugya*; see *Midrash, Mishnah, and Gemara*, 79.

56. *Meqorot*, 3:11. In *Meqorot*, 5:13–19, Halivni defines three categories of Stammaim: repeaters, editors, and combiners. He also describes their types of activity in greater detail.

57. *Midrash, Mishnah, and Gemara*, 82.

58. Ibid., 88. See also Yaakov Sussmann's description of the style of the BT over against the PT in "Veshuv lirushalmi neziqin," *Mehqerei talmud I*, ed. Y. Sussmann and D. Rosenthal (Jerusalem: Magnes, 1990), 97–99.

59. Friedman details his methodology in an introduction entitled "'Al derekh heqer hasugya" ("On the Method of Critical Research of the Sugya") in his "Pereq ha'isha rabba babavli," in *Mehqarim umeqorot*, ed. H. Dimitrovksi (New York: Jewish Theological Seminary, 1977), 283–321.

60. Ibid., 301–6. Friedman built on the work of Hyman Klein, "Gemara and Sebara," *JQR* 38 (1947), 67–91; "Gemara Quotations in the Sebara," *JQR* 43 (1953), 341–62; "Some General Results of the Separation of Gemara from Sebara in the Babylonian Talmud," *Journal of Semitic Studies* 3 (1958), 363–72.

61. Avraham Weiss first defined the *sugya* as a literary unit and began research into its structure and composition. See *Habavli behithavut hasifrutit*, vol. 2 (Warsaw, 1939); *Hithavut hatalmud bishleimuto* (New York: Alexander Kohut Memorial Foundation, 1943); *'Al heyetsira hasifrutit shel ha'amoraim* (New York: Horeb, 1962); *Mehqarim batalmud* (Jerusalem: Mosad Harav Kook, 1975). On Weiss's contribution see Shammai Kanter, "Abraham Weiss: The Search for Literary Forms," in *The Formation of the Babylonian Talmud*, ed. J. Neusner (Leiden: Brill, 1970), 95–103.

62. "Pereq ha'isha rabba babavli," 315–19; Shamma Friedman, "Some Structural Patterns of Talmudic *Sugiot*," *Proceedings of the Sixth World Congress of Jewish Studies–1973* (Jerusalem, 1977), 3:391–96 (Hebrew).

63. "Pereq ha'isha rabba babavli," 326–27.

64. The literal meaning of *savora'im* is "thinkers" or "reasoners."

65. In his early work Halivni considered the Stammaim to be the main authors of talmudic *sugyot* and limited their activity to the years between 427 C.E. (the death of Rav Ashi, one of the last Amoraim) and 501 or 520 C.E.; *Meqorot*, 3:16–27, especially n. 37, and *Midrash, Mishnah, and Gemara*, 76–77, 83–84, 99–100 and 140 n. 1. More recently, Halivni has given up the distinction between Stammaim and Saboraim and considers the two equivalent (Lecture delivered at Tel Aviv University, Dec. 22, 1997). Friedman does not use the terms "stam" or "Stammaim" to refer to the sages of a distinct age but to describe a type of literature. Nor does he date the compositional and redactional activity precisely. A rough *terminus ante quem* is the fixing of the base text of the Talmud in the mid to late seventh century C.E. ("Pereq ha'isha rabba babavli," 283). On the question of Stammaim and Saboraim, see too Richard Kalmin, *The Redaction of the Babylonian Talmud: Amoraic or Saboraic?* (Cincinnati: HUCA Press, 1989), 1–11, 89–94, and Yaakov Sussmann, "Veshuv lirushalmi neziqin," 102–6 and n. 192. The current consensus essentially identifies the Stammaim with the Saboraim who flourished in the late fifth, sixth, and seventh centuries. This coheres with the early critical work of Hyman Klein, Avraham Weiss, and Julius Kaplan that gave the Saboraim a major role in redacting the Talmud. On the dating of the Saboraic age see Yaakov Ephrati, *The Sevoraic Period and its Literature* (Jerusalem: Dror, 1973), 33–62, 74–81 (Hebrew). And see Hayes, *Between the Babylonian and Palestinian Talmuds*, 20–22.

66. This is essentially the position of Neusner, who gives the final redactors full responsibility for the talmudic text. See below, n. 91.

67. The following discussion builds directly on Friedman: see "Pereq ha'isha rabba babavli," 309–13, and *Talmud 'arukh: pereq hasokher 'et ha'omanin* (Jerusalem: Jewish Theological Seminary, 1990–96), 2:8–23. See also Birger Gerhardsson, *Memory and Manuscript: Oral Tradition and Written Transmission in Rabbinic Judaism and Early Christianity,* trans. E. J. Sharpe (Lund: Gleerup, 1961), 136–48.

68. Shamma Friedman, "Habaraitot shebatalmud habavli veyihasan latosefta" (forthcoming). See too Yaakov Elman, *Authority and Tradition: Toseftan Baraitot in Talmudic Babylonia* (Hoboken, N.J.: Ktav, 1994), 44–46, 145–64.

69. Let me emphasize that this is only a presumption. In some cases it can be demonstrated that a *baraita* is a late, redactional creation, not an authentic Tannaitic source. See the discussion of "pseudo-*baraitot*" in Chap. 8.

70. On the reliability of Amoraic attributions, see David Kraemer, "On the Reliability of Attributions in the Babylonian Talmud," *HUCA* 60 (1989), 175–90, and Richard Kalmin, *Sages, Stories, Authors and Editors in Rabbinic Babylonia* (Atlanta: Scholars Press, 1994). Jacob Neusner takes an extremely skeptical view of the reliability of attributions. See his *Judaism: The Evidence of the Mishna,* 14–22, and Green, "What's in a Name?" 77–96.

71. Friedman, *Talmud 'arukh,* 2:9–12; Halivni, *Meqorot,* 5:14–21, and *Midrash, Mishnah, and Gemara,* 77. Halivni considers the Stammaitic intervention most pronounced in the fragmentary argumentative statements that survived from the Amoraic periods, as opposed to apodictic law, which survived more intact. The Hebrew of the BT Amoraim differs slightly from Tannaitic Hebrew: see Yohanan Breuer, "On the Hebrew Dialect of the Amoraim in the Babylonian Talmud," *Mehqerei lashon* 2–3 (1987), 127–52 (Hebrew).

72. See Menahem Kahane, "Intimation of Intention and Compulsion of Divorce: Towards the Transmission of Contradictory Traditions in Late Talmudic Passages," *Tarbiz* 62 (1993), 230–31, 248–50, 260–62 (Hebrew); Halivni, *Meqorot,* 5:18–19; Hayes, *Between the Babylonian and Palestinian Talmuds,* 14–15.

73. *Talmud 'arukh,* 2:16–17.

74. Louis Jacobs, "The Sugya on Sufferings in B. Berakhot 5a,b," in *Studies in Aggadah, Targum and Jewish Liturgy in Memory of Joseph Heinemann,* ed. J. J. Petuchowski and E. Fleischer (Jerusalem: Magnes, 1981), 32–44. See also his *Structure and Form in the Babylonian Talmud* (Cambridge: Cambridge University Press, 1991), especially 100–106. Jacobs observes that the "editors/authors" of the BT substantially reworked their sources for dramatic effect.

75. *PAAJR* 57 (1990–91), 35–67. See too Elman, "The Suffering of the Righteous in Palestinian and Babylonian Sources," *JQR* 80 (1990), 315–40; Michael Satlow, "'Wasted Seed,' The History of a Rabbinic Idea," *HUCA* 65 (1994), 137–76; David Kraemer, "Composition and Meaning in the Bavli," *Prooftexts* 8

(1988), 271–91; idem, *Responses to Suffering in Classical Rabbinic Literature* (New York: Oxford University Press, 1995), 184–210; idem, *Reading the Rabbis: the Talmud as Literature* (New York: Oxford University Press, 1996); Eliezer Segal, *The Babylonian Esther Midrash: A Critical Commentary* (Atlanta: Scholars Press, 1994).

76. Shamma Friedman, "La'aggada hahistorit betalmud bavli," in *Saul Lieberman Memorial Volume,* ed. Shamma Friedman (New York: Jewish Theological Seminary, 1993), 119–63. An abbreviated English translation appears as "Development and Historicity in the Aggadic Narrative of the Babylonian Talmud—A Study Based upon B.M. 83b–86a," *Community and Culture: Essays in Jewish Studies in Honor of the Ninetieth Anniversary of the founding of Gratz College,* ed. N. M. Waldman (Philadelphia: Gratz College, 1987), 67–80.

77. "La'aggada hahistorit," 127–31.

78. However, Friedman seems to be more sanguine about the historical reliability of the earliest versions of stories, which Neusner treated with skepticism. See "La'aggada hahistorit," 162.

79. Friedman's study also suggests that much of the reworking occurred specifically during Stammaitic times and not during the Amoraic period or in earlier stages of oral transmission, for the reworkings postdate the Palestinian version of the fifth century. See also Sussmann, "Veshuv lirushalmi neziqin," 100–101, n. 186, discussing the character of the aggada of the BT: "It seems to me that here too [scholars] have not taken into account sufficiently the long span of time; and it seems that one should not necessarily make a firm, fundamental or essential distinction between halakha and aggada in this respect. The original Amoraic material (Palestinian and Babylonian—in this literary frame or another) continued to live, to change and to develop throughout a very lengthy period in Babylonia."

80. *Midrash, Mishnah, and Gemara,* 77. See also Louis Jacobs, *The Talmudic Argument: A Study in Talmudic Reasoning and Methodology* (London: Cambridge University Press, 1984), 21–22, 211–12: "Their main aim was purely academic. They evidently wished to provide argument and debate as an intellectual exercise, precisely because . . . the study of Torah was by this time the established and acknowledged supreme way of worship." And see David Kraemer, *The Mind of the Talmud* (New York: Oxford University Press, 1990). This is not to deny that the Stammaim were also interested in exegesis and practical law. See Jay Rovner, "Rhetorical Strategy and Dialectical Necessity in the Babylonian Talmud: The Case of Kiddushin 34a–35a," *HUCA* 65 (1994), 184–87, 220–22, and Menahem Kahane, "Intimation of Intention and Compulsion of Divorce."

81. I am not claiming that these devices are unique to the BT or to the

Stammaim. They are found, to a certain extent, in folktales and stories throughout the world, and are especially prominent in oral literature. My point is that Stammaitic composition consciously and intentionally employs such methods, hence they contribute significantly to the overall meaning.

82. In this I agree with Fraenkel (see the section on Literary Analysis), although I hesitate to speak for all rabbinic stories and all rabbis. The Stammaitic Babylonian academy differed from earlier situations of Torah study (see below). On narrative situations and the role of the reader (sometimes called the "implied reader") see Shlomith Rimmon-Kenan, *Narrative Fiction: Contemporary Poetics* (London: Routledge, 1983), 117–29. See also David Kraemer, "The Intended Reader as a Key to Interpreting the Bavli," *Prooftexts* 13 (1993), 125–40.

83. David Goodblatt, *Rabbinic Instruction in Sasanian Babylonia* (Leiden: Brill, 1975).

84. Ibid., 7.

85. Isaiah Gafni, "Yeshiva and Metivta," *Zion* 43 (1978), 12–37 (Hebrew).

86. For example, Gafni's reference to the phrase "*metivta* in heaven" (bBM 86a) as solid evidence of an Amoraic academy is not probative, for the passage appears in a story of late provenance (25, 29; and see Friedman, "La'aggada hahistorit," 139 n. 106).

87. Goodblatt published his *Rabbinic Instruction* in 1975, and Gafni's article appeared in 1978. But the research and writing was obviously done earlier. Halivni first articulated his theory of the Stammaim in the introduction to the second volume of his *Meqorot umesorot* published in 1975. Friedman's "Pereq ha'isha rabba babavli" appeared in 1977. Goodblatt refers once to Friedman's study in his response to Gafni ("New Developments in the Study of the Babylonian *Yeshivot*," *Zion* 46 [1981], 14–38 [Hebrew]). Goodblatt argues that some references to institutions derive from later copyists, and occasionally distinguishes between the Amoraic statement and a later gloss; see, e.g., 274. Gafni also recognizes that some references to *metivta* or *beit midrash* appear in Aramaic glosses to Amoraic statements. See, e.g., the discussion of bSot 7b, 29, and bShab 114a, 32. These are clearly Stammaitic additions that reflect a later historical period. And see the following note.

88. Goodblatt distinguishes "anonymous anecdotes" about biblical personages, Tannaim, Palestinian Amoraim and Babylonian Amoraim from "traditions attributed" to Palestinian and Babylonian Amoraim, but focuses more on the Palestinian/Babylonian distinction than the anonymous/attributed division. For example, in his analysis of instances of *be midrasha* he concludes that the anonymous anecdotes mention Palestinians sixty times and Babylonians only eight, and therefore these terms do not characterize Babylonian institu-

tional life (97, 105). Perhaps more significant is that there are sixty *anonymous* anecdotes as opposed to just seventeen *attributed* traditions. I shall return to this issue in Chap. 8, "The Academy."

89. See Jack N. Lightstone, *The Rhetoric of the Babylonian Talmud, Its Social Meaning and Context* (Waterloo, Ont.: Wilfred Laurier University Press, 1994), especially 264–81. Lightstone argues that the rhetorical traits of the BT shed light on the institutional and social setting of the editors, and also legitimate the newly emerged academies of the fifth and sixth centuries.

90. Because BT stories have been reworked by the Stammaim, there is no guarantee that their narrative art matches that of other rabbinic documents. Before we write a synthetic account of the poetics of the rabbinic story, the poetics of the stories in each rabbinic work must be studied independently.

91. Jacob Neusner has championed the method of redaction-criticism in his numerous studies of the Babylonian Talmud and other rabbinic works. See *The Bavli's One Voice: Types and Forms of Analytical Discourse and Their Fixed Order of Appearance* (Atlanta: Scholars Press, 1991), and *Sources and Traditions: Types of Compositions in the Talmud of Babylonia* (Atlanta: Scholars Press, 1992). However, Neusner argues that the sources have been reworked to such an extent that they can no longer be distinguished. For criticism of Neusner's position see Daniel Boyarin, "On the Status of the Tannaitic Midrashim," *Journal of the American Oriental Society* 112 (1993), 455–64, and Eliezer Segal, "Anthological Dimensions of the Babylonian Talmud," *Prooftexts* 17 (1997), 35–37.

92. For an interesting example, see Friedman, *Talmud 'arukh*, 1:152. In this case the story is short, and actually cited in a type of outline form. Lengthier stories generally have an intrinsic connection to their halakhic context.

93. Jacob Neusner argues that the redactors composed large-scale passages by applying logical rules, and therefore the Talmud is a work of purposive compilation. See *The Rules of Composition of the Talmud of Babylonia: The Cogency of the Bavli's Composite* (Atlanta: Scholars Press, 1991), and *The Bavli's Massive Miscellanies: The Problem of Agglutinative Discourse in the Talmud of Babylonia* (Atlanta: Scholars Press, 1992). Neusner claims that only a few talmudic passages are "miscellanies" devoid of systematic and principled organization.

94. On the viability of source-criticism—the lack of homogenization of sources—see Kalmin, *Sages, Stories, Authors,* and the references provided on 2–3, n. 5 and 10–11, nn. 30–31; Hayes, *Between the Babylonian and Palestinian Talmuds,* 9–17.

95. See Hayes, *Between the Babylonian and Palestinian Talmuds,* 11–14, for further discussion and documentation.

96. "La'aggada hahistorit." He concludes the English version ("Literary Development and Historicity in the Aggadic Narrative"): "Much of the narra-

tive Aggadah in the BT is of Palestinian origin. The literary sources used by the *BT* have generally not survived, but many parallels exist in the *PT* and Midrashim ... The resemblance of these extended passages in content and structure ... enables us to gain insight on the sources used by the *BT* " (75). See also his formulation in *Talmud 'arukh*, 2:15: "The two extant Talmuds draw from the same earlier traditions, which the version of the PT resembles more closely in the majority of cases."

97. A. Karlin, *Divrei sefer* (Tel Aviv: Mahberot lesifrut, 1952); Neusner, *Development of a Legend* and *The Rabbinic Traditions about the Pharisees before 70;* Zipporah Kagan, "Divergent Tendencies and Their Literary Moulding in the Aggadah," *Scripta Hierosolymitana* 22 (1971), 151–70; David Goodblatt, "The Beruriah Traditions," *JJS* 26 (1975), 68–85, and "The Story of the Plot against R. Simeon B. Gamaliel II," *Zion* 49 (1984), 349–74 (Hebrew); Joshua Efron, "Bar-Kochva in the Light of the Palestinian and Babylonian Talmudic Traditions," in *The Bar-Kochva Revolt: A New Approach,* ed. A. Oppenheimer and U. Rappaport (Jerusalem: Yad Izhaq Ben Zvi, 1984), 47–105 (Hebrew); Louis Jacobs, "The Story of R. Phinehas ben Yair and his Donkey in b. ḥullin 7a–b," in *A Tribute to Geza Vermes,* ed. P. Davies and R. White (Sheffield: Sheffield Academic Press, 1990), 193–206; Pinhas Mandel, "Hasipur bemidrash 'eikha: nusah vesignon" (master's thesis, Hebrew University, 1993), 1:192–93; Ofra Meir, "The Story of Rabbi's Death," and "Hateruma hahistorit shel 'aggadot hazal," *Mahanayim* 7 (1994), 8–25; Tal Ilan, "The Historical Beruriah, Rachel, and Imma Shalom," *AJSR* 22 (1997), 1–17; Catherine Hezser, *Form, Function and Historical Significance of the Rabbinic Story in Yerushalmi Neziqin* (Tübingen: J. C. B. Mohr, 1993), 349–50.

98. While it is generally agreed that the BT did not know the PT in its extant form, it is also clear that many PT traditions and even entire *sugyot* reached Babylonia in substantially the same state as they appear in the PT. Martin Jaffee, "The Babylonian Appropriation of the Talmud Yerushalmi: Redactional Studies in the Horayot Tractates," in *New Perspectives on Ancient Judaism,* vol. 4, ed. Alan J. Avery-Peck (Lanham, Md.: University Press of America, 1989), 23–24, observes: "The correspondences between Bavli and Yerushalmi Horayot suggest that the post-Amoraic editors of the former had something much like the extant version of the latter before them and reflected upon the logic of its construction as they composed their own commentary." Yaakov Sussmann, "Veshuv lirushalmi neziqin," 98–99, observes that the BT and PT typically share the same Amoraic material. The unattributed stratum of the PT, however, is very thin, while that of the BT is highly developed. This again suggests that the Stammaim knew the PT in something close to its final state. See the careful formulation by Christine Hayes, *Between the Babylonian and*

*Palestinian Talmuds,* 22–23 and nn. 46–48, with which I am in complete agreement. Hayes applies the comparative method to halakhic material, comparing parallel PT and BT legal *sugyot* in order to determine the changes introduced by Babylonian sages to the core Palestinian tradition. See also the survey of scholarship in Hezser, *Rabbinic Story in Yerushalmi Neziqin,* 345–48.

99. See Robert Alter, *The Art of Biblical Narrative* (New York: Basic Books, 1981), 131–54; Meir Sternberg, *Poetics of Biblical Narrative,* 13–14.

100. For a clear example of an internal contradiction resulting from two disparate sources, see Friedman, "La'aggada hahistorit," 136.

101. For an excellent discussion and evaluation of the constraints that limited the redactors, see Hayes, *Between the Babylonian and Palestinian Talmuds,* 15–17.

102. *Art of Biblical Narrative,* 12–13.

103. A literary device may occur in any genre of literature, including historiography, chronography, and legal drafting. Indeed, some would avoid the term "literary device" so as not to imply that other genres are not literature or be suspected of a false dichotomy between the writing of history (objective, accurate) and poetry or literature (fictional, artistic); see Sternberg, *Poetics of Biblical Narrative,* 39–40. Nevertheless, I think the term is useful at least for a study of this sort. What usually distinguishes poetry, drama, and some forms of narrative from historiography is the density of literary devices. The concentration of numerous literary devices in a small amount of text is part of the "literariness" of the rabbinic story, what makes it an artistic creation for didactic purposes, not an attempt mimetically to represent the past. See n. 23.

104. Gérard Genette, *Narrative Discourse: An Essay on Method,* trans. Jane E. Lewin (Ithaca: Cornell University Press, 1972); idem, *Narrative Discourse Revisited,* trans. Jane E. Lewin (Ithaca: Cornell University Press, 1988); Mieke Bal, *Narratology: Introduction to the Theory of Narrative,* trans. C. van Boheemen (Toronto: University of Toronto Press, 1985); idem, *On Storytelling: Essays in Narratology,* ed. D. Jobling (Sonoma, Calif.: Polebridge Press, 1991); Rimmon-Kenan, *Narrative Fiction.*

105. Although I contend that literary analysis must be combined with source- and redaction-criticism, it is difficult to present the methods together. I generally present the literary analysis first, on the grounds that it is more interesting and less taxing to the reader, and tackle source-critical evidence and redaction-critical questions thereafter. However, I introduce source-critical issues in the course of the literary analysis when necessary, and sometimes adumbrate issues addressed more fully in later sections. The approaches constantly informed one another throughout the interpretive process, hence the results are more interdependent than they might appear. The "hermeneutic circle" of

interpretation moves not only from the parts of the text to the whole in a dialectical process, but from the text to context and context to text.

106. See Robert Scholes and Robert Kellogg, *The Nature of Narrative* (New York: Oxford University Press, 1966), 27.

107. Ibid., 51. "In order to discover the formulaic character of a narrative's diction or the conventional nature of its structure and theme, the critic must consult a body of narrative large enough to embody norms and to serve as at least a fragment of a 'tradition.'"

108. There results a certain degree of circularity in that the intertexts, including other stories, also must be studied in terms of their general context. So other stories provide the general cultural context for a given story, while the given story is part of the general cultural context of the other stories. But since the text of the Talmud is the only entrance to its culture, there is no escape from this circle.

109. Certainly there is an element of subjectivity in the privileging of some stories over others. But the importance of these texts results not only from subjective considerations, but from the culture transmitted over the centuries, which derives, to a certain extent, from the texts themselves. On the matter of selecting texts and their representative value, see Stephen Greenblatt, *Renaissance Self-Fashioning: From More to Shakespeare* (Chicago: University of Chicago Press, 1980), 6–8.

110. Shamma Friedman has begun the task. See his "Le'ilan hayuhasin shel nushei bava metsia—pereq beheqer nusah habavli," in *Mehqarim besifrut hatalmudit* (Jerusalem: Israel Academy of Sciences, 1983), 93–147; "On the Origin of Textual Variants in the Babylonian Talmud," *Sidra* 7 (1991), 67–102 (Hebrew); *Talmud 'arukh*, 2:26–55. See also the references in the following notes.

111. Friedman, *Talmud 'arukh*, 2:26–55.

112. This situation is similar, in some ways, to current thinking about text-types among literary critics of the Bible. Biblical literary critics consider the texts represented by the Masoretic text, the Septuagint, and the Samaritan Pentateuch to require independent analysis. They should not be harmonized to create a synthetic version because the literary peculiarities of each text-type produce different meanings. See, for example, Yair Zakovitch's masterful analysis of the story of Ahab and of the significance of the divergences between the Masoretic text and the Septuagint ("The Tale of Naboth's Vineyard," in Meir Weiss, *The Bible from Within* [Jerusalem: Magnes, 1984], 379–405.) On the other hand, Meir Sternberg aptly warns against attempting to make sense of blatant errors (*Poetics of Biblical Narrative*, 14).

113. See Kalmin's criticism of Fraenkel on this point, "The Modern Study of Ancient Rabbinic Literature," 196–97.

114. See Genette, *Narrative Discourse*, 25–32.

115. See Sternberg, *Poetics of Biblical Narrative*, 187–90.

116. At least not in practice. On this point see Fish, *Is There a Text in This Class?* 13–15, 318–37. Hypothetically, perhaps, no objective standards exist. But in reality, as Fish argues, we all exist within "interpretive communities," and therefore "the fear of solipsism, of the imposition by the unconstrained self of its own prejudices, is unfounded because the self does not exist apart from the communal or conventional categories of thought that enable its operations (of thinking, seeing, reading)" (335). Consequently "meanings will be neither subjective nor objective. . . . they will not be objective because they will always have been the product of a point of view rather than having been simply 'read off'; and they will not be subjective because that point of view will always be social or institutional. Or by the same reasoning one could say that they are *both* subjective and objective: they are subjective because they inhere in a particular point of view and therefore not universal; and they are objective because the point of view that delivers them is public and conventional rather than individual or unique" (336). Clearly my readings hold only for certain interpretive communities and not for others (e.g., medieval Jewish mystics) because of the difference in standards, assumptions, methods, etc.

117. See Mieke Bal, *Lethal Love: Feminist Literary Readings of Biblical Love Stories* (Bloomington: Indiana University Press, 1987), 12–15, and *On Storytelling: Essays in Narratology*. See also Fish, *Is There a Text in This Class?* 341–71.

118. See Fish on "Demonstration vs. Persuasion," 356–71: "It has been my strategy in these lectures to demonstrate how little we lose by acknowledging that it is persuasion and not demonstration that we practice. We have everything that we always had—texts, standards, norms, criteria of judgment, critical histories, and so on. We can convince others that they are wrong, argue that one interpretation is better than another, cite evidence in support of the interpretations we prefer; it is just that we do all those things within a set of institutional assumptions that can themselves become the objects of dispute." Thus I have disputed Fraenkel's New Critical assumptions and argued in favor of my own.

Chapter 2  Torah, Shame, and "The Oven of Akhnai" (Bava Metsia 59a–59b)

1. To name a few (in alphabetical order): E. Berkowitz, *Not in Heaven: the Nature and Function of Halakha* (New York: Ktav, 1983), 47–50; Daniel Boyarin, *Intertextuality and the Reading of Midrash* (Bloomington: Indiana University Press, 1990), 34–36; Menahem Elon, *Jewish Law: History, Sources, Principles,* trans. B. Auerbach and M. Sykes (Philadelphia: Jewish Publication

Society, 1994), 261–65; Judah Goldin, "On the Account of the Banning of R. Eliezer ben Hyrqanus," *Journal of the Ancient Near Eastern Society* 16–17 (1984–85), 85–97; Daniel Gordis, *God Was Not in the Fire: The Search for a Spiritual Judaism* (New York: Scribner, 1995), 157–59, 198–202; Alexander Guttman, "The Significance of Miracles for Talmudic Judaism," *HUCA* 20 (1947), 363; David Weiss Halivni, *Peshat and Derash* (New York: Oxford University Press, 1991), 107–8; Susan Handleman, *The Slayers of Moses: the Re-emergence of Rabbinic Interpretation in Modern Literary Theory* (Albany: SUNY Press, 1982), 40–41; David Hartman, *A Living Covenant* (New York: Free Press, 1985), 32–33, 46–48; Yizhaq Heinemann, *Darkhei ha'aggada* (Jerusalem: Magnes, 1970), 11; Abraham Joshua Heschel, *Torah min hashamayim be'aspaqlaria shel hadorot* (London: Shontsin, 1962–1990), 3:23; Bernard Jackson, "Religious Law in Judaism," *ANRW* II.19.1 (Berlin: de Gruyter, 1979), 46–47; Louis Jacobs, *A Tree of Life* (Oxford: Oxford University Press, 1984), 27–28; Joel Roth, *The Halakhic Process: A Systemic Analysis* (New York: Jewish Theological Seminary, 1986), 123–27; Jonathan Sacks, "Creativity and Innovation in Halakhah," in *Rabbinic Authority and Personal Autonomy*, ed. M. Sokol (Northvale, N.J.: Jason Aronson, 1992), 127–30; Moshe Silberg, *Talmudic Law and the Modern State*, ed. M. Wiener, trans. B. Z. Bokser (New York: Burning Press, 1961), 63–66. This list is by no means complete.

2. Erich Fromm, *Psychoanalysis and Religion* (New Haven: Yale University Press, 1950), 54–57; Walter Kaufmann, *Critique of Religion and Philosophy* (New York: Harper & Brothers, 1958), 238–40; Suzanne Last Stone, "In Pursuit of the Counter-Text: The Turn to the Jewish Legal Model in Contemporary American Legal Theory," *Harvard Law Review* 106 (1993), 813–94; Edmond Cahn, "Authority and Responsibility," *Columbia University Law Review* 51 (1951), 838–39; Ronald Garet, "Natural Law and Creation Stories," in *Nomos XXX: Religion, Morality and the Law*, ed. J. R. Pennock and J. W. Chapman (New York: New York University Press, 1988), 225–26.

3. Izhaq Englard, "Majority Decision vs. Individual Truth: The Interpretations of the 'Oven of Achnai' Aggadah," *Tradition* 15 (1975), 137–52 – "The 'Oven of Akhnai': Various Interpretations of an Aggada," *Annual of the Institute for Research in Jewish Law* 1 (1974), 45–57 (Hebrew); Stone, "In Pursuit of the Counter-Text," 841–47, 854–65.

4. A few of the studies mentioned above (nn. 1–3) consider parts of the continuation of the story. Stone's review article criticizes others for failing to appreciate the entire story and its context (855–57).

5. Ari Elon, "Hasimbolizatsia shel markivei ha'alila basipur hatalmudi" [= The Symbolization of the Components of the Plot in the Talmudic Story] (master's thesis, Hebrew University, 1982).

6. Many of these sources use the abbreviated "wronging" (*'ona'a*) for the full "wronging in words" (*'ona'at devarim*).

7. So Elon, *Symbolization*, 15. This is noted by Stone, "In Pursuit of the Counter-Text," 857: "In the Babylonian Talmud the story is situated within the larger theme of hurting another through words. The talmudic discussion emphasizes the wrong done to Rabbi Eliezer."

8. On the superiority of the reading of ms Munich 95 see Elon, *Symbolization*, 3–35, and the variants to section I (the words "new month") in Appendix 2.

9. While there are numerous repetitions of words, represented by the underlined portions in the translation, these do not create major structural divisions. Nor do the groupings of miracles and disasters structure the whole story, and both could be grouped with a fourth part (C1, H).

10. Eliezer acts in every scene but the third, but there Rabban Gamaliel mentions him as the cause of the wave (H).

11. These connections vary in the mss. Some mss do not read "after that event" in section I (see the variants in Appendix 2), thus losing this connection. Others begin the third scene with "on that day," which also opens the second scene.

12. See yMQ 3:1, 81c–d, which cites mKel 5:10, and Mishna manuscripts of the Palestinian tradition such as Kaufmann and Cambridge. See also the notes to the translation in Appendix 2.

13. Cf. the story of the sages and R. Dosa b. Harkinas, bYev 16a, cited below. The sages began to "surround him with laws (*mesavevin 'oto bahalakhot*) until they reached [the question of] the daughter's co-wife." Here the sages cunningly attempt to ascertain Dosa's ruling on this question without his realizing that this is the purpose of their interview.

14. The pronominal object can also be translated "surrounded it," i.e., the oven, although I am not clear what it means to surround an oven with words. Even if the pronoun primarily refers to the oven, the ambiguity remains. In light of the burning of Eliezer's purities in E we might also find a double meaning in the second phrase, "they ruled *him* impure," referring to Eliezer as well as the oven.

15. Elon, *Symbolization*, 17.

16. Boyarin, *Intertextuality*, 30.

17. See Boyarin, *Intertextuality*, 35–36. Deut 30:11–12 reads in context, "Surely the instruction which I enjoin upon you this day is not too baffling for you, nor is it beyond reach. It is not in heaven, that you should say, 'Who among us can go up to heaven and get it for us and impart it to us, that we may observe it?'" Exod 23:2 reads, "You shall neither side with the multitude to

do wrong—you shall not give perverse testimony in a dispute so as to pervert it in favor of the majority."

18. That is, the narrator does not report the event in his own voice ("At that point the Holy One laughed") nor attribute it to Elijah alone ("Elijah said that the Holy One laughed"), but reports what Elijah told R. Natan that God did.

19. bPes 119a. The prooftext is Ps 106:23, an allusion to Moses convincing God not to destroy the people.

20. Rashi, s.v. *kol toharot*, explains that the sages burned the foods that provoked the question about this particular oven: pure foods had been prepared upon this type of oven into which an unclean object had previously fallen. R. Eliezer declared those foods clean, and after the confrontation the sages burned them. I think this is reading too much into the text. The sages burned "all the purities" of R. Eliezer, i.e., all the objects he had declared pure, not specific foods that are never mentioned in the text.

21. There is no indication that the sages deem Eliezer a "rebellious elder," a sage who rejects the authority of the court and is punished with a ban (mSanh 11:1–2). The debate takes place in the academy, not in court. Nor is there reason to burn the objects Eliezer declared pure. The sages could simply rule them impure. The ban and burning are retributive.

22. His innocent question, "Why is this day different from other days?" shows that he was not expecting a ban and presumably had done nothing extraordinary to provoke his colleagues.

23. This has been noted by Isaak Halevi, *Dorot harishonim*, ed. S. Bamberger (Frankfurt: Louis Golden, 1918), 3:374.

24. Dress: bShab 114a; yKet 12:3, 35a. Shoes: yMQ 3:5, 82d; bMQ 20b; bTa 13a.

25. Rabbinic sources associate wearing black with imminent judgment and impending doom. See bYom 39b; yRH 1:3, 57b.

26. I thank Dr. Joshua Levinson for this observation.

27. There is no explicit law in the BT to remain four cubits away from one who is banned. Some post-talmudic authorities deduce this prohibition from Akiba's action here and from bSanh 68a, a related story of sages who visit Eliezer but remain at a distance of four cubits. See Beit Yosef to *Tur, Yore De'a* 334:2, and the authorities cited there.

28. bKet 26a (=bBQ 114b) relates that people separated from a priest eating tithes, forbidden to non-priests. The term is also used of sacrifices (bMe 3a), temple-property (bPes 6a), corpses (bHul 88a), and idolatry (bBes 39a).

29. The BT raises the question of whether one under a ban is prohibited from wearing shoes but offers no conclusion. See bMQ 15b, bMQ 21a, and bTa

13a. Some commentaries suggest that our story settles the issue. See Tosafot, bBM 59b s.v. *veqara* and bMQ 15b s.v. *lo*.

30. See e.g. bMQ 17a: "What is the ban (*shamta*)? There is death there (*sham mita*)." Akiba's mourning also anticipates Gamaliel's death.

31. See the discussion of the "Literary and Halakhic Context."

32. See the ms variants in Appendix 2. Some mss begin the scene with "At that moment" (G1).

33. It becomes clear in G and H that God is responsible for the destruction, not Eliezer's mastery of nature or supernatural powers. For in G Gamaliel petitions God to stop the wave and in H Eliezer is not aware that his prayers caused Gamaliel's death. For a similar case where God both brings and stops the destruction, apparently due to an insult to a sage, see bBM 86a and Maharsha, ad loc., s.v., *hahu*.

34. The swelling of dough means that "it did not rise in its normal manner but swelled as if it had been kneaded without leaven" (Rabenu Hananel in *Shita Mequbetset* ad loc.).

35. See the section on "The PT Story and BT Compositional Technique" for source-critical reasons why Gamaliel rather than Yehoshua is mentioned.

36. Rashi, ad loc., comments that Rabban Gamaliel authorized the ban. bMQ 16a rules that one who is banned by the Patriarch is banned to all Israel, but one who is banned to all Israel is not banned to the Patriarch. By this cultural logic Gamaliel must have banned Eliezer (if the wave justly attacks him). And bMQ 17a states that if one knows that he has been banned, but does not know who placed the ban, the Patriarch has the power to remove it.

37. Shmuel Safrai, "Tales of the Sages in the Palestinian Tradition and the Babylonian Talmud," *Scripta Hierosolymitana* 22 (1971), 209, has noted that kinship ties between sages is a BT theme. The BT considers sages to be related even when the PT makes no such claim. See also Ilan, "The Historical Beruriah, Rachel, and Imma Shalom," 9–10, 16–17.

38. See Elon, *Symbolization*, 108–9.

39. Elon, *Symbolization*, 32–39, demonstrates that "falling on the face" is a type of spontaneous, private prayer, not the *tahanun* prayer specifically. See, e.g., the story of R. Shimi bar Ashi, cited below.

40. Elon, *Symbolization*, 54–81, 115–16, refers to bQid 81a, bShab 156b, bKet 67b, bMQ 28a, and by implication bTa 23b. See too bNed 50a and *ARNA* §38 (57b).

41. Elon, *Symbolization*, 117, points out that mention of the new month functions to illustrate the dichotomy between the outside world and the inside of Eliezer's house. Outside times change and a new month begins. Inside all is static as Ima Shalom day in and day out prevents her husband from praying.

When the beggar stands at the door, the liminal space between inside and outside, it marks the intrusion of the outside world into the inside and the collapse of the delicate situation.

42. bMQ 28a and bQid 81a. However in bKet 67b the sages provide money and in bShab 156b Akiba's daughter gives a "portion" of the wedding meal.

43. I bracket this link because it is not explicitly mentioned.

44. Elon, *Symbolization*, 82–103.

45. See bKet 17a=bMeg 29a, bMQ 27b. See also Alexander Sheiber, "Hashofar betekes haqevura," *Sinai* 29 (1951), 85.

46. bAZ 40a and 57b. See too bGit 60b and Neusner, *History*, 4:97–98 vs. Elon, *Symbolization*, 96–97.

47. That is the reading in ms Vatican 111. Printings omit "he took out his shofar." See also bMQ 16a and 17b, bShev 36a, bHul 105b, bSanh 7b (in mss; the parallel at yHag 2:2, 77d does not mention the shofar). And see Sol Finesinger, "The Shofar," *HUCA* 8–9 (1931–32), 223–25.

48. bQid 70a, bMQ 16a, bMQ 17a–b.

49. See Louis Jacobs, "The Device of *addehakhi*, 'just then,'" in *Structure and Form in the Babylonian Talmud*, 95–99.

50. See Genette, *Narrative Discourse*, 52, 195–97: "But there is another type of gap, of a less strictly temporal kind, created not by the elision of a diachronic section but by the omission of one of the constituent elements of a situation in a period that the narrative does generally cover. . . . the narrative does not skip over a moment of time, as in an ellipsis, but it *sidesteps* a given element. This kind of lateral ellipsis we will call, conforming to etymology and not excessively straining rhetorical usage, a *paralipsis*."

51. There are also several verbal links to the first scene. At the outset the sages do not accept or "receive" (*qiblu*) the arguments of Eliezer, and in the end Ima Shalom knows that her brother has died because of the tradition she "received" (*mequblani*). The heavenly voice "went out" in defense of Eliezer; when Eliezer falls on his face the shofar blast "went out." Natan "found" Elijah who reported God's laughing. When Ima Shalom "found" Eliezer fallen in prayer, it signaled her brother's death.

52. See Elon, *Symbolization*, 106.

53. In other words, while the fabula of both versions were probably based on the Toseftan tradition, the discourse in the BT quotes it directly. There is also an abbreviated version of the story in bBer 19a, corresponding to sections A1, A2, and E. This seems to be an excerpt from the full story. The Stammaim in Berakhot adduce part of the story in the discussion of matters relating to the ban. (On the terms *fabula* and *discourse* see the end of Chap. 1.)

54. See Neusner, *Eliezer ben Hyrcanus*, 1:425–27.

55. Another possible order is e-d2-a-b-f-g-i-h. But I think it more likely that R. Yirmiah's reference to "that day" (f1) refers to the burning of the purities (d2), not the miracle with the carob (b). Eliezer's anger at the burning produced the destruction.

56. The only exceptions are that A2 provides a proleptic summary of the sages' actions before the description in B2–C3, and D takes place in the time of Natan, who lived after Eliezer and Yehoshua. That encounter is really the last event in the fabula.

57. Several of these differences were noted by Alexander Guttman, "The Significance of Miracles for Talmudic Judaism," *HUCA* 20 (1947), 379–81. See also Neusner, *Eliezer ben Hyrcanus*, 1:426–27, for additional comparisons.

58. This was noted by Louis Ginzburg, *Perushim vehidushim birushalmi* (New York: Jewish Theological Seminary, 1941–48), 3:198.

59. See Chap. 6, n. 58.

60. See n. 7.

61. There are also a few changes in the nonnarrative comments. Compare the questions asked in C3 (BT) versus c and d1 (PT). (The question in C3 connects the statements of Yehoshua and R. Yirmiah which appear in different places in the PT.)

62. See the ms variants regarding "surrounded with laws/words" in Appendix 2. See too bQid 52b = bNaz 49b: "Let not R. Meir's disciples enter here because they are argumentative and they do not come to learn Torah but to overwhelm me *(leqapheini)* with laws."

63. Text cited according to ms Munich 95. See Rashi, ad loc. s.v. *shehiqru*. They permitted water to be drawn from the cistern on a festival.

64. For a related example see the story about Bar Qasha, bShab 110a. He was bitten by a snake, and when all medicinal means to cure him fail, Abaye concludes that he was bitten by "the snake of the rabbis that has no cure, as it says, *He who breaches a fence will be bitten by a snake (Qoh 10:8).*" That is, he violated a rabbinic "fence" or prohibition and was punished. See also tHul 2:22–23 and the parallels. While the "snake" is not a proper name here, it is reminiscent of the snake-oven.

65. See the manuscript variants to the translation. Some manuscripts read *ma tivkhem* in Yehoshua's rebuke and *ma lakhem* in God's. Others read *ma lakhem* in both places. The force of the question is identical.

66. This passage is analyzed in Chap. 3.

67. That is, they do not occur in classical rabbinic works, although they appear in medieval midrashim that postdate the BT.

68. God also calls Eliezer "my son" in the PT here (g) and in ms V1 of the BT (C1).

69. bBer 7a, bTa 16b, bSanh 7b, bMak 10a, bHul 133a. The phrase occurs infrequently in Palestinian sources.

70. *yahriv / mahriv 'et kol ha'olam:* bEruv 13a (=bSot 20a), bBB 16a, *SifDeut* §343 (398), *MidTan* 203.

71. Some mss read *nit'atef* and some *nitkasa*, which both mean "cover." This variant occurs regularly. Compare bMQ 17a and bQid 40a.

72. mMid 5:4; tHag 2:9 (=tSanh 7:1); yRH 1:3, 57b; bQid 40a (=bMQ 17a, bHag 16a).

73. *bedilin m-* (ms V1 reads *muvdalim*): bKet 26a (=bBQ 114b); bPes 87b, bBer 5a; yShab 1:2, 3a. The phrase "it seems to me" is also quite common, and see below on section H.

74. *zalgu 'einav dema'ot:* mSot 7:8; tYad 2:16; tSanh 9:5; ySheq 5:2, 49a; yHor 3:7, 48b; bPes 118a; bMen 18a, etc.

75. *SifNum* §115 (129) = bMen 44a; bPes 51a (in mss); bMen 32b.

76. See too bYev 121a. This has been noted by Peter Schäfer, "Rabbi Aqiva and Bar Kochba," in *Approaches to Ancient Judaism II*, ed. William Scott Green (Ann Arbor, Mich.: McNaughton & Gunn, 1980), 115, and n. 7. Only occasionally do we find other rabbis on a ship without Gamaliel (bYev 115a, bYev 121a, bBB 74b). In one case where the PT tells of Akiba and Eleazar b. Azariah on a ship, the BT version tells of Akiba and Gamaliel (yEruv 1:7, 19b = ySuk 2:4, 52d versus bSuk 23a)!

77. Because the passage appears in Hebrew, it looks like a *baraita*. In this case the passage is not introduced by technical terminology such as "our sages said" that typically introduce *baraitot*. But one can readily see how a pseudo-*baraita* could be created by a scribe or memorizer inadvertently adding the terminology. This indeed has occurred in G1, G3 = f1, f2. In the PT the Amora R. Yirmiah mentions the destructive gaze and decimation of crops. In the BT the corresponding passages are introduced as *baraitot* with the introductory term *tanna*. This phenomenon is well attested in the BT. See Hanokh Albeck, *Mavo latalmudim* (Tel Aviv: Devir, 1969), 47–50, who understates the case. For further discussion, see Chap. 8, "Pseudo-*baraitot*."

78. Some of these parallels read "against them" and some omit "to drown him." See too yBer 9:1, 13b.

79. Texts vary both here and in the parallels between *kemedume 'ani* and *kemedume li*.

80. See ms variants.

81. For other mentions of "disagreements multiplied in Israel" in Tannaitic sources see tHag 2:9, tSot 14:9, tSanh 7:1.

82. A similar phrase appears in bBM 86a: "the storm (*za'afa*) subsided." The phrase ultimately derives from Jon 1:16.

83. So ms Vatican 108. ms M reads "the sister of Rabban Shimon b. Gamaliel." A similar style appears in bAZ 18a: "Beruriah, the wife of R. Meir, was the daughter of R. Hanania b. Teradyon."

84. In the *Sifra* Eliezer answers the sages, not his wife (and he says, "Thus I have received a tradition from my masters"). See also the minor variants in yGit 1:2, 43c (=yShev 6:1, 35c); *LevR* §20:6 (459); *PRK* 26:7 (393).

85. See also Ofra Meir, "The Story of Hezekiah's Ailment," 117 n. 23 (Hebrew).

86. See Chap. 1, "Composition and Redaction of the Babylonian Talmud."

87. Nor was the shofar used in Palestine as a means of banning.

88. In the BT Elijah regularly speaks with or visits rabbis. See B. Kosovsky, *'Otsar hasheimot batalmud bavli* (Jerusalem, 1976), 1:167–68 (about forty instances.) In the PT there are only three such encounters: yBer 8:2, 13c; yKil 9:4, 32b = yKet 12:3, 35a; yTer 46b, 8:10.

89. See Safrai, "Tales of the Sages," 229–32. See also Adiel Schremer, "Kinship Terminology and Endogamous Marriage in the Mishnaic and Talmudic Periods," *Zion* 60 (1995), 5–35 (Hebrew).

90. Note that the two endings are consistent with the major difference in the order noted above. In the PT the sages contain the burning and destruction perpetrated by Eliezer by insisting "it is not in heaven" (f–g). In the BT the destruction *follows* this statement (C1) and the ban (F), which leads into the further calamities in H–I.

91. Cf. Friedman, *Talmud 'arukh*, 2:14 and n. 49.

92. The term used is *hiqpid*, which involves anger, irritation, and annoyance. In the PT the destruction follows Eliezer's anger. It seems to be caused either by his mastery of nature or by God because he supports Eliezer's legal position. At any rate, it does not comes as punishment for causing pain to R. Eliezer.

93. Cf. the brief reference to the story in bBer 19a. Here the context is the ban, as in the PT, so the BT only cites the relevant portions and omits the whole issue of verbal wronging.

94. bEruv 13b.

95. Lev 25:17, which refers to "verbal wrongs," commands "do not wrong one another, but fear your God." Lev 25:14, which refers to business wrongs, does not say "you shall fear God."

96. Friedman, "Le'ilan hayuhasin shel nushei bava metsia," 93–147, and *Talmud 'arukh*, 2:25–49.

Chapter 3  *Elisha ben Abuya: Torah and the Sinful Sage (Hagiga 15a–15b)*

1. Already B. Gurion, "'Erekh 'Aher,'" *Hagoren* 7 (1912), 81, realized that the rabbinic traditions are "an attempt to create a figure of religious opposition" and a symbol of heresy, apostasy, and rejection. For the (re)constructions of scholars see H. Graetz, *Gnosticismus und Judenthum* (Krotoschin: B. L. Monasch, 1846), 62–71, and *Geschichte der Juden*, ed. F. Rosenthal (Leipzig: Oskar Leiner, 1893), 4:93–94, 158–61; L. Finkelstein, *Akiba: Scholar, Saint and Martyr* (Cleveland: Meridian, 1962), 163–64, 253–56; Aharon Hyman, *Toledot tannaim ve'amoraim* (Jerusalem, 1964 [London, 1910]), 155–57. For other references see Louis Ginzberg, "Elisha ben Abuyah," *The Jewish Encyclopedia* (New York: Funk & Wagnalls, 1912), 5:138–39 and the bibliography there. For criticism of the distorted reconstructions of early scholars see P. Smolenskin, "'Am 'Olam," *Hashahar* 3 (1876), 644–47, who recognized that later sages having no first-hand knowledge of Elisha attributed to him all sorts of sins.

2. Several scholars have recognized that the talmudic traditions have little historical basis. See Alon Goshen-Gottstein, "Four Entered Paradise Revisited," *HTR* 88 (1995), 114–19, 126–29, and Fischel, *Rabbinic Literature*, 113–14. David J. Halperin rejects the historicity of the PT account and considers the BT a later reworking of the Palestinian material, a view with which I agree completely. See *The Faces of the Chariot: Early Jewish Responses to Ezekiel's Vision* (Tübingen: J. C. B. Mohr, 1988), 35–36, and *The Merkavah in Rabbinic Literature* (New Haven: American Oriental Society, 1980), 168–71. Ginzberg, "Elisha ben Abuyah," realized that the beginning of the BT tradition has no historical worth, but he insists that the traditions in the PT "are no doubt based on reliable tradition." I. H. Weiss, *Dor dor vedorshav* (Vilna, 1911), 2:127–29, noted that rabbinic traditions embellish Elisha's sins in unrealistic ways and present contradictory and irreconcilable images of the sage. (He nonetheless proceeds to discern the "true" sins of Elisha on the basis of those same traditions.) There is a great deal more literature on this point.

3. The only substantive prior discussion of the talmudic stories is that of Yehuda Liebes, *Het'o shel 'elisha*, 2d ed. (Jerusalem: Academon, 1990). While Liebes's study is full of valuable insights, both his method and overall interpretation are flawed. For criticism of Liebes's reading see my article, "Elisha ben Abuya: Torah and the Sinful Sage," *Journal of Jewish Thought and Philosophy* 7 (1998), 211–22, which forms the basis for this chapter. After I submitted that article for publication, I learned that Alon Goshen-Gottstein was working on a book about the Elisha traditions. He shared a draft with me and we were both struck by the similarity in our methods, interpretations, and conclusions. Our common findings should inspire confidence in the literary analysis of rab-

binic stories: there is something "objective" or replicable about a close reading, at least by academic conventions. Goshen-Gottstein also provides comprehensive treatment of secondary literature and textual variants, which I have dealt with briefly. Interested readers will benefit from Goshen-Gottstein's forthcoming book and by comparing our many points of agreement, as well as occasional disagreements.

4. Translation from Goshen-Gottstein, "Four Entered Paradise Revisited," 76–77, although I have substituted the JPS translations of biblical verses. For textual variants and notes see Halperin, *Merkavah*, 66–67.

5. First trend: Gershom Scholem, *Jewish Gnosticism, Merkabah Mysticism, and Talmudic Tradition* (New York: Jewish Theological Seminary, 1965), 14–19. Second trend: Ephraim Urbach, "Hamesorot 'al torat hasod bitequfat hatanna'im," in *Studies in Mysticism and Religion Presented to Gershom G. Scholem*, ed. E. Urbach, R. J. Z. Werblowsky and C. Wirszubski (Jerusalem: Magnes, 1967), 1–28.

6. A play on the name *'Aher*, which means "other, another."

7. Literally, "judged." However, the term "judged" also means punishment. See Saul Lieberman, "On Sins and their Punishment," in *Texts and Studies* (New York: Ktav, 1974), 32–33 and n. 31. See also mSanh 10:3 and bSanh 108a.

8. The context concerns the fate of the wicked man.

9. Prov 22:17 and Ps 45:11 contradict Mal 2:7. The solution is that a minor should not learn from a sinner, but an adult is able to distinguish the Torah from the deeds.

10. *sarah*, literally, "rot, spoil, stink."

11. Thus God cites a Mishna that contains a tradition of Meir.

12. For other examples of rabbinic stories with chiastic structures, see Norman J. Cohen, "Structural Analysis of a Talmudic Story: Joseph-Who-Honors-The-Sabbaths," *JQR* 72 (1982), 161–77; Jonah Fraenkel, "The Story of R. Sheila," *Tarbiz* 40 (1970), 33–40 (Hebrew); idem, "Chiasmus in Talmudic-Aggadic Narrative," in *Chiasmus in Antiquity: Structures, Analyses, Exegesis*, ed. John W. Welch (Hildesheim: Gerstenberg, 1981), 183–97; idem, "The Structure of Talmudic Legends," 45–97. See also Chap. 6.

13. II could be divided into a triplet, since the final section, "he brought him to thirteen synagogues," strays in form.

14. The words "gazed and" do not occur in any of the BT manuscripts I have consulted. Both the PT and tHag 2:3 include them. This was clearly the reading of the BT redactors for the story begins, "What did he see? He saw Metatron." (In current printings the reading has been changed to "What is this? He saw Metatron." The manuscripts are consistent.)

15. bHag 14b mentions only that "Aher cut the shoots." The *pisqa* (Mishnaic citation) on 15a adds the verse.

16. On the source of Elisha's tradition, see the section on "The PT Story of Elisha and the Comparative Evidence."

17. The confusion of the angel and God may devolve from the strange shift in the verse from "do not say before the *malakh*" to "else *God* may be angered." One would expect the subject to remain the same: "do not say before the angel ... else he (or 'the angel') be angered" or "do not say before God ... else God be angered." The Septuagint and Peshitta indeed read "God" here instead of *malakh*. The identity of the *malakh* as God or a God is therefore a plausible interpretation of the verse itself. This interpretive possibility perhaps provides additional background for the dualistic vision, which the BT then develops in more elaborate fashion.

18. See, e.g., Gen 37:15–18. The rabbis identify "*the* man" whom Joseph encounters as the angel Gavriel.

19. The punishment of Metatron by lashes may also derive from the clause "lead you into sin" (*lahati' 'et besarekha*), which can be translated "bring punishment upon your body" (so Robert Gordis, *Koheleth — The Man and His World*, 3d. ed. [New York: Schocken Books, 1978], 164.) Elisha's mouth brought punishment upon Metatron's body.

20. For "work of the hands" meaning commandments (or their merit), see *LevR* 16:5 (359); *QohR* 5:5; bKet 5a. For "work of the hands" meaning Torah see *LevR* 16:5 (358); *QohR* 5:5 and cf. bTa 5b.

21. See Goshen-Gottstein, "Four Entered Paradise Revisited," 127. For another example of a complex story constructed completely through exegesis of a verse, see bSanh 95b–96a.

22. In some manuscripts Metatron "uproots" the merits of Aher, which creates a nice verbal resonance. The verb "proposition" (*tav'a*) is the standard Talmudic phrase for soliciting a prostitute (or a woman for illicit sex). See bBer 22a, bSot 10a, bSot 11b, and bQid 81b, which, interestingly enough, has the sage present the "prostitute" (who turns out to be his wife) with a fruit.

23. At least in the BT's version, which is the reading of ms Erfurt of the Tosefta. Ms Vienna reads, "*Elisha* gazed and cut the shoots."

24. For interpretations (and Geonic traditions) of the name "Aher" other than "Other" see H. Yalon, "Midrashot umiqra'ot," *Leshonenu* 29 (1965), 215.

25. Cf. Alan Segal, *Two Powers in Heaven* (Leiden: Brill, 1977), 61: "Nor does Aher present his observation as a challenge to the rabbis. He is horrified by it. '*Heaven Forbid* that there are two powers,' he exclaims."

26. Printed texts read that Metatron "erases" the merits of Aher, the opposite of "writing" the merits of Israel.

27. The form of Metatron's revenge may be a function of his activity. He appears to be limited to writing down and removing merit, and thus takes his revenge in this way.

28. Ms Munich 95 lacks "on the Sabbath" (see the textual notes in the Appendix). But then it is difficult to make sense of the scene.

29. Cf. bBer 19a: "The School of R. Ishmael taught: 'If you witnessed a disciple of the sages sin at night, do not suspect him during the day, for perhaps he repented.' *How can you say 'perhaps'? Rather, he certainly repented.*" The italicized words are an Aramaic Stammaitic comment to the Hebrew source. The comment assumes that sages repent immediately.

30. Of course one must accept the plausibility of a sage seeing Metatron and the ensuing heavenly saga.

31. Moreover, Meir's interpretation violates the contextual meaning of the verse and dilutes its force. The full verse reads: "In a time of good fortune enjoy the good fortune; and in a time of misfortune, reflect: The one no less than the other was God's doing; consequently, man may find no fault with him." (The last clause is particularly obscure and there is no consensus as to its meaning.) Elisha's explanation accepts this theology and applies it to the next world. Meir avoids potentially problematic implications with his trivial interpretation.

32. Some mss make this more clear by adding "clay vessels that have no substance" (*'ein bahem mammash*). See the Appendix.

33. This interchange is presented as a *baraita*. It is introduced by the term "our sages taught" and appears in Hebrew. (The previous two interchanges are in Aramaic.) However, it seems to be a pseudo-*baraita*. First, no parallels are known in any Tannaitic collection. Second, the PT story's parallel scene is in Aramaic. It is unlikely that the PT would rewrite and revise a Hebrew *baraita* into Aramaic. Rather, the BT probably constructed a pseudo-*baraita* on the basis of the PT Aramaic story. The BT commonly represents Palestinian narrative traditions as *baraitot* and translates the Aramaic into Hebrew. See Albeck, *Mavo latalmudim*, 47–50. It is also possible that the Babylonian Amoraim or Stammaim simply translated the Aramaic into Hebrew and later scribes erroneously added the terminology. I return to this issue in Chap. 8, "Pseudo-*baraitot*."

34. *OG, Hagiga, Perushim*, §74, 62; Rabenu Hananel to bHag 15a. While the BT acknowledges that undeserved suffering occurs (see Elman, "The Suffering of the Righteous," 315–40), the idea that the righteous enjoy the merits of the wicked is substantially different.

35. The verses fit better in *GenR* because Resh Laqish mentions a double share and the verses use the term "double." Elisha's point is only that the righteous and wicked take each others' portion, whatever size it is. The series of

mountains, hills, seas, and rivers appears in mHul 2:8 and in a BT *baraita*, bHul 40a = bAZ 42b (the corresponding *baraita* in tHul 2:18 lacks the series). So the redactors have borrowed this phrase from other ready-made sources. (See also bAZ 43b = bRH 24b.)

36. Fraenkel analyzes this scene in *Darkhei ha'aggada vehamidrash*, 263–66. In my opinion he misinterprets it because of his methodological principle of ignoring the literary context. Fraenkel considers this scene an independent and self-contained story with no connection to the preceding and following scenes. Accordingly he suggests that Aher's riding is a "desecration of the Sabbath in public which comes to provoke or insult, and therefore it is no wonder that there can be no atonement or even repentance for this violation." Fraenkel then suggests that Aher habitually rode on the Sabbath, and for this reason he knows that he cannot repent. However, as Fraenkel himself notes (629 n. 29), riding on the Sabbath from a "formal point of view" is not a serious violation. Nor does Fraenkel provide compelling evidence that riding on the Sabbath is associated with provocation or insult. Rather, as we know from the larger context, Aher rides for the same reason that he visits the prostitute: he has no reason to obey the law because of the heavenly voice, and it is less tiring to ride than walk. (Nor is there evidence that the scene takes place in public; the two may be walking in secluded areas.) In any case, the reason Aher knows he cannot repent is that he heard the heavenly voice after the Metatron business in section I. Riding on the Sabbath was not the *cause* of the voice, as Fraenkel would have it, but the consequence of it. Fraenkel also claims that the reason Aher counts the paces of the horse is to know precisely when he will violate the Sabbath boundary, because he is eager to do so, and because this was his true purpose in riding the horse: "Leaving the boundary is a complete abandonment, a distancing for which there is no return, and this is the intention of Aher." Yet the text explicitly states that Aher told Meir to return so that Meir not violate the Sabbath. No evidence substantiates this understanding of Aher's hidden purpose or reason for counting. I agree that leaving the boundary symbolizes abandonment at some level, yet it is not Aher that abandons God, but God who rejects Aher from the beginning. Despite these problems, Fraenkel astutely recognizes the love between Meir and Aher and the tragic element of their relationship.

37. See Saul Lieberman, *Hellenism in Jewish Palestine* (New York: Jewish Theological Seminary, 1950), 194–99; Halevi, *Ha'aggada hahistorit-biografit*, 217–20 and nn. 19–21; and P. S. Alexander, "Bavli Berakhot 55a–57b: The Talmudic Dreambook in Context," *JJS* 46 (1995), 233 and nn. 6–7. These scholars cite numerous parallels from Greco-Roman literature.

38. "Thirteen" is a standard talmudic number. See Chap. 4, n. 27.

39. See the variants in the Appendix. It is possible that the shorter reading is original, and attempts were made later to tone down the brutal act. Then again, it is possible that the BT originally had Elisha threaten to kill the child, and a marginal gloss based on the PT later entered the text. See also bBB 21b, "Some say he [Yoav] killed him, and some say he did not kill him."

40. For another example of Palestinian material corrupting the BT text, see Jonah Fraenkel, "Remarkable Phenomena in the Text-History of the Aggadic Stories," 3:57–59 (Hebrew).

41. This stands in some tension with section I and the claim of the heavenly voice. The angels seem to assume that Elisha still has merit.

42. Cf. bHag 12b (from the preceding *sugya!*): "Resh Laqish said, 'Whoever engages in Torah in this world, which is compared to night, the Holy One draws upon him a thread of mercy in the next world, which is compared to day.'"

43. That Elisha deserves sympathy was already recognized by Abraham Zacuto (b. 1504), *Sefer yuhasin hashalem*, ed. H. Filipowski (London, 1857), 22–23: "Although the master (Maimonides) said that he should not be numbered among the rest (of the sages) because of what happened . . . As for me, my hands are open to accept him . . . . Most important, this man never caused his students to sin, but rather taught them Torah even after he went out to evil courses, and he wanted to earn merit for them, as he said to R. Meir, 'the Sabbath limit is up to this point.' But he did not repent fully because he was confused by the heavenly voice, 'Return rebellious children—except for Elisha, for he knew my power and rebelled against me.' Because he thought that they would not accept his repentance, he tried to earn merit for others." See also the tradition favorable to Elisha preserved in *RuthR* 6:3 (2:174) (at least in some textual traditions; see Lerner's note, 1:61).

44. This shift violates the temporal order. Yohanan, who appears in the previous scene, lived two generations after Rabbi Yehuda HaNasi. From a source-critical perspective the chronological anomaly devolves from the fact that the BT version adds Yohanan to the PT (or its source), in which Meir alone, not Yohanan, struggles for Aher's soul. See below, "The PT Story of Elisha and the Comparative Evidence" (5).

That Rabbi Yehuda HaNasi was Meir's student is not stated explicitly. According to bEruv 13b, Rabbi attributes his superiority to his colleagues to the fact that he "saw the back of R. Meir," which Rashi, s.v. *dehazitei*, takes to mean that Rabbi sat in a row of Meir's academy that had a rear view of Meir. (A similar tradition appears in yBes 5:2, 63a.) Traditions in both Talmuds claim that Rabbi formulated the Mishna based on the Mishna collection of Meir (bSanh 86a; yYev 4:11, 6b). So I think we can assume that the storytellers con-

sidered Rabbi to be Meir's disciple and prime transmitter of his traditions. See too H. L. Strack and G. Stemberger, *Introduction to the Talmud and Midrash*, trans. M. Bockmuehl (Minneapolis: Fortress Press, 1992), 140–41, 147.

45. Again the larger biblical passage is pertinent. The preceding verses state, "All mention of him vanishes from the earth; he has no name abroad. He is thrust from light to darkness, driven from the world." The lack of "mention" and "name" suits the term Aher, "Other," and vanishing from the earth without a name is exactly what happened when he died.

46. See the manuscript variants in the Appendix.

47. This idea probably draws on the fact that the BT considers Tannaitic traditions attributed to "Others" as the opinion of Meir (bHor 13b; see Chap. 6). Thus Meir, like Aher, is called "Other," a sign that he too was rejected at one point by God. And see Tosafot, bSot 12a, s.v. *'aherim*.

48. See bYev 97a (=bBekh 31b): "The lips of every sage, in whose name a tradition is said in this world, move in the grave."

49. The term for "sins" here is *sarah*, literally, "rot, spoil," which fits the vegetable analogy.

50. Without the voice Torah and sin should not coexist because the sage should either repent or reject his Torah. In Elisha's case Torah and sin stably coexist because he cannot repent.

51. See Rubenstein, "Elisha ben Abuya: Torah and the Sinful Sage," 141–73.

52. Because Rabbah bar Rav Sheila, a fourth generation Amora, is a character in the final scene, the story must postdate this time. The attributions to relatively late Babylonian Amoraim in these sections (e.g., Rava, Rav Dimi) suggest that the core of the PT story was transmitted to Babylonia in the Amoraic period. For arguments that the BT reworked a version similar to the core of the PT, see Rubenstein, "Elisha ben Abuya: Torah and the Sinful Sage," 200–203.

53. For a detailed explanation, see Rubenstein, ibid., 151–55.

54. Source-criticism of the PT story suggests that section C was independent originally. This section is introduced by an anonymous Aramaic question that interrupts the narrative flow, and Meir appears in B and D but not C. More important, the multiple explanations of Elisha's fall conflict with the account of B2 that blames his father. This point is not crucial to our interest, but it helps explain why the BT parallels to these sections appear elsewhere (bQid 39b and bHul 142a; see below). The section may have been a later addition to the PT story after it was transmitted to Babylonia. It is really B+D+E that forms the core of the BT story.

55. Halperin, *Merkavah*, 169–71 and n. 100. Halperin too concludes that the BT revised the Palestinian story by adding the Metatron incident (see n. 2

above). Reference to the "guard of the gate" of Gehenom is also a Babylonian motif. See Israel Ben-Shalom, "Torah Study for All or for the Elite Alone," in *Synagogues in Antiquity*, ed. A. Kasher et al. (Jerusalem: Yad Izhaq ben Zvi, 1987), 114–15 (Hebrew). Ben-Shalom notes that a "guard of the gate" is mentioned thrice in the BT, here and in two stories referring to the "guard of the gate" of the academy, bBer 28a and bYom 35b. The Palestinian parallel to bBer 28a at yBer 4:1, 7d lacks the motif.

56. Section III' seems to preserve authentic Amoraic traditions. Yet the role of the redactors is prominent. They transferred the dictum of Rabbah bar bar Hannah from bMQ 17a. There Rabba bar bar Hannah is a character in a story and he reports a tradition of R. Yohanan in response to a direct query. ("Thus said R. Yohanan . . ." The query is whether a sage whose behavior is suspect can be banned considering that the rabbis require his Torah. The connection to our story is patent.) The redactors have therefore attributed the dictum to "Rabbah bar bar Hannah in the name of R. Yohanan" here. The redactors then cite three Palestinian Amoraic statements to resolve the contradiction between this dictum and Meir's actions. The three Amoraim, therefore, originally were not responding to the contradiction generated by Rabba bar bar Hannah / Yohanan's statement, although they must have been responding to some such objection, for their remarks address the issue directly. These Palestinian statements are not found in the PT, but I can think of no reason that they would be fabricated. Still, the likelihood that the traditions are authentic does not help us date the extant story. All we can say is that the Amoraim knew a story in which Meir learned from a sinning sage.

57. As noted by the Tosafot, bHag 15a, s.v. *shuvu* and Halperin, *Merkavah*, 169.

58. This issue can be seen in terms of some interpretations of Aristotle's theory of tragedy. As is well known, some interpret Aristotle to have taught that the best tragedy requires a heroic protagonist who has a flaw. If the hero has no flaw, then we are outraged at his fate. If he has too many flaws, then he deserves his fate. The drama is tragic only when the flaw brings about his demise in such a way that we still feel pity. The sinning sage who cannot repent is heroic (a sage) but has a fatal flaw (sin). If the sin is too rebellious and offensive, we feel that he should be punished despite Torah, that he deserves damnation. If his sin is trivial, we are offended at his punishment. The PT negotiates this narrow strait by presenting serious sin but attributing it to various causes beyond his control (father and mother) or to loss of faith at theodicy, a perennially difficult issue. But this directs attention away from the main subject of the story. In the BT the Metatron encounter neatly solves the problem. The hero Elisha was justifiably rejected by the heavenly voice (measure-

for-measure), and then understandably went out to sin. So we are neither outraged at his fate nor do we feel he deserves it (although we understand why it happened).

59. See n. 54.

60. We noted in the literary analysis that the BT redactors probably drew on an earlier source to construct that exegesis. Another subtle difference: in the PT Elisha asks Meir what verse he was expounding in the Tiberian academy, for the story begins with Elisha passing by outside while Meir expounds within. The BT drops the mention of the Tiberian academy—a point of geographical interest mainly to Palestinians—and has Elisha quiz Meir about the verses directly.

61. This is the reading in most mss. There are numerous parallels including *SifDeut* §305 (325). The phrase "whose daughter are you" derives ultimately from Gen 24:23.

62. This flashforward is presented within the direct discourse—Meir tells his interlocutors what will happen (but the story does not narrate it actually happening). Some call this a flashforward "of the second degree." See Bal, *Narratology*, 57.

63. Genette, *Narrative Discourse*, 48–66.

64. The point is that the BT fails to indicate that the Yohanan account is a flashforward (or that the episode with Rabbi and Elisha's daughters is a flashback relative to that account). The audience realizes the anachrony based on its knowledge of Yohanan's life. The PT, by contrast, signals that the flashbacks take place in the past and the flashforward to Meir and the world to come will take place in the future.

65. The final sections of the BT continue the primary narrative time by settling Meir's ultimate fate several generations after his death in the time of Rabbah bar Rav Sheila. This scene too is in its proper temporal sequence following the time of Elisha's daughter.

66. On the terms *fabula* and *discourse* see the end of Chap. 1.

67. See Chap. 8, "Order."

68. The eulogizer's reference to the "guard of the gate" contributes to this point: R. Yohanan apparently encountered some angel or demon appointed to guard the gate of Hell. The PT is more restrained by having Meir *speak* of what he will do in the world to come.

69. ms London. For variants see the Appendix.

70. *qal vahomer*, i.e., *a minora ad maius*.

71. *nimos hagardi*. This figure is usually identified with Oenomaus the Gadarite (ms Vatican 171 reads "Avinomos"). Some translate *gardi* as "weaver." For full discussion see Menahem Luz, "Oenomaus and Talmudic Anecdote,"

*JSJ* 23 (1992), 75–80 and n. 63. The sense of "come up," according to Luz, is to emerge from the vat in a uniform color. He quotes examples from Hellenistic literature in which dyeing in a vat serves as an allegory for humans absorbing different moral traits.

72. See the mss variants. Most mss omit, "He said to him . . ." And no ms attributes the words "What about Aher?" to an Amora.

73. But what is the harm of Greek *song* (or poetry)? See the commentaries, who have difficulty with this question.

74. Indeed, these explanations conflict with the account of his sin in I–II. And the image of Aher as Hellenophile or heretic does not square well with his image as master of Torah and teacher of Meir in III–V. Of course we can harmonize the images by explaining that prior to his vision of Metatron Aher read too many heretical books and sang too many Greek songs, and this led him to make the fatal mistake. But this is clearly forced: in I he makes the error because his vision conflicts with a rabbinic tradition about the behavior of angels in heaven. He then sins because he has nothing to lose, not because he desires to imitate Hellenistic ways or to apostasize.

75. That the BT redactors possessed disparate traditions about Aher is clear from bQid 39b = bHul 142a, the traditions relating to theodicy. See the synoptic charts above. Yet another tradition about Aher is found in *RuthR* 6:3; see n. 43. Evidently a variety of traditions about him circulated among the sages.

76. The text is cited according to ms Florence 9. The manuscript variants are not significant for our purposes.

77. The interpretation plays on the alternate spelling of Doeg's name. "Doeg" means "worry" and the spelling "Doyeg" contains the word "alas" within it.

78. *la' savrei shma'ata*. The meaning of this expression is not completely clear.

79. It is interesting that here God presses for Doeg's reward and a human being advocates punishment. In the story humans struggle against God for Elisha's salvation and the rehabilitation of Meir's name.

80. bSanh 104b–105a. God even informs the angels that if David protests Doeg's reward, he will reconcile the two and make them friends.

81. For additional discussion of some of these issues, see Elman, "The Suffering of the Righteous," 315–40, and "Righteousness as Its Own Reward," 35–67, especially 63–64.

82. Cf. the commentary *'Iyyun Ya'akov* in *EY*, ad loc., s.v. *'af torah*. He claims that the opinion "Torah protects forever" is imprecise since sometimes sages die young. That phenomenon is inexplicable according to these assertions of the protective power of Torah.

83. bBer 58a (ms M) tells a story of a *mina bar bei rav,* a "heretic from the house of the master," that is, from the disciple-circle of a sage. The heretic had been a sage or student.

84. On the significance of *mistakel* in the Mishna and its relationship to the Tosefta, see Goshen-Gottstein, "Four Entered Paradise Revisited," 80–81.

85. bBer 63b and parallels. The story of Rav Kahana, *mutatis mutandi,* who hid under his master's bed at night to observe him make love to his wife, also comes to mind (bBer 62a). He explained his motivation as, "It is Torah and I must learn it." Ben Azai followed his master Akiba into a bathroom for the same reason (ibid.).

86. See the section on "The PT Story of Elisha and the Comparative Evidence." On the lack of integration of the PT stories with the body of the *sugya,* see Karlin, *Divrei sefer,* 7–8, and discussions of the PT term דלמא in the standard dictionaries. For other examples of the BT redactors creating contextual links that are lacking in the PT version see Hezser, *Rabbinic Story in Yerushalmi Neziqin,* 350–52.

Chapter 4   *Torah and the Mundane Life: The Education of R. Shimon bar Yohai (Shabbat 33b–34a)*

1. *HUCA* 49 (1978), 143–85. Reprinted in Hebrew in *Cathedra* 22 (1982), 9–42. See also the fine analysis of Mordechai Piron, *The Legends of the Sages* (Tel Aviv: Dan, 1970), 109–10 (Hebrew).

2. Ofra Meir, "The Story of R. Shimon bar Yohai and His Son in the Cave—History or Literature?" in *The Poetics of Rabbinic Stories* (Tel-Aviv: Sifriyat Po'alim, 1993), 11–35 (Hebrew). Originally published in *'Alei siah* 26 (1989), 145–60.

3. Reference to scholarship prior to Levine, which accepted the story as historically accurate to a great extent, can be found in Israel Ben-Shalom, "Rabbi Judah B. Ilai's Attitude toward Rome," *Zion* 49 (1984), 10 n. 3 (Hebrew), and in Levine's notes.

4. The first set of ten commandments reads "Remember (*zakhor*) the Sabbath" (Exod 20:8); the second reads "Observe" (*shamor*) the Sabbath (Deut 5:12).

5. Literally, "He encamped before the city." But this seems to contradict the first half of the verse, which says, "And Jacob came whole at the city of Shekhem in the land of Canaan, upon arriving from Padan Aram," implying that he had already entered the city. The midrashic exegesis solves this difficulty.

6. On the identification of the *turmos* as lupine, see Yehuda Feliks, *Talmud yerushalmi: masekhet shevi'it* (Jerusalem: Reuven Moss, 1979), 2:118–20.

7. See Meir, "The Story of R. Shimon bar Yohai," 30.

8. See ibid., 30 and n. 33.

9. Actually the parallelism in the halves of the chiasm is of the x / x + 1 type: C1' repeats C1 and adds a clause to each line, A' repeats the names of the rabbis listed in A and adds to each line. I have labeled RSBY's statement both C1', since it parallels C1, and C3, since it is the third opinion and completes the triplet.

10. See Chap. 6 for further discussion of chiastic structures, and see Chap. 8, "Structure."

11. See the section on "The PT Story, Other Sources and Compositional Techniques."

12. Rome: bBB 164b, bSanh 99b, bAZ 18a; Israel: bMeg 16a, bYev 79a, bSot 11b, bHul 92a. In bShab 149b it refers to the Babylonians. The three instantiations in the PT (in the form *ha'uma hazot* rather than *'uma zo*) all refer to Israel (ySheq 1:1, 45d; twice in yRH 1:3, 57b), as do references in the Palestinian midrashic collections: *SifDeut* §354 (416); *MidTan*, 219; *GenR* 10:7 (82; see the apparatus), 64:9 (712), 65:21 (734); *LevR* 18:3 (406), 22:3 (500); *LamR* (ed. Vilna), *petihta* 15 (7a).

13. Rabbis are regularly found in bathhouses and seem to have relished the time spent there. See mAZ 3:4; bBer 24b; bShab 10a, 40b; bZev 102b; bYev 63b. bSanh 17b prohibits a scholar from living in a town without a bathhouse. bShab 25b interprets Lam 3:17, "I forgot good," as "the [loss of] bathhouses."

14. See Halevi, *Ha'aggada hahistorit-biografit*, 510–11, for classical sources praising the technological prowess of the Romans.

15. It is possible that Yose sides with RSBY but refrains from speaking due to fear of the authorities. However, the balanced, tripartite structure suggests three disparate opinions.

16. The Tosafot ad loc. read "*Rabbi* Yehuda b. Gerim," as found in bMQ 9a. Both extant manuscripts of Tractate Shabbat and printed versions lack the title "rabbi." The problem is that in bMQ 9a RSBY praises R. Yehuda b. Gerim as an "important man," which is difficult to reconcile with his character here. See Ben-Shalom, "Rabbi Judah B. Ilai's Attitude," 22–23. Most commentaries prefer to explain that there are two men by this name, one a respected sage, one a wretch. All this confusion results from attempts to make historical sense out of literary creations. The storyteller made (R.) Yehuda b. Gerim a character in this story because of the connotations of his name. If the correct reading here is indeed "Rabbi Yehuda b. Gerim," then the questions raised by the name (see below) are more acute.

17. See Ben-Shalom, "Rabbi Judah B. Ilai's Attitude," 22–23, and Rashi ad loc., s.v. *vesiper*. The narrator does not say "he retold their words to the authori-

ties" but that the words "became known." The traditional commentaries dispute this matter, which becomes muddled with the question of whether to identify him with Rabbi Yehuda b. Gerim mentioned in bMQ 9a (see the previous note). That RSBY kills him in the end is adduced by some commentaries as proof that he informed intentionally. Else why such a severe punishment? See *'Anaf yosef* in *EY*, ad loc. Others, such as Tosafot, bShab 34a, s.v. *h"g*, are reluctant to ascribe such malevolent intent. But then it becomes difficult to explain why RSBY murdered him, and the Tosafot emend the text.

18. See Chap. 8, "Symbolic Names of Characters." *PRK* 11:15 (190) relates a story about RSBY and R. Yehuda bar Giorya. In Chap. 2 we noted the shift from the "Oven of Hakhinai" in the PT to the "Oven of Akhnai (=snake)" in the BT, and a similar process may have occurred here (bar Giorya > ben Gerim). Alternatively, the storyteller may have named the character after Rabbi Yehuda b. Gerim (see the previous notes).

19. This maxim appears in bQid 80b as the reason a man may not seclude himself with two women, whereas a woman may seclude herself with two men. The assumption is that women, like children, are unprincipled and naive. Therefore they can be seduced, deceived, and tricked into covering up the sin. Interestingly, this phrase seems to be a direct translation of *feminas . . . levitas animi* from Roman law (Gaius, *Institutes*, 1:190). See Boaz Cohen, *Jewish and Roman Law* (New York: Jewish Theological Seminary, 1966), 1:129 n. 19. Ironically RSBY, the great anti-Roman, has adopted a Roman legal principle. For late midrashim that use this phrase and for parallels in Greek literature, see Halevi, *'Olama shel ha'aggada*, 249–51.

20. bKet 39a–b, bBQ 59a, bNed 91b. So too the word "revealing" (*megalia*) has sexual connotations. Abuse of the wife causes the "revealing" of her husband, as opposed to proper "revealing" during licit sex.

21. On "reproducing" sons/students within the academy and without women, see the fascinating chapter by Daniel Boyarin in *Carnal Israel*, 197–225. The theme of the wife distracting from the study of Torah, opposing study, or problematizing study in some way, is prevalent in the BT. See the series of stories in bKet 62b–63a and the analyses of Fraenkel, *'Iyyunim be'olamo haruhani shel sipur ha'aggada*, 99–115; Shulamit Valler, *Woman and Womanhood in the Stories of the Babylonian Talmud* (Tel Aviv: Hakibbutz Hameuhad, 1993), 56–80 (Hebrew); and Daniel Boyarin, *Carnal Israel*, 142–66. See also bBer 27b–28a where the wife of Eleazar b. Azarya advises against his accepting the appointment as Patriarch (the PT parallel lacks this episode; yBer 4:1, 7d.) See also bBM 84b where the wife of R. Eleazar b. R. Shimon prevents him from going to the academy. In yPe 8:7, 21a the wife of R. Akiba discourages him from accepting the position of *parnas*.

22. The representation of the academy as a building in which one could hide may reflect the post-Amoraic reality; see Chap. 1, "The Social Setting of the Redactors."

23. Animal fodder: mShab 24:2. bBB 90b rules that "in years of famine one may not hoard even a *kab* of carobs, because one brings a curse on the market prices." bTa 24b reports that a heavenly voice declares each day, "The whole world is supplied food only on account of my son Hanina (b. Dosa), while my son Hanina suffices with a *kab* of carobs from Sabbath eve to Sabbath eve." That is, Hanina suffices with the minimal subsistence possible. See also *LevR* 13:4 (281) and 35:6 (824).

24. A carob tree featured in Eliezer's miraculous proofs in the "Oven of Akhnai" (Chap. 2) and also plays a role in the seventy-year sleep of Honi the Circle-Drawer (bTa 23a). The association of the carob tree with miracles suits the miraculous nature of the cave. Could there also be a wordplay between *haruv* (carob) and *lehahriv* ("to destroy my world") of the heavenly voice?

25. Their purpose is apparently to preserve their clothes from everyday wear and tear. At other times the sand provides protection from the elements in place of clothing.

26. Pinhas b. Yair cries upon seeing the "clefts" (*pilei*) in their flesh. This word is often used to describe furrows and cracks in the ground (bBB 54a; bSuk 44b), which contributes to the image of the sages as melding with the earth.

27. On thirteen as an exaggerated number see Rashi, bShab 119a, s.v. *treisar.* Levine, "Purification," 160, refers to the thirteen years that Rabbi Yehuda Ha-Nasi suffered a toothache (bBM 85a); the thirteen-year exemption from taxes (bAZ 4a); and the thirteen years that R. Zeira's father served as a tax collector (bSanh 25b). Besides these spans of thirteen years, there are thirteen "interpreters" (*'amoraim*) of the school of Rav Huna (bKet 106a); thirteen sessions studying tractate Uqsin (bBer 20a); thirteen thousand cattle of R. Eleazar b. Azarya (bBes 23a); and many other examples in both Palestinian and Babylonian sources. See also Louis Jacobs, "The Numbered Sequence as a Literary Device in the Babylonian Talmud," *Hebrew Annual Review* 7 (1983), 146–48, and the "thirteen" synagogues in Chap. 3.

28. In Chap. 2 Elijah revealed God's reaction to R. Yehoshua's statement, "It is not in heaven" (bBM 59b). In Chap. 3 Elijah reported that God recites traditions in the names of various sages (bHag 15b).

29. *Krakhi* literally means "fold." To "fold bread" is an idiom for "to have a meal." Marcus Jastrow, *Dictionary of the Targumim, the Talmud Babli and Yerushalmi and the Midrashic Literature* (New York: Jastrow Publishers, 1967), 668, explains that bread was folded over salt, spices or other condiments. See Jacob

Levy, *Worterbuch über die Talmudim und Midraschim* (Berlin: B. Harz, 1924), 2:402, for other explanations.

30. Like the charge that "women are simpleminded," this observation cites a rabbinic tradition and thereby provides another example of the redactors' compositional techniques. The source is mEd 2:10, which appears in a slightly different version in bRH 17a. The citation also appears in *PRK* 10:4 (165). See too ySanh 10:3, 29b.

31. See Joshua Levin, *Sefer 'atara yeshua* (Jerusalem, 1924), ad loc., who explains their return to the cave along similar lines. So too Joseph Hayyim b. Elijah (d. 1909), *Sefer ben yehoyada* (Jerusalem, 1964), 1:15: "In this way they will know that the people of Israel cannot be blamed for busying themselves with work and not acting like them (like RSBY and his son) . . . The meaning of 'the sentence of the wicked in hell is twelve months' is that twelve months suffices to punish even the wicked, so that if we sinned in burning everywhere we gazed, certainly the pain of twelve months suffices to atone for us."

32. bSanh 97b, *GenR* 35:2 (330). See Rashi, ad loc., s.v. *dai;* Maharsha, ad loc., s.v. *'amar lei;* Meir, "The Story of R. Shimon bar Yohai," 32.

33. The commentaries debate which intertext should be understood. See, e.g., Rashi, ad loc., s.v. *dai* and Maharsha, ad loc., s.v. *'amar lei.*

34. Note that RSBY's final utterance asks, "Is this one still in the *world?*"

35. It is interesting to note that the famous midrash that draws correspondences between the four species of the lulav and different kinds of Jews connects the myrtle—which has "fragrance but no food"—to Jews who do good deeds but have not learned Torah; *PRK* 27:9 (416); *LevR* 30:12 (709–10). The midrash concludes, "The Holy One says: It is unthinkable that I destroy them. Rather let them all form one band and atone for each other."

36. Yet even here some tension remains. The two extant manuscripts omit, "Their minds were set at ease," which I have supplied from the first printing. I think some such reaction is implied by the *tiqqun* which RSBY subsequently institutes. *Haggadot hatalmud* (Constantinople, 1511; reprint Jerusalem, 1961) reads, "his mind was set at ease," i.e., R. Eleazar was now appeased. But the potential lack of explicit reference in the manuscripts suggests that the tension remains unresolved, as does the end of the story (see below). Thus the unresolved narrative tension is mirrored by the uncertainty of the text.

37. See Safrai, "Tales of the Sages," 229–31, on the tendency of the BT to connect sages and other historical personalities by kinship ties, and see Chap. 2, n. 37.

38. See Chap. 6, "Literary Analysis." While the number twelve corresponds to the twelve month sojourn in the cave, both twelve and twenty-four are common numbers in the BT.

39. Similar tensions appear in the stories of sages leaving their wives to study in the academy, bKet 62b–63a. See n. 21.

40. This phrase was borrowed from bTa 21a and slightly modified. Disciples find Nahum of Gamzu blind, legs and hands amputated and covered with boils. When they exclaim, "Alas that we see you so," he responds, "Alas if you did not see me so." This must be the original locus of the phrase, since it provides the conclusion and crux of the story. In our story the entire exchange with Pinhas b. Yair is dispensable, and the phrase does not read easily. To render it intelligible the storyteller continues, "For if you did not see me so, you would not find me so," and we must in turn supply "learned" or some such modifier. Moreover, the phrase does not appear in the PT parallel, as we see below.

41. See Alter, *Art of Biblical Narrative*, 68.

42. On a very general level he repays the kindness done to him, if not directly to God then to God's creations. But why specifically the desire to make a *tiqqun* as opposed to some other kindness, such as teaching Torah?

43. Rashi in his Pentateuch commentary writes: "Whole in body—that he was healed from his limp. Whole in money—that he lacked nothing of the gift (which he sent to Esau; i.e., he was none the poorer). Whole in his Torah—that he did not forget his learning while in Laban's house." The Maharsha (in his talmudic commentary) cites Rashi and adds, "that is, a miracle happened to Jacob in each of these matters." Furthermore, in Gen 32:23–31 Jacob struggles with the angel. And in the rabbinic reading of Gen 33:4, Esau attempted to bite Jacob's neck, but God miraculously turned it into marble. See *GenR* 78:9 (926–27) = *SifNum* §69 (65; attributed to RSBY!). This exegesis does not appear in the BT, but it was probably well-known, since it is found in the Targums and numerous midrashic collections. Meir, "The Story of R. Shimon bar Yohai," 19–20, delineates other parallels between RSBY and Jacob.

44. The phrase "whole in body" (*gufo*) recalls Pinhas b. Yair "rubbing his body" (*gufei*). On "whole in money" see below.

45. Note that Rashi, s.v. *tiqqen*, tries to find exegetical support for Jacob "establishing" based on the following verse, "He (Jacob) bought (*vayiqqen*) the portion of the field," which he connects with *tiqqen*. This forced etymology is correctly rejected by the Maharsha. Clearly *tiqqen* is used here to parallel the opening scene. It was probably not the original language of the exegesis or the original words of the Amoraim cited.

46. The *derasha* explicitly mentions bathhouses and markets and alludes to bridges by mentioning money, which recalls the tolls. RSBY's act of purification now recalls the bridges. His statement to the "certain old man" mentions prostitutes and he encounters Yehuda b. Gerim in the market. The story thus returns to the three structures mentioned at the outset.

47. Because *teruma* (heave-offering) must be kept pure, the fact that Ben Azai gathered *teruma*-lupines indicates that the area was pure at that time. Hence it was not a full-fledged cemetery, and could be (partially) purified. The hard ground apparently indicates that no body was buried there, the soft ground that a body was buried. But why he had to cut down *teruma*-lupines to determine this fact is difficult. Tosafot, bShab 34a, s.v. *'avad*, accordingly refer the words, "he did the same," to the exegesis. RSBY "did the same" as Jacob and made a *tiqqun*. They offer this forced reading because it makes no sense that RSBY would do "the same" as Ben Azai and cut down lupines of *teruma*. Apparently Tosafot understand that RSBY examined the ground directly.

48. Rashi, bShab 34a, s.v. *'avad*.

49. Or the PT miracle was not understood by the BT redactors. For redactional misunderstandings of Palestinian exegetical traditions, see Segal, *The Babylonian Esther Midrash*, 3:232–33.

50. Tosafot, bShab 34a, s.v. *kol*, refer to bNid 61a, where wet sheets were spread on the ground. The sheets above impure ground remained wet but those above pure ground dried out. Maharsha, ad loc., comments: "They [Tosafot] mean that it was not through miracles as Rashi explained." While I do not understand the physics of this case any more than ours (and apparently neither did Maharsha), the point is that RSBY understood the nature of impurity and applied his knowledge to solve the problem. We should note that the story appears in Tractate Shevi'it of the PT, which deals with agricultural matters. In this context a miracle relating to vegetation is more relevant to the topic of the tractate. The BT context in Tractate Shabbat has nothing to do with agriculture. On the PT context see Meir, "The Story of R. Shimon bar Yohai," 13–15, and see n. 63 below.

51. The sense of *taharei* is "he ruled pure." He "purified" by issuing a legal ruling.

52. "Old man" is a verbal link to the encounter with the "old man" running with the myrtles. It makes little difference whether these men were old or not. The repetition of "old man" here and the fact that an "old man" answers RSBY's question about the precedent of purity adds to the story's coherence.

53. The idea is that because prostitutes, who are envious and competitive, nonetheless help one another to look beautiful (if only to receive like treatment in return), then scholars, who generally work for the same goals, should certainly support each other. Yet here the "old man" calls RSBY's ruling into question. Others will see internal dissension among the sages and consider them worse than prostitutes.

54. This is a good example of Fraenkel's principle of "closure." See Chap. 8, "Openness and Closure."

55. My reading of the murder of Yehuda ben Gerim as particularly harsh is not imposing my interpretation or contemporary sensibilities. The medieval commentators already sensed that the punishment does not fit the crime. See Tosafot, ad loc., s.v. *h"g*.

56. The version of *GenR* differs the most from the other three Palestinian versions, which are more closely related. See Levine, "Purification," 145–64, for discussion.

57. See Levine, "Purification," 145–64; Meir, "The Story of R. Shimon bar Yohai," 18–22.

58. Levine, "Purification," 166–69; Meir, "The Story of R. Shimon Bar Yohai," 23–34.

59. See Chap. 2, "The PT Story and BT Compositional Technique."

60. In the PT RSBY kills the Samaritan by decreeing that he descend. I do not include the presence of RSBY's son as a duplication since this is found in the other Palestinian versions.

61. For documentation on (a), (e), and (d) see nn. 19, 40, and p. 115. For (f) see below. For (b), see bTa 21a, bShab 10a, bBes 15b and below. For (g) see bShab 119a, bKet 69b, bHul 6a, and *OG, Berakhot, Teshuvot*, §20 (11). The Samaritan or scribe in the PT corresponds to the "old man" of the BT. (In the version in *GenR* it is a "commoner" — *'am ha'arets*.) (c) is a citation from mEd 2:10 that appears in slightly different form in bRH 17a. This Mishna is also cited in *PRK* 10:4 (165) and *Seder 'Olam Rabba*, ed. B. Ratner (Jerusalem, 1988), §3 (8b).

While caves (especially burial caves) figure in many rabbinic miracle stories (bBM 84b–85a, 85b; bBQ 117a; bMQ 17a; bBB 58a; yTa 3:10, 66d), the figure of a sage hiding in a cave is unparalleled and cannot be considered a motif. Levine, "Purification," 160, refers to *PRE* §26 (60b) in which Abraham hides from Nimrod for thirteen years. Luria's text reads "under the earth" not "in a cave," and *PRE* is very late in any case. Levine also refers to yHag 2:2, 77d, which reports eighty witches occupying a cave near Ashkelon, and yNed 11:1, 42c, in which Judah of Huza retreats to a cave for three days to ponder a difficult law. Neither of these is a case of hiding. It seems that the PT drew directly on the Bible: David hides from Saul in a cave (1 Sam 22:1, 24:4); Elijah hides in a cave while fleeing Jezebel and Ahab (1 Kgs 9:4–14); Obadiah hides one hundred prophets in caves to spare them from Jezebel's purge (1 Kgs 18:4–13); the five Canaanite kings hide from Joshua in a cave (Jos 10:16–17).

62. On thirteen as an exaggerated number see n. 27. In Palestinian sources the lethal gaze of a sage is rare. A lethal gaze appears in the PT version of the "Oven of Akhnai" (yMQ 2:1, 81c–d; see Chap. 2). *PRK* 18:5 (298) is the only other example known to me where the victim becomes a "heap of bones." This motif is far more common in the BT, which repeatedly observes, "wherever

the sages cast their eyes is poverty or death" (bMQ 17b, bHag 5b, bNed 7b, bSot 46b). A gaze of a sage also turns a man into a "heap of bones" in stories at bBer 58a and bBB 75a (=bSanh 100a). In both cases the victim doubts the sage's knowledge or teaching. See also bTa 9a and bYev 45a.

63. A story of a conflict between RSBY and a man gathering produce of the Sabbatical year precedes the story in the PT. This story has no substantive connection to the story of the cave, and does not appear in the other Palestinian versions. Meir, "The Story of R. Shimon bar Yohai," 14, suggests that the audience must have been acquainted with traditions about RSBY and the circumstances that forced him to flee. Hence the storyteller felt no need to explain. Perhaps. But it is circular to claim in each case of missing information that the storyteller assumed that his audience knew the background or he would have provided it.

64. On sages as holy men, see William Scott Green, "Palestinian Holy Men: Charismatic Leadership and Rabbinic Tradition," *ANRW* II.19.2 (Berlin: de Gruyter, 1979), 619–39; Geza Vermes, "Ḥanina ben Dosa," *Post-Biblical Jewish Studies* (Leiden: Brill, 1975), 178–95; Baruch Bokser, "Wonder-Working and the Rabbinic Tradition: The Case of Chanina b. Dosa," *JSJ* 16 (1985), 42–92.

65. See Chap. 1, "The Composition and Redaction of the Babylonian Talmud."

66. See bBQ 117a, bBer 27b, bTa 23a, bBM 84b, bMak 11b. The combination of "objection" and "solution" appears infrequently in standard talmudic legal discourse—as far as I can tell, only in bBQ 14a (a statement attributed to the late Amora Ravina), bAZ 50b (statements of both Sheshet and Ravina), and bBQ 66b (= bKet 42b; attributed to Rava). In the PT the term "solution" or "solve" (*paraq*) appears but once: yQid 4:6, 65d = yYev 8:2, 9b.

67. The parallels in *PRK, GenR* and *QohR* do not employ the word *taqqana* or *tiqqun*.

68. See Ben-Shalom, "Rabbi Judah B. Ilai's Attitude Toward Rome," 22–23; Meir, "The Story of R. Shimon bar Yohai," 28–29.

69. Except for the stock phrases and the exegesis of Gen 33:18, as is characteristic of BT stories.

70. The transitional line, "R. Yehuda and R. Yose and R. Shimon were sitting and Yehuda b. Gerim was sitting beside them," appears in Aramaic.

71. See bShab 49a, bBQ 117b, bKet 53a, bEruv 32b, etc. The form appears about fifteen times in the BT. In bKet 103b (cf. Shab 59b) one who "sits beside" is a colleague. When Levi's colleague died leaving no one "to sit beside him," he moved elsewhere, apparently because he could not learn Torah alone.

72. In bGit 66a a man "sits beside" a teacher and the teacher's son in a legal case. But the man is not a sage, and he takes no action.

73. The similar expression in ySanh 1:1, 18b and yAZ 1:1, 39b functions differently.

74. See Rovner, "Rhetorical Strategy," 192–94, 218–19, who attributes this tendency to the oral culture of the BT. See Chap. 8, "Local Traditions." See too Shamma Friedman, "Habaraitot shebatalmud habavli veyihasan latosefta," who demonstrates that the BT versions of *baraitot* are often influenced by the wording of proximate *baraitot*. Scholars who accepted the historicity of the story had trouble explaining why the Romans exiled R. Yose to Sepphoris. What punishment is it to exile someone to his home city? See the references in Ben-Shalom, "Rabbi Judah B. Ilai's Attitude," 13, n. 20. This problem disappears when the literary and redactional aspects of the story are appreciated.

75. See tMak 1:3 =yShev 10:3, 39d; tDem 3:14; tShev 4:13; tMeg 2:4; tKel 7:2, tMakh 3:5.

76. See also bShab 118b; bMQ 13b, 21a; bBB 75b; bSanh 19a, etc. While the Tosefta routinely associates Yose with Sepphoris (see the previous note), the PT rarely does so (see yQid 4:5, 65a for one example).

77. See n. 12.

78. The source does not appear explicitly elsewhere. The closest parallel is *GenR* 79:5–6 (940–41), which precedes the version of the story there.

79. Who quotes the first half of Gen 33:18? It must be RSBY's prooftext: he explains that he will fix something just as Jacob did. In the PT there is no question that these are his words. Yet the verse is simultaneously the basis of Rav's three comments, and the second half of the verse is clearly part of the other source. So the first half is both the words of R. Shimon b. Yohai and part of the source! Likewise, part of the exegesis, at least, must be the words of RSBY, for the verse itself does not explain anything. (In the PT he cites the verse and supplies a brief exegesis.) Yet the story attributes all of the exegesis to the Amoraim. From a purely literary perspective it appears as if RSBY is quoting the later Amoraim and their interpretations, but this is a chronological impossibility.

80. See Jacob Berdugo (d. 1843), *Sefer qedushat shabbat*, ed. A. Gabai (Jerusalem: Bigdei Shesh, 1991), ad loc.; Nissim Solomon, *An Encyclopedia of Talmudic Lore* (New York: Shulsinger, 1951), 1:422; Aharon Hyman, *Toledot tannaim ve'amoraim*, 1181; Israel Burgansky, "Simeon bar Yohai," *Encyclopedia Judaica*, 14:1552–53; Meir, "The Story of R. Shimon b. Yohai," 31. Meir even suggests that the entire story is a literary elaboration of this *baraita*.

81. In rabbinic sources RSBY often represents extreme views of this sort. See *SifDeut* §40 (83–84); *Mekhilta d'Rabbi Ishmael, Ki Tisa* §1, ed. H. Horovitz (Jerusalem, 1960), 342–43; and the sources cited by Beer, "Torah and Derekh Eretz," 146–47, 154–60. However, the traditions attributed to him are not mo-

nolithic (see, e.g., bMen 99b, bNed 49b). Likewise, R. Yehuda sometimes represents views opposite to that attributed to him in our story. In fact, this very *sugya* (bBer 35b) continues: "Rabba bar bar Hana said R. Yohanan said in the name of R. Yehuda b. Ilai, 'Come and see how the later generations are not like earlier generations. The earlier generations made the study of Torah primary and work secondary and both prospered for them. The latter generations made work primary and Torah secondary and neither prospered for them.'" This idea is similar to that expressed by RSBY. Beer tries to harmonize the sources and make the opinions consistent. I prefer to see the Tannaim as representing different ideas and disparate strands of thought. We need not expect consistency.

82. For other sources that value work see mAvot 1:11; *ARNA* §11 (22b); bBer 8a; bNed 49b. And see Nid 70b: "'What should a man do to become wise?' He (R. Joshua b. Hanina) said to them, 'Let him busy himself much in sitting (i.e., study) and little in business.' They said to him, 'Many did thus and it did not help.'" For the opposite perspective, see mAvot 4:10, bEruv 55a. For discussion, see Ephraim Urbach, *The Sages: Their Concepts and Beliefs*, trans. I. Abrahams (Jerusalem: Magnes, 1979), 608–16.

83. A slightly different version appears in tQid 5:15–16. See too mQid 4:14; tQid 1:11.

84. Other rabbinic sources are more candid about the trade-off. Thus mAvot 6:4 (an addition to the Mishna from later times) states: "This is the way of Torah: You eat [a morsel of] bread with salt, you drink water by measure, you sleep on the ground, and your life will be pain (*tsaʿar*), and you labor in Torah."

85. One strategy to resolve this tension appears in references to partnerships of men who agreed that one would earn a living, the other would study full-time, and they would split the reward (bSot 21a and Rashi, ad loc., s.v., *shimon*). This arrangement is best known from Palestinian traditions about the tribes of Issachar and Zebulun: the men of Zebulun engaged in sea-trade and supported the men of Issachar, who dedicated themselves to Torah study; see *GenR* 72:5 (841, 843), 97:9 (1220), 99:13 (1281); *LevR* 25:2 (570–71). Interestingly, while the BT judges that the partner who engaged in business made a poor choice, the PT relates that the Zebulunites received greater merit for facilitating their brethren's study. This should not surprise us given the BT's vision of Torah.

86. Ben-Shalom, "R. Judah b. Ilai's Attitude," 18–20, shows that Palestinian sources explain R. Yehuda's repute along different lines. The only other appearances of this title are at bBer 63b and bMen 103b. Ben-Shalom argues that bBer 63b is a reworking or misunderstanding of *SongR* 2:16, where R.

Yehuda speaks first because he comes from a city, an important place, not a village. For secondary literature on this title see there nn. 43–44.

87. So Meir, "The Story of R. Shimon bar Yohai," 29–30.

88. See Shamma Friedman, "Form Criticism of the Sugya in the Study of the Babylonian Talmud," *Proceedings of the Seventh World Congress of Jewish Studies–1977* (Jerusalem, 1981), 3:251–55 (Hebrew).

89. To some extent the context emphasizes the severity of "slander" or evil speech. The *baraita* claims that slander results in '*askara*, the story that it jeopardizes the lives of others and ultimately leads to the perpetrator's death. But if the literary analysis and compositional process proposed above are correct, then slander should not be seen as the main context of the story. Yehuda b. Gerim's indiscreet speech is a relatively minor point motivated by the need to explain why RSBY was forced to hide. Moreover, the term *leshon harʿa* does not appear explicitly in the story.

90. See Meir, "The Story of R. Shimon bar Yohai," 23–24, 29–30. Meir even believes that the redactors constructed this *baraita* to serve as a type of introduction to the story. This would certainly explain the many points of connection.

91. See Maharsha, ad loc.; Meir, "The Story of R. Shimon bar Yohai," 160 n. 30.

92. Lev 18:19; Num 15:17–22. Violations of laws of menstruation are punished by *karet* (excision) according to rabbinic law. Neglecting to separate the dough offering renders the bread *tevel*, consumption of which is also punished by *karet*.

93. Perhaps not even in the Talmud. In bShab 25b one sage considers lighting lamps "obligatory" and another a "commandment" (*mitsva*). However, the subsequent discussion questions this categorization and fails to provide a source. Even if the lighting of lamps has this status it is problematic that death should be the punishment. Failure to perform a positive commandment (as opposed to transgressing a prohibition) is rarely punished by death. The commentaries eventually find a basis for the ritual in the general principle of "delight in the Sabbath" (*'oneg shabbat*). It was only as a response to the Karaites in Geonic times that lighting lamps came to be considered a commandment and the blessing "who commanded us to kindle Sabbath lamps" was formulated.

94. The *sugya* takes up this question at the outset and provides a homiletical answer: the soul of man is considered the "lamp of God," so neglect of the Sabbath lamps causes loss of the divine lamp, the soul. But this analogy does not explain why the ritual is so important.

95. The story concludes the talmudic discussion of mShab 2:6 and immediately precedes the discussion of mShab 2:7, which, as noted, deals with Sabbath

preparations. The preparations too are not positive commandments but, like the lamps, contribute to the "delight of the Sabbath." The story should also be understood as an explanation of mShab 2:7.

96. See, e.g., the tradition attributed to Ben Zoma, tBer 6:2 = bBer 58a = yBer 9:2, 13c, upon which Fischel comments, "It is evident that b. Zoma's composition is designed to express gratitude for the progress of civilization within and through a multi-talented society and the ensuing division of labor which brings benefits to the individual, especially the Sage" (*Rabbinic Literature*, 52, and see the analysis there, 52–65).

Chapter 5  *Rabbinic Authority and the Destruction of Jerusalem (Gittin 55b–56b)*

1. Gedalia Alon, "Rabban Joḥanan B. Zakkai's Removal to Jabneh," *Jews, Judaism, and the Classical World*, trans. Israel Abrahams (Jerusalem: Magnes, 1977), 269–313; Jacob Neusner, *A Life of Yohanan ben Zakkai*, 2d ed. (Leiden: Brill, 1970); Peter Schäfer, "Die Flucht Rabban Joḥanan b. Zakkais aus Jerusalem und der Gründung des 'Lehrhauses'," *ANRW* II.19.2 (Berlin: de Gruyter, 1979), 62–101. See too Schäfer's references to other literature, 100–101.

2. However, it seems to me that the rabbinic sources are reworkings of Josephus's account (or of oral traditions devolving from Josephus) and cannot be considered independent historical witnesses. On the relationship of the rabbinic stories to Josephus see A. Schalit, "Die Erhebung Vespasians nach Flavius Josephus, Talmud und Midrasch. Zur Geschichte einer messianischen Prophetie," *ANRW* II.2 (Berlin: de Gruyter, 1975), 255–327 (an abbreviated Hebrew version appears in *Salo Wittmayer Baron Jubilee Volume*, ed. S. Lieberman and A. Hyman [Jerusalem, 1974], 3:397–422; see also the criticisms of Horst R. Moehring, "Joseph ben Matthia and Flavius Josephus," *ANRW* II.21.2 [Berlin: de Gruyter, 1984], 917–44); Y. Baer, "Jerusalem in the Times of the Great Revolt," *Zion* 36 (1971), 169–84 (Hebrew), with further references.

3. Jacob Neusner, "Story and Tradition in Judaism, 307–28.

4. Jonah Fraenkel, "Bible Verses," 80–87; Anat Taran, "Remarks on Josephus Flavius and the Destruction of the Second Temple," *Zion* 61 (1996), 8–12 (Hebrew); A. A. Halevi, *Shaʿarei haʾaggada* (Tel Aviv: Devir, 1982), 202–28; idem, *Haʾaggada hahistorit-biografit*, 209–36. See now Pinhas Mandel, "Aggadot hahurban: bein bavel leʾerets yisraʾel," in *Israel-Diaspora Relations in the Second Temple and Talmudic Periods*, ed. I. Gafni et al. (Jerusalem: Zalman Shazar Center, forthcoming). Anthony Saldarini, "Johanan ben Zakkai's Escape from Jerusalem: Origin and Development of a Rabbinic Story," *JSJ* 6 (1975), 189–220, attempts to reconstruct the "original version" of the legend by comparing different versions.

5. Weiss, *'Al heyetsira hasifrutit shel ha'amoraim*, 261–63.

6. Eli Yassif, "The Cycle of Tales in Rabbinic Literature," *JSHL* 12 (1990), 103–46 (Hebrew).

7. For some preliminary comments, see ibid., 141–42. On the three stories, see Efron, "Bar-Kochva in the Light of the Palestinian and Babylonian Talmudic Traditions," 77–88, 91–92, and Mandel, "'Aggadot hahurban: bein bavel le'erets yisra'el," 14–16.

8. See Isaac Hirsch Weiss, *Davar 'al 'odot hatalmud* (Pressburg, 1885).

9. The following clause refers to the ruler, understood as the king.

10. Ed. Buber, 71b–72a. The standard printed edition differs slightly from the textual tradition of Buber's manuscript. On the manuscript traditions see Strack-Stemberger, *Introduction to the Talmud and Midrash,* 308–9, and Mandel, "Hasipur bemidrash 'eikha," 25–88. My deep thanks to Dr. Mandel for sharing with me his collations of the manuscripts of *LamR*. Geniza fragments are published in Zvi Rabinowitz, *Ginzei midrash* (Tel Aviv: Rosenberg School for Jewish Studies, 1976), 118–54. The text of 4:2 appears on 153–54. Mandel, "'Aggadot hahurban: bein bavel le'erets yisra'el," provides an improved reading of that fragment.

11. *ARNA* §4 (11b–12b); *ARNB* §6 (10a–b); *LamR* 1:5, ed. Buber, 33a–34b.

12. *ARNA* §6 (16b) and, more briefly, *ARNB* §13 (16a); *QohR* 7:11, ed. Vilna 20a. This version presents R. Yohanan b. Zakkai's nephew, named Ben Batiah, as an adversary to the sage.

13. Ed. Buber 43b–44a; see n. 114. Related traditions about the ignominious fate of an aristocratic woman, variously called Miriam the daughter of Shimon b. Gurion, Miriam the daughter of Boethus or the daughter of Naqdimon b. Gurion appear in tKet 5:9–10; yKet 5:13, 30b–c; bKet 66b–67a; *SifreDeut* §305 (325). Marta the daughter of Baitos appears in other stories as well: mYev 6:4; tYom 1:14; *SifreDeut* §281 (298); bYom 18a.

14. See n. 48.

15. R. Yohanan's statement (B1) deviates from the chronological order by blaming the disasters on R. Zecharia b. Avqulos before they are narrated. His comments, like those of Rav Yosef / R. Akiba, stand outside of the narrative flow. The anonymous narrator tells the events in order, with the exception of the destruction of Jerusalem mentioned at the outset.

16. I argue this point below.

17. See the discussion in Rimmon-Kenan, *Narrative Fiction,* 16–22, and Seymour Chatman, *Story and Discourse* (Ithaca: Cornell University Press, 1978), 45–48.

18. *'akhul bahu qurtsa*. The idiom derives from the roots for "eat" (*'-k-l*) and (perhaps) "bite" (*q-r-ts*). See Jastrow, *Dictionary,* 1425, and Buber's n. 23 to

*LamR* 4:2 (71b). Bar Qamza could not eat at the banquet, so he decides to eat/bite/inform among the Romans. Cf. *'Iyyun Ya'akov* (printed in *EY*): "Since they prevented him from eating at that banquet he set himself on a wayward course to eat the king's food at the banquet of kings."

19. Note that the minor digression in D, that Rav Hisda "gave all the keys to his servant except for the key to the woodbin," also mentions a servant and implies that servants are not to be trusted with important matters—an interesting contrast to the host and Marta.

20. So Fraenkel, "Bible Verses in Tales of the Sages" (see below nn. 58 and 65); and Naomi G. Cohen, "The Theological Stratum of the Martha b. Boethus Tradition: An Explication of the Text in *Gittin* 56a," *HTR* 69 (1976), 187–95. On the other hand, Yassif, "The Cycle of Tales in Rabbinic Literature," 141–42, noted that the redactors constructed a tightly-structured and unified story from smaller units.

21. Rimmon-Kenan, *Narrative Fiction*, 48–49. Cf. Bal, *Narratology*, 63–64; Genette, *Narrative Discourse*, 67–79.

22. On the relationship between names and the content of stories and traditions, see Louis Jacobs, "How Much of the Babylonian Talmud Is Pseudepigraphic?" *JJS* 28 (1977), 56–57, and the references there. And see below on Abba Siqra = "Chief Assassin." For additional discussion, see Chap. 8, "Symbolic Names of Characters."

23. Jastrow, *Dictionary*, 1386. It is tempting to derive Qamza from the root *q-m-ts*, with base meaning "to close the hand, to grab, to scrape together," and also, "to be stingy, to be tight-fisted." However, stinginess is not the issue; the host is not concerned about the expense of the meal and even rejects Bar Qamza's offers to pay. Maurice Simon, in the Soncino translation, *Gittin* (London, 1936), 354 n. 3, comments: "The meaning is that a very trivial cause set in motion the train of events which led to the destruction of Jerusalem." This explanation seems to derive from the sense of "stinginess," smallness. It is interesting that the Geniza fragment of *LamR* 4:2 published by Rabinowitz (see n. 10) gives the names as *Bar Kamtsa* (with a כ) and *Bar Kamtsora*. If this is the original reading, then the BT redactors may have changed the names to *Qamtsa* and *Bar Qamtsa* for their symbolic purposes. Some historians trace the name ultimately to "Compsus the son of Compsus" mentioned by Josephus (*Life* §33).

24. A *baraita* on bGit 57a blames the destruction on shame: "R. Eleazar said: Come and see the power of shame (*busha*). For the Holy One helped Bar Qamza and destroyed his house and burned his sanctuary." This *baraita* may be part of the Tannaitic traditions that comprise the prehistory of the story. See n. 92.

25. A lateral omission of information. See p. 47.

26. This effect is lost somewhat in *LamR* 4:2. After the host throws out Bar Qamza the narrator adds, "R. Zecharia b. Avqulos was there, and he could have intervened but did not intervene. Immediately he (Bar Qamza) went and said, 'Since those elder rabbis sat peacefully and did not intervene . . . '"

27. Printed versions add to Bar Qamza's statement, "this implies that they approved" but the manuscripts lack this phrase. The obligation to intervene, protest, or prevent (*mohe*) improper behavior and punishment for failing to do so are common themes in the BT. See, e.g., bShab 54b: "Whoever can prevent his household [from sinning] and does not is seized (=punished) [for the sins] of his household, [prevent] the men of his city [and does not] is seized [for the sins] of the men of his city, [prevent] the whole world [and does not] is seized [for the sins] of the whole world." This tradition is consistent with the story in holding accountable those who could have prevented the offense, as Bar Qamza does the rabbis. The continuation of this passage also blames the "elders" for not protesting against "princes" (*sarim*), which could well apply to the sages not protesting against the behavior of the host, presumably a rich man. See also bShab 56a–56b; bAZ 18a; bSot 13b; bSanh 20a, 93a, 103a; bMen 35a; bSuk 29b. The phrases "the sages did not protest against him" and "the sages protested against him" (*mihu bo hakhamim*) function as technical terms for sanctioned or forbidden behavior; see, e.g., mPes 4:8, bEruv 96a, bKet 3b, etc. The same theme is prevalent in the PT.

28. The name Avqulos (variants include Avqalos, Avtulos) probably involves a wordplay, as do other names in the story, but I am not sure what it is. David Rokeah, "Zecharia ben Avkules—Humility or Zealotry," *Zion* 53 (1988), 56 (Hebrew), explains Avqalos from *eukolos* as "pleasant" or "good-natured" and claims that this quality is similar to humility. Louis Ginzberg, in his appendix to Alexander Kohut, *Tosafot ha'arukh hashalem* (New York: Alexander Kohut Memorial Foundation, 1937), 418, rejects any connection between the name and humility. I would suggest that the name perhaps should be read as Av-qolas, "Father Blockhead" or "Chief Blockhead." For *qolas* or *qolsa* meaning "blockhead" or "repulsive" see Jastrow, *Dictionary*, 1328, and bYev 118b. If the reading "Avtulos" is original (attested in the Vatican 140 and Leningrad-Firkovich I 187 manuscripts), then the play might be on *bitel* or *batala* in the sense of "nullify" (he nullified the decision) or idleness (they remained idle and did nothing). (Josephus, *War*, 4:225, calls one of the rebel leaders Zecharia b. Amphikaleus; this was changed in the rabbinic retelling for didactic purposes.)

29. See Joseph David Sinzheim, *Yad David* (Jerusalem, 1976), ad loc., 126: "This matter is certainly perplexing. If one may violate a negative commandment (sacrificing a blemished animal) in the interests of maintaining peace with

the ruling kingdom, then certainly because of this 'should people say . . . ,' which is merely a fear that others might make a mistake later, they should not have feared this danger at all."

30. See ibid.: "How could they not sacrifice it because of this concern? Certainly no one would make a mistake about this in the future. Behold, it is explicitly written in the Torah that it is forbidden to sacrifice a blemished animal."

31. In bHul 128b Rav Papa claims that Tannaim disagree whether the upper lip counts as a limb with respect to the law of the "limb severed from a living animal" (*'eiver min hehai*). The Stam then explains a similar disagreement between Tannaim on the same basis, i.e., whether the upper lip has the status of a limb. Thus the storytellers chose a bodily part that is itself the subject of a disagreement among rabbinic authorities. The same is true for the "withered spots" or "cataract" of the eye. According to bZev 35b, R. Akiba rules that if an animal with such a blemish is placed on the altar, the sacrifice is valid. The sages rule that the animal must be removed. Elsewhere the Talmud uses this dispute to explain or limit other disagreements (bPes 73a, bBekh 28a). These are marginal cases in rabbinic law and help achieve verisimilitude: the audience would find it plausible that (putative) Roman sacrificial law accepts such blemishes while the majority opinion of rabbinic law disallows them. At the same time, the marginal blemish magnifies the failing of R. Zecharia b. Avqulos and the rabbis. Even in such minor cases he refused to compromise and caused the Roman attack.

The commentators point out that it is difficult to understand how Bar Qamza could cause a "withered spot" or "cataract" in the eye, since these result from disease or internal causes. (Rashi therefore explains that the blemish was in the eyelid.) The storyteller probably borrowed this marginal case from elsewhere without realizing that it does not fully suit the context. Actually, I would not be surprised if the entire phrase, "in the upper lip, and some say in the withered spots of its eye, a place which we consider a blemish, but they do not consider a blemish," was a later gloss. It explains why the Romans would not themselves consider the sacrifice blemished and absolve the Jews. Indeed, the wording (found in all manuscripts and printings) "he made a blemish in it, in the upper lip" is slightly redundant; the first clause stands well by itself. The alternative opinion ("and some say . . .") also suggests a later gloss. This entire phrase is indeed lacking in the manuscript family represented by the first printing of *LamR* and the Geniza version published by Rabinowitz (above n. 10), which simply read, "he made a blemish in secret" or "a blemish that was not visible." Buber's manuscript family probably was influenced by the BT, since it reads, "he made a blemish in secret, in the upper lip, and some say in the

withered spots" This textual tradition redundantly glosses the words "in secret" with the BT phrase. This does not prove that the phrase was a gloss in the BT, but it is highly suggestive.

32. I am indebted to Pinhas Mandel, "Aggadot hahurban: bein bavel le'erets yisra'el," 11–13, for this point. Mandel points out that the phrase "should they say . . ." functions as a technical term in about ten other BT discussions. In these contexts there is good reason the people would reach mistaken legal conclusions, hence good reason for the sages to prohibit that which is technically permitted or to modify the law in minor respects. He suggests that the story is a "caricature of a halakhic discussion."

33. The three calamities "destroyed our temple and burned our sanctuary and exiled us from our land" are commonplaces. All three appear in bGit 57b (in the same unit as our story), and one or two are mentioned in bBer 3a; bSanh 96b; bAZ 18a; bShab 56b; bMeg 12b.

34. Halevi, *Sha'arei ha'aggada*, 208 n. 28.

35. Ed. Buber 71b–72a. And see below, "Comparative Evidence."

36. Rashi offers *savlanuto*, "patience" or "tolerance," as a synonym: R. Zecharia "was patient with him [Bar Qamza] and did not kill him." This explanation is problematic for it does not apply to the reluctance to offer the blemished sacrifice. See the parallel in tShab 16:7, cited below. Louis Ginzberg, "Beitrage zur Lexikographie des Jüdisch-Aramäischen, III," in *Essays and Studies in Memory of Linda R. Miller*, ed. I. Davidson (New York, 1938), 97, comments that R. Zecharia in tShab 16:7 did not have the courage to take a stand on the disputed law. He translates '*anvetanut* as "diffidence" and "lack of self-confidence." See also Ginzberg's notes in Kohut, *Tosafot ha'arukh hashalem*, 418, s.v. *'avqulos*.

37. bShab 30b–31a. The series concludes with the proselytes observing, "Shammai's impatience sought to drive us from the world, but Hillel's patience ('*anvetanut*) brought us under the wings of the divine presence."

38. bMeg 31a; bBer 16b; bNid 20b. Cf. bSanh 19b–20a.

39. God: bBer 16b; bMeg 31a; Moses: Targum Onqelos to Num 12:3; biblical heroes: bBM 84b–85a; bSanh 19b–20a; Rabbis: bShab 30b–31a; bBM 84b–85a; bSanh 10b–11a; bNid 20b; bSot 40a.

40. bSanh 88b.

41. With the exception of the parallels to R. Yohanan's statement in tShab 16:7 and the other versions of the story. In GenR 74:10 (866–67) and parallels, '*anvetanut* and *qapdanut* are used ironically, so the tradition positively valorizes the former. M. L. Lilienblum, "Haregesh vehamitsva be'inyan hayishuv," in *Hazeman*, ed. E. Goldin (Warsaw: Toshiya, 1896), found the use of '*anvetanut* in our story so problematic that he comments, "In truth his intention was to

say the *qapdanut* (punctiliousness) of R. Zecharia, but he said '*anvetanut* as a euphemism, since it is the opposite of *qapdanut*." M. Simon, in the Soncino translation, employs "scrupulousness," presumably alluding to Zecharia's anxiety at possible misinterpretations of law. But it is *qapdanut* that means scrupulousness! See too Rokeah, "Zecharia ben Avkules," 53–56, and the rejoinders there, 313–22.

42. bEruv 13b; see too Chap. 8, "Shame."

43. For interpretations of the story as condemning R. Zecharia's meekness along these lines see Lieberman, *TK,* 3:268; C. Reines, *Be'ohalei shem* (Jerusalem: Newman, 1963), 201; Daniel Schwartz, "More on 'Zechariah ben Avkules: Humility or Zealotry?'" *Zion* 53 (1988), 313–16 (Hebrew); Mandel, "Aggadot hahurban: bein bavel le'erets yisra'el." R. Judah b. Qalonymos (d. 1217), *Yehusei tannaim ve'amora'im,* ed. Y. Maimon (Jerusalem: Rav Kook, 1963), 169, comments that R. Yohanan meant that the rabbis should have acted as did Rav Kahana in bBQ 117a. There Rav Kahana "ripped out the throat" of a man who threatened to disobey them. This, I think, is the decisive sort of action R. Yohanan had in mind!

44. "Harden the heart" means to be stubborn or obstinate, as in Exod 7:3, "But I will harden Pharaoh's heart." Pharaoh obstinately refused to let the Israelites go despite the ominous plagues. Cf. Ezek 2:4, 3:7; Ps 95:8; *Exodus Rabba* 31:4. The host also hardened his heart by refusing to let Bar Qamza remain at the banquet.

45. Cf. Gersonides's comment to the verse: "'Happy is the man who is cautious always'—toward him who it is fitting to be cautious. For this reason he should be wise and seek judicious counsel so as to avoid the evil that he fears. However, he who 'hardens his heart' and leaves to God those matters about which he should be cautious 'will fall into misfortune.' Have we not seen that hardening the heart destroyed the first and second temples? Thus, if Zedekia had not hardened his heart and had placed his neck under the yoke of the King of Babylonia, we would not have been exiled from our land at that time. And so with the second temple; they did not surrender to a different empire and did not place their necks under their yoke." A marginal gloss in ms Vat 130 comments: "[cautious always] to see lest a misfortune occur on their account."

46. Cf. Ezek 21:26–27: "For the king of Babylon has stood at the fork of the road, where two roads branch off, to perform divination: *He has shaken arrows,* consulted teraphim, and inspected the liver. In his right hand came up the omen against Jerusalem—to set battering rams . . ." Cf. *Midrash Tehillim,* ed. S. Buber (Jerusalem, 1966 [Vilna, 1891]), 180a to Ps 79 and 168b to Ps 74, and Buber's n. 5. See also Lieberman, *Hellenism in Jewish Palestine,* 195 n. 20.

47. On this type of oracle, see Chap. 3, n. 37.

48. The conversion of an adversary of the Jews and the descendants of former enemies becoming scholars are common BT themes, as noted by Wilhelm Bacher, *Die Aggada der Tannaiten* (Strassburg: Trübner, 1890–1903), 2:5 n. 6. Bacher suggests that the story of Nero is based on the midrashic view that Judaism ultimately triumphs, and "even the most vicious enemies of Israel eventually convert, or their descendants enter the congregation of Israel." He refers to the story of Nevuzaradan, bGit 57b (=bSanh 96b), who felt remorse after killing hundreds of thousands of Jews and "fled and went and sent a document of inventory [and disposal of property] to his house and converted." (Note the almost similar phrasing "fled and went . . . and converted" to the Nero story, especially in the manuscript variants.) The passage then quotes a *baraita* asserting that the descendants of Haman, Sisera, and Sennacherib became scholars of Torah. In the continuation of the passage in bSanh 96b, God wants to convert the descendants of Nevuchadnezzar, but the angels protest that he destroyed the temple. The story in bGit 57b is part of the larger compilation of "stories of destruction" (see beginning of Ch. 5), and we have seen in previous chapters that the BT redactors often draw on material from proximate passages. There is perhaps another point of contact between the stories, for Nevuzaradan interprets the prophet Zecharia's boiling blood as a sign that God wants the Jews punished. The redactors also may have drawn on a story in bSuk 51b which tells that when Alexander Macedon came to Alexandria he found the Jews reading the verse, "The Lord will bring a nation against you from afar, from the end of the earth, which will swoop down like the eagle" (Deut 28:49). He remarks that the journey should have taken his ships ten days, but they arrived in five, and so he kills all the Jews of Alexandria. Nero too makes recourse to two oracles, one of which involves a verse.

49. Bacher's suggestion (ibid.) that Meir is designated a descendant of Nero because of the homophony Ner(o)/Meir seems plausible, especially since many other names in the story are symbolic. The same suggestion was made, apparently independently, by Jacobs, "How Much of the Babylonian Talmud is Pseudepigraphic?" 59 n. 45.

50. For a desperate attempt to discern a "historical kernel" behind the Nero tradition, see Naomi G. Cohen, "Rabbi Meir, a Descendant of Anatolian Proselytes: New Light on His Name and the Historic Kernel of the Nero Legend in Gittin 56a," *JJS* 23 (1972), 51–59. For further discussion and references, see Günter Stemberger, "Rom in der rabbinischen Literatur," *ANRW* II.19.2 (Berlin: de Gruyter, 1979), 346–49.

51. The only other source that places the three together (other than the parallels in *LamR* 1:5 and *QohR* 7:11) is *GenR* 14:1 (398), where they are designated "nobles of the city" and listen to R. Eliezer expound Torah. A later ver-

sion of this source appears in *ARNA* §6 (16a) and *ARNB* §13 (16a). The explanation of Naqdimon's name alludes to a story in bTa 19b–20a where a miracle occurs and the sun shines through the clouds despite its having already set. This allusion, incidentally, argues against Fraenkel's view of stories as hermetically sealed.

52. Urbach, *Sages*, 959–60 n. 400, notes that the etymology of *baryona* is unclear, and suggests it is a diminutive form of *briya* (creature) in a derogatory sense. If so, the anagram-like resemblance to *rabbanan* perhaps played a factor in the choice of term here. Martin Hengel, *The Zealots*, trans. David Smith (Edinburgh, T. & T. Clark, 1989), 53–56, provides a thorough discussion of the conflicting theories of the etymology. Most translators use "bandit" or "rebel" under the influence of the account in Josephus. In rabbinic literature a *baryona* is basically a thug or rogue, and need not be a bandit by trade. Cf. bSanh 37a and Rashi, s.v. *baryonei*.

53. Jonah Fraenkel has called attention to the prevalence of wordplays of this sort in aggadot. See his "Paronomasia in Aggadic Narratives," and *Darkhei ha'aggada vehamidrash*, 271–73.

54. In and of itself the story provides a vivid exemplum of the horrible punishments threatened by Deut 28 and the Ezekiel apocalypse. See Cohen, "The Theological Stratum of the Martha b. Boethus Tradition," 187–95.

55. The episode with R. Zadoq is told differently in *LamR* 1:5 (34a). There R. Zadoq's fasting has no connection to Marta's death. Rather, Vespasian allows R. Yohanan b. Zakkai to remove his colleagues from the city before the destruction. R. Yohanan makes sure to save R. Zadoq and presents him to Vespasian. He asserts that had there been another man as pious as R. Zadoq in Jerusalem, Vespasian could not have destroyed the city. His piety is explained in terms of fasting; the Buber manuscript family mentions that he subsisted on bean-bread, the other manuscripts mention the fig. The BT redactors probably revised a source similar to *LamR* 1:5. They changed the narrative order by bringing the story of R. Zadoq earlier, awkwardly inserted it into the Marta episode ("and some say . . .") and reworked it for their own purposes (see below). This also helps explain R. Yohanan b. Zakkai's curious request for doctors to heal R. Zadoq at the end of the BT story. In *LamR* 1:5 Vespasian sends for doctors to heal R. Zadoq after R. Yohanan b. Zakkai presents the ailing rabbi. The BT redactors seem to have preserved the mention of the doctors even though they moved the story of R. Zadoq earlier.

56. On embedded narratives and narrative level, see Genette, *Narrative Discourse*, 227–54; Bal, *Narratology*, 142–48.

57. The appearance of various portents forty years before the destruction is a rabbinic motif. See yYom 6:3, 43c; bYom 39b; bRH 31b; and bSanh 41a.

58. These points are lost if the Marta story is not read as an integral part of the story. See, e.g., Fraenkel, "Biblical Verses Quoted in Tales of Sages."

59. On the BT tendency to create kinship relationships among sages (and apparently other characters), see Chap. 2, n. 37 and the references there. Schremer, "Kinship Terminology and Endogamous Marriage," 9–12, notes several cases where the BT (and other rabbinic compilations) describes a "problematic figure" as the "son of the sister" of a sage. Thus Ben Dama, who wanted to be healed by "Yaakov of Kefar Sekania" (probably a disciple of Jesus) is introduced as the "son of the sister of R. Ishmael" in bAZ 27b. (In the Palestinian parallels this relationship is not mentioned.) Schremer also refers to bZev 62b; *GenR* 65:27 (742), 17:3 (152) and *LevR* 34:12 (796). bGit 56b (again a proximate narrative source) refers to Onqelos b. Qaloniqos (the righteous convert) as the "son of the sister" of Titus. Schremer also refers to numerous examples where the "son of the sister" is not a problematic figure but another sage. See n. 24 where Schremer considers the implications of these relationships but does not reach firm conclusions.

60. The word derives from the Latin *sicarius* (assassin) or *sica* (dagger). It appears in mMakh 1:6 meaning "bandits" or "murderers" (*siqarin*). The related word *siqariqon* appears in the proximate Mishna, mGit 5:6 (see at length below), and in the preceding and following talmudic *sugyot* (bGit 55b, bGit 58b) with a similar meaning. So the Latin provenance of the word does not preclude the wordplay. *LamR* 1:5 names the thug leader Ben Batiah and lacks the wordplay.

61. Pretending to be sick, *qetsirei*, R. Yohanan b. Zakkai goes out to the Romans. Bar Qamza informed, *qurtsa*, the Romans. Perhaps another wordplay. See n. 53.

62. The text does not state explicitly that Abba Siqra responds to the guards, but simply uses the pronoun "he said." Since Abba Siqra was the subject of the preceding sentences, I assume he is the antecedent. So too Rashi, ad loc., s.v. *'amar*.

63. Fraenkel, "Biblical Verses Quoted in Tales of the Sages," 84, characterizes Abba Siqra in negative terms: "Abba Siqra, the liar, is also underhand in the cunning advice he gives so as to get past his comrades' orders." But Abba Siqra is forthright with R. Yohanan b. Zakkai; he directs the lying and cunning toward his associates so as to help the sage. Fraenkel notes that in the other versions R. Yohanan b. Zakkai proposes the plan (n. 9). This deviation emphasizes that our version casts Abba Siqra in favorable light. The sage needed help, and Abba Siqra assisted him, even risking his life to get past the sentries. See the comparison with the version in *ARNA* below.

64. The sense of Abba Siqra's protest is not altogether clear. He seems to

argue that the Romans will learn that the thugs have defiled the corpse of a respected sage and consider them barbarians, or take heart at the discord within the Jewish camp. See Rashi, ad loc., s.v. *yomru*. It is possible that Abba Siqra cautions his sentries that the Jews will take offense at such outrageous behavior and abandon their cause.

65. Fraenkel, "Bible Verses Quoted in Tales of the Sages," 84–85, misses this point, since he starts his analysis with section F. He is hard-pressed to explain how R. Yohanan b. Zakkai knows this fact. Cf. Tosafot, bGit 56b, s.v. *'i lav*.

66. It is significant that the verse following Isa 10:34, which R. Yohanan b. Zakkai interprets as predicting the destruction of the temple, commences a prophecy about the birth of the Messiah, the salvation of Israel, and the punishment of the wicked (Isa 11:1). While Vespasian does not realize that R. Yohanan b. Zakkai predicts his downfall along with his victory, the rabbinic audience, which knew the scriptures by heart, undoubtedly appreciated this point. (Cf. yBer 2:3, 5a where the two verses are cited in tandem.) This prophecy reinforces Nero's understanding of Ezek 25:14, that the Romans subsequently will be punished and Israel will triumph in the end. Taken together, the verses offer a subtle message of comfort to the audience.

67. Jerusalem (the jar) was encircled by a snake (the thugs), so the rabbis should have broken the jar (turned over the city or destroyed its walls) to remove the danger of the snake. At least the honey (the people), or some honey, could be recovered. On the decoding of the parable, see Maharsha, ad loc.; Halevi, *Sha'arei ha'aggada*, 227.

68. My reading of this scene completely disagrees with that of Fraenkel, "Biblical Verses Quoted in Tales of the Sages," 85, who comments, "With tragic irony the narrator shows us a third dimension for understanding the situation. Generations later, from the distance of the diaspora Rav Joseph knows that R. Yohanan is the wise one, but his sorrow over the destruction of Jerusalem and his yearning for its glory do not permit him to fathom the greatness of spirit which R. Yohanan's silence expresses. The narrator gives us at length the simple answer suggested by Rav Joseph, thereby making it clear to us, who hear the story, that had R. Yohanan but wished, he could doubtless have given this reply." I do not see at all how the silence expressed "greatness of spirit." Fraenkel cites absolutely no evidence that silence is positively valorized. That the narrator implies that R. Yohanan could have given this "simple answer" (which is not so simple), is unproven. His point is that R. Yohanan had no answer, and even failed to give the response Rav Yosef devised.

69. The phrase "since you are so wise" also appears in bBer 58b and bSanh 102b, where R. Ashi asks Menasseh, who visits him in a dream, "Since you are

so wise, why do you worship idols?" bGit probably borrowed from bSanh or bBer, since here the phrase introduces a repetition of the previous interchange and both characters simply refer to their former words. A similar phrase, "seeing that you profess to be so wise," is found in bBer 56a.

70. Different terms are used, *sham'ei, sheluha, pristqa,* but the functions are similar. (The last word is actually of Persian derivation, although the messenger hails from Rome!)

71. It is unlikely that Rav Yosef / Rabbi Akiba made two almost identical statements, twice citing the same verse. More likely the redactors adapted one statement to two scenes. This and the partial repetition of the exchange ("why did you not come before me . . .") are examples of the BT doubling material from its sources, as we have seen in other chapters. (See Ch. 5, "The PT Story, Other Sources and Compositional Techniques"; and see n. 69 above and the following note for evidence of transferred material.)

72. See n. 22. The attribution "Rav Yosef and some say R. Akiba" is unique in all of rabbinic literature. In fact, nowhere else do we find "R. So-and-so and some say R. Akiba." And it is extremely unusual that a tradition should be confused between a third generation Babylonian Amora and a Tanna. The attribution is therefore suspicious. However, at this point I cannot explain the symbolism behind the attribution to Akiba. The phrase, "He should have said, 'Let them off this time,'" seems to derive from bGit 57a, the story about the destruction of Tur Malka. After Bar Daroma dies miraculously, the emperor says, "Since a miracle happened for me I will let them off this time" — and he does! Cf. R. Yohanan b. Zakkai's request to Vespasian in the version found in *LamR* 1:5, mentioned below. Efron, "Bar-Kochva in the Light of the Palestinian and Babylonian Talmudic Traditions," 97, also noted the criticism of R. Yohanan b. Zakkai.

73. Fraenkel, *Darkhei ha'aggada vehamidrash,* 243, appreciates the significance of this point. He insightfully compares R. Yohanan b. Zakkai to King Hezekiah during the Assyrian siege of Jerusalem, 2 Kgs 19:1–36 = Isa 37:1–38. Hezekiah beseeches Isaiah to ask God for help, and Isaiah assures the King that God will act. Indeed, God kills 185,000 Assyrian soldiers in one night. R. Yohanan b. Zakkai, on the other hand, "must decide by himself, based on his own insight, what will happen to the city and the temple, and how he should act vis-à-vis both the thugs and the Roman ruler." This underscores, for Fraenkel, the disparity between the hero in biblical stories and the hero in rabbinic stories.

74. See the previous note.

75. The term "for the sake of good order" (*mipnei tiqqun*) first appears in mGit 4:2, and then in mGit 4:3, 4:4, 4:5, 4:6, 4:7, 4:9, 5:3, and 5:5. The term

does not appear explicitly in mGit 5:4 but is found in the related passages in tGit 3:7–8. mGit 5:8–9 lists ten provisions "in the interests of peace." The ruling in mGit 4:2 concerns a law of divorce, which is probably why the entire block was inserted here.

76. On the relationship between *tiqqun* and *taqqana* see Martin S. Jaffee, "The Taqqanah in Tannaitic Literature: Jurisprudence and the Construction of Rabbinic Memory," *JJS* 41 (1990), 204–25. Jaffee notes that the term *taqqana* in the sense of a rabbinic legislative act does not occur in the Mishna, and that the term *tiqqun* refers "not to a legislative act itself but to the ameliorative results of the Sages' rulings" (207 n. 7). However, the term *hitqinu* (they enacted/ amended) appears regularly, and references to the "ameliorative results" of a ruling presuppose the rulings themselves.

77. This formulation is borrowed from Hayes, below n. 105.

78. For example, tGit 3:8, which comments on mGit 5:5, rules that a doctor authorized by the court to heal a sick person need not compensate the patient, even if he accidentally causes greater harm. The doctor is exempted from general laws of liability so as not to deter doctors from attempting to heal. This provision denies the injured party just recompense.

79. For example, one who takes animals from traps placed by hunters (in the wild) is considered a thief, although technically the owner of the trap has not legally acquired the catch. Clearly the owner believes that he owns the catch and will retaliate against those who snatch it.

80. The Mishna introduces a related law here. If one bought land from the husband and then from his wife, the sale is void. If one bought from the wife and then from the husband, it is valid. The explanation is similar to that of the *siqariqon*. The wife may not really wish to sell, and agrees to the sale out of fear of her husband.

81. See Hengel, *Zealots*, 50–53, and the references there. Attempts to relate it to Greek and Latin legal terms have been unsuccessful.

82. See Hengel, *Zealots*, 52–53 nn. 220 and 230; Lieberman, *TK*, 8:841 and n. 62. The "war" is presumably the war of 70 C.E., when the Romans destroyed Jerusalem, although the rebellion of 132–135 C.E. may be intended.

83. The first clause of the Mishna implies that the law was not applied during the years of slaughter. bGit 55b and the commentators explain that Jews who sold during that time did so voluntarily, believing that they would never get their land back, and so the sales were considered valid. Only after the war was the *siqariqon* law applied. See, however, yGit 5:6, 47b and Lieberman, *TK*, 8:842.

84. yGit 5:6, 47b explains: "They decreed a persecution on the Jews . . . and took their fields and sold them to others, and the original owners would

come and sue [to get their land back], so they stopped purchasing, and the land was permanently possessed by the *siqariqon*." See Rashba, ad loc.; Meiri, ad loc., ed. K. Shlezinger (Jerusalem, 1967), 241; Lieberman, *TK*, 8:842.

85. bGit 58b claims that the *siqariqon* charged only three quarters of the market value because he acquired the land at no cost.

86. tGit 3:10 explains that the law was enacted "for the sake of settlement of the land," that is, to encourage Jews to repurchase and resettle confiscated land. This seems to be a subcategory of "for the sake of the good order of the world." Lieberman comments, *TK*, 8:842: "For this reason Rabbi [Yehuda HaNasi] inserted this Mishna into this chapter which deals with *tiqqunim* (for the good order of the world, for the good of the altar, and, here, for the good of the land, its settlement)." See too Abraham Blum, *Yisa Berakha* (New York, 1984), to bGit 55b, 397; *Nimuqei Yosef*, ad loc., ed. M. Stern (Jerusalem, 1962), 140.

87. The Mishna rules that a stolen sin-offering is efficacious (provided it is not common knowledge that it was stolen). Otherwise priests would be reluctant to sacrifice sin-offerings for fear that they had been stolen.

88. R. Yohanan b. Zakkai asks Abba Siqra to find him a *taqqana* (remedy). The court decisions in mGit 5:6 are *taqqanot* ("enactments" or "amendments"), though this term does not appear explicitly. Reference to the sages "amending" appears in mGit 4:2 and 4:3 (*hitqinu*).

89. The dispute between the Houses (section A) is found in mShab 21:3, and R. Zecharia's policy (section B) appears in the discussion of that Mishna in bShab 143a (with a few textual variants). Section C, R. Yose's condemnation of Zecharia's meekness, does not appear in bShab 143a. But this statement appears explicitly in our story (with minor variations) attributed to R. Yohanan. (The attribution to R. Yohanan may have been influenced by the opening attribution of Prov 28:14 to him.)

90. See Lieberman, *TK*, 3:268. There are other interpretations of the dispute.

91. See Lieberman, *TK*, 3:269: "The sense is that R. Zecharia b. Avqulos resisted deciding between the House of Shammai and the House of Hillel, and did not want either to pick up the bones or to shake off the table. He therefore avoided putting the bones on the table so that he would never have to take any action at all. This meekness was his deliberate policy, and he applied it in other situations as well."

92. The BT attributes R. Yose's criticism of R. Zecharia [C] to R. Yohanan (B1) and embellishes it slightly by adding "destroyed our temple" and "exiled us from our land." (See Buber's n. 31 to *LamR* 4:2, 72a.) R. Yose's statement in the Tosefta may presuppose a version of the story. Whether that Tannaitic

tradition resembled the story of the BT or *LamR* is unknown. See Chap. 2 on the "Oven of Akhnai" and the related Toseftan tradition. It is also possible that R. Yose was speaking hyperbolically and figuratively rather than literally and concretely.

93. R. Yohanan b. Zakkai displayed this halakhic confidence too. The Mishna reports that the same R. Yohanan b. Zakkai who "saved a little" made a series of edicts (*taqqanot*) "after the destruction of the temple" (mRH 4:1–4). These *taqqanot* changed various laws to cope with the unprecedented situation of the absence of a temple.

94. Cf. Jaffee, "The Taqqanah in Tannaitic Literature." Jaffee notes that Mishnaic references to the sages emending the law (*hitqinu*) typically cite a brief story explaining why the legislation was necessary: e.g., "At first they would accept the testimony of the month from anyone. When sectarians disrupted matters, they emended (*hitqinu*) that they shall not accept [testimony] except from known individuals" (mRH 2:1, Jaffee's translation, 208). He suggests that such stories are legitimating devices: "In the present mishnaic context, the legislative report serves not to legitimate an obscure emendment or enactment *per se*, but rather to legitimate the notion of intervention into the customary practices of Israel by responsible authorities, namely the Patriarch and his representatives" (213). Likewise, I suggest that the BT story legitimates rabbinic amendments, both that of mGit 5:6 and in general. While the Mishnaic stories explain why the sages made the amendment, the BT story illustrates what happens in the absence of such activity.

95. On this relationship between halakha and aggada, see Daniel Boyarin, *Carnal Israel*, 15–16.

96. This is not always the case: some amendments simply enact a new law or add to a given law of the Torah.

97. *matnin beit din la'aqor davar min hatora*. The term *matnin* here means "enact" or "amend" (*matqin*). See Friedman, "Pereq ha'isha rabba babavli," 347 n. 7.

98. Yizhaq Gilat, "Beit din matnin la'aqor davar min hatora," *Bar-Ilan Annual* 7–8 (1972), 117–32.

99. For comprehensive analysis of this *sugya*, see Friedman, "Pereq ha'isha rabba babavli," 346–57. For other *sugyot* that raise this issue see bGit 36a–b (regarding mGit 4:3, part of the same Mishnaic unit as mGit 5:6), bGit 73a, bKet 3a, bKet 52b, and Friedman's references, 380 n. 37.

100. bGit 5b.

101. Gilat, "Beit din matnin," 125, 127–28. Gilat observes that some statements of earlier Amoraim suggest that they harbored similar reservations about such enactments. But we do not find explicit articulation of their views.

102. See too Jaffee, "The Taqqanah in Tannaitic Literature," 214.

103. *shev ve'al ta'ase*. For example, the sages ruled that one does not wave the lulav on the Sabbath lest one carry it to the synagogue. According to the Torah one should perform the ritual on the Sabbath. Hence the Torah's law is abrogated by refraining from action. On the other hand, in the case of bGit 80a mentioned above, the child of the remarriage would violate Torah law by marrying a *mamzer* (since the child is untainted according to the Torah, as the divorce is only invalid on account of the rabbinic amendment), and Rava presumably would not allow it.

104. yGit 4:2, 45c; Gilat, "Beit din matnin," 119 (see also 122, 125–26).

105. Christine Hayes, "The Abrogation of Torah Law: Rabbinic *Taqqanah* and Praetorian Edict," in *The Talmud Yerushalmi in Graeco-Roman Culture*, ed. Peter Schaefer (forthcoming). Hayes's explanation, however, differs substantially from that of Gilat.

106. A similar comparison could be made with the version of the story in *ARNB* §6 (10a–b), which differs in minor respects from *ARNA*. *ARNB* diverges in the same fundamental ways from the BT.

107. Neusner compares the versions and lists some of the differences in *Judaism and Story*, 127–28, 144–52. See also Efron, "Bar-Kochva in the Light of the Palestinian and Babylonian Talmudic Traditions," 99–102.

108. The text is difficult here. I follow Judah Goldin, *The Fathers According to Rabbi Nathan* (New Haven: Yale University Press, 1955), 37.

109. In the BT Abba Siqra says, "Should they say that they stabbed their master? . . . Should they say that they pushed their master?" in order to discourage the sentries from checking the corpse. These rhetorical questions recall those of R. Zecharia b. Avqulos. Hence it is not surprising that *ARNA*, which lacks that scene, should also lack this dialogue.

110. In *ARNA* Vespasian asks only for a token of submission. In the BT he makes no such offer, although the rabbis clearly believe that it is possible to sue for peace. *ARNA* does not specify how the men of Jerusalem destroy the city. The BT mentions famine and illustrates it with the Marta episode. In *ARNA* they do not put something repulsive in the coffin. And so on.

111. See Neusner, *Judaism and Story*, 127, 151; Saldarini, *Johanan ben Zakkai's Escape from Jerusalem*, 193–94.

112. A full analysis of the *ARNA* story would require a detailed reading in light of the literary context such as that accorded the BT version above. While that task cannot be accomplished here, a few general observations regarding the *ARNA* context are appropriate. The story appears in the commentary to mAvot 1:2, and, like the stories that precede it, responds to the theological problem caused by the destruction of the temple. If, as the Mishna asserts, the

world rests on three pillars, one of which is the temple service, how can the world continue after the destruction? In the preceding story R. Yohanan b. Zakkai responds to his colleague R. Yehoshua's theological trauma by arguing that the third pillar, acts of piety, serves as a replacement for the temple. In this context the story of R. Yohanan b. Zakkai and Vespasian shows that the destruction of Jerusalem and the temple was not as catastrophic as R. Yehoshua thought. R. Yohanan b. Zakkai anticipated the destruction and made provisions for life-after-destruction by asking for Yavneh as a place to perform the commandments, study Torah, and pray. R. Yohanan b. Zakkai's heroic character in *ARNA* as opposed to his flaws in the BT suits this context well. The world can survive the destruction because of sages like R. Yohanan b. Zakkai, men with discernment and foresight. The BT story fits the BT context of rabbinic amendments for political and social ends. The *ARNA* story fits its context of the survival of the world without a temple.

113. In the standard version of *LamR* (Vilna printing, 14b) R. Yohanan b. Zakkai responds, "One brings a charmer and charms the snake and leaves the jar."

114. Ed. Buber 43b–44a. The manuscript family represented by Buber's text lacks the second story, which Buber prints from the standard printing.

115. The story of the woman collecting barley appears in tKet 5:9; yKet 5:13, 30b–c; and bKet 66b, although the name of the heroine varies. Anat Taran, "Remarks on Josephus Flavius and the Destruction of the Second Temple," 150, insightfully observes that the function of the bare feet in the respective stories suggests that the BT reworked the *LamR* story. *LamR* tells that Marta never went out barefoot, and when she wished to see her son serve as high priest in the temple they laid out cushions for her to walk upon. R. Eleazar b. Zadoq subsequently relates that he saw the enemies tie her hair to the tails of horses and make her run. The reference in Deut 28:56 to the "most tender and dainty among you, that she would never venture to set a foot on the ground" suffering disaster fits this story well; throughout her life Marta indeed never "ventured to set a foot on the ground." She was eventually forced to run, presumably barefoot, as a punishment for her indulgent, barefoot lifestyle. In the BT it is difficult to understand why Marta went out barefoot to get food and how stepping on dung killed her (she was disgusted to death?). It seems the BT redactors replaced her barefoot journey to the temple with the servant affair and then attempted to connect her death to the verse by having her go out to seek food barefoot. Compare the version in *Midrash HaGadol* to Deut 28:56, ed. S. Fisch (Jerusalem: Rav Kook, 1973), 625. We also noted above that the BT has R. Yohanan b. Zakkai, not R. Eleazar b. Zadoq, apply the verse on account of his role in the subsequent scenes.

116. See too Mandel's superb analysis of the version of *LamR*, "'Aggadot hahurban: bein bavel le'erets yisra'el," 5–9, and the comparisons to the BT, 10–13. Efron, "Bar-Kochva in the Light of the Palestinian and Babylonian Talmudic Traditions," 91–92, also compares the two sources.

117. The manuscript is listed as Arras 889 by Michael Krupp, "Manuscripts of the Babylonian Talmud," in *The Literature of the Sages, Part 1*, ed. S. Safrai (Philadelphia: Fortress, 1987), 351, with a brief description.

Chapter 6   Torah, Lineage, and the Academic Hierarchy (Horayot 13b–14a)

1. For references to historians who accepted the story at face value, see David Goodblatt, "The Story of the Plot," 349 n. 1.

2. Louis Jacobs, "How Much of the Babylonian Talmud Is Pseudepigraphic?" 55–56 (emphasis in the original).

3. Shaye J. D. Cohen, "Patriarchs and Scholarchs," *PAAJR* 48 (1981), 85 and n. 68; Jacobs, "How Much of the Babylonian Talmud Is Pseudepigraphic?" 56 n. 27, also comments on the relationship of the story to the PT account. Goodblatt's claim that Aharon Kaminka, *Mehqarim betalmud* (Tel Aviv, 1951), 2:189–91 preceded Cohen in rejecting the historicity of the story is only half true ("The Story of the Plot," 349 n. 2). Kaminka does claim that the story is not historically accurate (although he accepts the basic historicity of the end of the story, the conversation between R. Shimon and R. Yehuda HaNasi, although not the exact words). But he does so, in part, because it contradicts other rabbinic stories that he believes *are* true. Hence Kaminka's approach does not differ fundamentally from the other scholars Goodblatt cites who accept *in principle* the historicity of such rabbinic stories and attempt to harmonize inconsistencies by separating the historical kernel from legendary embellishments. This is a far cry from Cohen who considers the story a free reworking of earlier sources and a literary creation, not because it happens to contradict other traditions, but on literary and methodological grounds.

4. David Goodblatt, "The Story of the Plot." Goodblatt also details the many divergences from the PT version.

5. Goodblatt suffices with the brief observation that the story perhaps reflects "power struggles between Babylonian sages and the Exilarch, or such struggles within the court of the Exilarch" (373). On this issue see below, "The Historical Context." My debt to Goodblatt's fundamental article will be clear from the copious references in the notes. To the best of my knowledge, the only analysis sensitive to literary issues appears in the forthcoming article by Devorah Steinmetz, "Must the Patriarch Know Uqtzin?" to be published in *AJSR*.

6. Ed. M. S. Zuckermandel, 426. I cite the *baraita* from the BT, which differs slightly from the Toseftan version.

7. That is, each student rises as he passes and sits down immediately.

8. That is, dreams are meaningless. Literally, "dreams neither bring up nor bring down."

9. On the force and reliability of the attribution, see below, "Sources and Compositional Art."

10. This tense structure is found in both biblical and talmudic stories. The initial situation or background is often presented with noun-clauses (or with the verb "to be"); the repeated, normal events of the pre-story time with iterative verbs and the plot with finite, active verbs. The third part of the story displays a similar structure (5'–4'). After RSBG throws Meir and Natan from the academy the new habitual situation is narrated again with iterative verbs: "they would write . . . and throw" before the resumption of active verbs. For another example see the story of Yehuda b. R. Hiyya, bKet 62b, and see Alter, *Art of Biblical Narrative*, 80.

11. R. Yohanan's mention of RSBG serves only to date the formulation of the teaching. It does not suggest that RSBG formulated it. On the contrary, specifying that the teaching was taught "in RSBG's days," *may* imply that RSBG did not teach it: it was taught in his time—but not by him. In bBQ 94b, for example, "in the days of R. Yehuda HaNasi" is followed by "*they* said," clearly not the Patriarch.

12. See p. 47.

13. Goodblatt, "The Story of the Plot," 362–69, suggests that the threefold division of patriarch, head of the court, and sage (*sage* being the title of an officer) is Babylonian and reflects the administration of the later Babylonian academy. He claims that in tSanh 7:8 and earlier sources the term is an honorific title bestowed on deserving sages.

14. See Jacobs, "How Much of the Babylonian Talmud Is Pseudepigraphic?" 56. In bSanh 106b Rava observes: "In the years of Rav Yehuda they only studied Damages, but we study a great deal of Uqsin. When Rav Yehuda came to [the law], . . *Olives preserved with their leaves are clean (=mUqs 2:1)* he said 'I see the discussions of Rav and Shmuel here' (i.e., it is very complicated), while we study Uqsin for thirteen sessions." Variations of this statement appear in bTa 24b and bBer 20a, also emphasizing the superiority of current study.

15. Their midrash derives from bMeg 18a: "Henceforth (namely, after the 'Eighteen Benedictions' was formulated) one may not speak the praise of the Holy One, blessed be He (i.e., one may not add more blessings), for R. Eleazar said . . . '*Who can tell the mighty acts of God, make all his praise heard? (Ps 106:2).* For *whom* is it pleasing *to tell the mighty acts of God?* For one who is able *to make*

*all his praise heard.'"* Because one cannot adequately recite *all* of God's praise, he should not attempt to add blessings to the standard prayer.

16. See John G. Peristiany, ed., *Honour and Shame: The Values of Mediterranean Society* (Chicago: University of Chicago Press, 1974 [1966]); David D. Gilmore, *Honor and Shame and the Unity of the Mediterranean* (Washington D.C.: American Anthropological Association, 1987); David A. deSilva, "The Wisdom of Ben Sira: Honor, Shame and Cultural Values of a Minority Culture," *Catholic Biblical Quarterly* 58 (1996), 433–55; Joseph Plevnick, "Honor/Shame," in *Biblical Social Values and Their Meaning*, ed. J. Pilch and B. Malina (Peabody, Mass.: Hendrickson Publishers, 1993), 95–103. See also Chap. 8, "Shame."

17. The stock-phrase "my honor and the honor of my father's house" also appears in bTa 20a, bMeg 3a, and bBM 59b (see Chap. 2).

18. This was already noted by Nathan b. Yehiel of Rome (citing Sherira Gaon), who claimed that R. Natan's father was the Exilarch; see Kohut, *'Arukh*, 7:127, who also identifies the *qamera*. See too Jacob Neusner, *A History of the Jews in Babylonia*, 3d ed. (Chico, Calif.: Scholars Press, 1984 [Leiden: Brill, 1965–70]), 1:74–79, and Shaul Shaked, "Items of Dress and Other Objects in Common Use: Iranian Loanwords in Jewish Babylonian Aramaic," *Irano-Judaica III*, ed. S. Shaked and A. Netzer (Jerusalem: Ben-Zvi Institute, 1994), 110–11.

19. Peristiany, *Honour and Shame*, 19–78 (above, n. 16). Pitt-Rivers lays out the main theoretical issues.

20. Ibid., 23–25, 36–38.

21. Ibid., 37.

22. Ibid., 27.

23. Ibid., 24.

24. See Chap. 4, p. 118 and Alter, *Art of Biblical Narrative*, 68.

25. The Mishnaic account of the conflict between Rabban Gamaliel and Rabbis Yehoshua and Hanina ben Dosa concerning the new moon begins in Gamaliel's upper-story where he interrogates the witnesses (mRH 2:8–9). Not only is this the most extensive Mishnaic story, but it has thematic connections to our story: a conflict between the Patriarch and other rabbis, an assertion of Patriarchal authority (summoning R. Yehoshua / throwing Meir and Natan out of the academy), and the capitulation of a sage despite recognition of his superiority to the Patriarch in knowledge of Torah (in mRH 2:9 Rabban Gamaliel concedes that Yehoshua is "his master in knowledge"). bBer 37a sets a meeting of Rabban Gamaliel and the elders in "the upper-story in Jericho" and tells of conflict between Gamaliel and Akiba over the proper form of grace.

26. Several sources relate that the elders entered the "upper-story of the

House of Guria" (or Gadia) where a heavenly voice made pronouncements about the excellence of certain sages (bSot 48b = bSanh 11a; yAZ 3:1, 42c = yHor 3:8, 48c; ySot 9:13, 24b). Of course a wide variety of stories, and not only rabbinic gatherings, are set in upper-stories. See, e.g., bShab 119a, bBM 84b, bBB 133b.

27. See n. 29.

28. Cf. the lengthy story at bBQ 117a. Resh Laqish tells R. Yohanan directly, "A lion has come up from Babylonia. Let the master carefully examine tomorrow's lesson." See also Chap. 8, "Shame."

29. Adiel Schremer, "'He Posed him a Difficulty and Placed Him'—A Study in the Evolution of the Text of TB *Bava Qama* 117a," *Tarbiz* 66 (1997), 409–10 (Hebrew), argues that the term *'oqim* means "stymie" or "confound," i.e., to ask a question that the other fails to answer. (Schremer attributes this explanation to Jonah Fraenkel.) This usage is attested at bYev 16a and (perhaps) bBQ 117a. Pseudo-Rashi, bHor 13b, s.v. *batar,* offers "stopped": RSBG stopped teaching the tractate after adequately demonstrating his proficiency.

30. In the final scene of the story of Elisha b. Abuya (Chap. 3), Elijah describes God as citing traditions "from the mouths" of all sages *except* Meir, because Meir learned Torah from Elisha. This is a similar type of anonymization. There too God subsequently reverses and cites Meir's traditions.

31. Goodblatt, "The Story of the Plot," 358–60, argues that removal from the academy is a Babylonian motif. The only three such accounts in rabbinic literature appear in the BT: bSanh 31a, bBB 23b, and bBB 165b.

32. In bBQ 117a–b, Rav Kahana resolves to keep quiet in the academy of R. Yohanan so as not to embarrass him with difficult questions. The students then think that Kahana knows no Torah and relegate him to the back of the academy.

33. It should be noted that the term for "designated" or "named" (*'asiqu*), which typically means "raised" (from the root *s-l-q*), recalls the theme of standing and rising, which initiated the conflict. Cf. bYom 38b ("we do not name children after them [*masqinan bishmaihu*],") bShevu 29a and bGit 11b.

34. To cite traditions in the name of their originator is a prominent rabbinic virtue: "Whoever cites a matter in the name of the one who said it brings redemption to the world" (bMeg 15a). Similarly, bYev 97a (=bBekh 31b): "The lips of every sage, in whose name a tradition is said in this world, move in the grave." Memory of traditions thus confers a type of immortality. In a few stories sages become angry when another sage does not cite their traditions in their names. See bYev 96b; bMen 93b; bBekh 31b, and yBer 2:1, 4b (=ySheq 2:6, 47a = yMQ 3:5, 83a). The sages understand the lack of citation as an insult to their honor, a theme that intersects with our story.

35. The narrator's knowledge of the dreams of characters, like his knowledge of their thoughts (reported through the interior monologues), raises the interesting issue of narratorial omniscience. Whence his source of knowledge? This topic deserves a comprehensive study.

36. In bBM 85a we find, "They made him (R. Yosef) read" a verse in his dream (similar to our "they showed him in their dreams"). Similarly in bTa 9b, "They made him (Rav Papa) read a verse in his dreams." Other cases of "reading" in dreams include bSot 31a, bHul 133a, bSanh 81b–82a. There are several accounts of dreams in which deceased sages bear messages, and in these cases the messages are taken seriously (bMQ 28a, bBM 84b, bBM 85b).

37. Pitt-Rivers, "Honour and Social Status," 25.

38. Actually RSBG's rebuke is ambiguous and can be interpreted as a disdainful dismissal and refusal to be pacified: "You should have been satisfied with being the Head of the Court. Now you have nothing." That R. Yehuda HaNasi in the next scene still refers to "*men* who tried to uproot your honor" perhaps suggests that neither Meir nor Natan had been forgiven until then. On this reading Meir's skepticism of dream-messages ironically proves to be warranted, not because dreams fail to convey the divine will, but because they need not yield tangible results. Dreams "neither bring up nor bring down" (as the idiom literally translates) for they did not raise Natan to his former position. Moreover, scholars have noted that Natan's name never occurs in the Mishna. (J. N. Epstein, *Mevo'ot lesifrut hatannaim* [Jerusalem, 1957], 170–71, claims that the two places in which Natan's name appears in printed texts [mBer 9:5 and mSheq 2:5] are later additions.) If the redactors knew this fact and purposefully chose Natan as protagonist on that basis, it would support this reading. The redactors may be providing an etiology for Natan's absence from the Mishna—RSBG rejected his apology. However, I think we should assume that RSBG accepted the apology because it seems odd that a dream-message duly obeyed should prove futile, and because Meir's disdain for dream-messages appears to be his idiosyncrasy.

39. See Chap. 4, n. 66. I return to this subject in Chap. 8, "Dialectics."

40. See the previous note.

41. See bNed 8a–b, "It is impossible that a dream not contain meaningless matters (*devarim beteilim*)." See too bBer 10b and the lengthy passage at bBer 55a–57b, including the story of the dream-interpreter Bar Hedya. In the story of the deposition of Rabban Gamaliel, bBer 28a, "they showed Gamaliel in a dream white casks full of ashes" to relieve him of anxiety that he had prevented worthy students from learning Torah. The message was that, like casks full of ashes, the students were not of worthy character. Yet the story continues: "This was not the case. They showed him this to settle his mind." That is, Gamaliel

had in fact frustrated worthy students, so the dream was untrue. On dreams in general see Richard Kalmin, *Sages, Stories, Authors*, 61–81, and P. S. Alexander, "Bavli Berakhot 55a–57b: The Talmudic Dreambook in Context," *JJS* 46 (1995), 230–48.

The phrase "dreams neither help nor hinder" first appears in tMS 5:9 (= yMS 4:9, 55b; bSanh 30a), which rejects the relevance of a dream-message to a halakhic ruling. The association of this line with Meir derives from bGit 52a. After Meir prevents a guardian from making disastrous transactions to an orphan's estate, "They showed him in his dream, 'I destroy and you build?' Nevertheless, he paid no attention. He said, 'Dreams neither help nor hinder.'" That is, God intended the guardian to damage the estate, yet Meir prevented him and ignored the dream-message. I deal with this borrowing in Chap. 8, "Supplements."

42. Several other BT stories contain similar shifts to the following generation or to different characters in parallel relationships; see Chap. 3, bBM 83b–85a, bTa 23a–23b, bKet 63a. In our case the shift is also crucial to the basic conflict of the story, as noted above. The appearance of the descendants of RSBG illustrates that the threat was not to RSBG alone, but to Patriarchal lineage.

43. R. Shimon's description of Meir and Natan as men "whose waters we drink" is a stock phrase that appears in tYad 2:16 and tSot 7:9 (=bHag 3a; yHag 1:1, 75d = ySot 3:4, 18d). In both cases a master asks his students to tell him what was discussed at the academy. They protest that they cannot make pretense to instruct him, since "we are your students and we drink your waters." The phrase also appears in the lengthy story at bBM 84b. Students of the academy object that Rabbi Yehuda HaNasi and R. Shimon b. Eleazar should not sit on the floor below RSBG (!) and R. Yehoshua b. Qorha. The former two were "raising difficulties and solving them" (*maqshei umefarqei*—the same words that appear earlier in our story), so the elders consider promoting them to benches. Here too the stock phrase expresses the dependence of disciples on their masters and the incongruity that obtains when sages do not receive appropriate honor.

44. This parallel is more clear in the Munich manuscript (see Appendix), which reads, "whose names we do not recognize (*mekirin*)," instead of "mention" (*mazkirin*). This creates a verbal link to RSBG's initial objection, "should there not be a distinction (*hekera*)."

45. Note that R. Shimon's alliterative protest, *hanei milei heikha de'ahani ma'asav; hanei la 'ahanei ma'asaihu* ("these words [apply] when his actions brought benefit, [as for] these [rabbis], their action brought no benefit"), echoes his father's words to Natan, that the belt could only "benefit" him so far.

46. On allusions to proximate scriptural passages see Fraenkel, *Darkhei ha'aggada vehamidrash*, 248–50.

47. The specific association of R. Yehuda HaNasi with humility seems to derive from bSot 49b, "When R. Yehuda HaNasi died, humility ceased from the world." It is interesting that the lengthy story at bBM 84b–85a cites a tradition in which R. Yehuda HaNasi calls his father, RSBG, an *'anvetan* because RSBG recognized another sage's superiority in learning. The same passage notes that R. Yehuda HaNasi also called the Bnei Betera "humble men" after they ceded their position to Hillel and appointed him Patriarch, for Hillel's knowledge of tradition exceeded theirs (bPes 66a). We may have a tendency to associate Patriarchs with humility on account of their inferiority in Torah, an idea echoed in our story. See also yKil 9:4, 32b (=yKet 12:3, 35a; GenR 33:3 [305–7]), which also characterizes R. Yehuda HaNasi as humble, perhaps somewhat ironically.

48. See Ofra Meir, "Hademut hamishtane vehademut hamitgale besipurei hazal," *JSHL* 6 (1984), 70–71.

49. It is unclear why the narrator quotes an Amora, unless the purpose is to create the formal symmetry of an attributed Amoraic statement at the beginning and end of the story. It may also function as a distancing tactic. The narrator does not call RSBG an *'anvetan* himself, and thus maintains his "objectivity." Of course the line may come from another source or an earlier version of this story. The story of Honi the Circle-Drawer, bTa 23a, also concludes with a statement of Rava. This matter requires further study.

50. M. J. Boda, "Chiasmus in Ubiquity: Symmetrical Mirages in Nehemiah 9," *Journal for the Study of the Old Testament* 71 (1996), 56–57, calls this flaw "lopsided design." See also Mike Butterworth, *Structure and the Book of Zechariah* (Sheffield: Sheffield Academic Press, 1992), 1–61.

51. Discerning a structure is no more objective than other aspects of literary analysis. There is no such thing as a purely "objective structure" because the decision as to what elements create the structure is subjective. At the same time, some structures are more persuasive than others. See Chap. 1, "Interpretation and Objectivity."

52. See Fraenkel, "The Structure of Talmudic Legends," 83–89, and *Darkhei ha'aggada vehamidrash*, 263–68. For productive use of an imperfect chiastic structure, see Robert L. Cohn, "Literary Technique in the Jeroboam Narrative," *ZAW* 97 (1985), 25: "The chiasmus, though not perfect, does create a sense of ascent and descent, linking the elements of the story into a single architecture marked off from what precedes and follows it."

53. On the various functions of chiastic structures see Fraenkel, "The Struc-

ture of Talmudic Legends," 83–89; idem, *Darkhei ha'aggada vehamidrash,* 263–68.

54. Note that 2 refers to Meir before Natan ("R. Meir—sage. R. Natan—Head of the Court. . . . When R. Meir and R. Natan would enter . . . ") despite the fact that Natan outranks Meir. As appropriate for a chiasm, 2a'–2b' reverses the order, first noting that "R. Natan went. R. Meir did not go" and then detailing Natan's apology before Meir's rehabilitation. The slightly anomalous order serves the structure.

55. And see n. 29. Not only does the Patriarch avoid the shaming, but he stymies Meir and Natan with his teaching—a complete reversal.

56. For this reason 6' ("Had I not learned it") alludes back to the grounds for the plot at 4: ("Because he has not learned it").

57. There may be an echo of this last line in the BT when Meir asserts that dreams neither "bring up (*ma'alin*) nor bring down (*moridin*)" (= dreams neither help nor hinder). This would be a remarkable substitution of one rabbinic saying for a similar-sounding maxim tailored to the new context.

58. The BT often replaces "assembly house" with "house of study" (*beit midrash*). See J. N. Epstein, *Mavo lenusah hamishna,* 2d ed. (Jerusalem: Magnes, 1964), 488–89.

59. See Goodblatt, "The Story of the Plot," 357–58.

60. The number of Babylonian motifs, stock phrases, and parallels suggests that the redactors changed the story, or at least a substantial part of it, although some development probably occurred in the Amoraic period. See the references in the following note. For evidence of the story's relationship to its context (a redactional concern), see below, "The Literary and Halakhic Context." The adaption of a fixed literary form also points to the redactors; see below.

61. See nn. 13, 31 and 67, and Goodblatt, "The Story of the Plot," 454–62. For additional examples see the discussion of the upper-stroy above, and nn. 14, 15, 17, 36, 39, 41, 43.

62. See bShab 3a–3b, quoted in Chap. 8, "Shame." Rav is rebuked for asking R. Yehuda HaNasi an unrelated question and potentially embarrassing him.

63. The BT redactors may have had a different version of the Tosefta, so it is not certain that they knew these passages. The similar themes, however, suggest that their version of this chapter did not differ much.

64. See Chap. 4.

65. Several of the BT stories we analyzed can be seen, in part, as narrative exegeses of Toseftan passages (see Chaps. 2, 3, and 5). Here too the BT story can be seen as an exegesis of tSanh 7:8 based in part on the Toseftan context.

66. See Friedman, "Pereq ha'isha rabba babavli," 301.

67. Goodblatt, "The Story of the Plot," 355–56 and nn. 18–21.

68. R. Yohanan: bBQ 94b, bBekh 30b, bBM 33b. R. Hanina: bShab 123b.

69. For example, a *baraita* cited in bBM 33b states, "Those who busy themselves . . . with Mishna—this is meritorious and they receive reward for it; with *gemara*—there is no greater reward than this. Always rush to the Mishna more than to the *gemara*." To resolve the internal contradiction R. Yohanan states, "This teaching was taught in the days of Rabbi Yehuda Ha-Nasi." He (or the Stammaim) relates that the Patriarch saw everyone abandoning the study of Mishna in order to study *gemara* and therefore added the final, albeit contradictory, sentence directing sages to the Mishna.

70. In bBekh 30b the opinion of Abba Shaul contradicts the first opinion of the *baraita* (=tDem 2:13). The story presents Abba Shaul's opinion as the original law and accounts for the change. In bBQ 94b R. Yohanan solves a contradiction between the *baraita* connected to the story and a second *baraita* by explaining that the latter reflects the law before the change. It is not clear that in this case the purpose of the historicizing story was to resolve the contradiction, but that is at least one of its functions in the *sugya*. Likewise in bShab 123b the attribution of the "first" ruling of the *baraita* (=tShab 14:1) to Nehemiah explains its provenance, which otherwise contradicts mShab 17:1.

71. For example, the redactors present an opinion, object, and then offer an alternative version introduced by the term "rather if it was said, it was said thus" (*'ela 'i 'itmar, ha 'itmar*). For an example of a Stammaitic *sugya* presented in the mirror-image of a previous *sugya*, see Kahane, "Intimation of Intention and Compulsion of Divorce," 239–50.

72. See bHor 13a and the commentaries for explanation of the hierarchy. (A *natin* is a descendant of the Gibeonites.)

73. For a related expression of this tension see bMeg 28a: "R. Yohanan said: Any sage who allows even a high priest–ignoramus to say grace for him deserves death." The ensuing discussion, however, presents opposing opinions. Here too the BT struggles with priestly lineage versus knowledge of Torah as claims to the honor of leading the grace.

74. Printed versions mistakenly place the Toseftan *baraita* before mHor 3:8, appended to mHor 3:7. But the passage belongs with mHor 3:8; in the Tosefta, the end of the *baraita* cites mHor 3:8. The manuscripts, which do not quote the Mishna, allow for either juxtaposition. Most likely, mHor 3:7–3:8 originally were not divided.

75. Granted that this is not the same type of lineage as in the Mishna, but it is lineage (*yihus*) nonetheless.

76. Moreover, the BT elsewhere claims that Meir was a descendant of

Nero, hence from a family of converts (bGit 56a), who rank next to last in the hierarchy of mHor 3:8. This information is not in our story, and it probably overreads to assume the storyteller had this in mind, let alone his audience. However, some BT stories allude explicitly or implicitly to others (see Chap. 8, "Openness and Closure"), so it is not impossible that this datum lurks in the background.

77. For a similar relationship between talmudic stories and the proximate law see Fraenkel, *'Iyyunim be'olamo haruhani shel sipur ha'aggada*, 99–115; Valler, *Woman and Womanhood*, 56–80, and Boyarin, *Carnal Israel*, 142–66. They see the stories in bKet 62b–63a as protests against, or at least contrasts to, the ruling at bKet 62b that husbands may leave their wives for several years to study in the academy.

78. The story is immediately preceded by the *baraita* mentioned above (tSanh 7:8–10) and a few comments. The *baraita* is preceded by a series of traditions of a folkloristic nature related to learning Torah, including lists of five things that "cause one to forget his learning," five things that "restore learning," and ten things that are "harmful to learning." The focus of the preceding material is therefore knowledge of Torah and how to preserve it.

79. I have translated ms Munich since ms Paris becomes illegible here.

80. According to Pseudo-Rashi, "Sinai" refers to one who has mastered tradition such that the sources are known to him as plainly as when they were given on Mt. Sinai. An "Uprooter of Mountains" is a sage of brilliant analytical ability.

81. I.e., one who knows traditions.

82. The commentaries offer two explanations: (1) Rav Yosef behaved humbly by going to bleeders himself (or going to Rabba's house to have bleeding done), rather than summoning them to his house as would a person of high honor. (2) Because of Rav Yosef's humility, no one in his house needed a bleeder for the twenty-two years of Rabba's rule. Both explanations emphasize Rav Yosef's humility.

83. Moshe Beer, *The Babylonian Exilarchate in the Arsacid and Sasanian Periods* (Tel-Aviv: Devir, 1970), 102–3 (Hebrew), interprets "the head" as the head of the academy. They gathered to select a leader. Neusner, *History*, 4:93–97, claims that the issue concerns who will lead the study-session. So Goodblatt, *Rabbinic Instruction*, 249.

84. This sentence is corrupt in ms Munich. I have restored it on the basis of ms Paris and the first printed edition.

85. Cf. Naftali Zvi Berlin, *Sefer Meromei Sade* (Jerusalem, 1956), 4:104, s.v. *pligi*.

86. Printed editions of B read "Which of them takes precedence (*qodem*)"

in place of "Which of them is superior." In section A *Haggadot hatalmud* reads, "One says, 'Of Sinai and an Uprooter of Mountains, Sinai takes precedence (*qodem*),'" parallel to the language of the Mishna.

87. While it is not known whether he advocates mastery of tradition or analytical brilliance, in the story he possesses neither. He does not know Uqsin and cannot solve all the difficulties submitted by Meir and Natan. It is interesting that bEruv 13b describes Meir as the most brilliant of sages, and bSanh 24a designates Meir an "uprooter of mountains."

88. The sense of "raise his head" is unclear. The phrase does not appear elsewhere in the Talmud. Whenever Rava calls Abaye "Nahmani" he expresses agreement or praise (bShab 74a, bMe 20b, bAZ 58a) and the other uses of this name are also complimentary (bGit 34b, 45a). In Ps 3:4 and 110:7 we find "He holds my head high" and "He holds his head high" (*yarim rosh*), indicating divine favor. Most commentators interpret Abaye's gesture as excitement, not pride.

89. A and D offer no conclusion; B defends both; only C is unambiguous.

90. See n. 82.

91. Lee Levine, "The Jewish Patriarch (Nasi) in Third Century Palestine," *ANRW* II.19.2 (Berlin: de Gruyter, 1979), 661, translates, "Two leading groups were in Sepphoris, the Bouleteri and Pagani," and identifies them with the city elite and rural landowners respectively. This is apparently based on *bouletēs* = councillor and *paganus* = rural. However, *paganus* has the sense of "villager" or "yokel." See Jastrow, *Dictionary,* 146 and 1134. The contrast is between upper class urban elites and lower class rural commoners, not between two elite groups.

92. The exegesis plays on *peninim* (jewels) and Holy of Holies (*lifnei ulifnim*), and derives from tHor 2:10.

93. See Seth Schwartz, *Josephus and Judaean Politics* (Leiden: Brill, 1990), 107–10; Reuven Kimelman, "The Conflict between the Priestly Oligarchy and the Sages in the Talmudic Period," *Zion* 48 (1983), 135–48 (Hebrew).

94. See Stuart A. Cohen, *The Three Crowns: Structures of Communal Politics in Early Rabbinic Jewry* (Cambridge: Cambridge University Press, 1990). The title devolves from mAvot 4:13, which lists "the crown of Torah" together with "the crown of Priesthood" and "the crown of royalty." An idealistic and prescriptive rabbinic tradition recounts that once a crowd of people escorting the high priest deserted him in order to follow two early masters, Shemaya and Avtalion, who happened to pass by (bYom 71b).

95. See Neusner, *Evidence,* 230–50, and Howard Eilberg-Schwartz, *The Human Will in Judaism: The Mishnah's Philosophy of Intention* (Atlanta: Scholars Press, 1986), 195–200. Eilberg-Schwartz writes: "The Mishnah thus forms a kind of palimpsest, where one view of reality is superimposed upon another.

At the foundation lies the priestly world view which was appropriated from Scripture. Superimposed upon the base is another system which is the sages' own contribution and speaks for and to their own social group" (197–98).

96. See Lewi Freund, "Über Genealogien und Familienreinheit in biblischer und talmudischer Zeit," in *Festschrift Adolf Schwarz*, ed. S. Krauss (Berlin: R. Löwit, 1917), 175–92; Isaiah Gafni, *The Jews of Babylonia in the Talmudic Era: A Social and Cultural History* (Jerusalem: Zalman Shazar Center, 1990), 121–25 (Hebrew); idem, "Expressions and Types of 'Local Patriotism' among the Jews of Babylonia," in *Irano-Judaica II*, ed. S. Shaked and A. Netzer (Jerusalem: Ben Zvi, 1990), 63–72; Richard Kalmin, *The Sage in Jewish Society of Late Antiquity* (Routledge, forthcoming), 115–33, and "Genealogy and Polemics," *HUCA* 67 (1996), 77–94.

97. The BT consequently devotes considerable attention to defining the geographic boundaries of Babylonia so as to identify the Jewish communities of superior lineage (*meyuhasot*). bQid 71a–b ranks geographic areas according to the purity of their lineage and asserts that various Babylonian cities "are as the diaspora in respect to lineage." See Gafni, "Expressions and Types of 'Local Patriotism.'"

98. bQid 71b. Other traditions report that certain Babylonian families were descended from slaves and have other taints in their lineage (bQid 70b). See also Rav Papa's statement, bYev 63a. And see the story of the prospective marriage between the son of Rabbi Yehuda HaNasi and the daughter of R. Hiyya, bKet 62b. The story essentially attributes the sudden death of the bride to an inequity in the lineage of the two families, that Rabbi descended directly from King David whereas R. Hiyya descended from King David's brother. Fortunately, providence prevented such an offensive union.

99. *mishpehot meyuhasot;* bQid 70b. The BT attributes the tradition to R. Hama b. Hanina, a Palestinian. But it is not found in the PT and reflects BT values.

100. Geoffrey Herman, "Hakohanim bebavel bitequfat hatalmud" (master's thesis, Hebrew University, 1998).

101. Ibid., 85–92. Given Goodblatt's assessment of the rise of rabbinic academies in Babylonia (see Chap. 1, "The Social Setting of the Redactors"), these later traditions are anachronistic. If not heads of the academy, these were nevertheless the most prominent Babylonian Amoraim of their time and leaders of disciple-circles.

102. Rav Hisda was a priest, Rav Papa and Rav Yeimar married daughters of priests.

103. Priests: Rabba bar Nahmani, Abaye, Rav Kahana, Rav Aha b. Rabba. Nonpriests who married daughters of priests: Rav Yehuda and Rava.

104. Herman, "Hakohanim bebavel bitequfat hatalmud," 92–96. See also Isaiah Sonne, "The Paintings of the Dura Synagogue," *HUCA* 20 (1947), 272 n. 22. Sonne notes that Babylonian sages asserted that Moses served as high priest and comments:

> It may be noted in passing that priesthood seems to have retained much more of its dignity and prestige in Babylonia than in the Palestinian center. In Babylonia, indeed, the priests, even during the Talmudic period, seem to have formed the majority of the learned nobility. Most of the famous Babylonian scholars were *Kohanim* (e.g.: Mar Samuel, R. Eleazar ben Pedat, R. Ami, R. Asi, R. Hisda, Rabba, Abaye, and Rava). It is also reflected in the following facts: a) There is a Babylonian Talmud on the fifth order of the Mishnah which deals mainly with matters concerning the sacrificial cult, but there is no Palestinian Talmud on this order; b) the Babylonian scholars were much more acquainted with the *Torah Kohanim (Sifra)*, the halakhic Midrash on Leviticus, than were the Palestinian scholars.

There is also evidence that Babylonian sages supported the claims of priests to collect priestly gifts and tithes, and that sages of priestly descent collected priestly gifts themselves. See Herman, "Hakohanim bebavel bitequfat hatalmud," 16–64; Moshe Beer, *The Babylonian Amoraim: Aspects of Their Economic Life*[2] (Ramat-Gan: Bar-Ilan University Press, 1982), 245–48, 350–62 (Hebrew); and Neusner, *History,* 2:260–62 and 4:143–49. According to Beer, 247–48, even Babylonian Amoraim of nonpriestly descent sometimes received the priestly tithes, which suggests that they "transferred to themselves the privileges that law and tradition conferred to the priests." (The degree to which such tithes and gifts were obligatory after the destruction and in the diaspora was debated.)

105. G. Alon, "The Sons of the Sages," in *Jews, Judaism and the Classical World,* trans. I. Abrahams (Jerusalem: Magnes, 1977), 436–57. See also the sources quoted by Raphael Yankelevitch, "Mishqalo shel hayihus hamishpahti behevra hayehudit be'erets-yisra'el bitequfat hamishna," in *'Uma vetoldoteha,* ed. M. Stern (Jerusalem: Shazar Institute, 1983), 156–62.

106. "The Sons of the Sages," 443.

107. "The Sons of Moses in Rabbinic Legend," *Bar-Ilan Annual* 13 (1976), 149–57 (Hebrew). Beer notes that some rabbinic homilies take great pains to explain why Moses's sons did not succeed him, while others depict God explaining to Moses that his sons will not inherit his "honor (*kavod*) because they did not busy themselves with Torah." The former apparently assumed that

Moses "Our Rabbi" should have bequeathed his rabbinic office to his sons were it not for exceptional mitigating factors, while the latter polemicize against a view that even unlearned sons inherit their fathers' positions. Behind these traditions Beer discerns a widespread debate over the question of whether and under what circumstances rabbinic position passes as an inheritance within the family. The Patriarchate, of course, was a family dynasty, and may have been one source of this debate. See too Beer's article "The Sons of Eli in Rabbinic Legend," *Bar-Ilan Annual* 14–15 (1977), 79–87 (Hebrew), and Cohen, *The Three Crowns*, 242–43. In "Torah and Derekh Eretz," *Bar-Ilan Annual* 2 (1964), 141–42 (Hebrew), Beer identifies aristocratic tendencies regarding the study of Torah in late second temple times.

108. Most interesting is the lengthy account of the deposition of Rabban Gamaliel in bBer 27b–28a. See Steinmetz, "Must the Patriarch Know Uqtzin?" who relates this story to ours (and see the following note). The many connections include: conflict between the sages and the Patriarch, exclusion from the academy, a dream, honor, public humiliation, and appeasement. Lineage figures in this story in several ways. First, after the sages depose Rabban Gamaliel from his position as head of the academy they decide not to appoint Akiba on the grounds that he has no "ancestral merit" (*zekhut 'avot*). Rather they appoint Eleazar b. Azariah "because he is wise and rich and is tenth [generation in descent] from Ezra." Second, Yehoshua initially disdains Rabban Gamaliel's apology and only relents when Gamaliel petitions him, "Accept it for the honor of my father's house." Even Yehoshua, despite being shamed by Rabban Gamaliel, respects his family lineage and forgives him for that reason. Third, when Yehoshua informs the sages that he has been appeased and Rabban Gamaliel should be restored, he uses priestly imagery. He first tells them that only "he who was invested with the robe" should wear it, and then says, "Let a sprinkler the son of a sprinkler sprinkle." The robe is the priestly robe, while the sprinkling refers to the ritual of the red cow, the exclusive prerogative of priests, and the repeated "son of sprinkler" emphasizes descent. Unlike our story, the Patriarch is successfully deposed. But like ours, the Patriarch, in the end, remains Patriarch primarily because of his lineage. This story also bases rightful claims to academic leadership on distinguished lineage.

Another relevant source is the interpretation of R. Yehuda HaNasi's deathbed testimony that "Shimon my son will be Sage; Gamaliel, my son will be Patriarch, Hanina b. Hama will sit at the head" (bKet 103b; cited by Steinmetz, "Must the Patriarch Know Uqtzin?"). The BT reads the first directive as "Shimon my son is wise" (*shimon bni hakham*) and then reads the clause as a concessive: *although* Shimon (the younger son) is wise, i.e., more proficient in Torah, *nonetheless* Gamaliel (the firstborn) will become Patriarch. The *sugya* explains

that R. Yehuda HaNasi had to specify that his firstborn son should be Patriarch because standard primogeniture would not apply in this case. Gamaliel did not suitably fill "the place of his forefathers," i.e., he was not proficient in Torah. Here too there is a tension between knowledge and lineage (in this case the status of the firstborn) for inheriting Patriarchal office. On the Babylonian nature of this entire section see Cohen, "Patriarchs and Scholarchs," 84–85.

109. bMen 53a, cited in Herman, "Hakohanim bebavel bitequfat hatalmud," 91. For this reading see *DQS* ad loc. While R. Preda is apparently Palestinian, this story appears only in the BT and reflects Babylonian values. Beer, "The Sons of Moses" (153 nn.) refers to the story of the deposition of Rabban Gamaliel (see the previous note) and to our story, and also (157) to bMen 53a. He too recognized the common thread among these traditions.

110. However, some manuscripts read, "If he is the offspring of nobility and a scholar, *that is well*" (*ya'e*) in place of "that is even better" (*ya'e veya'e*). I think this reading resulted from a scribal omission of the repeated word and should be seen as a corruption. If authentic, this textual tradition may imply that distinguished pedigree confers no advantage. Whether one is simply a scholar or a scholar with pedigree, "that is well." For this interpretation, see Urbach, *Sages*, 639. Here the different textual traditions themselves reflect different perspectives on the value of lineage relative to Torah. It should be noted that the Talmud continues with a homily that praises the forefathers Abraham, Isaac, and Jacob, a leading source of ancestral merit.

111. On the exalted status of Ezra in the BT, see, e.g., bSanh 21b (=tSanh 4:7): "Had not Moses preceded him, Ezra would have been worthy to receive the Torah." See also bSuk 20a and Kalmin, *The Sage in Jewish Society of Late Antiquity*, 25–29.

112. Translation from Robert Brody, *The Geonim of Babylonia and the Shaping of Medieval Jewish Culture* (New Haven: Yale University Press, 1988), 51, based on the original Arabic. Cf. Goodblatt, *Rabbinic Instruction*, 161–62.

113. Geoffrey Herman, "Priests and Amoraic Leadership" (paper presented at the Twelfth World Congress of Jewish Studies, Jerusalem, 1997). See also his article, "The Relationship between Rav Huna and Rav Hisda," *Zion* 61 (1996), 263–79 (Hebrew).

114. See Gafni, *The Jews of Babylonia*, 126–29; Kalmin, *The Sage in Jewish Society of Late Antiquity*, 115–33; Ehsan Yarshater, "Introduction," and "Iranian National History," xxxvii–xlii and 393–411; Arthur Christenson, "Sassanid Persia," in *The Cambridge Ancient History*, vol. XII, ed. S.A. Cook et al. (Cambridge: Cambridge University Press, 1956), 114–18.

115. Yarshater, "Iranian National History," 397–98. Yarshater mentions "the well-known story of a shoemaker" to illustrate this point: "He is prepared to

provide Khusrau I with four million drachmas so that the king can equip his army in a desperate war against the Byzantines. All the shoemaker asks is that his son be allowed to enter the ranks of the bureaucrats (*dabiran*). The king, however, forgoes the money rather than allow such a corruption of the ranks."

116. Yarshater, "Introduction," xl.

117. Yarshater, "Iranian National History," 406. The tactic of disparaging the ancestry of a rival is perhaps reflected in BT traditions that "whoever claims descent from a Hasmonean is nothing but a slave," bQid 70b. Where some rabbis or nonrabbinic Jews claimed descent from the Hasmonean priest-kings, these traditions sought to destroy the basis for their claim. See Kalmin, *The Sage in Jewish Society of Late Antiquity*, 134–47. See also bQid 70a–70b for numerous traditions concerning the impure lineage of various families and villages. A passage in bQid 76a observes, "when men feud with each other they feud about family lineage," which suggests that such aspersions were commonplace.

118. If we take lineage in the story as a symbol of status based on any consideration other than Torah, rather than pedigree specifically, then the conflict can be analyzed along general Weberian lines. In hierarchical and bureaucratic institutions positions of leadership and rank are not always based on merit. Patient plodding up the bureaucratic ladder, not to mention political connections, personal influence, bribery, and other such factors, sometimes promote less deserving individuals to positions of leadership and high rank. Even when a leader attained his position by merit, he will not be replaced immediately — or in some cases ever — if he loses his merit or another candidate proves more deserving. Similarly, some sages may have obtained positions of leadership although they were not superior in rabbinic merit, i.e., Torah. Others may have become leader initially because of their outstanding proficiency, but as years passed and age took its toll, as other duties demanded attention or general laziness and complacency set in, as a brilliant young prodigy rose to prominence or a star arrived from elsewhere, their knowledge of Torah became inferior. So it is likely that at times the head of the academy was not most proficient in Torah. The greater the disparity between the proficiency of the leader and others, the more incongruous the situation. At such times some sages probably believed that they should be leader and considered exposing the current leader's inferior knowledge. Thus the story can be seen as an expression of the general problems of leadership of the academy. However, I feel that this analysis does not sufficiently account for the specific emphasis on lineage or the juxtaposition with mHor 3:8.

119. bBB 89a; bQid 70a; yTa 4:2, 68a. See David Goodblatt, *The Monarchic Principle: Studies in Jewish Self-Government in Antiquity* (Tübingen: J. C. B.

Mohr, 1994), 290–97. And see Michael Satlow, "A Historical Source? B. Baba Batra 7B–8A," *JSJ* 28 (1997), 314–20, for arguments that the BT redactors invented pseudohistorical traditions about the Patriarch for polemical purposes.

120. For general sources on the Exilarch see Beer, *Exilarchate*; Neusner, *History*, 2:108–24, 3:41–94, 4:73–124, 5:24–27, 248–59.

121. yYom 7:1, 44a = ySot 7:6, 22a; I. Gafni, "The Rod and the Scepter: On New Types of Leadership in the Age of the Talmud," in *Kehuna umelukha*, ed. I. Gafni and G. Metzkin (Jerusalem: Zalman Shazar Center, 1987), 84–85 (Hebrew); Goodblatt, *Monarchic Principle*, 290–97.

122. In earlier times the Exilarchs remained at some distance from rabbinic circles, although they sometimes appointed rabbis to bureaucratic positions and granted them honors or exemption from taxes. In the third or early fourth centuries it seems that the Exilarchs became more involved in rabbinic enterprises. See Neusner, *History*, 5:248–49; Beer, *Exilarchate*, 50–51.

123. See bBer 46b, bShab 55a, bBQ 59b, bGit 67b, and Neusner, *History*, 4:105–17.

124. M. Beer, "The Dispute of Geniva with Mar Uqba," *Tarbiz* 31 (1962), 281–86 (Hebrew); Neusner, *History*, 3:75–81. So too I. S. Zuri, *The Reign of the Exilarchate and the Legislative Academies* (Tel Aviv: Mizpah, 1938), 210–20 (Hebrew), who claims that the Exilarch began appointing the head of the Nehardea Academy after the death of Rava, and the heads of other academies slightly later.

125. bGit 62a. See also bGit 31b. bGit 65b mentions Geniva "going out in chains."

126. Neusner, *History*, 3:75–81; 4:91–124.

127. Neusner, *History*, 3:79: "Geniva was not *opposing* a new development, but himself undertaking a revolution. He was the first significant figure both to see the 'incongruity' of rabbinical subservience to the Exilarch, something Rav, Samuel, R. Nahman, R. Huna and others never openly recognized, and to do something about it."

128. bAZ 38b and bGit 67b. See Neusner, *History*, 5:54–55 and 3:85–86.

129. Moreover, the sages showed (were forced to show?) tremendous deference and honor to the Exilarch; see Beer, *Exilarchate*, 160–78. Some sages visited the Exilarch to pay their respects every day or on Sabbaths and festivals (yTa 4:2, 68a; bSuk 26a; Gafni, "The Rod and the Scepter," 84; Beer, *Exilarchate*, 162–65). The sages looked on as the Exilarchs and their families were carried in decorated chairs, a mark of great honor. They granted the Exilarch various legal dispensations (bBes 25b; Beer, *Exilarchate*, 172–77; Neusner, *History*, 3:3–75). The sages may have said special prayers for the welfare of the Exilarch and his household. In one story Rav Nahman instructs Rav Yehuda

to obey a summons to the court of the Exilarch, not because he is legally required, but because of "the honor of the house of the Patriarch (=Exilarch)," a phrase that echoes R. Yehuda HaNasi's words in our story. At the same time, some sages probably objected to honoring the Exilarch, their inferior in Torah, especially in the academy, court, or similar setting. Many stories indeed tell of sages resisting a show of honor to the Exilarch (bGit 31b, bQid 70a-b, bBQ 58b, bEruv 25b–26a, bSanh 38a, etc.). Thus the sages were divided on this issue, and in different times, depending on the personal qualities of the Exilarch, the question would be more acute. The story may be responding to this cultural tension.

130. Joel Florsheim, "The Establishment and Early Development of the Babylonian Academies, Sura and Pumbedita," *Zion* 39 (1974), 185–86 (Hebrew); Gafni, "The Rod and the Scepter," 89–90 and n. 64. A similar criticism appears in Kalmin, *Sages, Stories, Authors*, 26–27, 227–29.

131. Neusner, *History*, 4:92–94.

132. See the introduction to the third edition of his *History*, 1:xxiv–xxxvi: "There is not a page, not a paragraph, not a sentence in this book that I could write today exactly as I wrote it twenty years ago" (xxxiv).

133. On the relationship between Exilarchs and Geonim see Brody, *Geonim*, 75–82.

134. *'Iggeret rav sherira ga'on*, ed. B. M. Lewin (Berlin, 1921), 92. See too *Seder 'olam zuta* in Felix Lazarus, "Die Haupter der Vertriebened," *Jahrbücher für jüdische Geschichte und Literatur* 10 (1890), 165–66.

135. See Alexander Goode, "The Exilarch in the Eastern Caliphate," *JQR* NS 31 (1940–41), 154–58; S. Assaf, "Gaon," *Encyclopedia Judaica*, 7:315–16; Brody, *Geonim*, 77–79. Indeed, David b. Zakkai deposed Rav Saadia Gaon (two years after appointing him!) and appointed in his place Rav Yosef bar Yaakov, scion of a noble family that had produced several Geonim, but whom Rav Sherira Gaon describes as "younger and less learned than Rav Saadia" (*'Iggeret*, 118). See Simha Assaf, *Tequfat hage'onim vesifruta* (Jerusalem: Rav Kook, 1955). On the Exilarch attempting to control the leadership of the Palestinian Gaonate see Moshe Gil, *A History of Palestine, 634–1099*, trans. E. Broido (Cambridge: Cambridge University Press, 1992 [1983]), 542.

136. Brody, *Geonim*, 41–42.

137. See Chap. 8, "The Academy."

138. See Avraham Grossman, "From Father to Son: The Inheritance of the Spiritual Leadership of the Jewish Communities in the Early Middle Ages," *Zion* 50 (1985), 189–204 (Hebrew), and S.D. Goitein, *A Mediterranean Society*, Vol. II, *The Community* (Berkeley: University of California Press, 1971), 14–20. The office did not always pass directly from father to son, but often to another

member of the family, at least initially. Goitein observes that "the Gaon promoted or demoted the members of the academy and could expel undesirable elements altogether" (14).

Chapter 7  Torah, Gentiles, and Eschatology (Avoda Zara 2a–3b)

1. Ofra Meir, *The Darshanic Story in Genesis Rabba* (Tel Aviv: Hakibbutz Hameuhad, 1987), 63 (Hebrew).

2. Some of the comments include traditions formulated in Hebrew from other sources, but because of their framing within the commentary, they are clearly delineated from the body of the homily. The version of the midrash in *Tanhuma, Shofetim* §9 (651–52) = *TanhumaB, Shofetim* §9 (5:31–32) already removes most of the Aramaic additions (see below n. 5) as does Israel ibn Al-Nakawa, *Menorat hama'or*, ed. H. G. Enelow (New York: Bloch, 1929), 3:212. A. Mishcon, the translator of the tractate in the Soncino series, accurately marks off the additions with parentheses (*'Abodah Zarah* [London: Soncino Press, 1935], 2–8). Isaac Hirsch Weiss, *Davar 'al 'odot hatalmud* (Pressburg, 1885), an essay devoted to the difficulties of translating the multitiered talmudic style in an intelligible manner, presents this homiletical story among his examples. Hirsch separates the Aramaic comments and prints them in the margins in different type. Asher Hilvitz, "Leharkava shel derashat ha'aggada be-reish masekhet 'avoda zara," *Sinai* 80 (1977), 119–40, separates the "talmudic expansions" from the "original version." He prints the comments in separate columns and discusses each in turn. See too R. Hammer, "Complex Forms of Aggadah and Their Influence on Content," *PAAJR* 48 (1981), 186 and n. 4; W. Bacher, *'Aggadat 'amora'ei 'erets yisra'el* (Tel Aviv: Devir, 1924), vol. 1, pt. 2, 327 n. 6; Joseph Heinemann, *Derashot betsibbur bitequfat hatalmud* (Jerusalem: Mossad Harav Kook, 1982), 67–69; Jacob Neusner, *The Bavli's Massive Miscellanies: The Problem of Agglutinative Discourse in the Talmud of Babylonia* (Atlanta: Scholars Press, 1992), 49–71; and Louis Jacobs, "Israel and the Nations: A Literary Analysis of a Talmudic Sugya," *The Tel-Aviv Review* 2 (1989/90), 372–83.

3. The comments must be from the redactors, not the Amoraim, since they transfer traditions from other talmudic passages.

4. This seems to be true of the story of Hillel and the Bnei Betera, bPes 66a. The BT version of the story differs significantly from that of its source, tPes 4:13 (and from the version at yPes 6:1, 33a.) A series of comments also has been appended to the end of the story. (In printed texts several of the comments are introduced by the term *'amar mar*, which is typically used to introduce a passage from a tradition previously quoted in full. The manuscripts lack some or all of the terms.)

It is difficult to date the addition of the comments to the homiletical story. Several comments borrow portions of completed *sugyot*, which points to a date well into the Saboraic period. The comment printed below in note *h*, for example, borrows verbatim from bBQ 38a (although it is possible that both bBQ 38a and bAZ 2b inserted the same preexistent *sugya*). This *sugya*, moreover, quotes Mar b. Rav Ashi, one of the last Amoraim. And with one exception, all of the traditions quoted in the comments appear elsewhere in the BT, which again points to a relatively late date when most of the Talmud was already redacted as *sugyot*. Yet that exception, the tradition attributed to R. Yohanan in note *f* below, is telling. It requires a date during the period when Amoraic traditions were still being formed into *sugyot*. This period was prior to a period of redaction during which *sugyot* were expanded or created by transferring and borrowing traditions redacted elsewhere, but when "new" Amoraic traditions (i.e., traditions not found in the proto-Talmud) were no longer incorporated. At least this comment, then, must predate the later period of redaction. It should be noted, moreover, that many tractates begin with Saboraic *sugyot*, as Avraham Weiss has argued in *The Literary Activities of the Saboraim* (Jerusalem: Magnes, 1953) (Hebrew). And see below on the literary and halakhic contexts, and especially n. 46.

5. The earliest parallel appears in the *Tanhuma*, generally dated to the seventh or eighth century (above n. 2). Most manuscripts of the *Tanhuma* were influenced by the text of the BT, and clearly that has happened here. The *Tanhuma* incorporates into its version the revised question of the gentiles proposed by one of the Aramaic comments (see note *f* of the translation below), and deletes the original Hebrew questions (IIA–IIB in the translation.) Thus the *Tanhuma* presents an emended version of the give-and-take based on the post-Amoraic Aramaic comments. In so doing the *Tanhuma* eliminates two of the exegeses of Isa 43:9, the verse which generates the homiletical story (IIA–IIB below). All this proves beyond a doubt that the *Tanhuma* editors (or copyists) borrowed from and revised the BT.

6. To avoid confusion let me repeat: it is unclear whether the redactors reworked the homiletical story or preserved it intact. But there is no doubt that they added the Aramaic comments, which are either unattributed or transferred from elsewhere.

7. Joseph Heinemann, *Aggadah and its Development* (Jerusalem: Keter, 1974), 165–74 (Hebrew). He refers to our text on 167–68. On the more limited tendency in the PT see Heinemann, 168–69, and Hezser, *Rabbinic Story in Yerushalmi Neziqin*, 254–62.

8. Chap. 3, section III' of the translation; Chap. 5, section H1–H2.

9. On the history of footnotes and the transition from glosses to footnotes,

see Anthony Grafton, *The Footnote: A Curious History* (Cambridge: Harvard University Press, 1997), 23–33. Grafton observes that "only the use of footnotes enables historians to make their texts not monologues but conversations, in which modern scholars, their predecessors, and their subjects all take part" (234). I think the Aramaic comments of the redactors create a similar "conversation" with their predecessors, the authors of the story.

10. See Saul Lieberman, "The Publication of the Mishnah," in *Hellenism in Jewish Palestine*, 83–99, and Gerhardsson, *Memory and Manuscript*. See also the articles by Martin Jaffee (n. 13) and the references there. On orality in the Geonic period see Brody, *Geonim*, 156–61.

11. See Gerhardsson, *Memory and Manuscript*, 147; Avigdor Shinan, "The Aggadic Literature: Written Tradition and Oral Transmission," *Jerusalem Studies in Hebrew Folklore* 1 (1981), 44–60 (Hebrew).

12. Lieberman, *Hellenism in Jewish Palestine*, 87–88.

13. Martin S. Jaffee, "Writing and Rabbinic Oral Tradition: On Mishnaic Narrative, Lists and Mnemonics," *Journal of Jewish Thought and Philosophy* 4 (1994), 123–46, and "How Much 'Orality' in Oral Torah? New Perspectives on the Composition and Transmission of Early Rabbinic Traditions," *Shofar* 10 (1992), 212–33.

14. See Gerhardsson, *Memory and Manuscript*, 115–16.

15. See Avram Reisner, "The Character and Construction of a Contrived Sugya: Shevuot 3a–4a," in *New Perspectives on Ancient Judaism*, vol. 4, ed. Alan J. Avery-Peck (Lanham, Md: University Press of America, 1989), 47–72.

16. The thorough interspersing of story and comments supports Jaffee's thesis of composition in writing. It is difficult to see how a two-tiered text of such complexity could be composed without the aid of writing to keep the strata distinct. The Hebrew homiletical story may well have been transmitted orally for generations, and some traditional comments may have accrued to it. But the composition of the current text with the embedding of lengthy and discursive Aramaic comments suggests the mediation of writing.

17. However, the homilist himself cites Gen 25:23 to prove that "people" refers to a kingdom and Deut 4:44 to prove that "this" refers to Torah. And God cites a clause from Isa 43:9 in his response to the first question of the nations (IIA).

18. This was noted by Heinemann, *Derashot*, 68. On threefold structures see Louis Ginzberg, *Ginzei shechter I* (New York: Jewish Theological Seminary, 1928), 24, who notes, "three examples of this matter are brought in the passage, as is typical of the aggada and the halakha." Friedman, "Some Structural Patterns of Talmudic *Sugiot*," demonstrates that units of three characterize numer-

ous *sugyot* in the Babylonian Talmud. See too Friedman, "Pereq ha'isha rabba babavli," 316–19, and the references there.

19. In the Bible *bw'* is sometimes a technical term meaning "come for judgment." See Ps 143:2; Job 9:32, 22:4.

20. See Claus Westermann, *Isaiah 40–66: A Commentary*, trans. D. Stalker (Philadelphia: Westminster Press, 1969); idem, *Forschung am Alten Testament* (Munich: Chr. Kaiser Verlag, 1964), 135–44; idem, *Old Testament Form Criticism*, ed. John H. Hayes (San Antonio: Trinity University Press, 1974), 165–67; J. Begrich, *Studium zu Deuterojesaja* (Munich, 1920), 26–48.

21. Westermann, *Isaiah*, 120. D. Karl Marti, *Das Buch Jesaja* (Tübingen: J. C. B. Mohr, 1900), 297–98, suggests the subject switches from the nations to their witnesses: Let them (the nations) bring their witnesses and be justified, and they (the witnesses) may say, 'So it is.'"

22. See John L. McKenzie, *Second Isaiah* (Garden City, N.Y.: Doubleday, 1968), 52, and see the note in the New JPS translation.

23. Cf. Isa 41:21–29: "Submit your case, says the Lord; Offer your pleas, says the King of Jacob. Let them approach and tell us what will happen. Tell us what has occurred, or announce what will occur, that we may know the outcome." Isa 41:1–5: "Stand silent before Me, coastlands, and let nations renew their strength. Let them approach to state their case; let us come forward together for argument. Who has roused a victory from the East, summoned him to His service? [Who] has delivered up nations to him, and trodden sovereigns down?" See also Isa 44:6–8, 45:20–25; Begrich, *Studium*, 19–42; and Westermann, *Forschung*, 134–37 (above n. 20).

24. In technical terminology, the scene is a *Völkerkampf*. See Gunther Wänke, *Die Zionstheologie der Korachiten* (Berlin: Alfred Töpelmann, 1966), 74–92; R. J. Clifford, *The Cosmic Mountain in Canaan and the Old Testament* (Cambridge: Harvard University Press, 1972), 152–54.

25. H.-J. Kraus, *Psalms 1–59: A Commentary*, trans. Hilton C. Oswald (Minneapolis: Augsburg, 1988), 123–35, and see the literature cited there; S. Mowinckel, *The Psalms in Israel's Worship*, trans. D. R. Ap-Thomas (Oxford: Blackwell, 1962), 1:46–50, 62–63.

26. In the form *hargishu*. There Darius's ministers conspire to charge Daniel with violating the law, much as the nations accuse Israel in the story. (*Ragshu* is translated "assemble" in the New JPS; "be in an uproar" in the old JPS. See the standard biblical dictionaries.)

27. Sages are often depicted carrying a Torah scroll in their bosom. See, e.g., mSot 7:7, bAZ 18a, bSuk 41b.

28. bQid 30a.

29. Cf. the manuscript variants in the Appendix. Some text witnesses add "Complete idiots" here too, which appears in ms Paris only in section IIC.

30. The story takes a minor liberty with the biblical text by changing the original third person "who among them" to "who among you" in order to frame a direct dialogue (assuming the homilist's text matched the Masoretic text here). See the discussion of the biblical passages above.

31. "Persian" in the Babylonian Talmud, refers to the Sasanians. See Gafni, *The Jews of Babylonia*, 156. The reference obtains whether we treat the homiletical story as a third-century source on the basis of the attributions or a product of the fifth- to seventh- century redactors. It is interesting to note that the Romans and "Persians" fought major battles in 231–33, 253–60, and again in 283–84. The Sasanians heavily defeated the Romans in 260 C.E. If the homilist lived at this time (as R. Simlai and R. Hanina b. Papa in fact did) it explains why he attributed claims of military prowess to the "Persians" rather than to the Romans.

32. This reversal bothered the traditional commentators. See the commentary *Hiddushei hage'onim* in *EY*, ad loc.: "These matters require explanation. How can God, who is witness and judge, debate (*lefalpel 'atsmo*) with the nations." This reaction fails to appreciate the satirical and humorous tone.

33. The dismissal of God's testimony recalls the "Oven of Akhnai," Chap. 2, where the sages reject God's testimony that R. Eliezer's opinion is correct.

34. The contextual meaning of the verse is: "As surely as I have established My covenant with day and night—the laws of Heaven and Earth—so I will never reject the offspring of Jacob and My servant David." The exegesis turns the verse on its head: God created the world only for the sake of the Torah, his covenant with his people.

35. The four served as Job's "comforters." Eliphaz the Temanite, Bildad the Shuhite, and Zophar the Naamathite appear together in Job 2:11. Elihu ben Barachel the Buzite, their younger contemporary, surfaces in Job 32.

36. *GenR* 38:13 (363–64). And see Louis Ginzberg, *Legends of the Jews* (Philadelphia: The Jewish Publication Society, 1909–38), 1:197–203 and notes.

37. Maharsha, in his commentary, asks why Bilaam, a true prophet of the nations, is not called to witness. Certainly he is precisely the type of "expert witness" whose testimony would be most compelling. But unlike the characters summoned, he never compelled Israel to violate the Torah.

38. Heinemann, *Derashot*, 67, emphasizes the satirical tone.

39. tAZ 8:4.

40. The indictment of the nations hides one ironic twist. In the course of the dialogue the nations quote scripture to disqualify God and then Heaven and Earth from testifying. Whereas at the outset God had accused the nations

of not "speaking *this*," meaning Torah, here the nations proficiently cite the text. Apparently they have learned something of the holy writ. Then again, in rabbinic midrash everybody—and everything—quotes verses: Roman officials, Satan, infants, cows, even the personified days of the week. In other midrashim the "nations of the world" routinely quote scripture, and perhaps we should understand their unexpected familiarity with Torah in this context. See Heinemann, *Darkhei ha'aggada*, 39–43 and especially 40. Moreover, by citing Torah the nations again subvert their own cause. Their mastery of the text and exegetical adroitness compromise the initial defense that they never received the Torah.

41. bBer 57b; cf. bShab 118a and mTam 7:4.

42. We noted in Chap. 4 that the BT redactors attribute to R. Yehuda *praise* for the Romans on account of these accomplishments.

43. Isa 1:8; Amos 9:11.

44. Cf. Maharsha, ad loc.

45. This prohibition, like many of the laws of the tractate, attempts to distance Jews from any involvement in idolatry. The Mishna is concerned that the gentile will use the items for his celebration, or that he will thank his god for the successful business transaction, and consequently the Jew unwittingly will have contributed to idolatrous worship.

46. David Rosenthal, "'Arikhot qedumot batalmud," in *Mehqerei talmud I*, ed. Y. Sussmann and D. Rosenthal, 179–80. Hilvitz, "Leharkava shel derashat ha'aggada," 125–27, dates the insertion of the story to Geonic times based on stylistic anomalies.

47. In this case the Talmud is correct to defend both variants although the suggested etymologies are fanciful. Kohut, *'Arukh*, 1:32 refers to the Syriac *'ida* and the targum to Prov 7:20, *yoma de'eida*. On the other hand the targum to Esth 1:3 reads *yoma de'eida*. See also Jastrow, *Dictionary*, 45.

48. See Friedman, "Pereq ha'isha rabba babavli," 324–25.

49. The attribution to Rav Huna b. Rav Yehoshua at F presents no objection to this reconstruction. He responds not to the anonymous sections of the objection at E, but to the tradents of the prooftexts. He originally commented directly on A, the Amoraic disagreement. Sections A1 and D are typical Stammaitic formulations.

50. Weiss, *The Literary Activities of the Saboraim*, argues that the first *sugya* of many tractates derives from the Saboraim, and several function as introductions to the content of the tractate. See n. 4.

51. See also Jeffrey L. Rubenstein, "An Eschatological Drama: Bavli Avodah Zarah 2a–3b," *AJSR* 22 (1996), 27–35, which discusses the meaning of the homiletical story in relation to the festival of Sukkot.

52. Robert Cover, "The Supreme Court, 1982 Term—Foreword: *Nomos*

and Narrative," *Harvard Law Review* 97 (1983), 4–68. See also the discussions of Cover's work in *Yale Law Journal* 96:8 (1987).

53. See George Foot Moore, *Judaism in the First Centuries of the Christian Era* (Cambridge: Harvard University Press, 1927–30), 2:279–398; E. P. Sanders, *Paul and Palestinian Judaism* (Philadelphia: Fortress Press, 1977), 206–11. See too Urbach, *Sages*, 542–54, and Paula Fredriksen, "Judaism, the Circumcision of Gentiles, and Apocalyptic Hope: Another Look at Galatians 1 and 2," *JTS* 42 (1991), 544–48; Sacha Stern, *Jewish Identity in Early Rabbinic Writings* (Leiden: Brill, 1994), 22–50.

54. Many Jews are in the same situation vis-à-vis certain subsets of commandments—women and blind men vis-à-vis positive, time-bound commandments for example—yet are not dissuaded from observing them on the grounds that the reward is negligible. See bBQ 87a (= bQid 31a), bQid 34a–35a. On R. Hanina's comment, see Urbach, *Sages*, 324–26.

55. bSanh 105a, according to ms Munich 95. Printings have been corrupted or censored. Cf. tSanh 13:2. In many ways the tensions concerning the eschatological fate of gentiles in rabbinic sources mirror tensions within the biblical corpus.

56. See the fine discussion of this passage in Sanders, *Paul and Palestinian Judaism*, 208–9.

57. bSot 35b.

58. That this anxiety was not unjustified we know from the report of coercion at the end of note *f*.

59. See Moshe Idel, *Kabbalah: New Perspectives* (New Haven: Yale University Press, 1988), 156–57; 170–72. The term "universe maintaining activity" derives from Peter Berger and Thomas Luckman, *The Social Construction of Reality* (New York: Doubleday, 1966). On the development of the concept of Torah, see Jacob Neusner, *Torah: From Scroll to Symbol in Formative Judaism* (Atlanta: Scholars Press, 1988).

Chapter 8  Conclusion

1. See especially Fraenkel, *Darkhei ha'aggada vehamidrash*, 235–86, and Meir, *The Darshanic Story*, 51–75.

2. A few of Meir's studies distinguish the BT from other compilations, including her comprehensive study of character, "The Acting Characters in the Stories of the Talmud and the Midrash."

3. For additional examples see Fraenkel, "Paronomasia in Aggadic Narratives," 27–51, and *Darkhei ha'aggada vehamidrash*, 271–73 and 631 n. 81; Meir, *The Darshanic Story*, 68–69.

4. For example, Nahum of Gamzu opines, "This too (*gam zu*) is for the best" (bTa 21a); Joseph-the-Sabbath-Honorer is famous for honoring the Sabbath (bShab 119a); the names of the disciples of Jesus are explained symbolically in bSanh 43a. See also bBer 20a; bShab 49a, 108a; bSuk 48b; bBB 89a; and see Segal, *The Babylonian Esther Midrash*, 3:259. Sometimes sages gave each other derogatory names based on puns. See bKer 8a, bMQ 16b, bQid 70a and Adiel Schremer, "The Name of the Boethusians: A Reconsideration of Suggested Explanations and Another One," *JJS* 48 (1997), 299. Louis Jacobs, "How Much of the Babylonian Talmud is Pseudepigraphic?" 56–57, compiles numerous examples in which the name of the tradent relates to the content of the tradition. See also Shmuel Moshe Rubenstein, *Leheqer siddur hatalmud* (Jerusalem: Maqor, 1971 [Kovno, 1932]), 59–60. Symbolic naming is mandated by tAZ 6:4 and parallels: "All places named for idolatrous worship should be given disparaging appellations."

5. René Wellek and Austin Warren, *Theory of Literature*, 3d ed. (New York: Harcourt Brace Jovanovich, 1977), 219.

6. Michael Rifattere, *Fictional Truth* (Baltimore: Johns Hopkins University Press, 1990), 33.

7. Thus ʿakhnai (= snake) is simply a proper name in the PT (Hakhinai); Qamza (locust) appears as *kamtsora* in the geniza text of *LamR*.

8. Occasionally the Bible comments on the relationship between name and character. Abigail tells David of her husband Naval, "He is just what his name says: his name means 'boor' and he is a boor" (2 Sam 25:25).

9. Moshe Garsiel, "Puns upon Names as a Literary Device in 1 Kings 1–2," *Biblica* 72 (1991), 385. See also idem, "Homiletic Name-Derivations as a Literary Device in the Gideon Narrative: Judges VI–VIII," *VT* 43 (1993), 302–17, and *Biblical Names: A Literary Study of Midrashic Derivations and Puns*, trans. Phyllis Hackett (Ramat Gan: Bar-Ilan University Press, 1987). Garsiel uses the term "charactonym" to mean "symbolic names invented for the purpose of punning" ("Puns upon Names," 386).

10. E. S. McCartney, "Puns and Plays on Proper Names," *The Classical Journal* 14 (1919), 343–58; C. J. Fordyce, "Puns on Names in Greek," *The Classical Journal* 27 (1932), 44–46.

11. See also Fraenkel, *Darkhei ha'aggada vehamidrash*, 269–71.

12. For additional suggestions of ironically symbolic names see Saul Lieberman, *Greek in Jewish Palestine* (New York: Jewish Theological Seminary, 1942), 182 n. 195, and Joshua Schwartz, "Ben Stada and Peter in Lydda," *JSJ* 21 (1990), 10 n. 40.

13. Reversal ("peripeteia") is less a figure of narrative discourse than a property of the fabula, and is most often discussed in connection with drama.

14. For other reversals see the stories of Joseph the Sabbath-Honorer, bShab 119a; the man clearing rocks from his property, bBQ 50b (=tBQ 2:13); Solomon's servants who attempt to flee from the angel of death, but unfortunately flee to the very place the angel was expecting them (bSuk 53a; a close parallel to this story appears in yKil 9:4, 32c); the story of Hillel and the Bnei Betera, in which Hillel rebukes his colleagues for forgetting the law and then forgets a law himself (bPes 66a; the reversal also appears in the version of yPes 6:1, 33a, but not in the original source, tPes 4:13); the fable of the lame man and the blind man, bSanh 91a–b. On irony in PT stories, see Hezser, *Rabbinic Story in Yerushalmi Neziqin,* 309, 317.

15. Scholes and Kellogg, *The Nature of Narrative,* 180. However, Scholes and Kellogg distinguish "interior monologue" — which for them is represented *thought* — from represented speech, even when the speech is a monologue expressing the character's thoughts. They claim that the former is rare in antiquity precisely because of the lack of a distinction between thought and speech, i.e., the story represents the character's speech, not his thought. Others distinguish "interior monologue" from "interior monologue quoted by the narrator." I do not see the advantages of such distinctions. For general discussion of methods of representing consciousness, see Wallace Martin, *Recent Theories of Narrative* (Ithaca: Cornell University Press, 1986), 134–41, and Seymour Chatman, *Story and Discourse* (Ithaca: Cornell University Press, 1978), 173–95.

16. See Friedman, *Talmud ʿarukh,* 2:436–38.

17. *Art of Biblical Narrative,* 67–68. He too suggests of the biblical narrators that "with their strong sense of the primacy of language in the created order of things, they tended to feel that thought was not fully itself until it was articulated as speech" (68).

18. Perhaps the cause and effect are reversed: the proclivity for interior monologue results from the appeal of its dramatic quality to storytellers. The explanation of Scholes and Kellogg is not completely satisfactory, for the BT employs a distinct term for "thought" (*savar*) in both legal and narrative passages. (For narrative examples see bBer 10b, 20a; bKet 53a; bKet 77b [here some mss read "said"]; bBQ 117a; bSanh 107a [see *DQS*]; bSanh 101b.) Hence the storytellers may not have been completely constrained by the ancient confusion between thought and speech. This suggestion, however, raises thorny issues of intentionality.

19. Alter, *Art of Biblical Narrative,* 68. See also Martin, *Recent Theories of Narrative,* 134.

20. Because the third scene places Rabban Gamaliel alone on the ship it cannot employ dialogue, and so resorts to interior monologue: "He said, 'It seems to me that this is because of the Son of Hyrcanus.'"

21. These terms are defined in Chap. 1, "Translation and Terminology." See Genette, *Narrative Discourse*, 33–85; Rimmon-Kenan, *Narrative Fiction*, 46–51.

22. See Bal, *Narratology*, 63: "One more or less traditional form of anticipation is the summary at the beginning. The rest of the story gives the explanation of the outcome presented at the beginning."

23. See, e.g., the story attributed to R. Yehoshua b. Hanania, bEruv 53b, and the story of Nahum of Gamzu, bTa 21a.

24. However, the entire PT version of the "Oven of Akhnai" [2] is out of order.

25. The statement of R. Yohanan, "The meekness of Zecharia b. Avqulos destroyed our temple," also appears before the narration of that event [5].

26. Genette, *Narrative Discourse*, 52.

27. See also Chap. 2, end of the "Literary Analysis" section.

28. See Genette, *Narrative Discourse*, 36; Meir Sternberg, "Telling in Time (I): Chronology and Narrative Theory," *Poetics Today* 11 (1990), 901–48, and idem, "Telling in Time (II): Chronology, Teleology, Narrativity," *Poetics Today* 13 (1992), 462–541.

29. I hesitate to base conclusions on this small sample. However, it is worth noting that the story of Elisha b. Abuya in the PT featured significant anachronies and substantial distortions of chronological time [3]. The flashbacks to Abuya's evil intention, Elisha's sin on Yom Kippur and his theological crises are all external analepses, recounting events prior to the opening scene, at some length, and with considerable detail. Indeed, the flashback to Abuya forms a self-contained story in its own right. If representative, this contrast may point to a difference in narrative technique between the two Talmuds.

30. Martin Buber, *Darko shel miqra'* (Jerusalem: Bialik Institute, 1964), 284–307; Alter, *Art of Biblical Narrative*, 88–113. See also Michael Fishbane, *Text and Texture* (New York: Schocken, 1979), 40–62. Gerhardsson, *Memory and Manuscript*, 143–47, observes that a type of keyword is used in halakhic material. For a recent study that makes extensive use of keywords, see Helen Vendler, *The Art of Shakespeare's Sonnets* (Cambridge: Harvard University Press, 1997).

31. The problems begin when Rabban Shimon b. Gamaliel institutes a "teaching" and intensify when Meir and Natan plan to humiliate the Patriarch by inviting him to "teach us Uqsin." R. Yaakov then teaches, i.e., studies, behind the upper-story, and the next day R. Shimon b. Gamaliel teaches the tractate in public. In the final scene R. Yehuda HaNasi teaches his son and then changes his teaching to restore Meir's name. The double use of the keyword for both the ability to teach traditions and the power to institute or reformulate sources cuts to the heart of the fundamental conflict. As for "rise, raise," the

conflict begins when RSBG perceives that the sages rise both before him and before Meir and Natan, and heightens when the rabbis then "do not rise" for Meir and Natan. When R. Shimon b. Gamaliel triumphantly "stands up" his opponents (i.e., stymies them), he survives the ordeal and turns the tables. Later Meir and Natan are readmitted to the academy but "raised" (=designated) by the anonymous quotation formula.

32. On types of repetition in the Bible see Alter, *Art of Biblical Narrative*, 88–113; Sternberg, *The Poetics of Biblical Narrative*, 365–440. In general see Bruce Kawin, *Telling it Again and Again: Repetition in Literature and Film* (Ithaca: Cornell University Press, 1972).

33. See Chap. 7, n. 18.

34. The BT often concludes a discussion with the phrase, "Learn three things from this" (*shmaʿ mina telat*), and lists the three points. However, in some cases the Talmud fudges a point or lists a law and its opposite, so the three are really two. Halivni, *Meqorot*, 5:271–72 comments: "It appears that the expression 'Learn three things from this' turned into a catch-phrase, and they used it even when there were not exactly three." The classic examples of artificial argumentation are the *'eitivei* sequences involving R. Yohanan and Resh Laqish. The medieval commentators already realized that some of the purported dialogue never occurred. See bYev 35b–36a and Tosafot, s.v. *kulei;* and see the marginal note for further references. See also bNaz 16b–17a, and R. Asheri, s.v. *veha d'otvei:* "That which R. Yohanan responded to Resh Laqish above was in fact the Talmud responding according to what it assumed they disputed — and there are many such cases in the Talmud." In other words, the dialogue was constructed by the Talmud (=redactors); despite the attributions, it does not represent the actual words of the named sages.

35. "The Structure of Talmudic Legends," 45–97; *Darkhei ha'aggada vehamidrash*, 261–68.

36. See Mike Butterworth, *Structure and the Book of Zechariah* (Sheffield: Sheffield Academic Press, 1992), 1–61. Butterworth creates a hypothetical chapter of Bible by combining verses selected at random, and then finds a chiastic structure. His point, of course, is that many purported chiasms are artificial.

37. E.g., the chiastic form of the conversation of Meir and Natan does not play a part in the larger structure. See Chap. 6, "Structure."

38. See Friedman, "Some Structural Patterns of Talmudic *Sugiot*," and "Pereq ha'isha rabba babavli."

39. See Reisner, "Contrived Sugya," 47–72.

40. "Hermeneutic Problems," 157–63, and *Darkhei ha'aggada vehamidrash*, 237, 260–63.

41. One could perhaps argue that the stories with chiastic structures also

display closure. God and an angel (Elijah) rehabilitate a sage's (Meir's) name and teaching in the end, whereas God and an angel (Metatron) rejected a sage (Elisha) at the beginning [3]. Rava's statement that the Patriarch (R. Yehuda HaNasi) formulated a distinct quotation formula for Meir recapitulates the Patriarch (Rabban Shimon b. Gamaliel) formulating a tradition to promote his honor at the expense of Meir and Natan [6]. On the other hand, these cases require a degree of abstraction to create the closure. The events take place much later chronologically and concern different characters; from this point of view the stories are hardly closed. The other stories display no internal closure in any obvious sense [2], [5]. However, bGit 57a eventually does quote a *baraita* that refers back to Bar Qamza, but only after including several other stories.

42. See, e.g., "Hermeneutic Problems," 167–68. After appealing to an "external" tradition to explain an aspect of the story he analyzes, Fraenkel apologetically writes: "Again, we must ask whether relying on a 'distant' text such as this does not violate the closure of the story. And again the answer is that this explanation fits the internal unity of the story so tightly that no mistake has been made." In other words, external sources may be adduced when appropriate.

43. See Chap. 4, "Literary Analysis."

44. In technical terminology, this reuse of language is an *echo*, not an allusion. An echo occurs when "elements of an earlier text reappear in a later one, but the meaning of the marked sign in the source has little effect on a reading of the sign with the marker in the alluding text" (Benjamin Sommer, *A Prophet Reads Scripture: Allusion in Isaiah 40–66* [Stanford: Stanford University Press, forthcoming]). Sommer provides a superb discussion of intertextuality, allusion, echo, and related concepts.

45. Robert Goldenberg, "The Deposition of Rabban Gamaliel II: An Examination of the Sources," in *Persons and Institutions in Early Rabbinic Judaism*, ed. William Scott Green (Missoula, Mont.: Scholars Press, 1977), 15, takes "Rosh HaShana" and "firstling" (*bekhorot*) as the names of tractates and translates: "Last year he insulted him (in Rosh Hashanah), he insulted him in the incident of R. Sadoq (in Bekhorot)." Goldenberg comments that the tractate names are later glosses. If so, then a later hand has already recognized the cross-references and provided the citations!

46. For another example see the story of the death of R. Yose b. R. Eleazar, bBM 85a. The story explains that the burial cave of his father R. Eleazar did not open for R. Yose because "this one (the father) suffered in the cave but this one (the son) did not suffer in the cave." The reference is to our story [4]. The story of R. Yohanan and Resh Laqish's son, bTa 9a, alludes to the story of the two sages, bBM 84a. See also the story of R. Yose b. Avin, bTa 23b–24a (in

this case the BT quotes the referenced stories after concluding the first story). In bShab 59b Rav infers from Levi's appearance in Babylonia that Rav Afes died, which is explained by the story at bKet 103b. See also the story of the Hasmonean siege, bSot 49b = bBQ 82b = bMen 64b. bSot and bBQ conclude the story with a reference to a second story. In bMen the second story in its entirety follows the siege story. bKet 103b mentions great deeds of R. Ishmael b. R. Yose, which probably alludes to the story at bBM 84a. bSanh 26a mentions the three cowherds of bSanh 18b.

47. For example, in the Stammaitic stratum we often find the question, "And he who holds such-and-such (*uleman da'amar*), what would he say," even though that opinion is not cited in the *sugya* but appears in another discussion. Those of us without comprehensive proficiency in the BT must turn to the commentators to find the cross-reference.

48. This is not to say that stories cannot contradict or stand in tension. Fraenkel is undoubtedly correct that stories ought not to be harmonized.

49. See Jacobs, *Structure and Form in the Babylonian Talmud*, 105: "In the light of our investigation, it is necessary to go much further than Halivni to see the Stammaim as far more than mere editors of earlier material. They were, in fact, creative authors who shaped the material they had to hand to provide the new literary form evident in the passages we have examined and, indeed, on practically every page of the Babylonian Talmud."

50. In this case the composer of the Titus story may have transferred from the Gamaliel story. The direction of the transferring does not affect my basic claim.

51. Shraga Abramson, "Min peh lefeh," *Meḥqerei lashon* 2–3 (1987), 23–50, shows that Amoraim occasionally incorporate phrases from Tannaitic sources and earlier *meimrot* in their statements. But these quotations never amount to wholesale transference and adaptation such as that of the Stammaim.

52. See Chap. 4, n. 66.

53. The dialogue "Alas that you see me so . . . happy that you see me so . . . " derives from bTa 21a.

54. This phenomenon has been described by Friedman, "La'aggada hahistorit," 126–29, 139 and n. 106, 144–45.

55. As I argued in Chap. 1, I am assuming that the Palestinian versions preserved in our texts were not known verbatim in Babylonia, but are fairly close to the versions known to the redactors. The previous chapters substantiate this point.

56. The exchange between Eliezer and the sages after each of the three miracles is almost identical [2]. The statements of Meir and Yohanan are simi-

lar but not identical. Here the BT does not reproduce verbatim the text of the PT, but corresponds to the description or dialogue of the PT.

57. See Friedman, "La'aggada hahistorit," 128 and n. 38.

58. See Friedman, "Pereq ha'isha rabba babavli," 303–4.

59. In some of these cases the scribes of manuscripts do not repeat the steps of the argument and simply write "etc." (*vegomer*).

60. See for now Hezser, *Rabbinic Story in Yerushalmi Neziqin*, 349–50 versus 354.

61. See Chap. 5, "Comparative Evidence."

62. Although it cannot be demonstrated conclusively that such thematic changes derive from the Stammaim and not the Amoraim, a compelling case often can be made. Some thematic changes involve borrowing and adaptation from other sources, and therefore indicate the hands of the redactors. That many of the changes correspond to the general thematic reworking, including the molding of the story to fit its redactional context, also points to the redactors. The redactors, for example, and not the Amoraim, must have created the extended story about the siege of Jerusalem, since the story results from the amalgamation of disparate sources [5]. As they reworked those sources into a new story in a new context, Tractate Gittin Chap. 5, they changed the Marta episode to conform to the new themes and context.

63. See Hayes, *Between the Babylonian and Palestinian Talmuds*, 14–17.

64. The line is preserved in *LamR* 4:2.

65. Such incongruities belie Neusner's claims that the redactors of rabbinic documents homogenized their sources with complete freedom and to such an extent as to preclude all attempts to recover earlier forms of the tradition. See Chap. 1, n. 91.

66. The Mishnaic story of the conflict between Rabban Gamaliel and the sages over the new moon also involves a shift in characters (mRH 2:8–9). The original conflict between Gamaliel and Hanina b. Dosa concludes with a showdown between Gamaliel and Yehoshua. But here the storyteller has Yehoshua tell Hanina b. Dosa that he agrees with his position, so the shift makes some sense. While the account may have combined different sources, they have been integrated to a certain extent.

67. Sometimes the redactors link stories together with a kinship datum. For example, the account of Honi the Circle-Drawer praying for rain is followed by a story about Abba Hilqia, Honi's son's son, and his prayers for rain (bTa 23a–23b). The PT version of the Abba Hilqia story calls the protagonist "a pious man of Kefar Imi," not Abba Hilqia, and makes no reference to any relationship with Honi; yTa 1:4, 64b. It seems that the BT redactors appended

to the story of Honi an independent story about Abba Hilqia and artificially connected the two by adding a parenthetic datum: "Abba Hilqia, *Honi's son's son*, once . . . " This probably functioned as a mnemonic aid. Friedman, "La'aggada hahistorit," 128, adduces a clear example where the shift in character results from the combination of sources.

68. Jacob Neusner, "When Tales Travel: Shammai and Jonathan Ben 'Uzziel,'" in *Method and Meaning in Ancient Judaism, Third Series* (Chico, Calif.: Scholars Press, 1981), 137–41. For another example see the story of Eliezer's death, bBer 28a versus yAZ 3:1, 42c, and Neusner, "Death-Scenes and Farewell Stories: An Aspect of the Master-Disciple Relationship in Mark and in Some Talmudic Tales," *HTR* 79 (1986), 190–95.

68. Albeck, *Mavo latalmudim,* 47–50. See also Hezser, *Rabbinic Story in Yerushalmi Neziqin,* 352.

70. Jacobs, *Structure and Form in the Babylonian Talmud,* 100–106, has observed "the pseudepigraphic nature" and "fictitious element" of BT stories. See also his article, "How Much of the Babylonian Talmud is Pseudepigraphic?" 46–59.

71. See Tosafot, ad loc., s.v. *hasakin,* who are perplexed that these two Amoraim contradict the Mishna.

72. Bal, *Narratology,* 126–29.

73. See Hezser, *Rabbinic Story in Yerushalmi Neziqin,* 254–61, on the nonnarrative comments in PT stories. She distinguishes comments that "transcend" the stories from those that do not.

74. "What is the Haqer cistern? Rav Yehuda said Shmuel said, 'A cistern about which they called forth (*hiqru*) words and permitted it'"; bEruv 104b (according to ms Munich 95).

75. The storytellers theoretically could have directed the audience's evaluation by having the narrator characterize R. Yehuda HaNasi as humble or making a character reproach R. Yohanan b. Zakkai. Here too we might conjecture that they accepted certain constraints and declined to modify antecedent sources—but this takes us back to a diachronic perspective. From a synchronic perspective attributions perhaps function as a slightly weaker method of influencing the evaluation. To criticize R. Yohanan b. Zakkai within the fabula, for example, leaves no room for debate. If the audience approves of R. Yohanan b. Zakkai's actions it has no choice but to reject the story. Criticism through the nonnarrative comment of an Amora outside of the fabula leaves room for interpretation and disagreement. The audience can dispute the judgment or criticism of the named sage and supply its own assessment of the characters.

76. See Chap. 4, "The PT Story, Other Sources and Compositional Techniques" (8).

77. bGit 56a–57b. See Chap. 5, n. 48. For another example, see the story of Avdan, bYev 105b, in which his daughters-in-law refuse their levirs, a datum mentioned in the legal *sugya* at bYev 108a.

78. Rovner, "Rhetorical Strategy," 192–95, 218–19.

79. Friedman, "Habaraitot shebatalmud habavli veyihasan latosefta," shows that the BT versions of *baraitot* are often influenced by the wording of proximate *baraitot*.

80. On the term "homiletical story," see Chap. 7.

81. Only the introductory segue "What did he see?" links the story to its source.

82. That is, Rabban Gamaliel protests that he banned Eliezer for God's honor "in order that disagreements not multiply in Israel."

83. The story of Avdan, bYev 105b, is also based in part on a provision of tSanh 7:8. See Adolph Büchler, "Maftsei'a 'al rashei 'am qadosh," in *Jubilee Volume in Honour of Edward Mahler* (Budapest, 1937), 379–405. On the late dating and Babylonian coloring of this story, see Israel Ben-Shalom, "'And I Took unto Me Two Staves: The One I Called Beauty and the Other I Called Bands' (Zach. 11:7)," in *Dor-Le-Dor: From the End of Biblical Times up to the Redaction of the Talmud. Studies in Honor of Joshua Efron,* ed. A. Oppenheimer and A. Kasher (Jerusalem: Bialik, 1995), 242–44 (Hebrew).

84. Hanokh Albeck, *Shisha sidrei mishna* (Jerusalem: Bialik and Tel Aviv: Devir, 1952–59), 1:336. See also Halivni, *Meqorot,* 2:346 n. 7.

85. While many classical *chriae* associate the same motifs with different wise men, they do not transfer passages and reproduce the exact language in the same way as the BT.

86. See Chap. 1, "The Rabbinic Story in Its Cultural and Literary Contexts."

87. Certainly few would claim that the redactors were completely arbitrary when they inserted stories into the Talmud. My claim is that many stories perform more significant "cultural work" than has been noted.

88. Jacob Neusner has stressed that the BT should be described primarily as a commentary to the Mishna. In *Talmudic Dialectics* (Atlanta: Scholars Press, 1995), 1:vii, Neusner reports that 90 percent of the BT is direct exegesis of the Mishna. On the relationship between PT stories and the redactional contexts, see Hezser, *Rabbinic Story in Yerushalmi Neziqin,* 228–68, 349–57. She concludes that "with the exception of only a few narratives, the large majority of stories (71 out of 80) can be called 'illustrations' of the M. [=Mishna] or of texts previously quoted within the *gemara* or the general issue of the *gemara*" (264). But she also notes that "the degree to which they merely illustrate or introduce new halakhic aspects varies" (268). Most of the stories she studies are brief

reports of legal cases or rabbinic pronouncements, unlike the stories treated here.

89. On this term see the references in Chap. 7, n. 59.

90. Parallels: bNed 32a; bAZ 3a. The verse means something quite different in context. See also the related concepts in bShab 88a (=bAZ 3a, 5a) and bTa 27b (= bMeg 31b).

91. *GenR* 1:1 (2) and 3:5 (20); *SifDeut* §37 (70) and §48 (114); mAvot 3:14; *ARNA* §39 (59b). See Ginzberg, *Legends of the Jews,* 5:5–6.

92. The traditions from bSanh 99b are not paralleled in Palestinian sources. The PT version of the tradition from bMak 10a reads "More precious to me is the *justice and righteousness* that you (= King David) do than sacrifices" (yMQ 3:7, 83d and parallels). The comparison again demonstrates the greater BT emphasis on Torah study. The traditions from bMeg 16b are attributed to Babylonians (Rav, Rabbah, Rav Gidel; see *DQS* ad loc.). There are no Palestinian parallels.

93. On the origins and problems with this account, see Brody, *Geonim,* 26–29.

94. There follow the rules of succeeding to one's father's place in the hierarchy, quoted in Chap. 6.

95. Translation from Goodblatt, *Rabbinic Instruction,* 161–62; original text found in A. Neubauer, ed., *Mediaeval Jewish Chronicles and Chronological Notes* (Oxford: Clarendon Press, 1887–95), 87–88. A slightly different translation and commentary appears in Brody, *Geonim,* 46–47. For additional details based on later accounts see S. D. Goitein, *A Mediterranean Society,* vol. II, *The Community* (Berkeley: University of California Press, 1971), 195–99. This representation of the academy and the related elements of talmudic stories have much in common with aspects of the Nestorian Christian school of Nisibis. See I. Gafni, "Nestorian Literature as a Source for the History of the Babylonian *Yeshivot,*" *Tarbiz* 51 (1981–82), 567–76 (Hebrew). See especially the references to rows and designated seats (573–74).

96. See Chap. 1, "The Social Setting of the Redactors." The most comprehensive discussion of the Geonic academies is now Brody, *Geonim,* 35–53.

97. Ginzberg, *Perushim,* 3:198, suggests that the columns may indicate that the "assembly house" was a stoa rather than a building.

98. The only other rabbinic source that mentions a guard at the door of the academy relates that, because Hillel could not afford to pay the entrance fee, he climbed to the roof to hear the discussions where he almost froze to death—a story found only in the BT (bYom 35b). Cf. Cohen, "Patriarchs and Scholarchs," 78 n. 51. Cohen also refers to *ARNA* §6 (16a). However, this source mentions neither academy nor door, and refers not to a guard routinely

stationed at the entrance, but to guards appointed specifically to intercept Horqanos. The reference to the "guard of the gate" in the eulogy of R. Yohanan [3], which refers there to Hell, uses the same terminology.

99. The PT parallel has no guard, and mentions 80 or 300 benches "excluding those standing behind the fence" (yBer 4:1, 7c–d). This reference to a fence (*gader*) is obscure, but possibly implies that the sages gathered outside in a field. See Ginzberg, *Perushim*, 3:198–99. In any case, the BT reworking probably provides an exaggerated picture of the Babylonian reality. On the fictional character of the BT versions see Israel Ben-Shalom, "Torah Study for All or for the Elite Alone," in *Synagogues in Antiquity*, ed. A. Kasher et al. (Jerusalem: Yad Izhaq ben Zvi, 1987), 106–15 (Hebrew), and Steinmetz, "Must the Patriarch Know Uqtzin?"

100. Daniel Sperber, "On the Unfortunate Adventures of Rav Kahana: A Passage of Saboraic Polemic from Sasanian Persia," in *Irano-Judaica*, ed. S. Shaked (Jerusalem, 1982), 83–100. See also the comments by Shaked in the introduction to the volume (xi) on the hierarchical arrangement of the Sasanian court with the assembly seated according to social status. Another relevant tradition is found at bMQ 16b: "*These are the names of David's great men: Yoshev-bashevet (2 Sam 23:8)*. When he (David) used to sit (*yoshev*) in the session (*yeshiva;* or 'in the academy') he would not sit on cushions and pillows but on the ground. Because as long as Irya the Yairite lived, he (Irya) would teach the sages on cushions and pillows. When he died, David taught the sages and sat on the ground. They said to him (David), 'Let our Master sit on cushions and pillows.' But he did not accede." Although this source uses the Hebrew (*karim, kesatot*), not the Persian term, the description of the master sitting on pillows and students on the ground recalls the description in bBQ 117a. In addition, the term *yeshiva* might refer to the academy; see below n. 103. This tradition is not paralleled in Palestinian sources. See also bMeg 21a and Moshe Aberbach, "The Relations between Ira the Jairite and King David according to Talmudic Legend," *Tarbiz* 33 (1964), 358–60 (Hebrew).

101. Isaiah Gafni, "The Babylonian *Yeshiva* as Reflected in Bava Qama 117a," *Tarbiz* 49 (1980), 192–201 (Hebrew); Adiel Schremer, "'He Posed Him a Difficulty and Placed Him,'" 403–16.

102. I say "partially" because the basic polemic and several Persian motifs appear in both textual traditions, which suggests a late provenance for both versions. The story continued to be glossed and reworked in one tradition, perhaps in the later Saboraic period. See Schremer, "'He Posed Him a Difficulty and Placed Him,'" 404–5 and n. 8. Schremer even suggests that the reference to rows of the academy was added in Geonic times (413–14 and n. 44).

103. The few references in the BT to the title *reish metivta* or *rosh yeshiva*,

usually understood as the "Head of the Academy," but which Goodblatt translates as "chairman of a study session," seem to occur in late passages (bBer 27b, 56a, 57a; bShab 114a; bBB 12b; bNid 14b; see *Rabbinic Instruction*, 86–88). Thus the references in bBer 56b and bBer 57a appear in the long "dream-book," a highly developed story that should be attributed to the redactors. In bBB 12b the title appears in a story about Mar b. Rav Ashi, one of the latest Amoraim, which must postdate his time. In bShab 114a the title appears in an Aramaic Stammaitic gloss to a Hebrew Amoraic tradition. Goodblatt's efforts to explain away these passages, whether correct or not, are unnecessary. They do not reflect Amoraic Babylonia but the post-Amoraic academy. See also Gafni, "Yeshiva and Metivta," 26–28.

104. The passage also claims that Rav Huna expounded with "thirteen Amoraim," thirteen assistants who repeated and amplified his lecture to the assembly. Goodblatt, *Rabbinic Instruction*, 54–58, 79–80, argues that the passage is a "later intrusion" from the *Shilta'ot* (a Geonic work). Yet it appears in all manuscripts; see *DQS*, 483. If it is a late addition it supports my thesis that these descriptions of the academy and of masses of students stem from the time of the redactors. Goodblatt claims that the term *metivta* means a study session, but it typically refers to the academy (Yeshiva).

105. Friedman, "La'aggada hahistorit."

106. That tradition is yBer 4:1, 7c–d, the Palestinian version of the deposition of Rabban Gamaliel, paralleled at bBer 27b–28a: "There we learn: 'R. Eleazar b. Azariah expounded this homily before the sages at the vineyard at Yavneh.' But was there a vineyard there? Rather, these are the scholars who were organized in rows like a vineyard." This explanation is clearly an interpolation (cf. mKet 4:6), but it is presumably Palestinian. However, the parallel to this tradition at *SongR* 8:11 reads: "But was there a vineyard there? Rather, this was the Sanhedrin which was organized in rows like a vineyard [var: in a vineyard]." Numerous Tannaitic sources describe the Sanhedrin with rows of judges and disciples, and talmudic discussions assume this structure. The description of scholars in rows, then, is probably about the Sanhedrin, which is mentioned explicitly if *SongR* preserves the original reading of the PT. On the other hand, the editor who added a tradition about the Sanhedrin's structure to a story about the Palestinian academy evidently pictured the academy in similar form.

107. Goodblatt, *Rabbinic Instruction*, 97 n. 7. The structure and organization of academies in Amoraic Palestine are unknown. Lee Levine, *The Rabbinic Class of Roman Palestine in Late Antiquity* (New York: Jewish Theological Seminary; Jerusalem: Yad Izhaq Ben-Zvi, 1989), 29 n. 17, observes: "The exact nature of this rabbinic institution requires clarification. The major centers . . .

had a *bet midrash,* apparently in a separate building (e.g. Tiberias, Sepphoris, and Caesarea).... In other places, certainly including all those cities and villages in which rabbis were resident, there was no permanent building, and their meetings took place in private homes or possibly in the local synagogue." Despite Levine's opinion about the "major centers," it is entirely possible that most of these so-called academies were no different than the disciple-circles described by Goodblatt, whether they met in a synagogue, private home or specific study-house. Shaye Cohen, "The Place of the Rabbi in Jewish Society," in *The Galilee in Late Antiquity,* ed. Lee Levine (Jerusalem: Jewish Theological Seminary, 1992), 167, suggests that the school of the Patriarch may have been a "real" academic institution, "but the schools of other rabbis were nothing more than disciple-circles." For recent discussion see Catherine Hezser, *The Social Structure of the Rabbinic Movement in Roman Palestine* (Tübingen: J. C. B. Mohr, 1997), 195–214, who concludes, "There is no reason to assume that study houses, houses of meeting, or halls were 'rabbinic academies,'" and places the rise of institutionalized academies in Palestine in the Islamic period. Aharon Oppenheimer, "Batei-Midrash in Eretz-Yisrael in the Early Amoraic Period," *Cathedra* 8 (1978), 80–89 (Hebrew), collects geographic and halakhic data but nothing about structure or organization. F. G. Hüttenmeister, "Synagogue and Beth ha-Midrash and Their Relationship," *Cathedra* 18 (1981), 39–42 (Hebrew), observes the paucity of archaeological remains of *betei midrash* in contrast to the copious remains of synagogues.

108. Thus the reference to the academy in the story of R. Shimon b. Yohai appears only in the BT version [**4**]. For other examples in which a PT passage does not mention the academy but the BT version adds such a reference, see (1) bQid 31b versus yPe 1:1, 15c = yQid 1:7, 61b; (2) bBer 16a versus yBer 2:4, 5a; (3) bBer 33a versus yBer 5:1, 9a and tBer 3:20; (4) bNed 49b versus yShab 8:1, 11a; (5) bShab 17a versus yShab 1:4, 3c (below, n. 137); (6) bTa 23a versus yTa 3:10, 66d: in the PT story of Honi's seventy year nap some unidentified people say to him "when you entered the temple it became light." In the BT Honi enters the academy and hears the sages say, "this law is as bright (i.e., clear) to us as in the days of Honi the Circle-drawer, for when he came to the academy he would solve all the difficulties of the sages." There are many more such cases. Goodblatt, *Rabbinic Instruction,* 97 n. 7, includes these passages (and the story of R. Shimon b. Yohai) as evidence of the situation in Palestine. In light of the lack of mention of the academy in the (more) original Palestinian versions, the references should be taken as Babylonian reworking and hence evidence of the Babylonian reality.

109. Goodblatt, *Rabbinic Instruction,* 106–7, was aware of the Babylonian coloring but discounted its significance:

Many of what I have called Palestinian pericopae were undoubtedly composed in Babylonia. Even quotations of Palestinian sages were colored by Babylonian language or usage. Still the "preference" I have observed could be explained by an hypothesis that both *bet hamidrash* and *be midrasha* represent Palestinian terminology. [The 'preference' is that the BT typically uses these terms to describe Palestinian institutions — J.R.] . . . The absence of a critical edition of BT and of a concordance of PT makes it difficult to come to any firm conclusions. But the facts cannot be denied. *Be midrasha* occurs in BT in reference to Palestinian settings much more frequently than it does in reference to Babylonian ones. And *be rav* appears in BT almost never with reference to Palestine, but quite often with reference to Babylonia. On this basis I think it is possible to conclude that *be midrasha* was not the common name for the academic institutions of Amoraim in Babylonia.

Unaware of the theories of Halivni and Friedman that much of the BT is post-Amoraic, Goodblatt had no other explanation for his observation than that the sources accurately depicted Palestinian institutions. But his observations are equally compatible with the conclusion that the sources have been reworked in post-Amoraic times and reflect post-Amoraic Babylonian life.

110. Gafni, "Yeshiva and Metivta," especially 31–37.

111. bBQ 117a–b, according to one manuscript tradition (see above, "The Academy"). In both manuscript traditions R. Yohanan comments on Rav Kahana's initial failure to object, "The lion you mentioned has become a wolf," i.e., he is not as brilliant a sage as you reported. Earlier in the story Rav Kahana gains an introduction to Resh Laqish by impressing the disciples: "He stated this question and that question (*qushiya*), this solution and that solution (*teirutsa*)."

112. Cf. the PT parallel, yShab 10:5, 12c: "When R. Eleazar b. R. Shimon entered the house of assembly, Rabbi [Yehuda HaNasi's] face darkened. His father said to him, 'Truly, he is a lion the son of a lion, but you are a lion the son of a fox.'" Rabbi Yehuda HaNasi was apparently jealous of R. Eleazar's abilities, or perhaps anxious that R. Eleazar knew more Torah or would outperform him. In any case, the theme of objections and responses does not appear.

113. The expression "surrounded us with bundles of objections" recalls certain passages of the "Oven of Akhnai" that reflect the dialectical mind-set: the sages "surrounded him with words" and "R. Eliezer responded with all the responses in the world." To "surround with words" suggests a proliferation of arguments of dubious force, whereas Eliezer marshals not just "twenty-four

objections" but "all the responses in the world," the acme of argumentative ability.

114. The story of Honi the Circle-Drawer in the BT relates a similar tragic death; bTa 23a. Honi returns to the academy after sleeping for seventy years but cannot convince the sages of his identity. Eventually he prays for death and dies, and the story concludes with Rava citing the proverb, "Either fellowship or death." The story does not emphasize "objections and solutions" specifically, but "fellowship" (*hevruta*) implies mutual study.

115. bMak 11b. The same tradition appears in bBQ 92a and bSot 7b. In these parallels some manuscripts read "conform his tradition to the law " (*salqa shmayta 'aliba dehilkheta*) in place of "solve an objection." In bMak 11b there are no variants. The different textual traditions contest the essence of academic activity. Indeed, a few BT passages value other academic abilities above dialectics, or express a tension over this question. See, e.g., the *sugya* following the story of the attempted deposition of Rabban Shimon b. Gamaliel (bHor 14a) [6].

The first part of this tradition is attributed to Palestinians (the texts vary: R. Shmuel or R. Shmuel b. Nahmani in the name of R. Yonatan or R. Yohanan). However, as Gafni has noted, the language shifts from Hebrew to Aramaic in the section cited above, which indicates a later addition ("Yeshiva and Metivta," 29). Moreover, the Palestinian parallels lack this section completely; see *GenR* 97:8 (1216), *MidTan* 214, *SifDeut* §347 (405–6).

116. The heavenly academy (*metivta deraqiyya; yeshiva shel ma'ala*) is mentioned in bBer 18b; bTa 21b; bGit 68a; bBM 85b, 86a; bMak 11b (=bSot 7b, bBQ 92a; cited below). The term *yeshiva shel ma'ala* appears a few times in Palestinian sources, but always refers to a heavenly *court*, a judicial institution, not an academy.

117. Many of these points were made by David Weiss Halivni in a lecture delivered at Tel Aviv University, December 1997.

118. bBM 86a. See Halivni, *Midrash, Mishna, and Gemara*, 67–68.

119. Amoraim certainly interpreted Tannaitic traditions, but they formulated the interpretations in terms of apodictic statements and fixed laws, not lengthy, discursive explanations. See Halivni, *Midrash, Mishna, and Gemara*, 66–70; Strack-Stemberger, *Introduction to Talmud and Midrash*, 211–12.

120. Each of these terms deserves a comprehensive study. *Halish da'atei*, literally "his mind became weak," typically indicates embarrassment but sometimes means grief, worry, distress, discouragement, and so forth.

121. See C. Reines, *Masot umehqarim* (Jerusalem: Rubin Mass, 1972), 45–63, 111–22, and especially Ari Elon, *From Jerusalem to the Edge of Heaven*, trans. T. Frymer-Kensky (Philadelphia: Jewish Publication Society, 1996), 114–17.

122. See the selections from the preliminary *sugya* in the Appendix to Chap. 2. See also bTa 24b–25a (R. Hanina's wife heated up the stove every Friday despite being too poor to purchase dough "because of shame," i.e., lest others see her poverty); bKet 67b (the story of Mar Uqba and his wife, which cites the maxim, "It is better for a man to throw himself into a fiery furnace, and let him not whiten the face of his fellow in public"); bBB 123a (Rachel tells Leah the secret signs which Jacob had given her lest Leah "be shamed"); bHag 5a, bNed 41a, bBer 58b, bShab 156b, bQid 81a, bSanh 11a.

123. Although they are far more common in the BT. See, for example, the story of Samuel the Little in bSanh 11a and ySanh 1:2, 18c. In both stories Samuel comes uninvited to the meeting of sages called by Rabban Gamaliel to intercalate the calender. In both he acknowledges that he was not invited but explains that he came anyway because he wished to learn the law. The BT version then adds (in an Aramaic gloss to the Hebrew story—obviously a later comment): "It was not Samuel the Little (who came uninvited) but someone else, and because of shame (*kisufa*) he [Samuel] acted thus (and said that he was the uninvited guest)."

124. The name Avdan sounds like '*avad* = "lose, perish," another symbolic name. The story concludes "Blessed be the Merciful One who shamed Avdan in this world." In other words, Avdan received appropriate punishment for shaming a sage in this world, and thus avoided punishment in the world to come.

125. On the relationship between honor and shame, see Chap. 6.

126. See n. 120.

127. bTa 9b. See Chap. 2, "Cultural Context" for the full text. See also bEruv 67a: "When Rav Hisda and Rav Sheshet encountered each other, Rav Hisda's lips trembled because of Rav Sheshet's [knowledge of] traditions, and Rava Sheshet's whole body trembled because of Rav Hisda's acumen [ *pilpul*]." Rashi ad loc. comments that Sheshet had an extensive knowledge of traditions, and so Hisda feared lest he point out a contradiction between two traditions and beckon Hisda to explain it. Sheshet feared because Hisda was sharp and asked complicated questions. Note that dialectical acumen causes more anxiety: Sheshet's whole body, and not only his lips, trembled. bBer 4a explains Mephiboshet's name, "for he used to shame David's face in legal [debate]."

128. Similarly, the story at bBer 27b partially justifies the appointment of R. Eleazar b. Azariah as the replacement Patriarch on the grounds that "he is wise, so that if anyone should object to his [traditions], he will answer him." A candidate less proficient in Torah could be shamed by difficult objections.

129. The parallel at yBiq 1:8, 64a does not mention shame: "You ask about a matter which the sages of the assembly house still need (to explain)." R.

Eleazar simply answers why he cannot explain the matter but makes no reproach.

130. Peristiany, *Honour and Shame;* David D. Gilmore, "Introduction: The Shame of Dishonor," in *Honor and Shame and the Unity of the Mediterranean* (Washington, D.C.: American Anthropological Association, 1987), 2–21; M. Herzfeld, "Honour and Shame: Problems in the Contemporary Analysis of Moral Systems," *Man* 15 (1980), 339–51; Saul M. Olyan, "Honor, Shame, and Covenant Relations in Ancient Israel and its Environment," *JBL* 115 (1996), 201–18, with further references; Martin A. Klopfenstein, *Scham und Schande nach dem Alten Testament* (Zurich: Meier, 1972); Johannes Pedersen, *Israel: Its Life and Culture* (London: Oxford University Press, 1926), 1:213–44.

131. This has been noted by Daniel Boyarin, *Unheroic Conduct: The Rise of Heterosexuality and the Invention of the Jewish Man* (Berkeley: University of California Press, 1997), 135–36, 142–43.

132. On shame and the shedding of blood, see Chap. 2.

133. For other examples of the metaphoric use of "fighting" or "defeating," see bBB 85b (=bKet 103b) and bSanh 91a ("The Torah of Moses has defeated you").

134. bSanh 24a. This tradition supplies the title for Israel Ben-Shalom's, "'And I Took unto Me Two Staves: The One I Called Beauty and the Other I Called Bands' (*Zach. 11:7*)," 215–44, which collects examples of hostile representations in the BT that do not appear in parallel Palestinian sources. See also the continuation of this tradition in bSanh 24a and Urbach, *Sages,* 620–30, and see the similar expressions in bBer 4a and bShab 63a.

135. bNaz 49b = bQid 52b. The PT version omits the hostile characterization and offers no explanation for the statement: "R. Yehuda ordered and said, 'Do not let the students of Meir enter here'" (yQid 2:8, 63a). The expression "strike me with laws" also appears in the BT version of the story of Dosa b. Harkinas (bYev 16a) but not in the PT version (yYev 1:6, 3a).

136. bBer 27b versus yBer 4:1, 7d. The expression also appears in bBekh 36a.

137. Military imagery is much less common in the PT. However, the PT version of the "Oven of Akhnai" contains the phrase, "If the sages are fighting, what care is it of yours?" yShab 1:4, 3c relates: "R. Yehoshua Onayya taught: The students of the House of Shammai stood below and were *killing* the students of the House of Hillel. It was taught: Six of them (the House of Hillel) went up [to the upper chamber] and they (the House of Shammai) stood upon the others with swords and spears." The BT version is less violent: "They stuck a sword in the academy and said: 'He who would enter, let him enter. But he who would depart, let him not depart.' That day Hillel sat submissive before Shammai like one of the students, and it was as painful for Israel as the day on

which the calf was fashioned." Nevertheless, I have yet to find the Amoraic academy represented in such terms in Palestinian sources.

138. The previous story describes how the disciples honor R. Yehoshua and receive a blessing. Fortunately, R. Eliezer subsequently prays and restores R. Yose's sight.

139. There is no PT parallel to this source. See also the story of the ostentatious piety of Yehuda b. Pappos (yBB 5:1, 15a = yBer 2:9, 5d) = Yehuda b. Qenosa (bBQ 81b). The BT concludes the story with R. Hiyya's comment, "Were you not Yehuda b. Qenosa I would have cut off your legs with an iron saw." No such comment appears in the PT. Similarly, upon raising a difficulty to which Resh Laqish could not reply, R. Yohanan comments, "I cut off the legs of that child"; bMe 7b. And see the story of Qarna at bBB 89a versus yBB 5:11, 15a. In the BT Shmuel says to him, "Let a horn come forth from your eye," and the narrator confirms that this occurred. See Urbach, *Sages,* 624–25 and n. 9. See also bBer 39b.

140. S.v. *na'asu*. The exegesis picks up on the rabbinic use of "gate" (Hebrew: *sha'ar* = Aramaic: *bava*) to refer to divisions of lengthy tractates (Bava Qama = first gate, Bava Metsia = middle gate, etc.).

141. Both traditions, bSanh 42a and bMeg 15b, are attributed to Palestinians, but neither is paralleled in Palestinian sources.

142. Walter J. Ong, *Orality and Literacy: The Technologizing of the Word* (London: Routledge, 1982), 43–46.

143. Jacob Neusner, *History,* 3:196, based on Arthur Vööbus's studies of the Christian Church in Nisibis (Persia), noted the parallel use of military terminology such as "struggle, fight, battle and war" in the context of monastic life. However, the Christian sources speak of a general spiritual war and struggle for self-control and asceticism, not the wars of academic debate. See Vööbus, *History of Asceticism in the Syrian Orient* (Louvain, 1958), 1:88–90.

144. Many have commented on the Bible's realistic representation of its heroes with faults and sins. The BT portrays its heroes—earlier sages—similarly.

145. See Chap. 5, "Comparative Evidence."

146. "La'aggada hahistorit," 124–25. The sage's remorse, moreover, appears in the demonstrably later strata of the BT story.

147. bHag 16a = bQid 40a = bMQ 17a.

148. Indeed, the somewhat parallel account of R. Zadoq in *ARNA* §16 (32a) relates that R. Zadoq was sold into slavery in Rome and his mistress sent a handmaid to seduce him, but he studied Torah all night and resisted her. A story found in *SifNum* §115 (128–29) and bMen 44a tells that "a certain man"

visited a prostitute, but his fringes struck him in the face and prevented him from sinning. This man is not designated a sage.

149. Fraenkel, *Hermeneutic Problems*, 140–42, 150–57. Only one of Fraenkel's examples derives from the PT, the story of Hillel and the Bnei Betera, yPes 6:1, 33a. Similar criticism appears in the version at bPes 66a, but not in the original source, tPes 4:13. There are some exceptions where the Palestinian version is more critical, such as the story of R. Hanina's return home after studying in the academy; *LevR* 21:8 (484–86) and bKet 62b (summarized in Chap. 1, "The Rabbinic Story in Its Cultural and Literary Contexts"). Here, however, the BT follows the story of Hanina with similar stories even more critical of sages who leave their wives.

150. See David Kraemer, "The Intended Reader as a Key to Interpreting the Bavli."

151. In bSanh 99b Rav Yosef defines a heretic (*apiqoros*) as "those who say, 'What have the sages benefited us? They read [Bible] for themselves. They study [Mishna] for themselves.'" This comment perhaps embodies a perception common among Babylonian Jews, or at least a rabbinic perception of their perception. On the degree of social integration of Babylonian and Palestinian rabbis, see Kalmin, *The Sage in Jewish Society of Late Antiquity*. Kalmin argues that the stories inform us of the social positions and relationships of the sages. My claim is more modest: because the BT was intended for the rabbinic elites in their academic training, it is internally focused and insular. I do not know if this tells us anything about their social position.

152. This does not mean the stories were not reworked at all in Palestinian academies. They were modified, but not to the same extent as the BT stories. See Hezser, *Rabbinic Story in Yerushalmi Neziqin*, 356–57, 408. The internal focus also helps explain several distinctive aspects of the BT. First, Safrai observed the BT tendency to portray kinship ties between sages, even when the PT makes no such claim (see Chap. 2, n. 37). This theme promotes close ties between sages and expresses a sense of community and mutual obligation. The "rabbinic family" of likeminded elites evidently recognized the ties that bind them. Second, as Shaye Cohen has observed, the BT contains extremely negative traditions toward, and outright hatred of, the common people, i.e., the nonlearned ʿam haʾarets, traditions without parallel in Palestinian sources ("The Place of the Rabbi in Jewish Society," 165). For example, one may rip apart an ʿam haʾarets like a fish, one may kill him on the Day of Atonement, their wives are vermin, etc. (bPes 49b). Such expressions of contempt for non-rabbis are a product of the elitist mentality and inward focus of the BT. Just as the BT points out the faults of sages (the intended audience), so it reviles non-rabbis

(who were *not* expected to be in audience). Third, the BT "rabbinizes" biblical and nonrabbinic figures by portraying them as sages who engage in quintessential rabbinic activities. The BT storytellers, the Stammaim, both construct these characters in their own image and use them to illustrate problems of their scholastic culture. See also Urbach's observation about "class consciousness" (and even blatant favoritism) of the sages, based mainly on traditions of the later Babylonian Amoraim, *Sages*, 626–27.

# Selected Bibliography

Albeck, Hanokh. *Mavo latalmudim*. Tel Aviv: Devir, 1969.
———. *Shisha sidrei mishna*. Jerusalem: Bialik and Tel Aviv: Devir, 1952–59.
Alter, Robert. *The Art of Biblical Narrative*. New York: Basic Books, 1981.
*'Avot derabbi natan*. Edited by Solomon Schechter. Vienna, 1887.
Bal, Mieke. *Narratology: Introduction to the Theory of Narrative*. Translated by C. van Boheemen. Toronto: University of Toronto Press, 1985.
———. *On Storytelling: Essays in Narratology*. Edited by D. Jobling. Sonoma, Calif.: Polebridge Press, 1991.
Beer, Moshe. *The Babylonian Exilarchate in the Arsacid and Sasanian Periods*. Tel Aviv: Devir, 1970 (Hebrew).
———. "The Sons of Moses in Rabbinic Legend." *Bar-Ilan Annual* 13 (1976), 149–57 (Hebrew).
———. "Torah and Derekh Eretz." *Bar-Ilan Annual* 2 (1964), 134–62 (Hebrew).
Israel Ben-Shalom, "'And I Took unto Me Two Staves: The One I called Beauty and the Other I Called Bands' (*Zach. 11:7*)." In *Dor-Le-Dor: From the End of Biblical Times up to the Redaction of the Talmud. Studies in Honor of Joshua Efron*, edited by A. Oppenheimer and A. Kasher. Jerusalem: Bialik, 1995, 215–34 (Hebrew).
———. "Rabbi Judah B. Ilai's Attitude toward Rome." *Zion* 49 (1984), 9–24 (Hebrew).
Daniel Boyarin. *Carnal Israel: Reading Sex in Talmudic Culture*. Berkeley: University of California Press, 1993.
———. *Intertextuality and the Reading of Midrash*. Bloomington: Indiana University Press, 1990.
Brody, Robert. *The Geonim of Babylonia and the Shaping of Medieval Jewish Culture*. New Haven: Yale University Press, 1998.

Cohen, Naomi G. "The Theological Stratum of the Martha b. Boethus Tradition: An Explication of the Text in *Gittin* 56a." *HTR* 69 (1976), 187–95.

Cohen, Shaye J. D. "Patriarchs and Scholarchs." *PAAJR* 48 (1981), 57–86.

———. "The Place of the Rabbi in Jewish Society." In *The Galilee in Late Antiquity*, edited by Lee Levine. Jerusalem: Jewish Theological Seminary, 1992, 157–74.

Cohen, Stuart A. *The Three Crowns: Structures of Communal Politics in Early Rabbinic Jewry*. Cambridge: Cambridge University Press, 1990.

Cox, Patricia. *Biography in Late Antiquity*. Berkeley: University of California Press, 1983.

Efron, Joshua. "Bar-Kochva in the Light of the Palestinian and Babylonian Talmudic Traditions." In *The Bar-Kochva Revolt: A New Approach*, edited by A. Oppenheimer and U. Rappaport. Jerusalem: Yad Izhaq Ben Zvi, 1984, 47–105 (Hebrew).

*'Ein ya'akov*. 8 vols. Jerusalem: Mansour, 1964.

Elman, Yaakov. "Righteousness as Its Own Reward: An Inquiry into the Theologies of the Stam." *PAAJR* 57 (1990–91), 35–67.

———. "The Suffering of the Righteous in Palestinian and Babylonian Sources." *JQR* 80 (1990), 315–40.

Elon, Ari. "Hasimbolizatsia shel markivei ha'alila basipur hatalmudi" [=The Symbolization of the Components of the Plot in the Talmudic Story]. Master's thesis, Hebrew University, 1982.

Epstein, Jacob N. *Mavo lenusah hamishna*. 2d ed. Jerusalem: Magnes, 1964.

Fischel, Henry, ed. *Essays in Greco-Roman and Related Talmudic Literature*. New York: Ktav, 1977.

———. *Rabbinic Literature and Greco-Roman Philosophy*. Leiden: Brill, 1973.

———. "Story and History: Observations on Greco-Roman Rhetoric and Pharisaism." In *Essays in Greco-Roman and Related Talmudic Literature*, 443–72. New York: Ktav, 1977.

———. "Studies in Cynicism and the Ancient Near East: The Transformation of a *Chria*." In *Religions in Antiquity, Essays in Memory of Erwin Ramsdell Goodenough*, edited by Jacob Neusner. Leiden: Brill, 1968, 372–411.

Fish, Stanley. *Is There a Text in This Class? The Authority of Interpretive Communities*. Cambridge: Harvard University Press, 1980.

Fornara, Charles W. *The Nature of History in Ancient Greece and Rome*. Berkeley: University of California Press, 1983.

Fraenkel, Jonah. "Bible Verses Quoted in Tales of the Sages." *Scripta Hierosolymitana* 22 (1971), 80–99.

———. "Chiasmus in Talmudic-Aggadic Narrative." In *Chiasmus in Antiquity: Structures, Analyses, Exegesis*, edited by John W. Welch. Hildesheim: Gerstenberg, 1981, 183–97.

———. *Darkhei ha'aggada vehamidrash.* Masada: Yad Letalmud, 1991.
———. "Hermeneutic Problems in the Study of the Aggadic Narrative." *Tarbiz* 47 (1978), 139–72 (Hebrew).
———. "The Image of Rabbi Joshua ben Levi in the Stories of the Babylonian Talmud." *Proceedings of the Sixth World Congress of Jewish Studies–1973.* Jerusalem, 1977, 3:403–17.
———. *'Iyyunim be'olamo haruhani shel sipur ha'aggada.* Tel Aviv: Hakibbutz Hameuhad, 1981.
———. "Outer Forms and Inner Values." In *Michtam Le-David: Rabbi David Ochs Memorial Volume,* edited by Y. Gilat and E. Stern. Ramat-Gan: Bar-Ilan University Press, 1978, 120–36 (Hebrew).
———. "Paronomasia in Aggadic Narratives." *Scripta Hierosolymitana* 27 (1978), 27–51.
———. "Remarkable Phenomena in the Text-History of the Aggadic Stories." *Proceedings of the Seventh World Congress of Jewish Studies–1977.* Jerusalem, 1981, 3:45–69 (Hebrew).
———. "The Story of R. Sheila." *Tarbiz* 40 (1970), 33–40 (Hebrew).
———. "The Structure of Talmudic Legends." *Folklore Research Center Studies* 7 (1983), 45–97 (Hebrew).
———. "Time and Its Shaping in Aggadic Narratives." In *Studies in Aggadah, Targum and Jewish Liturgy in Memory of Joseph Heinemann,* edited by J. J. Petuchowski and E. Fleischer. Jerusalem: Magnes, 1981, 133–62 (Hebrew).
Friedman, Shamma. "Habaraitot shebatalmud habavli veyihasan latosefta." Forthcoming.
———. "La'aggada hahistorit betalmud bavli." In *Saul Lieberman Memorial Volume,* edited by Shamma Friedman. New York: Jewish Theological Seminary, 1993, 119–63.
———. "Le'ilan hayuhasin shel nushei bava metsia—pereq beheqer nusah habavli." In *Mehqarim besifrut hatalmudit.* Jerusalem: Israel Academy of Sciences, 1983, 93–147.
———. "Pereq ha'isha rabba babavli." In *Mehqarim umeqorot,* edited by H. Dimitrovksi. New York: Jewish Theological Seminary, 1977, 277–441.
———. "Some Structural Patterns of Talmudic *Sugiot.*" *Proceedings of the Sixth World Congress of Jewish Studies–1973.* Jerusalem, 1977, 3:387–402 (Hebrew).
———. *Talmud 'arukh: pereq hasokher 'et ha'omanin.* 2 vols. Jerusalem: Jewish Theological Seminary, 1990–96.
Gafni, Isaiah. *The Jews of Babylonia in the Talmudic Era: A Social and Cultural History.* Jerusalem: Zalman Shazar Center, 1990 (Hebrew).
———. "The Rod and the Scepter: On New Types of Leadership in the Age of the Talmud." In *Kehuna umelukha,* edited by I. Gafni and G. Metzkin. Jerusalem: Zalman Shazar Center, 1987, 79–92 (Hebrew).

———. "Yeshiva and Metivta." *Zion* 43 (1978), 12–37 (Hebrew).
Genette, Gérard. *Narrative Discourse: An Essay on Method*. Translated by Jane E. Lewin. Ithaca: Cornell University Press, 1972.
Gerhardsson, Birger. *Memory and Manuscript: Oral Tradition and Written Transmission in Rabbinic Judaism and Early Christianity*. Translated by E. J. Sharpe. Lund: Gleerup, 1961.
Gilat, Yizhaq. "Beit din matnin la'aqor davar min hatora." *Bar-Ilan Annual* 7–8 (1972), 117–32.
Ginzberg, Louis. *Legends of the Jews*. 7 vols. Philadelphia: Jewish Publication Society, 1909–38.
———. *Perushim vehidushim birushalmi*. 4 vols. New York: Jewish Theological Seminary, 1941–47.
Goodblatt, David. *The Monarchic Principle: Studies in Jewish Self-Government in Antiquity*. Tübingen: J. C. B. Mohr, 1994.
———. *Rabbinic Instruction in Sasanian Babylonia*. Leiden: Brill, 1975.
———. "The Story of the Plot against R. Simeon B. Gamaliel II." *Zion* 49 (1984), 349–74 (Hebrew).
Goshen-Gottstein, Alon. "Four Entered Paradise Revisited." *HTR* 88 (1995), 69–133.
Green, Willian Scott. "What's in a Name? — The Problematic of Rabbinic 'Biography.'" In *Approaches to Ancient Judaism: Theory and Practice*, edited by William Scott Green. Missoula, Mont. Scholars Press, 1978, 77–96.
*Haggadot hatalmud*. Constantinople, 1511. Reprint. Jerusalem, 1961.
Halevi, A. A. *Ha'aggada hahistorit-biografit*. Tel Aviv: Niv, 1975.
———. *'Olama shel ha'aggada*. Tel Aviv: Devir, 1972.
———. *Sha'arei ha'aggada*. Tel Aviv: Devir, 1982.
Halivni, David Weiss. *Meqorot umesorot*. 5 vols. Vol. 1, *Nashim*. Tel Aviv: Devir, 1968. Vol. 2, *Yoma-Hagiga*. Jerusalem: Jewish Theological Seminary, 1975. Vol. 3, *Shabbat*. Jerusalem: Jewish Theological Seminary, 1982. Vol. 4, *Eruvin-Pesahim*. Jerusalem: Jewish Theological Seminary, 1982. Vol. 5, *Bava Qama*. Tel Aviv: Devir, 1994.
———. *Midrash, Mishnah, and Gemara: The Jewish Predilection for Justified Law*. Cambridge: Harvard University Press, 1986.
Halperin, David J. *The Merkavah in Rabbinic Literature*. New Haven: American Oriental Society, 1980.
Hayes, Christine. *Between the Babylonian and Palestinian Talmuds*. New York: Oxford University Press, 1997.
Heinemann, Joseph. *Derashot betsibbur bitequfat hatalmud*. Jerusalem: Mossad Harav Kook, 1982.
Heinemann, Yizhaq. *Darkhei ha'aggada*. Jerusalem: Magnes, 1970.

Hengel, Martin. *The Zealots*. Translated by David Smith. Edinburgh: T. & T. Clark, 1989.
Herman, Geoffrey. "Hakohanim bebavel bitequfat hatalmud." Master's thesis, Hebrew University, 1998.
Hezser, Catherine. *Form, Function and Historical Significance of the Rabbinic Story in Yerushalmi Neziqin*. Tübingen: J. C. B. Mohr, 1993.
———. "Die Verwendung der hellenistischen Gattung Chrie im frühen Christentum und Judentum." *JSJ* 27 (1996), 371–439.
Hyman, Aharon. *Toledot tannaim ve'amoraim*. Reprint. Jerusalem, 1964 [London, 1910].
Ilan, Tal. "The Historical Beruriah, Rachel, and Imma Shalom." *AJSR* 22 (1997), 1–17.
Jacobs, Louis. "How Much of the Babylonian Talmud Is Pseudepigraphic?" *JJS* 28 (1977), 46–59.
———. *Structure and Form in the Babylonian Talmud*. Cambridge: Cambridge University Press, 1991.
Jaffee, Martin S. "The Taqqanah in Tannaitic Literature: Jurisprudence and the Construction of Rabbinic Memory." *JJS* 41 (1990), 204–25.
Jastrow, Marcus. *A Dictionary of the Targumim, the Talmud Babli and Yerushalmi and the Midrashic Literature*. Reprint. New York: Jastrow Publishers, 1967.
Kahane, Menahem. "Intimation of Intention and Compulsion of Divorce: Towards the Transmission of Contradictory Traditions in Late Talmudic Passages." *Tarbiz* 62 (1993), 225–63 (Hebrew).
Kalmin, Richard. "The Modern Study of Ancient Rabbinic Literature: Yonah Fraenkel's *Darkhei ha'aggada vehamidrash*." *Prooftexts* 14:2 (1994), 189–204.
———. *The Sage in Jewish Society of Late Antiquity*. Routledge, forthcoming.
———. *Sages, Stories, Authors and Editors in Rabbinic Babylonia*. Atlanta: Scholars Press, 1994.
Karlin, A. *Divrei sefer*. Tel Aviv: Mahberot lesifrut, 1952.
Kohut, Alexander, ed. R. Natan b. Yehiel's *Sefer 'arukh hashalem* (with supplements by Benjamin Musafia). 8 vols. Vienna, 1878–92.
———. *Tosafot ha'arukh hashalem*. Edited by S. Krauss. New York: Alexander Kohut Memorial Foundation, 1937.
Kraemer, David. "The Intended Reader as a Key to Interpreting the Bavli." *Prooftexts* 13 (1993), 125–40.
*Lamentations Rabba* = *Midrash 'eicha rabba*. Edited by Salomon Buber. Reprint. Hildesheim: Georg Olms, 1967 [Vilna, 1899].
Levine, Lee. "R. Simeon b. Yohai and the Purification of Tiberias: History and Tradition." *HUCA* 49 (1978), 143–85.
Levy, Jacob. *Wörterbuch über die Talmudim und Midraschim*. Berlin: B. Harz, 1924.

Lieberman, Saul. *Hellenism in Jewish Palestine.* New York: Jewish Theological Seminary, 1950.

———, ed. *The Tosefta.* 4 vols. New York: Jewish Theological Seminary, 1955–88.

———. *Tosefta Ki-fshuta: A Comprehensive Commentary on the Tosefta.* 10 vols. New York: Jewish Theological Seminary, 1955–88.

Liss, Avraham, ed. *Diqduqei Sofrim: The Babylonian Talmud with Variant Readings. Tractates Yebamot, Ketubot, Nedarim, Sotah.* Jerusalem: Institute for the Complete Israeli Talmud, 1977–91.

Mandel, Pinhas. "'Aggadot hahurban: bein bavel le'erets yisra'el." In *Israel-Diaspora Relations in the Second Temple and Talmudic Periods,* edited by I. Gafni et al. Jerusalem: Zalman Shazar Center, forthcoming.

———. "Hasipur bemidrash 'eikha: nusah vesignon." Master's thesis, Hebrew University, 1983.

Martin, Wallace. *Recent Theories of Narrative.* Ithaca: Cornell University Press, 1986.

Meir, Ofra. "The Acting Characters in the Stories of the Talmud and the Midrash." Ph.D. diss., Hebrew University, 1977 (Hebrew).

———. "The 'Changing Character' and the 'Character Disclosed' in Rabbinic Stories." *JSHL* 6 (1984), 61–77 (Hebrew).

———. *The Darshanic Story in Genesis Rabba.* Tel Aviv: Hakibbutz Hameuhad, 1987 (Hebrew).

———. "Hashpa'at ma'ase ha'arikha 'al hashqafat ha'olam shel sipurei ha'aggada." *Tura* 3 (1994), 67–84.

———. "Hasipur talui-haheqsher batalmud." *Biqoret uparshanut* 20 (1984), 103–20.

———. "Hateruma hahistorit shel 'aggadot hazal." *Mahanayim* 7 (1994), 8–25.

———. "The Literary Context of the Sages' Aggadic Stories as Analogous to Changing Storytelling Situations—The Story of the Hasid and the Spirits in the Cemetery." *Jerusalem Studies in Hebrew Folklore* 13–14 (1992), 81–98 (Hebrew).

———. "The Narrator in the Stories of the Talmud and the Midrash." *Fabula* 22 (1981), 79–83.

———. *The Poetics of Rabbinic Stories.* Tel Aviv: Sifriyat Po'alim, 1993 (Hebrew).

———. "The Story of Hezekiah's Ailment in the Legends of Hebrew Homiletical Literature." *Hasifrut* 30 (1981), 109–30 (Hebrew).

———. "The Story of R. Shimon bar Yohai and His Son in the Cave—History or Literature?" *'Alei siah* 26 (1989), 145–60 (Hebrew). Reprinted in Meir, *The Poetics of Rabbinic Stories.* Tel Aviv: Sifriyat Po'alim, 1993, 11–35.

———. "The Story of Rabbi's Death: A Study of Modes of Traditions' Redaction." *JSHL* 12 (1990), 147–77 (Hebrew).

*Midrash bereshit rabba.* Edited by J. Theodor and H. Albeck. 3 vols. Reprint. Jerusalem, 1965 [Berlin, 1912–36].

*Midrash tanhuma.* New York: Horev, 1926.
*Midrash tanhuma.* Edited by Salomon Buber. Vilna: Romm, 1885.
*Midrash tannaim.* Edited by David Hoffmann. Berlin: H. Itzkowski, 1909.
*Midrash vayiqra rabba.* Edited by Mordechai Margulies. Reprint. New York, 1993 [Jerusalem, 1953–60].
Momigliano, Arnoldo. *The Development of Greek Biography.* Cambridge: Harvard University Press, 1971.
Neusner, Jacob. *Development of a Legend: Studies on the Traditions Concerning Yohanan ben Zakkai.* Leiden: Brill, 1970.
——. *Eliezer ben Hyrcanus: The Tradition and the Man.* Leiden: Brill, 1973.
——. *A History of the Jews in Babylonia.* 3d ed. Reprint. Chico, Calif.: Scholars Press, 1984 [Leiden: Brill, 1965–70].
——. *Judaism and Story: The Evidence of the Fathers according to Rabbi Nathan.* Chicago: University of Chicago Press, 1992.
——. *Judaism: The Evidence of the Mishna.* Chicago: University of Chicago Press, 1981.
——. *The Rabbinic Traditions about the Pharisees before 70.* 3 vols. Leiden: Brill, 1971.
——. "Story and Tradition in Judaism." In *Judaism: The Evidence of the Mishna,* 307–28. Chicago: University of Chicago Press, 1981.
'Otsar hageonim. Thesaurus of the Gaonic Responsa and Commentaries following the order of Talmudic Tractates. Edited by B. M. Lewin. 13 vols. Haifa and Jerusalem, 1928–43.
Peristiany, John G., ed. *Honour and Shame: The Values of Mediterranean Society.* Reprint. Chicago: University of Chicago Press, 1974 [London, 1966].
*Pesiqta derav kahana.* Edited by Bernard Mandelbaum. New York: Jewish Theological Seminary, 1987.
Pitt-Rivers, Julian. "Honour and Social Status." In *Honour and Shame: The Values of Mediterranean Society,* edited by J. G. Peristiany. Reprint. Chicago: University of Chicago Press, 1974 [London, 1966]: 19–78.
Rabbinovicz, Raphaelo. *Diqduqei Sofrim: Variae Lectiones in Mischnam et in Talmud Babylonicum.* 12 vols. Reprint. New York, 1960.
Reisner, Avram. "The Character and Construction of a Contrived Sugya: Shevuot 3a–4a." In *New Perspectives on Ancient Judaism.* Vol. 4, edited by Alan J. Avery-Peck. Lanham, Md: University Press of America, 1989, 47–71.
Rimmon-Kenan, Shlomith. *Narrative Fiction: Contemporary Poetics.* London: Routledge, 1983.
Rokeah, David. "Zecharia ben Avkules — Humility or Zealotry." *Zion* 53 (1988), 53–56.
Rovner, Jay. "Rhetorical Strategy and Dialectical Necessity in the Babylonian Talmud: The Case of Kiddushin 34a–35a." *HUCA* 65 (1994), 177–231.

Rubenstein, Jeffrey L. "Elisha ben Abuya: Torah and the Sinful Sage." *Journal of Jewish Thought and Philosophy* 7 (1998), 141–222.

"Ruth Rabba = *'Aggadat rut umidrash rut rabba*." Edited by M. Lerner. Ph.D. diss., Hebrew University, 1971.

Safrai, Shmuel. "Tales of the Sages in the Palestinian Tradition and the Babylonian Talmud." *Scripta Hierosolymitana* 22 (1971), 209–32.

Saldarini, Anthony. "Johanan ben Zakkai's Escape from Jerusalem: Origin and Development of a Rabbinic Story," *JSJ* 6 (1975), 189–220.

Sanders, E. P. *Paul and Palestinian Judaism*. Philadelphia: Fortress Press, 1977.

Scholes, Robert, and Robert Kellogg. *The Nature of Narrative*. New York: Oxford University Press, 1966.

Schremer, Adiel. "'He Posed Him a Difficulty and Placed Him'—A Study in the Evolution of the Text of TB *Bava Qama* 117a." *Tarbiz* 66 (1997), 403–16 (Hebrew).

———. "Kinship Terminology and Endogamous Marriage in the Mishnaic and Talmudic Periods." *Zion* 60 (1995), 5–35 (Hebrew).

Segal, Eliezer. *The Babylonian Esther Midrash: A Critical Commentary*. 3 vols. Atlanta: Scholars Press, 1994.

Shinan, Avigdor. "The Aggadic Literature: Written Tradition and Oral Transmission." *Jerusalem Studies in Hebrew Folklore* 1 (1981), 44–60 (Hebrew).

*Sifra*. Edited by Isaac Hirsch Weiss. Reprint. New York: Om Publishing, 1947 [Vienna, 1866].

*Sifre* to Deuteronomy = *Sifre devarim*. Edited by Louis Finkelstein. New York: Jewish Theological Seminary, 1983.

*Sifre* to Numbers = *Sifre 'al sefer bamidbar vesifre Zuta*. Edited by H. S. Horovitz. Jerusalem: Wahrmann, 1966 [Leipzig, 1917].

Steinmetz, Devorah. "Must the Patriarch Know Uqtzin?" *AJSR*, forthcoming.

Sternberg, Meir. *The Poetics of Biblical Narrative*. Bloomington: Indiana University Press, 1985.

Stone, Suzanne Last. "In Pursuit of the Counter-Text: The Turn to the Jewish Legal Model in Contemporary American Legal Theory." *Harvard Law Review* 106 (1993), 813–94.

Strack, H. L., and G. Stemberger. *Introduction to the Talmud and Midrash*. Translated by M. Bockmuehl. Minneapolis: Fortress Press, 1992.

Sussmann, Yaakov. "Veshuv lirushalmi neziqin." In *Mehqerei talmud I*, edited by Y. Sussmann and D. Rosenthal. Jerusalem: Magnes, 1990, 55–134.

Taran, Anat. "Remarks on Josephus Flavius and the Destruction of the Second Temple." *Zion* 61 (1996), 8–12 (Hebrew).

Urbach, Ephraim. *The Sages: Their Concepts and Beliefs*. Translated by I. Abrahams. Jerusalem: Magnes, 1979.

Valler, Shulamit. *Woman and Womanhood in the Stories of the Babylonian Talmud*. Tel Aviv: Hakibbutz Hameuhad, 1993 (Hebrew).
Weiss, Avraham. *'Al heyetsira hasifrutit shel ha'amoraim*. New York: Horeb, 1962.
Wiseman, T. P. *Clio's Cosmetics*. London: Leicester University Press, 1979.
——. "Lying Historians: Seven Types of Mendacity." In *Lies and Fictions in the Ancient World*, edited by C. Gill and T. P. Wiseman. Exeter: University of Exeter Press, 1993, 122–46.
Yarshater, Ehsan. "Introduction" and "Iranian National History." In *The Cambridge History of Iran*. Vol. 3, *The Seleucid, Parthian, and Sasanian Periods*, edited by Ehsan Yarshater. Cambridge: Cambridge University Press, 1983, xvii–lxxv, 359–480.
Yassif, Eli. "The Cycle of Tales in Rabbinic Literature." *JSHL* 12 (1990), 103–46 (Hebrew).
Zuckermandel, M. S., ed. *Tosephta*. Reprint. Jerusalem: Wahrmann, 1970 [Pasewalk, 1880].

# General Index

Abaye, 62, 104, 130–31, 199, 280, 320n. 64, 372n. 88, 373n. 103, 374n. 104

academy, rabbinic (*yeshiva, beit midrash*), 7, 12, 21–22, 30, 37, 50, 61, 63, 67, 78, 88, 93–94, 96, 103, 106, 108, 111–14, 117, 122, 125–26, 135, 150–51, 176–211, 243–82, 331n. 60, 335n. 21, 336n. 22, 363n. 13, 364n. 25, 365nn. 31 & 32, 367n. 43, 369n. 58, 373n. 101, 378nn. 124 & 129, 375n. 108, 377n. 118, 379n. 138, 396nn. 95 & 98, 398nn. 106 & 107, 399n. 108, 401nn. 114 & 116, 403n. 132; military imagery of debate in, 277–79, 403nn. 131–37, 404n. 139

aggadah / aggadic, 14–15, 17, 31, 19–20, 35–36, 60–61, 176, 213, 263, 266

Akiba, 4, 37–39, 42–45, 48, 52–55, 58–59, 63, 65–67, 69, 73–75, 83–84, 86–88, 91, 143–44, 146, 157–58, 171–72, 175, 249, 253, 259, 262–63, 271–72, 278–79, 318n. 30, 321n. 76, 333n. 85, 335n. 21, 346n. 15, 349n. 31, 356nn. 71 & 72, 364n. 25, 375n. 108; daughter of, 45, 319n. 42; wife of, 335n. 21

Albeck, Hanokh, 261, 265

Alon, Gedaliah, 203, 374n. 105

Alter, Robert, 27, 118, 249, 251, 312n. 102, 338n. 41, 363n. 10, 388n. 17, 390n. 32

Amoraim / Amoraic: attributed statements of (*meimrot* and pseudo-*meimrot*), 16–20, 22, 25, 81, 86, 95–99, 118, 129–31, 166, 190–91, 195–96, 244, 257, 260–63, 274, 329n. 52, 331n. 72, 338n. 45, 341n. 66, 342n. 79, 356n. 72, 368n. 49, 380n. 3, 385n. 49, 390n. 34, 392n. 51, 394n. 75; compositional method of, 127, 257, 259, 265, 393n. 62, 401n. 119; culture of, 90, 271; legal theory of, 165, 168, 359n. 101; midrashic collections of, 25, 64, 70, 86, 105, 335n. 19; as narrators, 32, 263; rabbis / rabbinic institutions: — of Babylonia, 21, 22, 166, 168, 197, 200, 202–3, 205, 208, 237, 267, 271–72, 274, 309n. 88, 365n. 28, 373n. 101, 381n. 4, 400n. 109, 403n. 137; — of Palestine, 21–22, 195–96, 201–3, 213, 271–72, 309n. 88, 330n. 56, 400n. 109, 403n. 137; stories and traditions, 12, 58–59, 101, 129, 213, 257, 259, 330n. 56; theological and ethical ideas of, 20, 98

*'anvetan* / *'anvetanut* ("humble/meek" / "humility/meekness"), 141, 149–54, 156, 158–59, 164, 168, 172–73, 191, 351n. 43, 358nn. 89 & 91, 389n. 25; issues of definition, 350nn. 36 & 37, 41; those praised for being thus, 190, 263, 350n. 39, 368nn. 47 & 49

Aramaic, 16–22, 24, 79, 108, 125–28, 148, 150, 213, 215–18, 225, 237–41, 250, 259, 261, 266, 272, 277, 279, 341n. 70, 380n. 2, 381nn. 5 & 6, 382n. 9, 383n. 26, 390n. 34, 398n. 103, 401n. 115, 402n. 123

argumentation, 16–22, 24, 79, 125–26, 150, 212, 250, 259, 272, 277, 279, 390n. 34

assembly house, 49–50, 194, 200–201, 271, 276

authorship and audience, theory of, 18, 21,

authorship and audience (*continued*)
27, 32, 75–76, 110, 147–48, 150, 156, 180, 182, 190–91, 215, 220, 224, 228, 248, 250–52, 263, 281, 341n. 63, 349n. 31, 355n. 66, 394n. 75, 405n. 151. *See also* redacors / redaction

Babylonia, Jewish culture of, 15, 21, 25, 58, 81, 86, 98, 136, 176, 194–96, 202–11, 229, 268–82 passim, 363n. 13, 365n. 31, 373nn. 97 & 98, 374n. 104, 392n. 55, 405nn. 151 & 152. *See also* Amoraim / Amoraic; Babylonian Talmud; Stammaim / Stammaitic

Babylonian Talmud (BT): conversion in, 111, 141, 151–52, 264, 352n. 48, 370n. 76; cultural data of, 15, 28, 150, 201–11, 264, 373nn. 97 & 99, 374n. 104, 405n. 152; depiction of women in, 112, 124, 129, 133, 135, 335nn. 20 & 21, 338n. 39, 344nn. 92–94; dialogue in stories of, 182, 247, 249–50; dream messages in, 178, 188–89, 256, 366nn. 35 & 36, 38, 41, 369n. 57, 375n. 108; Elijah communicating with the rabbis, 37, 41, 47, 52–54, 57–58, 68–69, 76, 79, 90, 93, 106, 113–15, 122, 317n. 18, 319n. 51, 322n. 88, 336n. 28; emphasis on importance of Torah, 97, 101, 105–38, 212–42, 268–70; esoteric topics in, 100–102, 266; literary features and terminology, 23, 128, 192–93, 196, 212, 214–15, 245–67 passim, 341n. 71, 342n. 74, 349n. 31, 350n. 32, 356n. 71, 363n. 10, 369n. 60, 387n. 4, 388n. 14; manuscripts of, 31, 349–50n. 31; *meimrot* found in, 18–19; names (symbolic) in, 111, 246–47, 335n. 18, 387n. 4, 402n. 124; numbers in: —3, 390n. 34; —12, 115, 122, 124, 137, 337nn. 30, 31 & 38; —13, 113, 122, 125, 137, 336n. 27, 340n. 61; —24, 107, 125–26, 258, 273, 282, 337n. 38, 400n. 113; —40, 353n. 57; Palestinian sources of rabbinic stories, 7–8, 18–20, 26, 48–60, 82–94, 121–30, 169–73, 194–97, 213, 265–67, 392n. 56, 393n. 67, 397n. 99; rabbis' right to abrogate Torah law, 166–69, 267; self-criticism in, 279–82; shame, 34–63 passim, 183, 254, 275–77; sin and punishment in, 133–34, 217, 344n. 93, 348n. 27; tendency of creating kinship relations among Palestinian sages, 281, 318n. 37, 337n. 37, 354n. 59, 393n. 67, 405n. 152; view of gentiles, 212–42

Bal, Mieke, 27, 33, 312n. 104, 314n. 117, 331n. 62, 389n. 22

ban, 46, 48–50, 274, 280, 318n. 30, 319n. 53, 322n. 87, 93, 330n. 56, 336n. 24; of R. Eliezer b. Hyrcanus, 37–44, 52, 58–59, 93, 255

*baraitot*, 18–19, 24–25, 35, 128–29, 133–35, 177, 179, 195, 215, 244, 262, 264, 270, 326n. 33, 327n. 35, 342nn. 74 & 80, 344nn. 89 & 90, 347n. 24, 352n. 48, 370nn. 69, 70 & 74, 371n. 78, 391n. 41, 395n. 77; pseudo-*baraitot*, 261–64, 321n. 77, 326n. 33

Beer, Moshe, 203, 207–8, 374nn. 104 & 107, 376n. 109, 378n. 129

*beit midrash*. *See* academy, rabbinic

Ben-Shalom, Israel, 127, 342n. 74, 343n. 86, 403n. 134

biography: late antique, 5–8, 299n. 11; in rabbinic stories, 6–8, 11, 21, 299nn. 12 & 13

Boyarin, Daniel, 14–15, 41, 304nn. 49 & 50, 316n. 16–17, 335n. 21, 371n. 77, 403n. 131

carob tree, 37, 44, 48–49, 51, 53–54, 57, 62, 106, 113–14, 118, 121–22, 126, 252, 258, 320n. 55, 336nn. 22 & 24

chiastic structure, 69–70, 77, 80, 108–9, 117–18, 181, 191–92, 253, 334nn. 9 & 10, 368nn. 50, 52 & 53, 369n. 54, 390nn. 37 & 41

*chriae*, 6–8, 265, 299–300n. 15, 395n. 85

context, of rabbinic tales: cultural, 11–22, 28, 30, 33, 58, 60–61, 65, 77, 90, 93–99, 105, 125–27, 130–33, 150, 164–69, 201–11, 238–41, 243–82, 313n. 108, 322n. 87, 395n. 87, 396n. 95; halakhic, 24, 29, 34, 35, 47, 50, 65, 90, 100–102, 105, 133–37, 160–65, 197–201, 235–38, 243–82; literary, 11–21, 24, 29, 34–36, 47, 50, 59–60, 64, 65, 93–99, 102, 105, 125–26, 133–37, 139, 150, 160–65, 179, 197–201, 235–38, 243–82, 342n. 74, 360n. 112. *See also* literary analysis; redactional context

conversion, 111, 141, 150–52, 264, 350n. 37, 352nn. 48 & 50, 370n. 76
Cox, Patricia, 6–7, 299n. 12

David, King / Davidic, 4, 96–98, 152, 233, 332n. 80, 340n. 61, 396n. 92, 397n. 100; lineage, 198, 201, 205–6, 373n. 98, 384n. 34, 387n. 8, 402n. 127
dialectic: in BT, 16–17, 20, 22, 117, 128, 245, 259, 272, 276, 400n. 113, 401n. 115; process of, 312–13n. 105, 341n. 66, 402n. 127; skill of sages, 117, 124–25, 188–89; technique of give-and-take objecting and solving, 272–75, 279, 282. *See also* argumentation

Eleazar b. R. Shimon, R. (son of RSBY), 20, 53, 55, 61–62, 103, 106–8, 111–17, 122, 125, 135–36, 246, 252, 254, 273, 280, 337n. 36, 340n. 60, 400n. 112; wife of, 335n. 21
Eliezer b. Hyrcanus, R., 34–63 passim, 84, 132, 136, 143, 169, 239–40, 243–67 passim, 278, 316nn. 7, 10, 14, 317nn. 20 & 22, 318n. 33, 319n. 51, 320nn. 55 & 56, 68, 322nn. 83, 90 & 92, 347n. 24, 352n. 51, 384n. 33, 388n. 20, 392n. 56, 394n. 68, 395n. 82, 400n. 113, 404n. 138
Elijah, 37, 41, 47, 52–54, 57–58, 68–69, 76, 79, 90, 93, 106, 113–15, 122, 126, 137, 249–50, 263, 317n. 18, 319n. 51, 322n. 88, 336n. 28, 340n. 61, 365n. 30, 391n. 41
Elisha b. Abuya, R., 29–30, 64–104, 174, 213, 243–82, 323nn. 1–3, 324n. 6, 325nn. 15, 16 & 22–26, 326nn. 31 & 35, 327n. 36, 328nn. 39, 41 & 43, 329nn. 45, 47, 50–52 & 54, 330n. 58, 331n. 60, 332nn. 72, 74, 75 & 79, 389n. 29, 391n. 41; daughter(s) of, 68, 70, 78, 82, 86–87, 89, 91–93, 97, 103, 250, 331n. 64–65, 333n. 86, 365n. 30
Elman, Yaakov, 19–20, 34, 307n. 75, 332n. 81
Elon, Ari, 34–35, 45–46, 63, 315n. 5, 316nn. 8 & 15, 318nn. 38–41, 319nn. 44, 46 & 52
emperor: Persian, 183; Roman, 106, 114–15, 141, 143, 145–46, 148–49, 151–52, 157–58, 163, 169–70, 172–74, 258, 260, 356n. 72
Exilarch / Exilarchate, 30, 122, 124, 129, 201, 205–11, 362n. 5, 364n. 18, 371n. 83, 378n. 120, 379nn. 133 & 135

fabula, 31–32, 50–51, 93, 155, 212, 219, 250, 262–63, 319n. 53, 320n. 56, 331n. 66, 387n. 13, 397n. 75
Fischel, Henry, 6–7, 298–99nn. 7–11 & 14, 300nn. 16 & 18–21, 345n. 96
Fish, Stanley, 11, 303n. 37, 314nn. 116 & 118
flashforward (prolepsis), 92–93, 147, 172, 243–44, 250, 331nn. 62 & 64. *See also* literary analysis
flashback (analepsis), 92–93, 243–44, 250–51, 331n. 64, 389n. 29. *See also* literary analysis
Fraenkel, Jonah: literary analysis of rabbinic stories by, 8–10, 23, 243, 246, 253–55, 281, 301–3nn. 24–35, 327n. 36, 335n. 21, 339n. 54, 345n. 4, 347n. 20, 353nn. 51 & 53, 354nn. 58 & 63, 355nn. 65 & 68, 356n. 73, 368nn. 46, 52 & 53, 371n. 77, 391n. 42, 392n. 48, 405n. 149; New Critical readings, 12, 303nn. 38 & 39; on Palestinian material entering BT text, 328n. 40; production of literarily superior text by, 313n. 113
Friedman, Shamma: on bBM 84a–b, 280; on BT versions of *baraitot*, 342n. 74, 395n. 79; on form criticism of *sugya* in BT, 244, 344n. 88, 359n. 99, 382n. 18; on lower-critical research, 313nn. 110 & 111; on redaction of BT, 17–22, 25, 57, 271, 305n. 59, 306nn. 60 & 62–63, 307nn. 67, 68, 71 & 73, 308nn. 76, 78 & 79, 309n. 87, 310nn. 92 & 96, 312n. 100, 322n. 96, 394n. 67

Gafni, Isaiah, 21–22, 208–9, 271–72, 309nn. 85–87, 384n. 31, 396n. 95, 401n. 115
Gamaliel, Rabban, 38–39, 44–48, 50, 52, 55–56, 58–60, 63, 143, 186, 250, 252, 255–57, 261–62, 264, 280, 316n. 10, 318nn. 30, 33 & 35, 321n. 76, 364n. 25, 366n. 41, 375n. 108, 388n. 20, 391n. 45, 392n. 50, 393n. 66, 395n. 82, 398n. 106, 402n. 123
Genette, Gérard, 27, 92, 251, 312n. 104, 314n. 114, 319n. 50, 331n. 63, 353n. 56

genres, literary, 312n. 103; classical literature, 5–9; of rabbinic stories, 3–9, 14, 19, 21, 299n. 11
gentiles, 111, 119, 132, 134–35, 212–82 passim, 384nn. 29, 32 & 40, 385n. 45, 386n. 55
Geonim / Geonic, 207, 209–10, 379n. 135; academies, 204, 210, 270–72, 379nn. 135 & 138; customs, 203–5, 344nn. 93, 379n. 133; sources, 17, 21, 204, 207, 210; time period, 210, 245, 261, 270–72, 385n. 46, 397n. 102, 398n. 104
Gilat, Yizhaq, 166–69, 359n. 101
Goodblatt, David: on BT stories, 177, 195–96, 362nn. 1, 3–5, 363n. 13, 365n. 31; on rabbinic institutions in Amoraic period, 21–22, 271–72, 309nn. 83, 84, 87 & 88, 373n. 101, 398nn. 103, 104 & 107, 399nn. 108 & 109

halakhah / halakhic, 1, 14–15, 17, 23, 31, 43, 61–62, 120, 149, 151, 163–64, 173, 244, 252, 265, 269, 280, 349–50n. 31, 350n. 32, 359n. 93, 367n. 41, 389n. 30
*halbanat panim* ("whitening the face"). *See* shame
Halivni, David Weiss: on composition and redaction of BT, 15–22, 25, 57, 305nn. 52, 54–58, 197 & 244, 306n. 65, 307n. 71, 309n. 87, 390n. 34, 401n. 119; on "The Oven of Akhnai," 34, 314–15n. 1; Stammaitic preference for give-and-take debate, 125–26, 250, 272
Halperin, David, 90, 329–30n. 55 & 57
Hayes, Christine, 168, 360n. 105
Head of the Court, 177–79, 181, 183–84, 196, 205, 210–11, 363n. 13, 366n. 38, 369n. 54
heavenly voice (*bat qol*), 1, 34, 37, 40–42, 47, 49–51, 53, 60, 63, 69–70, 72, 75–76, 80–81, 84, 87–93, 99, 102, 107–8, 114–15, 121–22, 124–26, 188, 251, 280, 282, 319n. 51, 327n. 36, 328nn. 41 & 43, 329n. 50, 330n. 58, 336n. 23, 365n. 26
Hebrew: Amoraic, 398n. 103; biblical, 249; rabbinic (Tannaitic), 249, 261–62; in stories, 108, 127, 213, 215–19, 380n. 2, 381n. 5, 382n. 16, 401n. 115, 402n. 123

Heinemann, Joseph, 213, 381n. 7, 384nn. 38 & 40
Herman Geoffrey, 202–3, 205
Hillel: House of, 2, 60, 150, 164, 282, 358nn. 89 & 91, 403n. 137; stories about, 1, 4, 6, 7, 16, 150, 350n. 37, 368n. 47, 380n. 4, 388n. 14, 396n. 98, 403n. 137, 405n. 149
history: attempt to reconstruct from rabbinic tales, 105–6, 176, 206–11, 262, 333nn. 1 & 3, 362nn. 1–5; late antique, 5–8; 19th century conception of, 3–8
homiletical story, 30, 212–42, 249, 263, 269, 380nn. 2 & 4, 381nn. 5 & 6, 384nn. 30, 31, 32 & 40, 385n. 51
Honi the Circle-Drawer, 275, 336n. 24, 368n. 49, 393n. 67, 399n. 108, 401n. 114
honor (*kavod*), 41–42, 59, 100, 132, 134, 179–80, 182–94, 196–202, 209–10, 256–57, 265, 269, 275–77, 282, 364nn. 16 & 17, 365n. 34, 367n. 43, 371n. 82, 374n. 107, 375n. 108, 378n. 129, 395n. 82, 404n. 138

Ima Shalom (wife of R. Eliezer), 35, 39, 43, 45–47, 56, 59, 63, 247, 252, 318n. 37, 319nn. 51 & 52
irony, 8, 23, 41–42, 46, 74–75, 93, 101, 117–18, 120, 151–52, 155, 180, 192, 230, 243, 247–48, 355n. 68, 384n. 40
Israel: land of, 62, 68, 103, 202–3, 277; people (Jews/Israelites) of, 38, 44, 48, 56, 62, 66, 68, 72, 110–11, 116, 118, 126–27, 130, 134, 141, 151–52, 173, 212–82 passim, 321n. 81, 334n. 12, 351n. 44, 352n. 48, 355n. 66, 359n. 94, 384n. 37, 392n. 82

Jaffee, Martin, 214–15, 382nn. 13 & 16
Jacobs, Louis, 19, 176, 195, 307n. 74, 308n. 80, 347n. 22, 352n. 49, 362nn. 2 & 3, 363n. 14, 387n. 4, 392n. 49, 394n. 70
Jerusalem, 29, 84, 139–43, 145–48, 151, 152, 154, 158–59, 165, 169–74, 201, 248, 250, 258, 261, 263, 266, 275, 347n. 23, 351n. 46, 353n. 55, 355nn. 67 & 68, 356n. 73, 357n. 82, 360n. 110, 361n. 112, 393n. 62
Jew(s) / Jewish, 111, 114, 116, 119, 121, 130, 132, 135, 137, 141, 152, 161–63, 167–68,

201–2, 205–8, 210, 229, 235, 237–39, 266–67, 280, 337n. 35, 349n. 31, 352n. 48, 355n. 64, 357nn. 83 & 84, 358n. 86, 373n. 97, 377n. 117, 385n. 45, 386n. 54
Josephus, 139, 345n. 2, 347n. 23, 348n. 28, 353n. 52, 361n. 115

Kahana, Rav, 271, 273, 276, 280–81, 333n. 85, 351n. 43, 365n. 32, 373n. 103, 397n. 100, 400n. 111
keyword, 116, 130, 146, 220, 243, 251–253

lethal gaze, 107–8, 116, 120, 122–26, 340n. 62
Levine, Lee, 105–6, 121, 123, 333nn. 1 & 3, 336n. 27, 340nn. 56–58 & 61, 372n. 91, 398n. 107
lineage, 197–211 passim, 267, 269, 370nn. 72, 73 & 75, 373nn. 97–99, 374n. 107, 375n. 108, 376n. 110, 377nn. 117 & 118. *See also* Patriarch / patriarchal / patriarchate
literary analysis: of Isaiah 43:9, 223–26, 383nn. 21 & 23, 391n. 44; —as methodological tool in this work, 26–27, 29, 312n. 105; methods of regarding rabbinic stories, 8–15, 20–21, 26, 30, 64, 106, 110–11, 176–77, 243–44; of Psalms 2:1–6, 223–26; of specific rabbinic tales: —Elisha ben Abuya, 65, 70–82, 86–93, 245–82, 331n. 60; —"The Oven of Akhnai," 40–48, 58–60, 245–82; —R. Meir's and R. Natan's attempt to depose RSBG, 176–77, 179–90, 196, 245–82, 363n. 10, 368n. 51; —RSBY and the Cave, 105, 110–21, 127, 245–82, 344n. 89; —R. Yohanan b. Zakkai and his escape from Jerusalem, 139–40, 141, 144–60, 245–82; —the "World to Come" and the Fate of the Gentiles, 219–35, 245–82; of symbols, motifs, and themes, 12–14, 27–28, 33, 93–99, 105, 144, 146, 158, 188–89, 194–96, 245–67 passim, 313n. 107, 352n. 48, 364n. 25, 387n. 4, 388n. 14

Marta (daughter of Baitos), 142, 144–46, 153–55, 157–59, 172, 253, 260, 346n. 13, 347nn. 19 & 20, 353nn. 54 & 55, 354n. 58, 360n. 110, 361n. 115, 393n. 62

master-disciple relationship, 7, 73–74, 76, 80–82, 85–86, 90, 98, 195, 327n. 36, 333n. 83, 367n. 43
*meimrot* (Amoraic dicta). *See* Amoraim / Amoraic
Meir, Ofra, 12–14, 303–4nn. 40–48; on homiletical story, 212; on poetics of rabbinic story, 23, 246, 322n. 85, 386n. 2; on RSBY and the Cave, 106, 127, 333n. 2, 334nn. 7 & 8, 337n. 32, 338n. 43, 341n. 68, 344nn. 87, 90 & 91; —on context of PT version of RSBY and the Cave, 121, 123, 339n. 50, 342n. 80; redactional context of rabbinic stories, 265–66
Meir, R., 30, 131, 141, 152, 166–67, 217, 239, 250, 277, 320n. 62, 322n. 83, 341n. 63, 352nn. 49 & 50, 367n. 41, 370n. 76, 392n. 56, 403n. 135; attempt to depose RSBG, 176–211, 243–82, 363n. 10, 364n. 25, 366n. 38, 367n. 43, 369nn. 54, 55 & 57, 372n. 87, 389n. 31, 391n. 41; as student of Elisha b. Abuya, 64–104, 213, 243–82, 324n. 11, 326n. 31, 327n. 36, 328nn. 43 & 44, 329nn. 47 & 54, 330n. 56, 331nn. 60, 62, 64, 65 & 68, 332nn. 74 & 79, 365n. 30, 391n. 41
Metatron, 66, 69–72, 74, 78, 80, 88–90, 93, 95, 98–102, 264, 266, 324n. 14, 325nn. 19, 22 & 26, 326nn. 27 & 30, 327n. 36, 329n. 55, 330n. 58, 332n. 74, 391n. 41
midrash / midrashic, 70, 86, 90, 105, 182, 225, 265, 333n. 5, 335n. 19, 337n. 35, 338n. 43, 352n. 48, 363n. 15; collections of Amoraim, 25, 64, 70, 86, 105, 335n. 19
Mishnah, 4, 15, 18, 23–25, 35, 40, 48, 50, 59, 79, 94, 98, 100–101, 133, 135–37, 139, 160–63, 166–67, 182, 197–202, 214, 235, 237–38, 244, 262, 265–67, 279, 322n. 89, 324n. 11, 328n. 44, 333n. 84, 340n. 61, 357nn. 76, 80 & 83, 358nn. 86, 87 & 89, 359n. 93, 360n. 112, 364n. 25, 366n. 38, 370nn. 69, 74 & 75, 372nn. 86 & 95, 374n. 104, 385n. 45, 393n. 66
*mitzvot* (commandments, good deeds), 73–74, 81, 98–99, 110, 116, 126, 132, 135, 137, 168, 170, 232–34, 236–37, 239, 241, 325n. 20, 344n. 93, 361n. 112, 386n. 54; seven

*mitzvot (continued)*
   Noahide commandments, 217, 222–23, 229–30, 232, 234, 239
Moses, 137, 150, 216, 247, 271, 274, 317n. 19, 350n. 39, 374nn. 104 & 107, 376n. 111, 403n. 133
myrtle(s), 107, 116, 118, 122, 135–37, 266, 339n. 52; and Jews, 337n. 35

narrative / narratological: art, 245–67, 388nn. 15 & 18; context, 34; discourse, 31–32, 87, 237, 245–67 passim, 282; drama, 248–49; exegesis, 65, 101, 195, 264–65, 369n. 65; sources, 139–40, 144, 197, 201, 213, 244, 255, 275; structure, 190–94, 219–23, 250–67, 368n. 51; unity 145–47
Natan, R., 30, 37, 41, 52–53, 249–50, 317n. 18, 319n. 51, 320n. 56; attempt to depose RSBG, 176–211, 243–82, 363n. 10, 364nn. 18 & 25, 366n. 38, 367nn. 43 & 45, 369nn. 54 & 55, 372n. 87, 389n. 31, 391n. 41
Nero, 141, 144–45, 151–52, 155–56, 159, 250, 258, 264, 352nn. 48–50, 355n. 66, 370n. 76
Neusner, Jacob, 3–5, 7–9, 20, 139, 207–9, 297nn. 1 & 2, 306n. 66, 307n. 70, 308n. 78, 310n. 91 & 93, 319nn. 46 & 54, 345n. 3, 360n. 107, 371n. 83, 378n. 127, 379n. 132, 386n. 59, 393n. 65, 395n. 88, 404n. 143
New Criticism, 10–12, 14, 127. *See also* literary analysis, methods of regarding rabbinic stories

'*ona'a* (wronging), 36, 38, 43, 46–48, 50, 57–62, 94, 266, 269, 280, 316n. 6, 322nn. 93 & 95
Ong, Walter, 279
oral literature / orality, 214–15, 243, 250–53, 255, 264, 279, 282
Oven of Akhnai, 29, 34–63, 64, 90, 93, 102, 243–82 passim, 335n. 18, 336n. 24, 384n. 33, 387n. 7, 389n. 24, 400n. 113, 403n. 137

Palestine / Palestinian: Jewish culture, 201–3, 229, 322n. 87, 374n. 104; textual tradition of Mishna, 40, 316n. 12; traditions, versions, and sources of rabbinic stories, 7–8, 12, 20, 25–26, 28–29, 58, 87, 92, 121, 127, 136, 139, 169–73, 194–97, 213, 243–82 passim, 328n. 40, 340n. 60, 341n. 63, 343n. 85, 380nn. 2 & 4, 381nn. 5 & 6, 392n. 55, 396n. 92, 401n. 116. *See also* Palestinian Talmud
Palestinian Talmud (PT): Elijah communicating with rabbis in, 322n. 88; esoteric topics in 100–102; literary symbols, motifs, themes, and devices in, 245–67 passim; *meimrot* found in, 18–19; number motifs in, 353n. 57; rabbis' right to abrogate Torah law, 168; redaction of, 25, 311n. 98, 374n. 104; terminology, 341n. 66; version and associated traditions of stories in BT, 243–82 passim, 397n. 99, 399n. 108; version of: — attempt to depose RSBG, 177, 194–95, 200–201, 242–83 passim, 362n. 3; — Elisha b. Abuya, 65, 72, 77, 82–93, 95, 100–102, 243–82 passim, 323nn. 2 & 3, 324n. 14, 325n. 16, 326n. 33; 328nn. 39 & 44, 329nn. 52 & 54, 330n. 58, 331nn. 64 & 68, 333n. 86, 389n. 29; — "The Oven of Akhnai," 35, 39, 48–60, 63, 90, 93, 102, 243–82 passim, 318n. 35, 321n. 76, 322n. 90 & 93, 340n. 62; — RSBY and the Cave, 105–6, 119–20, 121–30, 136, 243–82 passim, 334n. 11, 338n. 40, 340nn. 60 & 62, 341n. 63, 342n. 79; — the "World to Come" and the Fate of the Gentiles, 235–37, 243–82 passim; value of Torah study vs. worldly occupation in, 343n. 85
paralipsis (lateral omission of information), 47, 148, 180, 251, 319n. 50
Patriarch / patriarchal / patriarchate, 176–211 passim, 359n. 94, 363n. 13, 364n. 25, 368n. 47, 378n. 119; link to lineage, 183–85, 189, 193–94, 201, 367n. 42, 375n. 108; office of: — Rabban Gamaliel, 44, 186, 364n. 25, 375n. 108; — Rabbi (Yehuda HaNasi), 78, 162, 179, 183, 189–90, 263, 363n. 11, 369n. 69, 391n. 41; — RSBG, 176–211 passim, 273, 369nn. 55 & 56, 372n. 87, 389n. 31, 391n. 41; referring to the Exilarchate, 206, 209, 379n. 129. *See also* Gamaliel, Rabban; Rabbi (Yehuda HaNasi)
Pitt-Rivers, Julian, 184–85, 193
priests / priestly / priesthood, 201–11, 217,

224, 239, 252, 278, 280, 372n. 94, 373n. 95, 374nn. 94 & 104, 375n. 108
public institutions and structures, 106–14, 118–23, 126–27, 216, 219–22, 228–30, 233, 247–48, 258

Rabba, 166–67, 199, 281, 371n. 82, 374n. 104, 396n. 92
Rabbi (Yehuda HaNasi), 49, 53–54, 68, 70, 78, 86–87, 89, 91–93, 95–97, 103, 161–62, 164, 179, 182–84, 189–90, 211, 250, 263, 273, 275–76, 328n. 44, 331n. 64, 336n. 27, 358n. 86, 362n. 3, 366n. 38, 367n. 43, 373n. 98, 375n. 108, 379n. 129, 389n. 31, 391n. 41, 394n. 75, 400n. 112; Shimon (son), 179, 183, 189–90, 362n. 3, 363n. 11, 367nn. 43 & 45, 369n. 62, 370n. 69, 375n. 108, 389n. 31
rabbinic / rabbis (sages), 136, 141–42, 145–46, 148–49, 151–57, 159, 161–65, 167–69, 173, 176–77, 181–82, 186, 190, 192–95, 209, 214, 246, 271, 279–80, 348nn. 26 & 27, 349n. 31, 350n. 39, 355n. 67, 362n. 5, 363n. 13, 365n. 26, 370n. 73; and bathhouses, 113, 117–19, 121, 123–24, 126–27, 138, 155–56, 247, 252, 257, 259, 334n. 13, 338n. 46; communal behavior and culture, 45, 77–79, 81–82, 98, 101, 136, 149–50, 159, 176–211, 268–82, 348n. 27, 365n. 34, 377n. 117, 378nn. 122 & 129, 405n. 152; ethos, theology, and worldview, 28, 34, 37, 47, 54, 72–75, 97–99, 136, 150, 210, 212, 225–26, 238–41, 250, 268–70, 373n. 95, 405nn. 151 & 152; law (legislation) / legal theory, 160, 165–69, 173, 178–80, 266–67, 349n. 31, 358n. 88, 357n. 76, 359n. 94, 360n. 103, 361n. 112; leadership, 139–75, 197–211, 243–72, 377n. 118, 378n. 129, 393n. 66; literature, 148, 150, 153, 164, 186, 190, 202, 265, 268, 353n. 52, 356nn. 72 & 73, 365n. 31, 374n. 107, 386n. 56; memory, 97, 178–79, 188–92, 198, 214, 329n. 45, 365n. 30; midrash and hermeneutics, 70, 86, 90, 105, 227, 231, 333n. 5, 335n. 19, 337n. 35, 385n. 40, 338n. 43; prohibition (fence), 320n. 64; society and institutions, 21, 111, 159–60, 398n. 107; traditions cited in name of originator, 189, 365n. 34; view of:

— Rome, 106–12 passim, 256, 261; — women, 112, 335nn. 20–21, 338n. 39, 344nn. 92–94
Rav, 36, 62, 90, 107, 109, 119, 123, 129, 235, 268, 276, 342n. 79, 363n. 14, 369n. 62, 378n. 127, 392n. 46, 396n. 92
Rava, 24, 68, 96–99, 130, 132, 136, 166, 168, 179, 190, 195–96, 199, 211, 218, 263, 276, 329n. 52, 360n. 103, 363n. 14, 368n. 49, 372n. 88, 373n. 103, 374n. 104, 378n. 124, 391n 41, 401n. 114
redactional context, 24, 265–67, 304n. 40, 393n. 62
redaction-criticism, 23–24, 29, 60, 144, 312n. 105
redactors / redaction: of BT, 2–4, 14–21, 23–26, 30, 32, 57–60, 86–87, 89–91, 98–99, 101–2, 105, 124–25, 127, 129–30, 133–34, 136, 139, 144, 146, 164–69, 172–73, 177, 193–97, 201, 206, 208, 210, 212–13, 235–37, 244, 254–55, 257–62, 264, 266–67, 281, 330n. 56, 331n. 60, 332n. 75, 333n. 86, 342n. 74, 352n. 48, 353n. 55, 356n. 71, 361n. 115, 366n. 38, 369nn. 60 & 63, 370n. 71, 378n. 119, 380n. 3, 381n. 6, 385n. 42, 390n. 34, 393nn. 62, 65 & 67, 395n. 87; of PT, 82, 90, 101, 200
repentance (return), 67, 70, 72, 74–76, 79, 81, 84–85, 87–88, 328n. 43, 329n. 50
Resh Laqish, 68, 75, 125–26, 200, 218, 241, 262, 268, 272–73, 276, 281, 326n. 35, 328n. 42, 365n. 28, 390n. 34, 391n. 4 & 6, 400n. 111, 404n. 139
Riffattere, Michael, 247
Rimmon-Kenan, Shlomith, 27, 147, 312n. 104; 346n. 17, 347n. 21
Rome / Roman(s), 108, 110–12, 114, 117–20, 125, 127–29, 134, 139, 141–43, 149–53, 155, 156–57, 161–63, 174, 216–17, 219–21, 227–28, 237, 241, 247–48, 252–53, 256, 261, 264, 266, 275, 279–80, 334nn. 12 & 14, 335n. 19, 341n. 68, 342n. 74, 347n. 18, 349n. 31, 354n. 61, 355nn. 64 & 66, 356nn. 70 & 73, 357n. 82, 384nn. 31 & 40, 385n. 42, 404n. 148

Sabbath, 66–67, 71–72, 74, 76, 83–84, 87–88, 92, 102–3, 107, 116, 133, 135–36, 164, 218,

Sabbath (*continued*)
222, 232–33, 266, 270, 326n. 28, 327n. 36, 328n. 43, 336n. 23, 344nn. 93–95, 360n. 103, 378n. 129

Saboraim / Saboraic, 17, 271–72, 381n. 4, 385n. 50, 397n. 102

Sage, rank and title of, 177, 179, 181, 183, 196, 363n. 13

Sasanian Persia(n): culture and society, 127–28, 183, 205–6, 208–9, 216–17, 219–22, 229, 241, 252, 271, 278, 356n. 70, 384n. 31, 397n. 100; literature, 7–8, 271, 300–301n. 22; 384n. 31, 397n. 102

shame, 36, 43, 59, 60–62, 94, 178, 182, 185–88, 191–93, 195, 245, 249, 254, 266, 275–79, 282, 347n. 24, 364n. 16, 369nn. 55–62, 375n. 108, 389n. 31, 402nn. 122–24, 128 & 129, 403n. 132. See also *'ona'a*

Shammai: House of, 2, 60–61, 164, 186, 282, 358nn. 89 & 91, 403n. 137; stories about, 1, 6, 16, 150, 261, 350n. 37, 403n. 137

Shimon, b. Gamaliel, Rabban (RSBG), 30, 168, 176–211, 243–82, 363nn. 10 & 11, 365n. 29, 366n. 38, 367nn. 42–44, 368nn. 47 & 49, 369nn. 55 & 56, 372n. 87, 389n. 31, 391n. 41

Shimon bar Yohai, R. (RSBY), 61; story of hiding in Cave, 29, 105–38, 176, 189, 243–82, 335nn. 17–19, 337nn. 32, 34 & 36, 338nn. 42, 43 & 46, 339nn. 47, 50 & 53, 341n. 63 & 70, 342nn. 79–81, 344n. 89, 399n. 108; wife of, 106, 111–14, 117, 119, 122, 135, 252

Shmuel, 1–2, 37, 51, 54, 94–95, 97, 107, 109, 129, 235, 262–63n. 14, 394n. 74, 401n. 115, 404n. 139

Sinai, Mt., 37, 52, 63, 84, 217, 241; one who has mastered tradition, 199, 371n. 80, 372n. 86

source-criticism, 24–26, 29, 60, 75, 105, 127, 129, 134, 144, 150, 194–97, 260–61, 312n. 105, 318n. 35, 328n. 44, 329n. 54

Stammaim / Stammaitic, 16–23, 26, 30, 32, 57–58, 90, 127, 129, 134, 166, 197, 237, 241, 244, 250, 257–58, 265, 272, 308–9n. 81 & 88, 310n. 90, 319n. 53, 326n. 29, 370nn. 69 & 71, 385n. 49, 392nn. 47 & 51, 393n. 62, 405n. 152; time period and cultural setting of, 125–26, 168, 176, 189, 197, 200, 244–45, 268–82. See also redactors / redaction

study-verse of child, 67, 69–70, 76, 79, 88, 93, 141, 151–52, 159, 188, 253, 352n. 48

*sugya / sugyot*, 2, 23, 101, 197, 265, 275, 344nn. 88 & 94, 370nn. 70 & 71, 381n. 4, 385n. 50; aggadic, 19, 129; Amoraic (proto-*sugyot*), 134, 237, 244; halakhic, 129, 134, 252; relating to stories, 35, 40, 43, 57, 60–61, 65, 94–99, 128–29, 133–34, 166–69, 177, 179, 198–201, 206, 235–37, 240, 328n. 42, 333n. 86, 343n. 81, 354n. 60, 359n. 99, 381n. 4; structure of (legal *sugyot*), 16–19, 21, 57, 213, 215, 236, 244, 248, 250, 254–56, 258–59, 263–64, 267, 282. See also argumentation; dialectic

Tannaim / Tannaitic: academy (in Stammaim's opinion), 176–211, 271–72; anecdotes concerning, 309n. 88; legislation, 168, 357n. 76, 359n. 94; oral traditions of, 48, 401n. 119; pseudo-Tannaitic sources, 261–62; relations with R. Eliezer b. Hyrcanus, 49, 52, 58; sources, 55–56, 198, 261–62, 265, 321n. 81, 347n. 24, 392n. 51, 398n. 106; stories of in BT, 3, 237, 261, 265–66, 343n. 81; stories of Tannaitic provenance in BT, 12, 16, 18–19, 131, 240, 244, 261–63, 278, 309n. 88, 326n. 33, 349n. 31, 356n. 72, 358n. 92; teachings, 182; time period, 168, 176. See also *baraitot*

theodicy, 73, 75, 90, 101, 330n. 58, 332n. 75

*tiqqun / taqqana*, 107–8, 118–21, 123, 125–26, 130, 142–43, 160, 162–63, 165–69, 173, 178–82, 246, 248, 252, 280, 341n. 67, 357n. 76, 358nn. 86 & 88, 359nn. 93, 94 & 97, 360n. 103, 361n. 112

Torah, 2–3, 20, 22, 28–30, 34, 58, 61, 64–65, 67–84, 86–89, 91–99, 101, 103, 149–52, 160, 165–68, 176, 178, 181–83, 195, 245, 252, 263, 266–67, 273, 278–79, 282, 320n. 62, 324n. 9, 328nn. 42 & 43, 329n. 50, 330nn. 55, 56 & 58, 332nn. 74 & 82, 333n. 85, 338n. 42, 341n. 71, 352n. 51, 352n. 48, 360n. 103, 361n. 112, 364n. 25, 365n. 32, 366n. 41,

368n. 47, 371n. 78, 376n. 111, 386n. 59, 403n. 133, 404n. 148; crown of, 372n. 94; halakhah based on, 349n. 30; hierarchy based on knowledge of, 197–211, 267, 269, 276–77, 370n. 73, 374n. 107, 375n. 108, 376n. 110, 377n. 118, 379n. 129; and salvation, 212–82 passim, 382n. 17, 384nn. 37 & 40, 402n. 128; study as highest value, 268–70; study of, vs. worldly occupation, 106–38 passim, 343nn. 81–85

Tosefta / Toseftan, 18, 29–30, 48, 64–66, 70–71, 82, 85–86, 90, 101, 163–64, 195–96, 198–99, 264–65, 319n. 53, 325n. 23, 333n. 84, 342n. 76, 358n. 92, 369nn. 63 & 65, 370n. 74

verbal wronging. *See 'ona'a*
Vespasian, 139, 141, 143–46, 152, 156–59, 164, 169–72, 174, 258, 262–63, 279, 353n. 55, 355n. 66, 356n. 72, 360n. 110, 361n. 112

Weiss, Avraham, 140, 346n. 5, 385n. 50
wordplay, 10, 23, 30, 75, 87, 114–15, 153, 181, 243, 246–47, 314, 348n. 28, 353n. 53, 354nn. 60 & 61
World to Come, 66–67, 72, 77–78, 81, 86, 88, 90, 92–93, 95–101, 103, 131, 258, 269, 331n. 64, 402n. 124; and Fate of the Gentiles, 212–82 passim
world ('*olam*), this (the present life), 107, 115–16, 124, 126, 130, 136–37, 226, 248, 252, 254–55, 269, 343nn. 82–85, 348n. 27; greater society, 108, 111–14, 117, 119, 121, 160; vs. World to Come, 66, 72, 77–78, 81, 93, 98, 100–101, 131–32, 228–30, 234, 236, 238, 248, 254–55, 337n. 34

Yarshater, Ehsan, 205–6, 376n. 115, 377nn. 116 & 117

Yassif, Eli, 140, 346n. 6, 347n. 20
Yehoshua, R., 34, 37, 39, 41, 44–47, 49–51, 53–57, 59–60, 84, 143, 169, 240, 252, 255, 261, 318n. 35, 320n. 56, 61 & 65, 336n. 28, 361n. 112, 364n. 25, 375n. 108, 393n. 66, 404n. 138
Yehuda b. Gerim, 106, 108–11, 116, 118–20, 122–24, 127–29, 133–35, 136, 246, 252, 254, 266, 334n. 16, 335n. 18, 338n. 46, 340n. 55, 341n. 70, 344n. 89
Yehuda b. Ilai, R., 37, 46, 51, 54, 94–95, 99, 106, 108, 111, 128, 262–63, 334nn. 16 & 17, 341nn. 68 & 70, 343nn. 81 & 86, 363n. 14, 373n. 103, 378n. 129, 385n. 42, 403n. 135
*yeshiva / yeshivot*. *See* academy, rabbinic
Yohanan, R., 49, 61–62, 67–68, 70, 77, 79, 81, 89, 93, 95–96, 98, 107, 109, 125, 129, 132, 141, 144, 147, 149–51, 154, 177, 179, 190, 195–96, 199–200, 202, 211, 216–17, 250, 258, 260, 262–63, 271–73, 276, 279, 281, 328n. 44, 330n. 56, 331nn. 64 & 68, 343n. 81, 346n. 15, 350n. 41, 351n. 43, 358nn. 89 & 92, 361n. 115, 363n. 11, 365nn. 28 & 32, 370nn. 68, 70 & 73, 381n. 4, 389n. 25, 390n. 34, 391n. 46, 392n. 56, 396n. 98, 400n. 111, 401n. 115, 404n. 139
Yohanan b. Zakkai, R., 29, 92, 139–75, 213, 240, 243–82, 345nn. 1 & 4, 353n. 55, 354nn. 60 & 63, 355n. 65, 66 & 68, 356nn. 72 & 73, 358n. 88, 359n. 93, 361nn. 112 & 113, 394n. 75
Yose, R., 106, 108–11, 128–29, 164, 178, 183, 187, 264, 273, 277–78, 334n. 15, 341n. 70, 342nn. 74 & 76, 358nn. 89 & 92, 404n. 138
Yosef, Rav, 98–99, 143–44, 146, 157–58, 171–72, 199, 216–17, 259, 262–63, 279, 346n. 15, 355n. 68, 356nn. 71 & 72, 366n. 36, 371n. 82, 405n. 151

# Source Index

**BIBLE**

*Genesis*
1:31, 218
24:23, 331n. 61
25:23, 215, 227, 382n. 17
31:7, 231
31:30, 231
32:21, 174
32:23–31, 338n. 43
32:35, 237
33:4, 338n. 43
33:18, 107, 109, 118, 121, 123–24, 126, 129, 258, 341n. 69, 342n. 79
39:14, 231

*Exodus*
4:22, 217, 222
7:3, 351n. 44
15:13, 216
19:17, 217
20:8, 107, 333n. 4
22:20, 35
23:2, 37, 41, 49, 63, 316n. 17

*Leviticus*
16, 13
18:5, 217
18:19, 344n. 92
25:14, 35, 61, 322n. 95
25:17, 35, 61, 322n. 95

*Numbers*
15:17–22, 344n. 92

*Deuteronomy*
3:25, 143, 175
4:11, 84
4:44, 216, 228, 382n. 17
5:12, 107, 333n. 4
7:11, 218
11:14, 130
15:11, 132
22:6, 85
28, 353n. 54
28:36–37, 155
28:43–48, 155
28:49, 352n. 48
28:56, 142, 155, 361n. 115
30:12, 37, 41, 49, 316n. 17
32:35, 235–36
33:2, 217
33:7, 274, 278

*Joshua*
1:8, 130, 136
10:16–17, 340n. 61

*Judges*
19:29–30, 76–77

*I Samuel*
4:3, 170
16:7, 96
21:8, 95
22:1, 340n. 61
22:18, 95
24:4, 340n. 61
25:25, 387n. 8

*II Samuel*
23:8, 397n. 100

*I Kings*
1–2, 387n. 9
8:59, 216
9:4–14, 340n. 61
18:4–13, 340n. 61

*Isaiah*
1:8, 385
10:34, 143, 170, 355n. 66
11:1, 355n. 66
28:26, 279
33:18, 94
41:1–5, 383n. 23
41:21–29, 383n. 23
43, 225
43:9, 215–19, 221–23, 225–29, 235–37, 241–42, 381n. 5, 382n. 17
43:9–12, 223
43:9–15, 225
44:6–8, 383n. 23
44:9, 235–37
44:25, 143–44, 157, 259
45:20–25, 383n. 23
48:22, 67
61:5, 130
61:7, 66, 75

*Jeremiah*
2:22, 67
3:22, 66–67, 85, 87–88
4:30, 67

*Jeremiah (continued)*
17:18, 66, 75
30:21, 143
33:25, 218, 222, 268

*Ezekiel*
1–3, 100
2:4, 351n. 44
3:7, 351n. 44
7:19, 142, 155
21:26–27, 351n. 46
25:14, 141, 151, 355n. 66

*Joel*
2:20, 280

*Amos*
9:11, 385

*Jonah*
1:16, 321n. 82

*Habakkuk*
3:3, 217
3:6, 217

*Haggai*
2:8, 216

*Zechariah*
11:7, 277

*Malachi*
2:7, 68, 324n. 9

*Psalms*
2, 225
2:1, 225, 234
2:1–2, 225
2:1–6, 225
2:3, 218, 223, 234
2:3–4, 219, 224–25, 234
2:4, 219, 223
3:4, 372n. 88
9:7, 179
9:18, 239
37:7, 207
39:2, 207
45:11, 68, 324n. 9
50:16, 67, 76, 95–96
52:7, 96
76:9, 218

90:3, 85
95:8, 351n. 44
106:2, 178, 363n. 15
106:23, 317n. 19
109:12, 86, 89, 91–92
110:7, 372n. 88
113:7, 49
116:15, 65
127:5, 278
143:2, 383n. 19
145:9, 86

*Proverbs*
3:15, 200
14:34, 240
15:30, 143
17:22, 143
22:17, 68, 324n. 9
24:6, 278
25:16, 65
28:14, 140, 147, 151–52, 172, 351nn. 44 & 45, 358n. 89

*Song of Songs*
1:4, 65
6:11, 68

*Lamentations*
1:16, 172
3:17, 334n. 13

*Ruth*
3:13, 85, 86, 89

*Job*
2:11, 384n. 35
2:12–13, 42
4:6–7, 61
9:32, 383n. 19
18:19, 68, 78, 89, 91–92
20:15, 96
22:4, 383n. 19
28:17, 66, 73, 75, 80, 84, 87–88
32, 384n. 35
42:10, 83
42:12, 83, 88, 91, 260

*Qohelet*
5:5, 65–66, 70, 83, 87
7:8, 83–84, 88, 91, 260
7:14, 66, 73, 88, 91, 260

9:6, 179
10:8, 320n. 64

*Daniel*
3:13–23, 231
6:7, 225
6:8–24, 231
6:16, 225
7:5, 216
7:23, 216

**RABBINIC LITERATURE**

MISHNA

*Berakhot*
9:5, 366n. 38

*Ma'aser Sheni*
5:9, 55, 257

*Bikkurim*
3:3, 201

*Shabbat*
2:6, 133, 135, 266, 344n. 95
2:7, 133, 266, 344n. 95
16:1, 86, 89
16:8, 55, 257
17:1, 370n. 70
21:3, 358n. 89
24:2, 336n. 23

*'Eruvin*
4:1, 55

*Pesahim*
4:8, 348n. 27

*Sheqalim*
2:5, 366n. 38

*Rosh Hashana*
2:8–9, 255, 393n. 66
2:9, 364

*Ta'anit*
4:6, 165

*Mo'ed Qatan*
3:1, 50

## Source Index

*Hagiga*
2:1, 66, 82, 90, 100–102, 266

*Yevamot*
6:4, 346n. 13

*Ketubot*
4:6, 398n. 106

*Sota*
3:4, 98
7:7, 383n. 27
7:8, 321n. 74

*Gittin*
4:2, 166, 357n. 75, 358n. 88
4:2–5:9, 160, 168
4:3, 356n. 75, 358n. 88, 359n. 99
4:3–5:9, 164
4:4, 356n. 75
4:5, 356n. 75
4:6, 356n. 75
4:7, 356n. 73
4:9, 356n. 75
5:3, 160, 356n. 75
5:4, 357n. 75
5:5, 160, 163, 356n. 75, 357n. 78
5:6, 160, 162–64, 266, 354n. 60, 358n. 88, 359n. 99
5:8–9, 160, 357n. 75
8:5, 166

*Qiddushin*
4:14, 343n. 83

*Bava Metsia*
4:4–7:9, 35
4:10, 35, 266

*Sanhedrin*
6:5, 68–69, 79, 89
10:2, 94–95, 97, 240
10:3, 324n. 7
11:1–2, 317n. 21

*'Avoda Zara*
1:1–2:7, 238
2:1, 238
3:1–4:6, 238
3:4, 334n. 13

*Avot*
1:2, 360n. 112
1:11, 343n. 82
3:14, 396n. 91
4:10, 343n. 82
4:13, 372n. 94
6:4, 343n. 84

*Horayot*
3:7, 370n. 74
3:7–3:8, 370n. 74
3:8, 197, 198, 200–201, 267, 370n. 74, 371n. 76, 377n. 118

*Hullin*
2:8, 327n. 35
12:5, 218

*Bekhorot*
9:8, 179, 197

*Tamid*
7:4, 385

*Middot*
5:4, 321n. 72

*Kelim*
5:10, 36, 40, 48–49, 51, 316n. 12
14:5, 262

*Makhshirin*
1:6, 354n. 60

*Uqsin*
2:1, 363n. 14

TOSEFTA

*Berakhot*
3:20, 399n. 108
6:2, 345n. 96

*Demai*
2:13, 370n. 70
3:14, 342n. 75

*Shevi'it*
4:13, 342n. 75

*Ma'aser Sheni*
5:9, 367n. 41

*Shabbat*
13:14, 55
14:1, 370n. 70
16:7, 163, 265, 350nn. 36 & 41

*Pesahim*
4:13, 380n. 4, 388n. 14, 405n. 149

*Yoma*
1:14, 346n. 13
2:4, 55

*Sukka*
2:11, 55

*Besa*
5:2, 328n. 44

*Rosh Hashana*
2:1, 359n. 94
4:1–4, 359n. 93

*Megilla*
2:4, 342n. 75

*Hagiga*
2:3, 66, 82–83, 89, 100–102, 264, 266, 324n. 14
2:3–4, 65
2:4, 83, 86
2:9, 321nn. 72 & 81

*Ketubot*
5:9, 361n. 115
5:9–10, 346n. 13

*Sota*
7:9, 367n. 43
14:9, 321n. 81

*Gittin*
3:7–8, 357n. 75
3:8, 357n. 78
3:10, 358n. 86
5:6, 359n. 94

*Qiddushin*
1:11, 343n. 83
5:15–16, 343n. 83

*Bava Qama*
50b, 388n. 14

*Bava Metsia*
7:14, 55

*Sanhedrin*
4:7, 376n. 111
7:1, 321nn. 72 & 81
7:7, 195
7:8, 177, 194, 265, 363n. 13, 369n. 65, 395n. 83
7:8–10, 371n. 78
7:10, 195
9:5, 321n. 74
13:2, 240, 386n. 55

*Makkot*
1:3, 342n. 75

*'Eduyot*
2:1, 48, 56, 264
2:10, 337n. 30, 340n. 61

*'Avoda Zara*
6:4, 387n. 4
8:4, 384n. 39

*Horayot*
2:8–10, 198
2:10, 372n. 92

*Hullin*
2:18, 327n. 35
2:22–23, 320n. 64

*Bekhorot*
9:8, 262

*Kelim*
7:2, 342n. 75

*Nidda*
5:17, 55

*Makhshirin*
3:5, 342n. 75

*Yadayim*
2:16, 278, 321n. 74, 367n. 43

PALESTINIAN TALMUD

*Berakhot*
2:1, 365n. 34
2:3, 355n. 66
2:9, 404n. 139
4:1, 255, 330n. 55, 335n. 21, 397n. 99, 398n. 106, 403n. 136
5:1, 399n. 108
8:2, 322n. 88
9:1, 321n. 78
9:2, 56, 345n. 96

*Pe'a*
1:1, 399n. 108
8:7, 335n. 21

*Kilayim*
9:4, 322n. 88, 368n. 47, 388n. 14

*Shevi'it*
9:1, 121–22
10:3, 342n. 75

*Ma'aser Sheni*
4:9, 367n. 41

*Bikkurim*
1:8, 402n. 129
3:3, 176, 194, 201

*Shabbat*
1:2, 321n. 73
1:4, 399n. 108, 403n. 137
8:1, 399n. 108
10:5, 400n. 112

*'Eruvin*
1:7, 321n. 76

*Pesahim*
6:1, 56, 380n. 4, 388n. 14, 405n. 149

*Sheqalim*
1:1, 334n. 12
2:6, 365n. 34
5:2, 321n. 74

*Yoma*
3:9, 55
6:3, 353n. 57
7:1, 378n. 121

*Sukka*
2:4, 321n. 76
5:4, 55

*Rosh Hashana*
1:3, 317n. 25, 321n. 72, 334n. 12

*Ta'anit*
1:4, 393n. 67
3:10, 340n. 61, 399n. 108
4:2, 377n. 119, 378n. 129

*Mo'ed Qatan*
2:1, 340n. 62
3:1, 48, 51, 316n. 12
3:5, 317n. 24, 365n. 34
3:7, 396n. 92

*Hagiga*
1:1, 367n. 43
2:1, 87
2:2, 319n. 47, 340n. 61

*Yevamot*
1;6, 54
4:11, 328n. 44
8:2, 341n. 66

*Ketubot*
1:6, 403n. 135
5:13, 346n. 13, 361n. 115
8:6, 55
12:3, 317n. 24, 322n. 88, 368n. 47

*Nedarim*
5:7, 261
11:1, 340n. 61

*Sota*
3:4, 367n. 43
7:6, 378n. 121
9:13, 365n. 26

*Source Index* *431*

*Gittin*
1:2, 322n. 84
4:2, 360n. 104
5:6, 357nn. 83 & 84

*Qiddushin*
1:7, 399n. 108
2:8, 403n. 135
4:5, 342n. 76
4:6, 341n. 66

*Bava Metsia*
6:4, 55

*Bava Batra*
5:1, 404n. 138
5:11, 404n. 139

*Sanhedrin*
1:1, 342n. 73
1:2, 402n. 123
2:4, 55
8:6, 56
10:3, 337n. 30

*Shevu'ot*
6:1, 322n. 84
9:1, 121

*'Avoda Zara*
1:1, 342n. 73
2:1, 235
3:1, 365n. 26, 394n. 68

*Horayot*
3:7, 321n. 74
3:8, 200, 365n. 26

BABYLONIAN TALMUD

*Berakhot*
3a, 350n. 33
4a, 402n. 127, 403n. 134
5a, 321n. 73
5a–b, 19, 307n. 74
7a, 321n. 69
8a, 343n. 82
10a–b, 56
10b, 366n. 41, 388n. 18
16a, 399n. 108
16b, 350nn. 38 & 39
17a, 90

18b, 401n. 116
19a, 62, 319n. 53, 322n. 93, 326n. 29
20a, 336n. 27, 363n. 14, 387n. 4, 388n. 18
22a, 325n. 22
24b, 334n. 13
27b, 255, 341n. 66, 398n. 103, 402n. 128, 403n. 136
27b–28a, 271, 335n. 21, 375n. 108, 398n. 106
28a, 55, 330n. 55, 366n. 41, 394n. 68
33a, 399n. 108
35b, 130, 343n. 81
37a, 364n. 25
39b, 404n. 139
46b, 378n. 123
55a–57b, 327n. 37, 366n. 41
56a, 356n. 69, 398n. 103
56b, 398n. 103
57a, 398n. 103
57b, 385
58a, 333n. 83, 341n. 62, 345n. 96
58b, 355n. 69, 402n. 122
62a, 333n. 85
63b, 333n. 85, 343n. 86

*Shabbat*
3a–3b, 276, 369n. 62
10a, 132, 334n. 13, 340n. 61
12a, 186
17a, 399n. 108
25b, 334n. 13, 344n. 93
30b–31a, 350n. 39
33b, 128, 266
33b–34a, 29, 105, 122
38a, 129, 264
40b, 334n. 13
46a–b, 276
49a, 341n. 71, 387n. 4
54b, 348n. 27
55a, 378n. 123
56a–56b, 348n. 27
56b, 350n. 33
59b, 341n. 71, 392n. 46
63a, 403n. 134
74a, 372n. 88
88a, 396n. 90
108a, 387n. 4

110a, 320n. 64
114a, 309n. 87, 317n. 24, 398n. 103
116a, 56
118a, 385
118b, 342n. 76
119a, 340n. 61, 365n. 26, 387n. 4
119b, 56
123b, 370nn. 68 & 70
143a, 358n. 89
149b, 334n. 12
156b, 45, 56, 318n. 40, 319n. 42, 402n. 122

*'Eruvin*
13a, 321n. 70
13b, 1, 322n. 93, 351n. 42, 372n. 87
25b–26a, 379n. 129
32b, 341n. 71
53b, 389n. 23
55a, 343n. 82
63a, 56
67a, 402n. 127
96a, 348n. 27
104b, 54

*Pesahim*
7a, 317n. 28
18a, 346n. 13
49b, 405n. 152
51a, 321n. 75
66a, 368n. 47, 380n. 4, 388n. 14, 405n. 149
68b, 268
69a, 278
73a, 349n. 31
87b, 111, 321n. 73
104b, 394n. 74
113b, 278
118a, 321n. 74
119a, 317n. 19

*Yoma*
35b, 330n. 55, 396n. 98
38a, 55–56, 257
38b, 365n. 33
39b, 317n. 25, 353n. 57
71b, 372n. 94
77a, 90

## Sukka

20a, 376n. 111
23a, 55, 321n. 76
26a, 378n. 129
29b, 348n. 27
41b, 383n. 27
44b, 336n. 26
45b, 115, 255
48b, 387n. 4
51b, 352n. 48
52a, 280
53a, 388n. 14

## Besa

15b, 132, 340n. 61
23a, 336n. 27
25b, 378n. 129
39a, 317n. 28

## Rosh Hashana

17a, 337n. 30, 340n. 61
24b, 327n. 35
25a, 56
25a–25b, 255
31b, 353n. 57

## Ta'anit

5b, 325n. 20
9a, 340n. 62, 391n. 46
9b, 61, 366n. 36
13a, 317n. 24
16b, 321n. 69
19b, 255
19b–20a, 174, 353n. 51
20a, 55, 257, 364n. 17
21a, 132, 340n. 61, 387n. 4, 389n. 23, 392n. 54
21b, 401n. 116
23a, 275, 336n. 24, 341n. 66, 368n. 49, 399n. 108, 401n. 114
23a–23b, 367n. 42, 393n. 67
23b, 56, 318n. 40
23b–24a, 391
24b, 336n. 23, 363n. 14
24b–25a, 402n. 122
27b, 396n. 90

## Megilla

3a, 55–56, 257, 364n. 17
7b, 281
12b, 350n. 33
15a, 365n. 34
15b, 54, 238, 279, 404n. 141
16a, 174, 334n. 12
16b, 268, 396n. 92
18a, 363n. 15
21a, 397n. 100
28a, 370n. 73
28b, 272
29a, 319n. 45
31a, 350nn. 38 & 39
31b, 396n. 90

## Mo'ed Qatan

9a, 334n. 16, 334–35n. 17
13b, 342n. 76
15b, 317n. 29
16a, 318n. 36, 319nn. 47 & 48
16b, 387n. 4
17a, 318nn. 30 & 36, 321nn. 71 & 72, 330n. 56, 340n. 61, 404n. 147
17a–17b, 319n. 48
17b, 319n. 47, 341n. 62
20b, 317n. 24
21a, 317n. 29, 342n. 76
25b, 129
27b, 319n. 45
28a, 45, 56, 318n. 40, 319n. 42, 366n. 36

## Hagiga

3a, 367n. 43
3b, 278
5a, 402n. 122
5b, 341n. 62
12b, 328n. 42
12b–13a, 101
14b, 325n. 15
14b–15a, 66
15a, 325n. 15, 326n. 34
15a–15b, 29, 64, 66, 87
15b, 54, 336n. 28
16a, 321n. 72, 404n. 147

## Yevamot

16a, 54, 316n. 12, 365n. 29, 403n. 135
35b–36a, 390n. 34
45a, 341n. 62
47b, 111
63a, 54, 373n. 98
63b, 334n. 13

79a, 334n. 12
89a, 168
89a–90b, 166
89b, 167
96b, 365n. 34
97a, 329n. 48, 365n. 34
105b, 271, 275, 395nn. 77 & 83
108a, 395n. 77
115a, 321n. 76
118b, 348n. 28
121a, 321n. 76

## Ketubot

3a, 359n. 99
3b, 348n. 27
5a, 325n. 20
17a, 319n. 45
26a, 317n. 28, 321n. 73
39a–b, 335n. 20
42b, 341n. 66
52b, 359n. 99
53a, 341n. 71, 388n. 18
62b, 304n. 47, 363n. 10, 370n. 77, 373n. 98, 405n. 149
62b–63a, 335n. 21, 338n. 39, 370n. 77
63a, 367n. 42
66b, 92, 361n. 115
66b–67a, 346n. 13
67b, 56, 318n. 40, 319n. 42, 402n. 122
69b, 340n. 61
77b, 388n. 18
103b, 341n. 71, 375n. 108, 392n. 46, 403n. 133
106a, 271, 336n. 27

## Nedarim

7b, 341n. 62
8a–b, 366n. 41
32a, 396n. 90
41a, 402n. 122
49b, 343nn. 81 & 82, 399n. 108
50a, 318n. 40
91b, 335n. 20

## Nazir

16b–17a, 390n. 34
49b, 320n. 62, 403n. 135

## Source Index   433

### Sota
7b, 309n. 87, 401nn. 115 & 116
10a, 325n. 22
11a, 128
11b, 325n. 22, 334n. 12
13b, 348n. 27
21a, 98, 343n. 85
20a, 321n. 70
25a, 55
31a, 366n. 36
35b, 386n. 57
40a, 350n. 39
46b, 341n. 62
48b, 365n. 26
49b, 368n. 47, 392n. 46

### Gittin
5b, 359n. 100
6b, 54
7a, 207
11b, 365n. 33
31b, 378nn. 125 & 129
34b, 372n. 88
36a–b, 359n. 99
45a, 372n. 88
52a, 256, 367n. 41
55b, 354n. 60
55b–56b, 29, 139
55b–58a, 140
56a, 347n. 20, 352n. 50, 371n. 76
56a–57b, 395n. 77
56b, 55, 257, 354n. 59
57a, 347n. 24, 356n. 72, 391n. 41
57b, 350n. 33, 352n. 48
58b, 354n. 60, 358n. 85
60b, 319n. 46
62a, 378n. 125
65b, 378n. 125
66a, 341n. 72
67b, 378nn. 123 & 128
68a, 401n. 116
73a, 359n. 99
80a, 166, 360n. 103

### Qiddushin
30a, 383n. 28
30b, 278
31a, 239, 386n. 54
31b, 399n. 108
34a–35b, 386n. 54
39b, 88, 332n. 75
39b–40a, 280
40a, 321nn. 71 & 72
40b, 186, 404n. 147
52b, 320n. 62, 403n. 135
69b, 202
70a, 46, 319n. 48, 377n. 119, 387n. 4
70a–70b, 377n. 117, 379n. 129
70b, 373nn. 98 & 99, 377n. 117
71a–b, 202, 373n. 97
71b, 373n. 98
76a, 377n. 117
80b, 335n. 19
81a, 56, 318n. 40, 319n. 42, 402n. 122
81b, 280, 325n. 22
82a, 131

### Bava Qama
14a, 341n. 66
38a, 381n. 4
50b, 388n. 14
58b, 379n. 129
59b, 378n. 123
66b, 341n. 66
81b, 404n. 139
82b, 392n. 46
87a, 386n. 54
92a, 401nn. 115 & 116
94b, 363n. 11, 370nn. 68 & 70
114b, 317n. 28, 321n. 73
116b, 55
117a, 271, 340n. 61, 341n. 66, 351n. 43, 365nn. 28 & 29, 388n. 18, 397n. 100
117a–b, 276, 365n. 32, 400n. 111
117b, 281, 341n. 71

### Bava Metsia
24a, 174
33b, 370nn. 68 & 69
58b–59a, 69
58b–59b, 51
59a, 57, 335n. 20
59a–59b, 29, 34
59b, 257, 336n. 28, 364n. 17
83b–85a, 298n. 10, 304n. 50, 367n. 42
83b–86a, 20, 308n. 76
84a, 125, 262, 273, 281, 391n. 46
84a–b, 280
84b, 53, 271, 272, 273, 335n. 21, 341n. 66, 365n. 26, 366n. 36, 367n. 43
84b–85a, 340n. 61, 350n. 39, 368n. 47
85a, 336n. 27, 366n. 36, 391n. 46
85b, 90, 366n. 36, 401n. 116
86a, 274, 309n. 86, 321n. 82, 401nn. 116 & 118
114a, 54

### Bava Batra
7b–8a, 378n. 119
10b, 240
12b, 398n. 103
16a, 321n. 70
21b, 327n. 39
22a, 281
23b, 365n. 31
54a, 336n. 26
58a, 340n. 61
74b, 321n. 76
75a, 341n. 62
75b, 342n. 76
85b, 403n. 133
89a, 377n. 119, 387n. 4, 404n. 139
90b, 336n. 23
110a, 56
123a, 402n. 122
133b, 365n. 26
133b–134a, 261
164b, 334n. 12
165b, 365n. 31

### Sanhedrin
7b, 319n. 47, 321n. 69
10b–11a, 186, 350n. 39
11a, 365n. 26, 402nn. 122 & 123
17b, 334n. 13
18b, 392n. 46
19a, 342n. 76
19b–20a, 350nn. 38 & 39
20a, 348n. 27
21b, 376n. 111
24a, 372n. 87, 403n. 134

*Sanhedrin (continued)*
25b, 336n. 27
26a, 392n. 46
30a, 367n. 41
31a, 365n. 31
32b, 129
37a, 353n. 52
38a, 379n. 129
41a, 353n. 57
42a, 278, 404n. 141
43a, 387n. 4
68a, 255, 317n. 27
74a, 186
81b–82a, 366n. 36
82a, 278
86a, 328n. 44
88a–88b, 56
88b, 350n. 40
89a, 56
91a, 403n. 133
91a–b, 388n. 14
93a, 348n. 27
95b–96a, 325n. 21
96b, 350n. 33, 352n. 48
97b, 337n. 32
98a, 54
99b, 268, 334n. 12, 396n. 92, 405n. 151
100a, 341n. 62
101b, 388n. 18
102b, 355n. 69
103a, 348n. 27
104b, 103
104b–105a, 332n. 80
105a, 239, 240
106a, 128
106b, 95
107a, 388n. 18
108a, 324n. 7
109a, 129

*Makkot*
10a, 268, 321n. 69, 396n. 92
11b, 341n. 66, 401nn. 115 & 116
24b, 237

*Shevu'ot*
29a, 365n. 33
36a, 319n. 47

*'Avoda Zara*
2a, 235
2a–3b, 30, 212, 385
2b, 127–28, 381n. 4
2b–3a, 127
3a, 396n. 90
4a, 336n. 27
5a, 396n. 90
18a, 322n. 84, 334n. 12, 348n. 27, 350n. 33, 383n. 27
27b, 354n. 59
38b, 378n. 128
40a, 319n. 46
42b, 327n. 35
43b, 327n. 35
50a, 341n. 66
57b, 319n. 46
58a, 372n. 88

*Horayot*
10a, 55
13a, 370n. 72
13b, 256, 329n. 47
13b–14a, 30, 176, 206
14a, 401n. 115

*Zevahim*
35b, 349n. 31
62b, 354n. 59
102b, 334n. 13

*Menahot*
18a, 321n. 74
29b, 271
32b, 321n. 75
35a, 348n. 27
44a, 321n. 75, 404n. 148
53a, 376n. 109
64b, 392n. 46
93b, 365n. 34
99b, 343n. 81
103b, 343n. 86

*Hullin*
6a, 340n. 61
40a, 327n. 35
88a, 317n. 28
92a, 334n. 12
105b, 319n. 47
128b, 349n. 31
133a, 321n. 69, 366n. 36

137b, 271
142a, 88, 332n. 75

*Bekhorot*
28a, 349n. 31
30b, 370nn. 69 & 70
31b, 329n. 48, 365n. 34
36a, 255, 403n. 136

*Keritot*
8a, 387n. 4

*Me'ila*
3a, 317n. 28
7b, 404n. 139
20b, 372n. 88

*Nidda*
14b, 398n. 103
20b, 350nn. 38 & 39
61a, 339n. 50
70b, 343n. 82

TANNAITIC MIDRASHIM

*Mekhilta d'Rabbi Ishmael*

Ki Tisa
1, 342n. 81

*Sifra*

Shmini
1:32, 56

'Emor
16:2, 55

*Sifre Numbers*
69, 338n. 43
115, 321n. 75, 404n. 148

*Sifre Deuteronomy*
37, 396n. 91
40, 342n. 81
48, 396n. 91
281, 346n. 13
305, 331n. 61, 346n. 13
343, 321n. 70
347, 401n. 115
354, 334n. 12

*Midrash Tannaim*
103, 56
172, 55
203, 321n. 70
214, 401n. 115
219, 334n. 12

## AMORAIC MIDRASHIM

*'Avot derabbi natan version A*
4, 144, 169, 346n. 11
6, 144, 346n. 12, 353n. 51, 396n. 98
11, 343n. 82
16, 404n. 148
39, 396n. 91

*'Avot derabbi natan version B*
6, 346n. 11, 360n. 106
13, 346n. 12, 353n. 51

*Genesis Rabba*
1:1, 396n. 91
3:5, 396n. 91
9:5, 75
95, 304n. 47

10:7, 334n. 12
14:1, 352n. 51
17:3, 354n. 59
33:3, 368n. 47
35:2, 337n. 32
38:13, 384n. 36
65:27, 354n. 59
64:9, 334n. 12
65:21, 334n. 12
72:5, 343n. 85
74:10, 350n. 41
78:9, 338n. 43
79:5–6, 342n. 78
79:6, 121
97:8, 401n. 115
97:9, 343n. 85
99:13, 343n. 85

*Leviticus Rabba*
13:4, 336n. 23
16:5, 325n. 20
18:3, 334n. 12
20:6, 322n. 84
21:8, 304n. 47, 405n. 149
22:3, 334n. 12
25:2, 343n. 85
30:12, 337n. 35
34:12, 354n. 59
35:6, 336n. 23

*Lamentations Rabba*
petihta 15, 334n. 12
1:5, 144, 172, 346n. 11, 352n. 51, 353n. 55, 354n. 60, 356n. 72
1:16, 144, 145, 172
4:2, 144, 150, 172, 347n. 18, 347n. 23, 348n. 26, 358n. 92, 393n. 64

*Pesiqta derav kahana*
10:4, 337, 340n. 61
11, 121
18:5, 340n. 62
26:7, 322n. 84
27:9, 337n. 35
28:3, 75

*Qohelet Rabba*
5:5, 325n. 20
7:11, 144, 346n. 12, 352n. 51
10:8, 121

*Ruth Rabba*
6:3, 328n. 43, 332n. 75

*Song of Songs Rabba*
2:16, 343n. 86
8:11, 398n. 106

www.ingramcontent.com/pod-product-compliance
Lightning Source LLC
Chambersburg PA
CBHW031541300426
44111CB00006BA/126